BOLLINGEN SERIES XC · 3

Studies in Religious Iconography by Emile Mâle

EDITED BY HARRY BOBER, TRANSLATED BY MARTHIEL MATHEWS

This Volume Has Been Edited by Harry Bober;
Consulting Editor, Colin Eisler; Assistant Editors:
Elizabeth Parker, Claudia Marchitiello

EMILE MALE

Religious Art in France

THE LATE MIDDLE AGES

A Study of Medieval

Iconography and Its Sources

BOLLINGEN SERIES XC · 3

PRINCETON UNIVERSITY PRESS

Copyright © 1986 by Princeton University Press
Published by Princeton University Press, Princeton, New Jersey
In the United Kingdom: Princeton University Press,
Guildford, Surrey

Translated from Emile Mâle, *L'Art religieux de la fin du
moyen âge en France. Etude sur l'iconographie
du moyen âge et sur ses sources d'inspiration*.
Paris, Armand Colin. First edition 1908;
this volume has been translated from the
fifth edition (revised and corrected), 1949

Library of Congress Cataloging in Publication Data will
be found on the last printed page of this book

ISBN 0-691-09914-6

This is the third of several English translations of works by
Emile Mâle constituting number XC in Bollingen Series
sponsored by Bollingen Foundation

Clothbound editions of Princeton University Press books
are printed on acid-free paper, and binding materials are
chosen for strength and durability

Printed in the United States of America
by the Meriden-Stinehour Press, Meriden, Connecticut
Composed by Princeton University Press, Princeton, New Jersey

This volume, like the preceding one, is concerned with iconography, and one should not expect to find here a history of our schools of art, of their struggles, their triumphs, their evolution. I readily grant that a study of forms would have almost as much interest as the study of controlling ideas. Fundamentally, even the slightest line partakes of mind and spirit: the flow of drapery, the contour line of a figure, the play of light and shadow—all can reveal the sensibility of an epoch as clearly as the subject of a painting. No matter what problem the historian of art tries to solve, he will always be involved with the spirit. But this vast subject would require another book.

The history of iconography we have chosen to write is the history of the relations between art and Christian thought. In fact, Christian thought remained the sole inspiration of our art in the fifteenth century, just as in the thirteenth. The art of the Middle Ages seems to have remained quite apart from the vicissitudes of politics, indifferent to the victorious and the vanquished alike: the only events it took account of were the speculations of theologians and the visions of mystics. We marvel at the fidelity with which art reflected the successive phases of Christianity. It is like a sea, colored only by the sky, luminous and somber by turn. Thus, the serene art of the thirteenth century was followed by the impassioned, sorrowful art of the fourteenth and fifteenth centuries. The theologians of former times, grave men nourished by doctrine, were succeeded by poets who had the gift of tears, inspired men who were all-powerful in moving the heart. They were the disciples of St. Francis of Assisi. Did the artists read their books and listen to their sermons? Possibly, but Franciscan Christianity was presented to them as early as the fourteenth century, and in a way even more likely to appeal to their imaginations. First in Italian art, which was completely imbued with the spirit of St. Francis' disciples, and then in the religious theater, of like inspiration, put before the painters and sculptors the most tragic scenes of suffering, grief, and death. Thus a new iconography was born.

In the past, a superficial glance at the art of the fifteenth century had led me to believe that the late Middle Ages was a period of dissolution. It was nothing of the kind. The iconography of the fifteenth century differs in many respects from that of the thirteenth, but it obeyed rules almost as rigid. We can say that these rules were known all over Europe; Italian artists, however, developed strong personalities very early and were less submissive to these rules than were the artists of other coun-

tries. The iconography that we shall study here, therefore, is for the most part that of France and the northern countries.

As in the preceding volume, France remains the principal object of our study. But in the fourteenth and fifteenth centuries, France was no longer the center from which all ideas radiated as she had been in the thirteenth century; she in turn took ideas from others. We shall see how much she owed to Italy.

Just as in the thirteenth century, there is not a single artistic work produced in the fifteenth century that cannot be explained by a book. The artists invented nothing: they translated into their own language the ideas of others. The subtle perceptions of the amateur, even his most ingenious observations, are not enough to explain a fifteenth-century work of art. There is no point in guessing; we must find the book consulted by the artist, or if the precise book cannot be named, we must at least understand from what great current of religious thought the work derived. Thus, an essential part of our task is the study of theologians, mystics, hagiographers, and sermon-writers of the fourteenth through the sixteenth centuries. As far as the art of the Middle Ages is concerned, this is the only productive approach: through it we touch on the profound sources of the moral life of the times.

WE BEGIN here with the fourteenth century. For, in fact, we see the dawn of the new iconography as early as 1300, but it was only during the reign of Charles VI that its true character appeared. A new Middle Ages began at that time, one far less noble than earlier but more impassioned. Art seems to have a sharp forward edge that penetrates into the future.

It is this iconography, so different from the old, that needs to be made known. Therefore, the center of our book must necessarily be the study of the fifteenth century.

But could we have halted our study at the beginning of the sixteenth century? For those interested only in form, the reign of Francis I might mark a new epoch in the history of art; but for those preferring to pursue the great themes of Christian art, nothing ended with the reign of Francis I. The old traditions continued, and there was still no iconography other than that of the fifteenth century. We must not be misled by the architectural backgrounds done in the manner of antiquity, nor by the symmetry of groupings and the classical correctness of the faces: the subjects remained the same; there were the same naïve legends, the same apocryphal traditions, the same iconographical rules, the same minute details borrowed from the *mise en scène* of the Mystery plays. When Francis I died, medieval iconography was still alive, in spite of the Renaissance and in spite of the Reformation.

When did these seemingly immortal Middle Ages end? They did so on the day that the Church itself condemned them. In 1563, in the final session of the Council of Trent, the theologians made threatening pronouncements: they let it be understood that Christian art had not always been worthy of its high mission, and they decreed that the Church should no longer permit artists to scandalize the faithful by their naïveté or their ignorance.

This was the death sentence for medieval art. To question the credentials of the old iconography was to condemn it almost entirely. And in fact, in the years following the Council of Trent, all our traditions began to disappear one after another. The great tree, once so fruitful, withered and died.

The end of the Council of Trent (1563) therefore marks the natural conclusion of our study.

THE PLAN followed in our first volume cannot be retained for this one. It is true that until the late fifteenth century the ancient conception of the world changed very little. The edifice constructed by Vincent of Beauvais still seemed unassailable, and his plan, to all appearances the very plan of God, still informed every thinking mind. But to keep the great divisions of the *Speculum majus* would make it seem that the art of the late Middle Ages had preserved the encyclopedic character of thirteenth-century art. In the fifteenth century, the time had passed for those colossal works that with their thousands of figures explained the world; a Chartres cathedral could no longer be built. Were we to retain the categories of Vincent of Beauvais and the four chapters of his *Speculum*, those four great entries to his edifice would lend a majesty to the art with which we are concerned that it does not have.

When we have reviewed the innumerable and almost always isolated, dispersed, and unrelated works that comprise the art of the late Middle Ages, we perceive that this seemingly complex art could in reality say only two things.

It recounted first of all, and with a narrative richness and degree of feeling not found in thirteenth-century art, the history of Christianity, the saints, the martyrs, the Virgin, and especially, the history of Jesus Christ. Symbol had prevailed over history in the thirteenth century; in the fifteenth, symbolism, without disappearing completely, faded before reality and history.

In the second place, art taught men their duty. This was considered one of its essential functions. In no century of the Middle Ages had artists been ashamed of being useful; art was never an idle game. In the fifteenth century, it expressed with new force and originality all that concerned human destiny, life, death, punishment, and reward.

Such are the two aspects of the late medieval art. And from them come the two main divisions of this book: *narrative art* and *didactic art*.

TEN YEARS have passed since I finished the first volume of this history of religious art. In the past scholars often made prefatory apologies for such long delays, innocently supposing that readers were impatiently awaiting their next volume. I have no such illusions, but allow me to say that these ten years were needed for my work. The iconography of the thirteenth century could perfectly well be studied in a dozen great cathedrals, but where was I to go to study the iconography of the fifteenth? All over France. Almost anywhere I might come upon a beautiful Pietà, a moving Entombment, a saint's statue of real character, or an unknown stained glass window with its illustrated legend. And how many years has it taken me to examine all these riches!

So I began once more to travel through our provinces. They provide the historian of art his profoundest joys. Everywhere, in the towns, the villages, ancient France welcomed me with the best it had. I often thought of the beautiful inscription on the gates to Siena: *Cor magis tibi Sena pandit*. "Siena opens its heart wider than its gates." This salute to the traveler could be written on the façades of all our old churches. So many works and so many ancient thoughts still capable of stirring us await us there.

For it is in their original setting and not in museums that we must see the works of the Middle Ages. Our museums offer us thousands of curious facts, but they do not show us the impetus behind them. A work of art must be placed within the context of its province, its forests, its waters, and the fragrance of its woods and meadows. To find it, we must seek it out, following the great road. Once we have seen it, we must on our return brood over it for many hours. Then it will set all our inner powers in motion: this is the price it exacts for revealing some of its secrets.

DURING these ten years I have seen a great deal, but I have not seen everything. What I could not see, I was able to study in Paris. The fine collection of photography of *objets mobiliers* brought together in the Rue de Valois and constantly enlarged, has been very useful to me.[1] It is true that they are only the shadow of the originals, but how priceless such documents are for the history of iconography.

The statues and windows of our churches do not tell us everything: often I thought I could see behind them other works that had inspired them. Thus, on the one hand I was led to the study of the miniatures in manuscripts, and on the other, to the prints of the fifteenth and sixteenth centuries. Our Parisian libraries, especially the manuscript and

print rooms of the Bibliothèque Nationale, have almost inexhaustible riches. I will not say that I have seen all their contents: such a claim would make the knowing smile. However, during several years of daily research I have been able to study the essentials. There I was able to see, even better than in our churches, that iconography had its laws in the fifteenth century just as in the thirteenth; it was there also that I sometimes had the pleasure of discovering the models that had inspired the painters, tapestry makers, and glass painters.

A book that embraces more than two centuries, reviews so many works, and touches on so many problems, must necessarily contain more than one error. I apologize for them in advance. When I studied the iconography of the thirteenth century, I had masters: those like Didron and Cahier had shown me the way. This time I had no guide. No doubt it is a great joy to enter "the dark wood" alone, but we risk losing our way.

PREFACE TO THE SECOND EDITION

In the first edition of this book, much importance was given to the influence of the religious theater on the development of iconography. I still believe in the influence of the Mystery plays on art, to be sure, and during these last ten years new proof has been found to add to the old, as we shall see. But it has also become apparent that in certain cases I gave too much importance to the theater. Strangely enough, the subject has been clarified by the fairly recent discovery of the ancient frescoes of Cappadocia and the study of Byzantine works.[1] As early as the ninth and tenth centuries we see in Eastern art the same themes found in the French art of the fourteenth century. Because we did not know their true origin, we attributed several motifs to the theater (and in fact they are to be found there), which date far back to the East.

By what miracle did they arrive at the other end of the Christian world? They came in the most natural way. These ancient themes were transmitted by the Italian artists, by Duccio, Simone Martini, the Lorenzetti, all of whom were students of East Christian art but who added much to what they received. Today this relationship seems established beyond doubt. And now everything hangs together. Such is the train of thought set forth in a first chapter here that was lacking in the first edition.

CONTENTS

IX: Art and Human Destiny: The Tomb 356

I. The many tombs in France in earlier times. The Gaignières Collection. II. The earliest tomb statues and the earliest tomb slabs. III. The funerary image as conceived by the Middle Ages. The nobility of the conception. IV. Tomb iconography. The tomb as testimony to the faith of the deceased. V. Tomb iconography. The tomb as family feeling. VI. The tombs of the Dukes of Burgundy. The Mourners. VII. Changes in tomb iconography. The use of portraits. Death masks moulded on the faces of the deceased. VIII. The statue kneeling on the tomb. The recumbent effigy transformed into a corpse. The kneeling statue and the cadaver both used on the same tomb. The tomb of Louis XII. Its influence. The appearance of pagan tombs.

X: Art and Human Destiny: The End of the World. The Last Judgment. Punishments and Rewards 398

I. The fifteen signs before Doomsday. II. The Apocalypse. Dürer's work and its influence in Germany and France. The windows of Vincennes. III. The Last Judgment. The influence of the Mystery plays. IV. The punishments of the damned. *La Vision de Saint Paul* (The Vision of St. Paul). The journeys of St. Brendan, Owen, and Tungdal to the land of the dead. The influence of these books on art. *Le Calendrier des bergers* (The Shepherds' Calendar) and the mural painting at Albi. The stalls of Gaillon. V. Paradise. The painting by Jean Bellegambe.

XI: How the Art of the Middle Ages Came to an End 439

I. The spirit of medieval art and the spirit of Renaissance art. II. The influence of the Reformation. Gradual disappearance of the Mystery plays. III. The Church in the late Middle Ages and works of art: its tolerance. Paganism. The liberties taken in popular art. IV. The Council of Trent puts an end to this tradition of freedom. Books inspired by the Council of Trent. The *Discorso* by Paleotti. The *De historia sanctarum imaginum et picturarum* (Treatise on Holy Images), by Molanus. The end of medieval art.

Part One

NARRATIVE ART

I

French Iconography and Italian Art

I

The study of early fourteenth-century French iconography seems at first to reveal nothing. In fact, most of the artists recount the life of Christ by faithfully reproducing the models of the preceding age. The thirteenth century seems to have lasted well into the fourteenth. But now and then in a traditional work a scene, an attitude, a detail appears that comes as a surprise.

Let us examine the Portail de la Calende of Rouen Cathedral, and its tympanum devoted to the Passion (fig. 1). It was carved about 1300 and leads us into the new century. The two lower sections contain nothing unfamiliar: the Arrest in the Garden of Olives, the Flagellation, the Carrying of the Cross, the Anointing of the Body, the *Noli me tangere*, and the Descent into Hell—all remind us of hundreds of other such scenes from the thirteenth century. But when one looks up at the Crucifixion filling the vast triangle above, almost everything is new. In thirteenth-century Crucifixions there are only a few figures at each side of the cross: the Virgin and St. John, the lance bearer and the sponge bearer, and sometimes the Church and the Synagogue personified. Such a scene is neither emotional nor pictorial; it is solemn and dogmatic. The Rouen portal, on the contrary, has an abundance of figures— personages never before seen on Calvary.[1] The Jews are assembled at the left of Christ who has just breathed his last; in their midst, the centurion raises his hand to bear witness: "Indeed this was the Son of God."[2] At Christ's right, the holy women surround the Virgin, one taking her hand and the other keeping her from falling; St. John is part of this group. Angels hovering below the arms of the cross make gestures of sorrow. This scene is both moving and pictorial, and nothing like it is to be found in French art before this time.

Where did these innovations come from? Were they the bold invention of the French sculptor? We will think not if we recall that for more than half a century the Italians had been representing the Crucifixion in the way it appears here on the Portail de la Calende.

The Italian origin of several of the new themes that appeared in French art. —Scenes of the Passion: Christ Carrying the Cross. Christ Nailed to the Cross. Christ on the Cross. The Descent from the Cross. The Dead Christ on the Lap of His Mother. The Entombment. —Scenes from the Infancy: The Annunciation. The Nativity. The Adoration of the Magi.

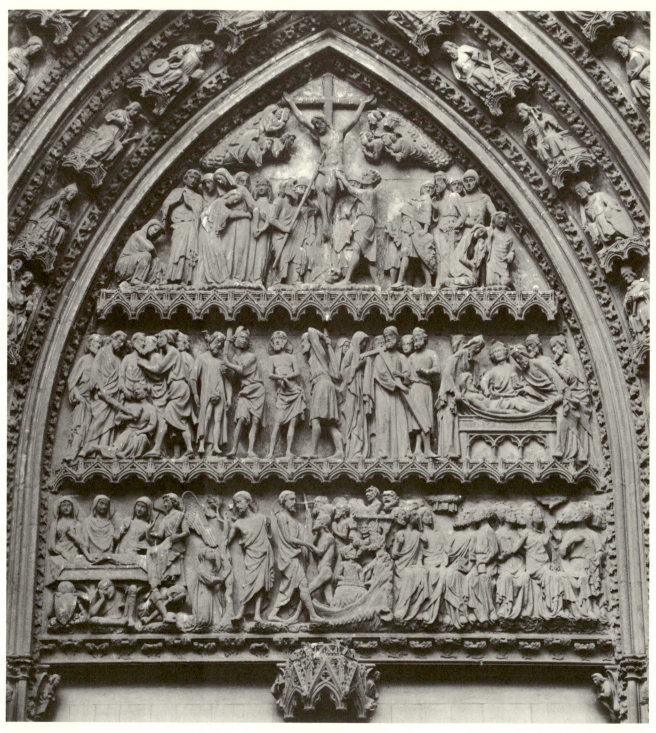

1. Crucifixion. Passion scenes. Rouen (Seine-Maritime), Cathedral, "Portail de la Calende."
South transept portal, tympanum. Late XIII c.

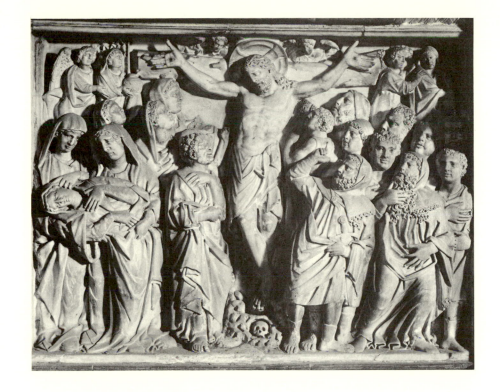

2. Crucifixion. Pisa, Baptistery. Pulpit, side. Relief panel. Nicola Pisano.

As early as 1260, Nicola Pisano had carved a Crucifixion on one of the panels of the pulpit in the Baptistery at Pisa which has the elements of the Rouen Crucifixion (fig. 2). There, also, the crowd has invaded Calvary and presses around the cross; on one side, the centurion raises his hand to proclaim that Christ is indeed the Son of God; on the other, the Virgin faints into the arms of the holy women.

Doubtless the sculptor of Rouen did not know the work of Nicola Pisano, but he had seen miniatures or paintings brought from Italy, and the thirteenth-century Italian painters represented the Crucifixion in the same manner as the sculptors. The fresco painted by Cimabue about 1290 in the Upper Church of Assisi is proof. There is even one detail at Assisi not found at Pisa: weeping angels hover beneath the arms of the cross, as at Rouen.[3]

Thus, while in thirteenth-century France the artists remained faithful to the stern, completely dogmatic Crucifixion of the past, the Italian artists were already representing an emotional scene that seemed to place reality itself before the eyes of the faithful. Since the Italian works preceded ours, there is every reason to believe that ours were inspired by them. A closer examination will furnish the proof.

Of the early fourteenth-century Parisian miniaturists, the most famous today is Jean Pucelle. During the last twenty years, his work has been restored to him by scholars. It is a charming oeuvre, somewhat thin, but elegant and refined. At first sight, nothing could seem more

purely French than Pucelle's fine miniatures; his iconography appears to be completely traditional. But when his compositions are analyzed, it must be admitted that he must sometimes have had Italian models before him.

3. Crucifixion. Hours of Jeanne d'Evreux. New York, The Cloisters, fol. 68v. Jean Pucelle. 1325-28.

Between 1325 and 1328 he illuminated for Jeanne d'Evreux, the wife of King Charles le Bel, a small Book of Hours which has been preserved:[4] the Crucifixion fills one entire page (fig. 3). The new theme used at Rouen is immediately recognizable: on one side, the centurion raises his hand among the Jews; on the other, the Virgin faints among the holy women. Here, also, the imitation of Italy seems evident and is confirmed by the group at the right. The centurion raising his arm, the thoughtful Jew stroking his beard, and the man reclining in the foreground are exact imitations of the figures placed near the cross by Duccio in his famous painting in Siena (fig. 4). The Siena *Maestà*, finished in 1311, was carried in procession to the cathedral by the entire town; fifteen years later, this great work was known and imitated in Paris.[5]

But that is not all; another miniature in Jean Pucelle's manuscript shows the Entombment (fig. 5).[6] The subject is treated with a pathos quite new to French art. Until now French artists had represented not the entombment of Christ, but the anointing of his body: two disciples

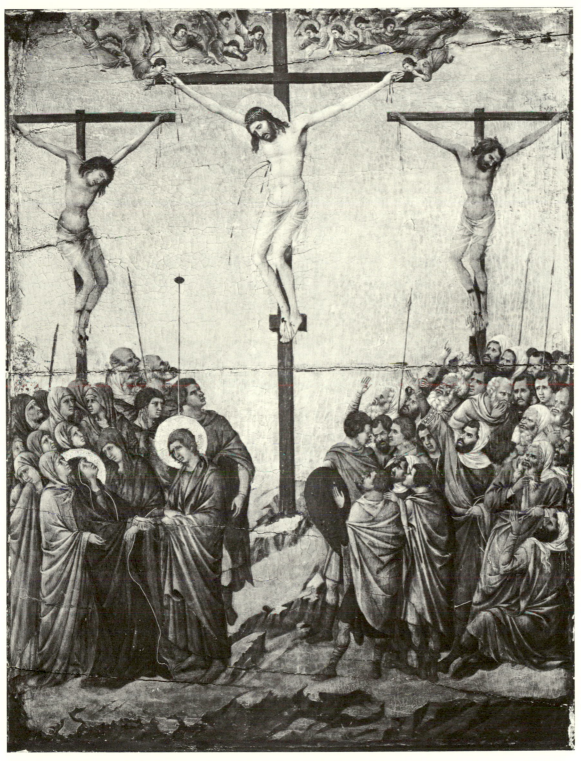

4. Crucifixion. Siena, Cathedral Museum. Panel from reverse of *Maiestà* altarpiece.
Duccio di Buoninsegna. Completed 1311.

held the ends of the sudarium, and a third poured the contents of a phial over the breast of the dead body; these three grave and attentive men showed no sign of emotion.[7] The Virgin and the holy women were rarely present at the scene. Here as elsewhere, the art of the thirteenth century preserved its noble serenity. But with Pucelle's manuscript, everything changes: it contains a real Entombment with all the characters of the drama: John, Joseph of Arimathaea, Mary Magdalene, the Virgin, and the holy women; all at once the scene attains an extreme intensity of feeling. The Virgin throws herself on the body of her son and covers it with kisses: she seems to wish to be buried with him in the sepulcher; a distraught holy woman raises her arms above her head.[8] Here again, Jean Pucelle is imitating Duccio. In the *Maestà* of Siena, there is a very similar Entombment (fig. 6). The Virgin, St. John, and Joseph of Arimathaea all have the same attitudes; one of the holy women makes the same despairing gesture with raised arms. The two compositions would be nearly identical except that in the French miniature Mary Magdalene replaces one of the disciples before the tomb.

These are two of Jean Pucelle's borrowings from Italian art, and there is a third. In his Annunciation scene he has given the angel an entirely new attitude.[9] From the beginnings of Christian art, the angel had remained standing in the presence of the Virgin, retaining the nobility of a heavenly messenger. Here we see the angel kneeling (fig. 7). Through the centuries, the Virgin had become so exalted that the

5. Entombment. Hours of Jeanne d'Evreux. New York, The Cloisters, fol. 82v. Jean Pucelle. 1325-28.

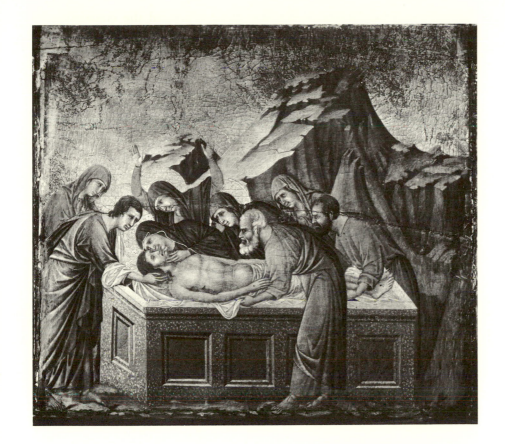

6. Entombment. Siena, Cathedral Museum. Panel from reverse of *Maiestà* altarpiece. Duccio di Buoninsegna. Completed 1311.

7. Annunciation. Hours of Jeanne d'Evreux. New York, The Cloisters, fol. 16. Jean Pucelle. 1325-28.

messenger now kneels before her. At almost the same time as Jean Pucelle, a sculptor represented on the portal of Meaux the angel of the Annunciation kneeling before the Virgin. This theme, which was to have a long history, was not of French origin; we find it as early as 1305 in a fresco by Giotto in the Arena Chapel of Padua.

Thus, during the first quarter of the fourteenth century, Italian art made its way into France and replaced several French formulas with its own.

How could this come about? A few documents preserved by chance are enlightening. In 1298, Philippe le Bel sent his painter, Etienne d'Auxerre, to Rome.[10] There, the French artist could admire in all their freshness the frescoes just completed by Pietro Cavallini at S. Cecilia in Trastevere and at S. Paolo fuori le mura; he could study the history of St. Peter and St. Paul as Cimabue painted them in the atrium of St. Peter's; he could see Giotto at work in the Lateran Palace; and, if he returned home by way of Assisi, he could contemplate the marvel of the church already more than half covered with frescoes. No painter could explore this world of beauty without being affected. The old frescoes, fading day by day and now sometimes no more than a spot of color, leave us with a feeling of nostalgic longing; with what power they must have acted when new on the imagination of artists! A Frenchman discovered in them, with delight, what was still lacking in the paintings of his own country: the play of light and shadow, the sense of space, the soft harmony of clear colors, a moving tenderness. One seemed to enter a world created for the soul. It is unlikely that Etienne d'Auxerre was able to escape the spell of Italian art. We would know how deeply he was affected by it, had the work he did for Philippe le Bel, when he returned to France, been preserved.

Etienne d'Auxerre must have spoken admiringly to the king of the work he had seen in Rome, for documents show that three Italian painters were established in France several years later, in 1304: Philippe Bizuti, his son Jean, and a certain Desmarz, whose name had been gallicized.[11] All three came from Rome. Philippe le Bel had wished to see with his own eyes what these famous Italian masters could do. Was Philippe Bizuti, as is claimed, the same person as the Filippo Rusuti who had signed the mosaics of the façade of S. Maria Maggiore in Rome? There is nothing to prove it. In 1308, the three Italian painters were working in Poitiers in the great hall of the king's palace. In 1322, Jean Bizuti was still in France in the service of King Charles IV le Bel.[12]

Thus Italian art came to France; its charm was too great not to captivate. Italian paintings were soon in demand as also Italian manuscripts.[13] In the Bibliothèque Nationale there is a manuscript with the

text in French, but the miniatures are Sienese;[14] it belonged to Jeanne d'Evreux, the wife of King Charles IV. Was it already in her possession when she was queen, that is, from 1325 until 1328? Or did she acquire it later? We do not know. A book of this kind proves that Italian art had already made a conquest among cultivated people. These beautiful miniatures devoted to the lives of the Virgin and of Christ naturally spread the new iconography. It was enough that the Queen showed them to her artists to admire. They could not be but charmed by the altogether human tenderness that had crept into the sacred scenes, by the soft colors, the celestial blues, the white robes flecked with gold, the small churches with spotless marble walls.[15]

Italian painters had come to Paris in the time of Philippe le Bel and they reappeared in Avignon in the time of Benedict XII and Clement VI. The popes were excellent connoisseurs: they chose their architects from France, but their painters from Italy. Benedict XII had wished to employ the great Giotto, but Giotto died in 1337, just as he was about to set out on the journey. The Pope, well informed on the merits of Italian masters, then called on Simone Martini of Siena. Very little remains in Avignon of the work of this poet-painter, but his exquisite art must have captivated more than one French artist. His famous altarpiece of the Passion, fragments of which are shared by the Louvre (fig. 15) and the museums of Antwerp (fig. 11) and Berlin, was still being imitated in France at the end of the fourteenth century.[16]

Under Clement VI, Avignon continued to be an Italian art colony: Simone Martini was succeeded by Matteo da Viterbo, who painted the St. Martial Chapel.[17] Among these beautiful legends painted against a background of deep blue, one could imagine that he was in Assisi.

Therefore, it is no surprise to encounter Italian iconography again in the French art of the time of Charles V. In the Parement of Narbonne,[18] now in the Louvre, a work devoted to the Passion, we recognize the now familiar themes. The Entombment (fig. 8), like that of Jean Pucelle (to which it is so closely related), was inspired by Sienese art: the grief-stricken Virgin throws herself on the body of her son, and a holy woman lifts her arms. The Crucifixion (fig. 9) is the Italian Crucifixion, just as it appeared on the portal of the Rouen cathedral: the centurion standing among the Jews raises his hand to bear witness, while the holy women support the fainting Virgin; as in Cimabue's fresco, the angels hover beneath the arms of the cross to gather the blood of the victim in chalices; as in Sienese paintings, the two thieves are crucified on each side of Christ.

The Crucifixion so conceived was henceforth to be the Crucifixion of French artists. Sculptors as well as painters adopted it. Most significant in this connection is the sudden change to be noted in ivories toward

8. Entombment. Harrowing of Hell. *Noli me tangere*. Parement de Narbonne (textile), right section. Paris, Louvre.

the middle of the fourteenth century. Until that time, the ancient theme had been faithfully preserved: the Virgin and St. John stand at the two sides of the cross; sometimes the lance bearer and the sponge bearer accompany them. About 1350, everything changes; instead of unfalteringly enduring her grief, the Virgin faints in the arms of the holy women, while at the left of Christ the centurion appears among the crowd.[19] The carvers of ivory repeated the old formulas, long remaining faithful to them and changing nothing until after a new formula in the other arts, had clearly replaced the old.

But it was above all in the late fourteenth and early fifteenth centuries that the Italian iconography enriched our traditional iconography. This is the time when the Duke of Berry had his remarkable manuscripts illuminated. Leafing through them, many new themes will be discovered the origin of which is clear.

ONE OF the Duke of Berry's beautiful Books of Hours is now in Brussels.[20] Among the miniatures devoted to the Passion, one is of the greatest interest, for in it can be recognized Simone Martini's Descent from the Cross, almost unaltered (figs. 10 and 11).[21] Two ladders lean against the

9. Crucifixion with saints and donors.
Parement de Narbonne (textile), center.
Paris, Louvre.

tall cross and a disciple supports the body, which is still nailed to the
cross by the feet; the Virgin strains forward with arms outstretched to
receive her Son. Simone Martini's altarpiece was still in Avignon at this
time, unless it was already in Dijon where it was later found. Our
miniaturist had surely seen it, but even though he faithfully imitated
the principal figures, he did not render all the pathos of the original.
In Simone's work, it is not only the Virgin who extends her arms
toward the body of Christ, but John and the holy women also; all the
outstretched arms make a moving drama of his Descent from the Cross.

It is interesting to see a Descent from the Cross so new in character
appear in French art. Instead of the low cross used until then (fig. 12),
there is one so tall that it requires ladders; the Christ, instead of resting
on the shoulder of Joseph of Arimathaea, is suspended between heaven
and earth; the holy women and more disciples are added to the four
figures formerly present—the Virgin, John, and two disciples. The scene
that had once been so noble in its simplicity, if somewhat remote, has
here taken on the aspect of real drama. Such were to be the Descents
from the Cross of fifteenth-century French masters, the Limbourgs and
Jean Fouquet (fig. 13).²² The theme, as we have seen, came from Italy.

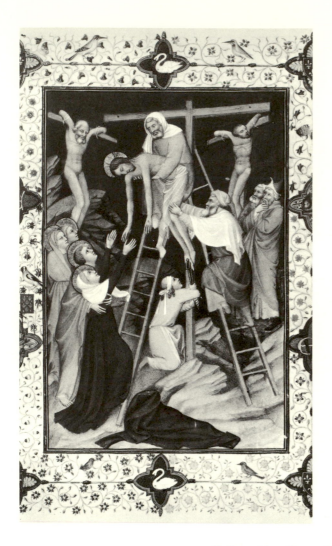

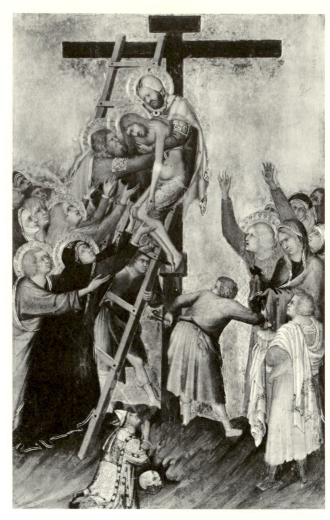

10. Deposition. Hours of the Duke of
Berry. Brussels, Bibliothèque Royale, ms.
11060-61, fol. 194.

11. Deposition. Antwerp, Royal Museum.
Panel from polyptych, tempera on wood.
Simone Martini.

12. Deposition. Paris, Cluny Museum.
Ivory triptych (detail). From St.-Sulpice du
Tarn.

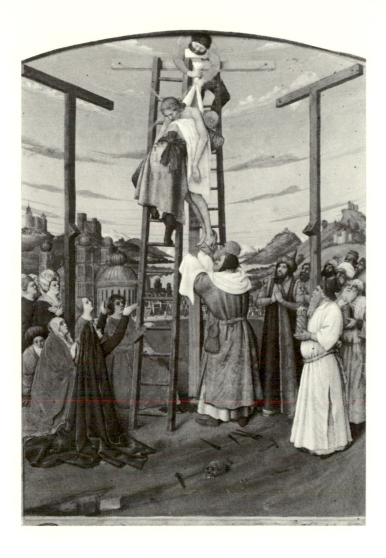

13. Deposition. Hours of Etienne
Chevalier. Chantilly, Musée Condé, ms. 71.
Jean Fouquet.

To turn now to the most beautiful of the Duke of Berry's manuscripts, the *Très Riches Heures* of Chantilly. In no work is the influence of Italian iconography more evident.[23] It is to be noted first in the scenes of the Passion. There can be no doubt that the illuminators of the book, the Limbourg brothers, had also seen Simone Martini's altarpiece; their Christ Carrying the Cross is proof (fig. 14). Christ advances with a tall cross resting almost horizontally on his shoulder, a rope around his neck; he has just seen his mother and John in the throng and turns his head toward them. The Virgin wishes to speak to him, to embrace him for a last time, but a soldier with raised mace thrusts her back.[24]

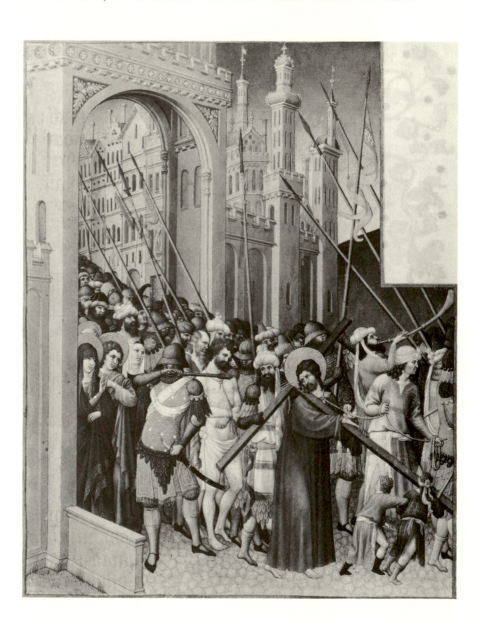

14. Road to Calvary. *Très Riches Heures* of the Duke of Berry. Chantilly, Musée Condé, ms. lat. 1284, fol. 147r. Limbourg brothers.

All these dramatic touches had already been used by Simone (fig. 15); and the similarities extend even to the details, such as the small children accompanying the cortege.[25] Thus, it is due to Sienese art that the scene of Christ Carrying the Cross, which had long been so simple, was transformed into one unfolding pictorially before the walls of a town with beautiful towers. The Limbourgs did not represent horsemen dominating the crowds as Pietro Lorenzetti had done, but these reappear later in the work of Fouquet.[26]

The Limbourgs' representation of the Flagellation was also inspired by Italian art. Until the end of the fourteenth century, the Flagellation

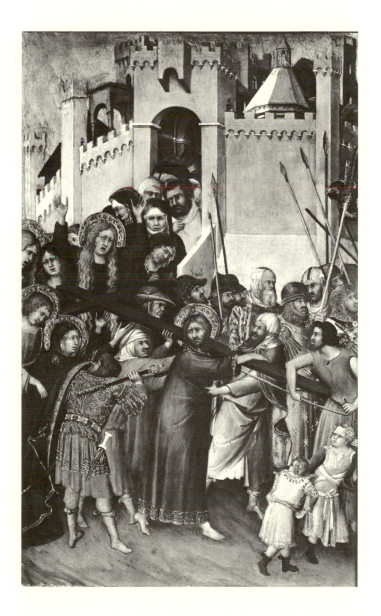

15. Christ carrying cross. Paris, Louvre. Panel, tempera on wood. Simone Martini.

by French artists is a scene of the utmost restraint. It has only three figures: the Christ lashed to a column between two torturers who scourge him by turns; there are no witnesses. With the Limbourgs all this changes; Jesus is flagellated in the praetorium before Pilate seated in the judge's seat; the high priests are present. The victim is tied to one of the tall columns of the hall. Thus, a scene filled with life has replaced the hieratic silhouette of earlier times, the fine but immutable calligraphy of thirteenth- and fourteenth-century manuscripts.

It is again in the art of Siena that we must look for the model used here by the Limbourgs. Duccio, in his great Siena altarpiece, was the first to show Jesus lashed to the column of the praetorium and flagellated in the presence of the Jews and Pilate, who stands on a dais with all the majesty of a Roman procurator. However, it was not Duccio's retable, but the fresco by Pietro Lorenzetti at Assisi that inspired the Limbourgs. In the fresco, as in the miniatures, Pilate is seated on a chair with a back, and Christ is tied to a column of the loggia.

As for the Limbourgs' Crucifixion and Descent from the Cross, there is no point in insisting further: after what has been said, we have no trouble recognizing in them the influence of Siena.

The scenes from the Infancy of Christ as these artists painted them also have several features borrowed from Italian iconography.[27] For the first time, in the *Très Riches Heures* of Chantilly, the Nativity was represented in the manner it would henceforth preserve in French art. Until the late fourteenth century, French artists represented the Virgin of the Nativity reclining on a bed, in conformity with the ancient Byzantine tradition; but it had been a long time since they had shown her turning sadly away from her son, lost in her own thoughts as she meditated on God's plan. They showed her extending her hand to caress his head gently, or drawing him to her and pressing him against her heart, or uncovering her breast like an ordinary woman to give him suck, but always she was shown either seated or reclining on her bed.[28] From the mid-thirteenth until the end of the fourteenth century, this scene was transformed little by little, as artists infused it with more and more tenderness.

In the work of the Limbourgs everything suddenly changes. The bed, an ancient legacy from the East, disappears. The scene takes place under the thatched roof of a hut, and the Virgin kneels before the nude Child (fig. 16), This is the aspect that fifteenth-century French artists would henceforth give to the Nativity; such is the Nativity of Fouquet,[29] of French miniaturists, glass painters, and sculptors.

Did this innovation originate with the Limbourgs? We might at first be tempted to think so, for neither Duccio nor Giotto had painted anything like it, both remaining faithful to the ancient Byzantine tradition of the recumbent Virgin. But if we look more attentively, we

will find that immediately after them the Virgin kneeling before the Child appeared in Italian art. About 1340, Taddeo Gaddi, on one of the panels of the sacristy of S. Croce in Florence, represented the Virgin of the Nativity kneeling.[30] At about the same time, Bernardo Daddi conceived the Nativity in the same manner in his painting now in the Uffizi in Florence.[31] Lorenzo Monaco, at the beginning of the fifteenth century, again used this theme which is also found in the work of Gentile da Fabriano (fig. 31), and was soon to appear in the paintings of all the Italian artists. Therefore it is not surprising that around 1410 the Limbourgs were familiar with an Italian formula that was already half a century old.

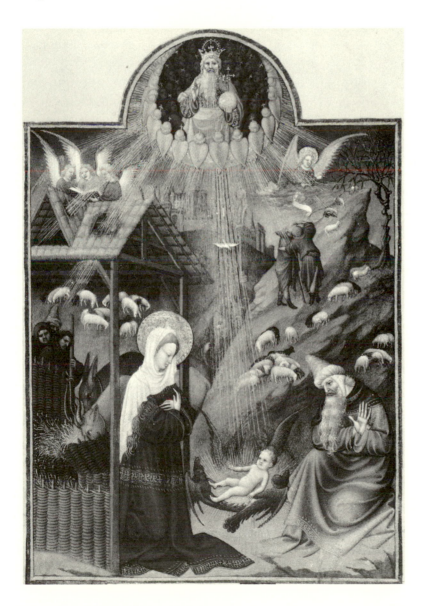

16. Nativity. *Très Riches Heures* of the Duke of Berry. Chantilly, Musée Condé, ms. lat. 1284, fol. 44v. Limbourg brothers.

The Adoration of the Magi with its retinue is one of the most magnificent of the Limbourgs' fantasies (fig. 17); everything here seems untraditional, but one detail betrays an Italian influence: the eldest of the three kings kneels before the Child and respectfully takes his foot in his covered hand and carries it to his lips. In France, this was an innovation. Until the fifteenth century, the aged man was shown kneeling on one knee and simply presenting his offering. But this was not true of Italy: shortly after 1266, Nicola Pisano, in one of the reliefs of the pulpit in Siena, represented the eldest of the magi kissing the foot of the Infant Jesus; at the beginning of the fourteenth century, Giovanni Pisano for the pulpit of Pistoia, and Giotto for the Arena Chapel of Padua, followed his example. This mark of tenderness on the part of the solemn aged man with bald head and white beard was touching. Henceforth, the Italian artists almost never represented the Adoration of the Magi otherwise.[32] Throughout the entire fourteenth century, the Italian formula opposed directly the French formula. It was during the lifetime of the Limbourgs that Italy won out. In French manuscripts and paintings of the early fifteenth century,[33] we sometimes come upon an Adoration of the Magi in which the aged man kisses the foot of the Child. In such works, the influence of Italian iconography is clear.

We could point out other imitations of Italian art in the manuscripts of the Limbourgs, but this is not the place to do so, for here we are concerned only with the major iconographical themes.[34]

Had the Limbourgs been to Italy? Had they studied the frescoes of Florence and Assisi? We do not know. But the Duke of Berry's artists had no need to travel to Italy: he had collections in which they could find Florentine and Sienese paintings that reproduced the creations of the Italian masters.

Italian iconography appeared again in our manuscripts of the Duke of Berry, notably in the *Petites Heures*, now in the Bibliothèque Nationale.[35] This book, illuminated before 1402 and perhaps as early as 1390 under the direction of Jacquemart de Hesdin, is one of the most perfect in existence; the miniatures are marvels of delicate handling; in the clarity of their colors they are equal to the work of Siena and surpass it in the softness of the modeling. The artist seems to have discovered new regions not reached by the Italians, but his work still owes a great deal to Italian iconography.

In this beautiful book we find two scenes not encountered before—two episodes of the Passion previously unknown to French artists.

First we see Christ lying on the cross, which is laid out on the ground,[36] for he was thought to have been nailed to the cross before it was raised upright. The executioners drive nails into his feet and hands. At the time, man's imagination dwelt with a kind of sorrowful curiosity

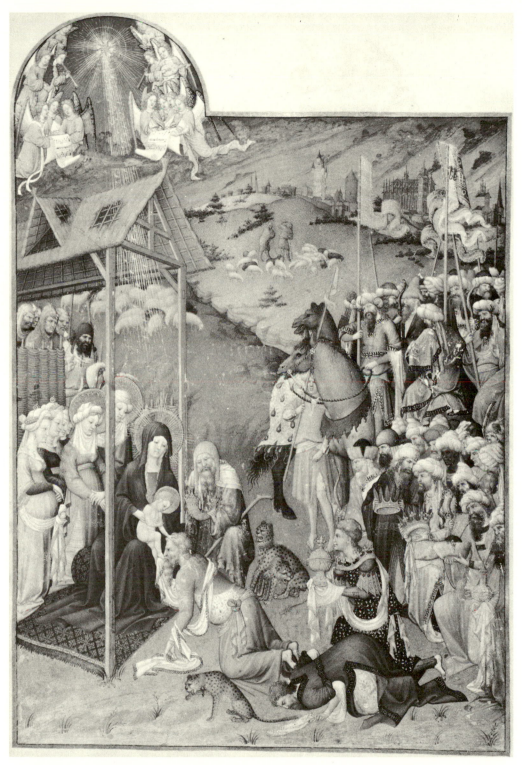

17. Adoration of the Magi. *Très Riches Heures* of the Duke of Berry. Chantilly, Musée
Condé, ms. lat. 1284, fol. 52r. Limbourg brothers.

on all the moments of the Passion. I know of no earlier example of this scene in France. A few years later it was to reappear with a few changes in the *Grandes Heures* of the Duke of Berry, illuminated by the pupils of Jacquemart de Hesdin (fig. 18). During the fifteenth century and until the sixteenth, the Christ nailed to the recumbent cross was fairly frequently represented.[37] Woodcuts contributed most to the theme's popularity. We find it in the *Speculum humanae Salvationis,* one of the most famous books of the fifteenth century;[38] and from there, the scene passed into French Books of Hours, in which the engravings were sometimes no more than copies of illustrations from the *Speculum.* Because they saw it so often, even the sculptors adopted the subject despite the limited plastic value it offered. In the niches of the portal of the charming church at Rue (Somme), the artist carved as best he could the recumbent cross to which the executioners are nailing Jesus.

It is not easy to believe that such a theme came from Italy, for it is found there only rarely, but there is little doubt that it did. In Jeanne d'Evreux's Sienese manuscript which we have already spoken of a miniature represents the recumbent cross to which Christ is nailed (fig. 19); there is a similar miniature in a fourteenth-century Italian manuscript, now in Munich;[39] and another in a Psalter in the Bibliothèque Nationale, illuminated in the fourteenth century by an Italian.[40]

Such images, which reflect the sensibility of the time, struck the imagination of our artists; they imitated them in their own way. Here again, Italy had preceded France.

18. Christ nailed to cross. *Grandes Heures* of the Duke of Berry. Paris, Bibliothèque Nationale, ms. lat. 919, fol. 74r.

19. Christ nailed to cross. Moralized Bible. Paris, Bibliothèque Nationale, ms. fr. 9561, fol. 176r.

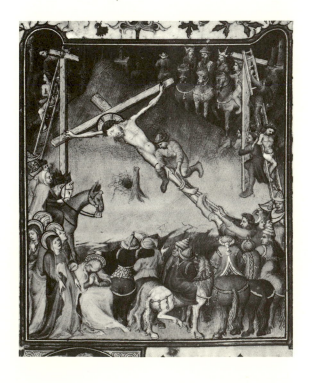

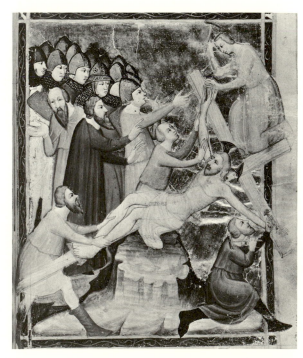

The *Petites Heures* contains another episode of the Passion. The miniaturist painted a scene that was new in French art. Between the Descent from the Cross and the Entombment, the tragedy was suspended for an instant, the action stopped: seated at the foot of the cross, the Virgin receives the body of her son on her lap and holds him in her arms for a last time; John and the holy women surround her.[41] The same scene, somewhat less condensed and richer in figures, reappears in the *Grandes Heures* of the Duke of Berry (fig. 20). In the latter, the Virgin holds the body on her lap while Mary Magdalene bends over the feet of her master, and a holy woman lifts her arms in a great gesture of grief.

Where should we seek the origin of this sorrowful lamentation, this kind of antique threnody? Again, we find it in Italy. In the late thirteenth century, Cavallini painted in the Upper Church of Assisi the Virgin with the body of her son just taken down from the cross by the disciples: the body lies beside her, but the head and shoulders rest on her knees. Giotto, with his incomparable dramatic power, repeated this theme in the Arena Chapel. Again, it was through the Sienese that the subject became known. A painting by Ambrogio Lorenzetti in the museum of Siena (fig. 21) contains several of the features to be found in the miniatures of the *Grandes Heures*: the seated Virgin holds the upper part of Christ's body on her lap while Mary Magdalene bends over the feet; a holy woman lifts her arms like a Greek mourner, and the crosses stand on Calvary.

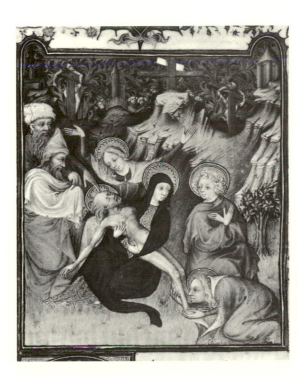

20. Pietà. *Grandes Heures* of the Duke of Berry. Paris, Bibliothèque Nationale, ms. lat. 919, fol. 77r.

Thus, the theme of the seated Virgin holding the body of Christ came from Italy; but French art was soon to make the subject its own. The Italians placed only the head and shoulders of the son on the lap of his mother; French artists placed the entire body there. They isolated the two figures from the rest of the world, doing away with the disciples and the holy women, and thus creating the group, so wonderful in its silent sorrow, that is called the "Virgin of the Pietà."[42]

So this is what French art owes to Italian iconography. It consists, as we have seen, in the rendering of several scenes from the Infancy and in the introduction of heightened feeling into several scenes from the Passion.

To recapitulate these innovations:

In the Annunciation scene the angel kneels before the Virgin, and in the Nativity scene the Virgin kneels before the newborn Child; in the scene of the Adoration of the Magi, the aged man kisses the foot of the Child. These are merely new attitudes, but the scenes of the Passion were more profoundly transformed. Henceforth, Jesus is represented as flagellated before Pilate and the Jews. As he carries his cross, he is accompanied by the throng and observed from a distance by his mother. He is nailed to the cross, which is not erect but lying on the ground. When the spirit has left him, his mother faints into the arms of the holy women, and the centurion, standing among the Jews, proclaims that he is truly the Son of God.[43] He is taken down from the cross by the disciples mounted on tall ladders. At the foot of the cross his mother weeps over him as she holds his body on her knees. Finally, he is buried by the disciples in the presence of the Virgin, the holy women, and John.

One after the other, these innovations appeared in the French art of the fourteenth and early fifteenth centuries. Almost all of them endured and they helped to give late medieval art its character.

21. Lamentation. Siena, Gallery. Panel, tempera on wood, from polyptych from St. Petronilla Convent. Ambrogio Lorenzetti.

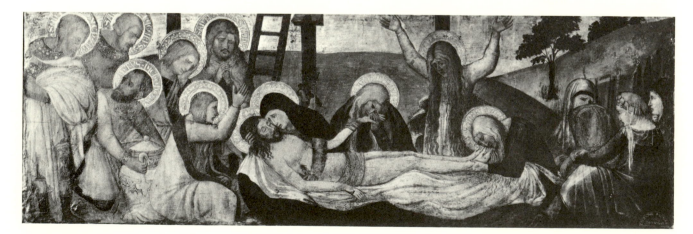

France owed much to Italy, but Flanders, Germany, Bohemia, and Spain owed no less. In its Sienese even more than its Florentine form, Italian art enchanted all of Europe. Poetic Siena, whose savage beauty has always charmed us, has become all the more precious now for it is clear that it must be ranked among those chosen cities whose genius radiated throughout the Christian world.

II

Italian art of the fourteenth century is too closely linked with that of France for us not to trace its origins. Where did this impassioned art, so different from the great art of the thirteenth century, come from? Under what influences did it come into being? Great as Giotto, Duccio, and Simone Martini were, they too had masters. Who were these masters? We can reply today that they were Byzantine artists.

For centuries, Italy had learned from the Near East. In the twelfth and thirteenth centuries, Italian art was completely imbued with Byzantine influences; Italian iconography was closely related to Eastern iconography. The Italian painters, and even the sculptors, owed to Byzantine artists several of the innovations we have in the scenes of the Passion. Let us briefly establish this fact.[44]

As represented by the Italians, the Crucifixion, the principal scene of the Passion, was almost entirely Byzantine. At an early date in the Near East, the illuminated manuscripts of the Gospels showed the centurion bearing witness among a group of Jews at the moment of Christ's death.[45] In the eleventh century, this episode figured in the Byzantine mosaics of S. Marco in Venice.

Very early, too, the Byzantines had broken with ancient symmetry and placed the Virgin, John, and the holy women at the right of the dying Christ.[46] True, they did not represent the Virgin fainting in the arms of her companions, as Nicola Pisano had done, but they did show one of the holy women holding the hand or the arm of the Virgin.[47] Often angels hovered near the cross and expressed their sorrow by their gesture.[48]

Thus, all the features that strike us in the Italian Crucifixions of the thirteenth century had appeared a century or two earlier in Byzantine art. We could cite several others found in Italian frescoes: the crosses of the two thieves stand beside the cross of Christ, and the soldiers cast dice for the victim's robe.

It was in Byzantine art that the Italians found the model for the historical Crucifixion in which all the circumstances surrounding the death of Christ on the cross are united.

The other scenes of the Passion as represented in Italian art had almost originated in Near Eastern art.

What Italian iconography owes to Byzantine art.

The idea of having Pilate and the Jews witness the Flagellation is Byzantine; these figures are to be found in eleventh-century Greek Gospels in the Bibliothèque Nationale.[49]

In the scene of the Carrying of the Cross, it was a Byzantine idea, also, to have Jesus led to the ordeal by a rope around his neck. The frescoes recently discovered in the churches of Cappadocia provide an ancient example of this.[50]

We might think that the Italians were the first to imagine the nailing of Jesus to a recumbent cross, but we would be mistaken. Greek Psalters of the eleventh century, which are copies of even more ancient Psalters, are illuminated by a miniature representing the cross lying on the ground and Christ being nailed to it; a short distance away, we see the hole already dug for the gibbet to stand in (fig. 22).[51]

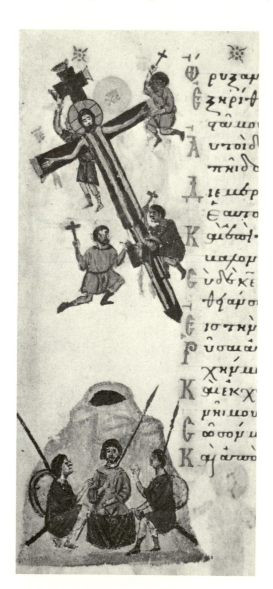

22. Christ nailed to cross. Barberini Psalter. Rome, Vatican Library, Barb. gr. 372, fol. 33v.

The novelty of the Descent from the Cross in Italian art consists partly in the height the artists give the cross; it is so tall that a ladder is required in order to detach the body of Christ. This ladder alters the entire composition. It had appeared as early as the eleventh century in Byzantine art: on the bronze doors of S. Paolo fuori le mura, brought to Rome from Constantinople, was to be seen a disciple mounted on a double ladder, freeing the hand of Christ.[52]

But the imitation is most striking in the moving scene of the Lamentation over the Body of Christ. This great theme appeared early in Byzantine art; if we arrange the examples of it chronologically, we see the theme born before our very eyes.[53] In the twelfth and thirteenth centuries, the Byzantines brought to perfection the composition that was to inspire Giotto. The seated Virgin bears on her knees the head and shoulders of her son; she holds him in her arms and places her cheek against his; one disciple holds his feet, another takes his hand; the holy women lament and the angels in the sky weep.[54] Clearly there was little left for Giotto's imagination.

There were several variations on this scene in Byzantine art, which represented it frequently, and one had a singular career. Instead of representing Christ on the lap of his mother, Byzantine artists placed his body on the Stone of Unction, a red stone stained with the tears of Mary and venerated by pilgrims in the church of the Pantocrator in Constantinople.[55] The composition was changed somewhat: the Virgin no longer bears her son on her knees—standing behind the stone, she bends over him.

A curious phenomenon came about in Italy. Artists who had never heard of the Stone of Unction thought it was a sarcophagus and, instead of representing the Lamentation over the Body of Christ, represented the Entombment, but endowed it with all the pathos of the Lamentation. In the Siena altarpiece, Duccio has the grief-stricken mother throw herself on the body of her son held suspended over the open sepulcher (fig. 6).[56]

Thus, the Italians derived two different scenes from a single model, but in both cases they remained the disciples of the Byzantines.[57]

It was the Byzantines, then, who transmitted some of the themes of the new iconography to Italy in the thirteenth century. The East preceded the West, and did so by several centuries. The East had understood much earlier than the West the reality of the sorrow of the Saviour's Passion. Very early, the fathers of the Greek Church had begun to meditate on the wounds of Christ and the sufferings of the Virgin at the foot of the cross. These refined Hellenic natures were capable of fully feeling all. It is strangely surprising to discover in the *Sermons* of George of Nicomedia, written in the eleventh century, an entire range of feelings such as was to appear in the West only five

hundred years later. George expressed the anguish of the Virgin on Calvary with all the power of our late medieval mystics. "When men believed that Christ was dead," he wrote, "when the throngs had disappeared and the soldiers retired for their meal, then might the Virgin approach the cross, kiss the feet of her son and the wounds made by the nails, gather the blood that flowed in a stream, and rub it on her eyes and her heart. ... Ah! she cried, would that these nails had been driven into my own members, would that I had felt all his suffering in my own body."[58] The Descent from the Cross is no less moving: "Think of the mother standing, trying to make herself useful," he said. "She takes the nails as they are extracted, she kisses his feet and his hands as they are freed, and tries to press them to her breast. ... When the sacred body has been laid on the ground, she throws herself on it and bathes it with her burning tears."[59]

The *Sermons* of George of Nicomedia are not isolated works; a century later, the same sentiments reappeared with as much force in the work of Simeon Metaphrastes. He wrote a lamentation of the Virgin holding the body of her son on her knees: "O head," he has the Virgin cry, "head torn by the thorns that I feel in my own heart. ... Now, my son, thou art in the arms that once carried thee with such joy. Then I made ready thy swaddling clothes, and now I prepare thy shroud. As a baby thou slepst on my breast; dead, thou sleepest there now."[60]

Thus, in the ninth and tenth centuries, Greek writers had already found the accents that we were to hear only much later in the West; they had created in their imaginations the sorrowful scenes that the Byzantine artists almost immediately translated into art.

In Italy, imbued as it was with Byzantine influences, these works must have been known very early; but they were really understood only after Francis of Assisi opened Italian eyes, and then the Italians, too were deeply moved by the Passion of the Saviour. Through sympathy they began to feel what they had long merely copied without emotion. Only in the time of Cimabue, Giotto, and Duccio did Italian artists make the beautiful creations of the Byzantines their own; it was then that they gave them new life.

III

What Italian iconography owes to the *Meditationes vitae Christi* (Meditations on the Life of Christ), by the Pseudo-Bonaventura.

The Italians added several "pathetic" or picturesque features not to be found in Byzantine art, but their artists did not invent them. They took them from a celebrated book in which something of the spirit of St. Francis lived again: the *Meditationes vitae Christi*, attributed to St. Bonaventura but in reality the work of an anonymous Franciscan of the thirteenth century.[61] Few books have had greater influence on art.

The *Meditationes vitae Christi* differed profoundly from anything the Gospels had previously inspired in the West. Other books had been addressed to the mind; this one spoke to the heart. There is certainly more scholasticism in it than we would like, but it should not be forgotten that the longest ascetic passages were added later, in the fourteenth and fifteenth centuries. The author was writing for a woman, a nun of St. Clare, and he well knew that she wanted only to be moved. Therefore, he offered her a series of vivid scenes from the life of Christ in which historical fact was rounded out by his imagination. Frequently the book reads like a new apocryphal Gospel. The author of the *Meditations* knew things no one else did: for example, that the infant St. John the Baptist so loved the Virgin that he did not wish to leave her arms; that on the day when Jesus and his parents left Egypt to return to Nazareth, the worthies of the country accompanied them beyond the gates of the city, "and one of them, a rich man, spoke to the Child in order to give him money, and the Child, out of love of poverty, held out his hand and thanked him."

The writer searches out the most minute details that would interest a woman; he speaks of household things, and even stoops to puerility. He asks himself what kind of meals the angels might have served Jesus after his forty days of fasting in the wilderness, and this is what he imagines: "The angels went to the Virgin and received from her a bit of the stew she had prepared for herself and Joseph. She also gave them bread, a napkin, and everything necessary. It is likely that she also sent fish, had she been able to find any. Returning to the Lord, the angels spread all these things on the ground and solemnly blessed the meal." But all the book is not like this. In the scenes of the Passion especially, there is real pathos, the work of a great artist.

He was a true artist, in fact, and one closely related in imagination to the Sienese painters who were soon to cover the walls of Tuscan churches with their frescoes. St. Francis of Assisi was a poet, the author of the *Meditations* was a painter; both were true artists and truly Italian. Reading the *Meditations* recalls the frescoes that perhaps already decorated the luminous cloisters of the monasteries the author mentions in passing, and where he had no doubt lived: Colle, and Poggibonsi.[62]

Artist he was, sometimes to the point of taking his inspiration from works of art. Byzantine paintings seem occasionally to have suggested some details of his descriptions,[63] but he owed much more to his own lively imagination and refined sensibility. It was from him that Italian artists borrowed the felicitous touches that contributed to the transformation of the old iconography. Let us review them.

In describing the scene of the Annunciation, the author of the *Meditations* was the first to imagine the angel as kneeling before the Virgin.

Gabriel knelt when he gave his message and listened to Mary's words. But the Virgin herself fell to her knees when she replied to the angel: "Filled with deep devotion, she knelt, clasped her hands, and said: 'Behold the handmaid of the Lord.' "[64] That is why Giotto, in his fresco for the Arena Chapel, depicted not only the angel kneeling, but the Virgin as well. In several instances, the Italian painters of the fourteenth century followed his example.

The author of the *Meditations* was also the first to imagine the Virgin of the Nativity as other than reclining on a bed. He saw her on her knees before her son. "The Mother having fallen to her knees meanwhile before her Son, worshiped Him, and then gave thanks to God, saying, 'I thank Thee, Lord and Holy Father, for giving me Thy Son. I adore Thee Eternal God, and I worship Thy Son who is also mine.' Joseph in his turn also worshiped the Child, and the angels of heaven themselves came to kneel before the newborn Child."[65] All these features are found in the work of the Italian painters. Very early, as we have seen, they represented the Virgin kneeling before her son. Earlier than the French and Flemish painters, they had angels descend from heaven to earth and showed them kneeling before the newborn Child. They already appear in this way in the painting by Bernardo Daddi in the Berlin museum.

The author of the *Meditations* introduced something of the pictorial into the scene of the Adoration of the Magi, a scene until now so simple and grave, and infused it with tenderness. He imagined that the magi kissed the feet of the Child: "The Three Kings then came, accompanied by a great multitude and a noble escort, and they stopped before the hut in which Our Lord was born. Our Lady heard the clamor made by this throng and took the Infant in her arms. They entered the little house, and worshiped the Child on bended knees. . . . Then they offered him gold, frankincense, and myrrh; they opened their treasures and presented them to Him; they spread precious cloth and carpets before Him. Having done so, they kissed His feet, out of great respect and devotion. Who knows whether this Wise Child, to strengthen their love of Him, might not have given them His hand to kiss?"[66] Such is the origin of the new iconography adopted by the thirteenth-century Italian painters for the scene of the Adoration of the Magi.

The scenes of the Passion, already so moving in the work of the Byzantine painters, were told with even more pathos by the author of the *Meditations*. In the Christ Carrying the Cross, he describes the crowd that pressed around Jesus and prevented him from speaking to his mother. "Watch Him advance, bent under His Cross, breathing heavily. . . . His Mother cannot approach Him nor even see Him because of the throng surrounding Him. With St. John and her companions she takes a short-cut to outstrip the crowds so that she may approach Him. She

meets Him outside the gates of the town, at a crossroads. When she catches sight of Him burdened with the enormous wooden Cross she had not seen before, she grew faint with anguish and could not utter a word. Nor could her Son speak to her, beset as He was by those pushing Him on to Calvary."[67] In this scene we recognize the Ascent of Calvary painted by the Sienese. Simone Martini and Pietro Lorenzetti were both inspired by this text. They represented Jesus surrounded by the mob as he carries his cross, and it is at the very moment when the long procession pours out of the town gates that the mother, as in the *Meditations*, sees her son; John and the holy women accompany the Virgin (fig. 15).

The Byzantines had represented the Virgin supported by the holy women at the foot of the cross, but controlling her grief and remaining standing; the author of the *Meditations* described her falling into the arms of Mary Magdalene. To cite the full passage; "Then it came to pass that many soldiers went out of the town to Calvary. They were sent to break the legs of those that had been crucified. Mary and those accompanying her looked and saw these men approaching. They did not know what this meant. Their grief was renewed, their fears and forebodings increased. Now these men arrived with great noise and furor, and seeing that the two thieves still lived, they broke their legs, finished them off, and hastily threw them into a pit. Then they returned to Jesus. Mary, trembling and broken-hearted that her Son might be treated in like manner, had recourse to her only means of defense, her humility. 'Brothers,' she said, 'I pray you in the Name of God, do not torture me further in the Person of my Son, for I am His grief-stricken Mother. ...' But one of the soldiers, named Longinus, now impious and arrogant but later a convert and martyr, scorned her pleas, raised his lance and with it made a wide wound in the Saviour's side. Blood and water flowed from it. Then His Mother, half dead, fell into the arms of Mary Magdalene."[68]

We know how frequently in fourteenth-century Italian art, the Virgin was represented fainting at the foot of the cross.[69] But it is not so well known that the episode of the Virgin's encounter with Longinus and the Roman soldiers is also to be found there. In the Sienese manuscript of Jeanne d'Evreux, a splendid page shows the Virgin, the holy women, and St. John on Calvary, speaking to the mounted soldier (fig. 23). An inscription in French leaves no doubt about the meaning of the scene. Below the miniature we read: "How the Virgin prayed the centurion not to break the legs of Our Lord Jesus Christ, her Son, as he had broken the legs of the two thieves." In a beautiful manuscript illuminated about 1430 for the house of Rohan by a French artist, we find this page reproduced in all its detail (fig. 24).[70] Such was the prestige in France for more than a hundred years of the Italian Trecento art.

23. Crucifixion. Virgin speaking to soldier. Moralized Bible. Paris, Bibliothèque Nationale,
ms. fr. 9561, fol. 178v.

24. Crucifixion. Virgin speaking to soldier. Rohan Hours. Paris, Bibliothèque Nationale,
ms. lat. 9471, fol. 27r.

The Lamentation over the Body of Christ, the great "threnody" endowed with such character by the Byzantine painters, was filled with a new poetry by the *Meditations*. From it the Italian painters learned that Mary Magdalene had been at the feet of her master: "When Joseph of Arimathaea had extracted the nails from Christ's feet, he descended," said the author. "All received the body of Our Lord and laid it on the ground. Our Lady took the head and shoulders to her breast, and Mary Magdalene the feet—the feet at which she had received so great a grace on another occasion. The others stood about and emitted deep groans."[71] We remember that Giotto, while imitating the Byzantines, nevertheless placed Mary Magdalene at the feet of Christ in his fresco for the Arena Chapel of Padua, just as the author of the *Meditations* had imagined her.

In this way the new Italian iconography was formed: it combined Franciscan sensibility with Byzantine pathos, to which the artists of the Trecento added their own ingenuous love of life.

When they entered France, these rich themes began to exert their seductive powers and little by little replaced the old themes.

We see how complex a fifteenth-century French miniature is which represents, for example, the Crucifixion or the Lamentation at the Foot of the Cross. Both parts of the Christian world made their contribution. The Near East had meditated profoundly on these subjects and had laid down their principal lines; the West brought them closer to us by introducing moving details. What learned alchemy! In analyzing these works, we uncover Eastern sensibility and Franciscan tenderness, the nobility of the Greek artists, the poetry of the Sienese painters, and the genial naïveté of the French painters. The art of the thirteenth century is rich in thought; the art of the late Middle Ages was to be, from this time on, above all rich in feeling.

II

Art and the Religious Theater

I

After Italian art, the religious theater made the largest contribution to the transformation of ancient French iconography.[1] Italian art had for the most part acted upon the iconography of the fourteenth century, and the theater upon that of the fifteenth and sixteenth centuries. However, the changes brought about by the Mystery plays were less far reaching than those due to Italian art. As we shall see, our artists borrowed several scenes from the Mystery plays, but above all they copied the costumes and scenery.

We know that the Mystery plays date back to the fourteenth century and are directly related to the liturgical drama of the twelfth and thirteenth centuries. But works from the period before 1400 are extremely rare, and it is exceptional to find even an occasional mention of dramatic representations.[2] In the fifteenth century, on the contrary, not only were the works abundant, but there are references to innumerable performances in all the large towns of Europe. The conclusion is, therefore, that the fifteenth century was the great period of Mystery plays. It was then that the taste for the theater gradually developed, and the plays, somewhat dry in the beginning, began to be enriched with episodes and almost limitlessly expanded.

Until the end of the fourteenth century, in staging the life of Christ the dramatic writers turned for inspiration only to the Gospels, whether canonical or apocryphal, and to the *Golden Legend*.[3] But then they began to consult the book attributed to St. Bonaventura, the *Meditations upon the Life of Christ*, which had until then remained, if not unknown, at least without influence, although it had been written more than a hundred years earlier. Such a book was well suited to beguile dramatic writers. In fact, the author of the *Meditations* had a feeling for drama and proved to be an accomplished disciple of St. Francis, who himself had given his sermons in mime and enacted the Nativity. Like his master, he presents his characters in action and has them speak. He imagined many

The *Meditationes vitae Christi*. Its influence on the theater.

conversations between Joseph and Mary, between Christ and his disciples, between Jesus and his mother. In his book, everyone speaks: God, angels, virtues, souls.

The *Meditations* are both pictorial and dramatic, which is why they so charmed the authors of the Mystery plays, who found in them a source for dialogue as well as setting. And above all, they found imagination, poetry, and feeling—everything that enlivens drama.

It was during the last years of the fourteenth century that our writers came to know the *Meditations*.[4] I find no trace of the manuscript's influence, however, in our anonymous poets who, about 1400, were writing the Mystery plays now in the Bibliothèque Ste.-Geneviève. But, toward 1415, Mercadé, the author of the *Arras Mystery*, frequently borrowed from it. The first dramas influenced by the *Meditations* have probably been lost. After Mercadé, all our dramatic writers drew, more or less, on it: Gréban, Jean Michel, and the author of the *Nativity Mystery* played at Rouen, all knew it perfectly.[5] It was the same in other countries. The Italians, the English, and the Spaniards all owed something to it.

The *Meditations* opens with a scene filled with grandeur. Five thousand years have already passed since mankind was separated by sin from God. The world is somber: the sons of Adam live and die without hope. God, enclosed within his eternity, seems indifferent to the fate of his creatures. But Heaven is moved. Two celestial figures, Mercy and Peace, who are the thoughts of God—"the daughters of God"[6]—appear as supplicants before the throne of the Heavenly Father. "Will He not finally take pity on mankind? Will He not deliver them from death? Should He have created them out of the void only to allow them to fall back into the void?" But at this point two stern figures rise up, Justice and Truth. They also are the daughters of God, but they are as inexorable as Law. "God cannot gainsay Himself," they say. "He condemned Adam and his race to death, His word must be fulfilled."—If he does not pardon them, that is the end of me," Mercy cries.—"It is the end of me if He does pardon them," cries Truth.

The struggle is long between these noble advocates. But in the end God pronounces sentence: "I will agree with both sides," He says; "the sons of Adam shall die, but death will cease to be an evil." Heaven was astonished by these words of Heavenly Wisdom. "To vanquish death," the Heavenly Father continues, "one of the just must consent to die for mankind. Thus, a breach will be opened in death, and through that breach mankind will pass."

Justice and Mercy descend to earth without delay to search out a just man, but they return without finding one. Then God speaks to Gabriel: "Go and say to the daughter of Zion: 'Behold thy King cometh.' " And he sent his Son into the womb of a virgin. It was then that the words of the Psalmist came to pass: "Mercy and Truth have met each other, Justice and Peace have embraced."

This bold way of accusing and justifying God by turn, this dramatic setting for the fundamental dogma of Christianity was not original with the author of the *Meditations*. He himself tells us that he was content to copy and abridge St. Bernard. Thus, we owe the famous "Dispute between Mercy and Truth" to the lyrical imagination of St. Bernard and not, as has been said, to Guillaume Herman.[7] It was from St. Bernard that the Pseudo-Bonaventura, Ludolphus, and many others borrowed it.[8]

We know what an important place the dispute of the Four Virtues had in the early days of our great Mystery plays: it formed the conclusion of the Prologue; it was the natural transition between the Fall and the Incarnation. Mercadé, and Arnoul Gréban, the author of the *Nativity Mystery*, both brought Justice and Mercy, Peace and Truth, before the throne of God. These great figures tower above the tragedy and give it its meaning. It is justice in conflict with love. It would be impossible to make it more clearly understood that the Redemption is a drama within God himself. Our poets had a profound sense that such a scene infused the drama with supernatural grandeur. Nothing is more beautiful than the moment in the *Arras Mystery* when Jesus, victorious over death, goes to sit at the right hand of his Father, and Justice embraces Mercy: the divine soul is reconciled with man and with itself, and returns to its repose. But, alas, how poorly they expressed what they so deeply felt. What pedantry and prolixity! We forget that we are before the throne of God and seem to be rather in some debating hall of the old Sorbonne.

We might ask whether in fact the authors of the Mystery plays owe the idea of the "Dispute" to the Pseudo-Bonaventura and not to St. Bernard himself. The borrowings we shall soon point out might be proof enough that our dramatic poets had had the *Meditations* before them. But a categorical proof exists. The anonymous author of the *Nativity Mystery* had the happy idea of indicating his sources in the margins of his book: there is no other example of such modesty. So, at the beginning of the dialogue between Justice and Mercy, a marginal note tells us that the entire passage is taken from the first chapter of the *Meditations*.

Thus, there is no doubt about it: it was through the Pseudo-Bonaventura that the great scene came into the Mystery plays. The vogue of the *Meditations* was such that the "Dispute" is also found in the English,[9] Spanish,[10] and Italian[11] Mystery plays.

Drama was then in its beginning stages. As we shall see, the Nativity play owes several picturesque features to the Pseudo-Bonaventura. But there is one entire scene that was taken from him. The Holy Family, as it approached the Jordan on its return from Egypt, crossed a desert. Now it was to this place, said the author of the *Meditations*, that St. John the Baptist had withdrawn while still a small child; he had resolved

to do penance even though he had committed no sin. He joyfully received the holy travelers and offered them wild fruit. Then the Holy Family crossed the Jordan and finally arrived at the house of Elizabeth. This curious episode was invented by the Pseudo-Bonaventura,[12] and we search in vain for it in earlier works.[13] The authors of the Mystery plays were not long in noticing it. A Florentine poet, probably Feo Belcari, made it the subject of a sacred drama entitled *St. John in the Desert*. The sole subject of the play, naturally very short, is the meeting between the two children in the desert. They speak gravely of the trying ordeals to come, and in taking leave, the Virgin Mary embraces the child St. John.[14] It is clear that the subject is not, as Creizenach thought,[15] an invention of the poet: he took it from the *Meditations*. The French dramatic authors, although they did not place the two children on the stage, nevertheless did borrow from the Pseudo-Bonaventura. Mercadé, for example, takes the travelers to the house of Elizabeth, and when they ask for John the Baptist, she tells them that he has withdrawn into the neighboring desert.[16]

The scenes of the Passion also reveal the inspiration of the *Meditations*. The medieval theater took a very moving episode from it: Jesus' farewell to his mother before his departure for Jerusalem. "Here we may introduce a beautiful meditation," said the Pseudo-Bonaventura, "of which the Scriptures, it is true, do not speak."[17] On Wednesday of the last week, Jesus supped with his disciples in the house of Martha and Mary. The supper over, he went to his mother and talked with her. "My son," the Virgin said to him, "do not go to Jerusalem where you know that your enemies wish to lay hold of you. Rest here and celebrate the Passover with us." "Dear mother," Jesus replied, "it is the will of my Father that I celebrate the Passover in Jerusalem. The time of Redemption is come; what has been written of me must come to pass; they may do with me as they will." The Virgin pleads; she is only a simple woman, a mother. Her mind cannot understand the workings of Divine Wisdom. She imagines that God can change the eternal order of things and save the human race without making her son die. Beside her, Mary Magdalene is sobbing, in a frenzy over her master (*ivre de son maître*). But Jesus, all gentleness, reminds them that he has come into this world to serve. There is no doubt that he must die, but he will reappear to them transfigured by death.

The author does not present this episode as history, nor even as legend; it is only a meditation, a pious dream that he has had in his cell, a dream born of love of the Virgin. For henceforth, no exercise was to be dearer to the mystics than reproducing within themselves the thoughts of the mother during the Passion of her son.

Thanks to the Mystery plays, this page from the *Meditations* acquired great fame. French dramatic authors always include this last conver-

sation between Jesus and his mother.[18] In reading their diffuse verse, we can only regret the sobriety and restraint of their model, but the humanity behind the idea is touching all the same. The scene must have moved fifteenth-century spectators deeply, and they no doubt accepted it as history.

Throughout the entire Passion, the author of the *Meditations* kept his attention fixed on the Virgin. When Jesus is abandoned to the mockery of the manservants after being brought before Annas and Caiaphas, St. John, who has seen it all, runs to tell Mary what has happened; for the Virgin had come to Jerusalem so as not to leave her son, and stayed in the house of Mary Magdalene. Sobbing, John tells of the betrayal in the Garden of Olives, the mock judgment of the high priest, and the abuse of the crowds. Then the Virgin turns her face to the wall, kneels, and prays: once more she entreats God to save mankind in some other way and preserve her son to her.

She spends the night thus, in prayer. The next day she goes to the road to Calvary: from afar she sees Jesus bent under the weight of the cross, but the crowds prevent her from reaching him. Followed by the holy women, she takes another road and awaits the procession at a crossroads. There she might see her son, but she cannot speak to him. Soon she sees the preparations being made for the torture. Jesus, divested of his garments, stands naked among the executioners. She cannot endure this final outrage. Tearing the veil from her head, she throws it over him to cover his nakedness.[19]

All these incidents, so filled with pathos, form a kind of Passion of the Virgin paralleling that of her son,[20] and we involuntarily think of Roger van der Weyden's famous Descent from the Cross,[21] in which the swooning Virgin is given the same posture as her dead son.

We see what an abundance there was to draw from in such scenes, and the dramatists neglected none of the details furnished by their model. We find them all in the *Passion* of Arnoul Gréban (to cite only one example): the conversation between John and the Virgin, her prayer to God,[22] the detour she takes to come near the procession,[23] her sudden gesture of covering her son's nakedness,[24] all were translated to the stage.

In the *Meditations*, the Pseudo-Bonaventura's imagination did not act upon the Resurrection of Christ and the scenes immediately following. The writer follows tradition and until the moment of the Ascension his story differs little from that of the *Golden Legend*.

But after the Ascension, we are again led to heaven. Followed by the patriarchs, Jesus opens the Gates of Paradise and kneels before his Father. "My Father," he said, "I thank you for giving me the victory." Raising him up, his Father seats him at his right hand. And then all paradise broke into song; never since the beginning of the world had

there been such joy in heaven. On Patmos, St. John heard the playing of forty-four thousand harps, and it was but a faint echo of that ineffable music.[25]

This triumphal scene could not but charm our poets, and was taken up by all of them. In the work by Gréban, Jesus presents to his Father the patriarchs whom he has delivered from death. He says in substance, "Father, here I am: I have finished the journey that you ordained for me in the past." And the Father, filled with grave joy, pronounces this Cornelian verse:

Il suffit, le devoir est fait.[26]

(It is enough. Duty is done.)

Successively, Raphael, Michael, Gabriel, and Uriel sing; then in chorus all the angels celebrate the victory of God.

We see how many episodes the authors of the Mystery plays borrowed from the *Meditations*.

And like the Italian painters, they also borrowed some of the attitudes that were indicated in the preceding chapter.

In the theater, the angel of the Annunciation knelt before the Virgin, and the Virgin knelt before the angel. For this scene, the author of the *Nativity Mystery*, who indicated his sources, did not neglect to cite here the passage of the *Meditations* in which the attitudes of the Virgin and the angel are expressly given.

The Nativity was also presented as it was described in the *Meditations*. At the moment of his birth, the Child is described as lying on the ground, protected only by a handful of straw; the Virgin and Joseph kneel before him to adore him; then the angels come also to bow before their God.[27]

After the Descent from the Cross, the Virgin sits at the foot of the cross and clasps to her breast the dead body of her son.

We can now measure the theater's debt to the *Meditations*. Had it not been for this book, the Mystery plays would lack some of their best scenes. The astonishing thing, and something we seldom think about, is that the Franciscan spirit had been instrumental in reviving medieval drama. St. Francis had renewed everything around him. "Like the sun that rises behind the mountains of Assisi,"[28] he made Italian poetry and art flourish; one of his rays touched the Mystery plays.

II

Certain iconographic innovations created by the author of the *Meditations* come into art by way of the Mystery plays.

We have shown what French art owed to the *Meditations* through the intermediary of Italian art; let us now show what was owed to it through the intermediary of the Mystery plays. The Mystery plays rendered the dreams of the Pseudo-Bonaventura visible. Our artists must have been

particularly affected by them, for they not only attended the plays, but collaborated on them. In the fifteenth century, Jean Hortart of Lyon, painter and artist in stained glass, made "pourtraicts"—that is, scenery—for the Mystery plays.[29] In the sixteenth century, the painter Hubert Caillaux was the producer of the *Passion Mystery*, played at Valenciennes;[30] and at the same time, he acted in the play. In a note, he tells us that he played four different roles: the black king, Gamaliel, one of Herod's knights, and a priest of the law. This is a clear example of the way in which the two arts were brought together.[31] When the artists returned home and set about painting scenes from the Gospels again, they no doubt had difficulty in putting these scenes out of their minds. It must have seemed to them that they had lived for a time with their God, and had actually been present at his Passion and Resurrection. Consequently, they painted what they had seen.

Several of the new scenes that were taken over at this time by plastic art had been represented on the stage before they appeared in painting. In miniatures, stained glass windows, and bas-reliefs we shall find all the episodes from the *Meditations* we have just reviewed.

The pleading at the foot of God's throne by the Four Virtues—the great struggle between Justice and Mercy, Peace and Truth which both prepares and explains the Annunciation—was soon to become a part of fifteenth-century art. The miniaturists were among the first to represent this new scene.[32] A manuscript in the Bibliothèque Nationale illuminated in the second half of the fifteenth century, first takes us to paradise: God is seated between Justice carrying a sword and Mercy carrying a lily. Angels appear as supplicants before the throne and seem to intercede for the salvation of mankind.[33] On the following page, God has ruled for the Incarnation: he is seen in the middle ground; he seems far away and withdrawn into the depths of the sky. Justice and Mercy are at his sides, but the two sisters are already reconciled, for the angel Gabriel bows to receive the message. In the foreground the angel reappears: he is on earth, in the chamber of the Virgin, and he kneels before her to announce that she will give birth to a God.

We come upon similar pages in many manuscripts of the same period.[34] Sometimes the scene shows additional details. In a beautiful manuscript of the *Golden Legend*, not only Gabriel and the Four Virtues are present before the Trinity, but also, Justice is shown embracing Truth at the moment of the Annunciation (fig. 25).

One detail proves that our artists were inspired by the Mystery plays rather than by the text of the *Meditations*. Many manuscripts, notably the famous Breviary of René de Lorraine, in the collection of the Arsenal, shows alongside the Four Virtues, the choir of prophets and patriarchs entreating God to send the one who is to come: *Domine*, one of them says, *obsecro, mitte quem missurus es*![35] Now it is precisely in the Mystery

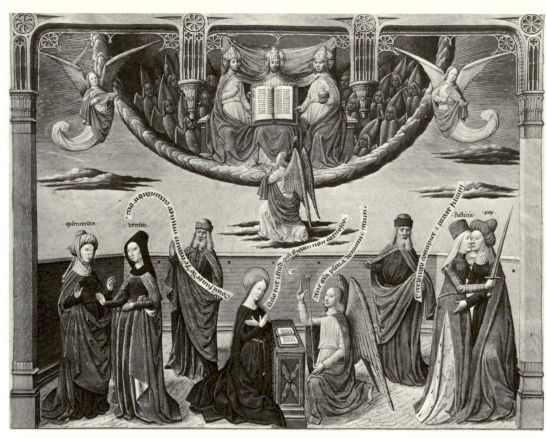

25. Justice and Mercy. Peace and Truth. Translation of *Golden Legend* by John of Vignay. Paris, Bibliothèque Nationale, ms. fr. 244, fol. 107r (top).

plays, before the scene in which the Virtues plead their cause, that the patriarchs and the prophets raise their arms toward God from the depths of Limbo and entreat him to send the promised Saviour.[36] In the manuscript in the Bibliothèque Nationale, the scene attains true grandeur, for it not only shows the patriarchs and the prophets, but all of mankind sending its supplication to God.[37]

The theme of the "Dispute in Paradise" passed from the manuscripts into printed books. It is found not only in illustrated editions of the Mystery plays,[38] but also in the Books of Hours where it accompanies the Annunciation.[39]

The decorative arts also took it over. Justice and Mercy often figure in the high warp tapestries of the fifteenth and sixteenth centuries. In a Flemish tapestry preserved in Rome, Justice and Mercy appear at the very beginning of things; they are present at the Creation and stand beside the throne on which the three persons of the Trinity are seated.[40] In a Madrid tapestry, they stand at the foot of the cross. Mercy gathers up the blood of the Saviour, and Justice, satisfied at last, returns her sword to its scabbard.[41] In the series of tapestries devoted to David, in the Cluny Museum, the two Virtues soar above the repentant king. In

the beautiful tapestry of the Last Judgment, in the Louvre, Mercy holding a lily welcomes the elect, and Justice with sword in hand pushes back the damned.[42] Thus, they are always present in the decisive moments of the world's history.

The glass painters also used the theme of the Four Virtues. A window of the church of St.-Patrice, at Rouen, shows Justice embracing Peace in the presence of Mercy and Truth; above them, Jesus has just fulfilled his sacrifice on the cross.[43] This is one of the rare windows of this kind still existing today,[44] but windows are fragile and similar ones may have been destroyed.

Even the sculptors, always a bit more resistant to innovation, finally accepted the henceforth consecrated motif. The fully developed allegory is carved on the pendentives decorating the chapel of the Virgin in the church of Fontaine-sur-Somme (Somme) (fig. 26). Inscriptions make its meaning quite clear.[45] First, God reproaches Adam and Eve for their transgression. Then the Four Virtues, Mercy and Truth, Peace and Justice, appear. While they plead their cause before God, the angels and the prophets join in their supplications: "Make manifest thy power and come,"[46] the angels say, and the three patriarchs in oriental turbans cry: "Bend down your heavens and descend."[47] Further on, the prophets hold streamers on which are written words of hope. So much faith finally finds its reward: on one of the pendentives, Gabriel announces to the Virgin that she will give birth to the Messiah so desired by angels and mankind. The drama is complete; it is the prologue to one of our Mystery plays translated into stone.

26. Adam and Eve (Fall of Man). Fontaine-sur-Somme (Somme), Chapel of the Virgin. Pendentive from series illustrating the *Procès de Paradis*.

Let us now come to the scene of the Nativity, in which there are small characteristic details to be noted. The author of the *Meditations* tells us that the humble shelter open to the four winds, in which the Virgin was to give birth, had been made a bit more comfortable by Joseph. "Since Joseph was a master carpenter," he said, "he no doubt made some kind of enclosure around it."[48] This is what the author of the *Rouen Mystery* shows in a domestic scene that is not without charm. There is nothing in the hut but some straw and branches of broom. Joseph, fearful of the night air, takes the broom branches and interlaces them; the Virgin helps him in his work, handing him the branches as he needs them. This sort of wattle enclosure which more or less protected the crib was part of the usual scenery of the Nativity. The proof is that in the fifteenth century (and in the late fourteenth), the miniaturists almost always depict it. To give only a single, but famous, example, I cite the scene of the Nativity in the Breviary of the Duke of Bedford.[49] It shows a low enclosure made of interlaced branches almost exactly reproducing that described in the *Rouen Mystery*.

Another special feature is worth mentioning. The *Meditations* reports one very curious detail about the Nativity: "When the moment came for the Virgin to give birth, at the hour of midnight, she leaned against a column that was there."[50] The author informs us, moreover, that in this he was not inventing anything, but only reporting the words of a friar of the Order who was subject to revelations and very worthy of belief. Did this detail catch the attention of the authors of the Mystery plays? I can well believe it, although I cannot furnish any proof. But it is remarkable that the great Flemish painters in their representations of the Nativity ordinarily do not omit the column. In the Nativity by Roger van der Weyden, the column supports a poor roof that would ordinarily have required only a beam (fig. 27). In the Nativity by Hugo van der Goes,[51] it is a magnificent Gothic column with a double row of foliage on the capital. Memling used a column in his Nativity of Bruges and also in his Nativity of Madrid.[52] The same detail is found in the work of certain German painters, such as Friedrich Herlin.[53] It is possible, of course, that this was a workshop practice belonging to the Flemish masters and their German pupils; however, such unanimity is surprising. I myself am quite ready to believe that in the oldest French or Flemish Mystery plays, the roof of the stable was supported by a column according to the text of the *Meditations*.[54]

To continue the review of the scenes from the life of Christ borrowed from the *Meditations* by the Mystery plays, there is the episode of the first meeting in the desert, as children still, of John the Baptist and Jesus.

I find no evidence that our artists were very much taken with this scene. I have been able to find only a small section from a window that

27. Nativity (triptych). Berlin, Staatliche Museen. Roger van der Weyden.

is related, and that somewhat distantly, to this apocryphal episode. It occupies the upper part of the beautiful John the Baptist window in the church of St.-Vincent, at Rouen. In it, we see the Precursor, still a child, taking leave of his mother and father and making ready to depart for the desert. As we see, it is only an allusion to the episode told in the *Meditations*.[55]

Following the reticence of our dramatic authors, our artists also had little to say about this episode.[56] But this was not entirely the case in Italy. Jacopo del Sellaio, in a painting now in the Berlin museum, represented the meeting of the two children in the desert. Moreover, we know that the type of John the Baptist as a child who had already been visited by the Holy Spirit is not rare in Italian art of the fifteenth century; Florentine sculptors treated the subject in several beautiful works. It was a bold enterprise to place the seal of God on a guileless forehead and an innocent mouth. We are all familiar with the young feverish face of Donatello's St. John. The same problem of uniting innocence with supreme knowledge had delighted Leonardo who, like a Hegelian philosopher, reconciled opposites into a superior harmony. His John the Baptist, in the Louvre, smiling against a background of shadows, is the most astonishing work to be inspired by the Infancy of the Precursor.

It seems likely to me that it was through such dramas as *St. John the Baptist in the Desert*, staged at Florence, that the artists had come to know so original a figure as this child-prophet.

At other times, the Italian painters represented the two children playing together beside the Virgin. Was this the meeting of St. John and Jesus in the desert? Often it is impossible to tell, and it is probable that the artists themselves did not always know. I believe that in most cases, however, the subject of the paintings is not at all the meeting in the desert. The artists followed another tradition also to be found for the first time in the *Meditations*. Returning from Bethlehem after the adoration of the magi, the Holy Family stopped for several days in the house of Elizabeth. "The two children played together, and the little St. John, as if he already understood, showed respect for Jesus."[57] This is the text that explains and justifies such compositions as the Belle Jardinière, the *Holy Family of Francis I*, and the *Madonna of the Blue Diadem*,[58] among a hundred others. It was, to be sure, a moving thought to show in their happy innocence the two children who were to have superhuman missions and tragic deaths. No one sensed this better than Raphael: his two beautiful nude children seem to live in Eden among flowers and beneath a clear sky; there is peace and divine innocence. Here again, we come upon the influence of the *Meditations*, the extraordinary book that guided European art until the sixteenth century.[59]

When we come to the cycle of the Passion, the influence of the *Meditations* on art is revealed by a moving scene. Jesus' farewell to his mother, which in the *Meditations* opens Holy Week, furnished the artists with a famous theme. This new motif appeared in French art in the second part of the fifteenth century, that is, at a time when the Mystery plays had already consecrated it.[60] It was known in Germany as well as in France. Everyone has seen the beautiful engraving by Albrecht Dürer representing the last meeting between the son and the mother: the Virgin seems to be overwhelmed; Jesus makes a gesture of great gentleness, but preserves the serenity of a God. In the sixteenth century, this theme was represented frequently in all of Europe. It will suffice to cite, for France, the window at Conches,[61] and that of St.-Vincent, at Rouen.

A last scene inspired by the *Meditations* remains to be mentioned, the triumphal return of Christ into paradise. In our Mystery plays, as in the text of the *Meditations*, Christ entered heaven, hitherto closed to humans, followed by a procession of all the patriarchs. One artist, at least, tried to express the great victory of Christ over death. In the choir of St.-Taurin, at Evreux, there is a sixteenth-century window representing the Ascension in a very unusual way. Jesus rises above the earth where his mother and the disciples have remained; but the saints of the Old Law rise along with him. We see them issuing out of Limbo as if drawn by an irresistible force; among the throng we recognize Adam, Eve, and John the Baptist. Thus, prophets and patriarchs participate in the triumph of Christ, and enter with him into heaven.

The glass painter of Evreux was inspired by a Mystery play he had recently seen: the categorical proof of this is found in the *Resurrection* by Jean Michel. In fact, there are stage directions in this play for the moment when Christ ascends to heaven: the saints of the Old Law must be represented by "well-made paper or parchment figures attached to the robe of Jesus and drawn upward at the same time as Jesus."[62] Could anything be more convincing?

A work such as this is, I believe, unique.[63] Artists usually chose another moment: they preferred to show Jesus approaching the throne of God to give an account of his mission. Illustrations representing the Son standing before the Father are not rare in French incunabulae. Jesus' breast is bare so that the marks of his passage on earth, the scars of his wounds, can be clearly seen.[64]

But there is something of greater interest to be noted. In our Mystery plays, once God has received his Son, he has him sit on the throne in the costume in which he presented himself, that is, in the crimson mantle of the Resurrection, opened to show his bare breast.[65] This was the way in which paradise was presented at the end of the play. The artists, who had often seen this tableau, felt free to change the ancient disposition of the three persons of the Trinity.

In the fourteenth century, the figure of the Trinity had scarcely varied at all: the Father, seated on a throne, supported the Son nailed to the cross; the Holy Spirit, symbolized by a dove, flew between the Father and the Son, seeming to go from one to the other (fig. 81).[66] This kind of mystical hieroglyph did not altogether disappear with the fourteenth century, but persisted until the beginning of the sixteenth.[67]

Toward the end of the fourteenth century, however, a new way of representing the Trinity appeared. The Father and Son are seated beside each other (as they necessarily would have been on the tiers representing paradise in the theater), with the dove spreading its wings overhead. Sometimes the Father and Son wear the same costume and have identical features.[68] They must have appeared in this way in the prologues to the Mystery plays, which go back to the beginning of things, to the time when the Son was not separated from the Father by his incarnation.

Soon, however, the Son came to be differentiated from the Father. He was given the marks of his humanity. We see the scar on his naked breast; sometimes he wears the crown of thorns and carries the cross. The Trinity is presented in this new way in a manuscript of Deguilleville's *Pilgrimage of Jesus Christ*, dating from the early fifteenth century.[69] Many other examples soon appeared. Only the epilogues to our Mystery plays can account for this change: Jesus sits beside his Father as he was when he returned from his pilgrimage among men. Henceforth, he is not only one of the persons of the Trinity, he is the one who has traversed death. The Mystery plays ended on this vision of the new Trinity. We

have seen that the idea for this figure of the Son, who might be said to introduce the notion of time into the eternity of God, goes back to the *Meditations*.

It now seems well established that the author of the *Meditations* influenced the theater and, through the intermediary of the theater, influenced the plastic arts. Thanks to him, motifs hitherto unknown became a part of Christian iconography.

III

Nevertheless, if fifteenth-century art owed much to the *Meditations*, it did not owe everything. We shall now look at scenes and groupings that cannot be explained by the *Meditations*, and for which credit must be given to the authors of the Mystery plays; for the dramatic poets did sometimes invent, or if they did not, they drew on apocryphal traditions that the Pseudo-Bonaventura disdained.

Let us again review the events in the life of Christ, bringing out all that art owed to the direct influence of the Mystery plays.

The dramatic writers of the fifteenth century generally grouped several picturesque details around the scene of the Nativity.

In our Mystery plays, Joseph wastes no time after adoring the newborn Child. He lights the fire, warms water, and then hastens to find the necessaries. He returns with swaddling clothes, *drapeaux* (diapers), as they are still called in the rural sections of our ancient provinces, and then says good naturedly:

> *J'ai apporté du lait aussi*
> *Que je vais bouillir sans targer*
> *Pour lui faire un peu à manger*[70]

(I have brought milk also
Which I will boil at once
To give him a little something to eat.)

Through the influence of the theater, these humble things—the fire, the swaddling clothes, the cooking pot—found a place in art. From 1380 until about 1450, during the period when the representations of the Nativity were allowed somewhat more freedom than later, the manuscripts often show Joseph sedulously making himself useful: he comes and goes, carrying wood, warming the swaddling clothes, tending the cooking pot (fig. 28).[71]

While these things are taking place in the stable, the angels have announced the glad tidings to the shepherds. We know that the medieval theater was synoptic: it seems to have gathered the whole world together under the eye of God. There is silence around the crèche, and on the

nearby mountain the shepherds speak. What gift will they offer the Child? Certainly, they would give their shepherd's crook if necessary, although they could scarcely do without it, but they possess rarer things. One will offer his shepherd's pipe, a new one bought at the Bethlehem fair. Another will offer a calendar fashioned out of wood: it shows the feast days and Lent, and each saint is represented by his attribute, carved with a knife. Another thinks of giving him a sheep bell.[72] Chatting in this way, they set off and arrive at the stable. As soon as they glimpse the Child, they kneel and adore him from a distance, not daring to approach. The Virgin has to urge them to take courage, and she presents the Infant for their homage so that they will finally decide to offer their gifts. In this presentation of the Adoration of the Shepherds there is both naïveté and tact. These good countrymen, at once timid and on familiar terms with God, are exactly as they should be. We feel that the public loved them, and the poet did not miss the opportunity to enlarge their role. In Gréban, as in the first scene of the *Rouen Mystery*, we hear them celebrating their calling in lively little verses and singing of the joyous frolics of rustic life and the dances to the music of pipes.[73]

None of this was lost in art. Let us first point out that the motif of the Adoration of the Shepherds was unknown in the thirteenth and fourteenth centuries, and only the annunciation of the angel to the

28. Nativity with St. Joseph carrying water and wood. *Golden Legend*. Paris, Bibliothèque Nationale, ms. fr. 244, fol. 24r (detail).

shepherds was represented. We must wait until the fifteenth century[74] to find the three herdsmen[75] hanging back timidly at the entrance to the hut (fig. 29), or kneeling, hat in hand, before the Child. From that time on, the scene appears frequently. Fouquet, Hugo van der Goes, and Ghirlandaio created the Adorations of the Shepherds that are now so well known.

In this also, Italy provided the example. By 1340, Taddeo Gaddi had already represented the Adoration of the Shepherds.[76] Nevertheless, the influence of the Mystery plays cannot be discounted. Sometimes, in fact, the works of art show the shepherds offering their simple gifts, just as they do in the Mystery plays. A manuscript in the Arsenal has one of them offering the Child his pipe,[77] just as in Gréban. Nor are the rustic joys whose praise they sing in the Mystery plays forgotten. Shepherdesses are sometimes shown with the shepherds: a shepherd receives a crown of flowers from his shepherdess;[78] or shepherds and shepherdesses join hands and dance a rustic branle.[79] The painters' geniality equaled that of the poets. But one proof is completely convincing. An engraving, found fairly frequently in the Hours of Simon Vostre, shows shepherds and two shepherdesses surrounding the Virgin and Child. One of the shepherdesses is named Mahault and offers a lamb. The other is named Alison and offers fruit (fig. 30). Now if we go back to the *Nativity*

29. Adoration of Shepherds. Chappes (Allier), Church. Stone relief.

Mystery preserved at Chantilly, we shall see that two shepherdesses accompany the shepherds to the crèche: one named Mahauls carries a lamb, the other is named Eylison and carries nuts and plums. The coincidence is so perfect it banishes all doubt.[80]

The Adoration of the Magi in the *Très Riches Heures* of the Duke of Berry, illuminated by the Limbourgs at the beginning of the fifteenth century, has one unusual detail. Behind the Virgin are two women with nimbuses whose presence at first seems unexplainable and whom the scholars have been unable to identify (fig. 17). That is because they overlooked the old liturgical drama that continued to be played in the church, while the Mystery plays were given in the public square. In the liturgical drama, when the magi advance toward the Child they are received by two women who are the midwives of the apocryphal gospels: "Here is the Child you are searching for," they say to the kings; "Come forward and adore him, for he is the redemption of the world."[81] It is these two midwives who were represented with nimbuses by the miniaturist of the Duke of Berry. The scene must have been played in the same manner in Italy—ten years or so after the Limbourg brothers, Gentile da Fabriano represented the two midwives near the Virgin in his famous painting of the Adoration of the Magi, in Florence. We see them also in his painting of the Nativity (fig. 31).

30. Adoration of Shepherds. Hours of Simon Vostre for use of Angers. Paris, Bibliothèque Nationale, Estampes Re 25, L 214, fol. E7r.

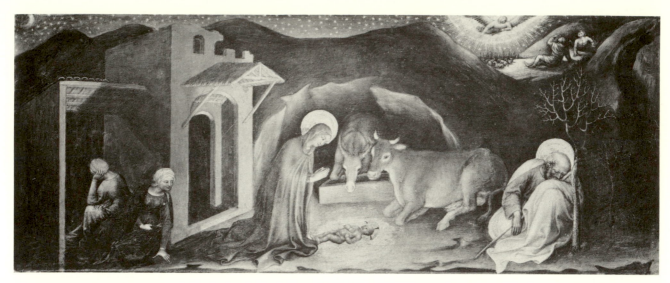

31. Nativity. Adoration of Magi altarpiece,
central predella panel. Florence, Uffizi.
Gentile da Fabriano.

When we move from the Infancy to the Ministry of Christ, we are struck by a singular phenomenon. We know that in the thirteenth century our artists did not represent the whole of Jesus' life: they chose only the events that correspond to the great feasts of the year. Even our richest cathedrals show only a small number of events, always the same, which by their sequence form a kind of liturgical calendar.[82]

It was no longer the same in the fifteenth century. Many episodes never seen in the preceding age began to take their place in art. The Ministry of Christ, which until this time had almost been eclipsed by the scenes of the Infancy and the Passion, henceforth is unfolded with a certain wealth of detail. The surprising thing is that in the fifteenth century whole windows were devoted to it.[83] In the beautiful chapel of the Virgin of the cathedral of Evreux, which inescapably recalls the memory of Louis XI, a series of windows of great archeological interest recounts the life of Christ. And alongside the traditional scenes, are some completely new subjects: successively we can make out the Marriage at Cana, the Meeting with the Woman of Samaria, the Temptation, the Woman Taken in Adultery, the Miracle of the Loaves, the Transfiguration, the Feast in the House of Simon, the Money Changers Driven from the Temple, the Raising of Lazarus, and the Entry into Jerusalem.[84] Some of these episodes, such as the Woman Taken in Adultery, the Woman of Samaria, and the Miracle of the Loaves,[85] had never before been represented in French art.[86] Whence came such sudden favor?

I think we may say that the source was the Mystery plays. In fact, we have only to read any of the great fifteenth-century *Passions*—those of Gréban or Mercadé—to see that the events in the life of Christ chosen by the poets are exactly those represented by the artists. Apart from two or three of the miracles of Christ not found in our windows, the

analogy is perfect. It was the Mystery plays that had placed before the artists' eyes certain hitherto unthought of scenes from the life of Christ and had given rise to the idea of representing them.[87] The vogue of certain subjects, such as the Woman Taken in Adultery and the Woman of Samaria, used in stained glass windows until the end of the sixteenth century[88] is explained by the part they played in the Mystery plays.[89]

But even the manner in which these subjects are represented sometimes reveals the influence of the theater. The Raising of Lazarus merits our attention for a moment. In the fifteenth century, artists introduced an astonishing detail into the scene: Lazarus is seated in his grave, half wrapped in his shroud, and Peter leans over him to unbind his hands. Such is the Raising of Lazarus painted by Nicolas Froment in 1461.[90] The scene was represented in the same manner by the enamelist of Limoges called by the name of Monvaërni,[91] and by Jean Bourdichon in the Hours of Anne of Brittany.[92] There was the same tradition abroad. Jan Joest von Calcar, in his painting in the church of St.-Nicolas in Calcar, also shows Peter unbinding Lazarus, who gazes fixedly at Christ.[93] This quite new role given to Peter is surprising because nothing like it is to be found in earlier art. In the work of Italian painters, faithful disciples of the Byzantines, the apostles are the spectators and not the actors in the scene: it is the Jews who roll away the stone from the sepulcher hewn in the rock or who unwind the shroud from Lazarus. The scene preserved its character of remote antiquity and its oriental color. Who could have given our artists the idea of having the apostles intervene in the Raising of Lazarus? If I am not mistaken, it was the authors of the dramas.

In the *Passion* by Jean Michel, in fact, when Jesus has given the order to unbind Lazarus, Andrew cries:

> *Mes frères,*
> *Deslyons cet homme-ci.*
>
> (My brothers,
> Let us unbind this man.)

And Peter adds:

> *Qu'on le deslye*
> *Puisque le maître le commande.*
>
> (Let him be unbound
> For the Master commands it.)

Here we see the apostles taking part in the drama; and probably Peter himself, with his mantle thrown back as shown in the painting by Nicolas Froment, freed the hands of Lazarus. The theater takes from the scene its antique grandeur and gives it a kind of homely

simplicity. The wrappings of a Syrian mummy, which might have surprised the spectators, become a simple cord binding the hands of Lazarus, and the sepulcher hewn in the rock is replaced by a grave in a country churchyard.

The life of John the Baptist is closely linked with the Ministry of Christ. At the beginning of the fifteenth century, an episode in the scene of the Feast of Herod appeared that was hitherto unknown. When the head of John is placed on the table, Herodias plunges her knife into the forehead. I believe that the *Belles Heures* of the Duke of Berry, illuminated by the Limbourg brothers before 1413, offers the earliest example of this scene.[94] We find it again in the sixteenth century in the bas-reliefs decorating the enclosure of the choir of Amiens Cathedral. Quentin Matsys, on one of the wings of the Entombment, now in the museum of Antwerp, also represented Herodias striking John on the forehead.[95] She holds the knife gracefully, and there is violent contrast between the elegant woman crowned with flowers and the severed head.

No mention is made of this in the Gospels, and there is nothing like it in Italian art. For a long time the Italians had not even seated Herodias at Herod's table. Giotto, Andrea Pisano, and Masolino[96] all placed her at a distance, outside the banquet hall: she sits under a portico, looking with indifference at the head presented to her by the kneeling Salomé. In this, as in many other things, the Italians remained the disciples of the Byzantines, for the composition is the same as that in the miniatures of the old Greek gospel manuscripts.[97]

Where is the first mention of Herodias' knife thrust? In the Mystery plays. In the *Passion* of Arras, attributed to Mercadé, there is the following stage direction: "Here the daughter bears the head of St. John the Baptist to her mother at Herod's table, and Herodias strikes the aforementioned head with her knife, thus making a wound above his eye." If the *Passion* of Arras is really the work of Mercadé, it is contemporary with the Limbourgs' miniature.

The same rubric is written into the *Passion* of Jean Michel. It says (in the feast scene): "Here Herodias plunges a knife into the forehead of St. John the Baptist, and the blood spurts."

A similar legend must have grown up at Amiens. In fact, since the beginning of the thirteenth century, the cathedral of Amiens had had in its possession the upper frontal section of John the Baptist's head which had been brought from Constantinople by the canon Wallon de Sarton. Now above the band of precious stones forming a crown around the skull, there is a small hole near the left eye socket.[98] It was no doubt to explain this wound that the episode of the knife thrust was imagined. Some support for it was supplied by a passage from Jerome's *Apologia contra Rufinus*, where it is reported that Herodias had pierced the tongue of John out of revenge for his invective against her.

When the legend of Amiens was included in the Mystery plays, it became famous: it was clearly through the Mystery plays that artists came to know it.

Not only did such episodes as this come into art through the Mystery plays, but even the best-known events in Christ's life were presented in new ways.

Until the fifteenth century, the composition of the scene of the Last Supper had scarcely varied: Jesus and his apostles are lined up on one side of a table, and Judas, to whom the Master offers bread, is by himself on the other. This is not the way it happened in the theater. The table companions were not aligned along one side of a narrow trestle-table, but were seated around a real table. On this subject, Jean Michel gave the most precise stage directions. He included in his drama a little diagram indicating the place of each apostle. The table was rectangular: two apostles were to sit at the right and two at the left of Jesus who occupied the center of one of the long sides; three apostles were to sit at each of the short sides, and only two figures were to face Jesus, Judas and Philip, on the other long side of the table. This grouping was traditional in the theater and was not invented by Jean Michel.[99] The beautiful Last Supper painted by Dirk Bouts in 1468[100] (more than twenty years before Jean Michel wrote his drama) conforms at every point to the indications of the Mystery play (fig. 32). The analogy is complete, and it would seem a miracle if the explanation were not so simple. Other details support the contention that Dirk Bouts painted his scene with the recollection of a recent performance of a Mystery play in mind. Two men, who are not apostles, stand near the table. Who are they? Jean Michel calls them Zachée and Tubal, while Gréban calls them Urion and Piragmon. They are the hosts who receive Jesus and his disciples and who are eager to serve them when needed. In the painting by Dirk Bouts, one of these good servants is thought to be the artist himself. Naïve testimony to piety. He meant to say that he also would have received his Saviour had he been worthy, and that he would gladly have given him everything in his house. A last detail also points to the imitation: Jesus has a chalice before him and in his left hand he holds the Host which he blesses with his right. Now Jean Michel tells us that once the lamb was eaten, a chalice and the Host were placed on the table. And he adds: "Here Jesus takes the Host and holds it in his left hand."

But the influence of the theater is most marked on the artistic cycle of the Passion. The following examples will, I hope, leave no doubt of this.

In the *Passion* by Jean Michel, there is an extraordinary figure, an old woman named Hédroit who is as hideous an old termagant as was ever imagined in art. Her speech is no less ignoble than her person.

32. Last Supper. Louvain, Church of St.-Pierre. Altarpiece of the Sacrament, central panel.
Dirk Bouts.

She is famous among the riffraff of Jerusalem, and even the worst scoundrels fear her cynical tongue. She has conceived a deadly hatred for Jesus. Consequently, when Malchus has collected together several ruffians like himself and comes to tell her that he is going to the Garden of Olives to lay hold of the man she hates, she agrees eagerly to be part of the expedition:

> *Si je veux être dépouillée*
> *Toute nue, si je ne frappe*
> *Plus fièrement qu'un vieil Satrappe,*

> (Let me be stripped
> Naked to the bone if I don't beat him
> More roundly than an old Satrap),

she says. And with her lantern she heads the procession. Later, when Jesus has been condemned to death, people run to the carpenter to have the cross made, and to the blacksmith for the nails. But the blacksmith is not there, and the messenger would have been in difficulty if old Hédroit had not by chance been on the scene. Never mind that the "*fèvre*" is not in his smithy, she will forge the nails. What would she not do to make the one she so detests suffer? So, she puts the iron to the fire, seizes the hammer and tongs, and with strong arm strikes the anvil.

This lively incarnation of evil, a figure of contrast done in the manner of Victor Hugo, would seem to be a creation of Jean Michel himself. However, he took the idea for her from his predecessors. In the work of Mercadé, for instance, the wife of the blacksmith forges the nails herself when her husband refuses to do so.[101] We can be sure that before Jean Michel the character of old Hédroit appeared in now lost Mystery plays. We find the proof in works of art. In fact, if we look carefully at the miniatures that Jean Fouquet painted for Etienne Chevalier, we come twice upon our heroine. At the moment of the Arrest of Jesus in the Garden of Olives,[102] it is her lantern that lights the face of the Master so that Judas cannot mistake him for one of the disciples (fig. 34). In another miniature, below Christ Carrying the Cross, there is a smithy where a woman is forging nails on an anvil (fig. 33). No one had thus far been able to interpret this scene, which now seems perfectly clear.

Since the Hours of Etienne Chevalier long antedate the *Passion* by Jean Michel, it is clear that already in the time of Jean Fouquet a Mystery play in which the old woman figured had been staged in Tours. But we can go back even further. In a miniature of the *Pilgrimage of Jesus Christ*, a manuscript illuminated in 1393, an old woman lights the scene in the Garden of Olives with her lantern.[103] Thus, the character of Hédroit was already present in the *Passions* of the late fourteenth

58

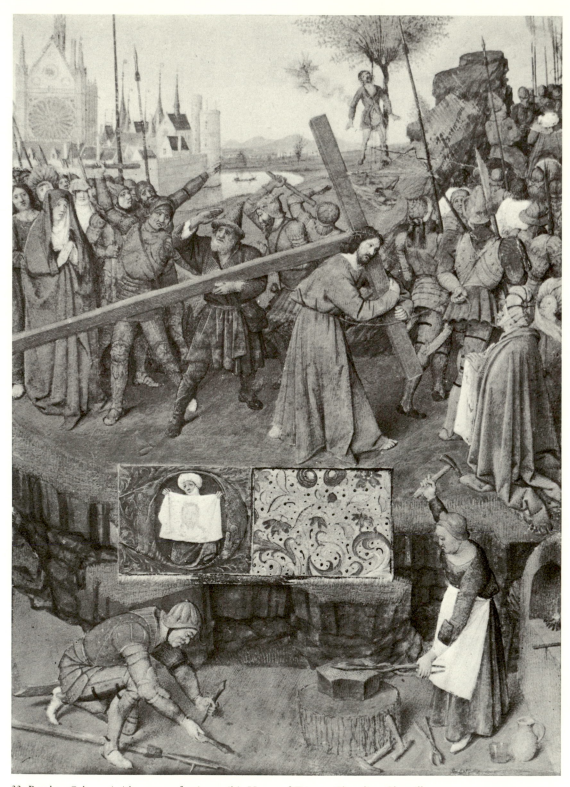

33. Road to Calvary (with woman forging nails). Hours of Etienne Chevalier. Chantilly,
Musée Condé, ms. 71. Jean Fouquet.

century. And she must even have figured in them from the beginning of the fourteenth century, at least in England: English miniatures painted not much later than 1300 already show her.[104]

What is more, the old woman still appears at the height of the sixteenth century, as the Limoges enamel by Jean III Pénicaud in the Cluny museum shows.[105] This was because the role of the old termagant had continued to be popular. In 1549, there was a procession to Béthune where "Ysaulde forging God's nails" was to be seen.[106]

In the same scene in the Garden of Olives, Fouquet's miniature depicts another characteristic episode. At the moment of Jesus' arrest, one of the disciples is seen to flee, leaving his mantle in the hands of a soldier (fig. 34). This detail, it is true, appears in the book of Mark,[107] but I had never come across it in art. It was Fouquet, I believe, who first represented it; he certainly did not borrow it from the Gospel, but from the Passion Mysteries being presented at the time. In Gréban's work, in fact, it is James, the son of Alphaeus, who flees leaving his mantle behind, and the soldier who snatches it announces that he will stake it in a card game at the tavern.[108] The same scene is found in several German Mystery plays:[109] consequently, Albrecht Dürer himself, in the large woodcut Passion and in the small engraved Passion, represented the young man fleeing and leaving his mantle behind.[110]

34. Betrayal. Hours of Etienne Chevalier. Chantilly, Musée Condé, ms. 71. Jean Fouquet.

We could point out other details no less typical. In the work of Fouquet, for example, as in our Mystery plays, we see the carpenters preparing the cross;[111] the same carpenters are found in the famous painting that Memling devoted to the Passion.[112]

In the scene of the Flagellation it was traditional in the theater for one of the characters to tie together the bundles of scourges, for it did not take the torturers long to wear them out. "You there, some whips!" Orillart cries. "How many?" Broyefort asks. "Two pairs; mine are worn out."[113] In the *Passion* by Jean Michel, it is Malchus himself who ties the canes into bundles. If we examine the Flagellations of the artists who were Michel's contemporaries, we frequently see the man preparing the whips, seated or kneeling in the foreground. In France, he appears in the window of the Passion at St.-Vincent in Rouen; I have seen him several times in engravings and drawings by Albrecht Dürer.

But without insisting further on these details, let us say a word about another scene from the Passion: Christ Carrying the Cross.

In fifteenth-century paintings and miniatures devoted to the Way to Calvary, it is rare for our attention not to be drawn to an episode in the foreground. One of the daughters of Jerusalem, St. Veronica, comes to kneel before Christ bent under the weight of the cross, and wipes the sweat from his face. Now the face of the Saviour was imprinted on the Sudarium, and Veronica, lost in admiration, remains on her knees before the marvel. Such is the scene shown by Fouquet (fig. 33);[114] such also, to take a foreign example, is that shown in the Oultremont triptych in the Brussels museum.[115]

The legend of the Veronica is very ancient but strangely enough appeared in art only toward the end of the Middle Ages.[116] The reason is extremely simple: the ancient tradition became famous only when it was taken up by the Mystery plays. We find it in all our great *Passions*—those of Mercadé, of Gréban, and Jean Michel, where it forms the principal episode of the Way to Calvary. That is why the legend, long dormant, blossomed in the art of the late Middle Ages.

The influence of the theater appears also in the scene of the Resurrection.[117]

In the thirteenth and fourteenth centuries, the guardians of the tomb were represented in deep sleep: it was while they were sleeping that the resurrection took place. In the fifteenth century, the soldiers are seen not asleep at the moment of the resurrection, but toppled by a supernatural force; as they fall they gesture in terror (fig. 35). The scene was staged in the theater in the same way. In the *Arras Mystery*, there is this note: "This is how the knights fell as if dead when they felt the earth shake and they saw great light and other marvels. ..." In the *Resurrection Mystery*, attributed to Jean Michel, we see even more clearly that the soldiers are not asleep. When the earthquake throws them

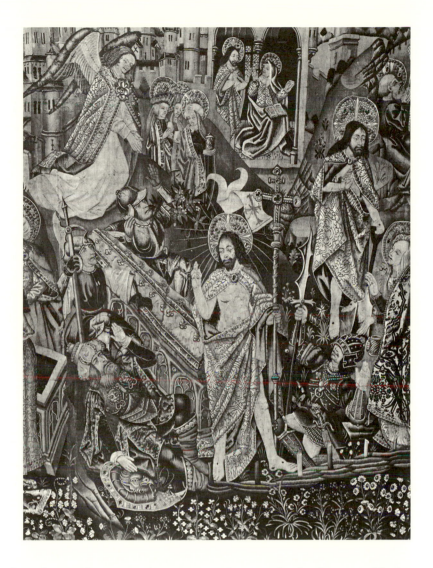

35. Resurrection. Angers, Diocesan Museum. Passion tapestry (detail).

down they do not lose consciousness, and not only do they see Christ but they hear his words. This is what they recount to the Jews later on, while two scribes take down their testimony.

Another detail clearly proves that the artists were inspired by the Mystery plays. Our fifteenth-century works of art show Jesus, just resurrected, walking in a meadow (fig. 35): He does not float above the ground, he walks. In fact, before the sixteenth century our artists had never represented Jesus soaring in the air above the tomb. We know that this was contrary to the Italian formula. In the Spanish Chapel, in Florence, Christ, surrounded by an aureole, is suspended between earth and heaven.[118] The Italian Resurrection has a supernatural character; we feel that Christ has become a glorified body, and has escaped the laws of gravity. In France, the scene was more realistic, weightier. The somewhat prosaic character of our Resurrections is explicable: Christ's Resurrection had this sort of simplicity in the theater.

The influence of the theater is again to be seen in the scene of the Descent of the Holy Spirit. In fifteenth-century works of art, instead of the long rays of light that had been shown in former times, reaching from the beak of the dove to the heads of the apostles, we see a rain of flames falling into the Cenacle.[119] Now if we consult the *Resurrection Mystery* attributed to Jean Michel, we read the following stage direction at the place in the text where the Holy Spirit descends: "Here a great torch of fire, produced artificially by alcoholic spirits, must descend, and it must descend visibly on Our Lady and on the women and the apostles, who must be sitting at this time. . . . a tongue of live fire from the above mentioned torch must fall on each one and they must be twenty-one in number." These torches of fire were wicks soaked in spirits which fell from the upper part of the theater. And this is what the tongues of fire in the art of the late Middle Ages sometimes look like. We further note that the stage direction in the *Mystery* indicates that there are "women" along with the Virgin and the apostles. These are the holy women. In the past they had never figured in this scene; they came to be included because of the influence of the Mystery plays. We see them in the engraving of this scene in the Hours of Pigouchet. The authors of the Mystery plays not only had the apostles, the Virgin, and the holy women present at the scene of the Descent of the Holy Spirit, but the disciples also. There are twenty-one figures in the *Resurrection Mystery*, twenty-five or twenty-six in the *Passion* by Gréban, and in the Hours of Anne of Brittany, twenty-five figures surround the Virgin in Bourdichon's scene of the Pentecost.[120]

As we see, there can be no doubt about the theater's influence on representations of scenes from the Gospels.

IV

Costumes are transformed by the practices of the *mise en scène*. The angels. God the Father. The purple tunic and the red mantle of Christ. The Virgin. The magi and their retinue. The prophets. The high priests as bishops. The armor of St. Michael. Nicodemus and Joseph of Arimathaea.

But that is not all. Artists were indebted to the Mystery plays not only for new groupings of figures that renewed and enriched the old iconography, but even went so far as to copy the costumes worn by these characters.

When we study the miniatures of the fourteenth century, we are quite astonished to see a sudden change take place toward 1380 in the costumes of the angels. They no longer wear the long white robes of the thirteenth-century scenes, the beautiful, modest tunic that belongs to no particular time or place, and seems to be the garb of eternal life. They are now enveloped in heavy copes of dazzling colors, fastened with a jeweled clasp; a thin golden circlet sometimes binds their blond hair. They remind us of young acolytes serving an endless Mass.[121] Who does not know Van Eyck's angel musicians, his adolescent clerics who give a concert in the heavens?[122] Such were the angels in the manuscripts

of the Duke of Berry,[123] painted fifty years before the Ghent altarpiece. And such they were in the Mystery plays of the fourteenth century. I can furnish proof for this, if not for the fourteenth century, at least for the fifteenth. In the Hours of Etienne Chevalier, Fouquet, as we know, had the happy idea of depicting a theater.[124] The martyrdom of St. Apollonia, as he conceived it, is a scene from a Mystery play. One could be in Tours on a feast day: the stage is set with heaven, earth, and hell; spectators, musicians, devils, the tyrant, the buffoon, all are in place. While the executioners torture St. Apollonia, the angels seated in paradise watch from afar. The angels are very small, it is true, but one can be seen perfectly: he wears the costume of a choirboy.

So one can be sure that this was the costume worn by the angels in fifteenth-century Mystery plays. What is true of the fifteenth century must, with even more reason, be true of the fourteenth; for this ecclesiastical dress must date from the time when dramatic representations were still somewhat in the hands of the clergy. To make the feast more magnificent, the bishops and the canons willingly lent beautiful ornaments from the treasury—a cope or a clasp set with precious stones.[125] The naïve idea of dressing the angels as acolytes must have come about in this way.

Nothing could seem beautiful enough when God himself was concerned. How could a poor actor communicate the idea of infinite power? There was only one way to invest him with majesty and that was to place on his head the emblems of human sovereignty: crowns in one, two, or three tiers. Thus he appeared, seated on the stage of paradise, sometimes with the circular crown of royalty, sometimes with the papal tiara. The tiara must have been used more often than the crown, because from the end of the reign of Charles V on, the artists preferred to represent God as a papal figure.[126] Until then, the image of God had retained the simplicity of the thirteenth century: on a backless seat, with head bare and clad in a simple tunic, he blessed with his right hand.[127] We seemed then to be in the presence of an ideal type that owed nothing to reality. Everything changes toward the end of the fourteenth century when painters begin to represent what they see before their own eyes. Thus, the God-pope or the God-emperor of the fifteenth century was created, a grave figure for which Van Eyck provided the most perfect model. His God, resplendent with jewelry, is shown with both the banded papal tiara and the imperial scepter of crystal and gold.[128]

Other details of costume can be explained as well by the customs of the theater.

In the windows of the late fifteenth and sixteenth centuries, the most surprising feature is that the figure of Christ is always clad in a purple tunic during his earthly life, and after his resurrection is draped in a mantle of the most vivid crimson. This is true from one end of France

to the other. Our surprise increased when, on leafing through the illuminated manuscripts, we find the miniaturists all following the same practices. How can such uniformity be explained? It cannot be attributed to the hieratic formulas imposed by the clergy, as it could be at the height of the Middle Ages. We must go back to the traditions of the Mystery plays which were presented in all the towns with the same costumes and the same scenery. In the Bibliothèque Nationale there is a precious manuscript with the text of a Mystery play given at Valenciennes in the fifteenth century.[129] This manuscript was illuminated by the painter Hubert Caillaux who, as we said above, had painted the scenery and supervised the *mise en scène* of the drama. The episodes from the life of Christ that decorate the book are certainly in some respects fanciful; nevertheless, they must often give a fairly exact idea of the performance. What is remarkable is that in the miniatures by Caillaux, Christ wears the purple robe during his lifetime, and the crimson mantle after his resurrection.

After the late fourteenth century, an interesting detail is common in the scene of the Transfiguration. Christ is clad in white, in accordance with the Gospels, but to express the supernatural light radiating from him, our artists often painted his face a yellow gold. This naïve detail is found fairly frequently in fifteenth- and sixteenth-century windows.[130] It was yet another borrowing from the Mystery plays. In fact, in the theater, to give the impression of radiant light, the face of the actor playing the role of Christ in the Transfiguration scene was painted with yellow gold. There are certain precise indications that dispel any doubt of this. In the *Passion* by Gréban, there is the following stage direction: "Here the clothing of Jesus must be white and his face as resplendent as gold." This text might not appear very significant but a note in the *Passion* by Jean Michel throws additional light on it: "Here Jesus goes into the mountain to clothe himself in the whitest possible robe, and his face and hands are covered with burnished gold. . . ."

I would explain in the same way several other similar traditions which otherwise remain enigmas. Everyone is aware that from the fifteenth century on, the Virgin is always shown with beautiful blond hair falling loose over a blue mantle; there are a thousand such examples in our miniatures and windows. The clear blue of the costume and the gold of the hair are charmingly harmonious in the stained-glass windows. These celestial colors are appropriate to the youth of the Virgin. But as she passes through trying times, her costume changes: the blue of her mantle seems almost black and her hair is hidden by a cloistered coif partly covered by her mantle. Standing at the foot of the cross, she resembles both a widow and a nun. Such a costume is a masterpiece of suitability: it was devised the day the Virgin had to be shown alive and active before the spectators of the Mysteries.

The three kings and their retinue also owe their rich attire to the drama. In fourteenth-century Italy, the story of the magi was played not only in the churches, but also in the open air. On 6 January 1336, the Dominicans of Milan organized a magnificent procession of the three kings. While the bells rang out, the cavalcade started from S. Maria delle Grazie and made its way to the sound of trumpets toward the church of S. Lorenzo. The crowds stationed along the way admired the kings on horseback, their many servants, the mules bearing the baggage, and the various animals of the East. Herod, surrounded by his scribes, was seated in front of S. Lorenzo; the magi paused and he questioned them about the King of the Jews who had just been born. Then the procession started off again and arrived at the church of S. Eustorgio, where a crèche had been prepared near the altar. It was there that the kings offered their gifts to the Child. Then the magi seemed to fall into a deep sleep; an angel came to them and told them to depart, but not to pass again by S. Lorenzo; they were told to take the street to the Porta Romana. This festival pleased the people of Milan so much that it was decided to celebrate it each year.[131]

A bas-relief in the church of S. Eustorgio, in Milan, carrying the date 1347, exactly reproduces this famous cavalcade of the magi. It shows the episodes that marked the three stages of the procession: the magi before Herod, the magi at the crèche, the magi awakened by the angel. And the entire procession is shown: the servants, horses, camels carrying baggage, dogs.[132] We may assume that the costumes of the actors in the theatrical presentations were very much like those depicted by the artist. Similar festivals were given in the other towns of Italy. In 1417 there was another cavalcade of the magi in Padua. In 1454, on the day of the feast of John the Baptist, the three magi and a retinue of more than two hundred horsemen passed through the streets of Florence. Some years later, another cavalcade of the three kings was organized: it was the most magnificent procession imaginable; Machiavelli tells us that the whole city had worked for several months on the preparations.[133]

Is it not clear that the rich Adorations of the Magi of fifteenth-century Italian painters preserve the memory of these festivals? Is not all the magnificence thus lavished upon a single day to be found in the Adoration of the Magi by Gentile da Fabriano, in those by Pisanello and Antonio Vivarini, and in the fresco by Benozzo Gozzoli in the Medici Chapel? Everything is included, the rich costumes, the banners and trumpets, the beautiful horses, the animals of the East—camels, monkeys, cheetahs—that fourteenth-century and later texts mention.

Were such cavalcades common in France also? We do not know, for the texts say nothing. We do not even know if the miniatures of the Journey and the Adoration of the Magi in the *Très Riches Heures* of Chantilly (fig. 17) were inspired by an actual procession. These two

miniatures are exceedingly picturesque: the Arab chiefs in turbans, the Persian princes with curved scimitars, the horsemen in Mongol head-dress, all combine to create a magnificent oriental atmosphere.[134]

I can readily believe that the Limbourgs had before them a beautiful Italian model, which they embellished even more. It was not in France but in northern Italy, and especially Venice, that people were familiar with Eastern costumes: it was there that the three kings were made to resemble traveling sultans. Moreover, at the very time the Limbourgs were illuminating the *Très Riches Heures* in 1414, an anonymous artist painted an Adoration of the Magi in the cloister of the cathedral of Brixen that strangely resembles theirs; in it, also, turbaned Arabs are drawn up in close ranks behind the three kings.[135] The similarities are such that this would seem to be the work of one of the Limbourgs' pupils. But we must remember that Brixen is on the main road to Venice by way of Verona and Trent. Working almost on the border of Italy, the artist of Brixen could only have been inspired by Italian art; no doubt he had before him an original differing little from the one known to the Limbourgs.

Thus, the scene of the Adoration of the Magi was enriched through a liturgical drama that had been expanded by the Italians into a triumphal procession. It was in Italy that for the first time the kings were seen clothed in gold and silk, the camel drivers in turbans, the huntsmen with falcons attached to their wrists, and the horsemen with banners unfurled in the breeze.

Many other details can be similarly explained. The extraordinary costumes in which fifteenth-century artists clad the prophets came from the theater. Jeremiah and Ezekiel, who in the fourteenth century were shown with the simple tunic and skullcap worn by the Jews,[136] were now dressed in tall hats with turned-up brims hung with strands of pearls; they wore rich furs, jeweled belts, and tasseled purses. Such bizarre apparel, somewhat beyond the dictates of fashion, could only have been imagined for an official procession, for a "show," or a representation. In this we sense a desire to startle the imagination and to free it from the customary. These magnificent old men were intended to evoke the idea of a mysterious antiquity.

It is in this guise that the prophets appeared in our manuscripts[137] and were soon to appear on the Well of Moses, at Dijon. It seems almost certain that the Well of Moses was the translation of a Mystery play into stone.[138] In fact, a foreign play called *The Judgment of Jesus* was played during the late Middle Ages; in it, the Virgin pleaded the cause of her son before the judges of the Written Law, who were the prophets. She hoped to obtain a favorable verdict from them, but the judges pronounced inexorable sentences taken from their books. One after another they replied that, to save men, Jesus must die. Zechariah said:

Appenderunt mercedem meam triginta argenteos; David said: *Foderunt manus meas et pedes meos, numerarunt ossa*; Moses said: *Immolabit agnum multitudo filiorum Israel ad vesperam*, etc. Now these are precisely the texts on the phylacteries of the prophets of Dijon. The grouping of the six prophets, who are brought together only in this Mystery play, and the agreement of the six texts, make the probability very nearly certain.[139] If this is granted, the work of Claus Sluter appears in a new light, and we understand better the grave, sorrowful, and implacable faces of the prophets-judges. It becomes clear, too, that their costumes are those worn in the Mystery play.

Early in the sixteenth century, the prophets of the windows at Auch[140] displayed a royal magnificence reminiscent of the almost fabulous richness of the celebrated *Bourges Mystery*.[141] In Italy, the prophets were presented in the same fashion, as the frescoes by Perugino, in the Cambio of Perugia, and the engravings attributed to Baccio Baldini testify. Consequently, the sublime simplicity of the draperies in which Michelangelo clothed his prophets of the Sistine Chapel astonished the pope; he would have liked a bit of gold. Michelangelo, we know, replied: "Holy Father, they were simple men who set little store by the wealth of this world."

Other costumes have the same origin. In Fouquet's miniature of the Judgment of Pilate,[142] at the back of the praetorium among the Jews, we see a figure wearing a mitre on his head: this is evidently a high priest naïvely represented as a bishop. But this is the way the high priests appeared in the Mystery plays. A note in the *Passion* by Jean Michel proves it: at the moment when Pilate leaves the praetorium, there is the following stage direction: "Here Pilate leaves the praetorium and goes out *with the bishops*." Moreover, in the *Passion* of Valenciennes, a large miniature representing the entire theater shows a house not far from the Temple of Jerusalem, which is called "the house of the bishops."[143]

In fifteenth-century scenes of the Passion, the Roman soldiers wear the armor of the late Middle Ages. Art followed the changes in military costume, and in sixteenth-century altarpieces the bands of soldiers at the foot of the cross wear the plumed helmets of the Swiss at Melegnano. The Mystery plays provided the artists with examples of such anachronisms. In the *Arras Mystery*, the Roman Diagonus announces that he goes to don his padded gambeson (*lacis*) and to pick up his armor (*brigandine*). "I need only my helmet (*hunette*)," says another. But it is strange indeed to see St. Michael himself buckle on the military armor of the time. The archangel, who in a fourteenth-century window at Evreux[144] leans on a shield but still wears the long robe of the thirteenth century, suddenly appears in a missal of the Duke of Berry (circa 1380 or 1390) wearing the costume of a knight;[145] in the fifteenth century the good champion of France against England was hardly ever repre-

36. St. Michael fighting demons. Hours for use of Rome, made in Paris, Jean du Pré, Feb. 4, 1488. London, British Museum. IA 39821.

sented otherwise (fig. 36). He must have appeared to Jeanne d'Arc wearing the plated armor and visored helmet in use around 1430. I believe that the idea of representing St. Michael as a soldier came from Italy: in fact, St. Michael appeared as a soldier in the frescoes of the Campo Santo at Pisa, and in the Orcagna altarpiece in S. Maria Novella.[146] Nevertheless, the Italian St. Michael was an imitation of the Byzantine St. Michael, whose armor he wears. In France, stage custom must have contributed greatly to the spread of the Italian practice. We know for certain that St. Michael appeared in the theater as a knight. In the miniature by Fouquet, which represents the stage of a Mystery play, we can make out on the tiers of paradise an angel wearing armor, who is St. Michael. We must add that the armor worn by the Italian St. Michael is almost like that of antiquity, while the French St. Michael, like the characters in the Mystery plays, wears the military apparel of the time (fig. 37).

We can give still another interesting example of the probable influence of the theater. Here we cannot cite any text, but on the basis of the facts we have assembled, the influence seems to have been most likely. In the scenes following the Passion, there are two figures whose ap-

37. St. Michael in armor. Rouilly-Saint-
Loup (Aube), Church.

pearance is worthy of notice: they are Nicodemus and Joseph of Ari-
mathaea.[147] Dressed in good rich cloth, they both are incarnations of
the wealthy fifteenth-century bourgeois. But while one wears a long
beard, the other is carefully shaven; and not only is he clean-shaven,
he is almost always bald. If we take the trouble to study carefully the
Descents from the Cross and the Entombments of the old German or
Flemish masters, we will frequently observe these details. We find them
in the work of Roger van der Weyden at the beginning of the fifteenth
century, and again in the work of Heemskerk and Van Orley in the
middle of the sixteenth.[148] The sculptors were as faithful as the painters
to this practice, as the sculptured altarpieces from Antwerp prove.

The strange thing is that French artists, also familiar with this tra-
dition, seldom followed it; in our Holy Sepulchers, the two old men
almost always have long beards. Nevertheless, there are two famous
exceptions: the Holy Sepulcher at Solesmes has, as is well known, a
bearded Nicodemus and a clean-shaven Joseph of Arimathaea. The
same is true in a fifteenth-century window at Evreux devoted to the
Descent from the Cross;[149] in it, one of the two men is both bald and
beardless.

What can we conclude from this except that the actors given the roles of Nicodemus and Joseph of Arimathaea in the Mystery plays of the fifteenth century very probably adhered to a tradition. This tradition must never have varied in Flanders and Germany. In France, the actors no doubt exercised a greater freedom and this was reflected in art.

<div align="center">V</div>

Decor and properties introduced into art by the theater. The chamber of the Annunciation. The candle of St. Joseph. The lantern of Malchus, etc.

The artists borrowed not only the costumes of the stage productions, but the scenery and stage properties as well.

In medieval art, the exact place of the Annunciation long remained undecided. At the end of the sixteenth century, the practice grew up of representing the Virgin meditating in a chamber: when the angel appears before her, she is kneeling before a lectern, reading a beautiful illuminated Book of Hours (fig. 38). The Italians were certainly the first to place the scene of the Annunciation under a kind of light portico;

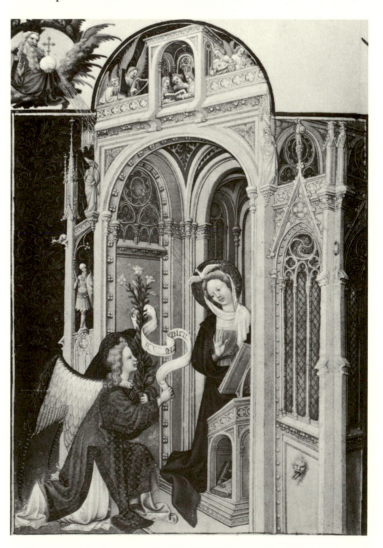

38. Annunciation. *Très Riches Heures* of the Duke of Berry. Chantilly, Musée Condé, ms. lat. 1284, fol. 26. Limbourg Brothers.

and before it was done in France, they represented the Virgin with a book in her hand, according to the Byzantine tradition.[150] And yet I believe that the practices of the Mystery plays contributed even more than Italian art to the enrichment of the Annunciation scene. On this point the Mystery plays give precise indications. Before the Annunciation, Gréban has the Virgin say:

> *Voicy chambrette belle et gente*
> *Pour Dieu mon créateur servir;*
> *Et pour sa grâce desservir*
> *Je voudray lire mon psautier*
> *Psaume après autre tout entier.*[151]

> (Here is a chamber beautiful and sweet
> For serving God my Creator;
> And to merit his grace
> I wish to read my psalter
> Entirely, one psalm after another.)

Thus, in the theater, the Annunciation took place in a real room. That is why the fifteenth-century masters sometimes give the Annunciation the setting of a lay sister's cell, where the old sideboard softly reflects the light and the copper candelabra gleams. Sometimes the small chamber was transformed into a chapel: for in the Mystery plays, the scene of the Annunciation was occasionally placed in an oratory. In the *Rouen Mystery*, Mary "goes into her chapel to pray to God," before the arrival of the angel. Fouquet, who thought that the oratory of the Virgin must have been as beautiful as those of our kings, gave his Annunciation the charming setting of a Ste.-Chapelle.[152]

We have already mentioned the wattle enclosure protecting the crèche in the scene of the Nativity. But another detail is worth noting. In the early fifteenth century, Joseph was rarely shown kneeling before the newborn Child without a candle in his hand. He almost always makes the gesture of protecting the flame against the wind, when he has not taken the precaution of placing the candle in a lantern. Having once noticed this detail, we recognize it with surprising frequency and always the same, in a Norman window at Verneuil, a Flemish triptych by Roger van der Weyden (fig. 27), a painting by the Master of Flémalle at Dijon (fig. 39), in a German painting by Herlin, and in a thousand other works spread over all of Europe. The explanation is basically a simple one. It was certainly the tradition in the theater to represent Joseph with a candle in his hand at the moment of the Nativity. It was a naïve way of conveying that the scene was taking place at night. The similarities in the works of art prove that this small detail was never omitted and that the setting of the Mystery plays was the same everywhere.[153]

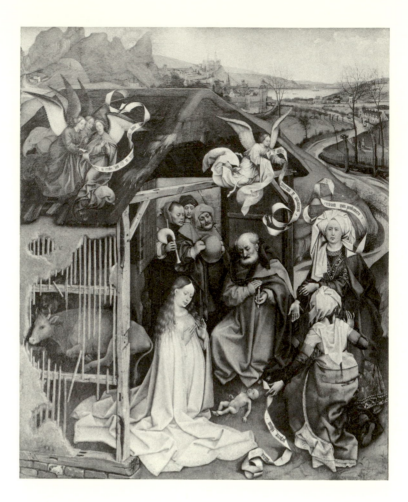

39. Nativity. Dijon, Museum. Master of
Flémalle (Robert Campin).

In art, the scenes of Jesus praying in the Garden of Olives and then the Arrest contain several curious details. Artists conceived the garden as a rustic orchard in Touraine or Normandy: it was enclosed by a paling fence in which there was a doorway, which sometimes was surmounted by a porch roof. I have rarely seen this detail omitted in the fifteenth century, and even well into the sixteenth century (fig. 34). Bourdichon was as faithful to it as the humblest of the miniaturists, and in the drawing Hubert Caillaux made of the Garden of Olives to illustrate the *Valenciennes Mystery*, he forgot neither the paling fence nor the doorway. We can only conclude that this was the traditional scenery. Near Jesus praying, the artists represented three apostles asleep. They were Peter, James, and John, whom the Master wished to have near him. Peter almost always clutched a sword to his breast while sleeping. We see this detail in the windows of Rouen, in the engravings of Albrecht Dürer,[154] and on the back of the episcopal throne at Burgos. Such remarkable agreement can be explained in the same way. And in fact, in the Arras *Passion* Peter goes to a sword furbisher to buy a sword before proceeding to the Garden of Olives.

Finally, when the soldiers seize Jesus and Peter cuts off Malchus' ear, the artists always placed a lantern beside the prostrate Malchus. Nothing of this kind appeared in the first part of the fourteenth century, but the lantern was shown in the fifteenth century and until the middle of the sixteenth.[155] Thus, we can be sure that it was a theatrical tradition for Malchus to have a lantern. And the certain proof is that it was Malchus himself who went to old Hédroit to ask for one in the *Passion* by Jean Michel.

In the thirteenth century, when Jesus appeared to Mary Magdalene[156] after his resurrection, he usually carried the triumphal cross surmounted by the banner. In the fourteenth century, and still more often in the fifteenth and sixteenth, he carries a spade. The oldest Christ with a Spade that can be cited is that of Notre-Dame, in Paris. This figure, as noble as a work of antiquity, was carved by Master Jean Le Bouteiller who finished that part of the choir screen in 1351 (fig. 40). Is this a recollection of a Mystery play? It could well be, for Gréban gives this stage direction: "Here Jesus enters from the back in the guise of a gardener." Jean Michel, for his part, tells us that Jesus appeared to Mary Magdalene "dressed as a gardener." However, we must remember that the Sienese, from the beginning of the fourteenth century, had already represented the resurrected Christ with a mattock on his shoulder: it is in this guise that he appears to Mary Magdalene in the Italian manuscript of Jeanne d'Evreux.[157] Had the Sienese themselves been influ-

40. *Noli me tangere*. Paris, Cathedral of Notre-Dame, choir screen (detail), side, south.

enced by the sacred representations given by the Italian Franciscans in their churches? This is a question that may one day be answered. The idea, anyway, came from Italy, but the production of the Mystery plays certainly contributed to its spread.

Likewise, it seems very probable, in fact I might say it is certain, that the large straw hat of the resurrected Christ is a legacy of the theater. In a window at Serquigny and in the engravings by Dürer, he is wearing this hat when he appears to Mary Magdalene.[158] No doubt this hatted figure lacks nobility, but how better could the spectators be made to understand Mary Magdalene's mistaking Christ for a gardener?

It is not only in the scenes from the life of Christ that details of this kind occur; they also appear in scenes devoted to John the Baptist.

In the ministry of John the Baptist as it was represented by fifteenth- and sixteenth-century artists, there is a curious small detail.[159] The saint preaches to the Jews from the top of a grass-covered knoll, and in front of him, a branch from a tree, placed horizontally on two posts, forms a kind of rustic pulpit.

This sort of improvised tribune is rarely missing in works of art.[160] It will suffice to cite the beautiful window in the church of St.-Vincent at Rouen, probably the work of one of the Le Prince: John the Baptist leans against a wooden barrier as he speaks, and all nature listens in silence; a beautiful stag is in the first row of auditors.[161] Even artists like Germain Pilon, whom we think of as liberated from the past, were faithful to this tradition (fig. 41).[162] There is no doubt that it was a

41. Preaching of the Baptist. Relief from the "Chaire des Grands-Augustins." Paris, Louvre. Germain Pilon.

legacy of the Mystery plays. The manuscript of the *Valenciennes Mystery*, illuminated by Hubert Caillaux, provides proof. The miniature devoted to the ministry of John the Baptist in fact shows him separated from his audience by the traditional wooden barrier.[163] It is certain that the artist reproduced a detail from a stage production he had seen.[164]

There were scenes from the Old Testament, also, in which the details can be perfectly explained by the Mystery plays. In Books of Hours, at the head of the penitential Psalms, there is usually a miniature representing David on his knees asking God's pardon for his sins. Toward the end of the fifteenth century, our illuminators put in this place, not the penance of David, but his sin. The spectacle is certainly less edifying. In a beautiful Book of Hours illuminated by Bourdichon,[165] Bathsheba is completely nude and standing up to her hips in an azure fountain that reflects the sky; her blond hair, flecked with gold, flows over her shoulders. Two ladies in waiting attend her; one hands her a mirror, the other holds a comb and carries a basket filled with jewels and flowers. From a balcony above, David admires her.[166]

If we turn to the *Old Testament Mystery*, we will find the original of this painting. While David gazes from a window of his palace, Bathsheba bathes in the fountain; and one of her servants hands her a mirror, saying:

> *C'est merveille*
> *De vous voir: onc rose vermeille*
> *N'eut la couleur que vous avez.*
>
> (It is a marvel
> To see you: never did blushing rose
> Have such color as yours.)

Another servant combs Bathsheba's beautiful hair. Her flowers and her jewels are made ready; for she has

> *Mis à part ses mirelifiques*
> *Senteurs, bouquets, bagues, affiques.*
>
> (Taken off her embroideries
> Perfumes, bouquets, rings, brooches.)

The Mystery play was no doubt given at Tours, and Bourdichon, whose amiable imagination was so easily moved by beauty, was charmed by it.

An attentive study of our miniatures and windows might reveal other imitations. The lives of the saints and the scenes from the Last Judgment will be seen, further on, to offer more than one example of these borrowings.

But those we have given will suffice to establish our thesis.

The Mystery plays give a realistic character to the art of the late Middle Ages. The Mystery plays unify art.

Much has been written about the Mystery plays; the art of these dramatic poets, their style, and their versification have all been the subject of lengthy discussion—all of it of little value. Everything has been said except the essential. For if they are worth attention, it is not because of their literary qualities: they are poor specimens, our fifteenth-century plays. But how can we be severe when we know that they inspired the greatest painters? Is it nothing to have taught Roger van der Weyden, Fouquet, and Memling the groupings and attitudes of their figures, and to have imposed on them the costumes for their paintings, even to their very color?

What this comes down to is that in the medieval theater only the *tableaux vivants* were of any interest. All the art of the Mystery plays resided, in fact, in them. And such, no doubt, was the opinion of the fifteenth-century public, for it is difficult to imagine that the metaphysical discourses of Justice and Mercy, or the long sermon of John the Baptist, could have been listened to with much attention. But to see Jesus in person, to see him before its very eyes, living, dying, resurrected—that is what moved the public, even to tears.

Scholars have posed a thousand questions about the staging of the Mystery plays, as if that were a difficult problem. We have only to look. Paintings, stained-glass windows, miniatures, and altarpieces contain countless images of what was seen in the theater. Certain works of art are even more striking copies, for they represent action, simultaneously, as in the Mystery plays. The paintings by Memling devoted to the Passion and to the life of the Virgin give us the most exact notion of dramatic representations. In them, we see ten different scenes taking place against the same background, in which the actors proceed naïvely from one scenic "frame" (*mansion*) to another.[167]

If one day fancy should prompt us to restage a Mystery play, nothing would be simpler than to costume and group the actors; and for an artist it would be a rare pleasure to see the Virgins of Memling or the figures in Etienne Chevalier's Hours come alive.

Thus, the Mystery plays offered new costumes, scenery, and figural compositions to art. They helped to give an air of familiar reality to the Gospel scenes.

It was during the second half of the fifteenth and the beginning of the sixteenth century that this influence was strongest. When Italian art was every day becoming more noble and more generalized, the art of northern Europe preserved a sort of popular simplicity. This simplicity it owed, in part at least, to the naïveté and to the down-to-earth realism of the contemporary theatrical productions.

Since the Mystery plays were presented everywhere in more or less the same way, it is not surprising to see the artists everywhere reproducing the same costumes, scenery, and stage business. In such a way, the theater had its share in unifying late medieval art.

According to Creizenach, who was the first to study the development of the medieval theater in all the regions of Europe, there is one influence found in all the Mystery plays: that of France.[168] This phenomenon, which he does not attempt to explain, seems however to have causes that can easily be explained. In fact, since 1402 Paris had been the only town in Christendom to have a permanent theater. Moreover, the University of Paris remained what it had always been, the first in the world; alongside the Papacy, it was the highest moral authority; students from every country gathered there. Is it not natural that these clerks, who surely attended the performances of the Confraternity of the Passion, would take home with them the practices of the Parisian theater? If such were indeed the case, then we must admit that most of the traditions of the *mise en scène* were created in France, so that the new religious iconography which owed so much to Italy, also owed a great deal to France.

VII

It is not surprising that the new formulas, which came from Italy and from the theater, spread so quickly and became so universal when the spirit of the art of the period is considered. The artists of the fifteenth century imitated with almost as much docility as those of the thirteenth. Imitation is always the great law in art. The miniatures of our Books of Hours, for example, are surprising in their uniformity: all the scenes are reduced to formulas with no variations. In Paris, Tours, Rouen, the illumination of prayer books had as much to do with industry as with art. Only the head of the workshop was a true artist,[169] and he alone was permitted to make discreet innovations.

Most interesting is the study of books from the atelier of Bourdichon at Tours.[170] The master was a charming artist of delicate sensibility who, while respecting the principal lines of tradition, was not afraid to introduce a pretty detail into a sacred scene. His inventions immediately became school rules which his pupils copied with so exemplary a submissiveness that we have no trouble in recognizing the books from his workshop.

Let us turn to an example of the liberty taken by the masters. Toward the end of the fifteenth century, one artist dared to change the iconography of the Tree of Jesse. Instead of showing the patriarch *reclining* and seeing in a dream the great tree grow out of his stomach, he

How the new formulas created by the theater were transmitted. The artists' docility in imitating them.

represented Jesse *seated* under a tent-like canopy. Four prophets, chosen from those who had foretold the birth of the Saviour, stand at his sides. Above his head rises the trunk of the great tree whose branches bear kings, a Virgin, and a Child, instead of flowers. Thus conceived, the scene is less mysterious but it is better balanced and the lines are more beautiful. The source of this innovation goes back to the *Speculum humanae Salvationis*. There, for the first time Jesse is seen, not reclining, but seated.[171] The miniaturists of Rouen seized on this innovation at once.[172] The glass painters of Normandy followed their example and adopted a composition that seemed to be made for them. Almost all the windows of the Tree of Jesse that I have seen in Normandy reproduce exactly the composition used in the miniatures (fig. 42);[173] I know of none any nobler. Thus, a new formula for the Tree of Jesse appeared at the end of the fifteenth century and was adopted by all of Normandy, an example of how artistic invention was immediately taken up.

The circulation of woodcuts in the course of the fifteenth century established even more firmly the consecrated types. It was then that the compositions imagined by the great artists acquired the force of law. Pious image made its appearance. In the eyes of the people, the principal merit of these naïve prints was in their uniformity. The appearance of xylographic books, and a little later of illustrated books, was to give even more cohesiveness to fifteenth-century iconography. The artists, who had the books constantly before them, often looked through them for models. Painters, glass painters, tapestry makers, and enamelers copied the prints. There was continual exchange and constant imitation. If we take the trouble to collate the iconographic series, it will become apparent how rare creative artists were; it will be seen, too, how small a part invention played in the work of even the greatest masters. Study of the admirable engravings by Martin Schongauer shows that in spite of his great originality, this great artist drew almost all his iconographic compositions from the Franco-Flemish tradition. But in turn, Martin Schongauer was servilely copied or freely imitated by a host of German artists. In the German and Flemish art of the fifteenth and sixteenth centuries, we come upon him continually. He is everywhere. Wenceslaus d'Olmütz copied his Annunciation and his Nativity, François Bocholt appropriated his Temptation of St. Anthony,[174] Israel van Meckenem his Ascent of Calvary, his Death of the Virgin, and his Wise Virgins; Aldegrever was inspired by his Annunciation, Cranach by his Temptation; an anonymous artist illustrated a pious book with a Passion of Christ that is none other than Martin Schongauer's.[175] Albrecht Dürer studied him endlessly: it is impossible not to be struck by the similarities between Schongauer's Passion and Dürer's copper engraving of the Passion dated 1508. But Albrecht Dürer was copied in turn. His Passion,

42. Tree of Jesse. Caudebec-en-Caux (Seine-Inférieure), Church of Notre-Dame.
Stained glass panel from north aisle of nave.

inspired by Schongauer, was soon imitated by Lucas van Leyden.[176] All the famous engravings in which Dürer was able to reconcile originality and respect for tradition were imitated a hundred times in Germany by anonymous artists, in Italy by Zoan Andrea and Benedetto Montagna,[177] and in France by our glass painters.[178]

It is now clear how the new iconography was able to acquire such cohesive force. It was thus that these formulas were propagated, and were seemingly so fixed as to give the illusion of religious canons; for the art of the fifteenth century is by and large almost as unchanging as the art of the thirteenth.

Such was the new framework that Italian art and dramatic art had prepared for the artists. Now we shall see hitherto unknown sentiments become part of this new iconography and imbue it with fresh life.

III

Religious Art Expresses New Feelings:
Pathos

I

After long years of contemplating the truly saintly figures adorning our thirteenth-century cathedrals, it is strangely surprising to turn to the art of the fifteenth century. We are almost tempted to ask if it is indeed the same religion that is being interpreted. In the thirteenth century, all the radiant aspects of Christianity were reflected in art: goodness, gentleness, and love. All the faces seem to be lit up by the effulgence from the Christ above the principal portal. Suffering and death were rarely represented, and when they were, they were clothed in matchless poetry. At Notre-Dame in Paris, St. Stephen dying under the blows of the executioners, preserves an air of innocence and charity; the dead Virgin lying on a shroud held by two angels seems peacefully asleep. Not even the Passion of Christ aroused painful feelings. On the rood screen at Bourges, the cross he carries on his shoulder as he ascends Calvary is one of triumph, adorned with precious stones. The entire remarkable Passion of Bourges cathedral equals the serenity of Greek art, recalling the ruined metopes of a temple.

Art never expressed the essence of Christianity better than in the thirteenth century; no Church father ever said more clearly than the sculptors of Chartres, Paris, Amiens, Bourges, or Reims that the secret of the Gospels was charity and their last word, love.

By the fifteenth century, this reflection of heaven had long since faded. Most of the works remaining from this period are somber and tragic; art presented only the images of suffering and death. Jesus no longer taught; he suffered. Or rather he seemed to offer his wounds and his blood as the supreme lesson. What we find in art, henceforth, is a Jesus who is naked, bleeding, and crowned with thorns; we see the instruments of his torture, and his corpse lying on the knees of his mother; or, in a dark chapel, we see two men placing him in his tomb while the women strain to hold back their tears.

The new character of Christianity after the late thirteenth century.

It would seem that the mysterious word, the word containing the secret of Christianity, was no longer to be "love," but "suffering."

Therefore, Christ's Passion was the favorite subject of the age we are now considering. The High Middle Ages had almost always represented the Triumphant Christ; the thirteenth century found its masterpiece in the type of Christ as Teacher.[1] The fifteenth century wanted to see in its God only the man of suffering, and henceforth, the dominant aspect of Christianity was to be pathos. The Passion, to be sure, never ceased to be its center: but previously, the death of Jesus Christ had been a dogma addressed to the mind; now it becomes a moving image that speaks to the heart.[2]

Certainly the Mystery plays, which were continually placing the suffering and death of Christ before people's eyes, familiarized artists with images of sorrow and mourning. But such an explanation is not sufficient. For where did this taste for Mystery plays come from? How did it happen that, in the fourteenth century, Christians wished to see their God suffer and die? Why, in the course of the fifteenth century, did the drama of the Passion continually grow longer, becoming even more terrible, more atrocious? The art and the theater of the fifteenth century clearly had their origin in the same fund of feeling.

On close study of the religious literature of the Middle Ages, we note the astonishing innovations that appeared late in the thirteenth century. Sensibility, until then, so contained, suddenly erupted.[3] This is a great surprise to those of us who have lived on familiar terms with the stern eleventh- and twelfth-century Church fathers who transposed all reality into symbol and moved in the pure ether of thought. St. Bernard alone, in a few of his sermons, gives us a foretaste of the transports, the sobs, the cries of wounded sensibility. Henceforth, the most austere thinkers— a Gerson, for example—will brusquely cast abstractions aside to describe Jesus suffering. He will weep over his wounds and count the drops of his blood. Souls gave way to a hitherto unknown tenderness.[4] One might say that all Christendom had received the gift of tears.

Who had released this gushing spring? Who had thus struck the Church in its very heart? This problem, one of the most interesting presented by the history of Christianity, has never been resolved, nor, to tell the truth, has it ever been clearly posed. Historians seem not to have noticed this overflowing of sensibility. This is surely because they have never studied Christian thought as it is revealed in Christian art, which so sensitively expressed its slightest nuances.

To reach the source from which so much compassion flowed over the world, I think we must go straight to Assisi. St. Francis is like the second founder of Christianity, and Machiavelli was not entirely wrong when he said: "Christianity was dying: St. Francis resurrected it."[5] It was as if St. Francis rediscovered Christianity; what for others was a

dead formula was life itself to him. Face to face with a Christ painted on a cross, he experienced the revelation of the Passion, suffering so deeply that from then on he bore its signs: a miracle of love that astonished all of Europe and gave birth to completely new forms of sensibility. His mendicant friars, who were soon to be found throughout the Christian world, spread his spirit. St. Francis had his imitators; there is something of him in all the great mystics of the fourteenth and fifteenth centuries.

II

But let us not claim to set forth a definitive solution to such a delicate subject and leave it to others to search out the causes. Let us be content to study the moral climate in which our works of art came into being.

With the beginning of the fourteenth century, the Passion became the chief concern of the Christian soul. St. Gertrude wrote that no exercise could compare with meditation on the Passion: it was Jesus himself who had taught her how.[6] One Good Friday, as she listened in tears to the account of Christ's sufferings, Jesus suddenly appeared to her and gathered her tears into a golden cup.[7]

It was not enough for Suso to meditate on the Passion. At night he acted it out for himself alone, in the solitude of his monastery. He imagined that one pillar of the cloister was the Garden of Olives, another the praetorium, another the house of the high priest, and he went from one to the other carrying a heavy cross, in union with Christ and suffering with him. His Passion ended before the crucifix of the chapel. Returning, he thought he accompanied the Virgin, and he saw her covered with the blood of her son.[8] Suso was probably the first to have the idea for what was much later called "the Way of the Cross."

The books devoted to the Passion—meditations, poems, dialogues— began to multiply; in the fifteenth century their number was to increase even more. To give them more authority, they were attributed to St. Bernard or to St. Anselm; but nothing in these books, which speak only to blood and flesh, bears the stamp of those great doctors.[9] Most of these tracts are anonymous.

We must be careful not to think that this excitation of sensibility was peculiar to the mystics: the entire Church shared such feelings. A look through the liturgical collections of Daniel, Mone, and Dreves, and their fourteenth- and fifteenth-century hymns shows how astonishingly large a place in them was taken up by the Passion.[10] These collections of hymns are a flood of poetry. For two centuries, man's soul overflowed with compassion. In France and Germany, poets who were unknown to each other and were not imitating each other's work, sang with equal fervor of the lance, the nails, the thorns of the crown,

The Passion of Jesus Christ. The place it was to hold henceforth in Christian thought.

the wood of the cross, the wounds and the blood of Christ; the same subject was reworked a hundred times and a hundred times renewed. These tender works, so ingenious and exquisite, were fashioned with as much love as a beautiful altarpiece of oak or ivory. Certain of these short masterpieces inspired by the Passion deserve comparison with the most moving Pietàs or the most tragic Christs on the Cross of the painters and sculptors. It is in this way that the depth of a feeling can be measured.

Those living in the lay world showed the same devotion to the sufferings of Christ. Philippe de Maizières, the faithful servitor of Charles V, dreamed of founding in his old age a new order of chivalry in honor of the Passion.[11] About the same time, Isabeau of Bavaria had commissioned a *Meditation* on the Passion of Jesus Christ.[12] The people were content to attend the Mystery plays, but when the printers began to produce books for them, they willingly bought the innumerable little *Treatises, Mirrors,* and *Horologia* of the Passion that appeared in all the languages of Europe.

What did these books say? If we want to taste in full their novelty, we must compare them with those of the old Church fathers.

A curious and striking fact is that there were so few treatises or sermons devoted to the Passion during the eleventh, twelfth, and even thirteenth centuries. The sermon writers preferred to speak of Christ's birth and resurrection rather than of his death; or, if they did speak of it, it was not to move the faithful to pity but to instruct them. The sermon by Ives of Chartres on the Passion is a model of its kind; we find there nothing but symbols.[13] The memory of the Passion did not move St. Anselm to tears, for at the moment when he might have wept, it occurred to him that he ought rather to rejoice since he had been saved by the death of his God.[14] To picture the details of Christ's sufferings was still distasteful to the imagination. People did not wish to see him emaciated, bleeding, waxen. In the twelfth century, Jesus was shown dying on the cross in this way: "He bends his head because he wishes to kiss us, he stretches out his arms because he wishes to embrace us, and he seems to say: 'All who suffer, come unto me.' If he wishes his heart to be opened, it is to show how much he loves us."[15] All the sweetness of early Christianity is contained in this passage from the *Meditations* of St. Anselm.

To find out how the fourteenth century imagined the scene we may open the *Revelations* of St. Bridget, one of those fervent books that had so profound an influence. The Virgin herself spoke to the saint and told of all that she had suffered. When she saw her son nailed to the cross, she fainted. This is the condition in which she found him when she revived: "He was crowned with thorns, his eyes, his ears, his beard streamed with blood. ... His jaws were swollen, his mouth open, his

tongue tinged with blood. His stomach was so sunken that it touched his backbone, as if he no longer had intestines."[16]

Is it not correct to say that fourteenth-century Christianity was not at all like that of the twelfth century?

An insatiable imagination set to work on all the circumstances of the Passion. How was Jesus flagellated? Tauler thought about it so often that it seemed to him he had been actually present at the torture. He knew that Jesus had been bound so tightly to the column that blood spurted from his fingertips. He was first beaten on the back and then he was turned around. He was one solid wound: "His blood and flesh flowed."[17]

Olivier Maillard tells us that he received five thousand four hundred seventy-five lashes.[18] Jean Quentin, author of the *Orologe de dévotion*,[19] added that "the rods and scourges broke on him, and the knots remained imbedded in his flesh." St. Bridget saw him led away after the Flagellation, and noted that he left bloody tracks.[20]

Because the scene of Calvary was the object of so much meditation, it was conceived with frightening precision in the early fifteenth century. Following the *Meditations*, it was said that before Christ was crucified, his robe, which was stuck to his wounds, was torn violently from him, reopening all the wounds.[21] Then, according to Gerson, the crown of thorns was placed on his head for the third time; and according to the *Speculum passionis*, the crown had seventy-seven thorns and each thorn had three points.[22] Finally he was stretched on the recumbent cross. The holes had been made in advance and it was no trouble to nail his right hand, but his left hand would not reach the other hole, which had been placed too far away. "Then," says the *Orologe de dévotion*, "they attached ropes to thy shoulder and under thy armpit. And to pull the harder, they braced their feet against thy Cross and pulled together so terribly that all the veins and nerves in thy arms broke."[23] Once the nails were driven in, the executioners lifted the cross. Raised by men's arms and pulled upright by ropes, the cross fell heavily into the deep hole dug to receive it. The jolt was terrible for the sufferer. "For," said Tauler, "the nails piercing his hands and feet had not yet caused his blood to flow because the skin had entered the wounds and sealed them; but when the cross fell into place in the ground, the shock was so great that the wounds opened and his blood spurted forth."[24]

The Descent from the Cross provided other subjects for tears. Drenched in blood, the corpse was placed on the mother's knees. She tried, St. Bridget said, to straighten the poor contracted body; she wished to cross the hands on his breast and give them the familiar attitude of death, but the joints refused to bend.[25] Then she threw herself on her son and covered his face with kisses; when she raised her head, her face was covered with blood.[26] For a long time she held him in her arms, not

wishing to be separated from him; she pleaded to be buried with him;[27] she wept so much that "her soul and her flesh seemed to wish to dissolve in tears."[28]

This was the most usual subject on which the faithful meditated in the fifteenth century: participation in the Passion became the principal act of Christian piety. The Mass, which had formerly been interpreted as an epitome of the history of mankind, was now seen only as a commemoration of the drama of Calvary.[29] Day itself, with its divisions, became a mystical figure for the Passion of the Saviour; each hour that rang recalled the suffering of Christ. Pious tracts pointed out the correspondences between the episodes of the Passion and the hours of the day.[30]

III

The representation in art of the Passion of Christ. Christ on the Cross. Seated Christ on Calvary.

What form did these new feelings take in art? When we review what is left to us from the fourteenth, fifteenth, and sixteenth centuries, we are struck first of all by the prodigious quantity of works of art devoted to the Passion. The stained glass windows and altars are still so numerous that we cannot even begin to count them. And even so, the losses must be incalculable.

These innumerable images did not satisfy the pious. They wished to have the Passion at their bedsides; consequently, the many ivory diptychs and triptychs that abound in all collections were, in fact, household altarpieces.[31] Generations hoped and suffered before these fragile reliefs, which today attract the interest of the connoisseur.

One senses everywhere a passionate desire to participate in the Passion. The kneeling donors often shown in altarpieces seem to wish to share in the sufferings of Christ.[32] They appear in both paintings and stained glass windows. They all seem filled with gratitude and love; their facial expressions and clasped hands clearly say: "He suffered for me; he died for me." There are even those who cannot restrain themselves and wish to aid Jesus in carrying his Cross.[33] In other instances, as in the fresco at Chauvigny, in Poitou (fig. 43), the entire Church comes to Jesus' aid: popes, cardinals, priests, laymen, all press forward, all wish to place their hands under the heavy cross. In this, art unites with the mystics, and especially with the author of the *Imitation*.

Let us study some of these scenes of the Passion more closely, and determine to what point they express this new world of feeling.

First of all, the figure of Christ on the cross reveals some of the new facets of the Christian sensibility. Nothing could be more moving than the silhouette of the Crucified that appeared in art in the early fifteenth century. His arms are no longer thrown open almost horizontally, as

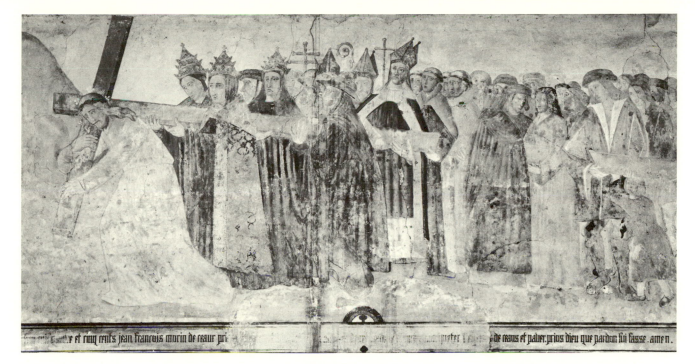

43. Christians helping Christ carry cross. Chauvigny (Vienne), Church of Notre-Dame. Fresco.

before; on the contrary, they rise vertically above his head. The head, once placed on the crosspiece, is now below it. We sense that all the weight of the body hangs from the two hands, and our instinctive reaction to this tragic hieroglyph, this sort of Y, is one of painful shock.[34] At once the cross ceases to be a symbol, and for the first time appears as a gibbet. The attitude of the body reinforces this impression: it is elongated, rigid, immobile. During the entire fourteenth century the legs were half bent and the body violently arched, forming an S. However, this tortured, convulsive silhouette is much less moving than the long hanging figure; it is so emaciated, so void of substance, that it is no wider than the shaft of the cross. When we are confronted with such physical annihilation, it is impossible not to recall St. Bridget's horrifying description (fig. 44).

A detail borrowed from the mystics completes the physiognomy of the fifteenth-century Christ. He was crucified, not with bare head as in the past, but wearing the crown of thorns: that is why his beard and his hair are sometimes glazed with blood.

This is the new aspect of the Christ on the Cross as it was represented throughout the fifteenth and part of the sixteenth centuries. Such an image no doubt corresponded exactly to men's feelings, for it was adopted all over France. In Normandy, we find it in the windows at Louviers and Verneuil, and in the painting in the Palais de Justice in Rouen, done during the the time of Louis XII;[35] in Champagne, in the

44. Crucifixion. Louviers (Eure), Church
of Notre-Dame. Stained glass window.

windows at Rosnay, Auxon, Creney, and Longpré; in the Franche-
Comté, in the window of St.-Julien; in the Bourbonnais, in the window
at Moulins; in Bresse, in the window at Ambronay. These examples
could be multiplied indefinitely.[36]

This type of Christ on the Cross was formulated during the last part
of the fourteenth century. The crown of thorns was rarely shown in
the thirteenth century;[37] it appeared during the first years of the four-
teenth century, and at that time it was given a lightly twisted circlet

resembling a graceful ornament. In the altar frontal of Charles V (c. 1370), now in the Louvre (fig. 9), it is shown in its true aspect. Henceforth, it would always be present.

The Christ with arms raised above the head and legs rigid was already to be found in the early fifteenth century, as the fresco of St.-Bonnet-le-Château, in the Loire, proves.[38]

In the sixteenth century, this touching figure of the Crucified Christ, the most moving ever imagined in art, was replaced on the cross by a kind of classical demi-god, a Prometheus with bulging muscles who, along with much else, came from Italy.

But our artists' most original creation was not the Christ on the Cross. They created a new figure of their own that was like a sorrowful summary of the entire Passion.

Naked and spent, Jesus sits on a knoll; his feet and hands are bound with ropes; the crown of thorns pierces his forehead and what blood is left in him flows slowly. He seems to be waiting; a profound sadness is reflected in his eyes, which he barely has the strength to keep open.

Who, traveling through France, has not seen this tragic statue? But the meaning of the works of the past has been so completely lost to us that I have never known this figure to be called by its true name. It is always called *Ecce homo*, and sometimes an inscription sanctions the error. For the error is glaring. Although it was infrequent, the scene of the *Ecce homo* did appear more than once in the art of the late Middle Ages. But in it, Christ is conceived quite differently: He is standing, dressed in the mock purple when he shows himself to the people, and he sometimes even holds the reed as a scepter.[39] But the statue we are speaking of represents Jesus seated, stripped of his mantle, his hands bound. It has to do with another moment of the Passion, but which one?

At the outset, one detail indicates that the scene did not take place in the praetorium. There is a skull at the feet of the seated Christ in the statues at Salives (Côte-d'Or), at Vénizy (Yonne) (fig. 45), and at St. Pourçain (Allier). Now in the language of religious art, the skull designates Calvary;[40] this suggests right away that the artists did not intend to show the beginning, but the end of the Passion. And in fact, a bas-relief at Guerbigny (Somme) proves that it is the rock of Calvary on which Christ is seated; for the cross rises behind him and beside him is the robe that has been torn from him, and on the robe there are dice. Once alerted, we can easily find other proofs. A bas-relief at St.-Urbain, in Troyes, represents the events of Calvary:[41] before the Crucifixion we see Jesus seated with bound hands, crowned with thorns, and stripped of his robe. A window at Maizières (Aube) shows a similar figure, which is placed between the Carrying of the Cross and the Crucifixion. Jean Bellegambe, in his famous triptych in the cathedral

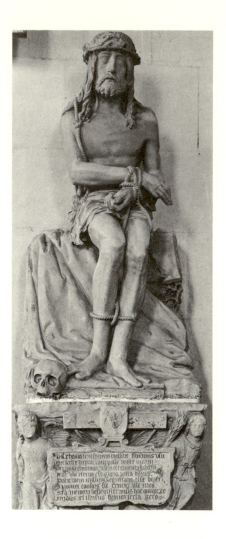

45. Christ seated awaiting death. Vénizy
(Yonne), Church.

of Arras, chose the same moment of the Passion: Jesus is seated on a
knoll such as we have described, and he waits while the executioners
drill the nail holes in the cross.[42] A stained glass window in the Hôpital
of Chalon-sur-Saône is equally characteristic.[43]

Thus, there is no possible doubt. The statue of the seated Christ
imagined by the artists of the fifteenth century does not represent a
Christ mocked in the praetorium, but a Christ awaiting death on Cal-
vary. I could easily believe that the artists borrowed this image of
suffering from the Mystery plays. It was in the theater, indeed, that
they would have seen Christ stripped of his robe and waiting with
resignation while the executioners made ready the Cross. The spread
of this new motif seems to correspond with the great vogue of the
Mystery plays, for almost all these seated Christs come from the late
fifteenth or early sixteenth centuries. I know of only one that is dated,
that of Guerbigny: it was placed in the church in conformance with
the last wishes of an inhabitant of the village who died in 1475.[44]

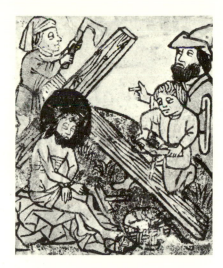

46. Christ seated awaiting death. Paris,
Bibliothèque Nationale, Cabinet des
Estampes. Anonymous print, XV c.

Whatever may have been the origin of this figure, its meaning is
now clear. The Christ had already been scourged, crowned with thorns,
spat upon, flagellated, and had carried his cross to Calvary; the exe-
cutioners had brutally torn away his robe which had become like his
own flesh since it had stuck to his many wounds. Now he is seated,
spent, with nothing left but to die. As a final insult, his feet and hands
have been bound as if he were capable of escaping; his head rests on
his shoulder, his arms are crossed on his breast. He waits. This seated
Christ summarizes the entire Passion; as he is here, he has exhausted
the violence, the ignominy, the bestiality of man.[45]

I do not think art has ever conceived a more poignant scene: here
is the abyss of suffering, and the extreme limit of art. The Christ on
the Cross described above, the elongated Christ suspended on the gibbet,
had already given up the ghost; the eyes are closed and the centurion
has just given the lance thrust. The seated Christ thinks and suffers.
Thus, art had to express the profoundest moral suffering imaginable
and link it with the extreme of physical suffering. A formidable problem
that might well intimidate even the greatest of artists. Our old masters
attacked it with their usual good faith and innocence of heart; and in
their customary simplicity, seemed not to suspect that they were at-
tempting something no one had dared before.

To recount the agony of a God, to show a God exhausted, bruised,
and covered with bloody sweat, was an enterprise to give the Greeks
of the fifth century pause. Their heroic conception of life made them
unsympathetic to suffering. For them, suffering was servile because it
destroyed the equilibrium between body and soul; such an imbalance
ought not to be eternalized in art. Only beauty, strength, and serenity
should be set forth for man's contemplation. In this way, art became

salutary and presented a model of perfection toward which the city might strive. Its assembly of marble gods and heroes said to young men: "Be strong, and like us, master life." This is the lesson everlastingly to be learned from antiquity. A great lesson, assuredly, and one that has affected men's souls ever since the Renaissance. Michelangelo, however much a Christian, was under the spell of classical heroism. His *Christ* at S. Maria sopra Minerva is as beautiful as an athlete and carries his cross like a conqueror; no trace of suffering shows on his impassive face.[46] Like a Greek, Michelangelo despised suffering and taught others to have contempt for it. Following his example, the French, toward 1540, began to be ashamed to express suffering. The *Christ at the Column* in St. Nicolas, at Troyes, is a hero who could not have been touched by the mockery of slaves (fig. 47). The artist who carved it not only imitated Michelangelo's style, he shared his state of mind. For the drama in the history of Renaissance art, in France and in the whole of Europe, arises from the struggle between two principles, two conceptions of life.

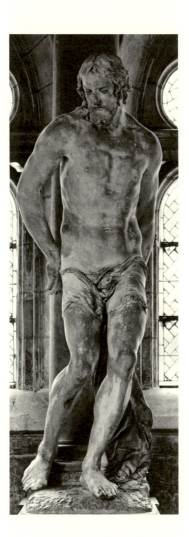

47. Christ at the column. Troyes, Church of St.-Nicolas.

What, then, were our old Gothic masters trying to say? They wished to say that suffering exists and that it is useless to deny what we see woven into the web of life. They were fundamentally right. A religion and an art in which suffering has no place does not express the whole of human nature. Even Greece grew weary of its beautiful but unconsoling legends and joined the women of Syria in weeping over the death of Adonis. Tears long restrained must find an outlet.

But let us not misrepresent our artists. We seem to have been saying above that in expressing suffering they wished to glorify it and to teach that *suffering* is the final meaning of the Gospels: but this was not their thought. What they really wished to glorify was not suffering, but love; for what they show us is the suffering of a God who died for us. Suffering, therefore, has no meaning unless it is accepted with love, transfigured into love: "love" remains the final lesson of Christian art in the fifteenth century, just as in the thirteenth.

Love, in fact, is combined with suffering in all the greatest works. To be sure, all the seated Christs were not masterpieces, but there is scarcely one that does not move us. We have only to look at them sympathetically to be moved. The head of painted stone, recently acquired by the Louvre, is a fragment from a seated Christ (fig. 48).[47] It is one of the most beautiful works of this type we could possibly cite. The cheeks are sunken, the swollen eyes ringed with greenish bruises, the forehead in which thorns are imbedded is red with blood. It might be the head of some poor beggar who had been put to the rack and almost killed, if the expression of the face had not so much sweetness, and if the half-open mouth did not let a sigh of resignation escape. By these signs the hidden God is revealed.

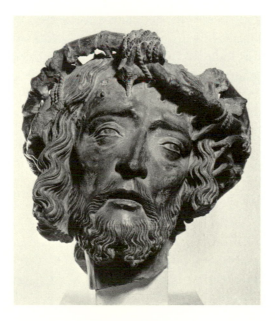

48. Head of Christ. Paris, Louvre. Painted stone (fragment).

49. Christ seated awaiting death. Troyes,
Church of St.-Nizier.

The Man of Sorrows. Origin of this figure.
The Mass of St. Gregory. The different ways
of representing the Gregorian Mass. The in-
struments of the Passion.

In St.-Nizier, at Troyes, a well-preserved seated Christ is worthy of
being included among the most moving examples of this type (fig. 49).
The crown of thorns is so deeply imbedded in the head that it resembles
a turban. The hair and the beard form heavy masses of coagulated
blood. The eyes express a kind of sad astonishment. The prescience and
foresight of this God were in vain, for he would seem not to have
imagined that such cruelty was possible among the sons of Adam. But
at the same time, the upright head and firm attitude of the body bespeak
the will to suffer to the end and to complete the sacrifice. I know of
no seated Christ that can rival this one; but France is still so little
explored that works of equal beauty may lie hidden in village churches.

IV

Another figure of the suffering Christ, often called The Man of Sorrows,
appeared in France at about the same time.[48] At first glance, it would
seem to resemble the figure just discussed, but it is in fact quite different.
This Christ is standing, the head is crowned with thorns and droops
on the shoulder, the arms are crossed on the breast. Sometimes the

figure leans against the cross. He seems still to be suffering although he has already passed over into death, for the feet and hands are pierced and the wound in the side is open. Furthermore, he is often shown standing in the tomb, visible only above the waist. This strange image, in which Christ's suffering and death are expressed simultaneously, is dreamlike. And in fact, it is a vision. According to a legend, Christ revealed himself in this attitude to Pope Gregory the Great as he was celebrating the Mass.[49] However, the legend does not go far back into the past. None of the Lives of St. Gregory compiled by the Bollandists mention it;[50] Jacobus de Voragine himself did not know of it at the end of the thirteenth century. The legend evidently came from Rome, and it must have originated in the church of S. Croce in Gerusalemme, where the event was said to have taken place.[51] A painting preserved in the church may very well have been the origin of the tradition.[52] In fact, in the work of the Flemish engraver Israel van Meckenem, a contemporary of Dürer, I found an engraving (fig. 50) that he identifies as a copy of an image preserved in Rome in the church of S. Croce in Gerusalemme: the inscription reads, "This is a copy of the holy image of compassion which Pope Gregory the Great caused to be painted for the church of S. Croce following his vision." The nude Christ with crossed hands is represented in half-figure and leaning against the cross.

50. Christ as Man of Sorrows. Paris, Bibliothèque Nationale, Cabinet des Estampes. Engraving by Israel van Meckenem.

This is the prototype of all the representations of the Man of Sorrows. But the strange thing is that the painting, as proved by the monogram IC XC and the inscription in Greek characters—so badly copied by the engraver that it is incomprehensible—was the work of a Byzantine artist.[53] It could be that the strangeness of the image brought from the East in the twelfth or thirteenth century had, after two or three generations, caused people to imagine that Pope Gregory had had the painting made to consecrate his vision.[54]

How can the success of this image be explained? Why did it spread all over Europe in the fifteenth century? The reason is very simple: it was because tremendous indulgences were attached to it. If, after confessing, people recited before an image of the Man of Sorrows seven *Paters*, seven *Aves*, and seven short prayers called "the prayers of St. Gregory," they were granted six thousand years of "true pardon."[55] St. Gregory himself, it was said, had obtained this favor from Christ. In the course of the fifteenth century, the popes increased these already astonishing indulgences, and the number of years of pardon came to be prodigious. A manuscript in the Bibliothèque Ste.-Geneviève gives fourteen thousand years,[56] an altarpiece at Aix-la-Chapelle refers to twenty thousand;[57] manuscripts and prayerbooks of the late fifteenth century proclaim no less than forty-six thousand years of indulgence.[58] An enormous figure, but one which the Church, viewing everything in the light of eternity, found small. Consequently, below the image of a Man of Sorrows at St.-Léonard (Oise), we read something even more astonishing. There it is said that if you cross the cemetery after you have recited the prayers before the image, you will earn as many years of pardon as the number of bodies buried in the graveyard.

In any case, as we see, the image of the Man of Sorrows had to be present before the one who was praying. That is why it appeared so frequently in Books of Hours, whether in manuscript or printed. The faithful, with those in mind who had no books, presented the churches with representations in stained glass windows, altars, and paintings. The engravers of the fifteenth century made copies for the use of the poor, the painters for the use of the rich.

Now the vogue of the image of the Man of Sorrows is understandable. It was no doubt brought back to France by pilgrims returning from Rome. In fact, in the early fourteenth century, the Italians had begun to reproduce the image venerated at S. Croce in Gerusalemme. Giovanni Pisano was one of the first to copy it. The Man of Sorrows with which he decorated the pulpit in the cathedral of Pisa is not at all his own invention, but is a simple imitation of the Roman painting.[59] After the pulpit of Pisa was finished in 1310, examples became fairly numerous in Italy. It will suffice to cite the tomb of the Gherardesca family in the Campo Santo of Pisa, the tomb of the Baroncelli at Santa Croce in

Florence, the tomb of Tedice Aliotti at S. Maria Novella in Florence, and, in the archeological museum in Milan, a funerary bas-relief which, of all these copies, seems to be the most literal.[60] All these monuments date from the early fourteenth century. It is to be noted that almost all these images of the suffering Christ were carved on tombs: people no doubt prayed before the tomb of the deceased in the hope of obtaining for his soul the indulgences promised in the name of St. Gregory.

In France, the images of the Man of Sorrows appeared somewhat later. A seal belonging to Jean, Abbot of Anchin, bearing the date 1374, is the oldest example.[61] The Man of Sorrows appeared a few years later in a Book of Hours, now in the Bibliothèque Nationale, which has all the characteristics of late fourteenth-century manuscripts.[62]

Although the representations of the Man of Sorrows stem from the same holy image, they were not uniform. They appeared in four different versions.

The nude Christ, with drooping head and hands clasped, was shown in half length issuing from the tomb. This was the simplest form and an exact copy of the original.

The Christ is again standing in the tomb, but two angels aid him, showing great respect. Sometimes they raise a curtain behind him and sometimes they support his body (fig. 51) or his arms, which seem about to fall helplessly to his sides.[63]

51. Christ as Man of Sorrows. *Très Belles Heures de Notre Dame* of the Duke of Berry. Paris, Bibliothèque Nationale, nouv. acq. lat. 3093, fol. 155r.

Or, oftentimes, the angels are replaced by the Virgin and St. John; and as we know, this was one of the Italian masters' favorite themes. It was the idea of the eternal Passion of Christ, a Passion that continued even beyond death, that brought about this new grouping of figures. The Christ had revealed his suffering to St. Gregory, and it seemed natural to associate his suffering with the Virgin and St. John. Then the simple image of suffering became a marvel of feeling. We all know the most beautiful of the *Pietàs*, that of Giovanni Bellini, in the Brera museum in Milan. A moan escapes St. John's half-open mouth, while with avid tenderness the Virgin places her cheek against that of her son.[64]

Finally, it occurred to the artists to represent the scene of St. Gregory's vision itself. The Pope celebrates the Mass: sometimes he is alone, but more often he is surrounded by cardinals and bishops. Suddenly the Man of Sorrows appears on the altar, either standing to his waist in the tomb or standing with his back to the cross. Oftentimes, he is shown pressing the lips of his wound with his hand and causing the blood to spurt into the chalice. This is called the *Mass of St. Gregory*.

Of the four ways of presenting the Man of Sorrows, the latter was the most customary in France, the Low Countries, and Germany. The woodcuts sold at the fairs always represented the Mass of St. Gregory.[65] These naïve prints, widely prevalent in all the northern countries, established the iconography of the subject. The greatest of artists were under their spell and dared not change a scene so completely fixed in the popular imagination; they exercised their originality only in the details. The "Master S,"[66] for example, without changing the main theme, gave it an epic grandeur by adding to it several details (fig. 52). He has the whole feudal world kneeling at St. Gregory's sides. Beneath the banner of St. Peter, decorated with the keys, both the regular and secular clergy are gathered. Facing him, under the imperial pennon emblazoned with the two-headed eagle, are the emperor, the kings, princes, dukes, barons, down to the most humble peasant. Thus, all humanity contemplates along with St. Gregory the miracle of a God suffering for mankind. But this did not suffice, for beyond this world the artist shows us the next. In the foreground there are figures enveloped by flames; these are the souls in Purgatory that humanity, following the promise made to St. Gregory, will deliver through its prayers. Thus, through his love, the Man of Sorrows unites the two worlds. "Master S" was able to extract dogma from a simple anecdote. But just when the Mass of St. Gregory attained its highest expression, it was to disappear: a few years later the Protestants were to attack indulgences and force the Catholics to scrutinize their traditions and reject their legends.[67]

52. Mass of St. Gregory. Paris,
Bibliothèque Nationale, Cabinet des
Estampes. Engraving by "Master S."

In describing the images of the Man of Sorrows, we have omitted several details which are not, it is true, essential but which occur with considerable frequency. Various objects, arranged with a childlike naïveté, surround Christ as he stands in the tomb. These are not only the instruments of the Passion, but various objects and emblems that recount in succession the scenes of the drama.[68] First there are Judas's thirty pieces of silver, the lantern, the sword of St. Peter to which Malchus' ear is still attached, a bestial head that spits, a hand that strikes a blow, a cock perched on the column of the flagellation, the ewer of Pilate; then, alongside the three nails are the hand holding the hammer, the seamless robe and the dice, the vessel of vinegar, the lance and the sponge; and finally, the ladder and pincers of the Descent from the Cross, and the three vases of perfume of the holy women.

In Italy, these various emblems were less readily associated with the Man of Sorrows. In France, the composition was complete from the very beginning. The manuscript of the Bibliothèque Nationale, which we attribute to the late fourteenth century, already shows the cross, the column, the lance, the ladder, the nails, and the crown of thorns distributed around the Christ standing in the tomb. Our artists had simply

united two motifs, one far more ancient than the other. The Man of Sorrows was still unknown in France, but the idea already existed of grouping together, like trophies, all the mementoes of the Passion. In the Bibliothèque de l'Arsenal, a curious miniature in a Book of Hours from the early fourteenth century[69] represents the cross, the column, the lance, the sponge, the scourges, the nails, and the vessel of vinegar, all arranged on the field of an heraldic shield. These were the Arms of Christ. Since the barons had coats of arms recalling their feats of valor, it was only right that Christ should have his. A commentary explains these new armorial bearings: the white background of the shield signified the body of Christ, the red spots arranged over the surface were the marks left by the flagellation, the five roses flowering on the wood of the cross symbolized the five wounds of the Saviour. There is no older example of the "arma Christi," as it was called in the Middle Ages.[70]

That this mystical composition should appear in the fourteenth century is quite natural. It was then that the Passion became the chief concern of Christendom; it was then that people began to meditate on the instruments of suffering and death that had saved mankind.

In the fourteenth century, hymns to the lance and to the crown of thorns began to appear in medieval liturgical texts, and they were to multiply until the sixteenth century.[71] "Hail, triumphal iron," a hymn to the lance says. "By piercing the breast of the Saviour, you opened

53. Emblems of the Passion. Vendôme, Church of La Trinité. Stone relief.

the gates of heaven to us."[72] Another says, "His crown was made of a thorn-branch, yet it was resplendent. ... The precious stones shining there like stars were drops of his blood."[73]

It was no doubt at this time that the practice grew up of carrying the emblems of the Passion in triumph. In the church of Billom in the Auvergne, I have seen the confraternity batons surmounted by the purse, the hammer, the sponge, and all the instruments of Calvary, placed there like souvenirs of another age.[74]

Fairly frequently, fifteenth- and sixteenth-century artists represented the emblems of the Passion alone, without adding the Mass of St. Gregory (fig. 53).[75] But then they usually placed these precious objects in the hands of angels. From the thirteenth century on, in the scenes of the Last Judgment, we see four or sometimes five angels bearing the cross, the column, the lance, the nails, and the crown of thorns. But toward the end of the Middle Ages, the angels become more numerous. There are seven in the beautiful tapestries of the cathedral of Angers (fig. 54). And often there were many more, since they were given even the purse of Judas to carry (fig. 55) and the lantern of the Garden of Olives. These angel figures were often associated with the Passion and placed in the spaces of the flamboyant tracery enclosing the window.[76] But often they were not associated with any specific scene. In a window of the cathedral of Evreux,[77] God the Father with the globe of the world in his hand appears above the choir of angels bearing the emblems.

54. Angels carrying instruments of the Passion. Angers, Cathedral. Passion tapestry (detail).

One might think that the scene takes place outside time and within the mind of God: that even before Creation, the purse of Judas and the ewer of Pilate had been a part of the world plan.

The cult of the wounds of Christ was naturally associated with the devotion to the instruments of the Passion. This new form of piety may go back to St. Bernard, if he is really the author of the hymn attributed to him: it is composed of a series of sorrowful strophes addressed to all parts of the body of Christ who suffered for mankind.[78] It was said that St. Bernard, after writing these strophes, recited them before a crucifix that leaned toward him and embraced him. It is probable that this poem, if it was really written in the twelfth century, was reworked and amplified in the fourteenth.[79] It was in the fourteenth century, in fact, that the devotion to the five wounds spread. St. Gertrude, when meditating on these five wounds, saw them shine like the sun; she thought that they must have been imprinted on her heart.[80] It was then, also, that prayers to the five wounds began to appear in Books of Hours.[81]

In the fifteenth century, confraternities were established in the name of the five wounds.[82] The rich bourgeois founded Masses in honor of the five wounds.[83] A prayer recited in honor of the five wounds was thought to keep one from dying "an unholy death."[84]

Art did what it could to participate in these feelings. In the fifteenth century, a coat of arms was invented for the wounds, just as one had been imagined for the instruments of the Passion in the fourteenth century. On the holy sepulcher of the church of St.-Etienne in Limoges,

55. Angel carrying purse of Judas. Paris, Louvre. Wood relief.

there was an escutcheon "with the five wounds done realistically on a gold background."[85]

The Germans and the Flemish thought to improve on this by placing the detached members on an escutcheon.[86] At other times they enclosed the Infant Jesus in a pierced heart and arranged around it two pierced hands and two pierced feet (fig. 56).[87] These old woodcuts, images intended for the common people and used by the peasants to decorate the mantles of their fireplaces, help us to penetrate deeply into the hidden spirit of the fifteenth century. It is a strange world. There we breathe an atmosphere of ardent and almost uncivilized piety. One of these images shows a monk at the foot of the cross; four long threads join his mouth to the four wounds of Christ; facing him, a layman is attached in the same way to six cardinal sins.[88] Like the mystics, this little image taught that all wisdom and virtue flow from the wounds of Christ and, as Tauler said, man must "glue his mouth to the wounds of the Crucified."

Of these five wounds, the wound in Christ's side was believed to be the most holy.[89] It was thought that its exact dimensions, the same as those of the holy lance, were known. In an *Image du monde*, a manuscript dating from the first part of the fourteenth century which later belonged to the Duke of Berry, we already see the wound in Christ's side represented in its actual dimensions;[90] in the fifteenth century, there were frequent representations of this wound in printed Books of Hours; two angels seem to carry it in a golden chalice (fig. 57).

56. The Five Wounds. Paris, Bibliothèque Nationale, Cabinet des Estampes. Anonymous woodcut.

57. Wound in Christ's side. Hours for use of Rome. Paris, Caillaut and Martineau, ca. 1488. Paris, Bibliothèque Nationale, Res. Vélins 1643, fol. r8r.

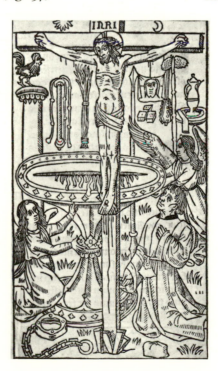

The Blood of Christ. The Fountain of Life.
The Mystic Wine Press.

But more moving than the wounds of Christ was the blood that flowed from them. Even before Pascal, how many Christians had meditated on the blood of a God whose every drop had saved thousands of souls. The *Vitis mystica*, attributed to St. Bernard, compares the Passion to a bleeding rose.[91] St. Bonaventura, in the *Lignum vitae*, declared that Jesus drenched in his own blood, had appeared to him robed in pontifical purple.[92] But it was in the fourteenth and fifteenth centuries that the divine blood flowed: St. Bridget, St. Gertrude, Tauler, and Olivier Maillard saw his blood flow like a river; they wished to bathe in it. In her visions, the Blessed Angela da Foligno[93] always saw the blood of God; in the church of St. Francis, when the organ played softly at the moment of the elevation of the Host, her soul was transported "into the uncreated light" and she almost always saw Christ covered with blood. A few moments before she died, she said that she had just received the blood of Christ into her soul and it felt as warm as if it were flowing down from the cross.[94]

In the early fourteenth century, the artists made this holy blood visible. They not only represented it flowing from the wounds of Christ, but they often showed his body blotched with red spots (fig. 58).[95] The old

58. Wounds of Christ. Paris, Bibliothèque Nationale, Cabinet des Estampes. Anonymous woodcut.

popular devotional prints of the fifteenth century representing the Christ on the Cross or the Man of Sorrows were often touched up with red so that the blood and the wounds would first catch the eye.[96]

The idea of suffering, joined to the idea of redemption, gave rise to a whole series of works of art exalting the virtue of the Holy Blood.

I refer to the mystical theme known as the Fountain of Life.[97] The cross rises from the center of a great basin; blood gushes in long spurts from Christ's wounds and fills the vat around which the sinners press; many have already torn off their garments and make ready to enter into this salutary bath. This is no doubt a eucharistic symbol, but one which could only have been created in the violently realistic age with which we are concerned; to have imagined it, man's thought would have had to be endlessly occupied with the Holy Blood. Moreover, these Fountains of Life seem to me to have been closely related in the beginning to the cult rendered in many churches to the Precious Blood.

Several drops of the Holy Blood had arrived in the occident in crystal reliquaries at the time of the crusades.[98] The Holy Grail, for which the Knights of the Round Table had searched the whole earth, seemed at last to have been found. In the small chapel of Thierry d'Alsace in Bruges, the poets' dream became reality; there, all Christendom could see the blood that had saved the world. An immense body of poetry radiated from the sanctuary of Bruges. Henceforth, doubt could not touch the believer and tarnish the beauty of the legend. Drops of the Precious Blood were soon to appear in France, Italy, Germany, and England. The Holy Blood exhibited at the Abbey of Fécamp had been found hidden in the trunk of an ancient fig tree washed up on the coast by the sea. The fig tree had come from the Holy Land, and it was Isaac, the nephew of Joseph of Arimathaea, who had placed the relic under its bark.[99] Thus, the poems of the Holy Grail were revitalized and gave birth to real marvels.

The devotion to the Precious Blood, always intense, increased even more toward the end of the Middle Ages. It was only at the end of the fourteenth century that the Confraternity of the Holy Blood was formed in Bruges where the famous Maytime procession was inaugurated;[100] it was in the following century that the High Gothic chapel, a more suitable setting for the remarkable relic, was erected above Thierry's Romanesque crypt where it had formerly been preserved.

The cult of the Holy Blood was organized in the fifteenth century and a literature composed in its honor appeared. There, too, the painters created the theme of the Fountain of Life, in its way a hymn to the Precious Blood.

It can almost be affirmed, I believe, that this new motif had been created in one of the towns where the holy relic was especially venerated. We know that the Fountain of Life by Jean Bellegambe, in the museum

of Lille (fig. 63), was painted for the Abbey of Anchin; now since 1239 the Abbey of Anchin had had in its possession several drops of the Precious Blood.[101] In Portugal, in the church of the Miséricordia of Oporto, there is a Fountain of Life which seems to be the work of a Flemish painter (fig. 59); experts have even attributed it to Gérard David.[102] If such is the case, the picture was painted in Bruges, the town of the Holy Blood. Ghent, neighbor to Bruges, also has a Fountain of Life in its museum. Troyes is one of the French towns to possess a relic of the Precious Blood,[103] and in the niches of the portal of St.-Nicolas, we see the remains of a Fountain of Life, known to be the work of the sculptor Gentil.[104]

But we can go even further. Other arguments bring us close to certainty. In the Office of the Precious Blood as it is found in the Roman Breviary, there is a hymn of special interest, for one of the verses contains the theme of the Fountain of Life: "Jesus let his blood flow to the last drop," said the anonymous poet. "Let all come who are stained with sin; whosoever washes himself in this bath will emerge purified."[105] Unfortunately, the date of this hymn is not known;[106] but if by chance it is relatively modern, we can cite another analogous hymn dating from the fifteenth, if not the fourteenth century: "The fountains of the Saviour pour out rivers of blood. Let sinners gather to draw from the holy liquor. ... Let them come to the fountain of the Saviour ... it is the bath of life."[107] In the Office of the Precious Blood as it was recited at the Abbey of Fécamp, the blood of Jesus was called "the bath of souls, the bathing-pool of the sick, the fountain of purity."[108]

Thus, from whatever side we approach it, we find the motif of the Fountain of Life linked with the cult and the liturgy of the Holy Blood.

Once the theme was formulated in art, it spread quickly over all of France. We find it at Beauvais,[109] Vendôme, Chinon (figs. 60, 62),[110] St. Antoine du Rocher (Indre-et-Loire),[111] Avignon,[112] Dissais (Vienne);[113] in the past it was to be seen at the Château de Boumois near Saumur (fig. 61),[114] and in the church of St.-Jacques in Reims.[115] These strange compositions do not all resemble one another, but they can all be reduced to several types.

The Oporto painting (fig. 59) shows the subject in its simplest form. Jesus is crucified between the Virgin and St. John, but the foot of the cross, instead of resting on the rock of Calvary, is sunk into a great vat. The streaming blood has already filled the basin. Surrounding it are men, women, and children of all ages and kinds, who silently contemplate the mystery. On the rim of the basin is written: *Fons vitae, Fons misericordiae* (Fountain of Life, Fountain of Mercy). This solemn painting, so introspective in feeling, resembles the hymns we have just cited, detail by detail.

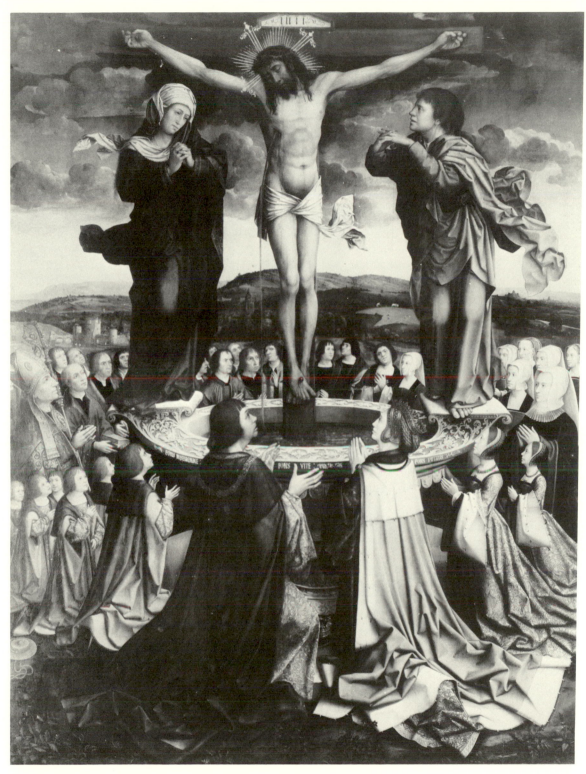

59. Fountain of Life. Oporto (Portugal), Church of the Misericordia. Altarpiece,
central panel.

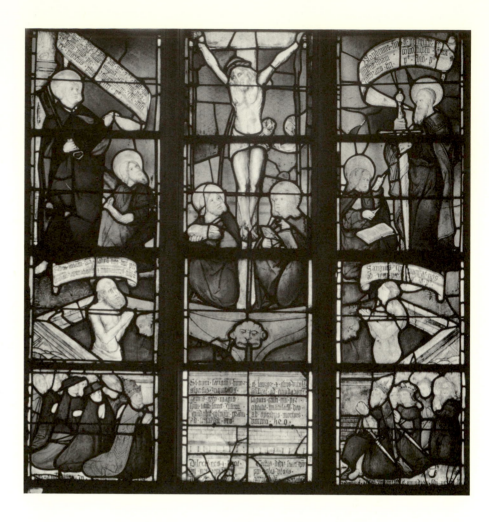

60. Fountain of Life. Vendôme, Church of
La Trinité. Stained glass panel, north
transept (detail).

But here is a more learned work: the stained glass window at Ven-
dôme also shows the Cross of Jesus standing in a basin of blood (fig.
60). The four evangelists are seated on the rim of the basin, and near
them stand St. Peter and St. Paul. Blood from the basin flows into a
great pool in which Adam and Eve stand to their waists. And in the
lower section, the pope and the Church, the emperor and the laity,
kneel and pray. The composition has a doctrinal breadth that makes
us think of great thirteenth-century works. The meaning is quite clear:
the blood of Jesus has washed Adam and Eve clean, that is to say, it
has washed away original sin; the four Gospels, the Epistles of St. Peter
and St. Paul recount the sacrifice and testify to its virtue; mankind must
kneel and give thanks to God for this miracle of love.[116] The Vendôme
window is not the work of a contemplative mind, it is the work of a
theologian setting forth basic Christian dogma.

Our Fountains of Life were usually conceived somewhat differently.
A formula was soon established to which our painters adhered, from
one end of France to the other. Two women, St. Mary Magdalene and

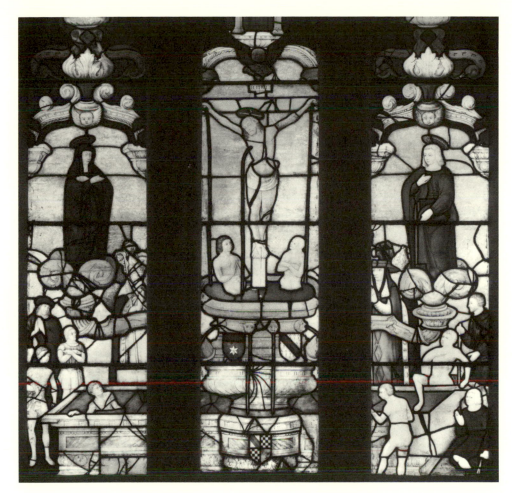

61. Fountain of Life. Greenville (SC), Bob
Jones University, Museum. Stained glass
window from the Château de Boumois.

St. Mary of Egypt stand beside the cross and the double basin;[117] they
gaze at it lovingly or point to the blood that has purified them. Such,
in all its simplicity, is the fresco at Chinon (fig. 62) and the painting at
Avignon. Even when the composition is richer in detail, as at Dissais
and at Lille, Mary Magdalene and Mary of Egypt are always shown
near the cross. The window of St.-Jacques at Reims, which has under-
gone many changes, also contains both these figures.

The reason is simple. These two illustrious sinners were chosen to
make it clear that there was no sin which could not be washed away
by the blood of Christ.[118] There is only one symbolic detail in these
simple, direct works: at Chinon, Dissais, and St.-Antoine du Rocher,[119]
the blood flows from the small basin into the large through the mouths
of four animal masks, which we recognize as the animals symbolizing
the evangelists of the Gospels. This is an ingenious way of saying that
the miracle of forgiveness has the Gospels as authority, that is to say,
the Word of God Himself.

Easy as such works may be to interpret, the unanimity of the artists

62. Fountain of Life. Chinon (Indre-et-Loire), Church of St.-Mexme. Wall fresco.

is constantly surprising. What was their source for choosing Mary Magdalene and Mary of Egypt as symbols of sin? The reason must be quite simple. There must have been a hymn sung at the end of the fifteenth century in which the pardon of the two sinners was given as an example of the virtue of the Holy Blood. It seems clear to me that such a liturgical chant did exist. However, I have searched for it in vain in the Corpus of hymns published in France and Germany;[120] but some scholar may by happy chance come upon it some day.

The painting by Bellegambe in the museum of Lille contains a detail we have not found before (fig. 63). Female figures personifying the Virtues encourage the faithful to come to the Fountain of Blood, and they help them to enter in. This is an idea fairly close to one often expressed by ascetic writers of the fifteenth century: they said that each outpouring of Christ's blood wiped away one of the seven cardinal sins.[121] Thus, mankind would find only virtues near the basin into which the Holy Blood had flowed.

Not even the passionate poetry of the mystical Fountain, the Christ whose every wound was a source of life, the blood that flowed from basin to basin, the warm bathing-pool of blood, satisfied the Christian sensibility. The artists imagined something even stranger, a work included with the atmosphere of the feverish piety of the late Middle Ages. To better express the horror of the Passion and convey that Jesus had shed his blood to the last drop, he was placed under the screw of a wine press; his blood flowed like the juice of the grape and ran into the vat. This is the theme known as The Mystic Wine Press.[122]

The symbolism, moreover, is very ancient. It is based on the combination of two biblical passages. The Book of Numbers tells of a miraculous cluster of grapes that the spies carried back from the Promised Land suspended from a pole. The Church Fathers were unanimous in recognizing in this cluster of grapes a prefiguration of Christ suspended on the cross.[123] The other passage was that in which the Prophet Isaiah, in mysterious verses, speaks of him that comes from Edom with red garments and has trodden the wine press alone. *Torcular calcavi solus, et de gentibus non est vir mecum* (*Isaiah* 63:3).[124] What is this wine press? It is the cross, the Church Fathers replied, and not only the cross but all the sufferings of the Passion. He whose garments are red with blood is the Christ whose blood flowed on Calvary as if under the weight of the wine press.[125]

It remained to reconcile the two texts. St. Augustine had already done so: "Jesus is the grape of the Promised Land, the *botrus* placed

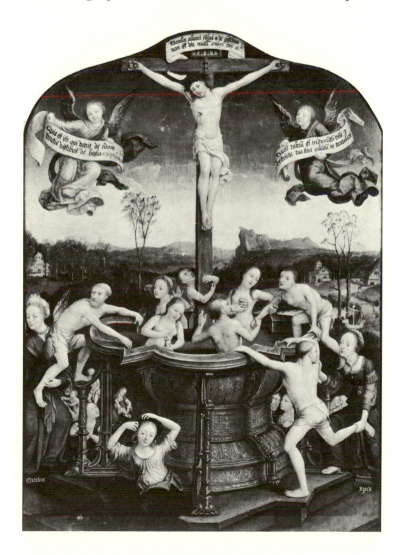

63. Fountain of Life. Lille, Museum. Triptych, central panel. Jean Bellegambe.

under the press," he said.[126] From this time on, the symbol was consecrated. In the Middle Ages it was used fairly often in hymns and prayers,[127] but the idea of expressing it in art had never occurred to anyone.[128] This required a more sensual imagination than the noble thirteenth-century artists possessed.

The theme of the Mystic Wine Press appeared in France for the first time in the fifteenth century. It occurs in a manuscript of the Bibliothèque Nationale which could scarcely have been finished before the reign of Louis XII.[129] Christ kneels under the screw of the press, the vat is ready to receive his blood, but the torture has not yet begun.

At the time so restrained an image had little chance of pleasing. Consequently, at Recloses near Fontainebleau, the artist took the symbol literally: Christ actually lies under the press which crushes him and causes his blood to run into the vat.[130] In the church of Baralle (Pas-de-Calais), the cross has been transformed into a wine press:[131] the screw is turned by God the Father himself; the blood of Christ spurts from all his wounds and mixes with the juice of the grapes in the vat. Shocking as it is to us, this barbarity, both subtle and naïve, has its value for the historian. Is it not strange to see Christian art embodied in flesh and blood at just the time when the reformers were to announce the reign of pure spirit? Even Spain, sensual and mystic as it was, dared nothing bolder than this.

I can willingly believe that these Mystic Wine Presses like the Fountains of Life, were connected with the devotion to the blood of Christ. Still today, the hymn sung at Lauds on the day of the feast of the Precious Blood alludes to both the wine press and the fountain.[132] Above the Fountain of Life by Jean Bellegambe, at Lille, we read the prophecy of Isaiah: *Torcular calcavi solus*, a text that no doubt figured in the Office of the Precious Blood as it was recited at Anchin, and a text that proves, in any case, that the idea of the wine press and of the fountain were closely related.

But as we advance into the sixteenth century, the theme of the wine press takes on new meaning: henceforth it will be less a symbolic representation of the Passion than a figure of the Eucharist. That is already clearly discernible at Conches (fig. 64). If we wish to understand the meaning of the window of the Wine Press at Conches,[133] we must not isolate it from the surrounding windows: all are devoted to the Eucharist. One of them represents the Last Supper; another the Manna, another Abraham receiving the bread and wine from Melchizedek, and the last represents the Host itself shining like the sun between God and the angels.[134] It is clear that, here, the Wine Press is only a figure for the Eucharistic Sacrament. In it I see the clearly expressed desire to affirm, in the face of Luther and Calvin, the essential dogma of Ca-

tholicism. This is one of the episodes in the battle that religious art was beginning to wage against Protestantism.

The thought is even clearer in the stained glass window of St.-Etienne-du-Mont, in Paris (fig. 66). Although the work belongs to the early seventeenth century, I speak of it here because I believe it to be a copy of an older original. In fact, in a collection of sixteenth-century engravings, I have found one that is exactly like the window of St.-Etienne-du-Mont and that was executed earlier (fig. 65).[135] The window must have been copied from the engraving, but both the engraver and the glass painter might have copied an even older work.[136] Windows representing the Mystic Wine Press were numerous in Paris: according to Sauval, there were such at St.-Sauveur, at St.-Jacques-la-Boucherie, at St.-Gervais, and in the sacristy of the Celestines;[137] and there was another at St.-André-des-Arts.[138] There were several in the neighbor-

64. Mystical wine press. Conches (Eure), Church of St.-Foy. Stained glass window, south aisle. XVI c.

65. Mystical wine press. Paris, Bibliothèque
Nationale, Cabinet des Estampes.
Engraving. Ed. 5g, fol. 110v.

hood of Paris, at Chartres,[139] and at Andrésy.[140] Thus, it is probable
that the artists' practice was to treat the subject according to a formula
given both by the engraving and the window at St.-Etienne-du-Mont.

The subject was conceived as a strange epic in which triviality mingled
with grandeur: it is both the poem of the vine and the poem of the
blood.

First we see the patriarchs and men of the Old Law planting the
vines, watched over by the eye of God. After long centuries of waiting,
the harvest time finally comes; the apostles pick the grapes and place
them in the vat. But it is not the grapes that we see under the press,
it is Christ himself; it is not the juice of the grapes that flows from the
vat, but the blood of a God. Henceforth, this blood was to be the potion
of mankind. A great barrel drawn by a Dantesque team—the lion of
St. Mark, the ox of St. Luke, and the eagle of St. John—and driven by
the angel of St. Matthew, carries the divine liquor over the world.[141]
The Church is born and will henceforth be the guardian of the blood.
The four Fathers of the Church set it aside in barrels; farther along, a
pope and a cardinal let the barrels down into a cellar with the help of
strong ropes; an emperor and a king, transformed into workmen, aid
them.[142] The blood preserved in the cellars of the Church will be dis-
pensed to the faithful; and in fact, in the middle ground we see sinners
confessing, who will take communion once they are absolved of their
sins.

The Real Presence, denied by the Protestants, is thus affirmed dogmatically. The window means to say that the virtue of the Eucharist, which had already been revealed in the Old Testament by means of symbols,[143] was taught to the world by the New Testament. The words of the evangelists as interpreted by the Church Fathers had become the doctrine of the Catholic Church: only the Catholic Church, sole dispenser of the Holy Blood, alone can save mankind.

Thus, in the sixteenth century, art again became dogmatic, as it had been in the thirteenth century. The window of St.-Etienne-du-Mont proved to the Calvinists the truth of the Real Presence, just as the window at Bourges proved to the Synagogue the harmony between the Gospels and the Old Testament.[144]

But one detail of the window is disquieting: the kings who come to the aid of the pope. What are the mighty of the world, the wielders of the sword, doing here? And we wonder if by chance these kings are not Charles IX and Philip II?

66. Mystical wine press. Paris, Church of St.-Etienne-du-Mont. Stained glass window, church cloister.

But let us return to the original meaning of the Fountain and the Wine Press, from which we have wandered. Let us recall that these themes were at first meditations on the Holy Blood, hymns of the Passion. Therefore, in the beginning, such works were quite different from the apologetical compositions of the late sixteenth century. And they are more interesting, for they lead us deeper into the Christian spirit.

<p style="text-align:center">VI</p>

The Passion of his mother did not end with the Passion of Christ. It was she who became the principal figure in the scenes that were to follow.[145] The idea of a Passion of the Virgin parallel to the Passion of Christ was a favorite one with the mystics who in their meditations never separated the mother from the son. Jesus and Mary, they repeated, were more than united in this Mystery; they were one. The Virgin appeared to St. Bridget and said to her: "The sufferings of Jesus were my sufferings, because his heart was my heart."[146] Her heart was torn asunder at the very thought that her son must die.[147] Man's heart is not great enough to feel the immensity of such grief, the mystics always said. Gerson complained he had not enough tears. Suso said, "Let it be given me to shed as many tears as the letters I have written down to recount the sufferings of Our Lady!"[148] Just as people said *Christi Passio*, for this reason they began in the fourteenth century to say *Mariae Compassio*: the Compassion of the Virgin was the echo of the Passion in her heart.

The Church welcomed these sentiments, which had become those of the entire Christian world.[149] In 1423, the Synod of Cologne added a new feast to the feasts of the Virgin, that of "the anguish and sorrows of Our Lady."[150]

The artists had not waited so long. Almost half a century before, they had introduced the Seven Sorrows of Our Lady into Christian iconography.

The earliest example I know of this theme is found in a French manuscript now in the Bibliothèque Nationale, which must have been illuminated about 1380 or 1390.[151] It is a collection of pious images showing, after the apostles and the saints, the sorrows and the joys of the Virgin. People had long meditated on the joys of Our Lady. The thirteenth century, always on the side of light, was devoted solely to the joyous side of the Virgin's life. But at the end of the fourteenth century, the somber episodes suddenly appear. From the beginning, they were seven in number:[152] the prophecy of the aged Simeon announcing to the Virgin that a sword would pierce her soul (*tuam ipsius animam pertransibit gladius*);[153] the flight into Egypt; the search for the

Child lost and then found in the Temple among the doctors; the story told by St. John to Our Lady of the betrayal by Judas; the Crucifixion; the Entombment; and finally the endless pilgrimages the Virgin would make to the places where the Passion had taken place.[154]

These Seven Sorrows are not the ones we will encounter later. However, the definitive list must have been completed a very short time later, if not at the same time, for we find it in a manuscript which I believe to be almost contemporary with the manuscript mentioned above.[155] This list gives the prophecy of Simeon, the flight into Egypt to escape the Massacre of the Innocents; Jesus lost and discovered in the Temple; Jesus scourged,[156] Jesus crucified; Jesus lying dead on the lap of his mother; the Entombment.

Out of piety, certain mystics of the late fifteenth century increased the number of the Virgin's sorrows to fifteen;[157] but that innovation seems not to have met with favor, and seven remains the consecrated number.

Many works of art testify to the fifteenth century's devotion to the Seven Sorrows of the Virgin, although this has never been pointed out. I need no further proof than the triptych in the museum of Antwerp, attributed to Gérard van der Meire. It represents Mary presenting the Infant to the aged Simeon, the flight into Egypt, Mary finding Jesus among the doctors, and Christ carrying the cross. These are the first four sorrows of Our Lady.[158] There is known to have been a companion piece to this triptych which represented the three other sorrows: the Crucifixion, the Deposition from the Cross, and the Entombment. This work, seemingly devoted to Christ, is in reality devoted to his mother.[159]

At the end of the fourteenth century, the Seven Sorrows of the Virgin were compared to seven swords piercing her heart. The prophecy of the aged Simeon had apparently provided the idea for this metaphor. In a manuscript already cited, the seven swords were mentioned; these are called the "triumphal swords of Mary," *triumphales gladios*,[160] and a miniature shows the Virgin with a sword in her heart.

There was evidence of tasteful restraint in representing only one sword, but in the late fifteenth century, all seven appeared; these seven blades are plunged into Mary's breast and form a sinister aureole around her.

It has been claimed that the honor of inventing this new motif belongs to Flanders;[161] there is no reason to doubt it. Such a subject could never inspire a great work of art: the Virgin of the Seven Swords is a pious image and nothing more. It was used in two books printed in Antwerp in the late fifteenth and the early sixteenth centuries for a confraternity of the Seven Sorrows of Our Lady.[162] This religious brotherhood had just been created by Jean de Coudenberghe, curate of St.-Sauveur in Bruges and later secretary to Charles V. One engraving represents the

Virgin pierced with seven swords bound in a sheaf; another shows the blades arranged in an aureole. The latter is the arrangement that prevailed.[163] In the course of the sixteenth century, the image became even more complicated: a round medallion representing one of the sorrows of the Virgin was attached to the handle of each sword.[164] Sometimes, as in the Flemish painting at Brou, the Virgin is surrounded by seven medallions and is pierced with only one sword. Again, as in the painting at Notre-Dame, in Bruges, there are no swords at all, but only the aureole of medallions.

I am quite inclined to believe that France borrowed this new motif from Flanders. Certainly the confraternities of Our Lady of the Seven Sorrows, whose escutcheon it was, propagated the motif in France. However, it appeared infrequently. I have found it in only a few sixteenth-century stained glass windows: at Ecouen, Brienne-la-Ville (Aube) (fig. 67), and La Couture, in Bernay.[165] The seven swords accompanied by medallions appear in a window of St.-Léger, at Troyes.

A far more discreet manner of representation, and one infinitely more worthy of art, also prevailed in France. Disregarding the six other sorrows of Our Lady the artists retained only one, the most poignant of all: they chose the moment when she had received the body of her son on her knees and could at last cover it with kisses and tears. They omitted the swords, but found a most ingenious way of referring to them. They placed the aged Simeon beside the Virgin, bringing him into the scene at the very moment when his tragic prophecy was fulfilled. In his hand he carries a banderole on which is written: *Tuam ipsius animam pertransibit gladius.* It is thus that all the sorrows of the Virgin are summarized in Champagne, in the windows at Bérulles, Nogent-sur-Aube, Granville, and Longpré (Aube) (fig. 68). In this our artists seem to me to have provided an example of refined taste scarcely attained by the Flemish.

67. Virgin of the Seven Swords. Brienne-la-Vieille (Aube), Church of St.-Pierre-et-St.-Paul. Chevet, stained glass window (detail).

68. Virgin of Pity with the aged Simeon. Longpré (Aube), Church. Stained glass window (central register at right).

The figure of the mother holding the body of her son on her knees summarized in France during the fifteenth and sixteenth centuries the entire Passion of the Virgin. We have discussed its origin. This moving group appeared in illuminated manuscripts that go back to about 1380.[166]

The Pietà (as the group of mother and son is called) seems to have appeared in painting before it appeared in sculpture.[167]

In the late fourteenth century, the main lines had become fixed, and seldom varied. The Virgin, enveloped in a great somber mantle, is seated at the foot of the cross. The body rests on her lap; the legs are stiff; the right arm hangs inert and touches the ground. With one hand the Virgin supports the head of her son, and with the other, she holds him against her breast.

The sculptors had only to copy this henceforth consecrated motif. It is difficult to tell at what period the workshops began to carve this group of the Virgin holding her son on her lap. The oldest carved Pietà mentioned in texts is a work by Claus Sluter; it was placed in the chapel of Chartreuse of Dijon in 1390; the Virgin holding her son was accompanied by two angels. The only sculptured Pietàs that have been preserved are no older than the fifteenth century.[168] I know of only one that is dated, that of Moissac, and it bears the date 1476.[169] Most of them have the mark of the art of Louis XII's time. It was in the late fifteenth and early sixteenth centuries that the sculptors' workshops produced most of the Pietàs still to be seen throughout France. The confraternities of Our Lady of Sorrows multiplied at precisely this time; in the late fifteenth century they were endowed with special indulgences and had a high Mass celebrated on the Sunday after the octave of the Ascension.[170] It is natural to suppose that these confraternities commissioned most of the sculpted Pietàs still extant.

How many times do we come upon this inexpressibly sorrowful group in the half-light of our village churches. Sometimes the work is excellent, more often it is crude and stiff, but it is never cold. Although they may seem alike, when we observe them closely these Pietàs express many nuances of tenderness and sorrow. One familiar with the medieval mystics will find here their whole range of feeling.

Here is an example: certain manuscripts show the Virgin holding the body of her son on her knees, but one singular detail seems at first inexplicable. The body is scarcely larger than an infant's, and its entire length rests on the lap of the mother (fig. 69).[171] Is this due to poor workmanship? Not at all, for farther on, the artist gives the body of Christ its proper dimensions.[172] What was he trying to express? In his way he wished to express a thought familiar to the mystics: that when she held her son on her knees, the Virgin must have imagined that he was a child again. St. Bernardine of Siena said, in substance: "She believed that the days of Bethlehem had returned; she imagined that

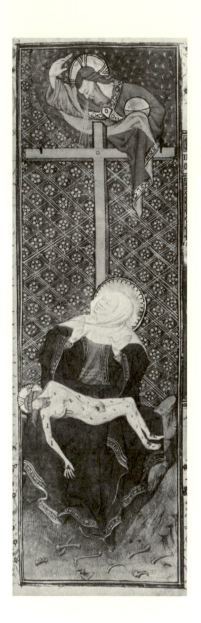

69. Virgin of Pity. Rohan Hours. Paris,
Bibliothèque Nationale, ms. lat. 9471, fol.
41 (detail).

he was sleeping, and she cradled him to her breast. She imagined the winding sheet in which he was wrapped to be his swaddling clothes."[173]

Sometimes, mostly in sculpted Pietàs, the Virgin bows her head over the face of her son and contemplates it with sorrowful avidity. What does she see? The mystics tell us. St. Bridget said: "She saw his eyes full of blood, his beard clotted and stiff as a rope."[174] Ludolphus the Carthusian said: "She looked at the thorns imbedded in his forehead, the spittle and the blood disfiguring his face, and she could not take her eyes from this spectacle."[175] Nevertheless, she did not cry out; she uttered not one word. Such is the Pietà at Bayel, in Champagne—a veritable masterpiece of controlled emotion (fig. 70).[176]

In other instances, the Virgin, without looking at him, holds her son against her breast with all her strength, and into her embrace goes all the life that is left to her: she seems to wish to protect him. The grim Pietà at Mussy, in Champagne, presents her in this way (fig. 71). The artist had clearly chosen the moment when Joseph of Arimathaea came to entreat the Virgin to allow him to bury her son's body. Weeping, he reminds her that the hour has come, and he attempts to take the body in his arms, but she neither wishes to release it nor let anyone take it from her. This episode was developed at length in all the pious literature of the fifteenth century.[177]

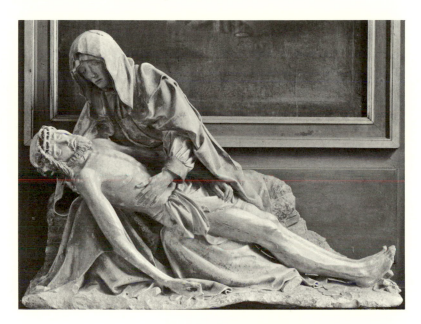

70. Virgin of Pity. Bayel (Aube), Church.

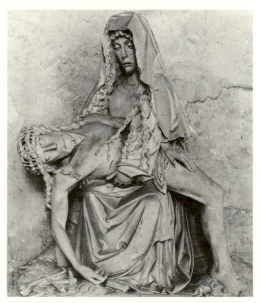

71. Virgin of Pity. Mussy-sur-Seine (Aube), Church of St.-Jean-Baptiste.

But there is a Pietà of quite different character. At Autrèche, in Touraine, a Pietà represents the Virgin with lowered eyes and hands joined in prayer; admirable restraint and modesty clothe her sorrow. Here, the beauty of the thought approaches the sublime: in conformity with the thought of St. Bonaventura, the Virgin gives to the world a model of self-sacrifice.[178] The Pietàs of Bayel and Mussy stir our feelings to their depths, but this one speaks to the higher reaches of the soul. With penetrating gentleness, she teaches the central idea of Christianity: self-forgetfulness. I consider the Pietà of Autrèche to be one of the beautiful inspirations of Christian art.

But even when the Pietàs resemble one another, there are slight differences among them that are expressions of the artists' feelings. Sometimes the lifeless body is worked with the greatest care; in one group it is rigid, but in another it is limp, as "supple as a ribbon," an empty envelope from which the soul has withdrawn.[179] Elsewhere, the hair, no longer held by the crown of thorns, follows the movement of the head, falling in a heavy mass.[180] These inspirations of a gifted artist were copied by a whole workshop. When all of the French Pietàs are considered these slight details, if closely observed, make it possible to classify them even perhaps to identify their origins. For example, there is one category of Pietàs that we may almost designate as belonging to Champagne. In these, the Virgin places her left hand on her heart (as if to indicate the source of her sorrow), while her right hand supports the body and arms of her son.[181] I do not know if this theme originated in Champagne, but in any case, it had great success there, for not only the sculptors but the glass painters represented the Virgin of the Pietà in this (fig. 68) way.[182] But this is merely a suggestion; at the present time, any attempt at classification is premature.

But no matter what formula the artists used, their work had one characteristic in common: the sorrow is always inward, and never expressed by a theatrical gesture; nothing draws attention to the artist and his talent. These old masters were themselves a beautiful example of self-effacement when they treated this great subject. All these works seem born of a disinterested impulse from the heart. From this comes their power. To experience their true beauty, we must compare them with an academic Pietà of the seventeenth or eighteenth century, to the one by Luc Breton at St.-Pierre, in Besançon, for example: this work certainly does credit to the artist and no doubt satisfies the connoisseurs; the anatomy of the Christ figure is above reproach, and the Virgin raises her arms heavenward in the best Italian tradition; but we are so busy admiring the artist's skill that we have no time to be affected emotionally.

Art is no doubt governed by the same fundamental laws as morality, and no one arrives at perfection except by self-effacement. Nothing in

our ancient Pietàs distracts us from the thought of sorrow. And they had the power of consolation. When we think of the sorrows brought to them down through the centuries by those seeking a lesson in self-abnegation, they would seem to be surrounded, as the poet said, "by an aureole of souls."[183]

The Virgin of the Pietà was almost always represented alone with her son. But it does sometimes happen that she is accompanied by two other figures, those who, next to Mary, loved the Master most tenderly: John and Mary Magdalene. In these scenes, John is always at the Saviour's head and the Magdalene at his feet (fig. 72). In the late fourteenth century, we find examples of this arrangement among the miniaturists.[184] In the fifteenth and sixteenth centuries, the painters, glass painters, and even the sculptors sometimes adopted the Pietà with four figures.[185]

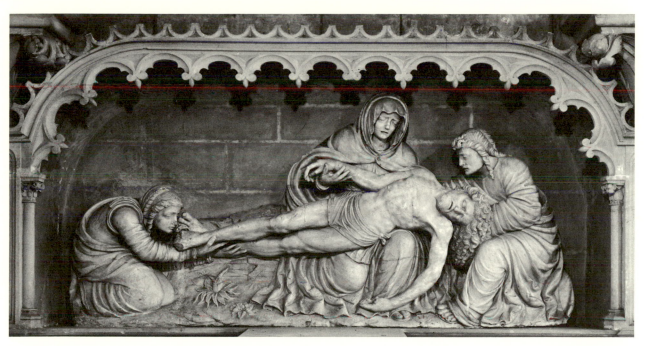

72. Pietà of Notre-Dame. Joinville (Haute-Marne), Church of Notre-Dame.

And there are cases in which the artist represented all the characters in the drama. Behind the Virgin holding her son on her knees we see Nicodemus, Joseph of Arimathaea, John, Mary Magdalene, and the holy women. Such are the Pietàs at Le Tréport; Marolles-le-Bailly in Champagne; Ste.-Catherine at Fierbois, in Touraine; Aigueperse in the Auvergne; and Ahun in La Marche (fig. 73).[186]

These complete Pietàs are more pictorial, but less moving; they distract the attention. How much more poignant is the simple group of mother and son. Concentrated in this way, the drama attains its highest

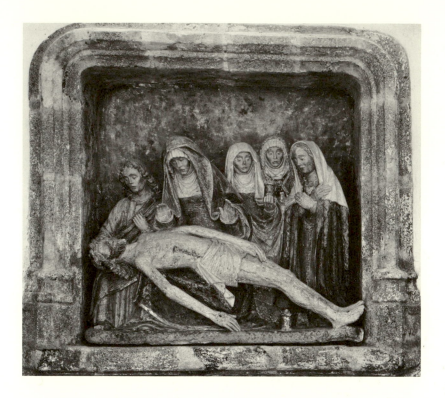

73. Pietà. Ahun (Creuse), Church of St.-
Sylvain. Church entry, painted stone.

emotional power. The faithful felt this so deeply that they rarely com-
missioned the too-elaborate Pietàs from artists. There are very few extant
today, and no doubt they were always the exception.

VII

The Holy Sepulchers. Their origin. Their
iconography.

When the Virgin had long contemplated the body of her son lying on
her knees, she finally consented to let him be buried. Depleted, "like a
woman who has just given birth,"[187] she gazed at him once more before
he disappeared into the sepulcher. This is the last act, and not the least
sorrowful of the Passion of the Virgin. It is clear that the Virgin was
the principal figure in the Entombment scene as it was conceived by
fifteenth-century artists.

To what period do the famous Holy Sepulchers belong that are still
so numerous throughout France?[188] When did these great figures appear
for the first time—figures that give so disquieting a sense of reality in
the dim light of a chapel? It is difficult to say with any certainty. But
we can come fairly close to the truth. I am quite sure that these great
sculptured Entombments were unknown in the fourteenth century, and
I offer the following proof, which seems to me conclusive.

In the fourteenth century, there were two chapels of the Holy Se-
pulcher in Paris: one in the Rue St.-Martin, dating from 1326; the other
in the monastery of the Cordeliers, also dating from the fourteenth

century although somewhat more recent.[189] Both had been founded by confraternities of pilgrims who had made, or proposed to make, the great journey to Jerusalem: the spirit of the crusades had at this time taken on a peaceful form. In these chapels we would expect to find an image of the holy tomb that all the brothers dreamed of seeing. And in the small church in the Rue St. Martin, in fact, there was an aedicule called the Sepulcher which had very certainly been copied, as was the custom, after the Holy Sepulcher in Jerusalem. But in this aedicule there was no Entombment.[190] And it was there that such a subject would have been placed.[191] Likewise, in the chapel of the Cordeliers there had been no Entombment, and the proof is that it did not occur to the confraternity to have one made until the sixteenth century.[192]

We must conclude from this that in the fourteenth century, at the time when the fervor of the confraternities of the Holy Sepulcher was at its height, the great Entombment scenes did not yet exist.

The oldest known Holy Sepulcher was carved in 1419, or at the latest in 1420, at the expense of Jean Marchand, canon of the cathedral of Langres; when the canon died in March 1421, the Holy Sepulcher was already in place in the chapel of the cloister.[193] The seven figures grouped around the Christ have disappeared along with him.[194]

More than twenty years later,[195] in 1443, Thomas Guillod, a citizen of Bourg-en-Bresse, commissioned a Holy Sepulcher of which some fragments were found several years ago.[196]

The oldest Holy Sepulcher preserved intact in France is the famous one of Tonnerre, dating from 1453 (fig. 76).[197]

Thus, the astonishing Entombments composed of large figures grouped around a sarcophagus first appeared in the early fifteenth century and it would seem, within the domain of the Burgundian school. At this time, the scene of the Entombment was constantly being placed before the eyes of the artists by the Mystery plays.

Our Holy Sepulchers seem to be exact reproductions of theatrical representations. The costumes of the figures are often striking: the hats with rolled brims, the fur-trimmed robes of the aged men, and the large turbans of the women could only have been theatrical costumes. Everything, even to the way in which the figures are grouped seems to derive from the traditions of dramatic production.

Our Holy Sepulchers were most often composed as follows: there are seven figures; the aged men standing at the two ends of the sarcophagus support the body lying on the shroud; the Virgin, nearly fainting, occupies the center, as is fitting for the principal character, and she is supported by John; at the right of the Virgin, a holy woman stands near the head of Christ; at the left, a second holy woman, accompanied by Mary Magdalene, stands near his feet. Such are the Entombments at Souvigny (Allier) (fig. 74), Joigny (Yonne) (fig. 75),

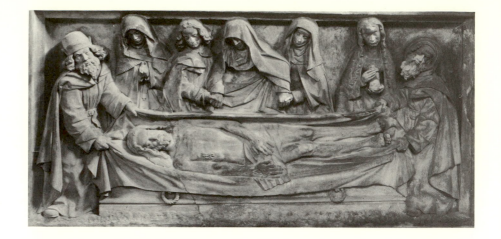

74. Entombment. Souvigny (Allier), Church of St.-Pierre. Stone relief, Old Chapel.

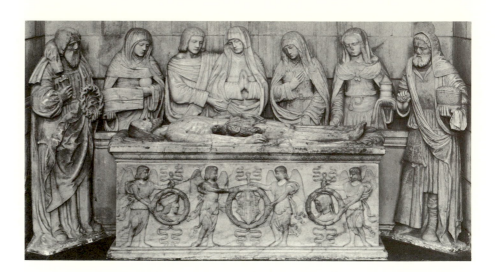

75. Holy Sepulcher. Joigny (Yonne), Church of St.-Jean.

Verneuil (Eure), St. Germain (Oise), Agnetz (Oise), St. Nizier at Troyes, St. Phal (Aube), Salers (Cantal), Carennac (Lot), Amboise (Indre-et-Loire), St. Valery (Somme), Villers-Bocage (Somme), Montdidier (Somme), Semur (Côte-d'Or), and Poissy (Seine-et-Oise).

This arrangement was so well established that a contract drawn up between a donor and an artist mentions the "Mary at his head" and the "Mary near the Magdalene," that is, the Mary who stands near his feet.

This grouping was not the only one, however. There was another almost as frequent. The Virgin, supported by John, is not centrally placed beside the sarcophagus but stands near the head of Christ while the two Marys and Mary Magdalene are all three placed near his feet. The two aged men, however, hold the two ends of the shroud. Such are the Holy Sepulchers at Tonnerre (Yonne) (fig. 76), Chaource (Aube)

(fig. 77), Louviers (Eure), La Chapelle-Rainsoin (Mayenne), Auch, the church of St.-Germain at Amiens, and Millery (Rhône). This grouping is not as successful as the other one, since the Virgin is no longer the center of the work.

It sometimes happened that Mary Magdalene was shown, not standing with the two Marys at Christ's feet, but seated or kneeling alone before the sarcophagus. We find this detail at Bessey-les-Cîteaux (Côte-d'Or), Rosporden (Finistère), and Solesmes (Sarthe). Everyone knows the Magdalene of Solesmes, one of the most modest images of sorrow in all of art (fig. 78).[198] It is clearly an echo of the passage from St. Matthew which says that Maria of Magdala was seated facing the sepulcher.[199]

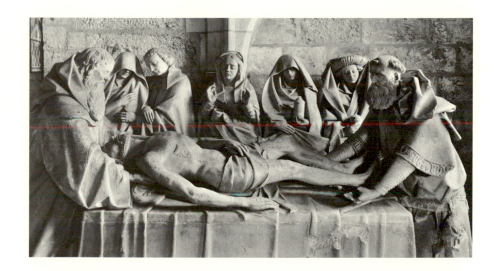

76. Holy Sepulcher. Tonnerre (Yonne), Hospital.

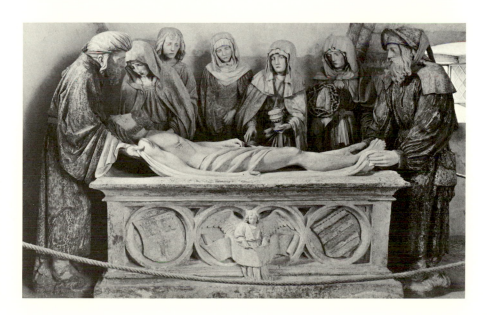

77. Entombment. Chaource (Aube), Church of St.-Jean-Baptiste, Chapel of the Sepulcher.

78. Magdalen seated before Tomb. Solesmes (Sarthe), Abbey Church. Holy Sepulcher (detail). 1496.

However, this grouping does not seem to have found favor in France. On the other hand, it was the established tradition among the Flemish and German artists to represent Mary Magdalene in front of the sarcophagus. Examples are numerous in northern art.[200]

To sum up, the two groupings first described were the two most often used in France. We find slight modifications here and there, but they do not change the general pattern. At Méru (Oise), one of the holy women is missing. At Quimperlé and Solesmes, there are three disciples instead of two—we recall that the three disciples figured in the unction scene in the thirteenth and fourteenth centuries. At Eu, there are four holy women instead of three—an addition authorized, moreover, by the Passion of Jean Michel, in which Mary Salomé, Mary Jacobi, Martha, and Mary Magdalene are placed beside the Virgin and St. John at the Tomb.

We must also point out the presence of the two soldiers, either standing or lying asleep near the Holy Sepulcher. This detail is found at Auch, Narbonne, Solesmes, Pouilly (Côte-d'Or), Pont-à-Mousson, Sissy (Aisne), Châtillon-sur-Seine (Côte-d'Or), and St. Phal (Aube). The soldiers, introduced artificially in the group, give the composition the aspect of a *tableau vivant*.

The two soldiers are sometimes replaced by two angels bearing the instruments of the Passion, as at Arles.

As we advance into the sixteenth century, we see all these elements handled with increasing freedom. The Holy Sepulchers of Villeneuve-l'Archevêque, Les Andelys, Le Mans, Joinville, and Arc-en-Barrois, depart more and more from the ancient formulas. But no one took greater liberties with the tradition than Ligier Richier in his famous Sepulcher at St. Mihiel (fig. 79). He invented nothing, but in the boldness of his groupings we sense a profound disdain for the practices of the

past. The Christ is no longer half concealed in the tomb; he is shown in the foreground, supported by the two aged men, so that we may admire his physique at leisure. The holy women are taken from their contemplation and made to prepare the sepulcher; Mary Magdalene kisses the dead feet. The angel bearing the instruments of the Passion is not set apart on a pedestal, but mingles in the action by darting forward to support the Virgin. The soldiers no longer stand guard beside the tomb; they gather around a drum to throw dice, thus providing a picturesque motif. This is the work of a skillful and vigorous artist, but one who shows off a bit too much. How much more moving the old, more modest, composition!

Movement is above all contrary to the true spirit of this subject. Deep silence should reign in such a scene. After the horror of the Passion, the clamor and mockery of the mob, Jesus finally rests in peace and in the twilight, surrounded by those who love him. Our great fifteenth-century artists sensed this profoundly. They conceived the scene not as a drama, but as a lyric poem. For at this moment there was nothing left to do, nothing left to say; only to watch in silence as the body was slowly laid in the tomb. Withdrawn into themselves, the figures seem to listen to their own hearts. Only the power of one single thought unites them. Even our dramatic poets showed tact in handling this scene; although as a rule they were verbose, here they were silent. In the theater, the Entombment was enacted without words.

The more withdrawn and immobile the figures, the more the work approached perfection. If only the male figures were as well done as the female, I would rank the *Holy Sepulcher* of Chaource (Aube) (1515)[201] among the finest (fig. 77). Not one of the women makes the slightest

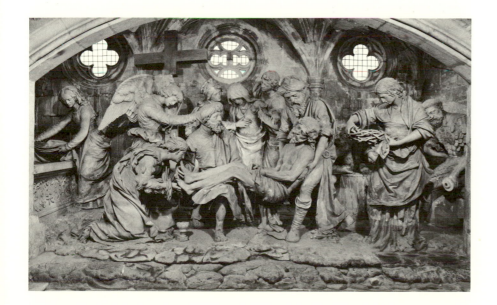

79. Holy Sepulcher. St. Mihiel (Meuse), Church of St.-Etienne. Ligier Richier. XVI c.

gesture. All we see are the slightly bowed heads with closed eyes. Never was a profounder emotion expressed more simply. This beautiful work makes us difficult to please and engenders distaste for what lacks simplicity. We ask ourselves what lesson such men could learn from Italy, and once more we confess that the term as applied to French art, has no meaning.

Almost always, our artists wished to direct attention to the Virgin. Often they show her fainting, falling heavily into the arms of a holy woman or of St. John.[202] This dramatic episode deprives the scene of the kind of beauty it derives from immobility and silence. Consequently, true artists were careful not to draw their characters from their sorrowful meditation; they held all of these in a state of lyricism. At Tonnerre and Solesmes, the Virgin is no doubt on the verge of fainting, but she still has the strength to stand. At Souvigny, John and a holy woman each hold one of the Virgin's hands, but their gaze is directed toward Christ and nothing distracts them from the thought they share.

It is clear that the figure of the Virgin presented the greatest difficulty for the artists. After they had expressed on the faces of the aged men, St. John, and the holy women, all the gradations of grief, they still had to impart to the Virgin's face the sense of supreme sorrow. Sometimes they seemed to be tempted to hide her face behind a veil, as if confessing, like Timanthes, the inadequacy of their art. In the Burgundian school it was the tradition to conceal the face of the Virgin in the shadow of the mantle drawn down over her head. This is evident at Souvigny, Tonnerre, Semur, and Avignon; and this was a practice, though less obvious, in other schools too.[203] The mourner's cowl and the face withdrawn into shadow give the Virgin a tragic aspect. There is a kind of funereal poetry surrounding the somber Virgin of Avignon. However, more admiration is due the respect for tradition of the Master of Solesmes; he did not try to hide the Virgin's face and was able to make it express that hers is the suffering of motherhood (fig. 80).

The Holy Sepulcher was the favorite subject of an age devoted to meditation on the Passion of Christ and the Passion of the Virgin. At the end of the fifteenth and the beginning of the sixteenth century, the subject appeared increasingly in art. In spite of destruction by wars and revolutions, many examples have been preserved; but a complete list including those destroyed would be surprisingly long.[204]

This was the epoch when a "Prayer to the Holy Sepulcher"[205] was included in Books of Hours. It is clear that these great figures, both moving and alarming, were much loved. They were always placed in a dark chapel or in a crypt; in the half-light they seemed to live and breathe. As the faithful knelt in the shadows, they lost their sense of time and place. They were in Jerusalem in the garden of Joseph of Arimathaea and with their own eyes saw the disciples placing the Master

80. Virgin and St. John. Solesmes (Sarthe),
Abbey Church. Holy Sepulcher (detail).

in the tomb at twilight. Certain Holy Sepulchers drew particularly large crowds, not because they were the most beautiful, but because they were the ones most enveloped in shadow.[206]

The Holy Sepulchers were donated by rich citizens, knights, and canons, with a view toward edification. But more than once we find a strange clause in the donation: often the donor asked to be buried in the same chapel with the Holy Sepulcher.[207] Thus, the Entombments took on a funerary character, and this was only natural. It was reassuring to be buried near the tomb of Christ, to lie at his feet, trustful of his word and sure of resurrection.

VIII

It was not enough to represent the Passion of the Son and the Passion of the Mother; the late fourteenth century even imagined a kind of Passion of the Father.[208]

God the Father supporting his dead Son. Origin of this group.

The twelfth, thirteenth, and fourteenth centuries, to be sure, had associated God the Father with the Passion of the Son. We know how the Trinity was represented during that time (fig. 81): the Father is seated on his throne, his hands holding the Son nailed to the cross; the Holy Spirit in the form of a dove flies from one to the other. But in delineating this strange image, the artist's intention was not to stir the feelings, but only to express the theological idea that the Son died on the cross with the consent of the Father and the Holy Spirit. This scene tells us that these were the three persons of the Trinity who had given mankind the example of sacrifice, and the figure of the cross was inscribed for all eternity in the bosom of God.

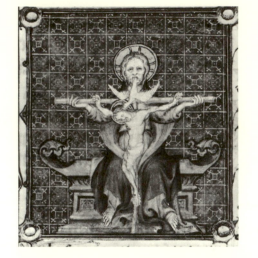

81. Trinity. Breviary of Charles V. Paris,
Bibliothèque Nationale, ms. lat. 1052, fol.
154r.

But the sentiment that the artists of the early fifteenth century tried to express is quite different. They wished to associate God the Father not with the abstract idea of sacrifice but with the sufferings of the Passion, in the conviction that if God is Love, as St. John said, then he must have been capable of feeling sorrow.

In the Bibliothèque Nationale, there is a Book of Hours illuminated in the first third of the fifteenth century that is one of the most astonishing masterpieces of French art.[209] The genius of this unknown master radiates from every page. Among the many beautiful illuminations, one is truly remarkable.

The bleeding and waxen body of Christ lies on the ground (fig. 82). The Virgin wishes to throw herself upon the body, but John prevents her. While holding her with all his strength, he turns his head toward heaven as if to accuse God. Then the face of the Father appears; his expression is sorrowful and he seems to say: "Do not reproach me for I also suffer." And in the blue sky we glimpse countless angels, "like the atoms of the sun,"[210] who fly in an attitude of sorrow.

This great dialogue between earth and heaven was recreated several times in the fifteenth and sixteenth centuries, but less sublimely. A small circular painting in the Louvre, a work of the late fourteenth century and attributed without proof to Jean Malouel,[211] represents the dead Christ in the arms of his father (fig. 83). Weeping angels cluster around, and the Virgin presses against her son, gazing at him with a kind of sorrowful avidity. The bold idea of bringing together the dead Christ, God the Father, and the Virgin comes from a page written by a mystic and found in the *Arbor Crucis* attributed to St. Bonaventura, and also in the *Stimulus amoris* by the Pseudo-Anselm. In both books, the body of Christ is compared to the blood-stained cloak of Joseph. His brothers

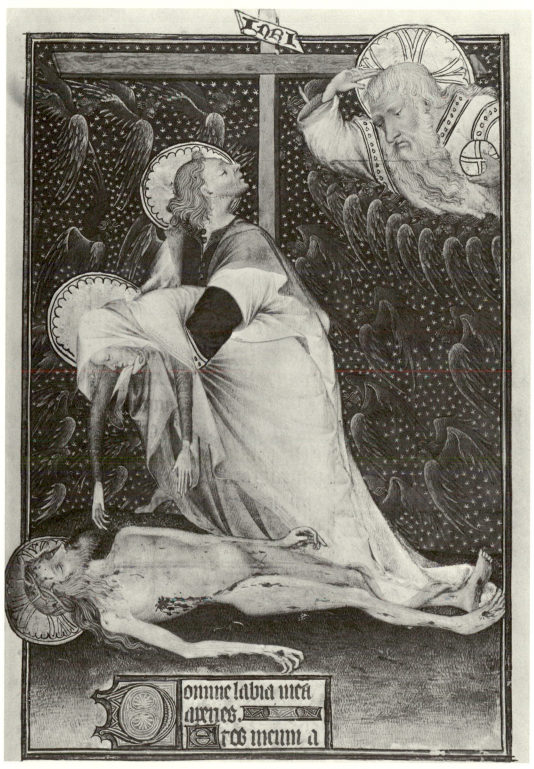

82. Dead Christ, the Virgin, St. John and God the Father. Rohan Hours.
Paris, Bibliothèque Nationale, ms. lat. 9471, fol. 135r.

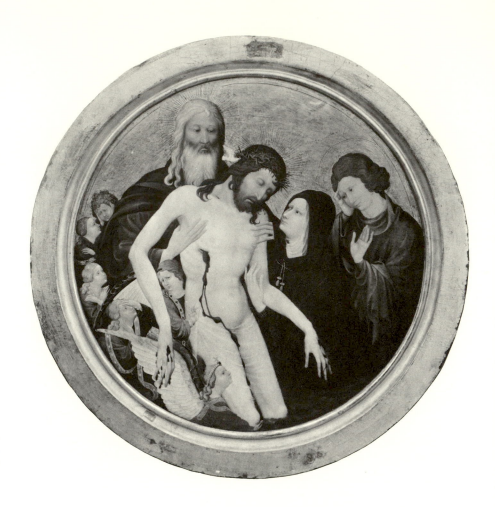

83. Dead Christ held by God the Father.
Known as the "Grande Pitié ronde." Paris,
Louvre.

brought it back to their father, saying: "A beast hath devoured Joseph."[212] St. Bonaventura placed God the Father and the Virgin in the presence of Christ's body, as bloody as Joseph's coat. He invoked them one at a time: "All-powerful Father, this is the cloak thy gentle son Jesus left in the hands of the Jews. And thou also, glorious Lady of Mercy, see this robe that was made and woven most artfully of thy chaste and precious flesh."[213]

If there is any doubt that the passage from the *Arbor Crucis* gave the artists the idea of bringing God the Father and the Virgin into the presence of Christ's body, the proof can be found in a painted panel from the sixteenth century at La Chapelle-St.-Luc, near Troyes. The inscriptions make the painter's idea quite clear. The dialogue takes place between God and the Virgin. The Virgin shows the bleeding body of Christ to the Father. "Look," she says. "Is this not the robe of thy son?"[214] And God sorrowfully replies in the words of the sons of Jacob: "A wild beast has devoured him."[215]

However, the scenes showing God and the Virgin lamenting together over the body of Christ are fairly rare;[216] ordinarily, the artists were content to represent the Father holding his dead son on his knees (fig. 84). Such groups were clearly conceived in imitation of the Pietà: sometimes the resemblance is quite striking, as in the ex-voto belonging to the La Trémoille family, which was exhibited in the Exhibition of French Primitive Art.

84. Dead Christ held by God the Father. Hours for use of Rome. Paris, Jean du Pré, Feb. 4, 1488. London, British Museum, IA 39821.

Painters,[217] glass painters,[218] sculptors,[219] and engravers[220] vied with each other, well into the sixteenth century, in reproducing this image.

It was thus, in the art of the late Middle Ages, that earth and heaven joined in mourning the death of Christ.

We see with what incomparable power medieval art was able to express sorrow. For the sorrow expressed in this art was sorrow raised to the absolute, carried to the infinite, since its subject was the Passion and Death of a God. What other sorrow can compare with this? It would be profoundly touching, certainly to see a mother holding the body of her dead son on her knees, a young man of thirty-three; but when medieval artists remembered that this young man whom the mighty of the world had killed was the personification of the Just, and whose only crime had been to say: "Love one another," then their hearts overflowed. "Mankind was capable of that!" This is the cry that seems to have been wrung from all our old masters. Sorrowful astonishment, renewed with each generation, is the principle of their remarkable art. And it is because of their profound sincerity that their art has retained its power over the soul through so many centuries.

IV

Religious Art Expresses New Feelings:
Human Tenderness

I

The influence of the Franciscans and the *Meditationes vitae Christi*.

While the scenes from Christ's Passion stirred man's compassion to the extreme, the scenes from his Infancy awoke a tenderness hitherto unknown.[1] St. Francis of Assisi had set the example for this dual mode of feeling: on Christmas Eve he rocked the Child in his crib with the hands that were soon to bear the stigmata of the Passion.[2] Another Franciscan, the author of the *Meditationes vitae Christi*, recreates for us the intimacy of the life of the Holy Family; for him, love abolished time. His wish was that his "dear daughter" (the nun of St. Clare for whom he wrote his book) should go every day to Bethlehem in her thoughts to visit the Mother and Child.[3] She should accompany them on their return from Bethlehem to Jerusalem. "Go with them," he told her, "and help them carry the Child."[4] Later, she should visit them in Egypt: "When you have found the Child, kneel before him and kiss his little feet, then take him in your arms and, filled with a sweet tranquility, remain for a time with him." She lives their life, watches Our Lady sew, and St. Joseph at his work; she admires the Child as he goes to the neighbors to deliver his mother's work. Finally, when she takes leave, she asks the blessing of the Child, the Virgin, and St. Joseph, and departs weeping.[5]

After St. Francis, all the mystics show this desire to draw near to the Virgin, and to contemplate the Child.

In one of her visions, St. Gertrude saw herself in the presence of the Virgin who held the Child out to her: "He did his utmost to embrace me, and although I was unworthy, I took him and he threw his little arms around my neck."[6]

The Church participated in these very feminine feelings. "When I see the Infant God in the arms of his mother," says a hymn of the late Middle Ages, "my heart melts with joy."[7]

It is clear that henceforth it was mankind's desire to be nearer to God. In the *Imitation*, after the soul's long soliloquy filling four books, suddenly Jesus is heard to reply. His low, gentle voice rising so suddenly in the silence produces a shiver. In the fourteenth and fifteenth centuries, these dialogues between God and the human soul were frequent; such were the *Dialogue du Crucifix et du pèlerin* (Dialogue between the Crucifix and the pilgrim) and the *Dialogue de l'âme pécheresse et de Jésus* (Dialogue between the sinful soul and Jesus).[8]

To be united with God: at the end of the thirteenth century, this was the desire that rose within Christianity. So it was that, little by little, the people brought their God down to their own level.

II

New Aspects of the Mother and Child group.

Nowhere are these feelings reflected more clearly than in art. To convince ourselves of this, we have only to study the sculptured groups of the Mother and Child.

After the late thirteenth century, the artists seemed no longer to understand the great ideas of the past. In earlier times, the Virgin was placed on a throne and held her son with the gravity of a priest holding the chalice. She was the throne of the All-Powerful, "the throne of Solomon," as the Church fathers said.[9] She seemed to be neither woman nor mother, for she was above the sufferings and joys of life. She was the one whom God had chosen before the beginning of time to clothe His Word with flesh. She was the pure thought of God. And the Child, a grave majestic figure with raised hand, was already the Master who commanded and taught. Such is the group of Virgin and Child of the Ste.-Anne portal at Notre-Dame, in Paris.

But at the end of the thirteenth century, we come down to earth again. The charming gilded Virgin of Amiens Cathedral is well known, but the small ivory statues of the same period are less so. Some of them are marvels of grace: the Mother and Child gaze at each other, and a smile passes between them.[10] It would be impossible to express a more intimate communion between two beings; they seem to be one, as if they were not yet divided. If this group is divine, it is only through the depth of tenderness it expresses.

When we reach the fourteenth century, we see the Virgin and Child come even closer to humanity. There is in the Louvre a Virgin carrying a Child who is nude to the waist:[11] it is the beautiful silver Virgin of Jeanne d'Evreux, made in 1339 (fig. 85). In the twelfth century, the Son of God was shown seated on the lap of his mother and dressed in a long tunic with the philosophers' pallium; in the thirteenth century he wore an infant's robe; in the fourteenth century he would have been

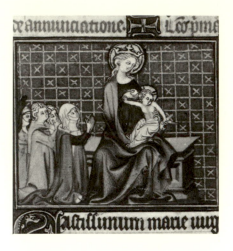

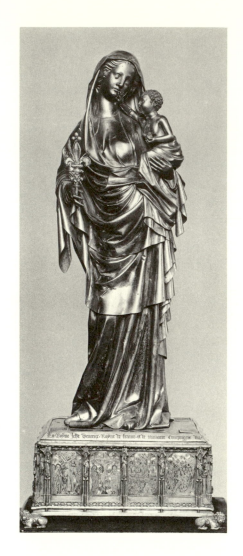

85. Virgin and Child. Paris, Louvre. Silver statuette given by Jeanne d'Evreux to Chapel of St.-Denis.

86. Virgin nursing. Belleville Breviary. Paris, Bibliothèque Nationale, ms. lat. 10483, fol. 203.

completely naked if his mother had not covered the lower part of his body with a fold of her mantle.

It was as if Christ's nakedness was a mark of his humanity; in this he resembled the sons of men.[12] He was even more like them in his whims and his winning baby ways: sometimes he was shown caressing his mother's chin (fig. 85);[13] and sometimes playing with a bird.[14]

And he is like the sons of men in his natural needs too: the Son of God knew hunger, and artists represented the Virgin nursing him.[15]

This is a motif that certainly goes far back in time. It appeared in the sixth century in the Christian monasteries of Egypt, as the fresco of the Monastery of Apa Jeremias of Saqqara, discovered some years ago, proves.[16] Carolingian art had borrowed it from the East: the Metz ivory[17] shows a Virgin nursing the Child that differs little from the Egyptian Virgins. After this, the West never entirely gave up the Eastern

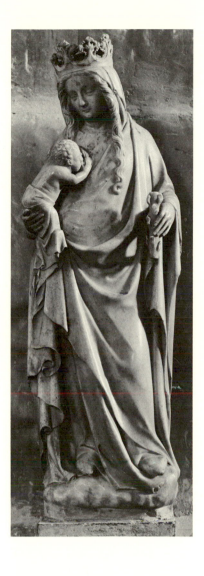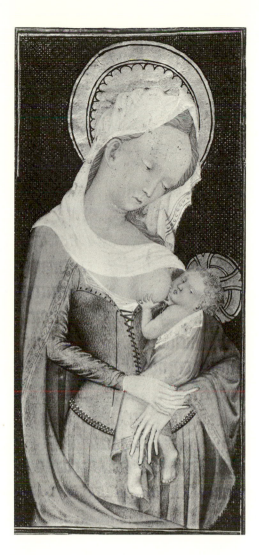

87. Virgin nursing. Monceaux-le-Comte (Nièvre), Church.

88. Virgin nursing. Rohan Hours. Paris, Bibliothèque Nationale, ms. lat. 9471, fol. 33v.

theme: there are examples of it from the twelfth and thirteenth centuries. We have only to cite the Virgin painted on the vault of the chapel of Le Petit Quevilly, near Rouen: there the Virgin, seated on the donkey of the Flight into Egypt, nurses the Child en route. The fresco was painted in the early thirteenth century.[18]

Nevertheless, these works are fairly rare. They became frequent only in the fourteenth century (figs. 86, 87);[19] then they appear constantly in France as well as Italy. But art was still timid. Often the Virgin's breast can be glimpsed only through a slit in her robe.[20] But in the fifteenth century, the Virgin gives suck with the serene immodesty of a wet nurse (fig. 88).

And finally, the Virgin who for long had shown such respect and was seemingly unable to forget that her son was also her God, dared to embrace the Child and press her cheek against his.[21]

In tracing the origin of these new feelings, we come again to St. Francis and his disciples. In the twelfth century, the Gospels were above all an idea. In the thirteenth century, the Franciscans again infused them with life. The *Meditationes vitae Christi* are permeated with gentle human warmth. All of the nuances expressed by fourteenth-century artists are already to be found in this new apocryphal Gospel. The Child Jesus sees his mother weeping and tries to console her: "The Infant who was at her breast raised his little hand to the mouth and face of his mother and seemed to implore her to weep no more."[22] This is precisely the gesture of the infant in the Jeanne d'Evreux group (fig. 85). Of the nursing Virgin who consoles, embraces, and gives suck to the Child, the *Meditations* says: "The mother pressed her face against the face of her little Child, nursed him and comforted him in every way she could, for he often cried, just as infants do, to demonstrate the misery of our human condition."[23] Or again: "She knelt when she placed him in his cradle, for she knew that he was her Saviour and her God. But with what maternal delight she held him, pressed him to her! ... How many times she gazed with loving curiosity at his face and each part of his sacred body ... what joy it was to give him suck! We can believe that she felt a sweetness unknown to other women when she nursed him."[24]

Such a book, made known to all of Europe through the preaching of the Franciscans, released feelings. At the beginning of the fourteenth century, the atmosphere the artists breathed was no longer the same; it had grown warmer.

The Mother and Child group has to be studied during the entire fifteenth and into the early sixteenth century in order to see it gradually lose its character of divinity. It was difficult, certainly, to be on intimate terms with Christ, but it was possible to be so with the Infant Jesus. It was thought that the Virgin herself was more touched by love than by respect; this inspired so many delightful works, but works that would have shocked the image makers of the early thirteenth century.

At St.-Urbain, in Troyes, for example, the Virgin is shown as a young woman of Champagne, with a high forehead and eyes half-closed in a smile; she is guileless yet arch; the Child is chubby cheeked, curly haired, smiling, intent on a cluster of grapes; he is the Word made flesh in a child from Champagne (fig. 89).

Nowhere were artists less concerned with respect than in Champagne. At Braux (Aube), the Son of God wears a little hood;[25] at St. Remy-sous-Barbuisse (Aube), he sleeps with his head on his mother's shoulder.

The art of the other provinces expressed similar feelings. The Virgin of Autun, graceful, smiling, her chin plump like those of Burgundy women, has swaddled the Infant according to local custom; she contemplates him for a moment before placing him back in his cradle.

89. Virgin and Child. Troyes (Aube),
Church of St.-Urbain.

At La Carte, in the Loire valley near Tours, the Virgin is a simple, modest, tender peasant woman from Touraine; the Infant Jesus is a little peasant who smiles at his mother before taking her breast.

German art historians have more than once expressed the idea that Christ's Passion was the particular domain of German art, but that only Italian art could represent the Madonna and Child.[26] Such statements make us smile. Our fifteenth- and sixteenth-century Virgins are not afraid of comparison. The Italian Madonna is undoubtedly beautiful, gracefully clasping her son to her breast, but the quality ours possess to so high a degree is often wanting: a kind of genial and down-to-earth simplicity. The French Virgin is not a lady; she and her child are closer to the people, to instinct, to the warm hearth of life.

Nothing would better prove what I have said than a collection showing the principal French Virgins of the fifteenth and early sixteenth centuries; but it will be a long time before such a book could be

completed. Such a beautiful collection would add to the glory of French art, but is not yet possible.

<div align="center">

III

</div>

The Holy Family.

While our sculptors were creating the Virgin and Child group, so rich in truth and poetry, our miniaturists were proving to be no less familiar and no less tender. Their art permitted liberties not possible in sculpture. The presence of some beautiful angels was enough to give supernatural meaning to these human scenes.

In a Book of Hours from the late fourteenth century, we see the Virgin giving suck. No doubt she thinks that she is alone, but an angel has come to support the Infant, and two others hold a crown above the mother's head.[27] In other miniatures, the Infant learns to walk, the mother encourages him by holding out her hands, but God has sent angels to support the first steps of his son (fig. 90). Sometimes the Infant is seated on the lap of his mother and plays with fruit or flowers or a small golden harp (fig. 91), and we might think him to be one of the sons of man were it not for the angel musicians expressing the joy of heaven on the viol.[28]

90. Christ Child taking his first steps. Paris, Bibliothèque Nationale, ms. lat. 1405, fol. 49r.

91. Virgin and Child with angels. Paris, Bibliothèque Nationale, ms. lat. 924, fol. 241r.

But our artists loved above all to place the mother and child in an orchard or under a portico opening out on the fields (fig. 92). The scene takes place in early spring; the daisies bloom in the grass, and an angel brings to its God a flowering branch or even a basket of cherry or apple blossoms (fig. 92).[29] Sometimes it is later in the season. Angels pick strawberries (fig. 90), and one presents the Infant with a basket of fruit.[30] How tender these artists were and how truly moved! They wanted the mother to enjoy these sweet years, and tried to make us forget that this Infant would one day die on the gibbet.[31]

These motifs, so frequent in our Books of Hours after the late fourteenth century, were to come to full flower in the most charming way in the School of Cologne and the work of Memling. The origins of the School of Cologne, as well as of the Flemish School, are to be found in French miniatures.

Moreover, such feelings were shared by the entire Christian world of the time. There was a meeting of art and liturgical poetry. In the hymns of the fourteenth century, the Virgin and Child seem to stand out against a background of roses, lilies and violets. They were crowned with the most beautiful names of flowers.[32] "O Virgin reposing against flowers," said a hymn of Mainz, "through thee everything blossoms,

92. Virgin and Child with angels gathering flowers. Paris, Bibliothèque Nationale, ms. lat. 1158, fol. 127v.

mother of the eternal lily. O rose bearing the lily ... Thou playest with thy son, thy hands filled with roses."[33]

The visions of the mystics were exactly like the artists' paintings and the illuminators' miniatures. St. Gertrude saw the Virgin and Child surrounded by angels in a beautiful garden "filled with thornless roses, lilies white as snow, and fragrant violets."[34]

All the scenes from the Infancy were recounted by our miniaturists with a tenderness sometimes pushed to the point of puerility; one might think a nurse was telling the Gospel stories to a child.

In the Nativity scene, the Infant, newly born and still lying on the ground, is often shown placing his finger in his mouth.[35] Elsewhere, a midwife brings a basin of water to wash the newborn; the Virgin makes sure that the water is warm enough by dipping her fingers into it; the Child, already very lively, caresses the muzzle of the ox who warms him with its breath.[36] These small domestic details abound: a cat warms itself near the boiling kettle;[37] Joseph goes to find his drinking-glass to keep up his courage.[38]

The same kind of genial detail appears in representations of the Flight into Egypt; Joseph whips the donkey with a tree branch,[39] he stops to drink from his gourd,[40] or gives the Infant the beautiful apple he has just picked.[41]

Sometimes the artists represented the joys of the Holy Family. In a manuscript from about 1400, the Virgin, Joseph, and the Infant, are out in the garden enjoying a beautiful spring day. The Child cannot yet walk very well, and his mother is obliged to hold him by the hand; Joseph, to make him bolder, has picked a strawberry and from a distance encourages him to come and take it from his hand; angels have alighted on the grass to watch the scene.[42] The stalls of Montréal (Yonne) show the interior of Joseph's workshop: he works at his bench while the Virgin watches an angel pushing the Infant Jesus in a baby cart (fig. 93).[43] In the window at St.-Julien (Jura), the Infant turns his mother's spinning wheel, and picks up chips of wood in his father's carpentry workshop.[44] In the window in St.-Aignan, at Chartres, a profound calm reigns in the house: Joseph works, the Virgin spins, and the Infant sleeps; one angel watches over the cradle and two others gather up chips of wood from the carpentry into a basket.[45] The German imagination adored all such details, and nothing in France equals the ingenuous charm of Dürer's famous wood engraving. The pitfall was puerility, and the German masters did not always avoid it. We have only to cite their anonymous engravings and drawings from the fifteenth century showing the Infant Jesus astride a hobbyhorse (fig. 94), or the infant St. John quarreling with Jesus over a bowl of porridge.

The truth is, only Rembrandt was capable of representing "The Carpenter's Family." Putting aside everything supernatural, he con-

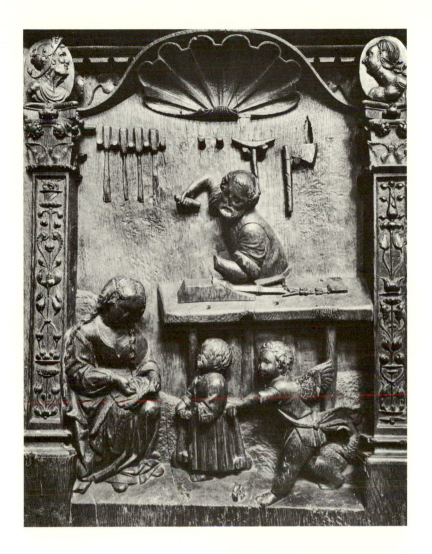

93. Holy Family. Montréal (Yonne),
Church. Oak choir stall. XVI c.

94. St. Dorothy and the Infant Jesus. Paris,
Bibliothèque Nationale, Cabinet des
Estampes. German wood-block print.

veyed a real sense of the scene's divinity by showing the family united by love in the half-light of an old house.

We must not expect the equal of this from our fifteenth-century masters. Their imagination was that of our old *noëls* (Christmas carols): they were as familiar with God as our rustic poets who had Jesus born in Burgundy or Provence. What we call the realism of our fifteenth-century artists might just as well be called their mysticism, for this realism was born of the desire to reach God.

If our artists of the late Middle Ages dared to draw God down to man, we can certainly believe that they did not hesitate to bring the saints too down from heaven to earth. Intimate as they were with God, they were still more so with the saints, as we shall see.

V

Religious Art Expresses New Feelings:
New Aspects of the Cult of Saints

I

The cult of the saints cast its poetic charm over the whole of the Middle Ages, and yet it can be said that the saints were never so loved as in the fifteenth and sixteenth centuries, just before half the Christian world was to reject their old friendship. The number of works of art devoted to them is almost prodigious. Even today in Champagne, the smallest village church possesses two or three statues of saints and two or three stained glass windows depicting their lives—charming works of the Middle Ages that were coming to an end. And it was the same all over France. Where the works of art have disappeared, at least documentary evidence remains.[1]

So the saints were everywhere. Carved on town gates, they faced the enemy and defended the town: Sts. Michael, Peter, Christopher, Sebastian, Barbara, Margaret, and Nicholas stood like so many sentinels on each of the towers of Amiens.[2] A saint's statue seemed as useful for fortifying a castle as good weapons. The heedless Duke of Orléans had Pierrefonds decorated with the images of knights; he received little benefit from them. The wiser Duke of Bourbon decorated the three towers of his Château de Chantelle with images of Sts. Peter, Anne, and Susanna.[3]

The burghers had no towers to defend, but were not their wooden houses in need of protection? And did they not have to guard against fire, plague, sickness, and death? That is why there were often more saints on the façades of our old houses than on altarpieces. On a house at Luynes, we see in addition to the Virgin, St. Geneviève, the patron saint of the town, St. Christopher, guardian against sudden death, and St. James, who never forgot those who undertook the great pilgrimage out of love for him.[4] Few of these old houses are left; even Rouen has only a few. Those that still stand testify to those former generations' unshakeable confidence in the benevolence of the saints. In the Middle

The saints of the late Middle Ages.

Ages, the streets of our great Gothic towns, Paris, Rouen, and Troyes, were an astonishing sight: not only did each house display to the passerby its gallery of saints, but signs swinging in the breeze also carried the images of St. Martin, St. George, and St. Eligius. The cathedral rising above the rooftops bore no more saints heavenward than they.

Although the saints' images in the villages were fewer, they were venerated with equal fervor. The image of a church's patron saint was believed to be a precious talisman. In the provinces of central France, on the feast day of the local saint, his statue was offered to the highest bidder beneath the porch of the church. For several hours the "king" of the auction became the master of the holy image, and he carried it to his own house where it was supposed to bring happiness. People vied for the honor of carrying the statue, relics, and standard of the saint in procession, and the various parishes often waged bloody battles around the reliquary in pilgrim churches:[5] it was like a revival of the heroic and wild spirit of the ancient clans.

In ancient and rustic France, the saints were associated in people's minds with the fragrance of the orchards: their power over men's hearts was all the greater for that. In Bourbonnais, when blossom-time was near, the equestrian statue of St. George was carried through the vineyards and his horse's feet were washed with wine.[6] In Anjou, on 23 April, people prayed also to St. George to set the fruit of the cherry trees.[7]

II

The saints are French in costume and physiognomy.

Thus, the saints were never closer to men than during the late Middle Ages, and this can best be proved by study of works of art.

It is surprising to see how the aspect of the saints changed toward the beginning of the fifteenth century. In the thirteenth century, long tunics and simple, noble drapery clothed them in majesty and gave them a certain timelessness: they soared above the generations who renewed themselves at their feet. For a long time the artists remained faithful to these great traditions.

In the *Breviary* of Charles V, Sts. Catherine (fig. 95), Ursula, and Helena still wear the long simple robe that belongs to no particular time: St. Martin wears one of those tunics men seem to have worn since the beginning of time.[8] The saints preserved this heroic aspect until the beginning of the fifteenth century. In a beautiful Book of Hours in the Bibliothèque Mazarine (from about 1400), Sts. Catherine and Margaret are dressed as simply as the Virtues and Beatitudes of the thirteenth century.[9]

With the fifteenth century, everything changed. The saints, who had long remained above man, seemed to come closer out of kindness: they

can scarcely be distinguished from other men. We see them wearing the fashions in dress of the reign of Charles VII, Louis XI, and Louis XII. Fouquet's St. Martin is a young knight just back from the campaign against England, having helped his sovereign to reconquer France.[10] But the St. Adrian of the Conches window, a young fair-haired soldier, is a hero of our Italian wars; it was perhaps from Milan that he brought the jewel decorating his hat.[11]

In the *Hours* of Anne of Brittany, Sts. Cosmas and Damian are shown as two physicians of the faculty of the University of Paris (fig. 96): over their greying hair they wear a cap or a hood, and their fur-lined houppelandes protect them during their winter rounds. They make no effort to be well-groomed; they do not even trouble to shave every day. They are hard workers, on whom life has already left its mark; they are completely absorbed in their profession and although they are a bit rough, they are kindly and can be approached without fear.

95. St. Catherine and the Doctors. Breviary of Charles V. Paris, Bibliothèque Nationale, ms. lat. 1052, fol. 576v.

96. Sts. Cosmas and Damian. Hours of Anne de Bretagne. Paris, Bibliothèque Nationale, ms. lat. 9474, fol. 173v.

Sts. Crispin and Crispinian, in a sculptured group in the church of St.-Pantaléon, at Troyes, are two young journeymen shoemakers working in their shop (fig. 97). One calmly cuts the leather and the other stitches the soles while two burly soldiers, with mustaches and beards and clad in slashed leather doublets like Swiss mercenaries, seize them by the shoulders. These are the saints with whom the shoemakers of Troyes felt at ease. The stool, the hatchet, the wooden tub, and the little dog under the table are all shown in loving detail.

Artists were never more at home with the saints than during the time of Louis XIII and Francis I. They may have wanted to refurbish the costumes of the apostles a bit, but did not dare. The sculptor of Chantelle, however, carved embroidery on the hem of St. Peter's tunic,[12] and Leprince, in an admirable window in the cathedral of Beauvais, gave St. Paul a great two-handed sword of the kind used in the battle of Melegnano.[13] They took greater liberties with the evangelists. In the *Hours* of Anne of Brittany, Jean Bourdichon shows St. Mark as an aged notary, apparently in very comfortable circumstances (fig. 98). He sits

97. Arrest of Sts. Crispin and Crispinian. Troyes (Aube), Church of St. Pantaleon.

in a rich office wearing a fine fur-trimmed robe and a cap on his head, as he prepares to draw up an inventory.

The traditional tunic of the somewhat less important characters in the Gospel story was gradually replaced. In the *Hours* now in the Arsenal,[14] Jean Bourdichon saw Joseph leading the Virgin and Child into Egypt as a journeyman carpenter making the rounds of France: he wears a cap on his head, a bag over his shoulder, and carries a stout staff in his hand. But nothing equals the boldness of the statue of Joseph, now in the church of Notre-Dame, at Verneuil (fig. 99). It is a faithful image of a young carpenter of the time of Louis XII: he wears a short coat, a rose in his cap, a bag of tools at his waist, and carries the insignia of his profession, a large axe. No one would imagine this young journeyman to be Joseph if it were not for the flowering rod of the legend and the small Child at his feet.[15] We may also mention that St. Anne was shown as a serious matron wearing kerchief and mobcap, and St. Elizabeth, cousin of the Virgin, as a young bourgeoise carrying her keys at her waist.[16]

98. St. Mark. Hours of Anne de Bretagne. Paris, Bibliothèque Nationale, ms. lat. 9474, fol. 24v.

99. St. Joseph as carpenter. Verneuil (Eure), Church of Notre-Dame.

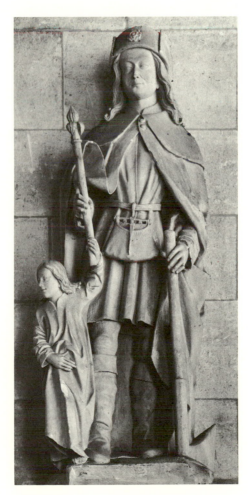

The painters' language was richer than that of the sculptors, and was sometimes charmingly impertinent. Fouquet and Bourdichon would have us believe that all the saints of the calendar had lived in Touraine. According to Fouquet, St. Anne lived with her daughters in a garden enclosed by a hedge of roses, from which the bell-towers of Tours could be seen.[17] It was along the embankment at Chinon that St. Martin gave half of his cloak to the poor man.[18] According to Bourdichon, Joseph led the Child not into Egypt but into a pretty valley of the Indre dominated by ancient manor houses.

But most charming of all, all these saints not only seemed to live in France and to wear French dress, but they looked French too—especially the female saints. There is not one, I think, that the Italians would have found beautiful. What! these little peasants of Touraine or Bourbonnais, with their round faces and snub noses, aspiring to be great art! They had scarcely any pretensions at all, and that is why we find them so charming today. One of the prettiest is the St. Magdalene of the church of St.-Pierre, at Montluçon (Allier) (fig. 100).[19] She is a young girl with

100. The Magdalen. Montluçon (Allier),
Church of St.-Pierre.

slender waist, still almost a child. Her graceful face would soon have grown heavy and her waist thick, but at this beautiful moment, the young saint is pure virginal grace. In Italy, from very early times, beauty claimed to be lasting, like essence and idea. But our French saints, like our young peasants, flowered for only a moment: their charm is all the more touching. No, we are not a race of demigods! In France, beauty has never been anything but expression, and thus it is never constant:

Toujours sa beauté renouvelle

(Her beauty is ever renewing itself),

Charles d'Orléans had already said, speaking of the wife he loved. Such are our young saints.

Many statues of St. Barbara or St. Catherine in the full beauty of youth and innocence are still to be found in our churches.

This little world of saints had endless charm for the people of the time. So conceived, they were less respected than loved, but perhaps they were never more persuasive. All these homely details affected men's hearts. The man of law, the attorney, might say: "This St. Yves, with his magistrate's hat and robe, and his brief in his hand, was all the same a man such as I am; thus it is true that in our profession it is sometimes possible to be altruistic." The shoemaker would willingly accept advice given him in the name of a saint wearing a work-apron like his own.

The spell was broken when Italy taught us the grand manner. Then the saints bade us farewell and returned to heaven. The classical heroes and ancient philosophers who claimed to represent St. Peter or St. James had nothing more to say to anyone. Where did those men with their regular profiles, their large cloaks and their conquering air come from? No one knew, and no doubt cared little about finding out. True, they may have pleased the scholars. A humanist walking about the church of St.-Etienne, at Troyes, may have been gratified to note that the recently completed sculpture representing the meeting of St. Anne and St. Joachim[20] could just as well have been an excellent representation of the last meeting between Portia and Brutus.

III

This ardent veneration of the saints was extremely productive: to it we owe the best part of our late medieval art.

The saint to whom a person is most attached is the one whose name he is given at baptism. A mysterious bond unites the Christian with the celestial protector who watches over him during his entire life and who will be his advocate on the great day of judgment. What could be wiser than to honor this invisible friend? All that we do for him here

Patron saints. St. Jerome. The windows of Champigny-sur-Veude and Ambierle.

below will be counted in heaven. That is why the nobles, the bourgeois, and the peasants all had one wish in common: to place in their parish churches a beautiful image of their patron saint which would remain there until Judgment Day.

This desire, as strong as an instinct, yielded innumerable stained-glass windows. When we come upon windows in the churches of Champagne depicting the legend of a saint, an inscription almost always tells us that a merchant, a furrier, an innkeeper of the French Arms, or even a simple plowman donated the life of the saint because he bore his name.[21] For donors were in the habit of looking after themselves. Since the saints received so much homage, it was a good thing, so they thought, to help them keep the names of their servants in mind. And was it not pleasant, also, to say to yourself that your own name, inscribed beneath the feet of St. Martin or St. Nicholas, would be carried down through the centuries along with them? All this was not very Christian, perhaps, but it rose out of the depths of human nature. I know of only one inscription that has a truly Christian tone; it is written along the lower edge of a window of a church in Montangon (Aube), and is beautiful enough to be transcribed here: "In 1530, unnamed good people had this window placed here; they did not care to inscribe their names, but God knows them."

The donor not only had his name inscribed but often had the artist represent him kneeling piously at the feet of his patron saint, and almost always the saint made the gesture of presenting his protégé to someone not shown. Was it to God Himself that the saint dared to recommend his servant? It would seem not. Certain more complete works always show the saint presenting the donor to the Virgin.[22] The Virgin holds the Child who blesses from afar the poor sinner. It was in this way that prayers rose, step by step, to God. A window at Beauvais, now destroyed, provided a detailed rendering of the miraculous ascent of prayers to heaven.[23] First, a canon was shown kneeling at the feet of his patron, St. Laurence, and saying:

> *Saint Laurent, patron d'icy prie*
> *Pour moi, pécheur, sainte Marie.*

> (St. Laurence, earthly protector, pray
> For me, a sinner, to St. Mary.)

And in fact, St. Laurence, with eyes turned toward the Virgin, seems to say:

> *Pour celuy-ci, Reine de la sus (là-haut),*
> *Veuille prier ton fils Jésus.*

> (For this one, Queen of Heaven,
> Kindly pray to thy son Jesus.)

Amenable to this appeal, the Virgin shows to her crucified son the breast that fed him, saying:

> *Mon fils qu'allaita ma mamelle*
> *Pour ce pauvre pécheur t'appelle.*[24]

(My son, fed by this breast,
I appeal to thee for this poor sinner.)

The crucified Jesus, covered with blood, looks toward his Father and cries:

> *Mon père avez compassion*
> *De ce pécheur pour ma passion.*

(My Father, have compassion
On this poor sinner because of my passion.)

And the Father, disarmed, replies:

> *Par tant de motifs animé*
> *Me plaît d'avoir pour lui pitié.*

(Prompted by so many reasons,
It pleases me to take pity on him.)

Thus, between the supplicant and the formidable figure of God the Father there were these gentle intercessors nourished on the same milk and with the same blood in their veins as ours. A Christian would never address an abstraction. So whenever a donor in a stained glass window, accompanied by his patron saint appears to be addressing a prayer to an invisible being, we must complete the picture in our imaginations with a figure of either the Virgin or the crucified Christ.

However, these figures of kneeling Christians tenderly presented by a saint, are sufficient in themselves. We do not see the Virgin or the Christ, but we divine their presence by the expression of faith in these faces. A window located in the right circle of the cathedral of Moulins is perhaps one of the most beautiful examples. It represents a kneeling family: father and mother, son, and no doubt the daughter-in-law. Each has his patron saint beside him. Their attitudes and faces so profoundly express their humble faith and timid hopes that not even the pictorial Life of a saint would be more edifying here than these four portraits. And everything about the four patron saints, who lean slightly toward their protégés, touching them with their hands and hovering over them lovingly, expresses benevolence.

From the fifteenth century on, the group of donor and patron saint was to be found everywhere. The familiar silhouette of the kneeling man and the standing saint appears in Flemish triptychs, French stained glass windows, and Italian paintings. Thus, few sentiments were more

productive than this faith in the prayers of the saint from whom each Christian receives his name at baptism.

Certain departures from the practice are worth pointing out. On occasion, in fact, the donor kneels at the feet of a saint who is not his patron. But there is always a reason for this seeming oddity, and it can sometimes be easily uncovered. It would be a surprise to see Jean d'Estouteville kneeling before St. Michael, in the window of the church at Blainville (Seine Inférieure),[25] if the magnificent history of the fifteenth-century Lords of Estouteville were not familiar to us. It was Louis d'Estouteville who with indomitable vigor defended Mont-St.-Michel against the English in 1425. Thanks to him and the one hundred and nineteen Norman knights confined with him in the abbey, the Mount remained French. For a long time, the names of these heroes could be read in the south transept of the church. Joan of Arc, far away in Lorraine, heard of their exploits, and from then on, St. Michael was for her the true champion of France. Later on, another d'Estouteville, the famous Cardinal Guillaume, when he was abbot of Mont-St.-Michel, had the light and airy choir of the church built over the heavy crypt. To him was given the honor of undertaking the rehabilitation of Joan of Arc. We can now account for the traditional veneration of the Lords of Estouteville for St. Michael; and moreover, Jean d'Estouteville is shown in the window at Blainville wearing the Order of St. Michael, which his family had so deservedly won.

Thus, for reasons we can sometimes uncover, the faithful occasionally chose a patron saint other than their own.

There is one category of these exceptions frequent enough to have been almost the rule. For men of the church, we often find as intercessor, not the saints whose names they bore, but the austere figure of St. Jerome. At Davenescourt (Somme), the chaplain Antoine Huot is presented to the crucified Jesus by St. Jerome.[26] At Albi, we see St. Jerome standing behind the cardinal Jean Joffroi.[27] Again, it is St. Jerome, and not John the Baptist,[28] who accompanies the prior Jean de Broil in the window of the church of Tressan, in the department of La Sarthe. These examples will suffice, although we could name many more. It is clear that these churchmen considered St. Jerome to be their true spiritual patron. The inscriptions sometimes accompanying the works of art leave no doubt about this. Beneath a fifteenth-century engraving representing St. Jerome in prayer, we read:

Ave, gemma clericorum,
Jubar, stellaque doctorum.[29]

A sixteenth-century engraving devoted to the same subject speaks more clearly still, as we see in these verses:

Ce sainct cardinal par sa vie
Abhorrant toute volupté
Les prélats exhorte et convie
Vaquer à toute sainteté.[30]

(This sainted cardinal who in his life
Abhorred all pleasure
Exhorts and urges the prelates
To seek complete holiness.)

Toward the end of the fifteenth century, when printing allowed copies of the Letters and Treatises of this great theologian to circulate, the clergy seemed for the first time to glimpse the true character of St. Jerome. This stormy soul, little understood by the Middle Ages, began to be revealed. The battle the great athlete had waged with himself was admired: lost in the desert, broken by labor and fasting, "black as an Ethiopian," he was barely able to master desire. A real man, who struggled as long as he lived, who always heard his own passion roaring like the lion the artists placed at his feet—such a saint was to captivate clerics. Like them, he was learned, a refined humanist, master of exegesis, and theologian; and like them, he was always stirred by the voices he had vowed not to hear. Works of art devoted to St. Jerome were frequent in the sixteenth century, and I am convinced that most of them were commissioned by priests.[31]

St. Jerome was the adopted patron saint of a whole group. At other times, a saint appears as the patron of an entire family. In Touraine, at Champigny-sur-Veude (Indre-et-Loire), there is an extraordinary monument: a chapel apparently erected to the glory of the Bourbons. It is decorated with beautiful sixteenth-century windows that are still almost intact.[32] What first attracts our attention in these large and striking windows are the portraits of the Bourbons. We see them kneeling in a long line, from Robert of France, the sixth son of St. Louis and head of the family, to Charles of Bourbon, the grandfather of Henry IV. We see Bourbons of Moulins alongside Bourbons of Vendôme and Bourbons who were Counts of La Marche. No French family ever displayed its nobility so proudly in the house of God. However, above these portraits, the life of a saint is represented; it unfolds in numerous episodes, from birth to death. Who is this saint to whose veneration the Bourbons seemed to have pledged themselves? We would guess at once, even if the inscriptions did not give his name. The saint was also one of the family, their illustrious ancestor, St. Louis. In venerating him, the Bourbons were also worshiping themselves a bit. All the individual patron saints, the many saints Peter and Charles, paled before the great saint who could very well defend his family all by himself. To the Bourbons of the sixteenth century, St. Louis must have resembled

the deified heroes who had founded the great families of Athens and Rome.

Thus, there was always a deep bond of feeling between the donors and the images of their accompanying saints, but sometimes what this bond is can be uncovered only by scholars.

At Ambierle, near Roanne (Loire), there is a monastic church which is one of the rarest masterpieces of the fifteenth century. The choir, above all, rising with magnificent thrust and transfigured by magical light from the windows, seems wholly spiritual. This beautiful church owes its perfection to the will of one man: the prior Antoine de Balzac d'Entragues, who committed his fortune to it. It was surely he who chose the saints whose great figures are placed one above the other in the windows, under canopies of white and gold.[33] This assemblage of saints at first astonishes us. We can easily explain the presence of St. Anthony, patron saint of the donor, and of several other saints—Sts. Germain, Bonet, and Haon—who were venerated in the neighborhood of Ambierle. But what are Sts. Apollinaris, Achilleus, Felix, Fortunatus, Ferreolus, and Julian doing here? To solve the puzzle, we must know that Antoine de Balzac d'Entragues, while he was prior of Ambierle, was also bishop of Valence and Die. This is what he wished to recall, and he did so with rare modesty. Instead of having himself shown with his cross and mitre, he settled for having the most venerated saints of his diocese painted in the windows.[34]

Thus, attentive study can frequently provide explanations backed by sound reasons for what has often been lightly attributed to caprice. But we must admit that our learning is often deficient. Many interesting problems must be left unsolved. I have often asked myself by whose refined piety had the saints ornamenting the chapel of Châteaudun been chosen. This chapel, now restored and painted white, by happy chance creates an impression of virginal purity in keeping with the statues lining the walls. We recognize Sts. Agnes, Catherine, Barbara, Apollonia, Elizabeth with flowers in her apron,[35] Mary of Egypt clothed in her long hair, Martha, Margaret carried by her dragon, Mary Magdalene,[36] and finally the Virgin, the most beautiful of all. There are only three male saints: the two St. Johns and St. Francis of Assisi. Thus, the little sanctuary was decorated with exquisite feeling: it includes what is most innocent, tender, and fervent in Christianity. It exudes a sweet aroma of feminine mysticism. Who chose these statues? Was it Dunois, the founder of the chapel, who remembered before he died[37] that in his youth he had seen a saint as pure as those in the chapel? Or was it not rather his wife, Marie d'Harcourt, who loved her little chapel to the point of wanting her heart to be buried there? I do not know, and I do not think scholars know much more.[38] Mystery has a charm of its own, but it would be better to know the truth, whatever it is.

Individuals were not the only ones to have their patron saints: societies had theirs also.

We have not the slightest idea today what Christian life was like in the late Middle Ages. Men were never less isolated. Divided into small groups, the faithful formed numberless confraternities. It was always a saint who brought them together, for at that time, the saints were the bond uniting men.

Try to imagine what old Rouen was like in the time of Louis XII. In the narrow little streets with their sculptured houses, the different trade guilds gathered; one street was reserved for the shoemakers, another for the butchers, and another dark labyrinth for the drapers. Sometimes a charming church rose up amid the shops and stalls: this was the church of the guild. There was St.-Etienne des Tonneliers, Ste.-Croix des Pelletiers, and still others that were destroyed during revolutions. The artisans not only lived together in the same street, but in church they were grouped together before the statue of their patron saint. All of them, from master to apprentice, belonged to the same confraternity, and guilds seemed to be first of all religious associations. They had a communal house decorated like a church. The house of the goldsmiths, near the Tour de l'Horloge, had windows decorated with the life of St. Eligius.

Not all the corporations could have a church, and many were content with a chapel in the church of St.-Maclou, St.-Patrice, or the cathedral. In the churches of Rouen, each chapel was the center of a confraternity, whether religious, professional, or poetic.

The meetings were very lively and picturesque; poems were recited, prizes given to the winners, Mystery plays were performed, symbolic ceremonies celebrated.[39] The statue of a benevolent saint presided at these festivities. The clergy did not need to work up the zeal of the faithful; they had rather to temper it.[40] Faith, and above all faith in the intercession of the saints, was alive and productive. Confraternities formed spontaneously. They were often of an astonishing austerity: men who had taken the vow to pray among the dead, silently examine their own consciences, and go then to visit the poor, assembled at dawn in the cemetery of St. Vivien.

Confraternities were continually enlivening the town with their activities. Sometimes it was a burial: carrying wax candles, the members followed the coffin on which the image of their patron saint was painted on a shield. Sometimes it was a pilgrim departing for Compostella whom they honored: the members, with pilgrim's staff in hand, accompanied him as far as the cross of St. James. At other times, it was the festival of a guild. Then would come the great procession of the

Patron saints of the confraternities. Religious confraternities. Military confraternities. Confraternities of the guilds. Works of art created for the confraternities. The Mystery plays and the confraternities.

fierte (the reliquary coffin of St. Romain): the *confrères* of St. Romain escorted the condemned man, who in memory of the goodness of the old bishop was then set free.[41] Sometimes all the confraternities would be out with banners unfurled in celebration of a feast day, or to commemorate a happy event: thus they were associated with our entire history. In dark times, when the plague broke out and the streets were deserted, the *confrères* could still be heard passing by, accompanying the dead.

Rouen was not exceptional during this time: what was seen there could have been seen throughout France; the monuments and the spectacles were less magnificent, but the same confraternities were everywhere. Each new study of our ancient towns mentions them. Ten guild confraternities and several religious confraternities met at Notre-Dame, in Vire (Calvados).[42] At Notre-Dame, in Dôle (Jura), not only did each confraternity have its own chapel, but many of them had chapels built at their own expense;[43] the shoemakers, it is true, did not build their own chapel, but they offered beautiful jewels and twenty-eight changes of attire to the statue of the Virgin.

Strangely enough, the confraternities existed in the country as well as in the towns. There was not a village in Normandy that did not have its own: in the church of the village of Ecouché (Orne), we know of as many as four.[44] The confraternity was the living cell to be found everywhere and always.

The confraternities of the late Middle Ages can be classified under three headings: religious, military, and guild.

There were religious confraternities in all sections of France, but scholars scarcely ever bother to mention them. Only Normandy scholars have recognized that it could be fruitful to study them, and for fifty years they have been adding to the works on confraternities, or as they are still called, the *charités* of Normandy.[45]

The Normandy *charités* were associations for prayer and good works, formed under the patronage of a saint. They first appeared in the fourteenth century and spread during the next. In the sixteenth century, there was not a village church that did not have its *charité*. Everything touched by the Middle Ages was permeated with a little poetry. These rustic confraternities were not without refinement; their members wore crowns of flowers. At Surville, on the feast of St. Martin in summer, the town magistrate and the *confrères*, along with their wives, were required to appear at the church wearing hats made of flowers. Elsewhere, the magistrate was crowned with spring violets. In a *charité* of St. John the Baptist, the *confrères* carried a crown made of three flowers: these three symbolic flowers signified the three functions of the Precursor, who had been sent by God as patriarch, prophet, and baptist. Symbols were everywhere. The dignitaries numbered thirteen, in mem-

ory of Christ and the twelve apostles. Like Christ, the magistrate washed the feet of twelve poor on Maundy Thursday. The feast of the patron saint was celebrated with naïve pomp. On the evening before, the confrères would go by torchlight to escort the magistrate to the church; the next day, the procession took place with a banner at the head and each brother carrying on his candle or his hat the image of the protecting saint. Everywhere in the Middle Ages, the people themselves functioned as the artist who out of himself creates all beauty. Burials had a noble gravity. The death of a confrère was announced in the squares by the ringing of a bell; then, if he had been poor, a shroud was bought for him, prayers for the dead were recited beside his bed, the whole charitable confraternity, with its insignia, bore him to the church and to the cemetery. One of the ceremonies had tragic grandeur: if a confrère contracted leprosy, the *charité* had the Mass for the dead recited in his behalf and then isolated him from the rest of the world.

The military, like the religious confraternities, multiplied especially during the late Middle Ages. Every province in France had confraternities of archers, crossbowmen, and harquebusiers. These warriors assembled under the patronage of a martyr or a virgin: the archers and crossbowmen had St. Sebastian on their banner, and the harquebusiers had St. Barbara. The religious spirit of the Middle Ages had marked these institutions with its own imprint. In the statutes of the confraternity of crossbowmen of Senlis, the crossbow is compared to the cross of Jesus Christ.[46] Frequently a new member took an oath that he would not blaspheme nor ever invoke the Devil. For all that, the confrères had no intention of imitating monks. They had a naïve love of brilliant colors, parades, fanfare, and glory. On St. Sebastian's day, they went in magnificent procession to shoot popinjays in the fields. Whoever brought down the bird was proclaimed king; if anyone shot it three years in succession, he became emperor.[47] That evening they all dined at the town's expense.[48]

It would be a mistake to smile and think that these were innocent meetings of the *Francs-archers de Bagnolet*. Our ancient confraternities of archers, especially in the military provinces of eastern France, often played an heroic role. In 1418, the confraternities or, as they were called the *serments* of Amiens, Lille, Douai, and Arras marched to the aid of Rouen, under siege by the English. In 1423, the *serment* of Noyon besieged Compiègne with Charles VII. The confrères of Abbeville took part in the battles of the Hundred Years' War. But the archers of St. Quentin were no doubt the most valiant. In 1557, they defended the town against the Spaniards and went down to death, almost to the last man, on the ramparts of the Porte de l'Isle.[49] The proud inscriptions on the banners of the confraternities were not empty boasts. The confrères of St. Quentin would have had the right to inscribe on their

standards the magnificent motto of the Senlis archer: *Florescet sartis innumerabilibus*—"We will fill him so full of arrows he will look like a field of flowers." It is too bad our ancient crossbowmen did not have themselves painted, as the valiant corporations of Holland did after the great wars: they deserved to be, and more than once.[50]

The guild confraternities are so well known that we need speak only briefly of them. It is enough to recall that they remained faithful to their religious origins until the end of the Middle Ages, and even later. Patron saints protecting the trades were never more honored than during the time we speak of. Each had its chapel in the church where the masters and journeymen assembled, and frequently the qualifying masterpieces were on display near the altar.[51] The image of the saint decorated the banners of the confraternity, and it was carved on the head of the baton carried through the town, to the sound of bagpipes on the feast day of the guild. It was also placed on the coat of arms of the guilds; for the commoners wished to have armorial bearings just like gentlemen. In Touraine, the farriers had a golden St. Eligius on a field of azure; the butchers, a St. Eutropius; the cooks, a St. Laurence. The bakers carried a banner showing, on a field of azure, St. Honoratus in pontifical dress holding a silver baker's shovel with three red round loaves.[52] They went even further: on the day of the guild's feast day, when the procession with its candles, bouquets, carved baton, and banner arrived at the church, one of the members, in apostle's or bishop's dress, represented the patron saint of the guild. At Châlons, St. Nicholas in person, accompanied by the three boys he had resuscitated, marched among the bargemen; and a great St. Christopher, carrying the Infant Jesus on his shoulders, led the procession of dock workers.[53]

This extended discussion of the confraternities is not a digression; it is to them, in fact, that we owe a good many of the images of saints that still today decorate our churches.

The trade guilds were as generous as they had been in the thirteenth century, and many works of art survive as evidence. A beautiful window illustrating the life of St. Eligius was given to the church of the Madeleine by the goldsmiths of Troyes. It bears an inscription reflecting both faith and humility: "The goldsmiths, out of devotion to St. Eligius, gave this window in the hope of gaining remission of their sins and complete pardon. . . . May they receive the peace of God in Paradise for this good work" (1506).

In the church of Pont-Audemer (Eure), we may still see the window given by the bakers in 1536, in honor of St. Honoratus, their patron. Charming windows telling the legend of Sts. Crispin and Crispinian decorate a chapel in the churches of Gisors (Eure), Clermont-d'Oise (Oise), and Notre-Dame at Bourg-en-Bresse (Ain): all were given by the shoemakers' guild. In the smallest towns, and even the villages,

there are traces of trade confraternities. At Villeneuve-sur-Yonne (Yonne), the window of St. Nicholas was given by the bargemen who had placed themselves under the protection of the old bishop. At Mergey (Aube), the bargemen of the Seine had chosen as their patron saint St. Julian the Hospitaller, the prodigious ferryman who took Jesus into his boat, and recorded the story of his miraculous life in a window that time has respected. At Créney, in Champagne, the winegrowers gave a window to the church in which their patron saint, St. Vincent, was represented with the pruning hook in his hand.[54]

Many similar works still exist, but in the past there were hundreds more. What has happened, for instance, to the works of art with which the trade guilds decorated the churches of Paris? They have all disappeared. The only record I could find of the window of Sts. Crispin and Crispinian, given by the shoemakers to the church of the Quinze-Vingts, is a poor eighteenth-century engraving.[55]

Towns in the Midi were once enriched by the trade confraternities with many painted or sculptured altarpieces. In 1471, the wool merchants of Marseille had Pierre Villate paint the story of St. Catherine of Siena, their patron saint.[56] In 1520, the carpenters of Marseille commissioned Peson to paint an altarpiece of the most charming naïveté: it shows Joseph building boats in his shop, as if Nazareth had been a seaport like Marseille.[57]

At this same time, the shoemakers of Toulon had Guiramand, an artist famous in Provence, carve the history of Sts. Crispin and Crispinian.[58] In archives we find records of many works of the same kind.[59] Such a rich artistic output is astonishing. There is evidence that all the towns of the Midi—Aix, Toulon, Marseille, and Avignon—had as many magnificent altarpieces in their churches as Siena or Perugia. Nothing remains of these marvels, and the two or three paintings shown in our *Exposition des Primitifs* give us only an idea of them.[60]

This is what the naïve piety of the trade confraternities produced in the south as well as the north of France.

The military confraternities left fewer traces: not that they did not also commission images of their saints from artists, but even when these works survive, they are difficult to identify. Statues of St. Sebastian and of St. Barbara abound in churches and museums, and many of them no doubt decorated the chapels where the archers, crossbowmen, or harquebusiers assembled,[61] but without an inscription or a coat of arms, we are usually reduced to conjecture.

In general, the windows are no more explicit. However, some do state the origin, written out in full. In St.-Nizier, at Troyes, there is a beautiful early sixteenth-century window representing the martyrdom of St. Sebastian: the saint is pierced by the many arrows of the Roman soldiers who wear the costume of the time of Louis XII. And at the

top of the window, we read this brief inscription, addressed to the martyr: "Protect your brother archers!" Thus, the window of St. Sebastian was a gift made by the archers of Troyes to the church of St.-Nizier.[62] Attentive study would no doubt enable us to attribute to the generosity of the military confraternities many of the works of art they had commissioned.

But it is to the religious confraternities that we owe most of the statues, bas-reliefs, and stained glass windows. Clearly each possessed an image of its patron saint, who is sometimes mentioned in the old registers, the *martyrologes* as they were called. At St. Lô, the confraternity of St. John had a statue of its patron saint, John the Baptist, made for the church of Notre-Dame.[63] The confraternity of the Conception, attached to the church of St.-Gervais, in Paris, noted in its records that the society possessed an alabaster image of Our Lady.[64] Sometimes, but too rarely, the registers mention a contract made with an artist: the confraternities of the Charité de St. Ouen, of Pont-Audemer (Eure), commissioned a carved altarpiece,[65] those of Menneval had a stained glass window made.[66] The records of notaries have revealed, and will continue to reveal, many contracts drawn up between religious confraternities and artists. In 1517, the confraternity of St. Claude, at Marseille, asked Peson to paint the life of its patron. In 1526, another confraternity of Marseille commissioned from Jean of Troyes a painted altarpiece showing the life of St. Anthony.[67]

It would be easy to gather more examples. But for what purpose? It would be better, I think, to look for some of the works of art with which these ancient confraternities decorated the churches. They are often quite easy to identify.

The church of St. Martin, in Laigle, has preserved in its south aisle two large sixteenth-century windows [dated 1557] devoted to the legend of St. Porcien. St. Porcien, or St. Pourçain as they say in his native province of Bourbonnais, was a poor slave of the seventh century whose sanctity and miraculous powers astonished the people of his time. When Thierry III marched with his army against Auvergne, the Merovingian chiefs wished to see this extraordinary man, whom they both admired and feared, as if he were a dangerous sorcerer. Thus, the window shows Porcien dressed in a somber Benedictine habit among multicolored warriors, who carry fifes and drums. To express the terror of these long ago days, the artist showed the warriors in Turkish turbans, alluding to that Eastern nation then threatening Europe. But, a curious scene in a lower corner of one of the windows attracts our attention. There is a long procession: a bell-ringer walks at the head, then we see the banner, the cross, and finally the confrères who carry great wax torches on the ends of handles. What is this procession? It is the confrères of St. Porcien, the donors of the window. They wanted to be shown beneath

their patron saint in all the magnificence they displayed on his feast day. The *charité* of St.-Porcien of Laigle (Orne) dated back to 1318; its archives contained a papal Bull; it was rich and generous. But it was not enough to give two windows to the church; when the south aisle was rebuilt, the confraternity contributed money to it.[68] Without this brotherhood, we would not have the pendentives, arabesques, and pretty Renaissance cartouches in which nude infants mingle with fruit and flowers.

In the church of St. James, at Lisieux (Calvados), there is a window dating from 1527 which depicts the famous miracle of the pilgrim (fig. 101).[69] A young man, who was traveling to Compostela, was falsely accused of theft by an innkeeper in Toulouse. Condemned and hanged, he was miraculously saved by St. James who mounted the gallows and supported his body for thirty-six days. This unusual window was donated by a religious confraternity, as indicated by the long procession occupying the lower portion (fig. 101). With what we have learned from the Laigle window, we recognize immediately here the confrères celebrating the feast day of their patron saint. In fact, documents tell us that there was a confraternity of St. James in the church of Lisieux, dating back to the year 14[67].[70] The brotherhood also honored several other saints, as was often the case, but St. James was its principal patron; which is why, from time to time, a confrère would undertake the long journey to Compostela. And thus the subject of the window is explained.

On entering the church of Pont-Audemer, we notice first two rather puzzling windows on the right aisle. They represent scenes in the life of a sainted bishop, to which several strange eucharistic miracles have been added. In the lower section there is a long procession (fig. 102), which begins in the first window and ends in the second. The bell-ringer, the "tintenellier," walks at the head, and seems to set the rhythm of the march with his two bells; then comes the banner decorated with the image of a bishop; the faithful carrying wax torches follow; and last of all, under a square canopy, comes the priest carrying the monstrance. This again has to do with a religious confraternity which, about 1530, decorated with these two beautiful windows of the chapel where it assembled. This *charité* was dedicated to the Holy Sacrament, but it also honored St. Ouen, patron saint of the church of Pont-Audemer (Eure). That is why the windows mingle with the history of the holy bishop several then well-known tales that revealed the virtue of the Host.

Here we have several instances of the confraternities' generosity. In all the examples cited, the works speak for themselves; but for the most part they are mute and only through lucky archival finds can we render the confraternities their due.

101. Miracle of St. James. Lisieux (Calvados), Church of St. James. Stained glass window (destroyed 1944).

Religious Art Expresses New 167
Feelings: New Aspects of the
Cult of Saints

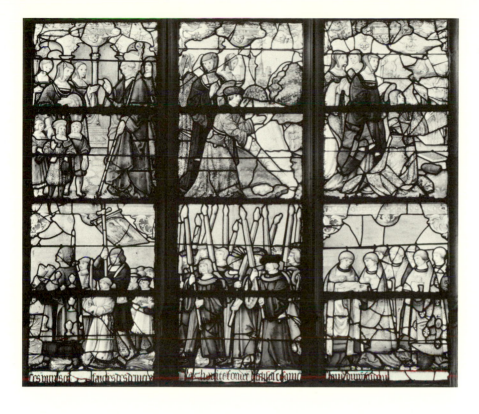

102. Procession of the Confraternity. Pont-
Audemer (Eure), Church of St.-Ouen.
Stained glass window given by the
"Charity of the Holy Sacrament" (detail).

On the right portal of the church of St.-Vulfran, in Abbeville (Somme),
two female statues, facing each other, have all the youthful charm of
early sixteenth-century French art. They represent two ordinary nurse-
maids surrounded by their charges. Once familiar with contemporary
iconographical themes, we quickly recognize the two Marys, sisters of
the Virgin and daughters of St. Anne. A fortunately rediscovered doc-
ument tells us that one of the confraternities of St. Vulfran paid the
sculptor Pierre Loeureux for the statues in 1502.[71]

At St.-Michel of Vaucelles, in the suburbs of Caen (Calvados), there
are several images of saints painted in medallions on the vault of the
choir. They are a somewhat disparate collection: John the Baptist is
placed alongside Sts. Christopher, Mathurin, Martin, Anne, and several
others. The statutes of a confraternity, preserved by chance, enable us
to explain this unusual assembly of saints. They were the patrons of an
ancient *charité* that met in the church of Vaucelles; and in the sixteenth
century, the confraternity had paintings made of the protectors it had
honored in this church for more than a hundred years.[72]

Sometimes the documents are so vague that we can assign such and
such a work of art to a confraternity only by conjecture, but there are
cases when such conjectures seem to be borne out.

In the church of Bourg-Achard (Eure), panels of wood, carved in
the fifteenth century and representing the life of St. Eustace, have been

preserved. Now if we consult the list of Norman *charités* drawn up by Veuclin, we learn that in the fifteenth century there was a confraternity at Bourg-Achard whose patron saint was St. Eustace.[73] It would seem only natural to credit this work of art to the generosity of the confraternity.

In the late fifteenth century there was a *charité* of St. Martin at Nonancourt (Eure). We would be right, I think, even though the documents are silent, to suppose that it presented to the church the window of St. Martin still to be seen there.

How many problems would be quickly solved if only we had a list of all the confraternities once sheltered by our churches! But we can never hope to arrive at such complete knowledge. Many confraternities have no doubt disappeared without a trace; but it is also certain that a great many as yet unnoted, can still be discovered. The advantage would be considerable, for whenever there is a window bearing no donor's name or image, there are grounds for supposing that it was given by a confraternity. Thus, the reason determining the choice of subject for the window, usually mysterious, would become clear.

Also the true meaning of the many isolated statues of saints would be better understood. They would appear even more beautiful, if their history were known, because they would seem more moving. In our museums, the art lover walks around them approving this drapery fold, that pretty line. But this way, our young saints lose their principal means of affecting us. They are beautiful, most of all, for having been so greatly loved. I confess that the St. Martha in the church of the Madeleine, in Troyes, remarkable as she is, seemed even more beautiful to me when I learned that she had been given to the church by a confraternity of servants.[74] It was to her that their prayers had been addressed for so many years at morning Mass—prayers less magnificent, no doubt, but equal in feeling to that written for the perfect servant by the poet: "Nous nous attachons au foyer, à l'arbre, au puits, au chien de la cour, et le foyer, l'arbre, le puits, le chien nous sont enlevés, quand il plaît à nos maîtres ... Mon Dieu, faites-moi la grâce de trouver la servitude douce et de l'accepter sans murmure, comme la condition que vous avez imposée à tous en nous envoyant dans ce monde." (We become attached to the hearth, the tree, the well, the dog in the courtyard; and the hearth, the tree, the well, the dog are taken from us when it pleases our masters ... God, grant me the grace to find my servitude sweet and to accept it without murmur, as the condition You have imposed on all when You sent us into this world.)[75]

It was not enough for the confraternities to have chapels built,[76] and to commission windows, paintings, and statues from artists; from time to time we find that a beautiful candelabra,[77] an altar ornament,[78] a pax,[79] an enamel,[80] a carved alms box,[81] an illuminated manuscript[82] had

belonged to confraternities. Thus, we have scarcely begun to glimpse the manifold influences exercised by the confraternities over the arts of the late Middle Ages. But there is one that so far no one has pointed out.

In organizing processions, *tableaux vivants*, and dramatic representations, the confraternities constantly provided models to be followed by artists. There was a confraternity at Vire (Calvados) whose duty it was to escort the monstrance on the day of the procession of Corpus Christi: twelve brothers followed the canopy, dressed in the traditional costume of the apostles, with bare feet and carrying the instruments of their martyrdom.[83] There was a similar confraternity at Châlons-sur-Marne (Marne). The confrères of Châlons, proud of playing so fine a rôle, wished to leave a lasting memory of the procession of the Holy Sacrament. So they gave a window divided into several sections to the church of St.-Alpin.[84] In the upper part are two eucharistic scenes: the rain of manna and the Last Supper of Christ. Below, twelve confrères, after taking communion from a priest just as the twelve apostles took communion from the hand of Christ, were shown walking behind the canopy, wearing the consecrated costumes and attributes.[85]

There can be little doubt that a confrère, in the rôle of a saint, sometimes served as a model for artists. We recall that the dockers of Châlons, on the feast day of their trade, had one of their members enact St. Christopher. Now, it is precisely at Châlons, in the church of St.-Loup, that we find an extraordinary statue of St. Christopher (fig. 103). The saint is a magnificent docker wearing his Sunday clothes: the sixteenth-century low-necked doublet worn over the shirt, and the breeches cut in tiers. Nothing of the traditional is left in this figure: it is the simple image of a workman dressed in his best clothes. I do not know if this statue of St. Christopher belonged to the dockers, but we can well imagine that it did.

If we return to the St. Joseph of the carpenters of Verneuil, the young journeyman described above, it seems certain that the artists copied what they saw. And moreover, it is likely that the confrères themselves wanted to have a saint who exactly resembled the person who walked at the head of their procession. No doubt they imposed their own conditions on the artists.

This would explain the increasing picturesqueness of the images of St. James. At the beginning of the thirteenth century, St. James resembled all the other apostles, and if he were distinguished from them at all, it was by a satchel decorated with a shell. But toward the end of the century, he gradually began to be transformed into a pilgrim.[86] In the fourteenth century, his hat was decorated with a shell and he carried the traveler's staff (fig. 104). In the fifteenth century, he became a real pilgrim with a large hat, traveler's cape, and a staff from which hung

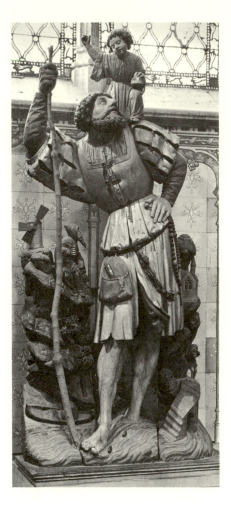

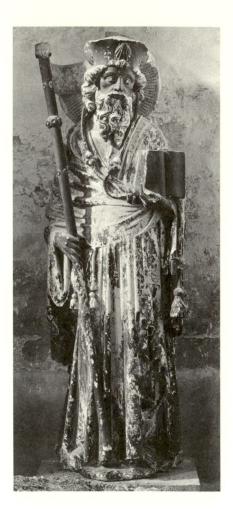

103. St. Christopher. Châlons-sur-Marne
(Marne), Church of St.-Loup.

104. St. James as pilgrim. Toulouse,
Museum. Stone statue from the Chapel of
Rieux.

a drinking horn.[87] This bold metamorphosis can be easily explained. In France there were countless confraternities of St. James whose members undertook the journey to Compostella. In processions, one of the pilgrims represented the saint: on that day he wore the costume that people who had worn it themselves were so proud of:[88] the wide-brimmed hat and the pilgrim's cape decorated with seashells picked up on the shore of Galicia. St. James, the patron saint of pilgrims, was himself transformed into a pilgrim. There is an interesting proof of this. A statue of St. James has been preserved at Notre-Dame, in Verneuil, that once belonged to a confraternity of pilgrims (fig. 105). Before setting out for Spain, the confrère who was making the journey received the pilgrim's hat in formal ceremony. This precisely is the subject of the Verneuil statue. St. James, already prepared for the pilgrimage, is seated on a chair; he rests a little, before the weariness that will come; meanwhile an angel has descended to earth and places a wide-brimmed hat on the saint's head. It is clear that the artist had guilelessly copied what he

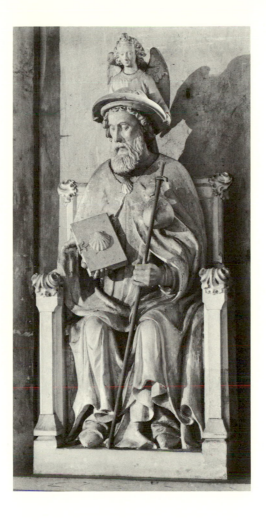

105. St. James with angel placing hat on
head. Verneuil (Eure), Church of Notre-
Dame.

had seen. If it were not for the small angel issuing from the clouds, we
would take St. James for a confrère of the *charité* of Verneuil.[89]

The confraternities did more than personify the saints in their proces-
sions. They represented them in *tableaux vivants*. In the cathedral of
Rouen, "les confrères du jardin" (the confrères of the garden) as they
were called, performed the Assumption of the Virgin on the fifteenth
of August. They transformed their chapel into a garden, and dressed
as apostles, performed the funeral and the miraculous resurrection of
the mother of God. Their "play" attracted such a crowd to the cathedral
that the chapter was aroused. The confrères were urged to give up their
old traditions; they were made to understand that it would be much
more proper to use their money for a window to ornament their chapel.
The window was installed in 1523; unhappily, it has disappeared. The
loss is regrettable for we may suppose that it represented the Assumption
of the Virgin just as it had been performed by the confrères.[90]

Fortunately, other windows exist in which the souvenir of these little

plays can still be found. The confraternities did more than put on *tableaux vivants*; they staged real plays. We know that most of the Mystery plays devoted to the life of a saint were commissioned by the religious confraternities. *La Vie et passion de monseigneur saint Didier* was written for a confraternity of St. Didier at Langres (Haute Marne); Gringoire wrote *La Vie de monseigneur saint Louis* for a confraternity of St. Louis attached to the Chapelle St.-Blaise, in Paris. *Le Mystère de saint Crépin et saint Crépinien* was composed at the request of a confraternity of shoemakers.[91]

The confrères themselves often played the roles of their saint; they thought this to be the best way of honoring their patron, and the most meritorious. At Compiègne, in 1502, the confraternity of St. James of Compostela played the *Miracle de monseigneur saint Jacques*; they invited other pilgrims of St. James, the confrères of Roye, to their celebration.[92] Many confraternities of St. James must have enacted this famous miracle play: several were not content merely to perform it, but wanted to commemorate the production in a stained glass window. In fact, close study of the windows devoted to the miracle of St. James makes it clear that the artists who designed them did not know the story in *The Golden Legend*, but depended on their memory of a recent performance of the play. *The Golden Legend* tells the story of two pilgrims, father and son, whom the innkeeper in Toulouse for some unexplained reason wished to ruin. He hid a silver cup in their baggage, and the next morning accused them of robbing him. They denied the theft in vain, and the judge ruled that one of them must die. After a struggle of generosity between father and son, it was the son who was hanged. But St. James was watching over them, and thirty-six days later, the son was returned to his father, miraculously saved.[93] This was the traditional story, and it was respected all the more because it was presented under the authority of Pope Calixtus.

It must be admitted that the story's substance was a bit thin for a dramatic poet; consequently the legend was somewhat embellished when it was transformed for the theater. An entire family—father, mother, and son—sets out for Compostela. The son is a graceful adolescent whose charm works on everyone he meets. In the inn at Toulouse, the chambermaid has only to catch a glimpse of him and she can think of nothing else. She tells him this frankly, but the young man, knowing the obligations of a pilgrim of St. James, thrusts her away. Her frenzy impels her to commit a crime; during the night she goes into the room where the three travelers are sleeping and slips a silver cup into the young man's bag. Thus presented, the story was not only lifelike, but also was something to interest a spectator.[94]

This is the theme that inspired all our glass painters. At Lisieux (Calvados) (fig. 101), Courville (Eure-et-Loir), Triel (Seine-et-Oise),

Châtillon-sur-Seine (Côte d'Or), Châlons-sur-Marne (Church of Notre-Dame), Vendôme (Loire-et-Cher)[95] and Sully-sur-Loire (Loiret), the servant is seen hiding the silver cup among the young traveler's clothes,[96] and in all of them the mother is shown sleeping beside the father, so all of the artists remembered the play. It is clear that the confraternity suggested their play as a model;[97] it is no less clear that the designers of these windows had seen a representation of the *Miracle de saint Jacques*.

Many other windows commemorate the dramatic plays put on by the confraternities. The windows devoted to Sts. Crispin and Crispinian given to their churches by the shoemakers of Gisors (Eure) and of Clermont d'Oise (Oise) are the proof. The confrères of Gisors and of Clermont certainly knew the *Mystère de saint Crépin et de saint Crépinien*, which the shoemakers of Paris had performed. The artist (the windows of Gisors and Clermont were designed by the same man),[98] had also seen the play. He followed it step by step;[99] the martyrs are first whipped with rods, then flayed, lacerated with awls, and thrown into the river with millstones around their necks. Several typical scenes clearly point to the imitation. A somewhat trivial episode, but one having its place in the drama, was reproduced: a magnificent messenger, with sword at his side and hat on his back, explains to the aged white-bearded emperor that it is impossible to finish off the two prisoners because the vats of boiling oil into which they were plunged had burst, killing all the torturers. The emperor gives orders to get on with it and behead the two saints. Other more significant scenes erase all doubt. In the Clermont window, an old man and a Christian woman bury the remains of the martyrs; then their relics are found, are placed in a reliquary and presented to the veneration of the faithful; the sick come in hordes and are cured. And this is exactly the same ending as in the Mystery play. The entire last day is devoted to the history of the relics.[100]

The window with the Life of St. Denis in the cathedral of Bourges[101] is also an illustration, often quite exact, of the *Mystère de saint Denis*. There are some striking resemblances. For example, *The Golden Legend*, after telling of the conversion of St. Denis, says that he was baptized by St. Paul "with his wife Damaris and all his household." The Mystery play, more precise, had five persons baptized at the same time as Denis: his wife, their two sons, his friend a philosopher, and a blind man who had been miraculously healed. Now the window shows exactly six neophytes kneeling before St. Paul. Farther on, *The Golden Legend* reports that before going to his martyrdom, St. Denis celebrated Mass in prison, in the presence of many of the faithful; suddenly, at the elevation of the Host, Christ appeared in vivid light and gave communion himself to the sainted bishop. The Mystery play presents this miracle, but has as witnesses only the two companions of St. Denis, Rusticus and Eleutherius; such was the tradition followed by the author

of the window. Finally, *The Golden Legend* tells that after his martyrdom, St. Denis took his severed head in his hands and walked away, guided by an angel. In the Mystery play, two angels walk ahead of the saint to guide him as they sing. Two angels appear in the window. Such concurrences could not be the result of chance.

I am convinced that most of the extant windows devoted to saints' legends have the same source. I sense everywhere the influence of the innumerable dramatic representations put on by the confraternities. All this, it is true, can only be surmised; formal proof is for the most part lacking. Take for example a window in the ambulatory of the church of St.-Alpin, at Châlons-sur-Marne (Marne); it is devoted to St. Mary Magdalene and was given by a guild which was probably that of the coopers. It tells of a singular miracle of the saint: when Mary Magdalene debarked at Marseille, all the people were moved by her beauty and her eloquence, but at first she could not convert them. The king asked for a sign. "The queen is sterile," he told her. "Through your prayers, let her conceive." The queen conceived, but the king still did not yet want to give in. "I shall go to Rome," he said, "to listen to Peter; I want to know whether his doctrine is the same as yours." He then embarked, and his wife was imprudent enough to accompany him. The crossing was so stormy that the poor queen gave birth prematurely and died. There was no way to feed the infant on the ship and, weeping, the king left the child with the body of its mother on a reef. He continued his voyage, heard Peter, went on to Jerusalem, and returned after an absence of two years. On its return, the boat passed near the reef and the king gave the order that he should be put down there. The first thing he saw was a small child playing with seashells, who ran away when he approached; then he came to a woman lying on the shore, seemingly asleep; it was the queen who slowly opened her eyes and recognized him. Transported by joy, the king took his wife and child, miraculously returned to him, in his arms, and dedicated himself and all his people to the God proclaimed by Mary Magdalene. Such is the subject of the St.-Alpin window; it dates from the early sixteenth century. Now at this very same time, there was a Mystery play performed that had this miracle as its subject.[102] The drama is fairly flat: a Shakespeare might perhaps have been able to make a charming play from this unlikely subject, something resembling both *The Tempest* and *The Winter's Tale*; but we must not expect so much of our old dramatists. Such as it was, the play had some success, for it was performed in several different places.[103] Is it not likely that the idea of making this the subject of a window had been suggested to the confraternity by a recent production of the play?[104] It could be objected, it is true, that the miracle of Mary Magdalene is told at full length in *The Golden Legend*, and that the artist had only to take it from there. It is often

difficult, in fact, to prove by conclusive arguments that such and such work of art was inspired by a Mystery play, for actual proof is wanting. One can concede, however, that after the examples we have given, probability is on our side.

From the fifteenth century on, artists no longer needed to go to *The Golden Legend*; it came to them.[105] It was no longer read, but it was constantly before people's eyes; every one of its stories was transformed into a play. By this time, we are a long way from the modest readings that were once given in the choirs of churches, and from the hymns that were sung in praise of the saints. In this century, the saints suffered and died before thousands of spectators. Something unheard of! All the legends were brought to life. Nothing to equal this had been seen since the splendid age of Greek tragedy. Saints returned to earth and lived again before men's eyes; for three days, for eight days, their adventures interrupted the life of the cities. How can we imagine that artists would have used other models than these? Their heads would have been full of what they had seen, and they would have done their best to reproduce it. In late fifteenth- and early sixteenth-century windows that recount these legends, we constantly sense the influence of the Mystery plays. In them, the saints move in a world where truth mingles with dream. The costumes are indeed those of the reign of Louis XII or Francis I, but from time to time a detail surprises and disorients us: the tyrants wear strange hats, the queens wear too many pearls in their elaborate coiffures, the knights wear golden armor like none ever worn before. However, the artists invented nothing: they copied what they had seen. One has only to read the descriptions of the costumes for the Mystery performed at Bourges to be convinced. Exquisite works of art grew out of this graceful mixture of reality and poetry. These beautiful sixteenth-century windows, so close to life yet suspended in a dream, make us think not of the Mystery plays (they are far richer in art and true beauty), but of Shakespeare's theater.

Such are the masterpieces born of the Mystery plays. And since it was the confraternities who commissioned most of the dramas devoted to the saints, who preserved them, produced them, and played the roles, we see how much art owes to them; they not only had windows, and statues made, but they also provided models for the artists to work from.

V

Thus, it was the confraternities above all who maintained the cult of the saints during the late Middle Ages. Now it remains to identify the saints most often honored by these confraternities. I refer mainly to the religious confraternities since the trade and military confraternities had

Saints who protect against sudden death. St. Christopher. St. Barbara. Saints who guard against the plague. St. Sebastian. St. Adrian. St. Anthony. St. Roch.

patron saints imposed upon them by ancient traditions.

On visiting the churches of Champagne and Normandy, so rich in fifteenth- and sixteenth-century works of art, it is a surprise to find that there are eight or ten saints whose images constantly recur. There are many others, certainly—local saints or ancient bishops of the diocese— but the same eight or ten always reappear. Exploring other provinces, we meet again these same saints. What determined these choices? Why, for example, were there thousands of statues of St. Barbara in France? This is the problem we must try to solve, and it is one of lively interest for the historian of art.

The Middle Ages looked upon saints in two different ways. They saw them as beautiful models to be imitated, but also as powerful protectors whose favor they sought.

Works of art clearly prove that in the fifteenth century what the faithful sought, above all, from the saints was efficacious protection. Saints were honored in proportion to the powers attributed to them: consequently, a long-forgotten saint might be elevated to the first rank.

What did the Christian ask of these celestial protectors? The healing of his maladies? No doubt; but death was not his greatest fear. To die before reconciling oneself with God was infinitely more to be feared. Sudden death, the death wished for by the Epicureans and that Montaigne found so desirable—this was the great terror of fifteenth-century men. They sought a powerful intercessor in heaven who would protect them, and they found several.

The saints who protected men against sudden death were those honored with a special cult during the last centuries of the Middle Ages.

St. Christopher, although famous already in the fourteenth century, became even more so later on.[106] As we know, it was enough to see his image to be protected from death on that day. In Books of Hours from the later fourteenth century on, St. Christopher was expressly invoked as the saint who guards against sudden death.[107] It was in the course of the fifteenth century, and even in the sixteenth, that the many statues of St. Christopher, of which the most gigantic have disappeared, were erected in our churches.[108] They were placed near the door so that the saint's influence would be shed on everyone, like a mysterious, suddenly impermeating fluid which would then slowly ebb away. In small village churches and poor mountain chapels where the sophisticated art of the cities does not penetrate, we sometimes even today see a crude, half-effaced painting representing St. Christopher:[109] people looked at this strange saint—like a giant from a fairy tale—murmured a prayer and went their way, reassured.

But at the same time, there was a young female saint who also guarded against sudden death. Her graceful bearing and gentle smiling face

inspired confidence and love. She was the most popular of all the sister saints: St. Barbara (fig. 106), the account of whose life, as it was told, was very moving.[110]

This Greek girl of Nicomedia had found nothing in paganism to satisfy her soul; she wrote to the illustrious Origen that she was seeking an unknown God. Moved by her anguish, the great doctor sent Valentine, one of his disciples, who revealed Christianity to her and baptized her. Once she became a Christian, she was invincible: when obliged to offer sacrifice, she preferred to undergo all the tortures and even to die by her father's hand. But this was not the story that charmed the fifteenth century. Many of the people honoring St. Barbara probably knew nothing about her life. What everyone did know was that Barbara had received from God the most precious of favors: through her intercession the Christian was sure of receiving the last sacrament before he died. This remarkable privilege brought her the love of all Christians. The study of collections of prayers leaves no doubt on this point. People asked of St. Barbara not fervent faith nor the strength to endure hardships, but solely the favor of dying only after receiving communion. In

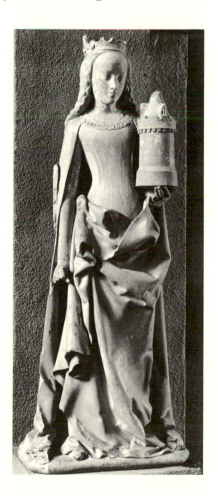

106. St. Barbara. Jaligny (Allier), Church.

a selection of prayers published by Vérard, with the texts taken from more ancient Books of Hours, we read this prayer: "Grant, O Lord, through the intercession of St. Barbara, that before we die we receive the sacrament of the Body and Blood of Our Lord, Jesus Christ."[111] This is why she was often represented (especially in fifteenth-century German prints)[112] carrying a chalice, and why religious confraternities, preoccupied above all with the idea of death, chose her as their patron saint.

With the logic often found in popular creations, St. Barbara was given new powers that were only the natural consequences of her miraculous privilege. Since she kept away sudden death, it followed that she must also protect against lightning. In the Midi, the peasants quickly said her name when they saw lightning flash;[113] the bell, rung at full peal when a storm threatened, was often decorated with her image;[114] and sometimes the high peaks that attracted lightning were dedicated to her.[115] When, "by diabolic suggestion," gunpowder was discovered, it was believed to contain fire from heaven: it had the same irresistible violence, it exploded just as suddenly; often the harquebus exploded in the soldier's hands. Who could protect the artilleryman, the sailor, the sapper, all those who handled lightning, if not the saint who turned away the thunderbolt?[116]

Thus, the power of St. Barbara spread. Let no one be surprised to find her image in so many churches: who did not need her protection?

At the time when the discovery of gunpowder, by multiplying the chances of sudden death, obliged Christians to turn to the protection of St. Barbara, a frightful scourge began to devastate the earth: the plague broke out. After the famous year 1348 when, according to Froissart, "a third part of the world died," France was never again to be free of the plague. Often it seemed to be conquered; the fifteenth century feared it less than the fourteenth, but in the early years of the sixteenth century it reappeared with renewed violence. Most terrible of all, it almost always struck suddenly; people were in good health one evening and dead the next. "The black death" was even more to be feared than sudden death, for people still had time to ask for a priest without being able to have one; they knew that they would soon appear before God burdened with all their sins, and oftentimes there was nothing they could do toward their own salvation.

It is hard to imagine the fear that now and then seized on large towns in the sixteenth century. Life stopped. At Rouen, the streets were empty except for the sinister tumbrel painted black and white. The *serviteurs du danger* went from quarter to quarter, entering the houses marked with a white cross, carrying out the corpses and throwing them into the cart. The inhabitants soon lost the courage even to look at the frightful cortège; a young girl died when she heard it coming. It was

decided to take the plague-stricken away during the night. The cart would climb slowly toward the cemetery of St. Maur by torchlight, with a priest walking ten paces ahead, reciting psalms and sniffing the aroma of pomander. People prayed all night in the dimly lit churches it passed. When the tumbrel arrived at the cemetery where there were neither monuments nor tombs, the attendants, who were sometimes monks hastily threw the corpses into trenches and covered them with so little dirt that wolves often came the following night and disinterred them.[117]

These frightful scenes of horror hanging over the city terrorized the imagination. Since human science was powerless, a heavenly protector had to be found at any cost: and several became the object of popular piety.

It is noteworthy that some of the saints invoked against the plague were invoked also against sudden death.[118] Thus, "the black death" was the form of sudden death most to be feared.

The people prayed first of all to St. Sebastian to turn away epidemics.[119] According to tradition, a contagious disease that devastated Pavia in 680 was brought to an end through his intercession, and fragments of a mosaic made in his honor still remain in the church of S. Pietro in Vincoli in Rome. It has been claimed with great ingenuity since the sixteenth century, that the ravages of the plague had awakened in men's still half-pagan imaginations the memory of the arrows once hurled by the angry gods:[120] St. Sebastian, whom the torturers had been unable to kill although they riddled him with arrows, thus seemed the natural protector of Christians in times of epidemics.[121] This conjecture seems quite likely. The relics of St. Sebastian brought from Rome to Soissons, in 826, spread his fame beyond the Alps. The reliquary of St. Sebastian was the richest treasure of the abbey of St.-Médard, and as early as the ninth century, people came from everywhere to ask the martyr to cure their contagious diseases. Therefore, when the great plagues of the fourteenth century broke out, St. Sebastian was the saint invoked throughout all of France. The consuls of Montpellier ordered that a rope of wax, long enough to encompass the town and its walls, be burnt in his chapel;[122] they thought that this symbolic belt would prevent death from entering.

St. Adrian did not have St. Sebastian's wide reputation.[123] For the most part, he was invoked in the twelfth century against sudden death,[124] and from the fourteenth century on, against the plague, mainly in the northern and eastern regions of France: Flanders, Picardy, Normandy, and Champagne. His relics were preserved in a famous monastery located at the place where the German and the Romance languages met; it was called Grammont in French, Gheraerdsberghe in Flemish. In times of epidemic, pilgrims flocked there. Louis XI, who courted all

the saints whose powers had been established, made sure to go. How had St. Adrian become one of the saints who guarded against the plague? It is somewhat difficult to determine, since nothing in his history points to his future acquisition of this virtue. However, his legend is quite beautiful. Adrian and his wife Natalia were a heroic couple; they were both young, beautiful, passionate; they are Polyeucte and Pauline without the doubts that Corneille gave them. When Natalia learned that her husband had been condemned to death by the emperor Maximian for his belief in Jesus Christ, she was filled with holy joy. She disguised herself as a man, found her way into his prison cell, and respectfully kissed his chains. Then, when the hour of his execution had come and the torturer began to break his thighbones on an anvil, it was she who kept up her husband's courage to the end.[125] These are the essentials of the story as told in *The Golden Legend*; not a word can be found to justify the powers attributed to St. Adrian. It is probable that the attention of the Flemish and Walloons were drawn to him toward the twelfth century by various reputedly miraculous acts. Little by little, his reputation for healing was established; by the late Middle Ages it was beyond all question. The author of the *Mystère de saint Adrien* refers to this tradition, which was clearly of recent origin and must have grown up around the saint's reliquary at Grammont: it was said that before St. Adrian died, he obtained from God the power to protect against sudden death and epidemics all those who prayed to him with faith.[126]

St. Adrian was famous in the north; St. Anthony first became famous in the Midi. The story was that the body of this famous hermit of the Thebaid had long rested in Constantinople, but in 1050, Joscelin, a nobleman from Dauphiné, had received this remarkable relic from the emperor Constantine VIII. He brought the treasure home and placed it in the church of St.-Antoine-de-Viennois, which soon became famous. In 1095, a gentleman was cured of the strange disease then called "the sacred fire" (*le feu sacré*) and later "St. Anthony's fire."[127] He founded a religious order. The Antonines dedicated themselves to the sick and particularly to those devoured by this frightful disease. Thus, it was by a curious chain of circumstances that after his death, St. Anthony, the great contemplative who fled the world during his lifetime, was involved like a good physician with all the miseries of man. People flocked to Dauphiné from all corners of France. When great plagues broke out, pilgrims went there from all parts of Europe to fulfill their vows. Among them were Charles IV, emperor of Germany, and later on, the emperor Sigismond; Gian Galeazzo Visconti, Duke of Milan, founded a Mass in the church of St.-Antoine and sent precious reliquaries. Many of our kings went there, and one can well believe that Louis XI did not fail to pay his respects to a saint who could keep death away.[128] For in the

fourteenth century, the powers of St. Anthony increased: he not only cured erysipelas, but all contagious diseases. However, this helpful saint was also a terrifying one who caused people to tremble when they looked at his images. The tall, aged man who looked so stern, and under whose feet flames burned, was the master of fire. Woe unto the perjurer who had deceived him, woe unto the stout spirit who dared question his power; he reduced them to cinders. Displayed at St.-Antoine-de-Viennois were the calcified bones of those who had offended him.[129] At the time of the Reformation, it was said that he burned three soldiers who had had the audacity to lay hands on his statue; flames were seen issuing from their mouths.[130]

Religious Art Expresses New 181
Feelings: New Aspects of the
Cult of Saints

Sts. Sebastian, Adrian, and Anthony were all three very old saints who had acquired quite late the prerogative of guarding against contagious diseases. But St. Roch was the last-born and greatest of these powerful protectors.[131] He lived in the fourteenth century, at the very time when the great epidemics began. He was a true saint of the kind the French love, a saint who was not a contemplative, but a man of action. He was born at Montpellier which then belonged to the king of Mallorca. When he reached manhood, he undertook a pilgrimage to Rome. He took the old route through Tuscany, the same road followed by the stagecoaches in the nineteenth century, and when he arrived at Acquapendente he found the plague raging there. Instead of fleeing, as another would have done, he stopped and cared for the sick. When the scourge slackened, he was about to set off again for Rome when he learned that the plague had broken out at Cesena: he went there at once. Then, following the path of the epidemic, he went to Rimini and finally to Rome. The holy city at this time was the very image of desolation: bereft of its popes, half empty, silent, ravaged by the plague, it was nothing more than a vast tomb. St. Roch remained there for three years. When he set off for France, the plague had reached northern Italy; he went to meet it. While he was caring for the plague-stricken of Piacenza he himself took the disease that he had braved for four years; he went to hide in a wood and there tranquilly awaited death. Here legend mingles with history, a touching story that the Middle Ages took to its heart. In these sad centuries, when reality was so somber and man so callous, it was an animal who took pity on him: a doe fed Geneviève of Brabant, a dog carried food daily to St. Roch. Thus he was able to stay alive, get well and return to France. No one in Montpellier was willing to recognize this emaciated pilgrim who looked like a beggar; he was suspected of being a spy and was thrown into prison. There he remained for five years. One morning the jailer found him dead, but he saw that the cell was illuminated by a strange light. Thus died the young man of thirty-six, without children, works, or fortune, rejected by his own people, and who in his life had known only how

to devote himself to others. When men heard his story told, they grew thoughtful. The belief was that God had wished to give his servant some recompense in this world. And so it was said that a tablet brought by an angel had been found in his cell; on it was written that this man was a saint, and that God would cure of the plague all those who invoked him in St. Roch's name.

The cult of St. Roch, already widespread in the fourteenth century, covered all of Europe in the fifteenth. In 1414, the bishops who had convened at Constance to try to stop the plague then devastating the city, walked in procession in honor of St. Roch; from that time on, he was invoked in all countries. Confidence in him was so great in Italy that the Venetians stole his relics from Montpellier. To house them, they built the church of S. Rocco, and the famous Scuola, decorated by Tintoretto.[132]

The cult of St. Roch was extremely ardent in France. Beginning with the sixteenth century, the great epidemics gave rise to confraternities of St. Roch in even the smallest villages: in Bourbonnais alone there were one hundred and fourteen parishes in which St. Roch was honored with a special devotion.[133] His power extended even to the animals: on his feast day, 16 August, the herbs were blessed—mint, pennyroyal, and rocket—which, mixed together with the animal feed, preserved them from contagious diseases.

These four saints, Sts. Sebastian, Adrian, Anthony, and Roch, were invoked in turn, in times of danger. In 1420, the town of Nevers offered to St. Anthony a candle weighing a hundred pounds; in 1455, torches were burned in the chapel of St. Sebastian in the cathedral.[134] In 1497, the town of Chalon-sur Saône (Saône-et-Loire), in which the plague had raged for six years, decided to disarm God's wrath by having the *Mystère de saint Sébastien* performed.[135] In 1458, Abbeville (Somme) put on *Le Jeu de monsieur saint Adrien*, and in 1493, *La Vie de monsieur saint Roch*. Following these representations, the spectators often formed religious associations to perpetuate the cults of the saints who protected the city against epidemics.[136] Confraternities dedicated to one, and sometimes several, of these guardian saints abounded.

It can now be easily explained why so many works of art were devoted to these four saints; private citizens and confraternities vied with each other in offering statues, stained glass windows, and alterpieces, not to mention the thousands of small pious images reproduced by engraving that were bought as talismans. An image of St. Sebastian accompanied by a certain prayer was a sure safeguard against the plague for those who always carried it.[137]

The type of the four saints we are here concerned with became fixed in the course of the fifteenth century.

St. Sebastian was represented nude, lashed to a stake, and pierced with arrows. For the artists of the late Middle Ages he was the martyr par excellence. They did not attempt to represent him otherwise; no effort was made to give him a specific character to explain his moral nature; his martyrdom was his reason for being. Moreover, artists were not free to represent him in their own way; the powers of protection assigned to St. Sebastian determined his type. By the arrows that riddled him, people recognized the patron saint of archers and, no doubt, the celestial physician who cured them of the plague.

St. Adrian appeared in the guise of a young knight of the proudest bearing; often he was shown leaning against the anvil of his martyrdom, with a lion crouching near him. Was this mysterious lion the symbol of the hero's strength of soul, or was it only a heraldic animal borrowed from a Flemish coat of arms? Or did it not rather recall that the abbey of Grammont was in Flanders? No one has yet been able to discover the answer.[138]

The image of St. Anthony included many naïve details. In the fifteenth century, one would have looked in vain for the anchorite burnt by the sun of the Thebaid, the emaciated athlete who struggled at night in ancient tombs against the demon. The artists of the Middle Ages represented St. Anthony as a venerable monk of the Order of the Antonines, wearing their habit with capelet, and bearing a gnarled staff and rosary of large beads (fig. 107). He was accompanied by one of the pigs belonging to the monastery of St.-Antoine-de-Viennois which was singularly privileged to let them run loose in the streets of the town.[139]

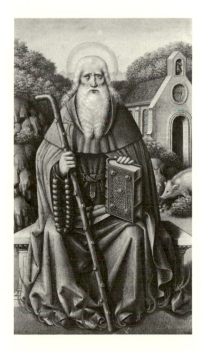

107. St. Anthony. Hours of Anne de Bretagne. Paris, Bibliothèque Nationale, ms. lat. 9474, fol. 193v.

With his full beard and grave air, he might be any superior of the Order if the flames playing beneath his feet did not recall his miraculous power;[140] by this sign the saint is revealed.

St. Roch was a charming figure for the artists. As traveler and hero, he was doubly poetic. From the beginning, it was known that this young man had been handsome. His portrait was preserved at Piacenza: it was said that he had been painted by a gentleman who had been led to virtue by St. Roch's example and who himself became famous under the name of St. Gothard.[141] This portrait of St. Roch still existed in the seventeenth century.[142] It showed a young man of short stature, but with a gentle, gracious face; his hair fell in long curls, and his somewhat reddish beard gave him the look of an apostle; the hands that had cared for so many of the sick were delicate. The portrait may not have been authentic, but it was taken for a faithful likeness. In any case, it is to be noted that the artists usually represented St. Roch in this manner; they almost always gave him the figure of an evangelist. He is represented in this way by the statues in the chapel of St.-Gilles, at Troyes (fig. 108), and at St.-Florentin (Yonne), and in the painting by Jean Bellegambe in the cathedral of Arras. Charity, it was thought, had

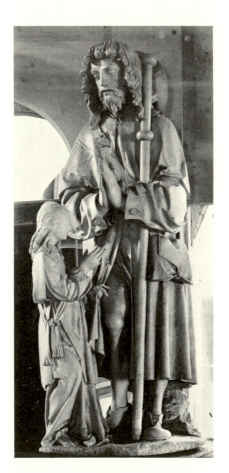

108. St. Roch and the angel. Troyes (Aube), Chapel of St.-Gilles. Stone sculpture (destroyed 1940).

marked his face with such sublimity, and had moulded it to resemble Christ, or at least one of his apostles. St. Roch resembled St. James, and his costume is similar: he wears the hat, the cloak, carries the staff and the scrip, all of which symbolized travel and adventure, storms and burning sun. At Troyes, the two keys engraved on his cloak recall that he had made the journey to the seat of the Prince of Apostles.

Several details, however, prevent us from confusing him with St. James. One of his legs is bare and reveals a wound, which conveys that he also had been a victim of the plague. As an interesting detail, this wound is almost always very deep, as if the arrow that caused it had just been pulled out. Thus, in the popular imagination, the plague was always conceived as an arrow hurled by the hand of God.[143] An angel comes to St. Roch and touches this wound with a light hand, either closing it or gently rubbing it with ointment: this is the angel who, according to legend, was sent by God to heal St. Roch. The faithful dog stands by his side and sometimes with a piece of bread in its mouth.[144]

The works of art devoted to the saints who cured the plague usually have a common characteristic: they are represented as a group. They were thought to be more powerful in relation to God when banded together. However, it is rare to find all four shown at the same time; I have seen them all assembled only once, in a window at St.-Léger-lez-Troyes bearing the date 1525. Usually there were only three: sometimes they were Sts. Anthony, Sebastian, and Roch, as at St.-Riquier (fig. 109); sometimes Sts. Adrian, Sebastian, and Roch, as in the archivolts of the portal of Caudebec or the window of St. André-lez-Troyes; sometimes Sts. Adrian, Sebastian, and Anthony, as on the tomb of Raoul de Lannoy, at Folleville (Somme).[145]

More often still, the protector saints were shown in pairs: St. Sebastian with St. Roch,[146] or St. Roch with St. Anthony.[147]

These are the saints in whom the late Middle Ages placed its confidence, the ones whom the confraternities preferred to honor, and whose images were most often reproduced by the artists. There are few who were prayed to with more fervor: how many generations had they strengthened against the fear of sudden death, the terrible pagan death bereft of all consolation.[148]

However, we must not imagine that the last centuries of the Middle Ages honored the saints only in proportion to the services they might render. It was no more forgotten in the fifteenth than in the thirteenth century that saints were above all models, noble examples, for men to imitate. Ancient saints, dead for centuries, still worked for the moral progress of mankind; their virtue had kept all its magnetic force. These were the thoughts that often guided the confraternities' choice of patron saints.

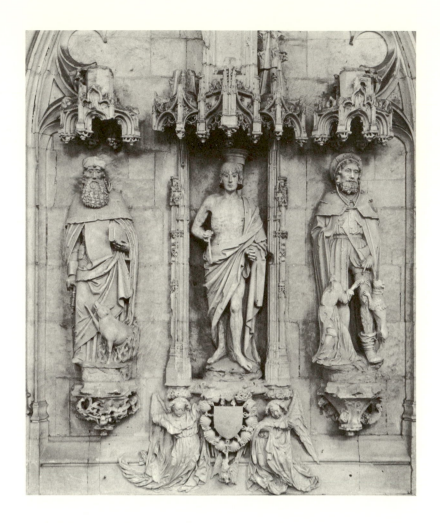

109. Sts. Anthony, Sebastian, and Roch.
St.-Riquier (Somme), Church. Interior,
south transept.

The trade guilds sometimes chose a saint who would be not only a protector, but an example. Sts. Cosmas and Damian, who had practiced their art out of love of God and asked nothing of the sick, were not bad examples for physicians to follow.[149] St. Yves, who had placed his eloquence at the service of the poor, might serve as patron saint for lawyers.[150] St. Eligius, the perfect craftsman, was worthy of adoption by the goldsmiths.[151] It is curious to observe the efforts made by the guilds to relate the saint to the trade he protected. To do so, they created legends. It was impossible, for instance, to explain why St. Honoratus, the bishop of Amiens, had been chosen the patron saint of bakers.[152] They imagined that he had been a baker himself in his youth, and works of art gave credence to this story and made St. Honoratus even dearer to the guild.[153] St. Eligius had been a goldsmith, but history does not tell that he had been a blacksmith. The blacksmiths, however, whose patron he was, wanted above all to claim St. Eligius as one of their number; that is why they so eagerly accepted a famous story carried from village to village by their journeymen. The story was told that St.

Religious Art Expresses New 187
Feelings: New Aspects of the
Cult of Saints

Eligius had once been a renowned blacksmith, but was too proud of his talents. One day a journeyman, making his rounds of France, asked him for work; Eligius in order to test the man's ability, asked him to shoe a horse that had just been brought to him. The newcomer raised the horse's foot, cut it off, shoed it properly on the anvil, and calmly rejoined it to the horse's leg. A master like Eligius was not to be outdone: when the next horse was brought, he himself cut off its foot, but when it was shod, he could not put it back. He was greatly perplexed. The mysterious journeyman smiled, rejoined the foot, and then, transfigured, appeared in his true light. It was Christ himself, come back to earth to remind Eligius that great artists have a duty to be modest, for what is their art in the eyes of him who holds the secret of life? This pretty little tale was often painted. We see it several times in the stained glass windows of Champagne; there is a notable example in one of the windows of the church of Creney (Aube). The naïve desire of the blacksmiths to lay claim to St. Eligius inspired many works of art in which this anecdote figures.

Thus a patron saint was counted on to set, in fact, an example. This expectation is revealed particularly in the choice of saints made by the religious confraternities. As we have said, they were much freer than the corporations of workers to dedicate themselves to any saint who pleased them; they did not have to seek out more or less felicitous likenesses or take account of ancient traditions. Consequently, when they did not dedicate themselves, as they did so often, to the saints who guarded against sudden death or the plague, or when they did not adopt the great miracle worker, St. Nicholas,[154] they chose a saint whose life would serve as an example. Norman *charités* often chose St. Martin as their patron, the young soldier who had given half his cloak to a poor man: it would have been hard to make a better choice. In many churches, there were sisterhoods of young women, and they were almost all under the protection of St. Catherine.[155] Now St. Catherine was a very charming patron for young girls, for she had not only been very good, but according to legend she was also a dazzling beauty. Thus, to be beautiful was a way of imitating St. Catherine; in that confraternity, at least, beauty was taken to be a virtue. St. Catherine also comforted the poor girl whose youth had faded; for she herself, charming as she was, had never desired earthly love; her only desire was to be "a pearl in the crown of Jesus Christ."[156] Consequently, on 25 November, the oldest member of the confraternity offered a beautiful lace veil to the statue of St. Catherine and had the privilege of fastening it on the saint's head; and this was called "coiffing St. Catherine."[157] Many of our pretty fifteenth- and sixteenth-century statues of St. Catherine once belonged to the confraternities; they resemble the young girls of yore who prayed before them.

110. St. Anne and the Virgin. Bordeaux
(Gironde), Cathedral.

111. Education of the Virgin. Hours of
Anne de Bretagne. Paris, Bibliothèque
Nationale, ms. lat. 9474, fol. 197v.

Mothers of families also had their societies; they almost always chose St. Anne as patron saint (fig 110).[158] An ingenious choice. St. Anne, mother of the Virgin, had educated the most perfect of the daughters of men. How had she been able to create this masterpiece, they wondered. By thinking that nothing was beneath her, by not disdaining to teach the abc's to her daughter so that she might meditate on the word of God. Thus was born one of those subjects so dear to the artists of the late Middle Ages, the Education of the Virgin. The child points with her finger to the letter she is spelling out in the book held by St. Anne. No one has exceeded Bourdichon in endowing this group with nobility (fig. 111). Dressed severely and according to the custom of aging women in the time of Louis XII, St. Anne is seated on a throne; she is the incarnation of the majesty of the family; the young Virgin, modest, attentive, and serious, seems the very image of docility. There is no doubt that the mothers of families contributed a great deal toward the spread of these images. In the seventeenth century, religious associations of mothers of families still existed: the engravings made for these confraternities always represented St. Anne educating the Virgin.[159]

As we have seen, certain saints were the object of a special worship. But no matter how fervent such veneration might be, it did not compare with the love inspired by the Virgin herself.

Here we come to the very heart of our subject. The Virgin we are going to discuss is not the mother who holds the Child on her lap, or who faints at the foot of the cross; this Virgin is "the Queen of Heaven," who sits above all the saints. She is above history and time, but even from the depths of her blessed eternity she does not cease to love mankind. The idea of the Virgin of heaven who protects and saves, whose pure beauty attracts and sustains humanity, was one that the Middle Ages had brooded over for centuries.

First of all, she was accorded power. All the specific powers scattered among the saints were united in her; she is so close to God that he refuses her nothing; all his graces pass through her.

The liturgy often expressed these ideas to which late medieval art, with winning naïveté, tried to give form.

A famous prayer, the prayer of the fifteen joys of Our Lady, celebrated her gentle influence, and called her "the fountain of all our blessings." Indeed, one sixteenth-century window showed her in fact at the top of a triple-basined fountain, whose sparkling water caused an orchard to flower.[160]

In the Masses of the Virgin, an antiphon was recited in which she was invoked as the universal protectress: "Holy Mary," it said, "save the poor, strengthen the weak, comfort those who weep, pray for the people, protect the clergy, intercede for women."[161] This vast invocation which placed all of humanity under the protection of the Virgin, was also given an artistic form. The windows in the choir of the church of Notre-Dame de la Couture, at Bernay (Eure), were decorated with large panes representing the complete antiphon to the Virgin. She appears in the center, crowned by the Father and by the Son; she could be taken for the third person of the Trinity. To her left and right the world kneels: we see the Christian peoples, the hierarchy of the clergy—pope, cardinals, bishops, monks. There are those who weep and, last of all, those who have nothing here below except their scrip and beggar's bowl. With clasped hands, all lift their eyes toward the omnipotent one.[162] In the church of Conches, a somewhat later window represents an analogous scene with the words of the antiphon inscribed in explanation near the figures.

The weakness of such a motif was perhaps that it was not striking enough; to be fully understood, it required an inscription. Consequently, to this liturgical theme the artists preferred a much clearer image. There are quite a number of paintings and bas-reliefs, in the fifteenth century,

that represent the Virgin sheltering the faithful under her mantle; in old documents, this was called "Our Lady of Consolation."[163] The simplest minds could understand at a glance this maternal gesture. In this beautiful composition, of magnificent breadth, in which the Virgin seems to open to the world the great wings of the woman of the Apocalypse, trust and love found their best expression (fig. 112).[164] It would seem to have come from the visionary soul of a monk. In the early years of the thirteenth century, a Cistercian monk told his abbot that he had experienced an ecstatic vision in which he had seen the entire triumphant church in paradise: the prophets and apostles, and after them, the numberless throng of monks. All were there except the monks of Cîteaux. Greatly troubled, he dared speak to the Mother of God and ask her why there were no Cistercians in heaven. Then the Virgin opened her arms and revealed the monks of Cîteaux hidden in the folds of her vast cloak; she kept them there because she loved them more than the others.[165]

The Order gave fitting welcome to this revelation. In the fourteenth century, the seals of the Cistercian abbots were decorated with the image of the Virgin opening her cloak to reveal the monks kneeling at her feet.[166] It was probably through the monasteries of the Order of Cîteaux that this new motif spread throughout the Christian world.[167]

The legend seemed so beautiful that other Orders tried to take it away from the Cistercians. The Dominicans wanted people to believe that St. Dominic himself had had the vision. Works of art consecrated this new tradition, and by the end of the fifteenth century, the Cistercians thought it necessary to remind people of their proprietary right to it.[168]

But the image of the Virgin of Mercy became really interesting only when the image was taken from both the Cistercians and the Dominicans for the benefit of Christianity as a whole. Thenceforth it expressed not the somewhat egotistical dream of a single Order, but the hope of all the faithful.

It is impossible to say precisely when and in what country the monks kneeling beneath the Virgin's mantle were displaced by the Church Militant with its double hierarchy, one headed by the pope and the other by the emperor; too many of the works have been lost. It is certain, however, that by the beginning of the fifteenth century the metamorphosis had been accomplished.[169] This beautiful image, elaborated during two centuries, ended by expressing with wonderful clarity the trust of all men in the auxiliary power of the Virgin.

But there were cases in which the image of "The Virgin of Mercy" had a particular meaning. What the faithful often sought beneath the mantle of the Virgin was protection against the most terrible of all scourges, the plague. A study of the famous painting in the museum of Le Puy, for example, shows several saints ranged above the protecting

112. Virgin of Mercy. Chantilly, Musée Condé. Panel by Enguerrand Charonton and Pierre Villate.

mantle of the Virgin, among whom we can distinguish St. Sebastian and probably St. Roch.[170] After what we have said about the virtues attributed to these saints during the Middle Ages, there can scarcely be any doubt that the Le Puy painting, done about 1410, recalls the souvenir of one of the great epidemics of the time.

Many of the paintings and bas-reliefs representing the Virgin of Mercy must have been commissioned in fulfillment of vows made in times of plague by confraternities and towns. The examples to be found in Italy are as convincing as we could wish. We know the altarpiece of Montona (1482): the Virgin shelters the town and its inhabitants under her out-spread arms; above her, God hurls his pestilential arrows in vain, for they break against her cloak; Death, who has been approaching the town with the scythe, is forced to flee.[171] Although less typical, French works of art no doubt often expressed the same thought. On reading the *Mass against the Plague* in fifteenth- and sixteenth-century missals, one is struck by finding that the Virgin appears in it as an intercessor between men and "the wrath of God":[172] the liturgy would seem to be recalling the image of the Virgin of Mercy.

Thus, in the fifteenth as in the thirteenth century, the Virgin was always the one who disarmed the wrath of God. Her miracles remained the cherished support and consolation of the faithful. Manuscripts, some of them beautifully illustrated, handed on the story;[173] small woodcuts sometimes refer to it in the margins of Books of Hours.[174] But the odd thing is that great art, remaining faithful to the traditions of the thir-teenth century, did not take up the subject. Until the middle of the sixteenth century, one particular legend served in our churches to express the omnipotence of the Virgin: as in the past, this was the famous miracle of Theophilus.[175] Why was so singular a favor bestowed on this legend? I have said elsewhere that the liturgy had adopted the miracle of Theophilus and that a passage of the Office of the Virgin commem-

orated it. The study of fifteenth- and sixteenth-century missals permits me to affirm that the passage continued to be recited at least until the Council of Trent. Hence, it was not surprising that the canons and the faithful in the time of Francis I continued to have the glass painters represent the ancient legend. The persistent influence of the liturgy can scarcely be doubted when we find that a window devoted to the legend of Theophilus in St. Nizier, at Troyes, bears this still legible inscription: *Theophilum reformans gratiae*—the very same verse recited in the Office of the Virgin.

But there is still another reason for the popularity of the story of Theophilus. This dramatic story, the inner struggle between good and evil symbolized by the Virgin and Satan, was a subject closely akin to the medieval spirit. The authors of Mystery plays had always been tempted by it. It was performed in the thirteenth and fourteenth centuries, just as it was in the sixteenth. A performance was given at Limoges in 1533, another at Le Mans in 1539;[176] the play probably toured all of France. Now it appears that all the windows devoted to the legend of Theophilus date, or seem to date, from 1530 to 1540.[177] Let us add that some of these windows contain an odd detail: to convey the idea that Theophilus is in the clutches of hell, the artists represented him tied by a rope held by the Devil. He is shown thus at Montangon (Aube), and at Le Grand-Andely (Eure). The two windows are too different for us to consider this the practice of a school; they certainly did not come from the same workshop. The only way to explain the likeness is to suppose that Theophilus appeared in the theater tied with a rope and led by Satan. This is more than likely.

So it was that the old legend, which had always been popular, again found a place in the art of the sixteenth century. The most beautiful work it ever inspired is the window at Le Grand-Andely (fig. 113): the Virgin holds at bay the monster with pig's snout and eyes like burning coals; rendered helpless he lets drop the indecipherable piece of writing in Hebrew characters that Theophilus had once signed with his blood.

The Virgin could work miracles like the miracle of Theophilus everywhere; stories testify to them. However, it was mostly in her favorite sanctuaries that she bestowed her graces. The ancient pilgrimages of Le Puy, Chartres, and Notre-Dame of Boulogne always remained popular, but in the early years of the sixteenth century there began to be talk in France about a distant town where the Virgin had revealed her power more often than at any other place in the world. This was Loreto, in the province of Ancona (Marche). Perhaps the soldiers who had fought in the Italian wars were the first to bring back to France the little pilgrim book of Loreto, a copy of which can be seen in the Bibliothèque Nationale.[178] However that may be, the French were already making their way to the Italian sanctuary in 1518.[179] The little

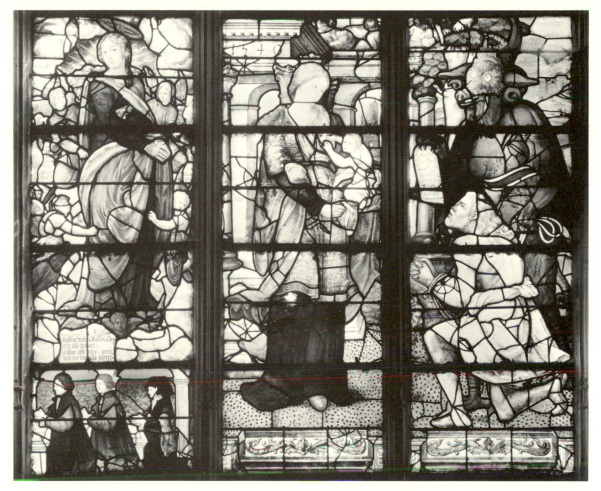

113. Miracle of Theophilus. Les Andelys (Eure), Church of Le Grand-Andely. Stained glass (detail).

book told the traveler of a strange marvel. It said that on 12 May 1291, at the very moment when the Saracens had driven the last Franks from the Holy Land, the angels appeared at Nazareth and carried the house of the Virgin to the West, the holy house in which the Word had been conceived. They first put it down in Dalmatia, and then in Italy in the middle of a forest, at the place later called Loreto. Throngs flocked to see this brick house resting on the ground without foundations. The great influx of people to this deserted spot gave rise to so much armed robbery and violence that the angels picked up the house again and set it down on a neighboring mountain. There two brothers lived who had suddenly gained riches at the expense of the crowds, and their fortune made them even more greedy. They quarrelled and fought so endlessly that the angels carried the house away for the third time. They took it back to Loreto, but this time it was set down near a main road in the place where it can be seen today. Revelations soon made it known to a local inhabitant and holy hermit, named Brother Paul, that this mysterious house was none other than the house of the Virgin.

It now seems well-proved that this legend, which was to become so famous, was created only in 1472, because no trace of it can be found before that date.[180] The story seems to have been made up by Pietro di Giorgio Tolomei, provost of Teramo, clearly in the effort to explain why, when the church of Loreto was rebuilt in the fifteenth century, the little chapel of the Virgin where people had come as pilgrims for centuries, had been so respectfully preserved in the very center of the sanctuary. He then wrote down this history, which found no disbelievers. Why, people thought, would the Virgin not have wanted to console Christians in this way for the loss of the Holy Land? People beyond the Alps were quite ready to accept a story of this kind: there were churches in France also that had been brought by angels;[181] and, moreover, did the beautiful Gothic cathedrals not seem ready to quit this sad earth and take flight to heaven?

Thus, in France, no effort was made to cast doubt on the Virgin, and people wanted to take the Italians at their word. The popularity of the pilgrimage to Loreto in the early sixteenth century explains certain works of art dating from the reigns of Francis I and Henry II.

The most remarkable is certainly the beautiful carved mantelpiece which once decorated a private house in Rouen and is now in the Cluny museum (fig. 114). It clearly recalls a pilgrimage, and the little pilgrim's book we referred to earlier served as a guide for the artist. The two front panels represent the house carried by the angels, flying like a great bird above the sea,[182] and the faithful pressing around the miraculous sanctuary. The lateral bas-reliefs are devoted to the scenes of violence that twice obliged the angels to move the holy house.

114. Legend of the House of Loreto. Paris, Cluny Museum. Relief on stone fireplace, from house in Rouen.

The composition of the beautiful window in St.-Etienne, at Beauvais,[183] which came from the Leprinces's workshop, is very similar. Alongside the pilgrims with their noble gestures and Raphaelesque profiles, who pray to the Virgin in her sanctuary, are shown the brigands falling upon a traveler, men reviling each other, and a corpse with a dagger plunged in its breast. That is why at the top of one of the panels outraged angels are seen once again carrying the house across the skies.

There is an analogous window at Dreux. In the church of the Cordeliers, at Parthenay, a stone altarpiece also tells the story of the *Santa Casa*. Here and there a bas-relief has been preserved (for example, at St.-Menou in Allier) that shows the Virgin seated or standing on her house as it is carried by angels: these are simply imitations of the religious images brought back by the pilgrims from Loreto.[184]

VII

The Middle Ages, however, did not always ask miracles of the Virgin; they could love her with a selfless love. They thought of her as a sublime idea in which the spirit and heart discovered new and endless marvels. Her purity above all was the perpetual subject of the hermit's colloquies with himself. Woman in her fallen state, fragile and dangerous, appeared in this celestial model as perfect and spotless, and worthy of an infinite love. The monk who had fled from women found the Virgin in his monastery.[185]

In the late Middle Ages, it was the religious Orders that contributed most toward the exaltation of the Virgin. The thousands upon thousands of pieces of prose, the hymns, and the little poems in honor of the Virgin, now being collected, were for the most part written by monks.[186] Each monastery had its poet, just as it had its Angelus. Many of these works, to be sure, were written according to formula, but we can distinguish in some of them the ethereal conception of the universe characteristic of the cloisters of the time. They reflected a world spiritualized by the habit of contemplation, in which reality flickered, grew dim, and dissolved in prayer. The perfumes given off by the flowers were virtues: modesty, charity, self-forgetfulness. Always thinking about the Virgin, the monks saw her everywhere: the beautiful spring flowing in the cloister was her purity, and the high mountain against the horizon was her greatness. She was springtime, wreathed in flowers making a garland of virtues.[187] When the monk left his cell, all the surrounding magnificence seeemed to him like pale reflections of the beauty he saw in the Virgin: she was the wheat field producing the bread of eternity, the rainbow illuminated by a ray of evening light from God,[188] she was the star from which the drop of dew fell on our inner aridity.[189] But morning, when the dawn whitened the window of his cell, was the

The Cult of the Virgin. The hymns. Suso. The Rosary. The Immaculate Conception. The painting by Jean Bellegambe. The Virgin surrounded by the symbols of the litany. Origin of this image. The Tree of Jesse. The Cult of St. Anne. The family of St. Anne.

time when the monk thought of her the most. He watched: the sky grew red, and nature quivered. Then came the dawn: it announced the approach of the sun, just as in this world the Virgin had preceded the Eternal Light.[190]

The clearest commentary of all on these hymns to the Virgin is to be found in the Life of Suso where, in a way, we see them in action. The young monk who throughout his childhood had contemplated the Lake of Constance and the white profile of the Alps, was a fine poet all his life; he always mingled nature with his outburst of praise to the Virgin.

He is in his monastery, and the watchman has just called the hour of dawn: "The servant,"[191] he said, "opened his eyes, fell on his knees, and greeted the morning star just rising, the gentle Queen of heaven; for, like the birds, he must greet the one who brings the light of eternal day. And while the morning star was rising, a voice within him sang these words, in a sweet and gentle mode: 'Mary, star of the sea, has risen today.' "[192]

"In his youth, when he saw the approach of spring and the flowers beginning to open, he did not pluck them at first. But when the time seemed right, gathering the flowers with a thousand pleasant thoughts, he brought them to his cell, and wove them into a crown. Then he went to the chapel and crowned the statue of Mary with this lovely coronet. Since she was the most beautiful of all flowers and, in some way, the springtime of his own young heart, he thought she would not refuse these first flowers offered by her servant."[193]

The Virgin rewarded him with ecstatic visions which brought him to the very threshold of eternal happiness: "Once, in the month of May, he had devoutly offered the crown of roses to the Queen of Heaven, according to his custom. That morning he wished to lie down to rest and sleep, for he had come back from the fields very tired. . . . But when the hour came for him to rise, he seemed to be in the midst of a heavenly concert which was singing the Magnificat; when it was over, the Virgin came toward him and told him to sing this verse: 'O vernalis rosula,' 'O young rose of spring.' He obeyed joyfully, and soon three or four angels who had been part of the heavenly choir joined him. Their voices were more beautiful and ravishing than all the musical instruments combined. Unable to endure such happiness, the servant came back to himself."[194]

This chaste poetry intoxicated the last centuries of the Middle Ages. In the religious Orders, the cult of the Virgin grew more and more impassioned. The crown of roses offered by Suso became, in the fifteenth century, the symbolic crown of the prayers of the rosary.[195] We know that in the Middle Ages the vassal, as a sign of devotion, offered to his lord a chaplet of roses;[196] the rosary was the homage of the faithful

given to the Queen of Heaven. It was in 1470, following a vision, that the Dominican Alain de la Roche imagined this chivalric symbol.[197] The rosary is composed of roses of three different colors: the white symbolize the joyful mysteries of the life of the Virgin, the red the sorrowful mysteries, and the gold the glorious mysteries. In the space of five years, Alain de la Roche had extended the new devotion throughout France, Flanders, and the provinces along the Rhine. And let it not be thought that only the monasteries adopted it; laymen enrolled en masse in the confraternities of the rosary; the confrères who numbered six thousand in the region of Cologne in 1475 increased to more than a hundred thousand a few years later.

Led by the religious Orders, these laymen soon celebrated the Virgin with as much fervor as the monks. It was in the fifteenth and sixteenth centuries that societies for devotional poetry were formed, the *puys* or *palinods* of Rouen, Amiens, Abbeville, Caen, Dieppe, whose sole function was to praise the virtues of the Virgin.[198]

This was not all: toward the end of the fifteenth century, a mysterious idea that had been secretly germinating in man's soul for more than five hundred years, suddenly blossomed. It now seemed clear to theologians that the Virgin could not have partaken of original sin, being especially exempted from the law by divine decree. Mary, the perfect model of newly created humanity, like Eve at the time she was created by the hands of God, had come into the world free of the burden of sin.

The dogma of the Immaculate Conception was an ancient idea that already had followers in England and Normandy as early as the eleventh century.[199] In this case, legend approaches history. The story was told that a canon, sent as ambassador to Denmark by William the Conqueror, was overtaken at sea by a violent tempest. At the height of the danger, the Virgin appeared to him: with a word she calmed the storm but demanded in return that the canon have a new feast celebrated each year in her honor, the Feast of the Conception. This legend was dear to the Normans, and for a long time there was a window depicting the story in the church of St.-Jean, in Rouen.[200] In the sixteenth century, the current opinion was that the Feast of the Conception had first been celebrated in Normandy and England, at the order of William the Conqueror,[201] a tradition that was not far from the truth, as we see.

In 1140, the mystical town of Lyon accepted both the idea and the feast of the Immaculate Conception. St. Bernard, and other famous theologians after him, in vain condemned a belief they thought dangerous; the dogma was developed slowly.

On leafing through manuscripts and incunabula of the fifteenth century, one becomes aware of how many books were written at this time on a subject of such great concern to the Church. Certain of these books

are collections of images whose purpose was to make the idea comprehensible even to the humblest minds. We cannot imagine anything stranger than the *Defensorium inviolatum beatae Mariae Virginis*,[202] which, taking examples from natural history, seeks to prove that a virgin can give birth and that she can, at the same time, be free from blemish. A print shows birds coming out of an egg while the sun shines in the sky: "If the sun can incubate and hatch the eggs of an ostrich," says the text, "why cannot the sun of justice cause a Virgin to bring forth a child?" Another illustration depicts a flower: "If the flower called *tylé* never fades, why cannot the Virgin have been sheltered from all sin?" Thus, all the marvels of the universe were only figures of the supreme mystery, the purity of the Virgin.

But theologians needed other arguments. We find them collected in other works, all of which date from the late fifteenth or early sixteenth centuries.[203] The most clearly organized is that published by canon Clichtove in 1513, under the title *De puritate conceptionis beatae Mariae Virginis*. The necessity of the Immaculate Conception is established by dogma, and in addition, by testimonials of the Church Fathers and doctors.

This doctrine, supported by the Synod of Basel in 1439, approved by Pope Sixtus IV in 1476,[204] and accepted as dogma by the Sorbonne in 1496,[205] would inevitably have found its expression in art. Christian art of the times expressed all aspects of Christian thought too faithfully for it not to accept an idea of deepest concern to so many souls.

A very unusual work, unfortunately damaged, summarizes visually with rare success the long work of the theological schools: it is the triptych by Jean Bellegambe, of which only two wings survive in the museum of Douai. The story of its origin is poignant. In 1521, a young girl from Douai, Marguerite Pottier, fell gravely ill on the eve of her marriage; she very soon became aware that there was no hope for her. She had always had a special devotion for the Conception of the Virgin; so she entreated her father to give to the parish church in her memory a painting representing this mystery.

Jean Bellegambe was commissioned to realize the wish of the dead girl. Such an undertaking went far beyond the theological knowledge of the modest artist. No doubt, he consulted a learned canon among his friends who helped him to conceive the composition of his triptych. The Virgin must certainly have occupied the central panel. A sort of ecumenical council composed of the most illustrious doctors of the Church filled the two wings, representing theology meditating on the Virgin. First we see the Church Fathers, Sts. Augustine, Ambrose, and Jerome; each seems to be uttering a phrase taken from his own works, and each of these phrases testify to belief in the Immaculate Conception. Next comes the most sober assembly in Christendom, the University

of Paris. It too speaks through the mouths of its great teachers, Peter Lombard, Bonaventura, and Duns Scotus: all bow before the mystery of an immaculate Virgin. Finally, there is the pope himself, Sixtus IV, seated on a marble throne, and overhead can be read these lines from his third constitution on the Immaculate Conception: *Mater Dei, Virgo gloriosa, a peccato originali semper fuit preservata.* As we see, the work is grandly conceived: like the fresco by Raphael, it is a disputation of the subject of the Virgin.[206]

After reading the treatises devoted to the Immaculate Conception, and especially the one by Clichtove, one is bound to note the extraordinary likeness between these books and Bellegambe's painting. In Clichtove's work in particular, the great testimonials invoked along with those of the Church Fathers, are precisely those of the University of Paris and of Pope Sixtus IV.[207] The triptych by Bellegambe was thus conceived by a theologian fully conversant with the new doctrine and who knew all the arguments by heart.[208] From this comes our particular interest in this work of art: it summarizes several centuries of controversy, and expresses the spirit of Christianity at the very moment the Reformation broke out.

Bellegambe's painting remained an isolated example in France;[209] to become popular, the idea had to be expressed in simpler terms.

The task was difficult. How was one to represent the Virgin as a pure concept? How convey her creation without sin, by God's decree, her existence in his thought before the creation of time?

From the fifteenth century on, artists tried to resolve the problem. They first thought of the woman spoken of so mysteriously in the Apocalypse. She has the moon beneath her feet, stars on her head, and the sun envelops her; she seems older than time, no doubt conceived before the universe. Such an image would express all that was awe-inspiring in the concept of a Virgin created before humanity and free of the laws governing it.[210]

In the fifteenth century, in fact, we find manuscripts containing a half-length figure of the Virgin who seems to rise out of a crescent moon and to shine like the sun.[211] Prints popularized this motif.[212] Beneath one of these images surrounded by the crown of the rosary are these words:

Concepta sine peccato.

(Conceived without sin.)[213]

So there can be no doubt that the Virgin of the crescent moon was the first symbolic representation of the Immaculate Conception.

A similar image that Albrecht Dürer himself seemed to find beautiful and expressive[214] did not fully satisfy French artists: they sought and found something different.

In the early years of the sixteenth century, a most poetic figure of the Virgin appeared in France (fig. 115). She is a young girl, almost a child; her long hair covers her shoulders. Her gesture is the same that Michelangelo gave to his Eve when life was breathed into her: she clasps her hands in adoration. This young Virgin seems to be suspended between heaven and earth. She floats like an unexpressed thought, for she is still only an idea in the divine mind. God appears above her, and seeing her so pure, pronounces the words of the Song of Songs: *Tota pulchra es, amica mea, et macula non est in te* (Thou are all fair, O my love, and there is not a spot in thee). And to express the beauty and purity of the betrothed chosen by God, the artist chose the most pleasing metaphors of the Bible: around her he placed the closed garden, the tower of David, the fountain, the lily of the valleys, the star, the rose, the spotless mirror. Thus, everything in the world admired by man is only a reflection of the Virgin's beauty.

115. Virgin with the emblems of the litanies. Hours for use of Rome. Paris, Thielman Kerver, December 17, 1505. Paris, Bibliothèque Nationale, Vélins 1509, fol. K8v.

Such an image is very complex; it had been developed by a long process which it will be interesting to analyze.

Already, and for several centuries, medieval doctors of theology had identified the Virgin with the Shulamite of the Song of Songs. This ancient love poem, as burning and feverish as Syria and permeated with all perfumes, had become for the commentators as virginal as Alpine peaks. The beloved "whose fingers dropped sweet-smelling myrrh upon

the handles of the lock," and whose garment had "the scent of Lebanon," is the Virgin Mary, the Mother of the Saviour.

One of the most mystical books of the fifteenth century, *The Song of Songs* (*Le Cantique des Cantiques*), illustrated with woodcuts, had made these similes almost popular.[215] Nothing purer could be imagined. The fiancé is God himself, conceived as an innocent adolescent, and the betrothed is the Virgin, slender and immaterial as a spirit. The most passionate words were translated into the language of the soul. The contrast is sometimes so strong, so unexpected, that it has the force of a great poet's lyrical outburst. The text says, "A bundle of myrrh is my beloved unto me; he shall lie all night betwixt my breasts." What does the engraving represent? The Virgin stands and clasps her crucified son against her breast (fig. 116). Such a book resembles the poems written by the monks in honor of the Virgin; to use St. Francis's words, it is as pure as water.

By the early sixteenth century, then, it was well established that the Virgin was the fiancée of the Song of Songs, and as we see, art itself had already made use of this theological concept (fig. 117). The sixteenth-century artist who created the image whose origins we seek was thus guided by tradition.[216]

The idea of arranging the biblical symbols around the Virgin was not an innovation either. The liturgists had for a long time been choosing the most beautiful metaphors from the Bible to embellish the Offices of the Virgin. As early as the thirteenth century, the Virgin was called the "star of the sea," "the closed garden," "the rose without thorns."[217] All these beautiful biblical phrases were like so many precious stones. They had only to be assembled to make the richest necklace, the most magnificent crown:

> *Botrus, uva, favus, hortus,*
> *Thalamus, triclinum.*
> *Arca, navis, aura, portus,*
> *Luna, lampas, atrium.*

Thus sang the Missal of Evreux.[218] What sweeter music could there be? Entire columns of epithets are found in all the missals: flowers, perfumes, precious metals, colors, honeycombs, all that is most delightful in nature. The most sensitive poets of our time are not more aware of the enchantment of words. The litanies of the Virgin, which in their present form appeared only in 1576, thus had their origins in the remote past.[219] Perhaps these beautiful words were repeated not so much to ask divine aid as to comfort the heart;[220] each golden word was food for dreams.[221]

It had surely required great ingenuity to embody these metaphors, to design them, and to arrange them around the betrothed of the Song of Songs.[222]

116. Virgin carrying Crucified Christ.
Blockbook of the *Song of Songs*. London,
British Library, 1B.46, fol. XIIr. XV c.

Where did this complex image first appear? The earliest known example is found in the *Heures à l'usage de Rouen*, printed in Paris in 1503 by Antoine Vérard.[223] This same engraving was reproduced in 1505 in Thielman Kerver's *Heures de la Vierge à l'usage de Rome*, and soon in other prayer books, and seems to have inspired all the sixteenth-century representations of the Immaculate Conception. Not one can be assigned with any assurance to a date before 1503. Manuscript illumination, which usually inspired the engravers, are all more recent; but again, all the stained glass windows and reliefs devoted to this subject were, or seem to have been, done after 1503.

Thus we must admit, until there is proof to the contrary, that the engraving in a Book of Hours made this new motif known all over France. This would not have been impossible: we will show in later chapters that engravings in Books of Hours explain the vogue of the Sybils and of certain figures of the Virtues.

Vérard's artist surrounded the Virgin with fifteen emblems resembling heraldic figures (fig. 115). At the right of the Virgin we read: *Electa ut sol,—pulchra ut luna,—porta coeli,—plantatio rosae,—exaltata cedrus, virga Jesse floruit,—puteus aquarum viventium,—hortus conclusus.* At her left is written: *Stella maris,—lilium inter spinas,—oliva speciosa,—turris David,—speculum sine macula,—fons hortorum,—civitas Dei.* All these metaphors, borrowed for the most part from the Song of Songs, had long been enshrined in sequences honoring the Virgin.[224] The artist made a selection and thus composed a new sequence.

Such an image no doubt answered the innermost feelings of Christians, for it was soon repeated ad infinitum. Five years after it appeared,

117. Virgin in aureole. Blockbook of the
Song of Songs. London, British Library,
1B.46, fol. 1v. XV c.

it was taken up in Champagne: in 1510, a window at Villy-le-Maréchal (Aube) reproduced it faithfully. In 1513, the sculptor Des Aubeaux carved it in the chapel of the church of Gisors (Eure);[225] in 1521, it appeared in a window of St.-Alpin, at Châlons-sur-Marne (Marne), and in 1525, in a window at St. Florentin (Yonne): after that, it was to be seen everywhere. It decorated tapestries,[226] and stalls;[227] it appeared in frescoes,[228] and bas-reliefs.[229] There is no point in citing every one of these works;[230] the interesting thing is that they are all much alike and clearly derived from a common source. Almost always, the emblems are arranged as in the engraving of Vérard's Hours. However, we do find variants here and there: a sculptured panel at Bayeux (Calvados) (from a fairly late period) adds several new symbols to the already consecrated ones, which inscriptions call *scala Jacob, hortus: voluptatis, fons gratiarum*; a painted panel from Arras names *flos campi, nardus odoris, stella non erratica*; and on a stained glass window at La Ferté-Bernard (Sarthe), *fenestra coeli* is written near a small window designed in the style of the Renaissance.[231] There is nothing extraordinary about this. If we go back to the missals of the sixteenth century and read through some of the many sequences written in honor of the Virgin, we find almost all these metaphors. For example, the expression *fenestra*, applied to the Virgin, is found in the Missal of Evreux and the Missal of Bayeux; the metaphor *nardus odoris* or *odorifera* appears frequently.[232] From these examples it becomes clear that the image of the Virgin surrounded by symbols was actually inspired by the liturgical sequences.

The place assigned to this image of the Virgin in works of art is also worthy of our attention. A stained glass window in the church of St.-

Alpin, at Châlons-sur-Marne, is devoted to the life of the Virgin and begins with this mystical figure. Now the curious thing is that the next panel represents St. Anne on her bed and the birth of the Virgin. So there is no possible doubt: the first panel shows the Virgin *before her birth*, as pure concept. At the same time, this solidly confirms the interpretation we have given to the Virgin surrounded by biblical symbols: it does in fact represent the Immaculate Conception. Excellent sixteenth-century bas-reliefs, preserved in the crypt of the church at Decize, are composed in the same way as the St.-Alpin window (fig. 118).[233] This means that there was an accepted doctrine imposed on the artists.

118. Virgin before her birth. Decize (Nièvre), Church. Bas-relief, crypt.

Images of the Immaculate Conception usually appeared alone. Their numbers increased due to the confraternities of the Virgin which celebrated her Conception, for these confraternities were numerous, and more than one document mentions them.

Without question, the most famous of all was the confraternity of Rouen. It was in 1486 that this old religious confraternity took on a literary character and began to distribute prizes.[234] We see that the *Palinods* of Rouen appeared at the time when the idea of the Immaculate Conception was becoming popular. In fact, it was of the Immaculate Conception that the poets of Normandy were to sing. From 1515 on, the victors of competitions received as prizes the biblical emblems recalling this mystery: a silver tower, a sun, a rose, a star, a mirror. It

thus seems probable that the confrères had either a painting or a statue made of the famous image of the Virgin surrounded by these symbols, and that they placed it in the church in which they assembled. This church, which had belonged to the Carmelites, has unfortunately disappeared completely.²³⁵ But it is easy to believe, as I do, that the Virgin of the Immaculate Conception had once been placed there when it is remembered that this image was like a coat of arms for the confraternity, and that it can be seen at the head of the collection of *Palinods* printed in 1525.²³⁶

However, not all the confraternities offered their church the figure just described; they sometimes preferred the traditional image of the Tree of Jesse. Explicit documents prove this. At Toulon (Var), in 1525, the prior of the confraternity of the Sainte-Conception had a painting representing the Tree of Jesse made for the cathedral.²³⁷ Also, a study of the missals printed at the beginning of the sixteenth century shows that the Office of the Conception of the Virgin is sometimes illustrated with two engravings, one representing the Virgin surrounded by biblical symbols, and the other, the Tree of Jesse.²³⁸ Moreover, during the Office, the genealogy at the beginning of the Gospel of St. Matthew was read. Thus, the Tree of Jesse was considered a sort of symbol of the Immaculate Conception. If an immaculate Virgin had been able to issue from a defiled and often crime-ridden race, it could have only been by an eternal decree of God;²³⁹ at the top of this tree composed of voluptuaries, perjurers, and idolaters, an immaculate Virgin appeared as a crowning miracle.

Nowhere is this idea more clearly expressed than in the famous window by Leprince, at St.-Etienne in Beauvais.²⁴⁰ A great white lily crowning the Tree of Jesse opens to reveal the Virgin, who can scarcely be distinguished from the flower. This magnificent lily clearly symbolizes her miraculous purity.

The true reason for the presence of the Tree of Jesse in so many churches lies, I believe, in the cult of the Virgin and, especially, in the cult of her Conception.²⁴¹ It forms the subject of a great many windows in the rustic churches of Champagne, in particular, and all of them date from the first part of the sixteenth century.

In the interests of clarity, even a new genealogical tree was created for the Virgin. A window in the church of St.-Vincent, at Rouen, represents St. Anne in the manner that Jesse was usually represented.²⁴² A trunk emerges from her which divides into several branches; these bear all her progeny, her three daughters and seven grandchildren. As is natural, the Virgin and Child occupy the preferred place. Contemplation of this window, calls to mind the fifteenth-century sequence that it exactly depicts: "Anne, fruitful stock, salutary tree, you are divided into three branches that seven times bore fruit."²⁴³ The St.-

Vincent window is evidence of a curious mental phenomenon: as love of the Virgin grew more and more fervent, it came to include St. Anne. In the late fifteenth century, the cult of St. Anne came to be completely bound up with that of the Virgin, and all her family shared in it. About 1500, the works of art devoted to St. Anne and her daughters increased. Sometimes St. Anne is seated like a venerable grandmother among her descendants, her daughters around her and her grandchildren playing at her feet. And behind a balustrade, three aged men, her husbands, stand side by side and thoughtfully contemplate this preordained family (fig. 119).[244] This is the cradle of the new religion: here are the Virgin and her son, and the little children, scarcely beginning to walk, who are named Jude, Simon, Joseph the Just, John, James the Less, and James the Greater. They play in all the innocence of their childhood, admiring an apple, plucking a flower, turning the pages of an illuminated missal; we reflect that these guileless children, soon grown to manhood, will be torn apart by torturers; and here are their mothers, the two Marys, who will be the first witnesses of the resurrection. The scene is shown thus in a bas-relief at St.-André-les-Troyes, in a window of the church of St.-Nicolas at La Ferté-Milon, and in a window at Cour-sur-Loire. Sometimes the scene is simpler. In the window of the

119. Family of St. Anne. *Encomium Trium Mariarum.* Paris, Bibliothèque Nationale, Inv. Rés. H, 1010. Engraving. Jean Bertrand de Périgueux, 1529.

Chapelle-St.-Luc (Aube) the three husbands are not shown. Certain windows still more simplified show only the three Marys and their children, as in the windows at Louviers (fig. 120), Serquigny, and the cathedral of Evreux.[245]

This sweet idyl was so charming that no one wanted to see what was basically shocking in such a subject. People thought it a way of honoring the Virgin and St. Anne, and no one seemed to be aware that it was at variance with all the new ideas. The image of St. Anne accompanied by her three husbands and three daughters was most naïvely associated with the image of the Virgin of the Immaculate Conception.[246] Yet, it was already perfectly clear to the theologians that the mother of an immaculate Virgin could not have been married three times. After the late fifteenth century, the ancient legend of St. Anne's three husbands was condemned. Past centuries, which had conceived of the Virgin and St. Anne in a less elevated way, might have accepted the legend, but now it was no longer possible because the mother of the Virgin was also included in the idea of the Immaculate Conception.

The essential book to read on this subject was written by the German humanist, Tritheim.[247] It appeared in 1494, and marks an epoch in the history of religious ideas. This was the book that gave lively stimulus

Religious Art Expresses New 207
Feelings: New Aspects of the
Cult of Saints

120. Three Maries and their children. Louviers (Eure), Church of Notre-Dame. Stained glass window, nave.

to the cult of St. Anne and the mystical ideas surrounding her. And it was no doubt this book to which Luther alluded when, in 1523, he said in one of his sermons: "People began to talk about St. Anne when I was fifteen years old; before then, nobody knew the least thing about her."[248]

Tritheim's thesis is that St. Anne was as pure as her daughter: she had conceived and given birth without sin.[249] Even more, she also had been chosen by God before the creation of the world;[250] she had existed in his thought for all of eternity. Why then, since we honor the daughter, should we omit the mother? What honors were not due this vessel that had carried the Ark of God, the Queen of Heaven![251]

Thus, in Tritheim's book, the grandeur of St. Anne was boundless. It is hardly necessary to add that he did not deign to mention the legend of her three marriages.

Such ideas, which were only the logical consequence of the nascent dogma of the Immaculate Conception, had immediate success. A hymn of the church of Mainz dedicated to St. Anne calls her *Anna labe carens*.[252] And also, St. Anne was associated with the rosary from 1495 on, and a clausula in her honor was added to the Ave Maria.[253]

These ideas, which had come out of Germany, also made their way in France, but somewhat more slowly. While our glass painters tranquilly continued to represent St. Anne with her three daughters and three husbands, an extraordinary image appeared.

The 1510 edition of the Hours for the use of Angers, published in Paris by Simon Vostre, contained an engraving which shows St. Anne in an entirely new way (fig. 121). She is standing, and around her are arranged all the biblical symbols that were usually placed around her daughter: the rose, the garden, the fountain, the mirror, the star. . . . She holds open her mantle and in her womb we see the Virgin and Child encircled by rays of light, like an aureole. God appears in the depths of heaven and contemplates, not his work, but his thought; for this mysterious figure has not yet been brought into being. Beneath St. Anne's feet, an imposing inscription borrowed from the Bible is written: *Necdum erant abyssi et jam concepta eram* ("The abyss was yet nonexistent and I had already been conceived").[254]

No doubt all these symbols of the litany and all these biblical inscriptions apply to the Virgin; but St. Anne seemed to participate in her greatness and her purity, and like her, seemed preordained. This engraving can be considered as a summary of Tritheim's book. Thus, in the sixteenth as in the thirteenth century, theological thought transformed consecrated types, and mind fashioned matter.

Are we to believe that this mystical figure of St. Anne appeared for the first time in 1510, in Simon Vostre's Book of Hours? I have no positive evidence for this. However, it seems certain to me that Vostre's

engraving inspired the artists of the sixteenth century. The late sixteenth-century St. Anne in the window of the church of Notre-Dame, at La Ferté-Milon, wears the same costume, has the same pose, and makes the same gesture of opening her mantle and disclosing the Virgin and Child, shining in an aureole; although the symbols are absent, the imitation is flagrant.[255]

This image of St. Anne completes the artistic cycle of the Immaculate Conception. It was not possible to go farther, and henceforth, the mother and daughter were both to be placed above humanity, in the lofty region of divine thought.

Thus the era of the Middle Ages ended. For more than a thousand years it had worked to fashion the image of the Virgin; this was its ever-abiding thought, its secret and profound poetry. And it might be said that the Middle Ages came to an end at the exact moment when it had made this cherished image as perfect as its dream.

121. St. Anne with emblems of the litanies. Hours for use of Angers. Simon Vostre, 1510. Paris, Bibliothèque Nationale, Cabinet des Estampes, Re 25, fol. 82v.

Dante perceived that as he rose toward heaven Beatrice became more beautiful; the historian of the Middle Ages recognizes the passing of the centuries by this sign: the concept of the Virgin becomes purer.

By 1520, art had fully expressed the double ideal of the Middle Ages; it offered men two essential images: a suffering Christ who taught them sacrifice, and an immaculate Virgin who urged them to resist the fatality of the flesh and to triumph over nature. Let Luther and the Renaissance come! The Middle Ages could die: its supreme revelation had already been made.

VI

The Old and the New Symbolism

I

Having considered the world of new ideas that the art of the late Middle Ages expressed, we must now determine how faithful artists were to the old ideas.

The thirteenth century believed the world to be a vast symbol, a kind of divine hieroglyphic. The heavenly bodies, the seasons, light and shade, the movement of the sun across a wall, the rhythm of numbers, the plants and the animals—all dissolved into thought. Of this wondrous world we might say, like Shakespeare, that it was "of such stuff as dreams are made of."

And such indeed was the conception of the world still held by four-teenth- and fifteenth-century theologians, but day by day these lofty ideas were losing their creative force. A profound symbolism had gov-erned the arrangement of the sculptured figures on the portals of our thirteenth-century churches; the statues of Chartres formed a perfectly coherent system of ideas; but from the fourteenth century on nothing like it is to be found.[1]

To be sure, traces of the ancient symbolism lingered on. The churches were still oriented from east to west, and until the end of the fifteenth century, the Last Judgment was carved on the side of the setting sun, as at St.-Maclou in Rouen. It was still remembered in the fifteenth century that the cold region of the north, the symbol of the Old Law, was appropriate to the patriarchs and the prophets, and the south, symbol of ardent charity and the Law of Love, was the place for the apostles and the saints. The windows of St.-Ouen at Rouen, and St.-Sergius at Angers (Maine-et-Loire), were arranged in this way.[2]

The taste for symmetrical correspondences did not disappear: at Langres (Haute Marne), a statue of Moses, presented to the cathedral in 1500 by one of its canons, served as a pulpit for the deacon who read the Gospel:[3] the thirteenth century could not have conveyed more clearly that the Old Law was the foundation of the New. The prophets con-tinued to prefigure the apostles.

The decline of the symbolic view of the world.

Even in the fifteenth century a prominent place was given to a new kind of symbolic correspondence. The four evangelists were compared, not with the four great prophets, as in the thirteenth century, but with the four Latin Church Fathers: Sts. Augustine, Jerome, Ambrose, and Gregory the Great.[4] Such an idea is certainly less lofty. The thirteenth century wished to convey that there was a providential harmony between the Old and New Testaments, and that the prophets had foretold the same truth as the evangelists. The fifteenth century simply pointed out that, just as there were four evangelists, there were four great commentators on the Gospels and that this, no doubt, was in God's thought. This idea might seem ingenious, but it is obvious that it did not have deep roots; we sense that it was not a thought on which theologians had pondered throughout the centuries. And, in fact, the artists were never quite sure which Church Father should correspond to which evangelist. At Notre-Dame in Avioth (Meuse), for instance, St. Gregory is paired with St. Luke, but in a window at Bar-sur-Seine (Aube),[5] he is paired with St. John. At Notre-Dame in Avioth, St. Augustine corresponds to St. John, but in the church of Souvigné-sur-Même (Sarthe), to St. Matthew.[6]

Nevertheless, the artists liked to bring St. Mark and St. Jerome together, not that they saw any profound relation between the spirit of the evangelist and of the translator of the Bible, but simply because both had the lion as attribute. They are shown together on the buttress

122. Sts. John, Matthew, Mark, and Luke. Beauvais (Oise), Cathedral. Wood reliefs. North transept, portal, left door.

of the church at Rue (Somme);[7] at Souvigné (Sarthe), in an engraving by the Master of 1466; on the portal of the cathedral of Beauvais (figs. 122, 123);[8] and in a painting by Sacchi in the Louvre.[9] Still this could not be called a general rule. Thus, the new correspondence imagined by the fifteenth century had neither dogmatic solidity behind it, nor the profundity of former correspondences.

In the last centuries of the Middle Ages there was a visible decline in the symbolic imagination; we find nothing that even distantly recalls the learned encyclopedia of Chartres. The fourteenth century, it is true, did not create a single great ensemble, and we can judge it only by details. But the fifteenth century, in one great burst, built beautiful churches almost as richly decorated as the cathedrals of the thirteenth century. The façade of St.-Vulfran at Abbeville, is one of the most magnificent and one that has best preserved its sculptural decoration. So, what do we see there? Statues of prophets, apostles, bishops, male and female saints, all seemingly placed at random. We search in vain for a governing idea, a plan. There is none. After long reflection on this remarkable disorder, we come to the conclusion that many of the statues must have been individually commissioned from the artists by religious confraternities for the greater glory of their patron saints.[10]

The arrangement of the statues of saints and bishops on the façade of the church of St.-Riquier[11] seems to me neither clearer nor more instructive. The façade of the cathedral of Troyes, built and decorated

123. Sts. Augustine, Gregory, Jerome, and Ambrose. Beauvais (Oise), Cathedral. Wood reliefs. North transept, portal, right door.

in the early sixteenth century, is better conceived, but offers nothing very erudite in the way of a plan. All of the niches are now empty, but church records tell us some of the subjects that were shown.[12] Since one of the towers was dedicated to St. Peter and the other to St. Paul, the history of the two apostles was carved in the archivolts of the portals. Scenes of the Passion carved on the main portal completed the decorative scheme. Here at least there is a kind of order; but how poor and meagerly conceived this seems beside the great dogmatic ensembles of the thirteenth century that told the entire history of the world!

All the works of the late Middle Ages, however vast, give the impression of being fragments: they are isolated chapters, and never a complete story. Art forgot that it owed a summary of universal learning to the ignorant. The works of art of this period no longer testify to the powerful minds of those who conceived them, but to the piety of confraternities and of individuals,[13] or of kings—and sometimes to their pride.[14]

Moreover, if we undertake a detailed examination of these works, we discover that some of the great symbolic ideas of the thirteenth century had become unintelligible to the artists. To cite some examples:

We know that when the Creation was represented in the thirteenth century, God was always given the features of Christ. Theologians, in fact, taught that God had created the world by means of his Word. Such indeed was the doctrine of the Schools in the fourteenth and fifteenth centuries, but it did not reach the artists. In the time of Charles V, they were profoundly ignorant of it. Nothing is stranger than a study of the type of the Creator in the *Bibles historiales* in the Bibliothèque Nationale, which date from the early fourteenth through the fifteenth centuries and form an uninterrupted series. Until about 1350, it was the Word, it was Christ, who had created the world.[15] But then we begin to see the large figure of an aged man who measures the world with a compass and hurls the sun and stars into the heavens.[16] To be sure, this white-haired God with his long white beard has grandeur (fig. 124); He is the Ancient of Days; the passing of the centuries has left ashes on his head. The formidable old man of the Sistine Chapel ceiling was already taking shape. But is it not true that the artists who conceived him had lost the meaning of the old theology?

We know what a world of thought was evoked by the four evangelistic animals in the minds of the twelfth- and thirteenth-century theologians, to whom they were symbols of Christ as well as symbols of the evangelists and of the Christian soul.[17] The old sculptors shared these sober thoughts and gave the four animals strange and mysterious shapes that still belonged within the realm of vision and dream. One need but glance at the tympanum of Moissac (Tarn-et-Garonne) to know that its marvelous animals are symbols, or the signs of divine writing.

124. God speaking to Adam and Eve. Rohan Hours. Paris, Bibliothèque Nationale, ms. lat. 9471, fol. 7v.

The manuscripts of the second half of the fourteenth and the entire fifteenth century frequently show the four animals. But how little style they have! And how quickly we sense that the artist's hand was no longer guided by any great thought. Miniaturists from the time of Charles V on clearly did not know that the four animals symbolized the birth, death, resurrection, and ascension of Christ, as well as the many aspects of Christian life. The artists merely placed them beside the evangelists as attributes that would properly and conveniently identify their subject. They placed the eagle beside St. John, just as they placed the lion beside St. Jerome, or a pig beside St. Anthony. From this time on, the lion, the eagle, and the ox have nothing supernatural about them; they are lifelike animals crouching at the feet of their masters like domestic pets. Sometimes the ox and the lion obligingly lend their backs as desks for St. Luke and St. Mark to use while writing down the Gospels; sometimes the eagle carries an ink bottle hung from its neck and docilely offers it so that St. John may dip his pen[18] (figs. 125 and 126). Here, we are a long way from the vision of Ezekiel: such

125. St. Luke. Hours for use of Troyes.
Paris, Bibliothèque Nationale, ms. lat. 924,
fol. 19r.

126. St. John the Evangelist. Hours for use
of Troyes. Paris, Bibliothèque Nationale,
ms. lat. 924, fol. 17r.

bourgeois realism has no room for dream.[19] It is clear that after the mid-fourteenth century, the artists lost all understanding of the old symbols. Art descended from the realm of pure ideas to the realm of feeling, and increasingly ceased to be the auxiliary of theology.

II

Artists use the compilations of the preceding age as sources. The *Biblia pauperum* and the *Speculum humanae Salvationis*. Their influence.

However, there was one great symbolic idea that could not be forgotten, and this was the pre-established harmony between the Old and the New Testaments. To the Church Fathers, was this not one of the strongest proofs of the Christian religion? For this reason, art had expressed these divine correspondences from the beginning. We know with what amplitude the thirteenth century had translated theological thought into art, and we remember that the artists of Chartres never represented a prophet, a patriarch, or a King of Judah without thinking of Christ.

Poor theologians that they were, even the fifteenth-century artists were not unaware that the Old Testament perpetually prefigures the Gospels: thus, the consecrated correspondences were still used in the fifteenth and even in the sixteenth centuries.[20] But if we look carefully at these seemingly profound works, we see that they all have something in common. Not at all the fruit of theological teaching or the study of the old commentators, they are nothing but almost mechanical copies of originals dating from the thirteenth century. This servile imitation,

seemingly devoid of any thought, attests to the incapability of the fifteenth-century artists to bring the ancient symbols to life. This is what we shall establish here.

When we open the fine *Bible moralisée*, illuminated about 1400 for a great anonymous lord, and now in the Bibliothèque Nationale,[21] the bizarre and subtle symbolism of the miniatures seems at first to be quite new. The windows and bas-reliefs of our thirteenth-century cathedrals contain nothing similar. Here, each event of the Old and the New Testaments is interpreted as a moral allegory, or better, as a revelation of one of the aspects of the moral world.

One of a pair of miniatures shows God creating the reptiles, the birds, and the fish; the other represents peasants digging, monks meditating, and a king upon his throne. What is the relation between these two scenes? An inscription tells us. The reptiles symbolize the men who are born for the things of the world, for the "active life," as theologians call it; the birds, on the other hand, are the men who, with their eyes lifted to heaven, live the "contemplative life"; the great fish who devour the small are the powerful of the world.[22] This is the explanation of the symbolic miniature accompanying the scene of the Creation.

Further on, we come upon Jacob wrestling with the angel.[23] A facing miniature represents a monk kneeling before Christ while a gentleman, indifferent to the presence of God, is about to set off for a hunt, his falcon on his wrist, and a young woman looks at herself in a mirror. A commentary establishes the connection between these two scenes. The angel, who wrestles with Jacob and touches the sinew of his thigh, is God touching man's heart and filling it with disgust for the flesh and the world: such a one is the monk of the miniature who turns away from vanity to kneel before Christ (fig. 127).

127. Miniatures interpreting the symbolic meaning of Jacob's struggle with the angel. Paris, Bibliothèque Nationale, ms. fr. 166, fol. 10.

These two examples are enough to demonstrate the method of the author: to him, the Bible was a vast moral allegory.

This curious book is not unique; several others could be cited which are completely identical or differ only slightly. The most famous is the *Bible moralisée* that belonged in 1404 to the library of the Dukes of Burgundy.[24] As we leaf through this beautiful manuscript we cannot help recalling that the tragic Jean sans Peur had also turned its pages and may have been edified by the beautiful moral harmonies pointed out by the commentary.[25]

A superficial observer might judge from these examples that the old symbolic spirit of the Middle Ages was far from dead and had in fact been renewed and refreshed: such is not at all the case. This moral symbolism, somewhat strange and perhaps seeming to be new, is not new at all.[26] The fifteenth-century miniaturists did no more than copy, and copy servilely, those of the thirteenth century. These subtle allegories had been conceived in the first part of the thirteenth century by a monk, very likely a Dominican. His book, in which everything relates to the duties of the monastic life, was clearly intended for the monks of his own monastery. The fragments of this manuscript, the archetype from which the others derive, are shared by the Bibliothèque Nationale, Oxford University, and the British Museum.[27] It is a collection of miniatures from the first part of the thirteenth century in which the moral symbol is placed beside the event; a commentary explains all these mysteries, for certainly no one would by himself undertake to guess their meaning.

Consequently, for this family of manuscripts it is not a question of the symbolic genius of the fifteenth century. The miniaturists here were merely copying, and nothing more. True, they copied charmingly: in their hands, the thirteenth-century scenes that were still hieroglyphic became pretty little genre paintings. The portion of the French manuscript 166 dating from the middle of the fifteenth century is exquisite. The cold moral allegories come to life and become animated scenes that are sometimes even voluptuous. The artist took marked pleasure in representing sin; the rogue pretends to imitate, but he gently introduces into the formula his own experience. A number of these subtle paintings would have scandalized the sober thirteenth-century author of the book. Fundamentally, these fifteenth-century artists were more and more strangers to the spirit of their model.

But are we here jumping to conclusions? Does an examination of some of the miniatures confirm that the fifteenth century lacked a sense for symbolism?

If the manuscripts tell us nothing, can we find elsewhere symbolic works that are truly new? Let us take, for example, the incomparable tapestries of La Chaise-Dieu (Haute-Loire).[28] All the scenes from the

life of Christ are placed in correspondence with two events from the Old Testament and with four prophetic texts. Of this genre, the thirteenth century itself had produced nothing richer nor more complete, and what is most remarkable, several of these symbolic correspondences seem new and totally foreign to the tradition (figs. 129, 131). For example, the Massacre of the Innocents is flanked on one side by Saul having the priests who welcomed David killed, and on the other, Athaliah's killing of her grandsons so she herself might reign. Facing the Entry of Christ into Jerusalem, there is, on one side, the victorious David carrying the head of Goliath, and on the other, the prophet Elisha welcomed triumphantly at the gates of the city. These figures, as well as several others, never appeared in our thirteenth-century cathedrals. Can it be said that the artist who selected the subjects and composed these complex works had lost the sense for symbolism?

The tapestries of the Life of the Virgin in Reims Cathedral are even more extraordinary.[29] The passages from the Old Testament that are made to correspond to the life of Mary are sometimes so bizarre, so distant from the prefigured event, that we wonder how the idea of making symbols of them ever occurred to the artist.

For example, in the tapestry devoted to the Presentation of the Virgin, we see fishermen taking a golden table from their nets and using it as an offering in the temple of the Sun. The Flight into Egypt is annotated by two episodes: on one side, Jacob is sent by his father to Laban, and on the other, David climbs down from a window by a rope to escape Saul. Would it not be natural to suppose that these curious correspondences were made in the fifteenth century? Far from being ignorant of symbolism, these artists seem to have had a passion for it.

But this only appears to be so: I was long deceived, but discovered at last that none of all this was original. The tapestries of La Chaise-Dieu and those of Reims were designed according to two symbolic compilations, one of which, the *Biblia pauperum*, goes back to the thirteenth and perhaps even to the twelfth century; and the other, the *Speculum humanae salvationis* to the early fourteenth. Fifteenth- and sixteenth-century artists owed all they knew of the old symbols to these two books, and they purely and simply copied the illustrations, rejuvenating them in the process. We shall see how all these figurative works of the late Middle Ages are merely reworkings of these old sources.[30]

The influence on art of the *Biblia pauperum* and the *Speculum humanae salvationis* was so great that we should say a few words about the works themselves.

The *Biblia pauperum* is nothing more than a collection of images that we encounter first in the late thirteenth century, but which probably are older.[31] The story of Christ is told in the thirteenth-century manner,

that is, by developing the Infancy and the Passion at length, at the expense of the life in between. The work ends not with the Ascension but with the Second Coming, that is, with the Last Judgment.

Each scene in the life of Christ is made to correspond with two events prefiguring it in the Old Testament; at the same time, four prophets, placed in medallions, unroll banderoles on which are written cryptic words that provide a clue to the mysteries of the Gospel; a brief inscription explains each of the Old Testament figures, but clearly the text is of little consequence and the book was designed to speak mainly through the illustrations.

The oldest known manuscript of the *Biblia pauperum*, belonging to the Baron Edmond de Rothschild,[32] dates from the second half of the thirteenth century. Long untitled, the manuscript was given the name *Biblia pauperum* at a fairly late date.[33] The title itself was old, having been used as early as the thirteenth century, but then it was applied to abridged Bibles having no relation to the book under consideration.

The *Biblia pauperum* has been thought to have originated in Germany, the oldest manuscript having, in fact, been discovered in Germany or in Austria.[34] But this is a speculation that has not been proved; I am not even convinced that the manuscripts found in Germany have been established as German.

Moreover, so long as the *Biblia pauperum* remained in manuscript form, it had little influence on art. It became popular and was adopted by artists only when a woodcut edition provided many copies.[35]

When did the first woodcut edition of the *Biblia pauperum* appear?[36] It is hard to say precisely; however, the costumes worn by the figures seem to indicate a period near the middle of the fifteenth century. It is even harder to pin down the country in which the wood blocks were designed and cut: they have been variously thought to be German, Flemish, Dutch; now it is suspected that they might have been French. Schreiber, historian of engraving, who for a long time credited France with so small a role,[37] has come to recognize that the wood blocks of the *Biblia pauperum* resemble certain woodcuts whose French origin seems clear.[38] Perhaps it will be possible one day to substantiate that the first woodcut edition of the *Biblia pauperum* was made in France.[39]

The *Speculum humanae salvationis* is slightly more recent than the *Biblia pauperum*. From a note found in several of the manuscripts[40] we learn that "the book called *Speculum humanae salvationis* is a new compilation, edited by an author who, out of humility, wanted to conceal his name."[41] Thus, the author was a man who lived in the last part of the thirteenth century and was permeated by its spirit.[42] Outdoing his predecessors, he placed in correspondence to each event in the lives of the Virgin and of Christ, not two but three prefigurations taken from the Old Testament: the Annunciation, for example, is symbolized by

the Burning Bush, the Fleece of Gideon, and the Meeting between Rebecca and Eliezer. As it was not always easy to find three passages in the Old Testament that corresponded with equal verisimilitude to each evangelical event, the author often found himself in trouble. He had promised more than he could fulfill, and from that came the farfetched correspondences that the tradition of the Church Fathers would never have countenanced.[43]

Like the *Biblia pauperum*, the *Speculum humanae salvationis* is a book of images; the text, however, is given more importance, and a long commentary in rhymed prose accompanies each figurative scene and explains its meaning.[44] Even without the miniatures the book would still retain some interest; and, in fact, there are unillustrated manuscripts of the *Speculum humanae salvationis*. Nevertheless, it is quite clear that the book's attraction lay in its miniatures.[45]

These are the miniatures that were freely copied by the anonymous block cutter who, shortly after the middle of the fifteenth century, produced the first edition of the *Speculum*, half woodcuts and half printed pages.[46] The book had great success, as is proven by the ensuing transformation of the *Biblia pauperum* itself. The first editions of the *Biblia pauperum* were composed of forty wood blocks. Toward 1470 or 1480, an edition of fifty pages appeared.[47] Now these ten additional plates, devoted to the life of the Virgin and to several episodes in the life of Christ, were taken from the *Speculum*.

It remains to be proven that the symbolic works of the fifteenth century were inspired by these two models, and this is not difficult.

Artists began to look for symbolic motifs in the manuscript of the *Speculum humanae salvationis* around 1400. The miniaturist who illuminated the *Très belles Heures* of the Duke of Berry had already used it. This wonderful manuscript was lost when the library of Turin burned, but happily, it had already been photographed.[48] Studying these reproductions, we note that the episodes from the Passion are accompanied by scenes from the Old Testament. These scenes are clearly prefigurations, but however familiar we may be with the spirit of the Middle Ages, we cannot help being struck by their strangeness. For example, Christ Nailed to the Cross is shown with Tubal, father of blacksmiths, striking his anvil, and beside him the prophet Isaiah is sawed in half by torturers.

If the artist himself had been capable of thinking of such subtle correspondences, he would certainly have been a most ingenious theologian. But he was not thinking it up, he was copying two figures in the *Speculum humanae salvationis* accompanying the scene of Christ Nailed to the Cross.[49] The other symbolic correspondences found in the Turin Book of Hours have the same source.[50]

We can state affirmatively that from this time on any self-respecting

artist would have had a manuscript of the *Speculum humanae salvationis* in his studio. Jan Van Eyck had one, and here is the proof.

In 1440, he began a triptych for the church of St.-Martin, in Ypres, but died before finishing it.[51] The central panel is devoted to the Virgin holding the Child; the right wing represents the Burning Bush and the Fleece of Gideon; the left, the Flowering Rod of Aaron and the Closed Gate of Ezekiel. These are the exact figures which correspond to the virginity of Mary in the *Speculum humanae salvationis*. It could be objected, it is true, that these were traditional types and that Van Eyck could have found them anywhere. But a look at the reverse side of the wings reveals a completely new scene not to be found in painting before this time: the vision of the *Ara coeli*. The Tiburtine Sibyl raises her hand to point out to the Emperor Augustus the Virgin and Child in the sky. Now it so happens that in the *Speculum humanae salvationis* the scene between the Sibyl and Augustus accompanies the miracle of Aaron's Rod, and immediately follows the Burning Bush and the Fleece of Gideon, which are on the preceding page. Thus there can be no doubt; the presence in the work of Van Eyck of a subject as new as the Meeting of Octavius and the Sibyl—a subject introduced into art solely by the *Speculum humanae salvationis*—disposes of all uncertainty. Moreover, we can see that Van Eyck used the manuscript before him as his source for showing the *porta clausa* of the prophet as a town gate opening between two towers, and the Burning Bush as a tall, slender tree spreading out at the top.

Thus, the *Speculum humanae salvationis* had been in Van Eyck's workshop, and in that of Roger van der Weyden. When the latter painted the famous triptych of the Nativity (fig. 27) for Bladelin, about 1460, he did not have to look far for the subjects of the two wings. He opened his manuscript to the page of the Nativity: for one side he took the subject of the meeting of Augustus and the Sibyl, and for the other, the Vision of the Three Magi seeing the figure of a child appear in a star. We can even say, I think, that Rogier van der Weyden's book belonged to that class of manuscripts in which, by a slight error, the meeting between the Sibyl and Octavius is placed beside the vision of the Three Magi.[52]

But what Flemish artist did not have the *Speculum humanae salvationis*? Thanks to this valuable book, more than one artist who was probably no great scholar could seem to be a theologian.[53]

Meanwhile, toward 1460, the first woodcut edition of the *Biblia pauperum* appeared. This book, which had been little known as long as it remained in manuscript form, began to be used by artists. Sometimes they preferred it to the *Speculum humanae salvationis*, but for the most part they used both.

It was by combining these two models that an unknown artist of the late fifteenth century designed the cartoons for the Chaise-Dieu tapestries. Yet he owed much more to the *Biblia pauperum* than to the *Speculum*.

Following the *Biblia pauperum*, the tapestries first show Christ's Infancy, then his Passion, and finally, the Last Judgment; like the *Biblia pauperum*, the tapestries bring together with each scene from the New Testament two events that prefigure it and four prophetic biblical verses.

But it is in the details that the resemblances are most striking. Each tapestry is almost always an exact copy of the *Biblia pauperum*. For example, take the first page of the *Biblia pauperum*. In the center there is the Annunciation accompanied, on the left, by the Temptation of Eve, and on the right, by Gideon's Fleece; above and below, the busts of two prophets appear in architectural niches holding scrolls. This is the exact arrangement of the first Chaise-Dieu tapestry: the artist did no more than bring the costumes up to date and enrich the décor, but otherwise copied even down to the inscriptions on the prophets' scrolls. A quick glance at the reproductions can tell us more than any commentary (figs. 128 and 129).

128. Annunciation. Temptation of Eve. Gideon's Fleece. *Biblia pauperum*. Paris, Bibliothèque Nationale, Xylographes 2, f. a.

129. Annunciation. Temptation of Eve. Gideon's Fleece. La Chaise-Dieu (Haute-Loire), Church of St. Robert. Tapestry above stalls in choir.

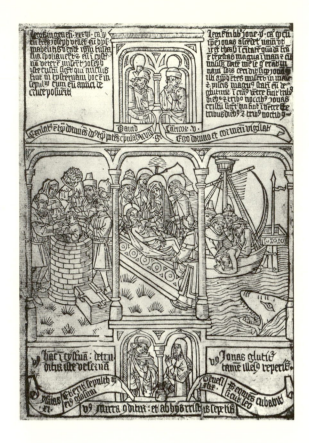

130. Entombment. Joseph lowered into the well. Jonah. *Biblia pauperum*. Paris, Bibliothèque Nationale, Xylographes 2, f. g.

131. Entombment. Joseph lowered into the well. Jonah. La Chaise-Dieu (Haute-Loire), Church of St. Robert. Tapestry above stalls in choir.

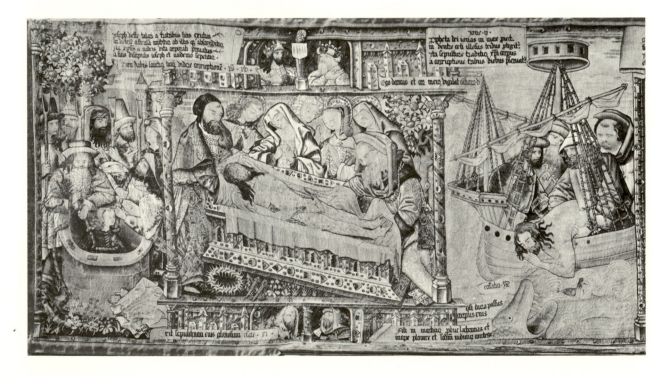

The same is true of all fourteen tapestries of La Chaise-Dieu: they reproduce exactly fourteen pages of the *Biblia pauperum* (figs. 130 and 131).[54]

Then come five tapestries that are also copied from the *Biblia pauperum*, but with a visible effort at simplification. In fact, three of the tapestries, instead of presenting two scenes from the Old Testament, show only one.[55] Two other tapestries combine two pages of the *Biblia pauperum* compressed into one.[56] It is apparent that these simplifications are for reasons of economy.

Eight remaining tapestries reveal a strong influence of the *Speculum humanae salvationis*. These eight tapestries are either exact copies of the *Speculum*,[57] or are combinations of the *Speculum* and the *Biblia pauperum*,[58] with variants.[59]

That the artist did not follow the *Biblia pauperum* faithfully to the end and thought it necessary to use the *Speculum humanae salvationis* is proof that the two books were equally well-known in the late fifteenth century.

The tapestries of Reims Cathedral, moreover, present an analogous compromise. As we know, they are devoted to the life of the Virgin. They were given to the cathedral by the Archbishop Robert of Lénoncourt, who perhaps had the work begun during the first year that he occupied the episcopal seat of Reims, that is, in 1509; they were finished in 1530. Thus, they are almost contemporary with those of La Chaise-Dieu. Not all these tapestries are symbolic; several have nothing figurative about them. But there are eight in which an event in the life of the Virgin is made to correspond with two events from the Old Testament. And these eight tapestries are copies either of the *Biblia pauperum* or of the *Speculum humanae salvationis*. Unaware of this, writers describing the tapestries of Reims have not always understood their meaning.[60]

Seven tapestries were copied after the *Biblia pauperum*: the Marriage of the Virgin, the Annunciation, the Nativity, the Adoration of the Magi, the Presentation in the Temple, the Flight into Egypt, and the Assumption. Two Old Testament figures accompany each scene.

One example will suffice. Alongside the Adoration of the Magi, the *Biblia pauperum* shows Abner kneeling before David and the Queen of Sheba kneeling before Solomon; above, David and Isaiah hold scrolls. These are exactly the same scenes and personages shown in the tapestries of Reims. The composition is better, the costumes are richer, and the décor has an amplitude not found in the original, yet we recognize it at a glance. The six other tapestries are also faithful copies of the *Biblia pauperum*.[61]

The eighth tapestry is taken from the *Speculum humanae salvationis*. It shows the Presentation of the Virgin. Two events from the Old

Testament accompany this scene: Jephthah's daughter going to meet her father, and the fishermen drawing the golden table from their nets and carrying it to the Temple of the Sun. These prefigurations are exactly the same as those accompanying the Presentation of the Virgin in the *Speculum humanae salvationis*. The artist used the *Speculum* because the Presentation does not occur in the *Biblia pauperum*.[62]

We see in what favor our two books were held by the artists who designed the tapestry cartoons. In fact, there is scarcely one symbolic tapestry that was not inspired by one or the other of these works. Let me offer one or two more proofs.

In the treasury of the cathedral of Sens, a very fine tapestry from the late fifteenth century shows the Coronation of the Virgin together with two scenes from the Old Testament that prefigured it: the Crowning of Bathsheba by Solomon, and the Crowning of Esther by Ahasuerus (fig. 132). Now precisely these three scenes are found on a page of the *Biblia pauperum*, of which the Sens tapestry is a copy.

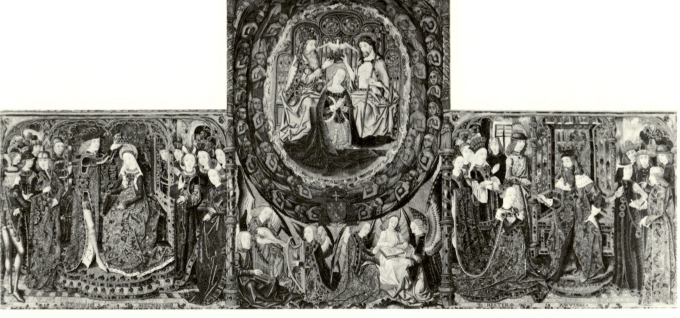

132. Coronations of the Virgin, Bathsheba, Esther. Sens (Yonne), Cathedral Treasury. Tapestry.

At Chalon-sur-Saône (Saône-et-Loire), in the former cathedral, a large sixteenth-century tapestry is devoted to the Eucharist. Alongside the Last Supper are three episodes prefiguring it in the Old Testament: Melchisedek offering bread to Abraham, the Hebrews gathering manna in the desert, and the Jewish Passover. In the *Speculum humanae salvationis*, the Last Supper is accompanied by exactly the same three scenes.

A Flemish tapestry, now in Madrid, places the Nativity in correspondence with the Burning Bush of Moses and the Rod of Aaron: in this we recognize the *Biblia pauperum*, from which the artist also borrowed the prophetic texts held by Isaiah and Micah.

It would be pointless to insist further. These examples suffice to prove that the *Speculum humanae salvationis* and the *Biblia pauperum* were veritable manuals for the cartoon painters attached to the great tapestry workshops.

The glass painters also owed something to these two books; and they probably owed more than we can imagine today. Many of the fragile works inspired by the *Biblia pauperum* and the *Speculum* have certainly disappeared, but one, at least, remains.[63]

I refer to the two large windows of the Sainte-Chapelle of Vic-le-Comte (Puy-de-Dôme), which are almost intact; they date from the sixteenth century. The south window is devoted to the episodes of the Passion, the north window to figurative scenes taken from the Old Testament: each historical panel of the first window has a corresponding symbolic panel in the second.

This well-composed work was much admired in the past by Dulaure, who was astonished at the theological erudition of the artist.[64] His admiration was misplaced, for the artist simply had a copy of the *Biblia pauperum* before him and faithfully copied it; but because space was limited, he put only one prefiguration from the Old Testament opposite each event from the New. Only the Triumphal Return of David corresponds to Christ's Entry into Jerusalem; and the Gathering of the Manna alone corresponds to the Last Supper. As usual, the *Speculum humanae salvationis* was consulted along with the *Biblia pauperum*: a prefiguration not found in the *Biblia pauperum* but in the *Speculum*, the episode of Achior bound to a tree and beaten by the servants of Holophernes, corresponds to the Flagellation of Christ.

The sculptors who decorated the portals of our churches in the fifteenth and sixteenth centuries also owed something to these two books.

The central portal of the cathedral of St.-Maurice of Vienne, in the Dauphiné, although deprived of its statues, has preserved some charming figurines in the archivolts,[65] in which we easily recognize the consecrated concordances. A scene from the New Testament corresponds to a scene from the Old: facing the Adoration of the Magi, for example, is the scene of the warriors bringing David water from the well, a figure borrowed from the *Speculum humanae salvationis*; and opposite the Ascension, Elijah rises to heaven in a fiery chariot, a figure borrowed from the *Biblia pauperum*.[66] Thus, the artists found their models sometimes in one, sometimes in the other of the two famous books.

Many portals, now stripped of their statues, must have once been decorated like the portal of Vienne.

The archivolts of the great portal of the cathedral of Troyes, now empty, were once decorated with figurines representing the scenes of the Passion and their symbolic types. The church accounts for the years 1523 to 1527 tell us the cost of each group as the sculptor was paid.[67] Unfortunately, these accounts are not complete; however, enough is recorded to make it clear that each Passion scene was accompanied by an Old Testament prefiguration. For instance, the story of how Job was smitten by the devil corresponded to the Flagellation; and to the Resurrection, the story of how Jonah emerged from the stomach of the whale. The second figure may not seem very typical, but the first is a clear borrowing from the *Biblia pauperum* or the *Speculum humanae salvationis*, for it is found in both. Thus, we can concede that the portal of Troyes was composed like the portal of St.-Maurice in Vienne and that the artist drew on the same sources.

The ivory carvers also knew these valuable models. I need no other example than the late fifteenth-century reliquary casket in the Cluny Museum.[68] The artist not only borrowed his symbolic correspondences from the *Biblia pauperum*,[69] but even copied the prints in the book: the figure of Eve tempted by the serpent, or Samson carrying off the gates of Gaza seem to be tracings of the original.[70]

Copies of the *Biblia pauperum* or the *Speculum humanae salvationis* would certainly have been found in all artisan workshops.

The enamelers of Limoges used the *Biblia pauperum*; from it they borrowed the biblical verses they placed in the hands of each prophet.[71]

The woodcarvers of Brussels and Antwerp, who fashioned the great altarpieces famous throughout Europe, used the *Biblia pauperum* and the *Speculum*: from them they took the small symbolic scenes that usually accompanied the scenes of the Passion.[72]

But the *Biblia pauperum* and the *Speculum* became really popular when printers first thought of decorating the margins of their Books of Hours with figures borrowed from these two ancient books. The faithful had them constantly before their eyes, for when they read their prayers they saw, encircling the text, Job smitten by the devil and Jesus flagellated, Tubal striking his anvil and Jesus nailed to the cross. Inscriptions and prophetic texts told them the meaning of these figurative scenes.

The printer Caillaut seems to have been one of the first to decorate the margins of his Books of Hours[73] with prints copied without scruple from the *Speculum humanae salvationis* published at Lyon in 1478.[74] But Vérard, who had published a very beautiful edition of the *Biblia pauperum*,[75] preferred to use reproductions from it in the margins of his Books of Hours,[76] and his example was generally followed. Kerver, Pigouchet, and Etienne Johannot[77] also decorated the margins of their charming Books of Hours with woodcuts copied from the *Biblia pau-*

perum (fig. 133). But they sometimes borrowed also from the *Speculum* (fig. 134). These Books of Hours, which circulated by the thousands throughout France, made everyone familiar with the *Biblia pauperum*.[78] No book ever had such success.

In the sixteenth century we find something even more extraordinary: the *Biblia pauperum* came to life; each of its pages became a *tableau-vivant*. In 1562, the town of Béthune arranged a magnificent procession in which all the guilds took part.[79] Each guild defrayed the cost of a float on which unmoving figures depicted the principal scenes in the life of Christ. The Annunciation was assigned to the barrel makers, Christ among the Doctors to the fish de-salters, and the Last Supper to the sack porters. On that day, a light from on high seemed to fall on the humblest of the trades. Now on each of these floats there was not only a scene from the life of Christ, but also there were "two figures." Who were they? The records do not say, but it is not hard to guess. They represented the two scenes from the Old Testament which, in the *Biblia pauperum*, accompanied the one from the New Testament. And what renders the source easily recognizable is the arrangement of the scenes from the New Testament, beginning with the Annunciation and ending with the Last Judgment. As we have seen, this was precisely the arrangement of the *Biblia pauperum*.

These examples suffice to establish the point we want to make. Henceforth, it will be evident that most fifteenth- and sixteenth-century symbolic works were derived from the *Biblia pauperum* or the *Speculum humanae salvationis*.[80] This proves that the artists and even the churchmen (who commissioned the works of art) were no longer close to the Church Fathers or the great theologians of the Middle Ages. These manuals had been adopted once and for all to save the trouble of going back to the sources. Appearances to the contrary, it is clear that the life was gradually ebbing from the old symbols.

All these works would have been extremely cold had they not been enlivened by the artists' charming imaginations and their love of nature. The artists were no doubt indifferent to the thought involved, but they were interested in costume and décor. What did it matter if the tapestries of La Chaise-Dieu were copied from the *Biblia pauperum*? They are masterpieces, none the less. We must imagine these delicate marvels hanging in the great bare and austere church of Clement VI.[81] Their faded colors harmonize with the color of the stone and with the light touches left on the vaulting and columns by time and winter. Close up, we are charmed by a thousand graceful details: the magnificent mantle of the resurrected Christ billowing in the wind and revealing its star-sprinkled lining, or the brocaded robe of Mary Magdalene. Flowers bloom everywhere: carnations, bell-flowers, lilies of the valley. Birds sing in flowering trees, rabbits peer out of their holes, a peacock spreads his tail before the resurrected Christ. This is eternal spring. And we are so absorbed in the enjoyment of all these charming details that we forget the symbols and do not even take note that the three warriors with braided beards and Tartar headdress, who offer chased flagons of the water of Bethlehem to David, are there to prefigure the Adoration of the Magi.

III

The concordance of the Old and the New Testaments. The *Credo* of the prophets and the *Credo* of the apostles.

There was a far simpler way of conveying the divine concordance between the Old and New Testaments and this was to place the prophets face to face with the apostles.[82] The thirteenth century had been fond of this kind of opposition which was self-explanatory. Anyone seeing such figures in the upper windows of Bourges, those on the north and those on the south, all alike and all wearing the same kind of tunic, could not but admire the astonishing resemblance. One recalled that these men had heralded the same Saviour. Perhaps some in contemplating them, thought they heard a great two-part choir with voices singing at first in response to each other and then in unison.

The correspondence of the prophets and the apostles was one of the favorite subjects of fifteenth-century art, and strangely enough, takes

on a kind of grandeur in the fifteenth century that it lacked in the thirteenth. Each of the apostles holds a scroll on which an article from the *Credo* is written, while the prophets display verses from their books. Each verse of the prophets corresponds to an affirmation of the *Credo*. These are phrases from the great dialogue between the Old and New Law. There is no dissonance in this alternating song; centuries before Christ, the prophets already recited all the articles of the Apostles' Creed, but in another mode.

I do not know how the accord between the two Testaments could be expressed in a simpler or grander way. Had the artists of the fifteenth century invented all this, they would have equaled those of the thirteenth in the profoundness of their religious thought.

But we are dupes of appearances. Here again the fifteenth century invented nothing, and as usual, credit for this great thought must go to the thirteenth.

The idea of assigning a sentence from the *Credo* to each apostle is an old one. It was said that on the day of Pentecost the apostles, having assembled in the Cenacle and feeling enlightened by the Holy Spirit, spoke one after the other. Peter, the first, said: "I believe in God, the Father Almighty, creator of heaven and earth." St. Andrew added: "And in Jesus Christ, his only son." The others followed, and in a dozen sentences the twelve apostles promulgated the twelve articles of faith.

A sermon attributed to St. Augustine offers the first example of each apostle reciting one of the articles of the *Credo*.[83] This sermon, considered in the Middle Ages to be the authentic work of a Father of the Church, must have been very famous. The proof is that the *Credo* phrases assigned by Pseudo-Augustine to each of the apostles are precisely those usually assigned to them in the Middle Ages.[84]

However, there are exceptions; Durandus, for instance, in his famous *Rationale*, adopted a quite different order.[85] He even goes so far as to say, in another work, that it is arbitrary to assign one phrase rather than another from the *Credo* to each apostle, and that writers had come to no agreement on the subject.[86]

Despite what Durandus said, a tradition had begun to be established during his time; in several thirteenth-century manuscripts, the apostles pronounce the exact words assigned to them by St. Augustine:[87] moreover, St. Augustine is named expressly and the entire list is placed under his patronage.[88]

If there was still a good deal of wavering in the fourteenth century, the order adopted by St. Augustine, despite some exceptions, was decisively the rule in the fifteenth.[89]

The truly original and profound idea was to make the twelve articles of the *Credo* correspond to the twelve words of the prophets. The credit

is most certainly due a thirteenth-century theologian. The oldest examples I know of this parallelism are found in manuscripts dating from about 1300. In these curious books, the vices, and the virtues, and the sufferings of Christ are presented in diagrammatic pictures.[90]

One of these paintings emphasizes the harmony between the prophetic and the apostolic doctrines: each article of the *Credo* recited by an apostle corresponds to a biblical verse recited by a prophet. To St. Thomas, for example, who proclaims: "He descended into Hell, the third day he arose again from the dead," the prophet Hosea replies: "O death, I will be thy death, O Hell, I will be thy bite."[91]

It is unlikely that the author of these manuscripts invented the correspondences; his modest little manuals present an accepted doctrine, and nothing more. The idea must go back to some theologian contemporary with St. Thomas Aquinas.

Had artists begun as early as the thirteenth century to express in visible form the harmony between the prophetic *Credo* and the apostolic *Credo*? There seems to be no doubt of this, as the still very simple miniatures of the Bibliothèque Nationale manuscript prove.[92] But it was at the beginning of the fourteenth century that the subject appeared in all its grandeur; it appears in a Book of Hours illuminated in Paris about 1330 for Jeanne II, Queen of Navarre.[93] At a date before 1343, the very same pages that were devoted to the prophets and the apostles in the Book of Hours of Jeanne II are found again in the famous Belleville Breviary;[94] but in the latter, a commentary placed at the beginning of the volume explains in the clearest possible way the artist's intention.

This ingenious work is arranged as follows: at the bottom of each page of the calendar, an apostle is placed in correspondence with a prophet. The prophet stands beside an edifice representing the Synagogue or, if you will, the Old Law. The prophet has drawn from this edifice a stone which he seems to present to the apostle, for these stones taken from the Temple will be the foundation of the Church. Each time a prophet pronounces one of his verses, a wall falls down, a tower crumbles; on every page we turn, the Temple seems to be more destroyed; and, when the last word is spoken and all is fallen, the ruins themselves are engulfed. Meanwhile, the apostles seem to march toward the prophets and tear away the veils from their heads which, no doubt, hid their faces. This is the ancient metaphor made visible: "The Old Testament is the New Testament covered with a veil, and the New is the Old unveiled." And, to assure against any remaining obscurity, a scroll beside the prophet carries the biblical verse that is explained by a phrase of the *Credo* given to the apostle.

At the top of the page is another scene: an apostle speaks to an assembly of men. These men are sometimes called the Colossians, some-

times the Corinthians, sometimes the Romans: consequently, this apostle is St. Paul, who also teaches his *Credo*. He was not in the Cenacle when the Apostle's Creed was composed; nevertheless, he proclaimed the same truths to the Gentiles. A sentence taken from his Epistles and placed in correspondence with the prophetic verse and the article of the *Credo* proves the unity of the doctrine.[95] This unity of the faith, moreover, was given visible form by the artist through a personification of the Church. She appears on every page, standing on the top of a tower, crowned with a golden diadem; she raises a standard on which an image is painted. This image changes twelve times. Each change recalls one of the sentences of the *Credo*: the hem of a robe, the top of which is lost in the clouds, is the Ascension; a dead person rising from his tomb is the resurrection of the flesh, etc. Thus, the twelve emblems on the banner of the Church summarize at the same time the teaching of the prophets, of the apostles, and of St. Paul.[96] The miraculous continuity of revelation is apparent.

Each page is composed with impeccable knowledge; the work is in every way worthy of the thirteenth century. If really conceived at the beginning of the fourteenth century, it is proof that the theological spirit and the feeling for great schemata still lived.

These pages from the Hours of Jeanne of Navarre and from the Belleville Breviary are found again, with a few changes, in the *Grandes* and the *Petites Heures* of the Duke of Berry. The drawings are identical, but the order of the apostles is different. The Duke of Berry's artist arranged them according to Pseudo-Augustine and assigned to each the same articles of the *Credo*. The sentences presented by the prophets on their scrolls are not exactly the same either; for on this point, tradition had never been completely fixed (fig. 135).

This correspondence between the prophetic *Credo* and the apostolic *Credo* seems to have been particularly dear to the Duke of Berry. It was not enough to have three of his prayer books decorated with them;[97] he also had them represented on the windows of his Sainte-Chapelle in Bourges, of which only fragments remain;[98] and there are indications that the same motif was used on other monuments he had built. The statues of apostles and prophets in the Bourges Museum clearly had phrases from the *Credo* written on banners. Since all these statues are characteristic of Beauneveu,[99] the Duke of Berry's favorite artist, they could only have come from one of the ducal chapels.[100]

The Duke of Berry's artists could very well have contributed to the introduction of this motif into large-scale monumental art. Rare before 1400,[101] it becomes frequent in the fifteenth century; from then on, it spread throughout Europe.[102]

In France, the correspondence between the prophets and the apostles inspired some truly magnificent works in the fifteenth century.

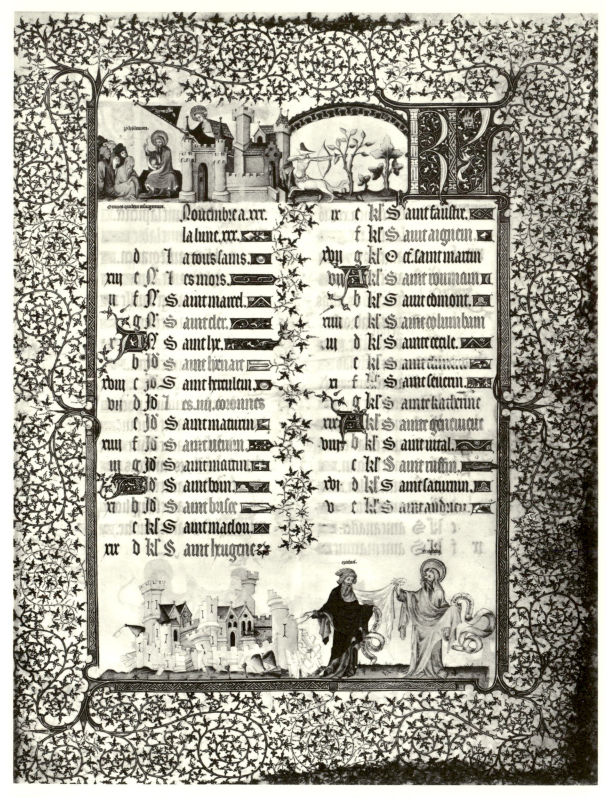

135. November. Calendar page from the *Grandes Heures* of the Duke of Berry. Paris, Bibliothèque Nationale, ms. lat. 919, fol. 6.

First of all, there are the windows of the Sainte-Chapelle of Riom, given in the second half of the fifteenth century by the Duke of Bourbon,[103] who is shown kneeling at the feet of the Virgin. Clumsy restoration has unfortunately disturbed the order of the figures. The dialogues no longer have any meaning; a prophet speaks of the Crucifixion to an apostle who proclaims the resurrection of the flesh. Such was the ignorance, only a few years ago, of our so-called restorers (fig. 136).[104]

136. Apostles and prophets. Riom (Puy-de-Dôme), Sainte-Chapelle. Stained glass panels.

Fortunately, the statues in the choir of Albi have remained in place.[105] This beautiful ensemble is well-known; it has remained intact. Like a kind of holy city, the choir is surrounded by walls on which thorny vegetation flourishes. Outside are the prophets who foretold the Church but did not see it, and within the sanctuary are the apostles who finally promulgated the articles of the faith.

There is another work that could be compared with this one, were it not almost completely destroyed. I refer to the statues of the small chapel erected by the Abbot Jean de Bourbon beside the vast church of Cluny. The work is related by ingenious symbolism to the masterpieces of the thirteenth century. The great statues of apostles were placed under canopies, but only their names, carved in stone, remain. Each clearly held a banner on which was written an article of the Creed.

Proof of this is that the figure of a prophet also holding an inscription is placed beneath their feet: now each verse is an article of the *Credo* that artists placed in the hands of the prophets.[106] Thus, at Cluny, as formerly at Chartres, the Old Law served as foundation for the New. The apostles at Cluny were arranged in an unusual order. St. Thomas occupied the place of St. James, and St. Matthew that of St. Philip, and there is no explanation of this oddity.[107] It so happens that the apostles are arranged in this same way at Albi,[108] and this is the only analogous example I know.

On the other hand, if we compare the inscriptions carried on banners by the prophets at Cluny and at Albi,[109] we see that they are identical, while elsewhere they almost always varied.[110] The only way to explain these surprising analogies is to assume that artists trained in the same ateliers worked at both Cluny and Albi. The dates agree,[111] and the style, insofar as it can be judged at Cluny, does not differ greatly. Courajod identified the sculpture at Albi as Burgundian: evidently he was not mistaken, if our contention is granted that the Burgundian sculptors of Cluny worked at Albi also.

Thus, it was at the end of the fifteenth century that the theme of the concordance of the two Laws, the two Creeds, was consecrated by real masterpieces. But here again, let us repeat, the fifteenth century did not invent anything and was content to follow the thought of the thirteenth century.

IV

New symbolic conceptions. Antiquity and Christianity. The twelve sibyls placed in correspondence with the twelve prophets.

However, the fifteenth century did not always imitate: it invented, also. It was able to find symbols appropriate to minds already troubled and tormented by new problems.

The men of the fifteenth century were the first to understand antiquity.[112] For them, Virgil was something more than a collection of grammatical examples.[113] For the first time they felt the beauty of the art of antiquity, and glimpsed the profundity of its thought. They were intoxicated by antiquity, with its dazzling genius, as it was unveiled for them: it was a magician, a dangerous Circe. But how had these pagans been able to write such divine verses, such sublime pages? How could they have lived and died heroically when they knew nothing of the true God? Had Jehovah turned his back on these wise men and immortal poets, and made his Word known only to the Jews? Had he foretold his Son only to the Hebrew prophets? Formidable questions and profoundly troubling ones.

A reply was necessary, and in the mid-fifteenth century learned men tried to formulate one. In a treatise entitled "The Christian Faith proved by the authority of the pagans,"[114] a theologian reasoned something like

this: "The true God had not turned away from the pagans; he had favored them with a special revelation. All the dogmas of the Christian religion had been perceived, and even sometimes clearly enunciated by the sages of antiquity. Plato and Aristotle had spoken of the Trinity; Apuleius knew that there were good and bad angels; Cicero foretold the resurrection. Virgins filled with the spirit of God, called sibyls, foretold the Saviour in Greece, Italy, and Asia Minor: Virgil, instructed by their books, sang of the mysterious Child who was to change the face of the world."

This was to be the doctrine, henceforth, of all noble minds. Marsilio Ficino expressed it with the same force in his *Treatise on the Christian Religion*:[115] he also placed Plato among the prophets; and invoked the authority of the sibyls; for this noble spirit, all that was beautiful was Christian.

Italian art seized on this great idea and gave it magnificent form. Facing the *Dispute of the Holy Sacrament*, in which all the doctors of the Church were assembled, Raphael painted the *School of Athens*, which represented all the philosophers.[116] Thus, in the Vatican itself, he affirmed that the thought of antiquity was holy, that the philosophers were the legitimate ancestors of the theologians, that Greek wisdom and Christian faith were fundamentally one and the same.[117] The *Disputa* is an eternally memorable work, the most ample and the most humane ever conceived by the Renaissance, and one in which its noblest thoughts are expressed. In it, the two halves of humanity were finally reconciled.

Such a work is unique.[118] However, fifteenth-century art expressed in its own way the harmonies between paganism and Christianity: the artists chose not the philosophers but the sibyls to express these mysterious consonances.[119]

The thirteenth century had already been acquainted with the sibyls; Vincent of Beauvais named the ten sibyls listed by Varro; but in France, artists represented only one, the Erythraean Sibyl, the terrible prophetess of the Last Judgment.[120]

Italy honored another sibyl: the Sibyl of Tibur.[121] This was because she was a part of the legends enveloping in a net of poetry the marvel that was medieval Rome. It was told that the Emperor Augustus, uncertain of the future and desiring to know who would succeed him as head of the empire, had the Tiburtine Sibyl brought to Rome. The prophetess consented to lift the veil of the future; from the top of the Capitoline Hill she showed him, through a rift in the clouds, a Virgin holding a Child; at the same time, a voice pronounced these words: *Haec est ara coeli*. Moved by this vision, the Emperor Augustus had these mysterious words engraved on an altar dedicated to the future Master of the World, and it was on this same spot that the church of

the Ara Coeli was to be erected.[122] From the late twelfth century on, this scene was represented in Italian art,[123] but it was known in the north only much later.[124]

The Tiburtine Sibyl and the Erythraean Sibyl are thus the two sibyls who were first represented by the artists of the Middle Ages.

In the late thirteenth century Italy began to give special honor to the sibyls. There is reason to believe that the admirable seated figures with which Giovanni Pisano decorated the pulpit of Pistoia are figures of sibyls. No inscriptions identify them, but their attitudes are eloquent enough: like Virgil's sibyl, they struggle with the spirit.

The sibyls are sometimes found in fourteenth-century Italian art: there are two on the campanile in Florence, and two others on the façade of the cathedral of Siena. Italy never forgot the sibyls, but there was not yet the passion for them that developed in the following century.

In the course of the fifteenth century, sibyls suddenly appeared all over Europe. Until then, they had appeared as isolated figures, but from then on, they formed an imposing assembly.

Several distinct family groups can be recognized.

The first is the simplest of all. It comprises ten sibyls whose oracles came from the *Divinae institutiones* of Lactantius.[125] We find them in a chapel of the Tempio Malatestiano in Rimini.[126] They were carved about 1455 by a workshop probably directed by Agostino di Duccio. They are not named, but eight carry on phylacteries some of the following prophetic verses borrowed from Lactantius:

One foretells the sufferings of the Passion: *In manus infidelium postea veniet, dabunt autem alapas manibus incestis.*

Another predicts the Flagellation: *Dabit vero ad verbera simpliciter sanctissimum dorsum.*

Another speaks of the Crucifixion: *Ad cibum autem fel et ad sitim acetum dederunt.*

Another foretells the prodigies that will accompany the death of the Saviour: *Templi vero velum scindetur et medio die nox erit atra nimis.*

Another proclaims Him the liberator of the human race: *Jugum nostrum servitutis intolerabile super collum tollet.*

A few years later, between 1469 and 1474, Jörg Syrlin the Elder, in Germany, carved the sibyls for the stalls of the cathedral of Ulm.[127] There are nine of them, and each pronounces an oracle having to do with the life or the death of the Messiah. These are the oracles:

Sybilla Delphica. Dabit ad verbera dorsum suum et colaphos accipiens tacebit.

Sybilla Libyca. Jugum nostrum intolerabile super collum nostrum tollet.

Sybilla Tiburtina. Albuna dicta. Suspendent eum in ligno et nihil valebit eis, quia tertia die resurget et ostendet se discipulis, et, videntibus illis, ascendet in coelum, et regni ejus non erit finis.

Sibylla Hellespontica, in argo Trojano. Felix ille fructus ligno qui pendet ab alto.

Sibylla Cumana, quae Amalthea dicitur. Templi velum scindetur, et medio die nox erit tenebrosa nimis.

Sibylla Cimeria, octavo anno. Deum de virgine nasciturum indicans. Jam nova progenies coelo demittitur alto.

Sibylla Frigia (sic), *Ancirae. In manus infidelium veniet. Dabunt autem alapas Domino manibus incestis et impurato ore exspuent venenatos sputus.*

Sibylla Samia. Agnus coelestis humiliabitur.

Sibylla Erithraea. Ex coelo rex adveniet per saecla.

Most of these inscriptions were borrowed from the *Divinae institutiones* by Lactantius.[128] This long forgotten work had been restored to honor by the humanists:[129] they found in it their favorite idea, that paganism itself had been inspired and prophetic. Lactantius, in order to influence the pagans, had in fact reminded them that stern Varro had admitted the existence of the sibyls and named ten;[130] then he cited various oracles of these sibyls and accorded them as much authority as the prophets. According to him, the sibyls had foretold to the pagan world the Birth, the Miracles, the Passion, the Death, the Resurrection, and the Last Coming of Jesus Christ.[131]

Today we know the source of the prophecies that Lactantius attributed to the sibyls. They were taken from the vast compilation of the *Oracula sibyllina*, which was composed by the Jews of Alexandria toward the second century before Christ, but later reworked by the Christians.[132] These predictions—at least all that foretell a precise event—were composed after the fact. However, Lactantius wrote in good faith; and, since the Greek text of the *Oracula sibyllina* was not discovered until 1545,[133] it is not surprising that the humanists of the fifteenth century took Lactantius at his word.

The sibyls of Rimini and of Ulm testify to the vogue enjoyed by Lactantius in the second half of the fifteenth century.

Lactantius' book, which had inspired beautiful works of art in Italy and in Germany, inspired several others in Italy, also. The sibyls in the pavement of the cathedral of Siena, and those that Perugino painted in the Cambio of Perugia all hold phylacteries on which are written the prophecies taken from the *Divinae institutiones*.[134]

But there is a second family of sibyls far richer than the foregoing. Shortly before 1438, Cardinal Orsini had a series of sibyls—quite different in appearance—painted for his palace in Rome. The work has disappeared, but two manuscripts have preserved descriptions of it,[135] and several details are worth noting.

Up until then, there were only the ten sibyls of Lactantius, but in the Orsini palace there are twelve. The two new sibyls are named Europhile and Agrippa. Each sibyl is of a definite age, wears a particular

costume, and sometimes has an attribute. And the verses of a biblical prophet correspond to each oracle. Thus, the Delphic Sibyl is twenty-four years old, is dressed in silk, holds a horn in her hand, and her oracle corresponds to a verse of Moses. The Persian Sibyl is thirty, wears a golden robe, and crushes a serpent beneath her feet; a verse of the prophet Micah corresponds to her words. The Erythraean Sibyl is fifty, has a sword in her hand and beneath her feet is the circle of the heavens with its stars. She utters a mysterious phrase, and David replies with another. These examples give an idea of the work. It is important to note that the lines spoken by the sibyls differ greatly from those given to them by Lactantius. They are strange, obscure, and often incomprehensible. Where did they come from? And whence the traits that so explicitly characterize each sibyl? It is very difficult to say. We sense that we are in the presence of a fully developed cycle, but one whose origins we cannot uncover.

A third family of sibyls closely related to the preceding came into art in 1481. We find it in Italy, in a small volume called *Discordantiae nonnullae inter sanctum Hieronymum et Augustinum*, written by the Dominican Filippo Barbieri.

The title gives no indication of the contents, for the dissertation on Sts. Jerome and Augustine opening the volume is followed by several short treatises on disparate subjects, one of which is devoted to the sibyls and the prophets. This is the part that made the book famous;[136] it is also the only part that was influential.

Following the idea of the designer of the frescoes in the Orsini palace, Filippo Barbieri placed the sibyls in correspondence with the prophets. This is a dialogue between the pagans and the people of God; they speak in turn and one after the other foretell the coming of the Saviour. It will be helpful to reproduce all this part of Filippo Barbieri's little book.

I. *Sibylla Persica.* —*Sibylla Persica vestita veste aurea cum velo albo in capite dicens sic: Ecce bestia conculcaberis et gignetur Dominus in orbe terrarum, et gremium virginis erit salus gentium et pedes ejus erunt in valitudine* (sic) *hominum.*
—*Oseus propheta.* —*De manu factis . . .*[137]
II. *Sibylla Libyca.* —*Sibylla Libyca ornata serto viridi et florido in capite, vestita pallio honesto et non multum juvenis sic ait: Ecce veniet dies et illuminabit condempsa* (sic) *tenebrarum et solventur nexus Sinagogae et desinent labia hominum et videbunt regem viventium; tenebit illum in gremio virgo domina gentium et regnabit in misericordia et uterus matris erit statua*[138] *cunctorum.*
—*Jeremias propheta.* —*Ecce dies veniunt . . .*
III. *Sibylla Delphica.* —*Sibylla Delphica vestita veste nigra et capillis*

circumligatis capiti, in manu cornu tenens et juvenis, quae ante Trojana bella vaticinata est, de qua Chrysippus; ait: Nascetur propheta absque matris coitu ex virgine ejus.[139]

—*Jeremias propheta.* —*Revertere virgo . . .*

IV. *Sibylla Cimmeria.* —*Sibylla Emeria,*[140] *in Italia nata, Chimica, vestita coelestina veste deaurata, capillis per scapulas sparsis, et juvenis, de qua Ennius; ait: In prima facie virginis ascendet puella pulchra facie, prolixa capillis, sedens super sedem stratam,*[141] *dans ei ad comedendum vis*[142] *proprium, id est lac de coelo missum.*

—*Joel propheta.* —*In diebus illus effundam . . .*

V. *Sibylla Erythraea.* —*Sibylla nobilissima Erythraea, in Babylonia orta; de Christo sic ait: In ultima autem aetate humiliabitur Deus et humanabitur proles divina, jungetur humanitati divinitas. Jacebit in feno agnus et officio puellari educabitur Deus et homo. Signa praecedent apud Apellas.*[143] *Mulier vetustissima puerum praemium corripiet. Boetes orbis mirabitur, ducatum proestabit ad ortum.*[144]

—*Ezechiel propheta.* —*Porta haec clausa erit.*

VI. *Sibylla Samia.* —*Sibylla Samia a Samo insula, nudum ensem sub pedibus, formosum pectus, subtileque velum capiti habens, sic ait: Ecce veniet dies et nascetur de paupercula et bestiae terrarum adorabunt eum et dicent "laudate eum in atriis coelorum."*

—*David propheta.* —*Adorabunt eum . . .*

VII. *Sibylla Cumana.* —*Sibylla Cumana fuit tempore Tarquinii Prisci, scripsit de Christo haec, referente Virgilio in lib. Bucolic. in hunc modum:*

> *Utima Cumaei venit jam carminis aetas;*
> *Magnus ab integro saeclorum nascitur ordo.*
> *Jam redit et virgo, redeunt Saturnia regna,*
> *Jam nova progenies coelo demittitur alto.*
> *Casta, fave, Lucina, tuus jam regnat Apollo.*

—*Daniel propheta.* —*Abscissus est de monte lapis . . .*

VIII. *Sibylla Hellespontica.* —*Sibylla Hellespontica, in agro Trojano nata, vetusta et antiqua, veste rurali induta, ligato velo antiquo [capite] sub gula circumvoluta usque ad scapulas quasi despectu de qua scribit Heraclides; dicens: De excelsis coelorum habitaculo prospexit Deus humiles suos. Et nascetur in diebus novissimis de virgine hebraea in cunabulis terrae.*

—*Jone (VI)*[145] —*"Ponam vellus hoc lanae in area, si ros in solo vellere fuerit, et in omni terra siccitas, sciam quod per manum meam, sicut locutus es, liberabis Israel. Factumque est ita: de nocte consurgens et, expresso vellere, concham rore implevit."*

IX. *Sibylla Phrygia.* —*Sibylla Frigia, nata apud Phrygios, mediocris aetatis, habitu et mantello rubeo, in modum mulieris nuptae, licet virgo, de Christo sic dicit:*[146] *Flagellabit dominus potentes terrae, et Olympo*

excelso veniet, et firmabit concilium in coelo, et annuntiabitur virgo in vallibus desertorum.

—*Malachia propheta.* —*Ecce ego mittam angelum.*

X. *Sibylla Europa.* —*Sibylla Europa, decora, juvenis, facie rutilans, velo subtilissimo capite ligata, induta veste aurea, de Christo sic ait: Veniet ille et transibit montes et colles et latices sylvarum Olympi; regnabit in paupertate et dominabitur in silentio et egredietur de utero virginis.*

—*Zacharias.* —*Exulta, Filia Sion . . .*

XI. *Sibylla Tiburtina.* —*Sibylla Tyburtina* (sic), *quam Lactantius Tyburtem vocat, nomine A[l]bunea, quae Tyburi colitur ut dea juxta ripas amnis, in cujus gurgite simulacrum ejus inventum dicitur tenens in manu librum; haec de Christo prophetavit: Nascetur Xristus in Bethleem et annunciabitur in Nazareth, regente Tauro pacifico, fundatore quietis:*[147] *O felix mater cujus ubera illum lactabunt! —Haec tunica crocea vestietur, violato mantello superimposito.*[148]

—*Micheus propheta.* —*Et tu, Bethleem . . .*

XII. *Sibylla Agrippa.* —*Sibylla Agrippa sic ait de Christo: Invisibile verbum palpabitur et germinabit ut radix et siccabitur ut folium, et non apparebit venustas ejus et circumdabit eum alvus maternus et flebit Deus laetitia sempiterna et ab hominibus conculcabitur et nascetur ex matre ut Deus et conversabitur ut peccator.*[149]

A close examination of these pages reveals that Barbieri's sibyls have a strong resemblance to those of the Orsini palace. Like them, they are twelve in number. The oracles they pronounce are similar, and the prophets' words reply to theirs. Thus, the general composition of the two works is identical, but the details vary. It is not the same prophets who reply to the sibyls and the verses they utter are different. Barbieri does not indicate the numerical age of the sibyls, content to represent them as young, middle-aged, or aged. He does not always give them a costume and an attribute similar to those of the Orsini palace. He retains the name of the Sibyl Agrippa,[150] but calls Europhile *Europa.*

In Barbieri's work, the oracles of the sibyls, which are the same as those of the Orsini palace, are sometimes much longer. These additions are valuable, for they allow us at least one glimpse of the source of this strange prophetic literature. Many oracles circulated throughout Italy which apparently originated in the monasteries of the south.[151] One interesting example that has been preserved is a long prophecy spoken by the Erythraean Sibyl, and begins with these words: "Exquiritis, ilustrissima turba Danaum. . . ."[152] Filippo Barbieri knew this passage perfectly, and the proof is that he extracted two passages from it. From it come the words: "In ultima aetate humiliabitur Deus, et humanabitur proles divina," etc., which he attributed to the Erythraean Sibyl; and also the mysterious words that he put into the mouth of the Sibyl of Tibur: "Regente Tauro pacifico, fundatore quietis."[153]

If he borrowed these two passages, it is certain that neither he nor the designer of the frescoes in the Orsini palace invented the others;[154] it seems to me that Italian scholars could easily find all the originals.

Filippo Barbieri's book had astonishing success in Italy. It was published in 1481; and, it is precisely just after that date that the use by Italian artists of the motif of the twelve sibyls began to increase. It was at a date later than 1481 that Baccio Baldini (if indeed it was he) made copper engravings of them, as well as of the prophets (fig. 137).[155] In 1485, Ghirlandaio painted them for the church of the S. Trinità in Florence. In 1492, the miniaturist Attavante used this new motif to ornament the Breviary of Mathias Corvin. In 1493, they appeared in Rome on the bronze tomb of Pope Sixtus IV, the work of Pollaiuolo.[156] In 1494, Pinturicchio represented them in one of the rooms of the Borgia apartments in the Vatican, and in 1501, in the church of S. Maria Maggiore at Spello.[157] In 1509, an unknown artist drew them on the walls of the church of S. Giovanni at Tivoli. At very nearly the same time, they were painted in Rome at S. Pietro in Montorio and at S. Maria sopra Minerva. These examples, which could easily be added to, will suffice.[158] But what is worth noting here is that all these figures of sibyls are accompanied by inscriptions borrowed from Filippo Barbieri's

137. Sibyl of Samos. London, British Museum. Engraving attributed to Baccio Baldini.

book. In all of them, the Tiburtine Sibyl says: "Nascetur Christus in Bethleem"; the Persian Sibyl says, "Ecce bestia conculcaberis"; the Sibyl of Samos says, "Ecce veniet dies et nascetur de paupercula"; etc. Sometimes the artists even went so far as to borrow the costumes and attributes assigned to the sibyls by Barbieri. This was why Baccio Baldini in his engravings, and the anonymous painter of Tivoli in his frescoes, gave a cornucopia to the Delphic Sibyl and covered the head of the Hellespontine Sibyl with a veil.

The motif of the sibyls and the prophets, made fashionable by Filippo Barbieri, was used by Michelangelo himself. The imposing figures painted on the ceiling of the Sistine Chapel from 1508 to 1512, are not mysterious and inexplicable, as they have so often been said to be; they belong to an already long tradition. Michelangelo did what twenty others had done before him; what is more, he had recourse to the same guide: that proud genius did not disdain to leaf through Filippo Barbieri's little book.[159]

We are aware that he took great liberties with his model. The man who had the audacity to break with the oldest traditions of Christian art, who painted Christ as a wrathful Apollo, stripped the apostles of their tunics and the angels of their wings—such a man was not disposed to submit to the caprices of a Filippo Barbieri. He did not fall in with the childishness of the good monk. He began by divesting the sibyls of their swords, their cornucopias, their garlands of flowers, and their golden robes; then he clothed them in costumes that were beyond the human, that seemed to be timeless, evoking the sense of the eternal.

However, there are several indications that Michelangelo had looked at the book; they are small, but they reinforce each other.

First of all, he placed the Erythraean Sibyl beside the prophet Ezekiel, and the Cumaean Sibyl beside the prophet Daniel: this is the disposition adopted by Filippo Barbieri. Following his model, he represented the Delphic Sibyl as young, and placed a veil over the head of the Persian Sibyl. The prophets represented by Michelangelo—Isaiah, Ezekiel, Daniel, Jeremiah, Joel, Zechariah, and Jonah—are precisely the same in number as those chosen by Filippo Barbieri, who did not name them all. Michelangelo would probably not have thought of Zechariah and Jonah, among the least of the prophets, had he not had before him a list from which he had only to choose.[160] It is the choice of Jonah, above all, that is unusual and reveals his borrowing. In fact, Filippo Barbieri's book, which is decorated with wood engravings, shows Jonah cast up by the whale; and this is the way Michelangelo represents him. But what is extraordinary is that the words attributed to Jonah by Filippo Barbieri do not belong to Jonah at all, but to Gideon; this is the famous passage about the fleece wet with dew, found in the Book of Judges. A theologian as learned as Filippo Barbieri would not have committed

such an error; we surmise that the substitution of the name Jonah for that of Gideon was due to a printer's error.[161] The artist illustrating the book saw the name of Jonah and read no further; he thought he was doing the right thing in representing the prophet cast up by the whale. Thus, through the mistake of a printer, Jonah was introduced into the company of the sibyls. Michelangelo, who probably did not look very closely at Barbieri's book, saw a print representing Jonah and the whale, and that was enough.

It seems to me there can be no doubt that Michelangelo had seen Barbieri's book. If such was the case, we can hardly exaggerate our respect for the humble little volume; it contributed to the conception of a sublime work of art. Possibly the alternating chants, which all refer to a Saviour, had opened the dream world to Michelangelo. The magical names of the sibyls and prophets, these mysterious words were perhaps enough to cause a storm of poetry to burst in his soul.[162]

V

Filippo Barbieri's book was read in France also, and it helped to spread the theme of the twelve sibyls here at home. In 1474, only one of the sibyls figured in the *Incarnation Mystery* played at Rouen, the Erythraean Sibyl who followed the prophets and recited the traditional verses on the Last Judgment. But at the end of the fifteenth century, the author of the *Valenciennes Mystery* introduced all twelve into his play.[163]

It must have been at a date not much later than 1481 that a French artist for the first time painted the twelve sibyls. I have encountered them in a missal of the Sainte-Chapelle, which must have been illuminated in the last years of the fifteenth century probably in Paris;[164] they accompany the representation of the Nativity. Never was an artist more respectful: not only did he borrow from Filippo Barbieri the words spoken by each of the sibyls,[165] he even conformed scrupulously to his descriptions. Thus, the Libyan Sibyl wears a crown of flowers on her head, the Persian Sibyl is dressed in a golden robe, and the Samian Sibyl tramples a sword beneath her feet. But if Barbieri's sibyls were famous in France, those of the Orsini palace were not unknown. Here is an example.

In 1506, an unknown artist painted the sibyls in the cathedral of Amiens. Only eight remain, found behind the paneling in 1844.[166] At first glance, these appear to be Barbieri sibyls: the oracles they carry on phylacteries are, in fact, borrowed from him word for word.[167] But a single detail proves that the artist had seen a somewhat different series, that of the Orsini palace. In fact, the Erythraean Sibyl has under her feet the starry circle of the heavens, which is found in the Roman fresco and derivative manuscripts but not in Barbieri's book.

The importance of the book by Filippo Barbieri.

In spite of their vogue, these two series of sibyls, of Filippo Barbieri and the Orsini palace, did not make our learned men forget Lactantius. The sibylline oracles recorded in the *Divinae institutiones* were still read with respect; certain theologians, perhaps judging them to be more authentic, seemed even to prefer them. At the beginning of the sixteenth century, the painter Simon de Châlons decorated a chapel in Avignon with figures of sibyls. It was undoubtedly a theologian who planned the artist's program. Faithful to the tradition followed by Lactantius, he limited the sibyls to ten; the words to accompany each figure were all taken from the *Divinae institutiones*.[168]

This is a significant example; it proves that minds were divided about Barbieri sibyls, the Orsini sibyls, and those of Lactantius. Consequently, the compromise at which literary men and artists arrived can be easily explained. Instead of setting these families of sibyls apart, they combined them. It was from this ingenious combination that our French sibyls, which differ so profoundly from the Italian, were born, and whose origin is well worth study.

This fourth family of sibyls, wholly new in character, appeared in the second part of the fifteenth century. It is thought that a book of woodcuts, preserved in the library of St. Gall, offers the earliest known example of this series. It has been dated about 1475.[169]

What is astonishing in this book is the novelty of the attributes the twelve sibyls carry. The Persian Sibyl holds a lantern, the Libyan Sibyl a candle, the Samian Sibyl a crèche, the Tiburtine Sibyl a hand, the Delphic Sibyl a crown of thorns, etc. The age of each is indicated precisely and the numbers correspond exactly to those of the Orsini palace. Their oracles are all the same as those of the Orsini palace, but several times combined with those given by Lactantius.

Is the St. Gall book the real prototype of this new family of sibyls? One may well ask, for one of the most beautiful manuscripts of the Bibliothèque Nationale was illuminated at almost the same time, the Hours of Louis de Laval.[170]

Born in 1411, Louis de Laval died in 1489; in 1469 he received the Order of St. Michael, and he was shown wearing it in one of the miniatures. Hence, the manuscript must be later than 1469, but perhaps not very much. It could be contemporary with the book of St. Gall, possibly even somewhat earlier in date. The two works are similar, but there is perhaps no direct connection between them. The canon was so firmly established that we sense an earlier model, conceived with such feeling for order and method that we wonder if it was not French. In any case, most of the French sibylline series certainly belonged to this group.

It is thus worthwhile to study the sibyls of the Hours of Louis de Laval carefully.

First of all, there is the Persian Sibyl (fig. 138). We shall see quite clearly what the artist (aided no doubt by a scholar) borrowed from Lactantius, what he borrowed from the Orsini palace, and what he imagined for himself.

Above the Persian Sibyl we read this inscription: "Sibylla Persica, XXX annorum, cujus mentionem facit Nicanor." And at once we recognize that this precise specification, "the Persian Sibyl mentioned by Nicanor," is taken from Lactantius.

Beneath the feet of the Persian Sibyl there is another inscription. This time, it is the sibyl who speaks and says: "Ecce bestia conculcaberis et gignetur Dominus in orbe terrarum et gremium virginis erit salus gentium. . . ." It does not take long to realize that these are the very words assigned to the Persian Sibyl in the frescoes of the Orsini palace. But there is something new: the Persian Sibyl carries a lantern in her hand. Where did this unusual attribute come from? It is the invention of the artist, or rather of his collaborator, the theologian. In fact, we read this explanation above the head of the sibyl: *Videtur (Persica) vaticinari de futuro salvatore gentium sub nubilo.* ("The Persian Sibyl seems to foretell the Saviour under a cloud.") The oracle is obscure, and in order to show the light as if it were veiled, the artist gave the sibyl a lantern from which a dim light glimmers.[171] A last detail is borrowed from the Orsini palace. The inscription ascribes a definite age to the sibyl: she is thirty years old, as in the Roman fresco.

138. Persian Sibyl. Hours of Louis de Laval. Paris, Bibliothèque Nationale, ms. lat. 920, fol. 17v.

The Libyan Sibyl follows (fig. 142). She holds a lighted candle. The following inscription accompanies her: "Sibylla Libyca, XXIV annorum, cujus meminit Euripides. *Videtur clare vaticinari de adventu Salvatoris cum prophetis.* Ecce veniet deus et illuminabit condensa tenebrarum et solvet nexus Synagogae . . ." etc.

This is the inscription of the Orsini palace fresco, but the commentator added a sentence which reveals its meaning: the sibyl, he says, *clearly* foretold the coming of the Saviour. That is why the artist, wishing to make it understood that the Libyan Sibyl's prophecy was clearer than that of the Persian, placed in her hand a lighted candle with unveiled flame rather than the lantern.

The Erythraean Sibyl holds a flower (fig. 143). The inscription above her head reads; "Erithraea (XV) annorum, dicta Eriphila. *Videtur vaticinari de Christi annuntiatione per angelum facta.* De excelso coelorum habitaculo prospexit Deus humiles et nascetur in diebus novissimis de Virgine hebraea . . ." etc. The oracle borrowed from the Orsini palace could, perhaps, relate to the Annunciation. This was suggested by the artist in giving the Erythraean Sibyl a flower as attribute. For, as we have explained elsewhere,[172] the flower is a symbol of the Annunciation: ever since the thirteenth century painters had placed without fail a beautiful vase of white roses or lilies between the Virgin and the Angel Gabriel.

139. Cimmerian Sibyl. Hours of Louis de Laval. Paris, Bibliothèque Nationale, ms. lat. 920, fol. 22v.

140. European Sibyl. Hours of Louis de Laval. Paris, Bibliothèque Nationale, ms. lat. 920, fol. 23v.

141. Persian Sibyl. Hours for use of
Rouen. Paris, Simon Vostre, 1508. Paris,
Bibliothèque Nationale, Vélins 1657.

142. Libyan Sibyl. Hours for use of Rouen.
Paris, Simon Vostre, 1508. Paris,
Bibliothèque Nationale, Vélins 1657.

143. Erythraean Sibyl. Hours for use of
Rouen. Paris, Simon Vostre, 1508. Paris,
Bibliothèque Nationale, Vélins 1657.

144. Cumaean Sibyl. Hours for use of
Rouen. Paris, Simon Vostre, 1508. Paris,
Bibliothèque Nationale, Vélins 1657.

The Cumaean Sibyl carries a small gold-colored basin (fig. 144).
"Sibylla Cumana," the inscription says, "XVIII annorum. *Videtur va-*
ticinari de nativitate Christi in Bethleem. Ultima Cumaei venit jam car-
minis aetas ..." etc. These are the verses from Virgil inscribed in the
Orsini palace. The inscription tells us that these verses relate to the
Nativity of Christ. But how could the golden bowl held by the sibyl
symbolize the Nativity? This is a real enigma that even contemporaries
scarcely understood, for I have often seen sixteenth-century represen-
tations in which the artist gave the Cumaean Sibyl, instead of a bowl,
something resembling either a round loaf of bread split in the middle,
or a shell.

250

145. Samian Sibyl. Hours for use of
Rouen. Paris, Simon Vostre, 1508. Paris,
Bibliothèque Nationale, Vélins 1657.

146. Cimmerian Sibyl. Hours for use of
Rouen. Paris, Simon Vostre, 1508. Paris,
Bibliothèque Nationale, Vélins 1657.

147. Sibyl Europa. Hours for use of
Rouen. Paris, Simon Vostre, 1508. Paris,
Bibliothèque Nationale, Vélins 1657.

The Samian Sibyl carries a crèche (fig. 145). The inscription reads:[173] "Sibylla Samia, annorum XXIII. *Videtur vaticinari de hoc quod virgo reclinavit puerum in praesepio.* Ecce veniet dies et nascetur puer de paupercula, bestiae terrae adorabunt eum." The artist and his collaborator had ingeniously interpreted the text of the Orsini palace. It is clear that they wished to see in "those beasts of the earth who adored the Child," the ox and the ass of the Nativity. This interpretation naturally led them to place a crèche in the hands of the Samian Sibyl.

The Cimmerian Sibyl had a horn-shaped vessel as attribute, which is nothing but a baby's bottle (fig. 139). The inscription, in fact, says: "Sibylla Cymeria, (annorum) XIIII.... *Vaticinatur quo modo Virgo lactet puerum.* In prima facie virginis ascendit virgo quaedam ... nutriens puerum, dans ei ad comedendum lac...." Thus, the prophecy heralded the feeding of a child by a virgin. We must admit that it was not easy to find an attribute for the Cimmerian Sibyl: with a naïveté that draws a smile, the artist had her carry a nursing bottle.

The Sibyl Europa holds an unsheathed sword (fig. 140). "Sibylla Europa," the inscription says, "annorum XV, inter ceteras pulcherrima. *Videtur vaticinari de fuga pueri cum matre ejus in Aegypto.* Veniet ille et transiliet colles et montes et latices Olympi, regnabit in paupertate et dominabitur in silentio...." Nothing could be vaguer, it must be admitted, than these words given to the beautiful Sibyl Europa. Our theologian wished to be precise, even at the price of subtlety. He imagined that the phrase, "He climbed the hills," referred to the Flight into Egypt. Thus, he decided that the Sibyl Europa should carry a sword to recall the Massacre of the Innocents and the danger the Infant escaped by his flight.

The Tiburtine Sibyl holds an amputated hand (fig. 148). The inscription is fairly long; the first part reads: "Sibylla Tiburtina, XX annorum, quae prophetavit Romanis et *vaticinata est de Christi alapatione.* Flagellabit homines potentes, excelsus veniet et firmabit consilium in coelo, annuntiabitur virgo in vallibus desertorum. . . ." This text is obscure and in fact suggests nothing very precise. That is why the theologian, trying in desperation to draw something from it, added this passage from Lactantius: "In manibus infidelium postea veniet, dabunt Domino alapas, accipiens tacebit, ne quis agnoscat." At least the second part of the prophecy is clear: it has to do with the beginning of the Passion and the blows Jesus uncomplainingly received. Consequently, it was the passage from Lactantius that determined the choice of attribute: the amputated hand the sibyl carries like a barbaric trophy is the sacrilegious hand that struck Christ.[174] This is indeed a strange attribute for the young sibyl! But at the time it was still the custom to cut off the hands of parricides and desecrators.

The Sibyl Agrippa carries a whip (fig. 149). Above her head is this inscription: "Agrippa, XXX annorum. *Viticinatur de flagellatione.* Invisible verbum palpabitur . . . et conversabitur ut peccator." This time our author thought the sentences had a reasonable meaning. He was seeking in them a new allusion to the Passion: he found it, but somewhat suiting himself. It is clear that he translated "verbum palpabitur," not by "the Word might be touched," but by "the Word might be scourged." Given this meaning, it was only natural to give the whip as attribute to the Sibyl Agrippa.

The Delphic Sibyl holds a crown of thorns (fig. 150). The inscription reads: "Delphica, XX annorum. *Vaticinatur de Christi coronatione.* Nasci

151. Hellespontine Sibyl. Hours for use of Rouen. Paris, Simon Vostre, 1508. Paris, Bibliothèque Nationale, Vélins 1657.

152. Phrygian Sibyl. Hours for use of Rouen. Paris, Simon Vostre, 1508. Paris, Bibliothèque Nationale, Vélins 1657.

debet propheta absque maris coitu de femina nomine Maria ex stirpe Judaeorum, filius Dei, nomine Jesus, qui videbitur in manibus infidelium et corona spinea coronabitur." This is a composite prophecy, made by combining a text from the Orsini palace with one from Lactantius. The first part of the prophecy refers to the birth of the Saviour. But our theologian needed a sentence that could apply to the Passion: he found it in Lactantius, who had the sibyl foretell the crown of thorns. Consequently, the attribute of the Delphic Sibyl was quite appropriate.

The Hellespontine Sibyl carries a large cross (fig. 151). The inscription explains this attribute as follows: "Sibylla Hellespontica. L annorum. *Vaticinata est de futura Christi crucifixione*. Jesus Christus nascetur de casta. Felix ille Deus ligno qui pendet ab alto." Here again our author found the first sentence too vague. Since he wished to have the entire Passion foretold by the sibyls, he needed a text that referred to the death of Christ on the cross. He found none in Lactantius, so he used a passage from Sozomen, which must have been famous as it was also inscribed on the stalls of Ulm. By this artifice, the Hellespontine Sibyl, who until now had foretold only the birth of Christ, could also foretell his death on the cross.

The Phrygian Sibyl also carries a cross, but it is the tall cross decorated with a banner, called the Cross of the Resurrection (fig. 152). This is the triumphal cross carried by Christ, the conqueror of death, when he rose from the tomb. In the hands of the Phrygian Sibyl, it could only recall the Resurrection. In fact, the text explains it as follows: "Sibylla Phrygia, vetusta, *vaticinata est de Christi resurrectione*. Nascetur Christus in Bethleem, annuntiabitur in Nazareth, regnante Tauro pacifico.[175] Suspendent illum in ligno, et occident, et nihil eis valebit, quia tertia

die resurget et ostendet [se] discipulis suis, et ipsis videntibus, ascendet in coelum et regni ejus non erit finis."—A prophecy contrived like the others by combining a text from the Orsini palace and one from Lactantius.

We now see how the French sibyls differed from the Italian. The sibyls of the Orsini palace and those of Filippo Barbieri foretold only one event: the coming of a Saviour who would be miraculously born of a Virgin. The new sibyls were much more knowledgeable: they spoke not only of the supernatural birth of the Son of God, but also of his infancy, his sufferings, his death and resurrection.[176] Lactantius completed the Orsini palace inscriptions. The attributes our sibyls carry have particular meanings: they foretell in abridged form the life of Christ. They are not placed haphazardly, but in logical order: first come those who foretold that a Saviour would be born; then those who spoke of his birth and infancy; and lastly, those who spoke of his Passion, death, and resurrection.[177]

These new sibyls, encountered for the first time in France in the Hours of Louis de Laval, were soon to be found in other French manuscripts. They occur in a prayer book, now in the Arsenal, illuminated by Jean de Montluçon, who perhaps had the Hours of Louis de Laval in front of him as he worked.[178] We find them again in the Hours of René II of Lorraine, painted in the early years of the sixteenth century.[179] Henceforth, the type was established; the attributes the sibyls carried and the words they pronounced would not vary.

But I believe that the vogue of the sibyls in France dates from the period when the great Parisian printers began to decorate their Books of Hours. In 1488 the sibyls appeared in the Hours of Vérard, and soon after in the Hours of Simon Vostre; we find them among the periwinkles and strawberry blossoms decorating the margins. They carry their usual attributes: the lantern, the candle, the rose, the crèche, the crown of thorns. Sometimes not very good French verses translate or paraphrase the Hours of Louis de Laval.[180]

We know what favor the charming little books of Vérard and Vostre found. They were adapted to the use of a large number of dioceses in France: thus, the images of the sibyls were known everywhere. Painters, glass painters, and sculptors were provided with a guide which told them what attribute belonged to each sibyl. This explains the close resemblance between widely separated works of art.[181]

It would be tedious to review all the series that are so much alike.[182] Let one remark suffice. Sibyls were frequently used to decorate the doors of churches: at Clamecy, Dreux, and St.-Michel in Bordeaux, they are carved on the portals; at the cathedral of Aix (fig. 153), and the cathedral of Beauvais (figs. 122 and 123), they are carved on the panels of the door. Here, more than mere chance must be involved.

Theologians probably decided that this was the most suitable place for the sibyls. The prophetesses of the Gentiles had, in fact, seen the City of God from afar but had not entered; their place was on the threshold of the temple.

The sibyls are often shown alone, but sometimes they are included in great dogmatic groups.

Usually they are associated with the prophets, as we have seen. That there was something dramatic in the words of hope these inspired orators uttered was soon evident. In Florence they were made into a Mystery Play.[183] Italian art seized on this motif which Michelangelo consecrated with his incomparable masterpiece.

In France, we also find the sibyls associated with the prophets. On the stalls of Les Ponts-de-Cé,[184] sibyls and prophets are grouped as they are in Filippo Barbieri's book: the Persian Sibyl with Hosea, the Hellespontine Sibyl with Jonah (fig. 154), the Phrygian Sibyl with Malachi, the Erythraean Sibyl with Ezekiel.

But sometimes a further step was taken: the sibyls were united with both prophets and apostles. On the backs of the pages devoted to each sibyl in the woodcut book of St. Gall, an apostle and a prophet are represented; above them is shown the scene in the life of Christ which they, along with the sibyl, foretold, but in different terms. The Hours of Louis de Laval has a quite similar composition (fig. 155), and one to be found also in manuscripts and stained glass windows.[185]

Thus, the pagan prophetesses brought together with the prophets and the apostles became part of the great concert. The plan of the world seemed to be revealing itself.

At times the sibyls were introduced into even ampler cycles. For breadth of thought, no work of this period compares with the windows of Auch.[186] They are laid out as follows:

A first window shows the Creation, and then the Fall. Adam spades the ground, Cain kills Abel: labor and death enter the world as a consequence of the original sin.

Then, the history of the world unfolds.

First, there are the patriarchs: Noah, Abraham, Isaac, Jacob, and Joseph, who are the ancestors of the Saviour awaited by man. Then comes the line of prophets who, from one generation to another, herald the Messiah to the people of God. Then, there are the sibyls who, among pagans, speak the same language as the prophets. Finally, there are the apostles who make known to all the world the doctrine of the God whose death on the cross is depicted in the last window.

Thus, the windows of Auch tell the history of the world, making its harmony felt. Each window unites in its compartments a patriarch, a prophet, a sibyl, and an apostle:[187] the different ages of the world meet and acknowledge each other.

153. The Sibyls. Aix-en-Provence (Bouches-du-Rhône), Cathedral. Wood sculptures, doors (detail).

154. Hellespontine Sibyl and the Prophet Jonah. Les Ponts-de-Cé (Maine-et-Loire), Church of St.-Maurille. Wood stalls.

155. Nursing Virgin. Prophet and apostle. Hours of Louis de Laval. Paris, Bibliothèque Nationale, ms. lat. 920, fol. 23.

It is difficult not to be struck by the analogies between the Auch windows and the ceiling of the Sistine Chapel. There is the same conception of history. True, the apostles are missing from the Sistine Chapel: Michelangelo's work is solely prophetic, and the impression it gives is one of vast expectancy. But in the Sistine Chapel, as in Auch, we see the creation of the world, the creation of man and woman, the Fall, the history of the patriarchs, the ancestors of Christ according to the flesh,[188] and finally, the ancestors of Christ according to the spirit, that is, the prophets and the sibyls. The analogy is complete. It would be childish to suppose that Arnaud de Moles, who created the windows at Auch, knew Michelangelo's frescoes; moreover, the two works are exactly contemporary.[189] They simply testify to the rapid spread of humanistic ideas and to the profound influence of the books devoted to the sibyls.[190]

Thus, it is not exactly true to say that the artists of the late Middle Ages had lost the ability to create great symbolic ensembles. And neither is it true to say that they were content merely to copy; they too invented. By placing the sibyls alongside the prophets and apostles, they broadened history and enlarged the City of God. This, indeed, is the noble symbolism to be expected of a century that had rediscovered antiquity.

Even today the sibyls stir us. Their names are enough to move us. Asia, Africa, Greece, and Italy speak through their mouths. From Persia to the Hellespont, from the Hellespont to Cumae, from Cumae to Libya, they form a circle around the cradle of Christ. At Samos where Anacreon sang, at Tibur where Horace sang, they foretold an unknown God. The Erythraean Sibyl of Ionia who spoke to the Atrides proclaimed that a virgin would give birth.[191] The Sibyl of Cumae, guardian of the golden bough and the gates of the dead, wrote on leaves carried by the wind that a Child would descend from the heavens. The beautiful priestess of Apollo, she who sat on the sacred tripod, the Delphic Sibyl herself, carried in her hand a crown of thorns. Wonderful poetry! And this is the supreme revelation of the "sacred Python," and what is taught by "the word of Golden Hope":[192] a God will come in order to die and he will be greater than the immortals.

The thoughts that occur to us today in the presence of the dazzling sibyls of Auch or of Beauvais must often have come to the minds of the learned men of the sixteenth century. All the poetry of antiquity seems present to us. What does it matter that the texts spoken by the sibyls were invented in the fifteenth century? The truth that they express is not tied to a few obscure phrases. They teach us that the pagan world had a presentiment of Christianity. They remind us that Plato defined virtue as "the imitation of God," that Sophocles spoke of the laws that are superior to the laws of men, that Virgil placed in the Elysian fields,

alongside poets and heroes, "those who love others," and that in all his truly prophetic work

> *L'aube de Bethléem blanchit le front de Rome.*

(The dawn of Bethlehem lightened the face of Rome.)

VI

The fifteenth century, as we have seen, was capable of expanding the old symbolism. By introducing the sibyls into the choir of prophets and apostles, they paid homage to the newly rediscovered wisdom of the pagans.

But this is not yet all: we shall discern through other aspects the spirit of the new age.

The miraculous continuity of the Old and New Testaments that the artists of the Middle Ages had expressed in such diverse ways appeared at the end of the fifteenth century in a completely novel form.

The history of the City of God was conceived as a triumphal march.[193] Christ advances mounted on a triumphal chariot, preceded by the men of the Old Law and followed by the heroes of the New; thus, he appears in the middle of Time and divides the history of the world in two.

The idea of this magnificent symbolic procession must have been conceived in Italy in the fifteenth century. Italy loved glory. The ideal of the thirteenth century had been "the saint"; the ideal of the fifteenth century was "the hero." A great ethical aspiration without glamor and radiance could no longer be imagined. The truly great man must have on his brow the flame lit by Athena above Achilles' head in the *Iliad*— the flame of glory. What man of this time was not dazzled by the heroes of antiquity who seemed bathed in light?

In the life of a Roman, one hour was the most dazzling of all: the hour of triumph. To ascend the Capitoline dressed as Jupiter, to be acclaimed by an entire people and followed by vanquished kings was to be raised above men and to become the equal of the gods.

All fifteenth-century Italy dreamed of these triumphant Romans. Alfonso of Aragon, the humanist who wanted to enter Naples through a breach in the wall, like the winners of the Olympic games, was represented on the gate of the Castel Nuovo mounted on a triumphal chariot. In 1491, Lorenzo de' Medici had the triumphs of Aemilius Paulus, as described by Plutarch, performed in the streets of Florence. During the same year, Mantegna was working at Mantua on the cartoons for the Triumph of Caesar, a work remarkable for precise erudition and for poetry, one of the most astonishing ever inspired by antiquity.[194]

The continuity of the Old and New Testaments conceived as a Triumph. The *Triumphus crucis* of Savonarola. The Triumph of Christ and the Triumph of the Virgin in French art.

France and Germany, in their turn, were inspired by the idea of glory. Maximilian wanted to be represented as triumphant conqueror, and he asked Dürer to make a drawing of his cortège and chariot.[195] In France, Roman triumphs found admirers even among the bourgeois of small towns: at Gisors, a sixteenth-century house was decorated with paintings representing the Triumph of Caesar.[196]

But it is most surprising of all to come upon a Triumph of Caesar in the margins of Simon Vostre's Hours (fig. 156).[197] The text accompanying the illustrations explains to the reader all the details of the ceremony. Thus, like temptation, the pagan idea of glory slipped into even the missal.

In the sixteenth century, mythology, allegory, and abstraction quite naturally took the form of triumphs in the hands of artists. There were triumphs of the gods, triumphs of the seasons, triumphs of the virtues, triumphs of the arts.[198]

Why should we be surprised that the fifteenth century conceived Christ himself as a triumphant hero, and the history of Christianity as a triumphal march? The idea has its grandeur, but belongs to this

156. Triumph of Caesar. Marginal illustration from the Hours of Simon Vostre. Paris, Bibliothèque Nationale, Vélins 2867, fol. K3v. 1508.

period alone. It would have shocked the Christians of the thirteenth century, the true disciples of St. Francis who loved a God "humble, patient, who had not reigned." It would have shocked the austere Christians of the seventeenth century also, who thought with Pascal "that Jesus Christ came in great pomp and in prodigious magnificence only to the eyes of the heart."

It was Italy that transformed Christ into a conquering hero. I have observed that Savonarola was the first in the fifteenth century to treat the history of the Christian faith as a triumphal ceremony. It was in his famous book *Triumphus Crucis*, that he demonstrated the truth of Christianity,[199] and in it this great scene appears:[200]

Christ is described as seated on a four-wheeled chariot. The Conqueror of Death allows the marks of his torture to be seen. Before the chariot march the patriarchs, the prophets, and the numberless horde of heroes and heroines of the Old Law. Around the chariot are grouped the apostles and the preachers who seem to join forces to make the chariot advance; then come the martyrs, and finally the theologians, who carry open books.[201]

In imagining this triumphal procession, Savonarola yielded to the taste of the time. And he undoubtedly had also in mind the miraculous Triumph of Beatrice, described by Dante in the *Purgatorio*, and above all the Triumphs of Petrarch and the many other works they had inspired.[202]

This page, in which Savonarola gives so picturesque a form to an abstract idea, was bound to attract artists' attention. Sandro Botticelli, the disciple of the great reformer, seems to have been the first to take note of it; he used the subject as the basis for a large composition, which he also engraved. "The best engraving done by his hand," said Vasari, "is the Triumph of the Faith, by Fra Girolamo Savonarola of Ferrara."[203] A previously mysterious sentence has now been clarified. Botticelli's engraving, which without any doubt represented the triumphal procession of Christ as it was described by Savonarola, is unfortunately lost.

Was Titian's great woodcut representing the Triumph of Christ inspired by a reading of the *Triumphus Crucis*, or simply by Botticelli's engraving?[204] We cannot say. But we can say that any such work is definitely related to the book by Savonarola.

In Titian's print, Christ appears in the center of the procession, mounted on a four-wheeled chariot (fig. 157). Before him march the heroes of the Old Law who hold up triumphal emblems, like Mantegna's Romans (fig. 158): Moses holds the Tables of the Law, Noah the ark, Abraham the sword of sacrifice, Joshua a breastplate surmounted by a sun. Women carry banners that billow in the breeze: these are the pagan sibyls who mix boldly with the patriarchs and the prophets.[205] This is the world of antiquity.

157. Chariot of Christ. Engraving from the series *Il Trionfo della Fede*. Titian. Berlin (Dahlem), Staatliche Museen Preussischer Kulturbesitz, Kupferstichkabinett.

But following the chariot is the procession of the Christian Church: apostles, theologians, martyrs; the instruments of torture held up against the sky become emblems of triumph; a giant St. Christopher, towering above the other saints, carries the Infant on his shoulders.

Certain details complete or correct Savonarola's description. The chariot is drawn by the four evangelical animals; four stalwart men carrying the mitre and the tiara push the wheels of the chariot; these are neither apostles nor preachers, as Savonarola had said; they are the four Fathers of the Church.

Titian's print, in its simplicity and its severity bordering on harshness, has epic grandeur. It must have aroused keen admiration, for several copies of it were made in France and Germany. It was through Titian's woodcut that the theme of the Triumph of Christ came to be known to our artists.

There is a representation of this new subject in a window in the church of Brou. Didron admired it very much, and not without reason, but his praise of the artist who drew the cartoon really belongs to Titian, for the glass painter of Brou merely copied his woodcut (figs. 159 and 160).[206]

The designer of the window of St.-Patrice, in Rouen, showed more originality (fig. 161). He also represented the Triumph of Christ, but without borrowing from Titian. However, he was acquainted with Savonarola's *Triumphus Crucis*: a theologian had probably made the picturesque beginning of the book known to him. The learned com-

158. Heroes of the Old Law. Engraving from the series *Il Trionfo della Fede*. Titian. Berlin (Dahlem), Staatliche Museen Preussischer Kulturbesitz, Kupferstichkabinett.

position of the window, which is conceived as a treatise on the Fall and the Redemption, would seem to indicate the participation of a man of the Church.

A triumphal chariot occupies the center of the composition. The heroes of the Old Law precede it, and among them we recognize Moses carrying the brazen serpent. Christ is mounted on the chariot, but he is the Christ nailed to the cross and dying for mankind. Precious vases stand at the foot of the cross, and seated in the front of the chariot is a woman. Who is she, and what is the meaning of the vases? Savonarola explains: "Placed on the chariot along with the victim, there must be the chalices and vases containing water, wine, oil, and balm. . . . Then, below the Christ, sits his mother."[207]

Thus, the vases symbolize the sacraments of the Church, "for," said Savonarola, "the Church with its sacraments succeeded the Passion, and it is from the Passion that the sacraments draw their virtue."[208]

Up to this point, the correspondence between the written work and the work of art is almost perfect. But in a lower section, there are unexpected figures for whom there is no longer an explanation in Savonarola: first there are Adam and Eve after the Fall, then a devil who is Satan, a fleshless figure who is Death, and lastly a magnificently dressed woman who is the Flesh.

Thus, the window at Rouen is even richer in thought than Savonarola's chapter, in which he simply says, "Christ triumphed." The window of Rouen adds: "Christ triumphed over the enemies unleashed by

159. Triumph of Faith. Brou (Ain),
Church. Stained glass window, left section
(detail).

160. Triumph of Faith. Brou (Ain),
Church. Stained glass window, right
section (detail).

man's transgression: Sin and Death." And in fact, in the upper section of the window we see a skeleton crushed by the victor under the wheels of his triumphal chariot: this is the defeat of Death.

The graveness of the thought, the grand manner of summarizing Christian doctrine by retaining only the two essential dogmas, indicate that we are entering a new era. The window of St.-Patrice is probably later than 1560.[209] For more than thirty years, the Protestants had been scoffing at the old exegesis, deriding the symbolic tradition of the Middle Ages, and setting the example of going back to the beginnings. They stripped Christianity of everything that had been added by the centuries, and brought it back to its two essential dogmas: original sin, and redemption through the blood of Christ.

Catholics were not unaware that there was some justification for sweeping away all secondary considerations and for leading Christian thought back to essential doctrines. Even they found medieval symbolism losing its authority. And they too were becoming accustomed to confronting directly the two essential dogmas of Christianity: the Fall and the Redemption. The Rouen window testifies to this new state of mind. Even a Protestant could have admired it, on condition that

161. Triumph of Christ. Rouen (Seine-Inférieure), Church of St.-Patrice. Stained glass window, north aisle.

he overlooked the vases at the foot of the cross, which bore witness to the virtue of the sacraments and the everlastingness of the Church.

I could cite several similar works created at the same time that testify to the same state of mind. A Flemish engraver, Hieronymous Cock,[210] had depicted a Triumph of Christ which closely resembled that of St.-Patrice in Rouen. Christ was mounted on his chariot bearing the standard of the cross;[211] marching behind the chariot like prisoners of war were the four vanquished enemies: the Devil, the Flesh, Sin, and Death.[212] The analogy is astonishing.

Other works dealt insistently with the theme of the entry of sin and death into the world as the result of man's transgression, and of their final defeat by a Redeemer. We do not know if such works were Catholic or Protestant.[213] I shall cite only one—from which the others seem to have derived: the engraving attributed without proof to Geoffroy Tory (fig. 162).[214]

162. Man between Sin and Redemption. Engraving. Paris, Bibliothèque Nationale, Cabinet des Estampes.

A nude figure, who is Man, appears in a great landscape. He is weighed down with guilt, for nearby we see the products of his transgression: Sin and Death. Alone, miserable, and naked, he would fall in despair were it not for two men who approach him: one is a prophet who tells him that a Saviour will come,[215] and the other is John the Baptist, who tells him that this Saviour has come. And in fact, on

the right is the Incarnation, inscribed with the name "Grace." Further on, Christ dies on the cross, to which an inscription gives the title "Our Justice."[216] The Lamb carries the banner; this is called "Our Innocence." Christ resurrected, rises from the tomb and crushes Death and the Devil underfoot, and this is called "Our Victory."[217]

It is clear that we have here the essentials of Christianity, expressed in a way that is forthright, decisive, and somewhat dry. In this engraving, the rich symbolism of the Middle Ages appears to be reduced to its simplest expression.

But let us return to our Triumphs, from which the window of St.-Patrice has caused us to stray.

Our artists were accustomed to seeing Christ on the triumphal chariot, and it soon occurred to them to honor his mother in the same way; Savonarola, moreover, seemed to invite this, since he had placed both Christ and Mary on the same chariot.

In one of his Books of Hours,[218] Geoffroy Tory, who was printer, writer, and artist all at once, included a curious plate devoted to the Triumph of the Virgin (fig. 163). The work is so ingenious and complicated, and contains so many references to classical antiquity, the Triumphs of Petrarch, and the poems of Jean Lemaire de Belges, that I have no hesitation in bestowing the honor of its invention on Geoffroy Tory himself. This humanist and former professor of rhetoric, the subtle author of *Champfleury* who Platonized and Petrarchized in turn, who found symbols in capital letters and mysteries in the seven holes of the flute, was quite capable of imagining this ingenious allegory; nothing could better express his turn of mind.

The Virgin is mounted on a chariot drawn by unicorns. Behind the chariot, as in Petrarch's Triumph of Chastity, Venus walks in chains with the captive women. Groups of young women walk ahead of the chariot: these are the seven Virtues, the seven Liberal Arts, and the Nine Muses.[219] This cortège proceeds toward a noble Renaissance edifice labeled "The Temple of Honor" clearly a reference to that other Temple of Honor in which Jean Lemaire de Belges placed the abode of wisdom.[220] Meanwhile, under the portico of a palace, kings watch this triumphal ceremony who are the descendants of Jesse, the ancestor of the Virgin. They are the kings the thirteenth century placed on the façades of cathedrals dedicated to Our Lady. Here, they line the route of her passage. The aged Jesse points to the daughter of their blood, and says to them:

> *Nobles rois, voici de Dieu l'ancelle*
> *Qui tous vous ennoblit, et non pas vous icelle.*

> (Noble kings, this is the servant of God
> Who ennobled all of you, you did not ennoble her.)

163. Triumph of the Virgin. Hours of the
Virgin, Geoffroy Tory, 1542. Paris,
Bibliothèque Nationale, Rés. B, 21303,
between fol. D8 and E1.

The artist who composed this allegory in the grand style was clearly
an admirer of Petrarch, but he was also a humanist whose mind was
filled with the glory of Rome. There can scarcely be any doubt that the
idea of a Triumph of the Virgin was suggested to him above all by the
recollection of Roman Triumphs. These four verses accompanying the
engraving are proof:

> *Les antiques Césars triomphèrent par gloire*
> *Mais par humilité (ainsi le faut-il croire)*
> *La Noble Vierge va triomphant en bonheur,*
> *Du palais virginal jusqu'au temple d'honneur.*

> (The ancient Caesars triumphed by glory
> But by humility (thus we must believe)
> The noble Virgin goes triumphant and happy
> From the virginal palace to the temple of honor.)

This Triumph of the Virgin seemed a happy invention. The en-
graving was thought worthy of being reproduced in a stained glass
window. In fact, a magnificent window in the church of Conches (Eure)
is simply a copy of the engraving from the Hours of the Virgin.[221] The
artist had before him the original we have attributed to Geoffroy Tory,
but he was of another school: his canon of beauty was that of the
Masters of Fontainebleau;[222] and this accounts for some slight differences
in detail. However, our description of the engraving may be applied to
this window in every detail.[223]

The window at Conches had great meaning for the donor: by this pious homage he wished to avenge the Virgin for all the insults heaped upon her by the Protestants. In fact, the church of Conches as a whole is a kind of refutation of Calvinism. In the right aisle, the windows demonstrate by symbols and events the dogma of the Eucharist, while the windows of the left aisle affirm the sanctity of the auxiliary powers of the Virgin. Not all these windows are contemporary, it is true, but it is clear that each donor had been told the theme to be developed and had conformed to it. The ardor of the religious controversies explains the success of the Triumph of the Virgin as it was imagined by Tory.

A window in the church of St.-Vincent, in Rouen, offers another example of the Triumph of the Virgin; but the subject is conceived with a grandeur not achieved by the window at Conches (fig. 164).[224] It is the history of the Fall and of Redemption; one woman releases all the sins of the world, another restores all the virtues.

First we see the Earthly Paradise, the graceful dream of a poet-artist. A beautiful procession winds its way through a great natural park where lambs graze with lions, and flights of birds pass overhead. Adam and Eve, innocent and naked, are seated on a gold chariot; they are the rulers of this new world. Young girls, the Virtues, walk before and behind the chariot. Thus, all is innocence, purity, faith, and love in the air breathed by this beautiful pair.

Lower in the window, the first sin has already been committed, and Evil has triumphed. Now it is the serpent, with the torso of a woman,

164. Window of the Chariots. Rouen (Seine-Inférieure), Church of St.-Vincent
(destroyed 1944).

who is mounted on the chariot. She is curled around the trunk of a tree, and a banner decorated with an image of Death flies above her head: such is the blazon of this new ruler of the world. Adam and Eve walk ahead of their conqueror, with hands tied and heads lowered. Toil and Grief accompany them, while a retinue of Vices walks behind the chariot. A mockery of pomp. Women mounted on symbolic beasts seem to flaunt their bestiality. They carry the noble banner stamped with the image of Justice that Adam had carried in the Earthly Paradise; but, by satanic irony, they have reversed the pennant, and the figure of Justice is upside down.

Another triumph follows this demoniacal victory. The first innocence returns at last; again all becomes pure, sweet, and enchanting. This time it is the Virgin, the New Eve, who is seated on the chariot. A band of angels flies before her and heralds her; a grave procession of prophets and patriarchs precedes her. A banner decorated with a white dove flies in the sky, and behind the chariot, a pensive crowd follows apparently meditating on the inscription unfolding on a streamer: *Tota pulchra es, amica mea, et macula non est in te.*

Such is this beautiful poem. A work unique of its kind, and one to which the thirteenth century itself could not have objected. Everything about this Rouen window is full of charm: the purity of the design, the liveliness of the colors like flowers fresh from the fields—red poppies, cornflowers, buttercups, crimson clover—and even the pretty background of pale azure where cathedrals are bathed in the blue of the atmosphere. The artist had surely seen Italian engravings: his Virtues are related to the dancing nymphs of Mantegna; his chariots recall those in the engravings of Baccio Baldini; but he remains no less original.

Had he also invented the subject? That would be difficult to say. At first I thought that some prize-winning *chant royal* of the *puy* of Rouen might have provided an outline for him, but I have found nothing comparable in the collection of pious verses written by sixteenth-century Norman poets in honor of the Virgin.[225] Generally, these little poems were as complicated as the window of St.-Vincent is simple; bad taste and puerilities abound in them. We have only to remember that Christ appears in one as an apothecary filling a prescription for Adam and Eve, who have had an attack of ague.[226] The *chants royaux* of the poets of Amiens were neither simpler nor more reasonable. The artists whose task it was to illustrate these riddles had a thankless task.[227] It is not easy to convey the idea that the Virgin is a scale of justice or a palm tree.

So, our artist owed nothing to contemporary poets. By its simplicity and nobility, his work is greatly superior to the *chants royaux* of Rouen and Amiens. The symbolism of the Middle Ages appears in it, reju-

venated by the spirit of the Renaissance. Some humanist canon probably provided him with an outline.

The window of St.-Vincent was much admired in Rouen, for the church of St.-Nicolas wanted to have one like it. The church of St.-Nicolas in Rouen has been destroyed, but happily, an eighteenth-century artist made sketches of its windows. His drawings have been preserved:[228] one of them represents the Triumph of the Virgin. Sketchy as they are, we have no trouble in recognizing almost all the details we have just pointed out in the window of the church of St.-Vincent. The St.-Nicolas window seems to have been a copy, pure and simple, and it was perhaps the work of the same artist.

This was not all. A bourgeois of Rouen had the same symbolic subject carved on the façade of his house. In 1841, the serpent could still be distinctly seen carried in triumph on a chariot preceded by the captives, Adam and Eve, and followed by the Vices mounted on animals. On another mutilated bas-relief, we can make out the Triumph of the Virgin.[229]

No doubt there were other works of the same genre that time has not spared. Those that remain are enough to prove that the Italian theme of the Triumph had been welcomed by our artists and was often renewed by their talent.

In short, we must recognize that it was Italy that toward the end of the fifteenth century enriched our old symbolism. France and the northern countries remained faithful to the teaching of the *Biblia pauperum* and the *Speculum humanae salvationis*, and the new works were often mechanical copies of the old. The genius that had presided over the marvelous symbolic combinations of the thirteenth century seemed to be exhausted. It was then that the Italians, in an effort to annex antiquity to Christianity, had invented these new themes. It was they who introduced the sibyls, that is, pagan wisdom, into Christian art; it was they who conceived the history of Christianity as equivalent to the triumphal ceremony of a Roman emperor.

Our artists accepted these symbols, but they did not imitate the models servilely. As we have seen, they were able to transform, combine, and arrange them;[230] consequently, we might say that this new symbolism (the last effort of Christian art) was born of the collaboration between France and Italy.

Part Two

DIDACTIC ART

VII

Art and Human Destiny: Human Life,
Vice and Virtue

Until the very end of the Middle Ages, as we have seen, the Church
had never ceased to instruct men in dogma by means of art. Did it
continue to provide moral instruction through its stained glass windows,
its frescoes, and statues? Was it as solicitous in the instruction of Chris-
tian obligation in the fifteenth century as it had been in the thirteenth?

We know how important a place was given to the images of the
Vices and Virtues in our cathedrals. We shall see that the art of the
late Middle Ages was not less profuse with warnings and counsels. But
a curious phenomenon had taken place: engravings, woodcut and il-
lustrated books dispensed to the faithful the moral instruction that had
once been the province of the cathedral.[1] To repeat the prophetic words
of Victor Hugo: "The Gothic sun set behind the gigantic printing press
of Mainz." The subjects once expounded on church porches were now
to be found in the margins of Simon Vostre's Book of Hours.[2] Small
and fragile books, printed in one day, were soon to replace the great
books in stone that it took a century to write. Monumental art did not
abdicate suddenly, however; for a long time to come, until the mid-
sixteenth century, stained glass windows and reliefs were to instruct
man in his duty and expound his destiny.

But illustrated books were often more expressive and more eloquent.
More than once we shall be able to make books speak when the church
is silent.

I

The art of the late Middle Ages first of all taught man his place in the
world. The fresco of the Campo Santo in Pisa is well-known: God
holds the universe in his arms; the earth is the center and the seven
planets describe circles around their immobile queen; the sun keeps its

Art of the late Middle Ages and scientific
discoveries. Art remains bound to the old
conception of the world. Art and astrology.
The influence of the planets.

place like a modest vassal; beyond the orbit of the planets is the invisible world and the hierarchies of angels.[3]

What could be more reassuring? How solid the earth was under the feet of those generations!

We find the same charming explanation of the enigma of the world here in France. Books published in the late fifteenth century, such as *Le Calendrier des bergers* (The Shepherds' Calendar)—a small encyclopedia of knowledge and ethics[4]—contain a similar illustration.[5] And it continued to be found in later editions reprinted until almost the end of the sixteenth century.

However, in 1491, the year when the first edition of the *Calendrier des bergers* appeared, a man was born who would halt the wheels of this antique machine, a mechanism as ingenious and naïve as the clock of the Strasbourg cathedral. As early as 1507 Copernicus had already glimpsed the true workings of the universe. His book, which dispossessed the earth of its ancient primacy, appeared in 1543. If by chance the printers and artists heard talk of these new ideas, they were not much disturbed by them. In 1560, the old *Calendrier des bergers* was reissued, without any changes. It still contained an engraving of a shepherd lost in contemplation of the circles made around the earth by the sun, moon, and planets (fig. 165); the good rustic is so enchanted with his learning that he forgets his flock; he does not notice that a wolf is making off with one of the lambs while his eyes are fixed on the stars.

Thus, to the end, the art of the Middle Ages remained faithful to the old conception of the universe; nothing troubled its serenity. In 1492, Christopher Columbus discovered new worlds, and just what he had discovered was soon apparent: no less than half the earth. Were the artists affected? Not at all. At the height of the sixteenth century, they continued to represent God the Father holding a globe divided into three golden zones; these were the three parts of the earth: Europe, Asia, and Africa. Why change anything in that old figure of the world? Could one really be sure that this fourth part of the earth belonged to God's plan? There earth had three parts just as there were three magi; and one of the magi was black, as was fitting, because he symbolized Africa.[6]

Such was the power of tradition in Christian art.[7] In 1560, the old truths, long since shown to be untrue, were still being taught with the same serenity as in the time of St. Louis.

If true science did not become a part of late medieval religious art, false science, on the other hand, was readily used. Astrological notions that were not given quarter in the great art of the thirteenth century were accepted in the sixteenth century, even by the Church.

The ancient belief that the planets governed human destiny had never died out; the Church Fathers had not unanimously condemned it. The medieval Church, without encouraging the study of astrology, seems not to have interfered with astrologers.[8] But in the fifteenth century there was a true revival of astrology,[9] which reappeared along with the ancient philosophy that had justified it. The contention was that if everything in the world is of a piece, if everything coheres, if an active sympathy unites all parts of the universe, how can it be doubted that man is linked by invisible bonds to even the remotest planets? The influence of the sun cannot be denied; the influence of Mars, Venus, and Saturn, even though less marked, can be no less real. Man, who is fashioned by these influences that come from all parts of the universe, is a microcosm. That is why each part of his body, each faculty of his mind, is in harmony with one of the states of the heavens.

It was an accepted belief, for example, that Mars acted on the liver, Saturn on the lungs, the sun on the stomach. Each of the four temperaments, choleric, phlegmatic, melancholic, and sanguine, were also in harmony with a planet. For instance, when the moon was in conjunction with the sign of Leo and the sign of Sagittarius, this was thought to be the proper time to bleed choleric people.

These notions appeared in the late fifteenth century as established facts. Where are they to be found? On the opening page of Books of Hours (and also in the *Calendrier des bergers*—fig. 166).[10] A simple figure represents the human body; the planets surround it; long lines reach from Mars, Saturn, and the sun to the liver, lungs, and stomach. In the four corners, the four temperaments are symbolized by four figures of

165. Shepherd contemplating the stars. *Calendrier des bergers*. 1491. Printed book. Paris, Bibliothèque Mazarine, Incunables 584 (617), fol. a iir.

166. Four Temperaments. *Calendrier des bergers*. Guyot Marchant, 1491. Printed book. Paris, Bibliothèque Mazarine, Incunables 584 (617), fol. c iiiiv.

men accompanied by animals.[11] Inscriptions indicate under what sidereal conjunctions it is proper to bleed the choleric, the phlegmatic, the melancholy, and the sanguine man.

We are rightly surprised to find such an illustration at the beginning of a Book of Hours: astrology appears there as a revealed truth. On reflection, however, it becomes clear why these conceptions did not shock anyone at the time. They fitted in so well with the prevailing ideas of the universe. What could more ingenuously affirm that man is the center of the universe? It was for man that God set the planets in their orbits to turn around the earth; they were there not only for the enjoyment of his eyes, but to teach him the rules of health.

These ideas came naturally to the mind of any Christian who turned the pages of his Book of Hours, and far from scandalizing him, they became quite simply a source of instruction. This is why the clergy was not shocked to have the planets and their influence figure in the decoration of their churches. This motif is to be found in the church of La Ferté-Bernard: the sixteenth-century reliefs decorating the balustrade of the south aisle contain personifications of the seven planets accompanied by the four temperaments; inscriptions leave no doubt about the meaning of these figures.[12] Thus, in the sixteenth century, astrology passed from Books of Hours into monumental art.

This is the most innocent aspect of astrology, but there is another. The influence exerted by the planets on the course of our lives is no doubt great, but their daily influence is nothing compared to their influence over us at the instant of our birth. The newly born is like virgin wax, ready to receive any imprint. The planet reigning in the sky at that moment imprints an indelible stamp on his being.[13] At that moment, the child's character and destiny are inscribed within him. Although just born, limits are already set for him in everything; he can only become what he is. A formidable fatalism, but one which the Church as a whole could accept. The Church has never given much scope to freedom: in its eyes, freedom is only the power to accept or reject grace. It is by grace alone that we escape the mechanistic universe; everything else is nature, that is, fatality. It is entirely according to nature that our temperament and character should be predestined, but in the end, it matters little. All temperaments can participate in redemption. St. Peter was of a sanguine temperament, St. Paul was choleric, St. John was melancholy, St. Mark was phlegmatic: all four sit at the right hand of God. That is what Albrecht Dürer meant to convey when he represented the four temperaments as the four apostles.[14]

Thus, sixteenth-century astrological theories were no more disturbing to the Church than the modern doctrine of heredity. A Christian might form his own opinion about the truth or falsity of astrology: whatever he thought on the subject was of no consequence.

When the popes had the planets and their influence painted at the Vatican, they doubtless did not intend to give astrology the force of dogma. If they had been questioned about it, they would no doubt have replied in somewhat the same way as Pascal: "When we do not know the truth of something, it is good to have an accepted error for men to fix their minds on, as on the moon, for example, to which the change of seasons, the progress of maladies, etc., are attributed; because man's principal malady is his troubled curiosity about things he cannot know, and it is not so bad for him to be in error as to be caught up in useless curiosity."

From these reflections we can understand why, in the fifteenth and sixteenth centuries, the Church never forbade artists to use astrological subjects. They were frequently used in Italy, and from there they passed into France.

The earliest example of this genre of representation is the curious series of Italian engravings usually attributed to Baccio Baldini.[15] Each planet, personified by a pagan god, traverses the sky mounted on a chariot pulled by time-honored animals: the eagle is harnessed to Jupiter's chariot, and the dove to the chariot of Venus.[16] The signs of the zodiac are shown on the wheels of the chariots, and indicate the positions in the sky where the strength of the planet is greatest. Below are the men touched by the planet's ray at birth; following their bent, they give themselves to the work or the pleasure to which they are predestined by the influence of the stars. For example, under the sign of the planet Mercury (fig. 167) we see sculptors, goldsmiths, and painters decorating the walls of a Florentine palace with garlands; farther on, a mathematician regulates a clock, a musician plays an organ, and astrologers

167. Planet Mercury and its influences. London, British Museum. Engraving attributed to Baccio Baldini.

speculate on the celestial sphere. As the inscription tells us, Mercury is the planet that dispenses genius, inspires love for scientific knowledge—especially mathematics, and inspires the inclination to divination.[17]

Beneath the planet Venus, couples embrace and there is dancing and singing. Ladies throw flowers down from the top of the Castle of Love. French and Italian fashions in dress are mingled in the rich costumes, embroidered with gallant French devices. Venus is the planet that loves "beautiful clothing decorated with gold and silver, singing, and games." This "science" may make us smile, but we cannot help admiring the refreshing naïveté of the artist, his pretty inventions, his realism tempered by Florentine grace. His engravings were highly successful, and were imitated all over Europe. Lippmann has already indicated some of these copies, but there are other interesting ones that were unknown to him.[18] For example, the graceful figures of the planets decorating the ceiling of the Cambio in Perugia, thought to have been created by Perugino, were borrowed with almost no change from the Florentine engravings. True, there is more skill and refined elegance in the work of the great painter. Sometimes we think we are looking at the copy of an ancient carved gem—and find that it is only a copy of a Baccio Baldini engraving.

The frescoes of the Borgia apartments in the Vatican reveal a much freer imitation, but the painter clearly knew the engravings, for certain similarities cannot be explained otherwise.

In Germany, it was not only Hans Sebald Beham who interpreted Baccio Baldini in a series of fine engravings; printers had the planets copied from Italian engravings as decoration for their astrological books.[19]

The astrological engravings of Baccio Baldini were known in France also.

In the Berlin print room there is a series of engravings, rather rough and popular in character, that are fairly free interpretations of the Italian work. Schreiber[20] and Lippmann,[21] following an old tradition that generously assigns all engravings of unknown origin to the Low Countries, see them as Flemish work. Nevertheless, certain details of costume and architecture suggest that they might have been done in France, and Bouchot was perhaps not wrong in attributing these engravings to the region of Artois or Picardy. Whatever their origin, it is certain that they were well-known in France at the end of the fifteenth century. It was these—and not the originals by Baccio Baldini—that inspired the artist who illustrated the *Calendrier des bergers*. In fact, this popular book, that is both an almanac and a catechism, has an entire chapter devoted to the influence of the planets. The usual doctrine is set forth: whoever is born under the sign of Mercury, for instance, will be "of subtle talent, a good mechanical worker, great preacher, philosopher, geometer, musician, etc." The engraving represents an artist paint-

ing, a sculptor carving a statue, a scholar observing the stars. If this engraving is compared with the corresponding work in Berlin, the imitation is immediately apparent. One detail is enough to erase all doubt: in both series, the planets are represented by divinities on foot, not by gods in chariots.

Thus, France, along with the rest of Europe, adopted the astrological images created in Italy.[22] I have not encountered any in our monumental art, but I should not be at all surprised if some were discovered one day under the whitewash of a church. They would be no more out of place there than in the Vatican.

But I can cite at least those on the stalls of the chapel of Gaillon, which are now at St.-Denis (fig. 168). These designs of inlaid wood are so well-concealed in the lower parts of the magnificent stalls that, unless I am mistaken, no one else has noticed them. We see the planets personified: the sun, Mercury, etc.; and farther on are representations of the ordinary occupations of the men born under the influence of these planets. Artists paint and carve in their workshops: these are the ones touched at their birth by a ray from Mercury. A lady receives her lover while musicians play a serenade in the street: such is the fate of those born under the sign of Venus. The artist of Gaillon, moreover, invented nothing; he simply had the *Calendrier des bergers* before him, and either copied or interpreted it.[23]

Astrology, going back to Chaldea, could not long survive the great astronomical discoveries; the day Copernicus made his discovery, he killed that ancient lore. Was it likely that the planets sent their emanations to earth, when earth was itself but one of the smallest of the planets? Henceforth, man would raise his eyes to the heavens without fearing the evil influence of the stars, but he would be appalled by their bleak indifference.

168. The sun and its influence. St.-Denis (Seine), Abbey Church, nave. Painted stalls from the chapel of the Château de Gaillon.

Fortunately, art had no part in these empty speculations; the ideas it expressed about human life were truer, and can still move us, even today.

Man's life was placed in relation to the months of the year; it was conceived as a spring and a summer, followed only too soon by autumn and winter. To be sure, the comparison was not new, but in art it was given value by the truth or inventiveness of detail.[24]

Artists were inspired by a fourteenth-century poem,[25] which was both modernized and singularly weakened in the sixteenth century. The old poem is a sad and bitter work whose disillusioned verses sometimes sound like those of Hesiod.

First of all, the poet sets the limit to human life: according to him, it cannot last longer than seventy-two years. At seventy-two, man

> *S'en va gésir en l'ombre.*
>
> (Is taken away to lie in darkness.)

His short life is divided into twelve periods corresponding exactly to the months of the year. Each of the twelve periods of our existence lasts for six years.

The child of six resembles the month of January, "which has neither strength nor virtue." At twelve, he is still in the half-light of February. But at eighteen, he is already throbbing, like nature in the month of March, with the coming of spring. At twenty-four, he has attained the April of life: the tree flowers and the young man falls in love; and, along with love, nobility and virtue enter his soul.

Just as nature blooms in May, man arrives at his full physical development when he is thirty. This is the age when "he holds the sword well in his hand." His thirty-sixth year marks the summer solstice of his life: then his blood is as hot as the June sun. At forty-two, he has acquired experience: "He is no longer called *valet*," but his youth is fading; he is in the month of July, no more producing flowers. "Then a creature's beauty begins to fade." At forty-eight, he is in the month of August, that is, his youth is gone just as summer is past; this is harvest time and he must think of reaping. At fifty-four he enters the September of life; he must hasten to "garner" and gather, for if he has nothing by this time, "he will never have anything." His sixtieth year corresponds to the month of October. Now he is in his old age and must think of death. This is the period when it is well to be rich, for the poor man now has only the time to bemoan the time he has badly "spent." At sixty-six, he comes to the somber month of November; everything around him dries up and dies. Why does he cling to life,

when, as the poet says in some naïvely poor verses, all he sees around him are his "heirs" who want him to die? If he is poor, they want him to die, and even more so if he is rich:

> *Et s'il a grand planté d'avoir*
> *On le voudrait veoir mourir*
> *Si que on puist aui sien partir* (partager).

(And if he has goods in plenty
They would want to see him die
So that they could share them.)

Then comes December:

> En ce mois-ci se meurt le temps.

(This is the month when time dies.)

Man is seventy-two years old; life is as cheerless for him as the winter landscape; all he can look forward to is death. And the old poet, to whom the sad secrets of life, one after another, have been revealed, now begins to reflect. To live for seventy-two years is no doubt very little, but it would be a great deal if we really lived during every moment given to us. But sleep takes up half our lives, that is, thirty-six years; we spend fifteen years in the heedlessness of childhood; sickness and prison[26] may take five more years from us. When it is all added up, we do not live seventy-two years, but sixteen. . . . That is all life amounts to.

Such is the sad little poem without a glimmer of Christian hope, whose every verse has the bitter taste left by the knowledge of life.

In the late fifteenth century, an unknown and mediocre poet condensed the already very short text into twelve quatrains. Watered down and insipid, his work lacks the bitter savor of the original: these are the quatrains that supplied artists with the themes for their work.

The twelve stages of human life are to be found at the beginning of a certain number of Books of Hours from the presses of Thielman Kerver. Miniaturists also used this motif, as proved by the charming pages detached from a Missal of Mirepoix, which belongs to the Société Archéologique du Midi de la France.[27] All these works resemble each other and derive from the same source.

In January (fig. 169), children ride hobbyhorses, play ball, fly captive birds, turn toy windmills. That happy age has neither cares nor duties.

In February, the boy goes to school. He recites his lesson as he stands before his teacher, while a comrade, with breeches down, is whipped: an amusing picture of old customs.[28]

In March, adolescents, trying to act like men, hunt with bow and arrow in the forests.

169. Ages of life: January. Hours, Thielman Kerver, February 16, 1522 (23). Printed book. Paris, Bibliothèque Nationale, Res. B 2936, fol. Aii v.

170. Ages of life: April. Hours, Thielman Kerver, February 16, 1522 (23). Printed book. Paris, Bibliothèque Nationale, Res. B 2936.

In April (fig. 170), the young man goes walking with a girl, along the edge of a budding wood. This is the beginning of the season of love that lasts into May, for in the following month, we see the young people again, mounted on a single horse and on their way, no doubt, to dance at a village festival.

But in June the idyll is over. The young man marries. This same girl? Another? We do not know. He marries because he is thirty-six years old and

> *En tel temps doit-il femme quérir*
> *Si, luy vivant, veut pourvoir ses enfants.*

(This is the time for him to find a wife
If he is to provide for his children during his lifetime.)

In July he has begun his family: his wife and children surround him; and in August, he has solidly established his fortune, for he pays the reapers who have come to cut his grain.

In September, we see a "poor beggar" respected by neither man nor dog. This cannot be our hero who has conquered fortune through his wisdom, but rather some heedless creature who has never thought of the future. At fifty-four, he has abandoned his empty barn and gone off to beg.[29] However, in October we have our own good man again, the successful one. He is sixty years old, aged but rich; he sits in his own house, at his own table, surrounded by his wife and children.

In November, he begins to fail. Clothed in his dressing gown, the old man sits in a chair; a physician has been called; he examines the sick man's urine in a glass phial.

In December, there is no more hope. The dying man lies in his bed holding a candle, women clasp their hands, and no doubt the prayers for the dying are being said.

We see that the artist imagined a complete little poem, parallel with the other one but his own contribution is substantial. There is clearly no bitterness in his soul; his work does not have the flavor even of the accompanying quatrains, much less of the fourteenth-century poem. To him, life endowed with an honest fortune acquired through wisdom seemed quite acceptable; in his eyes, life had only one fault: it is too short. These pleasant drawings do not sadden; we do not get from them the impression that after age forty-two life becomes a winter voyage.

III

Moral instruction. The growing importance of books.

Such a conception of life is purely pagan. According to these artists, man's only duty would seem to be to get rich. The Church, however, taught unceasingly that many things must be placed above practical wisdom and wealth.

We must admit, however, that this sermon appeared far less often in fifteenth-century plastic arts than in books. Figures of the Virtues are rare; books devoted to Christian duties abound.

A methodical study of the books published by our first printers shows that they brought out an astonishing number of moral treatises. We find nothing but *Miroirs de l'âme pécheresse, Destruction des vices, Fleurs de la somme évangelique, Jardins de dévotion, Poèmes sur les quatre vertus, Remèdes convenables pour bien vivre, Examens de conscience, Doctrines pour les simples gens, Art de gouverner les corps et l'âme.*

These books must not be thought to be intended only for clerics and monks, although there are such books, too; for example, *La Montagne de contemplation*, attributed to Gerson. A beautiful miniature illustrates its spirit marvelously well:[30] hermits are climbing a mountain which rises out of a somber sea; a woman—no doubt Faith—guides and encourages them, and when they arrive at the summit, they see God face to face. Meanwhile the rest of humanity, gathered into boats, is tossed by a great harborless sea.

It is clear that such a book was addressed to a very few; this kind of elevated virtue is the privilege of an elite. But the solid and reasonable treatises mentioned above were meant for everyone. We must read some of them to understand what our ancestors owed them for moral refinement; for these books not only condemned transgression itself, but the very thought of transgressing; they kept an eye on even the slightest workings of the imagination. It was not in this or that situation that virtue was to be practiced, but at every moment; virtue was shown to be a form of vigilance. We seem to be witnessing the birth of one of

the most refined sentiments of the soul: scruple. If we wish to know where the many standings of the modern conscience came from, we must go back to these ancient books. They helped to form us.

These are strange books. They penetrate to the very depths of the soul, judge secret wishes and are not above going into the smallest details of practical life. In the *Règles de bien vivre*,[31] the author gives women advice on their toilette. Sometimes these moral treatises become treatises on how to live: each vice is studied in its most subtle variations, and morality is extended to include good manners. Among the results of gluttony, the moralist mentions the indecorousness of drinking with "something in your mouth" or spilling gravy on oneself out of greed.[32]

To be sure, fifteenth-century society was still quite coarse. The men of the time, as seen in miniatures and wood engravings, have something mean about them; even their affluence lacks nobility. And yet these poor people, with their pinched features and puny appearance deserve our respect. They were tormented by the desire to be better; the soul undertook the hard labor of bettering itself.

The moral treatises of which we have just spoken were addressed to all classes. The poor were not forgotten, poverty is even celebrated as a condition particularly pleasing to God. Poverty is a preparation for

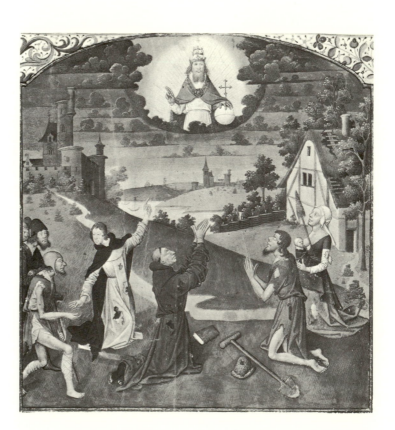

171. The poor. Paris, Bibliothèque Nationale, ms. fr. 9608, fol. 20.

all the virtues; it is even a virtue in itself.[33] A fifteenth-century min-
iaturist expressed this idea with exceptional force (fig. 171). Beside a
hut situated below a château in a French landscape, a peasant and his
wife are kneeling; they are clothed in rags, and the woman nurses an
infant at her breast. A half-naked beggar, even poorer than they, is also
present. But all eyes are raised to heaven; a Franciscan and a Dominican
in ragged robes, who like them have espoused poverty, point to the face
of God the Father in a rift of the clouds.

Another page is devoted to the rich.[34] The rich man is seated on a
throne, like a king; men prostrate themselves before him, and his riches
abound at his feet. But no heaven is to be seen above his head.

It was thus that the fifteenth century understood the eminent dignity
of the poor; they suffered, but under the eye of God. The gentleness
and sustained patience of our remote forebears can thus be explained.

With so many moral treatises to offer the faithful, the Church might
well have done without artists' images of vices and virtues. But it did
not do so and until the end of the Middle Ages remained attached to
the old traditions. Thus we do find figures of personified vices and
virtues in the sanctuaries, but of so unexpected an aspect,[35] and so
different from those of the thirteenth century, that the subject requires
another chapter.

IV

The figures of the Virtues seated on their thrones in French thirteenth-
century cathedrals had no attribute other than a shield bearing an
emblem. Nothing could be more simple or more noble. These beautiful
images, no doubt understood by everyone, continued to preach their
silent sermons throughout the fourteenth century; they sufficed for a
long time.[36]

It was in the time of Charles V that artists for the first time seemed
to try to create something new. In a Breviary made for the king,[37] I
have encountered figures that bear little resemblance to our thirteenth-
century reliefs.

We note first that these Virtues are seven in number, three theological
Virtues—Faith, Hope, and Charity, and four cardinal Virtues—For-
titude, Justice, Temperance, and Prudence. This is a new classification,
at least for artists. We have said elsewhere that Virtues carved in the
thirteenth century corresponded in no way to these divisions;[38] why
they were chosen remains a mystery. Beginning with the fourteenth
century, the artists conformed docilely to the program laid out by moral
treatises: the representation of the three theological virtues was always
followed by that of the four cardinal virtues. Certain famous books,
like the *Somme le roi*, which compared the four cardinal Virtues to the

The images of the Virtues in the fourteenth
century. The Virtues in the fifteenth century.
The strangeness of their attributes. The Ital-
ian Virtues differ from the French Virtues.
The Italian Virtues are gradually adopted by
the French artists.

"four towers of the stronghold of the man of integrity (*prud'homme*)," helped sanction this division. The *Livre des quatre Vertus cardinales*, attributed to Seneca, became very popular in a French translation during the fifteenth century and gave the force of law to this classification.

There were other innovations in the Breviary of Charles V. Each Virtue no longer carries a heraldic shield as in the thirteenth century. Those shields were sometimes quite subtle, but they did provide a name for each Virtue. Here there is a difference. Only three or four of the Virtues have attributes that help us to recognize them.[39] The others make vague gestures, or engage in actions that are difficult to interpret. Temperance, for instance, is a woman seated at a table and, we must suppose, eating and drinking temperately.[40] Prudence receives a cup presented to her by a man:[41] what does this cup symbolize? It would be hard to say.

At about the same date, an illuminator illustrated the *Miroir du monde* with the four cardinal Virtues.[42] They are not much easier to recognize, although the scribe had taken pains to lay out the artist's program for him. At the place where Prudence was to be drawn, he wrote: *Prudence doit estre une dame qui siet en une chaiere et tient un livre ouvert et lit à ses disciples qui sient à ses pieds.* (Prudence must be a lady seated in a chair, holding an open book, and reading to her disciples who sit at her feet.) This is surely a vague way to characterize a virtue. But there is another that is entirely obscure: *Atrempance (Tempérance) doit estre peinte à costé. . . . Doivent estre deux dames séant à une table mise, demandant l'une parole à l'autre*[43] *par contenance de mains. Et dessous la table a un poure* (pauvre) *à genoux qui prend un hanap à pié et boit."* (Temperance must be painted here. . . . There must be two ladies seated at a table which is set, one of whom asks the other for the privilege of speaking by the attitudes of her hands. Beneath the table kneels a poor man who takes a goblet and drinks.) Such is the scene shown in the miniature and in spite of the explanation it is completely incomprehensible to us.[44]

It would be very interesting to follow these attempts during the early fifteenth century, but unfortunately examples are almost entirely lacking,[45] and persistent search has brought no results. The theme of the Virtues was certainly not abandoned during this long period,[46] but the monuments have disappeared.

Several indications lead me to believe that the artists never succeeded in giving the Virtues characteristic attributes. First of all, the writers of the first part of the fifteenth century, who so often personified the Virtues, never or almost never speak of their attributes—something they would not have failed to do had a tradition already been established. Gerson in the prologue to his diatribe against the *Roman de la Rose*, Alain Chartier in the *Consolation des trois Vertus*, and a little later, Georges Chastellain in his *Temple de Boccace*, all make the Virtues act

and speak, sometimes even describe their costumes, but say nothing about their attributes.[47]

Moreover, several miniatures which must have been painted toward the middle of the fifteenth century, or even about 1470, still show the Virtues almost completely devoid of attributes. In *Le Château périlleux*,[48] the Virtues are young women crowned with a circlet of gold; their white robes, with a bluish cast in the shadows, give an impression of purity. They are as alike as sisters, and not a single one of them could be identified if Justice did not hold a sword.

In *Le Champion des dames*,[49] the Virtues form a circle around the Virgin; but for their names written at their sides, they could not be distinguished one from the other.

In the *Speculum historiale* of Vincent de Beauvais,[50] Faith, Hope, and Charity have no attributes: they merely point out the heavens to the kneeling people.[51]

In the beautiful *Saint Augustin* of 1469,[52] the Virtues who usher the elect into heaven again have no emblems.

These examples[53] tend to prove that artists made no great effort to characterize the Virtues during the greater part of the fifteenth century. Clearly they had been unable to create a tradition.

Then suddenly, completely new figures for the Virtues appear; they differ profoundly from anything seen before. We find them first in a Aristotle manuscript, now in the library of Rouen.[54] This manuscript was certainly illuminated in the second half of the fifteenth century, but there is nothing that permits assignment of a specific date. Happily, I have discovered another manuscript, illustrated with figures similar to those of Rouen, whose date can be fairly closely determined. It is a historical compilation made for Jacques d'Armagnac, Duke of Nemours:[55] the coats of arms decorating various pages leave no doubt on this point. We know that the Duke of Nemours was beheaded in 1477; thus, the date of the book cannot be later. And on the other hand, since the Duke of Nemours was forty when he died, it is hardly likely that he began to collect books before 1460.[56] Therefore, we would not be far wrong in supposing that the manuscript was illuminated about 1470.[57]

This is the approximate date when the curious figures we are about to discuss must have been created.

The Duke of Nemours' manuscript contains only the four cardinal Virtues: only the Rouen manuscript has the complete series of seven. However, the two works scarcely differ and seem to be about contemporary. It would be extremely difficult to explain the innumerable attributes with which the Virtues are laden were it not for the verses (often obscure themselves) that accompany the four cardinal Virtues in the manuscript of the Duke of Nemours and, after a fashion, make the

intentions of the artist comprehensible.[58] We do not have such a guide for the three theological Virtues, but fortunately their attributes are clearer.[59]

Faith, like all the other Virtues, is represented by the figure of a woman; she holds a book and a lighted candle. The book is the Old and New Testaments, and the candle the light illuminating the darkness into which natural man is plunged. But what is most odd: Faith carries a small church on her head. We are reminded of those magnificent emblems that adorned the crests of knights' helms in the fifteenth century: *guivres, mélusines, dextrochères*. The artist had probably thought of them too.[60] Unfortunately these bourgeois Virtues do not wear the beautifully festooned tournament helmets, and so the attributes they balance on their heads can only seem ridiculous.

In her left hand, Hope carries a beehive, and in her right, a spade and three scythes; she is mounted on a cage in which we glimpse a captive bird, and she bears a ship on her head.[61] What does this riddle mean? The sense is fairly clear. The spade, the scythes, and the beehive symbolize the hopes of the peasant: he spades because he hopes to gather a crop; he prepares the beehive in the hope of collecting honey. The Christian also hopes to gather the harvest he has sown. And he will have this reward when he enters his kingdom, as a ship enters port, on the day when his soul leaves its prison, as a bird takes flight from its cage.

Charity, standing on a stove, holds in one hand the monogram of Jesus Christ which radiates like the sun. With the other, she raises her heart toward heaven. On her head a pelican feeds its young with its own blood.[62] All of this is perfectly clear and almost traditional. Only the stove might surprise, but as the Church Doctors of the late Middle Ages said, "Charity is of the nature of fire."[63]

The first of the cardinal Virtues, Temperance, carries a clock on her head (fig. 172); she has a bit in her mouth and holds a pair of spectacles. Her feet, clad in spurs, rest on the wings of a windmill.

How are these bizarre attributes to be explained? Here we must refer to the verses accompanying the miniatures in the manuscript of the Duke of Nemours.[64] The clock, to paraphrase the words of the poet, is the symbol of the rhythm that must regulate the life of a wise man.[65] The bridle in the mouth means that he is master of his words. The spectacles before his eyes enable him to perceive clearly what is usually seen only dimly.[66] The spurs on the young knight signify maturity of mind.[67] The windmill that grinds the wheat and makes it ready for bread never turns capriciously: it symbolizes steady work.[68]

Justice has a scale and two swords as attributes (fig. 173). The strange thing is that one of these swords is pointed down with the handle in the air and seems to have fallen from heaven into the hand of Justice.

She sits on a bed with a pillow at the head. By chance, it so happens that the execrable verses of our manuscript are very clear on this point;[69] and two of them are even good.

The scale and the sword of Justice hardly need explaining; with the scale, Justice weighs the evidence and makes the sentence respected by the sword. But what is the sword that seems to have fallen from heaven? It is the sword of God:

> *L'espée du souverain juge*
> *Est dessus cil qui autrui juge.*

(The sword of the sovereign Judge
Hangs above him who judges others.)

The bed means that the judge must prepare the sentence in repose, and the soft pillow signifies the mercy that tempers justice.

Prudence holds a sieve in one hand and a mirror in the other (fig. 174).[70] A shield over her arm is decorated with the signs of the Passion; on her head she bears a coffin, and underfoot, a half-open sack from which pieces of gold spill.[71]

These various attributes characterize the different aspects of Prudence. Prudence may be Practical Wisdom which discriminates between truth and error, and as such is symbolized by the sieve that sifts the grain from the chaff. Prudence may also be the complete self-knowledge

174. Prudence. Manuscript of Jacques
d'Armagnac, Duke of Nemours. Paris,
Bibliothèque Nationale, ms. fr. 9186, fol.
304r.

175. Fortitude. Manuscript of Jacques
d'Armagnac, Duke of Nemours. Paris,
Bibliothèque Nationale, ms. fr. 9186, fol.
304r.

that enables us to regulate our conduct, in which case it is characterized by the mirror in which our image is reflected. But Christian Prudence has her eyes turned toward eternity. She tramples the things of this world because she thinks of death and of the narrow coffin where our riches will not accompany us. And since supernatural forces are needed in the struggle against the world, she protects herself with the memory of the Passion, as if it were a shield.[72]

Fortitude has a tower beside her from which she draws out a dragon (fig. 175). She stands on a wine press and holds an anvil on her back, without being weighed down by it.[73]

Without the poet's gloss, these details would be very difficult to interpret. The anvil is not, as we might think, the force that resists. It is the force that takes pleasure in exercising itself, the force enhanced by struggle, just as in the course of time the hammer refines and polishes the anvil. The press symbolizes not brute force, but the triumph of the soul over itself, the contrition that makes tears flow like the liquid spurting under the pressure of the wine press. As for the monster pulled out of the tower, no one has so far been able to explain it satisfactorily: now, if we believe the poet, the dragon is the sin that tries to enter the fortress of the conscience but which the strong man dislodges.[74]

Such are the new figures that appeared in French art toward 1470.[75] Earlier we regretted that the fourteenth- and fifteenth-century Virtues

had no attributes by which to distinguish one from the other; the same cannot be said for these. Sympathetic as we may be toward the old forms of French thought and art, we cannot but be shocked by this symbolism whose subtlety borders on incomprehensibility, and by its disconcerting lack of taste. This is what the simple and noble Virtues of our thirteenth-century cathedrals had come to! These might well be acrobats parading across a stage at a fair.[76]

I am convinced that so extravagant and uninspired a work could have been conceived only by some illustrious pedant, some future prize winner among the composers of *Palinods* or within the literary confraternities. Certainly no moral treatise written by a theologian, no popular treatise drafted by a cleric present the Virtues in this form. In an effort to understand the attributes of these strange Virtues, I think I must have read through almost all the moral literature of the fifteenth century without finding anything satisfactory; I was about to give up when, by happy chance, I came upon the unpublished verses that account for all the details of the work under consideration. This proves that these figures of the Virtues did not derive from tradition or from theological teaching, but from individual fantasy. I would be willing to believe (if I may risk a hypothesis) that some wit from Rouen thought up this masquerade,[77] and this because, as we shall see, these Virtues were nowhere so frequently represented as in that city.

It might seem that such a work does not deserve so much discussion, and this would be true if the work were unique, but it set a fashion. What is extraordinary is not that a work of this kind was created in the first place, but that it was admired and soon imitated. Its success testifies to a state of mind unimaginable today.

The work most closely related to the Rouen manuscript is a stained glass window of the cathedral of Rouen devoted to the life of St. Romain.[78] It is one of the most beautiful windows of the Renaissance, a dazzling mosaic of color. Its composition is ingenious, and sometimes even moving. The work would be perfect if the Virtues did not appear in each episode balancing their attributes on their heads.

The window presents not so much a biography as a panegyric of the old bishop; it develops the theme that St. Romain, in the different circumstances of his life, practiced all the virtues in succession. We see him resisting temptation: while praying in his cell on a winter's night, a woman knocked at the door; hesitating at first to open it, but thinking she might be perishing of cold, he took pity on her. The woman warmed herself by the fire, then suddenly unpinned her hair which reached to her feet. The saint was moved, and might have succumbed to temptation had God not sent one of his angels.[79] This is the episode represented by the artist, but instead of an angel, he placed a Virtue beside the bishop. She is Temperance, with a clock on her head and spectacles in

her hand. Such lack of taste is all the more shocking because the scene itself is quite beautiful; the temptress is charming, and the bishop who now sees her only as a poor human creature, raises his hand in blessing. —Elsewhere, St. Romain is shown celebrating the Mass[80] shortly before his death. His biographer says that on that day he was so illuminated by divine love that his clerics believed they saw him shining with supernatural light. Consequently, the artist placed Charity, that is, Love, beside him. She presents the book to him and seems to serve him at Mass. The scene would indeed be beautiful were it not for Charity's headdress which consists of a pelican surrounded by its famished young. —Farther down we see the saint on his deathbed. He is no longer surrounded by his clerics, but by a more imposing assemblage: personifications of all the virtues he had practiced during his life are present at his death. They are the same as those of our manuscript.[81] Prudence, for example, bears a coffin on her head, and a sieve and mirror in her hand; Faith holds a candle and balances a church on her head.[82]

This is one example that shows how faithfully the artists of Rouen transmitted to one another the attributes of the Virtues. There are others. When the Archbishop of Rouen, Georges d'Amboise, built his château at Gaillon, he wanted to have images of the Virtues on the façade. One of the figures is preserved;[83] it represents Prudence whom we recognize by two already familiar attributes, the sieve and the coffin (fig. 176).

176. Prudence. Gaillon (Eure), Château. Relief sculpture from façade.

177. Faith, Hope, and Charity. Paris,
Bibliothèque Nationale, ms. fr. 9608, fol.
41v.

Until fairly late in the sixteenth century, the artists of Rouen remained
attached to these traditions which had been forgotten elsewhere. The
manuscripts of the *chants royaux,* dedicated to the Virgin by the poets
of Rouen, still contained figures of the Virtues related to those of the
Aristotle manuscript.[84]

If we cannot say for certain that the new tradition was born in Rouen,
at least we cannot deny that it was firmly established there.

These figures of the Virtues soon spread to other regions. Their
popularity was greatest during the reign of Louis XII. Toward 1500,
they were known to Parisian miniaturists who, with unexpected naïveté
for such able men, artlessly placed the traditional churches, boats, and
pelicans on the heads of their Virtues (fig. 177), and supplied them with
all their other attributes.[85]

The Flemish artists, also familiar with the new Virtues, do not seem
to have been unduly shocked by them. Jean Bellegambe, in his painting
of the Fountain of Life,[86] depicts Hope with a boat on her head.

The curious thing is that the new theme reached Spain very early.
It could only have been introduced by the French or the Flemish. On
the tomb of John II and Isabella of Portugal at the Carthusian Monastery
of Miraflores [near Burgos], we see the figure of Fortitude with a wine
press as attribute and carrying an anvil on her head. Hope has a boat
on her head, and Faith has a church on her head and a book in her
hand.[87]

Our artists were soon to find such an overload of attributes shocking. They discarded, first of all, the extraordinary headdresses in which the Virtues were decked; then they made a selection from among the symbolic objects assigned to each by the imagination of their inventor. True, choices varied, so that in sixteenth-century France and Flanders there were no two series of Virtues absolutely alike; however, several Virtues had attributes that almost never varied.

In sixteenth-century France and Flanders, the series of Virtues were usually presented in the following way:

Justice has the scales and the sword; Fortitude pulls the dragon from the tower; Temperance most often carries a clock, and sometimes, in the other hand, holds a bridle and bit[88] or a pair of spectacles;[89] Prudence carries a mirror;[90] Faith holds a candle in one hand, and in the other, the Tables of the Law or a small church; Hope sometimes carries a spade,[91] sometimes a boat,[92] and at others, the anchor of a boat;[93] Charity carries a heart in one hand, and in the other, the radiant monogram of Christ.[94]

Such are the French Virtues, quite different, as we shall see, from those of Italy.

While representations of the Virtues were rare in France in the fourteenth and fifteenth centuries, they were abundant in Italy.

There is an odd reason for this.

In the early fourteenth century, the Italians had the idea of including the Virtues in the decoration of tombs—a very strange idea, it must be admitted. To place Faith, Charity, Temperance, and Fortitude around the tomb of St. Peter Martyr in Milan,[95] or of St. Augustine at Pavia,[96] was the most natural thing in the world: it was homage rendered to the dead and a lesson for us.

But what are these noble Virtues doing on the tomb of the Scaligeri in Verona?[97] Are we by chance supposed to believe that the Scaligeri practiced them? This resembles the lies of funeral orations and the bombast of Italian dedications in which the paltriest condottiere qualifies as a "Poliorcetes" [Taker of Cities], or a "Father of the Arts."

The Virtues decorating certain Italian tombs appear to be either base flattery or cruel irony. ... We are tempted to wonder whether the six Virtues decorating the tomb of Innocent VIII at St. Peter's, in Rome, are not six epigrams.[98]

As long as they followed the beautiful traditions of the Middle Ages, French artists never committed such improprieties. I have never seen a Virtue on a French tomb dating from the fourteenth or fifteenth centuries. In Italy, on the contrary, there is not a fourteenth- or fifteenth-century tomb of any pretension that does not have its Virtues. The great tombs of the Doges of Venice, those in the churches of Naples, in St.

Peter's at Rome, and in Florence, are familiar to everyone and in all of these the Virtues figure importantly.[99]

In Italy, then, the traditions of funerary art explain why figures of the Virtues are so numerous.

Very early, the Italian Virtues could be recognized by a few extremely clear attributes which they always retained; however, even in Italy there were some variations.

These attributes will be briefly indicated in order to make what follows understandable.

From the fourteenth until the sixteenth centuries, Faith was characterized by the chalice and the cross, and often by one or by the other of these attributes.[100]

Hope, who in the fourteenth century sometimes carried a cornucopia or a flowering branch[101]—somewhat vague symbols of peasants' hopes—came to be almost always represented by the figure of a winged woman extending her arms to take a crown,[102] or simply raising her arms to heaven. The latter formula was adopted during the fifteenth century.[103]

Charity could be recognized by the children she gathered around her to comfort and to nurse. Sometimes she held one hand out to them, and with the other, raised her heart toward God.[104]

Temperance carried a vase in each hand, pouring the contents of one into the other; she was evidently mixing water with wine.[105]

Prudence was represented in an extraordinary way during the entire fourteenth century. To make it clear that the prudent man is not only attentive to the present but also looks to the past and the future, artists sometimes gave Prudence three faces.[106] But this three-faced monster soon shocked Italian taste; consequently, fourteenth-century sculptors usually limited themselves to giving her two faces.[107] She became a sort of Janus, one face young, the other old: the artist wanted to convey that Prudence gives the wisdom of the aged to the young. This two-faced Prudence was still being represented in Italy well into the fifteenth century; the exquisite taste of a Luca Della Robbia did not find it offensive.[108] But this was an exception. The great artists of the Quattrocento rejected a symbolism that deformed nature; to them it seemed sufficient to give Prudence her two traditional attributes: the mirror[109] and the serpent.[110]

Fortitude was presented in two ways in Italy: sometimes she was armed with a sword or a club, a shield on her arm, and her head covered with a lion's skin;[111] sometimes a column, one she had toppled and broken and from which she had knocked the capital, was placed in her arms.

What was the meaning of this column? It recalls the one Samson had pulled down on the heads of the Philistines. Specific texts establish

this beyond doubt.[112] Fortitude carrying the column appeared in Italian art as early as the fourteenth century[113] but enjoyed the greatest popularity in the fifteenth and sixteenth.[114]

Justice was always represented with the same attributes: the scales and the sword.

This quick glance at the Italian Virtues shows that they were simpler and less laden with attributes than the French Virtues of the late fifteenth century. The Italians were wise enough to remain faithful to the types that had been created in thirteenth-century France: Faith with her cross and chalice, Hope extending her hand toward the crown, Prudence with her serpent, Fortitude with her sword and shield as seen on the portals of our cathedrals.[115] Instead of weighing them down with new attributes, the Italian artists—quite the opposite—set about lightening their load. While the fifteenth-century French Virtues did not have hands enough to carry all their trinkets, the Italian Virtues cast off everything that was not essential and expressed their inner spirit primarily by their attitudes. They are beautiful, passionate, and moving women who vibrate with vitality. We have only to think of Matteo Civitali's Faith,[116] who is in ecstasy before the chalice, or Andrea Pisano's Hope,[117] whose soul carries her toward heaven, and above all, of Raphael's youthful Charity,[118] who is sublime without being aware of it. She does not smile at the infants sucking at her breast, she does not even look at them; she seems to be tasting the secret joy of feeling her life flow in her veins. These works are not abstractions; they are profoundly human.

It should now be easy for us to distinguish the French from the Italian Virtues. Except for Justice, which is the same in both series, none of the others are alike.

The Italian artists who came to work in France naturally brought their own formulas with them. Even if we did not know that the frescoes in the cathedral of Albi were painted by Italians at the beginning of the sixteenth century, we would guess it with the first glance at the figures of the Virtues.[119] Faith carries a cross and a chalice, Hope raises her clasped hands, Charity nurses two infants, Temperance pours water into wine, Prudence carries a mirror, Justice has the sword and scales, Fortitude has the shield and mace. This is the Italian tradition at its purest.

In the early sixteenth century, something very strange took place in France. Our artists, who were becoming familiar with the Italian Virtues, sometimes gave certain of their attributes to our Gothic types. Thus, combinations were created that may seem surprising at first, but we do not have to be great alchemists to separate their components.

Let us first of all remark that only now did the Virtues begin to be associated with tombs in France. The pride of the humanists triumphed

in the sixteenth century over ancient Christian modesty. It was on the famous tomb at Nantes, carved by Michel Colombe, that the Virtues first appeared.[120] But surely such an idea did not come from the master himself, imbued as he was with our traditions: it was imposed on him by the lavish Perréal.[121] Jean Perréal had been to Italy, was a great success there and brought back a thousand new ideas. He was not a man to be surprised by Virtues adorning a tomb; modesty does not seem to have been his dominant quality. In Italy he had learned that talent itself confers dignity. While Michel Colombe had remained an artisan of the Middle Ages, Jean Perréal had already become a modern artist. Without any doubt, it was he who thought of placing the four Virtues at the four corners of the Nantes tomb.

The Virtues themselves are a curious mixture of French and Italian traditions. Temperance, with clock and bit, is completely French (fig. 178). Fortitude, who pulls the dragon from the tower, is French in attribute, but Italian in costume. She wears a helmet in the form of a lion's head and a cuirass—details never before encountered in France, but to be found in Italy.[122] Prudence is almost entirely Italian (fig. 179):

178. Temperance. Nantes (Loire-Inférieure), Cathedral. Stone figure from the tomb of Francis II and Marguerite de Foix. Michel Colombe.

179. Prudence. Nantes (Loire-Inférieure), Cathedral. Stone figure from the tomb of Francis II and Marguerite de Foix. Michel Colombe.

she has a mirror in her hand and a serpent at her feet; but the key to her origin is her double face, young on one side and old on the other.[123] Justice, with her scales and her sword, belonged to both countries, as we have said. This is an interesting example of the kind of combinations devised by sixteenth-century artists.

The monument by Perréal and Michel Colombe was imitated. Henceforth in France, the Virtues would be associated with tombs. Several of these tombs, moreover, seem to have been the work of Michel Colombe's pupils: for example, the tomb of François de Bourbon, the remains of which are now in the museum of Vendôme; the tomb of Pierre de Roncherolle at Ecouis, which we know only through the drawing by Millin;[124] the tomb of the Poncher family, now in the Louvre; and even, at least in part, the famous tomb of the Cardinals of Amboise, in the cathedral of Rouen (fig. 180).[125]

These tombs in turn inspired others. It seems to me certain that the artist who decorated the tomb of François de Lannoy, at Folleville (Somme), with four Virtues, and that of Cardinal Hémard, in the cathedral of Amiens, knew the Virtues of the Rouen tomb: the attributes are exactly the same.[126]

Attentive study of the figures of Virtues carved on all these tombs, reveals the mixture of French and Italian traditions already observed at Nantes. Sometimes the pupil faithfully reproduced the work of the master. The Virtues of the Vendôme tomb (circa 1520), insofar as we can judge from a very poor drawing,[127] were identical with those of Michel Colombe.[128]

But sometimes the artist introduced innovations. For example, on the tomb at Ecouis (executed between 1503 and 1518), alongside Fortitude, who pulls the dragon from the tower, stands Temperance between two wine vessels[129]—a detail that clearly testifies to Italian influence.

On the tomb of the Poncher family (executed between 1515 and 1525), the Italian influence is even greater: the three theological Virtues (for which the Nantes tomb provided no models) were almost completely Italian.[130] The statue of Faith, which has been preserved, holds a cross in one hand and probably held a chalice in the other. Charity bore two infants in her arms.[131] Hope, also preserved (fig. 181), clasps her hands and would be completely Italian also, like her two sisters, were it not for one detail that reveals her French origin. She carries a long pilgrim's staff, no doubt to signify that Hope is the staff which sustains the Christian throughout his journey here below. This attribute is much to the taste of our artists, and I have found it in a French manuscript illuminated at Rouen in the early sixteenth century.[132]

All the monuments just cited date from the first twenty-five years of the sixteenth century; that is why their iconography is still three-

180. Temperance. Rouen (Seine-Inférieure), Cathedral. Stone figure from the tomb of the Cardinals of Amboise.

181. Hope. Paris, Louvre. Stone figure from the tomb of the Poncher Family.

quarters French. But as the century advanced, Italian influence became more tyrannical.[133] Our most beautiful sixteenth-century tombs were in great part, either carved or designed by Italians.[134]

The tomb of Louis XII, at St.-Denis, was sculpted by the Giusti brothers, who were not from Tours, as it was once thought, but from Florence (fig. 182).[135] Consequently, the four cardinal Virtues who are seated at the four corners of the monument are almost completely Italian. Prudence has the serpent and the mirror; Justice the sword and the globe, Fortitude, draped in a lion's skin, holds a column in her arms. The attribute of Temperance alone reveals her French origin: she carries a clock in her hand. This small detail and certain extremely characteristic stylistic factors[136] tend to prove that the Giusti had French collaborators who were very probably the pupils of Michel Colombe, and insofar as they were able, preserved the traditions of his workshop.

Thirty years later, when the tomb of Henri II was begun at St.-Denis, all our artists were under the influence of Italy.[137] So it is no surprise to see four completely Italian Virtues at the corners of the

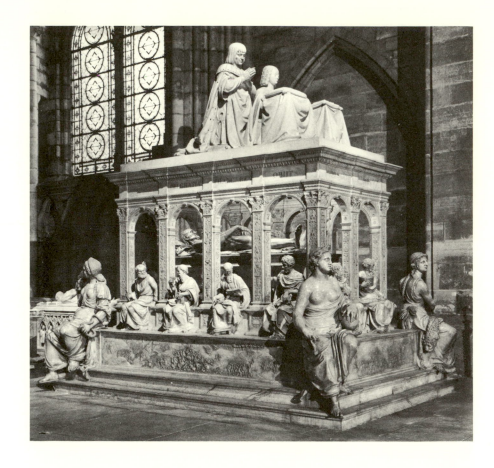

182. Tomb of Louis XII. St.-Denis (Seine),
Abbey Church.

monument: Justice with her sword, Temperance with two vases, Prudence with a mirror, and Fortitude leaning against a column.[138] It has been thought, and not without reason, that Primaticcio created the plan for the tomb.[139] The iconography of the Virtues only confirms this hypothesis that recently disovered documents have made a certainty.[140]

Thus, Italian traditions triumphed over the French. This is not surprising. The Virtues of the Rouen manuscript, conceived by some facile genius, were from the outset not destined to endure: even simplified and relieved of some of their attributes, they still remained somewhat pedantic; they betrayed their origin. It required the great talent and sensibility of Michel Colombe to make them beautiful for once. Coming upon them unexpectedly in the cathedral of Nantes, it is difficult not to be moved by these four symbols of duty. It is believable that the artist who carved them saw in them something more than an ingenious motif. Michel Colombe was then an old man; like the grave countenance we glimpse behind the face of Prudence, he looked toward the past. At seventy-five, he knew better than anyone how difficult it is to be temperate, prudent, just, and self-disciplined. It was within his own experience and the secret recesses of his moral life that he found these images of the Virtues. One might say that in spite of their costumes,

the Virtues he represented are not the ostentatious virtues of the great; they are the virtues of men like himself, artisans and stonecutters; virtues that are practiced in silence and obscurity. That is why he conceived them as young women—modest, gentle, unostentatious. Another trait reveals the wisdom of the aging master: he gave their faces an expression of serenity. That was the lesson taught him by the years. He had learned that these beautiful virtues bring peace to the soul. Fortitude effortlessly pulls the dragon from the tower just as a hero who after long struggle is master of himself at last. The man who conceived this figure of Fortitude was something more than a skillful artist: he was a wise man.

V

If the Church had presented the faithful with only the Virtues that were placed on tombs out of pride, she could be accused of failing in her mission. As we shall see, the reproach is unmerited. In the fifteenth century, she taught virtue by inspiring distaste for vice. That is why, if images of the Virtues are fairly rare, those of the Vices are frequent. The seven capital sins were one of the favorite subjects of mural painting in the fifteenth and sixteenth centuries. Throughout France at the time, art produced a kind of systematic sermon; many country churches today still display the strange allegorical figures we shall consider here.[141]

The personified Vices. The Vices and their corresponding animals. Vices represented by figures of famous men.

The thirteenth century, that had so nobly personified the virtues, had not thought it necessary to personify the vices. At Paris, Chartres, and Amiens, a small quite understandable scene below the Virtues' feet represents the Vices *in action*.[142]

The fourteenth century remained faithful to this tradition for a long time. Miniatures of the *Somme le Roi* and of the Breviary of Charles V place the Virtues in correspondence with biblical scenes from which we learn to know vice by its effects. Opposite Hope, for example, the suicide of Judas symbolizes Despair (fig. 183);[143] and near Fortitude, Samson asleep while Delilah cuts his hair represents Weakness.[144]

183. Hope with despair personified by Judas. Breviary of Charles V. Paris, Bibliothèque Nationale, ms. lat. 1052, fol. 217, lower margin.

However, the idea of personifying the vices was soon to occur to the artists; it was induced by the taste of the times. One of the most famous books of the fourteenth century, *Le Pèlerinage de vie humaine*, by Guillaume de Deguilleville, presents the vices as female figures who are sometimes charming and sometimes hideous: they strive without success to lure the pilgrim from the right path.[145] One detail is worth notice. The poet has given two of the Vices he personifies mounts appropriate to their character. Gluttony is mounted on a pig, and Lust on a horse. Why a horse? Because the horse sleeps on its own excrement:

Car là où plus il a ordure
Se couche il de sa nature.

(For, where there is the most dung,
He will naturally lie down.)

However, Vices mounted on symbolic animals were not an innovation; the idea had begun to take shape as early as the thirteenth century.[146] But it was not until the late fourteenth century that art followed the lead of the poets.

Nevertheless, it must be said that there had been curious beginnings in this direction as early as the first years of the fourteenth century. In certain illuminated manuscripts of the *Somme le Roi*, the Virtues (not the Vices) stand on animals.[147] There is a pig below Chastity; a dog, symbol of avarice, below Liberality; and the dragon or serpent, symbol of hate, below Amity. Justice has a fox beneath her feet because, the text says, she moves directly and not obliquely as does the fox. In this, do we not recognize the traditions of thirteenth-century monumental sculpture? The Virtues crush the Vices underfoot, as the apostles on the portals of cathedrals crush their persecutors. The figures of the *Somme le Roi* simply perpetuate a tradition; but what should be noted here is the attempt to associate an animal form with each vice.

In pagan antiquity, animals had seemed to be infallible guides for men, repositories of profound wisdom and the secrets of the future.[148] Christianity robbed them of their divine character. The symbolic spirit of the Middle Ages saw in the animal world a dim image of the moral world. To it, the animals seemed to express all aspects of degradation. The *Roman de Renart* is a kind of mirror of nature after the Fall. Dante also saw in animals only the symbols of our vices. Lost in a dim wood at the limits of two worlds, he comes upon a panther, a lion, and a lean wolf; they are the three passions that assail man during the three stages of his life: lust, the will to rule, and avarice. These ideas were not Dante's alone, but belonged to everyone;[149] they explain the works of art we are about to study.

It was about 1390, I think, in an illuminated manuscript now in the Bibliothèque Nationale, that personified Vices riding symbolic animals

appeared for the first time.[150] These Vices, seven in number, are the seven capital sins. Since the Virtues had fairly recently been reduced to seven, it was natural to oppose to them a like number of Vices;[151] henceforth, artists would represent only seven Sins, just as they represented only seven Virtues.

It will be useful to describe briefly the miniatures in this manuscript.

Pride is a king riding a lion and carrying an eagle in his hand (fig. 184).[152] Envy is a monk mounted on a dog and carrying a sparrow hawk (fig. 185). Wrath is a woman riding a boar and holding a cock (fig. 186). Sloth is a wretch on a donkey carrying an owl (*bubo*) (fig. 187). Avarice is a merchant on a mole or a badger (*taxus*) holding an owl (fig. 188). Gluttony is a youth on a wolf with a kite attached to his wrist (fig. 189). Lust is a lady riding a goat and carrying a dove (fig. 190).[153]

184. Pride. Paris, Bibliothèque Nationale, ms. fr. 400, fol. 53r.

185. Envy. Paris, Bibliothèque Nationale, ms. fr. 400, fol. 53v.

186. Wrath. Paris, Bibliothèque Nationale, ms. fr. 400, fol. 54.

187. Sloth. Paris, Bibliothèque Nationale, ms. fr. 400, fol. 54v.

188. Avarice. Paris, Bibliothèque
Nationale, ms. fr. 400, fol. 55r.

189. Gluttony. Paris, Bibliothèque
Nationale, ms. fr. 400, fol. 55v.

190. Lust. Paris, Bibliothèque Nationale,
ms. fr. 400, fol. 56r.

A subtle mind had imagined these allegorical figures. We note, for
example, that each vice is related to a class of society, a sex, and a stage
of life. Pride is the vice of kings, just as avarice is the vice of merchants,
envy the vice of monks, intemperance the vice of youth, wrath the vice
of women: the artist (or whoever inspired him) was a moralist with a
sense of irony. The two animals characterizing each vice could only
have been chosen by some cleric conversant with the literature of the
time. In the *Dieta Salutis*, a work attributed to St. Bonaventura,[154] I
found interpretations suitable to several of these animal figures.

The *Dieta Salutis* reviews all the vices and characterizes them by
comparisons with animals. For example, Wrath is like a boar because
"just as the enraged boar attacks and rushes onto the sword, the wrathful
man strikes blindly and kills." Avarice resembles the mole who lives
underground; it also resembles certain birds who live in solitude.[155]

Gluttony is like the bird of prey who is reluctant to return to its master's hand once it has seen bleeding flesh. Lust resembles the lustful bird, the dove. Sloth can be symbolized by the ass, not because the ass is slothful by nature, but because it likes to eat thistle; now the thistle with its spines is the image of those temptations which Sloth dreams of, and which from time to time prick him.[156]

This is enough to prove that our miniatures were not the work of pure caprice; their symbolism was in large part traditional. These comparisons, and others of the same kind, were transmitted by the theological schools.[157]

French manuscript 400 of the Bibliothèque Nationale is, at present, the earliest work of art devoted to the seven capital sins. No doubt there were earlier ones; nevertheless, it seems certain to me that it is at about this time (late fourteenth century) that the personified Vices first appeared in art. The inventory of Charles V mentions a tapestry representing "the seven Mortal Sins," the earliest reference to the subject I have found.[158] Another inventory from 1396 mentions a similar tapestry;[159] and a Morality Play of the Seven Virtues and the Seven Deadly Sins, in which the Vices of course were personified, was performed at Tours in 1390.[160]

Thus, it was between 1360 and 1390 that the poets and artists were working on the motif of the seven capital sins and giving it form. If this is indeed the case, the manuscript of the Bibliothèque Nationale, which we would date about 1390, takes us back almost to the origins of the theme.

All the works to be discussed generally resemble the miniatures of our manuscript (B.N., ms. franç. 400). They obviously are not derived from it, but rather are related to a tradition very similar to the one represented by the manuscript.

I know of nothing older in this genre than the mural paintings in the small church of Roussines (Indre). To judge by the costumes, the work is contemporary with Charles VII. What can still be seen of it conforms fairly closely to the miniatures of Manuscript 400: Pride is mounted on a lion, Envy on a dog carrying a bone, Sloth on a donkey, Gluttony on a wolf,[161] Lust on a goat. The work, however, like all those that we shall discuss, is simplified. The figures do not have the symbolic birds on their wrists and the social classes do not seem to have been placed systematically in relation to the Vices.

The church of Roussines offers the first example of the treatment in mural painting of the theme of the deadly sins, which was soon to be adopted throughout France. It is always found in modest village churches; the clergy clearly wished to impress simple souls by these images. The peasant was well aware of the faults of his donkey, his goat, his pig, and his dog. The paintings spoke his language: these rural frescoes

resemble fireside stories and proverbs. Instead of saying to a congregation of laborers and winegrowers: Nature is evil, it is better not to give in to it; all moral progress is a victory over nature," the preacher pointed to the paintings on the walls and said: "Do not do as your donkey does who goes only when it is beaten, do not be like your dog who growls when he sees a bone in another dog's mouth." Could it be better said? And to make the lesson more effective, the painter chained the seven Sins together and had a devil lead them along with their mounts toward the gaping mouth of Hell.[162]

We should not be too hard on these naïve figures, and should remember that they were appropriate for a country church.

We find the Vices and their mounts in the church of La Pommeraie-sur-Sèvre (Vendée), at Champniers-près-Civray (Vienne), at Chemillé (Maine-et-Loire), at Pervillac (Tarn-et-Garonne) and in several small churches of the Hautes-Alpes.[163] Probably many other churches were similarly decorated. The widespread diffusion of the motif throughout France suggests that it was systematically brought about: whitewash may still conceal many similar frescoes. The motif also occurs in printed books: for example, Jacques le Grand, *Livre des bonnes moeurs*, printed by Caillant, Paris, 1487 (fig. 191).

The many variations in these works are of little interest and are scarcely worth mentioning. Wrath, for example, is often mounted on a leopard[164] or a bear,[165] instead of a boar; Avarice is often mounted on a monkey;[166] the pig is sometimes associated with Gluttony,[167] and sometimes with Lust.[168] In one work, we find Gluttony mounted on a

191. Pride. Engraving from the *Livre des bonnes moeurs*, 1487, by Jacques le Grant, printed by Caillaut. Paris, Bibliothèque Sainte-Geneviève, no. 1733, fol. a. ii.

bear and Lust on a monkey.[169] These are not to be attributed to any profound thought; they are either fantasies or mistakes on the part of the artist. However that may be, it is clear that the symbolic traditions were not as strict in the fifteenth and sixteenth centuries as they were in the thirteenth.

While the clergy had Aesop-like allegories painted in village churches, the urban artists had another way of representing the Vices. They showed them as famous historical figures: Injustice, for instance, was Nero, and Cowardice was Holophernes; but in conformity with the old tradition, they placed all these contemptible "heroes" under the feet of the Virtues. Such symbolism could have been understood only by the learned, and was addressed to them.

The idea of making certain famous men incarnations of Vices seems to have come from Italy. J. von Schlosser has cited two fourteenth-century manuscripts, both Italian, in which the Virtues trample heretics, philosophers, and tyrants.[170] Justice has Nero underfoot; Fortitude has Holophernes; Temperance has Epicurus; Prudence, Sardanapalus; Charity, Herod; Hope, Judas; Faith, Arius. There are several similar manuscripts, two of which are in France: one at the Bibliothèque Nationale,[171] the other at the Musée Condé at Chantilly;[172] there is no doubt that their origin is Italian.

The earliest of these seem to have been illuminated before the middle of the fourteenth century.[173] This kind of encyclopedia of the Virtues (and of the Liberal Arts) did not pass unnoticed in Italy. The artist who painted the chapel of S. Agostino in the church of the Eremitani in Padua,[174] and the artist who painted the Spanish Chapel in Florence, both knew such works.[175] And from them came the beautiful figures of the Sciences and the Virtues trampling on famous men of antiquity.

France welcomed these ideas that Italy had in large part borrowed from her. We noted previously that in the *Somme le Roi* there are below the figures of the Virtues not only a famous man symbolizing Vice, but a scene in which the man acts out his rôle. Beneath Temperance, for example, we see Judith beheading Holophernes; the idea is the same.[176] Was the shortened form developed in Italy taken over by our artists in the fourteenth century? We may suppose so, although proof is lacking;[177] the monuments that we come upon suddenly at the end of the fifteenth century can scarcely have been cases of spontaneous generation and they testify to an old tradition.

The Hours of Simon Vostre contains the first French examples of the Virtues crushing their most famous enemies underfoot. Faith has Mahomet under hers, Hope has Judas, Charity has Herod, Prudence has Sardanapalus, Temperance has Tarquinius,[178] Justice has Nero, Fortitude has Holophernes (figs. 192, 193, 194). We see that only two names, Mahomet and Tarquinius, differ from those found in the Italian

192. Faith trampling Mahomet. Hope trampling Judas. Hours of the Virgin for use of Saintes. Paris, Simon Vostre, ca. 1507. Paris, Bibliothèque Nationale, Vélins 1661 (details of margins).

193. Justice trampling Nero. Strength trampling Holofernes. Hours of the Virgin for use of Saintes. Paris, Simon Vostre, ca. 1507. Paris, Bibliothèque Nationale, Vélins 1661, fols. diir. and diiir. (details of margins).

194. Temperance trampling Tarquin. Hours of the Virgin for use of Saintes. Paris, Simon Vostre, ca. 1507. Paris, Bibliothèque Nationale, Vélins 1661, fol. diiv. (detail of margin).

manuscripts. The relation thus seems clear and presupposes numerous intermediaries.

It is possible that our Books of Hours, so widely distributed at this time, helped to sanction this motif in the sixteenth century. We find it in two Flemish masterpieces. The magnificent bronze tomb that Cardinal Erard de Lamarck, Bishop of Liège, had commissioned during his lifetime in the cathedral (1535) showed the Virtues trampling on their enemies. The monument has disappeared, but a description lists the names of the personages associated with each Virtue. They are the same ones we encountered in the Hours of Simon Vostre: Temperance has Tarquinius underfoot, Faith has Mahomet, Charity has Herod, etc.[179]

One of the famous Brussels tapestries, now in the royal palace of Madrid, offers the same subject (fig. 199). The Virtues are seated on thrones surrounding Justice, and as footrests they have Judas and Mahomet, Herod and Nero.

VI

All these images celebrated the victory of virtue over vice. But was this an easy victory? Did not fierce battles have to be waged before victory could be won? Assuredly so, and this is the great lesson that the moralistic literature of the fourteenth and fifteenth centuries constantly teaches.

Such is the dominating and even sole idea in the poem of Guillaume de Deguilleville. His pilgrim is Man who goes through life and encounters the Vices, one after another, along the way. Youth has its own vices, just as maturity and old age have theirs; each has its own battles, each of which must be won. A fine idea and an eternal truth. With more imagination, Guillaume de Deguilleville would have been our Dante,[180] for he too, along with his pilgrim, traversed the three worlds.

The prodigious success of his book in France and abroad helped,[181] I believe, to restore to honor the timeworn Psychomachia, the ancient battle between the Vices and Virtues. In any case, could such an idea have been forgotten? Was not the daily struggle against nature the very foundation of Christian teaching? In the fifteenth century, an age devoted to allegory, the Psychomachia reappeared everywhere; we find it in sermons[182] and in the theater. In the *Moralité de l'Homme pécheur*,[183] man is placed between the Vices and the Virtues: he is the battle-prize they fight for. In the *Moralité de l'Homme juste et de l'Homme mondain*,[184] we again find a true psychomachy.

The battle between the Vices and Virtues occurs in books where least expected. There is a pleasant little poem by Gringoire called *Le Château de labour* (labeur).[185] This is the story of a young man, only recently married; he is in bed, "lying as close as possible to his wife," who sleeps soundly while he reflects upon her youth, her fondness for pleasure, and the fact that he is poor; the future seems black. Then strange figures surround his bed: Necessity, Care, Despair—the whole procession of unhappy night thoughts. Happily, toward morning a gentle figure comes and sits by his bed. She is Reason, and says to him: "Man of little faith, why are you afraid?"

> *Crains Dieu et entretiens sa loy,*
> *Et je te promets, par ma foy,*
> *Que tu n'auras que trop de bien.*

The battle of the Vices and Virtues. The French tradition. The German tradition.

(Fear God and keep His law,
And I promise you, on my faith,
That you will have only too much wealth.)

"Your only enemies are your vices. Fight with courage against the seven capital sins, fearing neither their lances nor their shields." And Reason describes to him at length the hard psychomachy in which he must be victorious.

The young man arises consoled. He goes straight to the blacksmith's forge "in the Castle of Work," where he labors valiantly the whole day long; when he returns to his home in the evening, he finds the table set "with bread, soup, a little wine and relish."

> *Ma femme, après, la nappe ôta,*
> *Et pour prendre, après, son déduit*
> *Sur mon épaule s'acouta.*

(My wife, afterwards, cleared the table,
And then, to have a little lovemaking,
Leaned on my shoulder.)

All is smiling now in the little house, and he calls it "the house of repose."

We see how strong the imprint of the Psychomachia was upon the imagination: so it is not surprising that the timeworn subject, disdained by the thirteenth century, should reappear in art.

The Psychomachia provided illustrations for several books published by Simon Vostre, and for *Le Château de labour* in particular (figs. 195-198). The Virtues, mounted on steeds, carry shields and lances. The Vices combat them astride their customary mounts—Pride on a lion, Avarice a monkey, Lust a goat, Envy a dog, Gluttony a pig, Wrath (Ire) a bear, Sloth an ass. Thus, the artist was perfectly familiar with the old traditions,[186] and his work conforms in almost every respect with the miniatures of French Manuscript 400, illuminated a century earlier.

195. Humility fighting Pride. Generosity fighting Greed. *Le Château de labour.* Paris, Pigouchet, May 31, 1500. Paris, Bibliothèque Nationale, Rés. Ye 1330.

196. Chastity fighting Luxury. Charity fighting Envy. *Le Château de labour*. Paris, Pigouchet, May 31, 1500. Paris, Bibliothèque Nationale, Rés. Ye 1330.

197. Sobriety fighting Gluttony. Patience fighting Anger. *Le Château de labour*. Paris, Pigouchet, May 31, 1500. Paris, Bibliothèque Nationale, Rés. Ye 1330.

198. Diligence fighting Sloth. *Le Château de labour*. Paris, Pigouchet, May 31, 1500. Paris, Bibliothèque Nationale, Rés. Ye 1330.

A manuscript in the Cluny Museum, illuminated in the sixteenth century for Louise de Savoie, also contains episodes of a battle between the Vices and Virtues.[187] But its allegory is even richer: instead of being on horseback, the Virtues are also on symbolic animals. Humility, on a lamb, attacks Pride riding a lion; Liberality, on a cock, attacks Avarice on a monkey; Patience, on an ox, defeats Wrath on a boar; Sobriety, on an ass, strikes Gluttony upon a pig; Chastity, standing on a dove, opposes Lust on a he-goat; and Charity, riding a horse, triumphs over Envy who rides a dog.[188] As is apparent, the mounts of the Vices are those assigned them by tradition; as for the animals associated with the Virtues, more than one is to be found on the coats of arms of our thirteenth-century Virtues.

The Psychomachia motif was most popular in the workshops of high warp tapestry makers. Flemish tapestries in the Vatican museum, in the royal palace of Madrid, and in private collections, are devoted to the battle of the Vices and the Virtues; but we see at a glance that these works do not belong to the French tradition. The contending forces ride mounts that we have never come upon before: unicorns, dragons, dromedaries, stags, chamois. Other symbolic animals, equally novel, decorate their helmets and shields: peacocks, bats, serpents, mermaids.

This rich composite bestiary, in which fable enriches nature, is the German bestiary. Flanders, on the threshold of the Germanic world, followed German tradition.

In 1474, a book entitled *Buch von den sieben Todsünden und den sieben Tugenden* appeared at Augsburg. Woodcuts represent the Vices and the Virtues mounted on animals: they look like knights ready to enter the lists. Each of the champions has a shield with coat of arms, and beside him, a helmet decorated with a tall symbolic crest such as feudal Germany loved. It must have been strange to see such an enchanted forest floating above the knights' heads in tourneys and battles.

The book was so successful that three editions appeared within eight years.[189] This was the original that inspired the artists who composed the cartoons for the tapestry makers of Brussels and Arras. Sometimes they took certain liberties with it; they seem even to have known some other German work, such as the *Sermons* of Lutzemburg;[190] nevertheless, the Augsburg book remained their principal source.

In the center of one of these tapestries,[191] we see a knight mounted on a dromedary; his shield is embossed with an eagle, and his helmet has a peacock for crest. Is this a Vice or a Virtue? We have only to open the Augsburg book to learn that the warrior on the dromedary with the eagle and peacock as heraldic emblems is none other than Pride. In the same tapestry, we easily recognize Envy on a dragon,[192] Chastity on a unicorn, and Temperance on a stag.[193]

Such works, although different from the French, prove that the Psychomachia theme had spread over almost all Christian Europe.[194]

VII

The allegorical tapestries of Madrid. The influence of the *Grands Rhétoriqueurs.*

The most magnificent composition ever inspired by the Virtues and Vices is a series of Flemish tapestries that now decorate the royal palace of Madrid.[195] I speak of them here because in inspiration and iconography the work is half French; but I shall discuss them only briefly because a description alone would require an entire volume. Each of the hangings is a world in itself; rich architecture, banners and standards, heralds-of-arms and knights, allegorical figures, gods of fable, illustrious women, philosophers, conquerors, all the world of fable and of history

brought together by a poet enamored of grandeur and beauty. Grouped around enthroned Justice are the great men who honored her, while in the background we glimpse the ancient criminals, the famous rebel angels smitten down by heaven. Prudence has her retinue of Sages, and Faith her train of Virtues (fig. 199).

The learned man who organized the diverse episodes of this *Légende des siècles* was an erudite and eclectic poet, who knew and loved antiquity but was not convinced that its heroes were any greater than our knights. His head was full of Virgil and Ovid, but he did not disdain Alain de Lille. As I soon realized, it was in fact from Alain de Lille that he borrowed the initial idea for his most ingenious compositions.

We know that the twelfth-century monk recounted in his *Anticlaudianus* how Human Prudence had undertaken a daring journey to reach the Court of Divine Wisdom. His Latin verses are so harmonious and sometimes so exquisite that they explain their own long success.[196]

The author of the libretto for the tapestries often followed Alain de Lille fairly closely. He first presents the Liberal Arts (the seven Muses of the Trivium and the Quadrivium) constructing the chariot of Prudence. Some make the shafts, others the wheels, while Reason brings up the five horses that will draw the chariot: their names are Sight, Hearing, Taste, Touch, Smell—in short, the five senses.

A second tapestry is devoted to the journey. Prudence, mounted on the chariot, gives over the reins to Reason, who audaciously starts the horses off into the heavens.[197] Thus she arrives at the Temple of Divine Wisdom situated among the signs of the zodiac. What does she learn in this sanctuary? Nothing less than the secret of happiness. Unerring Wisdom teaches that, to be happy, we must master our natural instincts; the man who has Strength of soul and Temperance as his allies is greater than Fate; he can enchain Fortune. Such is the allegory represented in the center of the tapestry: Fortitude and Temperance hold Fortune prisoner, while a philosopher whips a satyr.[198]

Then we return to earth, to the Temple of Fortune, just as Alain de Lille described it, on a rock, surrounded by the "River of Adversity." Many are the unfortunates who struggle against the current and try to reach the bank.[199] Fortune makes sport of them: seated before her wheel, she changes the balance of the world with a flick of her finger.

Alain de Lille ends his poem with a Psychomachia, a long battle that ends with the triumph of the Virtues.[200] Two hangings show respectively the Vices battling the Virtues or great men, and the victorious Virtues receiving the great men into heaven.

Inspired by Alain de Lille but no docile imitator, our author enriched his source with a thousand new inventions as he went along. Moreover, he did not owe everything to Alain de Lille. For example, he borrowed from Petrarch the idea of the Triumph of Renown, the subject of another

199. Faith with Virtues who crowd at the feet of celebrities of antiquity. Madrid, Royal Palace. Tapestry.

of the Madrid tapestries. On the other hand, he seems not to have borrowed from anyone the subjects of the other tapestries; those in which he celebrated the great royal virtues, Honor, Justice, and Faith, seem to be entirely his own.

A careful analysis of these extraordinary works reveals in them the turn of mind, the imagination, and, if we may so call it, the poetic art of the leading *rhétoriqueurs*.

For example, Jean Molinet, in his *Throsne d'honneur*, described Justice as follows: we are far above the earth, higher than the planets, in the fifth heaven: "There, in a very rich golden chair, was Justice whom Honor had seated in great majesty in the center of the heavens, like the sun among the planets, to illuminate all the celestial court and to wield her sharp and flaming sword; the great king Charles was seated at her right in imperial triumph."[201] Could this not be a description of

the Madrid tapestry devoted to Justice? True, the great king Charles is missing, but there are David and biblical heroes and heroines.

But the Madrid tapestries resemble most closely the inventions of Jean Lemaire de Belges.[202] In his *Temple d'Honneur et de Vertu*, he conducts the Duchess of Bourbon, whom he calls Aurora, to the threshold of a miraculous edifice. Six Virtues decorate its façade, "and were seated on firm bases of alabaster in seats of porphyry and covered with canopies of crystal sprinkled with stars." They resemble "exquisite and precious" statues, but nevertheless they are alive, they breathe, and wise words issue from "their coral red lips."—Thus, in the tapestry of Faith the Virtues sit enthroned on the façade of a marble palace and are, at the same time, both statues and women (fig. 199).

In the tapestry of Honor, the analogy is even more striking. Lemaire de Belges, in fact, brings, Aurora into the Temple. This is the Temple of Honor inhabited by heroes. In the sanctuary, Honor is seated "on a godly throne," surrounded by the great leaders of all countries and all times: David, Joshua, Hector, Cato, Gideon, Scipio, Fabricius, Camillus, Judas Maccabaeus, Octavius Augustus, Titus, Trajan, Antoninus Pius, Constantine, Theodosius, Charlemagne, Otto. The princes of the House of France have their place beside these illustrious men; transfigured by death, St. Louis, Charles VII, Charles VIII, Philippe de Bourgogne, Jean de Bourbon, and Robert, count of Clermont, have become "sublime spirits." Illustrious women, Marguerite de Provence and many others, also are seated among the heroes.

Is not this program the same as that of the Madrid tapestry? There we see Honor seated beneath a canopy in the center of the Temple; two angels place an imperial crown on his head. Around him are three tiers of thrones occupied by the great men and illustrious women of history. Here and there we can make out a name: Octavius, St. Louis.[203]

The resemblance, it must be admitted, is extraordinary. So much so that I wonder if it was not Jean Lemaire de Belges himself who created the program for these tapestries. The dates agree perfectly. The cartoons for the Madrid hangings could have been composed only in the first years of the sixteenth century: the style of architecture, the costumes, the character of the drawing do not permit either an earlier or a later date.[204] Thus the work was conceived at the very moment when the poetry of Jean Lemaire was at the height of its brilliance.[205]

Was he the one chosen to create the plan for the painter's work? I am inclined all the more readily to believe it because Jean Lemaire loved to direct artists and was named "Inspector of the buildings of Brou" by Marguerite of Austria.[206] His genius would have seemed appropriate inspiration for the artists because the tapestries in the cathedral of Beauvais representing the mythical kings of Gaul were based

on one of his books.[207] A detail on the Madrid tapestry that represents the Punishment of Infamy merits our attention. In the place of honor we see a figure seated at a worktable among folio volumes; a manuscript is open before him, and with raised pen he awaits inspiration. In large letters above his head is written *Author*. Who is this great man? Certainly not the painter, as it is still maintained in Madrid,[208] but rather the poet who organized the whole of the work. To have been given this honor he must have been the most famous writer of his country, so famous, in fact, that there was no need to name him: and it was no doubt thought that posterity would also be able to recognize him. Now among the writers of the court of Marguerite of Austria, I know of none except Jean Lemaire de Belges who could have elicited such admiration.

Whoever the author of the Madrid tapestries was, they constitute the masterpiece of the school of the *Grands Rhétoriqueurs*.[209] I must confess that I have found these writers less mediocre than I had expected. Georges Chastellain, and even more so, Jean Molinet and Jean Lemaire de Belges, often had a true sense of beauty. They aspired with all their strength to the beauty they glimpsed in the works of antiquity. They loved beautiful myths, heroic narrative, splendid names. They called their shepherds Amyntas and their shepherdesses Eglé. They felt the charm of colorful adjectives, harmonious words, names of precious stones. They arranged even their prose according to the laws of an inner music. Here for the first time we have poets who had feeling for art itself. To be sure, they are obscure, bizarre, affected, but they are not bourgeois and prosaic like Deschamps and Chartier.[210] The world in their heads resembles a dream of Polyphilus.[211] They dream of sacred woods, temples, muses, satyrs, shepherd musicians; but they place biblical heroes and knights of the Round Table in their vale of Tempe, along with the heroes of antiquity. Their composite poetry resembles the charming architecture of the time of Louis XII in which Italian arabesques, antique candelabra, and medallions of emperors decorate Gothic façades.

Nothing gives a fairer idea of the art of the *Grands Rhétoriqueurs* and their imaginations than the tapestries of Madrid. These are their best work. Had they inspired only these masterpieces, they would deserve to be remembered.

VIII

Conclusion.

Such are the lessons taught by art. The Christian is obliged to meditate for a moment on the vices and the virtues. On the walls of churches and tombs, in the pages of Books of Hours, appear the images of his duty.

The conception of life expressed by artists ever since there has been a Christian art in France is, finally, always the same. Life is a battle, man must struggle ceaselessly against himself. It all has to be done over again by each succeeding generation; there may be individual but no collective progress. Thus, the paintings of the Vices and the Virtues on the walls of ancient churches always retain their eloquence. What the father has learned, the son will learn in turn; each will come to know that he must attain self-mastery with the help of God.

In French Books of Hours there is frequently a curious engraving that was reproduced on glass in a window of Nonancourt (Eure). It shows people kneeling before a church, watched over by the Trinity: all human society is included, pope, emperor, kings, the great of the earth, the people. This peaceful, well-organized world, in which each has his place, is called the "Church Militant." Thus, all the unmoving, silent men are combatants in the struggle against themselves. Noiselessly they wage war against their vices, sometimes winning, sometimes losing; and they will fight until the very hour of their death.

VIII

Art and Human Destiny: Death

I

Images of Death appear in art at the end of the fourteenth century. The corpse in sculpture. The thought of death is always present in man's mind.

To make its teaching more forceful, art placed the image of Death beside those of the Vices and the Virtues. The church in Kermaria, Brittany, is one of the very few to have preserved almost intact the paintings with which the fifteenth century decked its walls. There, beside the figures of the Virtues, we may still see the legend of the Three Dead and the Three Living, and the Danse Macabre. Even the most untutored mind must have been struck by this arrangement. The church seemed to be saying: "Wait not until tomorrow to live the Christian life, for there may be no tomorrow."[1] The corpse rising from the tomb to teach us, not the nothingness, but the seriousness of life, was a completely new figure in art. There had been nothing like it in the thirteenth century.

Death has never been more modestly attired than in the thirteenth century. It is hard to imagine anything purer, sweeter, than certain figures carved on gravestones or recumbent on tombs. With clasped hands and open eyes, these youthful, beautiful, transfigured dead seem to partake already of eternal life. Such is the poetry with which our noble thirteenth-century artists surrounded death: they induce not fear of death but almost love for it.

But then in the late fourteenth century, death suddenly appeared in all its horror. In the episcopal chapel of Laon (Aisne), there is an astonishing funerary statue of a corpse that has not decomposed but has dried up—this poor half-mummy, half-skeleton covers his nakedness with his bony hands. The anguish, the forlornness, the nothingness of this dead man are inexpressible. Who was this forthright person who wanted to be shown on his tomb as he was in his coffin?—a famous physician of the fourteenth century, Guillaume de Harcigny. He had studied with the Arabs and in the schools of Italy, and was considered the most able man of his time: he treated Charles VI at the beginning of his madness and calmed him during the violence of his first attacks.

He died in 1393; his tomb was begun at once,[2] and the statue under discussion cannot be much later than 1394.

It is one of the earliest examples of sepulchral realism, something that would never have occurred to the great centuries of the Middle Ages.[3]

Cardinal Lagrange died in Avignon in 1402. He had wanted two tombs: one at Amiens for his flesh, and another at Avignon for his bones. Only a few fragments of the Avignon tomb have survived: one of the most interesting is a relief showing a corpse (fig. 200). This is Cardinal Lagrange himself, dry and mummified, like Guillaume de Harcigny. But here the dead man speaks; his harsh words to us are written in Latin on a scroll: "Unhappy man, what reason do you have to be proud? You are nothing but dust, and soon you will be as I am, a stinking corpse, food for worms."[4]

Thus, it was in the reign of Charles VI, at the critical moment when art was abandoning most of its old traditions, that the corpse first appeared in all its repugnant ugliness.

200. Corpse of Cardinal Lagrange. Avignon, Musée Calvet. Stone figure from tomb of Cardinal.

The image of Death appeared a little later in manuscripts. It was in the first part of the fifteenth century that Death began to inspire miniaturists; I have found only a few timid images that are earlier—unconvincing images that would frighten no one.[5] Toward 1410 or 1415, one of the Duke of Berry's illuminators painted a formidable figure of Death.[6] He showed a desiccated corpse, a black mummy wrapped in a white shroud; it brandishes an arrow and is about to pierce an elegant young man who is unaware of his terrible visitor. We cannot help thinking of the Duke of Orleans' vision of death shortly before he was assassinated.[7] A few years later, an unknown miniaturist illuminated the remarkable Rohan Hours.[8] His was a powerful and

somber imagination; death both repelled and attracted him; in eight successive scenes he expressed its loathsome and terrifying aspects.[9] First we see a funeral procession and monks praying around the coffin; next, gravediggers prepare the grave in an ancient church and, at each strike of the pick, bring up the bones of the buried dead. The next scenes are mysterious and terrible: the dying man lies in his bed; his wife and son are beside him; they take his hands and try to hold him back, but frozen with horror, he stares at something he alone can see—a tall, black mummy who has come into his room carrying a coffin on its shoulder. Farther on, there is a coffin resting on a trestle in the center of a cloister; suddenly the lid opens by itself and we see the waxen face of the dead man. Next, the nude and rigid corpse is stretched out among skulls and bones on a black pall with a red cross (fig. 201). In the sky above, God the Father, with sword in hand, shows his formidable head. The hour of Judgment has come; there is no time to pray; however, while the angel and the devil contend for his soul, the poor dead man is still hopeful, and a prayer of supplication written on a long streamer issues from his mouth.[10]

There had been nothing in earlier art to prepare for these frightening images.

From the beginning of the fifteenth century, Death seemed to have become the great source of inspiration. In 1425, the Danse Macabre was painted at the Cemetery of the Innocents, in Paris; similar works appeared in all parts of Europe in the course of the century; the old story of the "three dead and the three living" appeared in art, and became one of the favorite subjects of mural and miniature painting.

In the fifteenth century the image of Death was to be seen everywhere. Some of these funerary works still exist, but many have disappeared. Documents and old drawings reveal strange scenes. For a long time, a fifteenth-century panel was preserved in a church at Avignon, representing the decomposed corpse of a woman lying beside an open coffin in which a spider has spun its web.[11] King René had a seated crowned king painted above his tomb at Angers, but a close view showed this king to be a skeleton looking through empty sockets. A terrible funeral sermon that no preacher could equal.[12] Even the amiable Bourdichon himself, so enamored of grace, submitted to the taste of the time; a document states that he painted "a corpse devoured by worms in a cemetery where there were several tombs."[13]

The sixteenth century went even farther than the fifteenth. The century that we think of as young, healthy, optimistic, like the heroes of *Pantagruel*, was obsessed with Death. We shall speak later on of its lugubrious tombs, but here I wish to mention a figure that seems to be a creation of the sixteenth century. We sometimes encounter a relief of a corpse that is set into the wall of a chapel. A hasty observer might

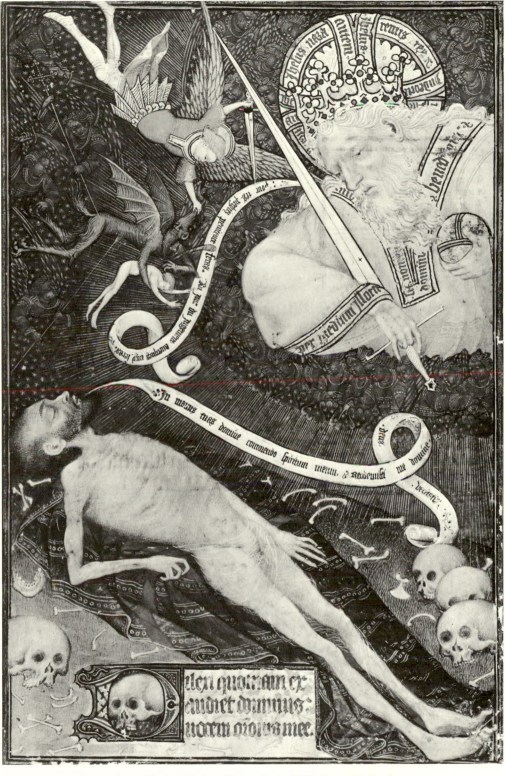

201. Dead man face to face with God. Rohan Hours. Paris, Bibliothèque Nationale,
ms. lat. 9471, fol. 159.

think that this is a tomb like that of Guillaume de Harcigny, but such is not the case. Neither name nor epitaph accompany the relief; the inscription, if one exists at all, is a commentary on the nothingness of life and is a warning to the passerby. Thus, the corpse was carved there to make us reflect, and is surely as eloquent as a Bossuet sermon.[14] It tells us what we shall become. One inscription says: "I am what you will be, a pinch of dust";[15] and another: "My body, once beautiful, is now rotten; and you who read this will become as I am."[16] And the image shown is truly hideous: at Gisors (Eure), the corpse's mouth and eyes are open, its hands are crossed on its breast; at Clermont d'Oise, the bony toes grip the stone (fig. 202); at Moulins, decomposition has already begun: the stomach splits open like an overripe fruit, and worms crawl out; the corpse of the cathedral of Châlons-sur-Marne is much nobler (fig. 203).

Such images go beyond the limits of art; they are almost unbearable. Fortunately, we feel life stirring deep inside of us and are reassured. We know that this will happen to us, but we do not believe it. Nevertheless, the ordeal is trying; robust faith and unswering hope were necessary to the generations who dared look death in the face.

All these effigies were made between 1526 and 1557.[17] During this same period, the famous statue of Death was erected in the Cemetery of the Innocents. Now that it is relegated to the Louvre it has lost all meaning. For its domineering air to be understood, it had to be seen in the middle of our ancient Campo Santo; there, it was sovereign among its subjects.[18]

No century was more at home with death than the sixteenth; its denizens seem to have made of it a friend, placing its image everywhere. The father having a house built for his family inscribed the thought of death upon its walls. Above the door of a house in Périgueux (Dordogne), this warning is engraved: *Memento mori*. On the fireplace of a house at Le Fay, near Yvetot (Seine-Inférieure), a skull and bones are

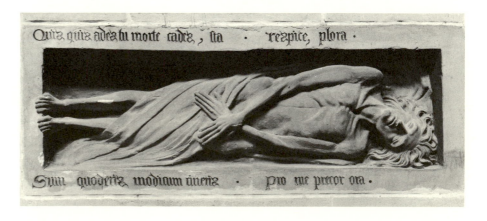

202. Cadaver. Clermont d'Oise (Oise), Church of St.-Samson. Stone relief.

carved, with the following inscription: *Pensez à la mort—mourir convient—peu en souvient—souvent avient*. (Think on death—we all must die—few remember—it comes often.)

And the old Norman who believed he was acting wisely in making all of his descendants think of death, wrote: "Robert Beuvry had his mantel made for God and for the dead, 1503."

The mission of the hearth where the family gathered was to speak of death. The mantel of the fireplace at the Château de Coulonges-les-Royaux bears the inscription: *Nascendo quotidie morimur*.[19] At Panneville, in Normandy, we see the portrait of the first owner on one side of the chimney piece, and a skull on the other. This was called "man's mirror":[20] in it he could see what he would one day become. Nearby, at the father's request, an inscription worthy of a Carthusian cell was carved: "All must die. I await the hour of death. 1533." On another fireplace,[21] *Hodie mihi cras tibi* is written, with all the eloquence of a tomb.

Even at table, the family could read on an earthenware jug used for cider or wine: "Think of death, poor fool."[22]

Such small things, long considered beneath notice—the inscription on an earthenware jug, a phrase carved above a door, on a plaque in the entry, or on the chimney mantel—all tell us more about ancient France than the *Heptameron* or *Pantagruel*.[23] These were the people no one wrote about. How deeply serious they were! What austerity, and Christian melancholy![24]

To be sure, this serious view of life was not new. The thought of death is "the thought in the back of the Christian's mind"; it enables him to judge the value of men and things. Back in the twelfth century, poets had sung eloquently of the omnipotence of death. Hélinand, a monk of Froimont, wrote a poem in French on death, and even today we can feel its virile beauty; during the thirteenth century it was read aloud in the monasteries.[25]

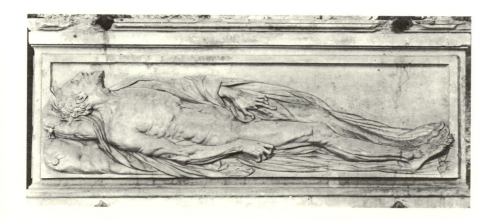

203. Cadaver. Châlons-sur-Marne (Marne), Cathedral. Stone relief.

Hélinand sang of the nothingness of greatness; Innocent III, in his *De contemptu mundi* cast anathema on the flesh.[26] The Middle Ages produced no writing more somber: the ugliness of life and the horror of death are described in almost offensive terms. This omnipotent pope was as unhappy on the throne of St. Peter as Job on his dungheap. He makes us smell the stench of the corpse, he shows us the process of decomposition, and repeats the Bible: "I have said to corruption: thou art my father and mother; and I have said to the worms of the sepulcher: thou art my brothers." [*sic*, Job 17:14.]

It would be easy to cite a number of somber pages from the thirteenth century that had been inspired by the thought of death.[27] Nevertheless, such literature did not change the character of the times at all; none of these sorrowful thoughts troubled the serenity of the artists; Christian art never seemed so pure, so consoling, as if it had banished suffering and death.

But when we come to the late fourteenth century we enter a new world. The artists' souls had changed, becoming less elevated, less serene, and more easily moved; Christ's teaching touched them less than his suffering; for the first time, art expressed suffering. It was also at about this same time that artists attempted to represent death. One might almost say that a new Middle Ages began toward the end of the reign of Charles V.

This profound change will not be completely understood until the history of the mendicant orders of the thirteenth and fourteenth centuries has been written. The Franciscans and the Dominicans, by constantly addressing themselves to the emotions, ended by transforming the Christian temperament; it was they who caused all of Europe to weep over Christ's wounds; and they, also, first began to terrify the crowds by speaking of death. I am convinced that the original idea of the Danse Macabre, which we are about to discuss, came from the Franciscan and Dominican preachers.[28]

II

Le dit des Trois Morts et des Trois Vifs (The Tale of the Three Dead and the Three Living) in literature and art.

The *Story of the Three Dead and the Three Living* could be considered as a first and timid sketch of the Danse Macabre. This is the legend: three dead people suddenly rise up before three of the living, who recoil in horror; the dead speak, and cause the living to reflect on their own conduct in a salutary way. This strange subject found its way into literature in the thirteenth century: Baudoin de Condé, Nicolas de Margival, and two anonymous poets wrote four little poems on this theme that differ only in a few details.[29]

The three living are young gentlemen of the highest rank: one is a duke, another a count, and the third the king's son. At the far end of

a field, they suddenly find themselves in an old cemetery[30] where three of the dead stand as if awaiting them; their fleshless bones show through their shrouds. At the sight of them the three young men tremble "like aspen leaves."[31] They stop abruptly and the dead begin to speak. From their toothless mouths issue serious words. The first says, "I was pope." The second says, "I was a cardinal." The third: "I was notary to the pope."[32] And they continue: "You will beome as we are; in anticipation, mirror yourselves in us;[33] power, honor, riches are nothing; only good works count at the hour of death." The three young men, profoundly moved, listen to these words coming from another world, and think they hear the voice of God.

Such a legend is more than a monk's pious tale; we sense the collaboration of the people. The terror inspired by old cemeteries, the fear of what may be met at the crossroads when night falls, all the poetry of winter tales is here distilled.

Famous as it was in the thirteenth and fourteenth centuries, copied and recopied, the *Tale of the Three Dead and the Three Living* was seldom taken up by artists. I except an elegant miniature in a thirteenth-century manuscript accompanying the poem of Baudoin de Condé (fig. 204).[34] This is an isolated attempt of a book illustrator.[35]

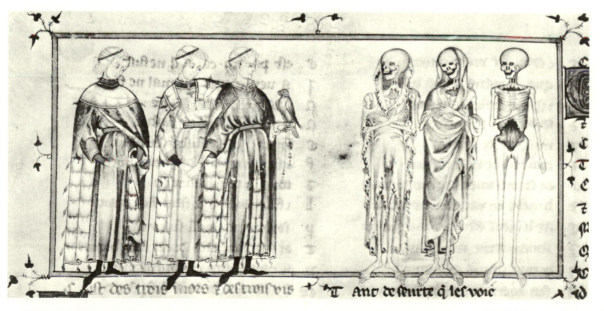

The legend really came into art only when the thought of death began to weigh heavily on man's soul, that is, at the end of the fourteenth century. I have found it in one of the Duke of Berry's Books of Hours, done about 1400;[36] the subject must have pleased the Duke, for in 1408 he has it carved on the portal of the Church of the Innocents, where he wanted his tomb to be.[37] From this time on, the legend was constantly

204. Dialogue of Three Living and Three Dead. Paris, Bibliothèque de l'Arsenal, ms. 3142, fol. 311v.

used by artists; its vogue lasted until the middle of the sixteenth century and even later.[38]

A fact worth mentioning is that the artists followed two different traditions. At the beginning of the fifteenth century the young men were shown on foot, as indicated by the thirteenth-century poems; but they soon began to appear on horseback, and by the end of the fifteenth century, this was the rule.

Not that the painters took this liberty by themselves; the two artistic traditions correspond to two literary traditions.

At the end of the fifteenth century a version of the *Tale of the Three Dead and the Three Living* was printed that differed markedly from the four little poems already cited.[39] The story is put into the mouth of a hermit, and he presents it as a vision sent to him by God.

One day while he was sitting before his poor hut he saw three hideous corpses appear:

> *Les trous des yeux et ceux du nez ouverts.*

> (The cavities of the eyes and nose both empty.)

At the same moment there arrived

> *Sur leurs chevaux trois beaux hommes tous vifs.*

> (On their horses, three splendid men, all alive.)

Such was the stupefaction of the three knights when they saw the three corpses that they almost fell off their mounts; one dropped his dog's lead, and the other let his falcon go.

Meanwhile, the dead lecture the three living, and they speak with an eloquence they very much lacked in our thirteenth-century poems. One pronounces words of terrifying mystery: "You will die," he says in substance, "and soon you will know the supreme terror; for at the moment of death such terrible things take place that, even if God allowed it, we would not wish to relive them." Another skeleton speaks threateningly, and there is a strange note of hatred in his words: "When I see your crimes," he says, "and the suffering of those naked ones who toil for you, who cry out and gape with hunger, I often think that God's vengeance will descend suddenly, leaving no time even to beg for mercy." The three living men feel their senses take leave of them. Fortunately a cross is nearby which permits them to pray for their bodies and souls, and then their souls are illuminated: they understand that God has meant to warn and save them; the words they speak edify even the hermit.

Such is the poem that by far outdoes the others in the originality of details. What period does it belong to? It is difficult to say. However, one thing seems to be certain and that is that it had already spread throughout Europe in this form as early as the fourteenth century. The

proof is that it inspired the famous fresco of the Campo Santo at Pisa. The knights who stop before the three dead[40] meet them precisely in front of a hermitage. The hermit presents them with a scroll on which the moral meaning of their adventure is written. Without any doubt, this is the vision of the hermit, almost exactly as we have just told it.

In France, this poem seems to have been known to artists only in the fifteenth century.

About 1450, miniaturists who illuminated prayer books, painters who decorated country churches, and later the artists who cut the wood blocks for the Books of Hours, unfailingly represent three horsemen in the presence of the three dead men (fig. 205). All the indications given by the poet are scrupulously followed: the stone cross at the crossroads, the hunting dog who runs away, the falcon who flies off. And often the hermit is shown sitting near his hut, reciting his rosary as he meditates on the vision sent by God.

205. Dialogue of Three Living and Three Dead. Hours for use of Rome. Paris, Jean du Pré. Oxford, Bodleian Library, Arch. B, f. 38, Sigs G8v. and H1r.

The fifteenth-century clergy adopted this story, which seemed well suited to influence the faithful. The *Tale of the Three Dead and the Three Living* was one of the subjects most often given to painter-decorators, and it is still to be seen in a great many churches today. It does not belong to any one region: Normandy, Lorraine, the provinces of central and southern France offer many examples.[41] It was sometimes associated with the Last Judgment and the tortures of Hell. The combination is self-explanatory: all the thoughts inspired by death occurred together to the mind of the spectator.[42]

III

The Danse Macabre. Its origin. Its relation to sermons on death. French origins of the Danse Macabre. The painting of the Danse Macabre in the Cemetery of the Innocents. *La Danse Macabre*, published by Guyot Marchant, is an imitation of it. The Danse Macabre of Kermaria and of la Chaise-Dieu. The Danse Macabre of women. *La Danse aux Aveugles* (The Dance of the Blind), by Michaut. *Le Mors de la Pomme* (The Bite of the Apple).

In the *Tale of the Three Dead and the Three Living*, death is certainly formidable, but in the end, clement. It speaks harshly to the great of the world, but grants them respite; it does not place its dry hand upon their shoulders. God has instigated Death to warn the sinner, not to strike him down.

In the *danse macabre*, on the other hand, all traces of compassion are gone.[43]

First, let us look at this terrible dance in its usual setting. In Rouen, there is a sixteenth-century cemetery called *l'aître St.-Maclou*,[44] one of the most moving places in that stirring city. The consecrated ground where so many generations slept, where the lightest rain used to uncover thousands of small white pebbles—the teeth of the dead—is now the playground of an elementary school. The brightness of the grass and trees and the little girls dancing in a ring contrast so strongly with the surroundings that we are more moved than in the presence of a masterpiece. Life and death have never been so simply contrasted. The cemetery is surrounded by a cloister surmounted by a charnel house, where the bones of the ancient dead were placed to make room for the new. A frieze of carved wood decorates each tier of the cloister: tibias, vertebrae, pelvic bones, the coffin, the gravedigger's spade, and the priest's holy water basin, the acolyte's bell, all form the funeral garland. Each column of the cloister is decorated with a group carved in relief, in which we can make out the couples in a *danse macabre*.[45] One of the dead issues from his tomb and takes the hand of a pope, an emperor, a king, a bishop, a monk, a laborer, and draws them along with quick step. The brevity of life, the uncertainty of tomorrow, the nothingness of power and glory: such are the great truths proclaimed by this Danse Macabre. The thoughts evoked by this charnel house penetrated deeply into men's souls.

The Danse Macabre painted in the Cemetery of the Innocents in Paris must have been even more moving. In the fifteenth century, the

cemetery was a place filled with violent poetry. The ancient soil where so many dead reposed was considered sacred.[46] A bishop of Paris, who could not be buried there, asked in his will that at least some of the earth from the Innocents be placed in his grave.[47] However, the dead did not remain in this holy ground for long; they were constantly being displaced for new arrivals, since twenty parishes had the right to bury their dead in that small enclosure. And at this time there was perfect equality among the dead: the rich did not have their own houses in the cemetery, as they do today. When the time came, their grave was sold[48] and their bones taken to the charnel houses that stood above the cloister. At every opening thousands of nameless skulls could be seen; as Villon said, there was no difference between a magistrate and a delivery boy.[49] We understand why the poet might seek inspiration there: he would be moved by all he saw. Built against the church of Les Saints-Innocents was the cell of a recluse who was immured in her prison like the dead in their tombs;[50] there was a hollow column in which a lamp was lit nightly to drive away ghosts and "that thing who walks in the shadows";[51] there was the *Tale of the Three Dead and the Three Living* carved on the portal of the church; and above all, there was the Danse Macabre painted in the cloister.

The Danse Macabre we meet here for the first time had distant origins.[52] We see it taking form as early as the twelfth century, for it was germinating in the verses of Hélinand. There, Death seizes cardinals in Rome, an archbishop in Reims, a bishop in Beauvais; it seizes kings, poor men, usurers, youths, and infants, and is called "the hand that snatches all." Does Hélinand's Death not already seem to be conducting a *danse macabre?*

By the fourteenth century, the idea of a procession of all human conditions marching toward death had appeared in distinct form.

In a manuscript of the Bibliothèque Mazarine, I had the good fortune to come across a little Latin poem from the early fourteenth century that might be considered the earliest of the Danses Macabres.[53] Personages arranged in hierarchical order—king, pope, bishop, knight, physician, logician, young man, old man, rich man, poor man, fool—all lament dying and yet they walk toward death. The bishop says, "I walk toward death whether I like it or not; I leave behind the cross, sandals, and mitre."[54] The knight says, "I walk toward death. I have won many a contest, but I have not learned to win over death."[55] The logician says, "I walk toward death. I have taught the art of winning an argument to many others, but this time death has won over me."[56] It is almost as though one were hearing already the verses that accompany the Danse Macabre in the Cemetery of the Innocents.

The little poem of the Bibliothèque Mazarine is like a sketch for a

morality play. Reading it, it is impossible not to think of the liturgical dramas in which the characters file past the spectators, one after the other, each reciting a verse.

This is not a simple conjecture: documents prove that the *danse macabre* was first presented in the form of drama. The following evidence has thus far escaped historians of art: Abbé Miette, who studied the antiquities of Normandy before the Revolution, had seen a precious document, now lost, in the archives of the church of Caudebec. From it he learned that in 1393 a religious dance, closely resembling a drama, had been performed in the church itself. He described it thus: "The actors represented all the human conditions, from crown to shepherd's crook. Each time around, one of the dancers dropped out, to indicate that each would come to an end, king and shepherd alike." Then he added, "No doubt this dance was none other than the famous *danse macabre*."[57] What a pity that Abbé Miette did not take the trouble to copy the document instead of summarizing it in such antiquated and vague language. Nevertheless, there is no doubt that the *danse macabre* was danced in the church of Caudebec in the late fourteenth century. If the dancers spoke—which is quite likely—they probably recited lines like those given in the manuscript of the Mazarine library.

Did Death play a part at Caudebec? Did a corpse enter the ring of dancers, take one of the living by the hand and lead him toward a tomb? That is the important thing to know. For the stroke of genius was the mingling of the dead with the living. Who was the first to dare represent this nightmare? No document tells us, but we can almost guess. Several paintings of the *danse macabre*, in fact, contain a singular detail. In the paintings at La Chaise-Dieu (Haute-Loire), Basel, and Strasbourg (Bas-Rhin), we can still, or could in the past, see a monk speaking to people grouped around his pulpit:[58] this is the prologue to the drama. Sometimes a biblical theme accompanies this first scene: Adam and Eve, tempted by the serpent, eat of the forbidden fruit,[59] and then the *danse macabre* begins.

These episodes shed light on our problem. It becomes clear that the earliest *danse macabre* was a mimed illustration of a sermon on death. A mendicant monk, Franciscan or Dominican,[60] conceived the idea of making the great truths he preached more effective by having them acted out. First of all, he himself explained that death entered the world because of the disobedience of Adam and Eve, and he demonstrated the results of the divine curse. He called forth the actors dressed in the costumes of pope, emperor, king, bishop, abbot, soldier, laborer; and each time, a hideous figure, a sort of mummy wrapped in a shroud, rushed out, seized the living man by the hand and went off with him. If done well, the scene might profoundly stir the spectators. The mendicant monks had long since tested the effect of mimed sermons; we

know that as they preached the Passion, they had it acted out in the church.[61]

This is unquestionably the real origin of the *danse macabre*. The drama may for a long time have been performed in conjunction with a sermon. When in 1453, the Franciscans of Besançon (Doubs), following the example of their provincial chapter, had the *danse macabre* performed in the church of St.-Jean,[62] it was perhaps still accompanied by a sermon. However, a somewhat earlier document establishes the fact that the *danse macabre* had already moved out of the church in the fifteenth century and was performed outside on a stage, like a simple morality play. In 1449, the Duke of Burgundy, in his home town of Bruges, had the *Play of the danse macabre* performed "dans son hôtel." A painter, Nicaise de Cambrai, who no doubt had also designed the costumes, was one of the actors.[63]

Performed inside the church in the fourteenth century, the *danse macabre* was painted in the fifteenth. Here again, the drama preceded the work of art.[64]

No painting of the *danse macabre* earlier than that in the Cemetery of the Innocents is known. The *Journal of a Parisian Bourgeois* gives its exact date: "In the year 1424 the Danse Macabre of the Innocents was painted; it was begun about the month of August and finished during the following Lent."[65] There is no earlier example in all of Europe. Unfortunately, this oldest Danse Macabre was destroyed. In the seventeenth century, in order to widen one of the neighboring streets, the bordering charnel houses were demolished, and the old fresco disappeared without any artist bothering to copy it.[66]

Nevertheless, it behooves us to form some idea of the first of the Danses Macabres, and it is possible to do so.

In the Bibliothèque Nationale, there are two manuscripts from the Abbey of St.-Victor which give a long dialogue in French verse between the dead and the living.[67] At the beginning of both volumes, in each table of contents, opposite the number of the page where the dialogue begins, we read: "Verses of the Danse Macabre, as they are at the Cemetery of the Innocents."[68] There can be no possible doubt that we have here an authentic copy of the verses inscribed beneath the figures of the fresco. The two St.-Victor manuscripts seem to date from the first half of the fifteenth century, very little later than the painting itself;[69] the verses in all their novelty were transcribed by some monk of the abbey.

This settles one point. Thanks to the St.-Victor manuscripts (which agree perfectly), we know the names of figures painted by the artist, we know their number, and we know the order in which they were presented to the spectator.

This is already a great deal, but we can find out even more.

Guyot Marchant, the Parisian printer, brought out the first edition of his *Danse Macabre* in 1485;[70] very fine woodcuts illustrate a dialogue between the dead and the living. Now if we read the verses accompanying the engravings carefully, we see immediately that they are precisely the same as those in the two manuscripts from St.-Victor. Guyot Marchant had simply copied the inscriptions from the Cemetery of the Innocents.

But if he copied the verses, might he not also have copied the figures? Could his famous prints be, by any chance, pure and simple reproductions of the Danse Macabre of 1424? If this is true, we have nothing to regret, for the work we thought lost has been found.

However, we should not leap to conclusions. It seems certain that the *danse macabre* of Guyot Marchant is an imitation of the Danse Macabre of the Cemetery of the Innocents, but not a close copy. Several small details are proof. It is clear, first of all, that the costumes have been brought up to date, for several figures are dressed in the style of the reign of Charles VIII. The square-toed shoes, for example, date from that period and not from 1424. In fact, shoes with very long pointed toes, called *souliers à la poulaine*, were worn during the entire first part of the century and until about 1480.[71] And again, I note that one of the prints does not correspond exactly to the accompanying text. In Guyot Marchant's work, the sergeant-at-arms is taken away by only one dead man (fig. 209), while at the Cemetery of the Innocents he was certainly taken by two. The text is explicit—the sergeant says:

> *Je suis pris de çà and de là.*

> (I am taken from this side and that.)

Thus, we are warned that the copy is not exact; but on the other hand, we can see that several traits are faithfully copied from the original. The emperor, for example, carries the globe of the world in his hand (fig. 206), and it so happens that the text has him say:

> *Laisser faut la pomme d'or ronde.*

> (You must leave behind the round golden apple.)

The archbishop, seized abruptly by the dead, recoils and draws back his head. This attitude is indicated precisely by the text:

> *Que vous tirez la tête arrière,*
> *Archevêque!*

> (How you draw back your head, Archbishop!)

the corpse says, teasingly.

Other details of the same kind could be mentioned.

Thus, Guyot Marchant's prints may be considered to be imitations, but fairly free imitations, of the fresco of the Cemetery of the Innocents.

Since we do not have the original, let us study the copy (figs. 206-210). It shows thirty couples composed of a live man being led by a corpse. Who is the live man's strange companion? Is he Death, personified thirty times? This is what is generally maintained, but incorrectly so. The two manuscripts from the Abbey of St.-Victor do not call this figure "Death" ("*la* Mort"), but "the dead" ("*le* Mort").[72] Guyot Marchant did the same. Thus, as the text of his *danse macabre* says, the couple consists "of a dead man and a live man." The dead man is the double of the living; he is the image of what the living is soon to become. In the Middle Ages, it was believed that if a man wrote a formula on parchment with his own blood and then looked in a mirror, he would see himself as he would be after death. This dream is illustrated here: the living see themselves in death, before the fact. Moreover Guyot Marchant entitled his Danse Macabre: *The Salutary Mirror*. In the verses accompanying the prints, there are curious traces of this original conception. For example, the emperor says that he regrets dying, and adds these singular verses:

> *Armer me faut de pic, de pelle*
> *Et d'un linceul,—ce m'est grand peine.*

(Arm me I must with pick and spade
And with a shroud—that is painful to me.)

Now the dead man who takes the emperor by the hand carries pick and shovel on his shoulder, and is draped in a shroud (fig. 206); we see what the emperor is now, and what he soon will be. Thus, the dead

206. Pope and emperor. Danse Macabre. Paris, G. Marchant, October 15, 1490. Paris, Bibliothèque Nationale, Rés. Ye 1035, fol. A3.

man is presented as a sort of precursor; he is our future walking before us. We now understand why the *danse macabre* was called "The Dance of the Dead," and not "The Dance of Death."[73]

True, this distinction faded toward the sixteenth century; several fairly late manuscripts no longer call the corpse "the dead," but "Death."[74] By about 1500, people no longer knew the identity of the companion who preceded each of the living. Holbein would have been astonished had he been told that it was not Death. Perhaps one will find, as we do, that the older conception was the more formidable one.

In the fifteenth century, the dead of the Danse Macabre were not skeletons; they were dried up corpses. Certain soils have the property of preserving the dead. In the dim crypts of St.-Michel in Bordeaux, and at St.-Bonnet-le-Château (Loire), there are hideous parchment-like mummies that have been preserved by their long burial in clay soil. There were formerly others to be seen in several places. These were the models for medieval artists. The mummified corpse is more terrifying than the skeleton; he seems still to be living a ghastly life. These specters who dance and balance on one leg are almost lifelike; they remind us of a slender student who has neither belly nor calves to his legs. The mummies of our Danses Macabres are hardly any thinner than Pigalle's Voltaire, and they have the same smile.[75] They preen themselves in a thousand ways: one drapes his shroud around him as if it were a shawl; another modestly covers his sex, which he no longer has. They are pleasantly ingratiating and persuasive: they pass their arms familiarly through those of their victims. They do not walk, they leap, and seem to keep step to the sound of a fife.

207. Cardinal and king. Danse Macabre. Paris, G. Marchant, October 15, 1490. Paris, Bibliothèque Nationale, Rés. Ye 1035, fol. A3v.

The corpse's irony, the smile that opens his toothless mouth, all his atrocious gaiety so well rendered by the artist, was expressed by poets also, but even more bitterly. We are astonished to find the verses of the Danse Macabre so harsh and sometimes so cruel; the sermon of earlier times had been transformed into satire.

The poet announces with ferocious joy that the curate "who had fed on the living and the dead," would himself now be devoured by worms. An abbot was grossly insulted: "Commend the abbey to God," his dead double tells him. "It made you big and fat; and you'll rot all the better for it":

> *Le plus gras est premier pourry.*
>
> (The fattest are the first to rot.)[76]

His dead double speaks to the bailiff in menacing tones: "I bind you over to the Great Judge to account for your acts." Usually, the dead double is less tragic; he prefers to jeer. He laughs at the bourgeois who has to leave his income behind, at the physician who has not been able to cure himself, at the astrologer who sought to read his future in the stars, at the serious Carthusian who also must join in the dance:

> *Chartreux . . .*
> *Faites-vous valoir à la danse!*
>
> (Carthusian . . .
> Show how well you can dance!)

The terrible dead double has pity only for the ploughman.

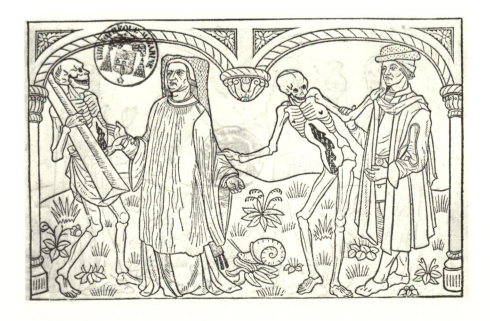

208. Priest and merchant. Danse Macabre. Paris, G. Marchant, October 15, 1490. Paris, Bibliothèque Nationale, Rés. Ye 1035, fol. A7.

Laboureur qui en soing et peine
Avez vécu tout votre temps,
De mort devez être content
Car de grand soucy vous délivre.

(Laborer, who in care and sorrow
Have lived all your life,
You will be happy to die
For it will deliver you from care.)

In this, we sense a social condition in which the abuses were great, and in which privilege began to be severely judged: death, happily, is the same for all and puts everything in order. Nevertheless, this old society was solid; it seemed built for eternity. The living go forward according to the laws of a perfect hierarchy: the pope leads, then come the emperor, the cardinal, the king, the patriarch, the constable, the archbishop, the knight, the bishop, the squire, the abbot, the bailiff, etc. Such a splendid ordering of things must have seemed as immutable as the mind of God. It will be noted that a layman always alternates with a cleric;[77] these are the harmonies to be admired in a well-regulated society: men of thought are balanced by men of action.

The live men who are drawn along by the dancing dead do not dance: they walk with a step already heavy with death. They move forward because they must, but all lament and none wants to die. The archbishop realizes that he will "no longer sleep in his beautiful painted chamber," the knight that he will no longer go in the morning "to awaken the ladies" and play them a morning song, the curate that he

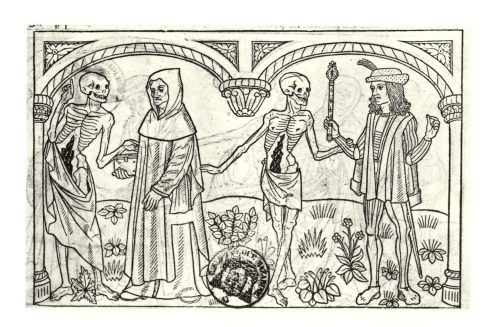

209. Carthusian and sergeant. Danse Macabre. Paris, G. Marchant, October 15, 1490. Paris, Bibliothèque Nationale, Rés. Ye 1035, fol. A8.

will receive no more offerings. The sergeant is indignant that his dead double dares lay hands on him, "an officer of the king"! He tries to hold onto his titles and duties, all the human things that seemed so solid and now crumble like straw in his hands. Even the ploughman is not eager to follow his companion, for he says:

> *La mort ait souhaité souvent,*
> *Mais volontiers je la fuisse,*
> *J'aimasse mieux, fut pluie ou vent,*
> *Etre en vignes où je fouisse.*

> (Death has often beckoned me,
> But I would gladly flee it,
> I would like better, even in rain or wind,
> To be in the vineyard where I dig.)

And even the newly born infant who can say only "a, a, a," regrets life, like the aged emperor and the aged pope.

The unquenchable wish to live and the impossibility of escaping death—this terrible contradiction in human nature has never, I think, been more forcefully presented. The Danse Macabre may offend our sensibilities; we do not have to like it and may find it a bitter brew, but we must admit that it is among the great creations that envision and communicate to all eyes some of the soul's primordial feelings.

The Danse Macabre in the Cemetery of the Innocents was the oldest in Europe. The so-called Danse Macabre painted at Minden (Westphalia) in 1383, considered by Peignot to be the earliest of all,[78] differed from a true Danse Macabre: it was a simple figure of Death painted

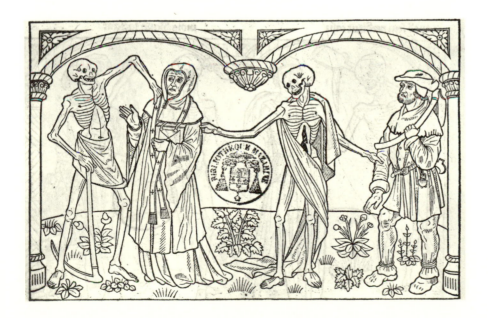

210. Curate and laborer. Danse Macabre. Paris, G. Marchant, October 15, 1490. Paris, Bibliothèque Nationale, Rés. Ye 1035, fol. B2.

on a mobile panel; on the back was painted a woman symbolizing the World, or the Flesh.[79] The Danse Macabre in the Dominican monastery in Basel, long attributed to the early fourteenth century on the strength of a misread inscription, dates in reality from the mid-fifteenth century.[80]

Thus, the Danse Macabre did not originate in Germany. All that has been said about the German spirit's affinity with such a subject is contradicted by the facts. The Danse Macabre is no more German than Gothic architecture, although certain ingenious minds have tried to prove that it had to be so.

Moreover, when we study German Danses Macabres, we find all of them to be of French inspiration. The origins of the Danse Macabre in the Marienkirche in Lübeck, painted in 1463 but since restored, are revealed by a host of details: as in the Paris fresco, the laity and the clergy alternate,[81] the dead man who leads the pope carries a coffin on his shoulder, the physician carries a phial, the infant lies in a cradle. The German verses accompanying the text seem to have been translated from a fourteenth-century French original, the common prototype of the poem of the Cemetery of the Innocents, the Lübeck poem, and a Spanish poem entitled *La Denza general de la muerte*.[82]

Since the Danse Macabre of Lübeck inspired the Danses Macabres of the northern countries—those of Berlin, Reval [or Tallin in Estonia], and the Danish prints of the sixteenth century—there is no point in looking for originality in them.[83]

Nor will we find much more in southern Europe. The two Danses Macabres of Basel presuppose a French original;[84] in spite of additions and interpolations, several of which could be due to retouching, we find again our hierarchy and almost all the same characters.

Since the Danses Macabres of Basel inspired German woodcut books, and these books, in turn, the Danse Macabre of Metnitz (Carinthia),[85] we must conclude that the southern as well as the northern countries were influenced by France.

We might also recall that the first painting of the *danse macabre* done in England, that of London, was made in imitation of the Paris fresco shortly before 1440; John Lydgate, a monk who had returned from France where he had seen the original, translated the verses of the Cemetery of the Innocents into English.[86]

It now seems established beyond doubt that the Danses Macabres, which spread all over Europe in the fifteenth century, originated in France.[87]

Therefore, let us return to France to study those surviving. They must once have been numerous, for texts refer to them in various places where no trace now remains: at Amiens in the cloister of the Macchabées;[88] at Blois, under the arcades of the château;[89] at Dijon in the cloister of the Ste.-Chapelle.[90] How many others must there have been

of which not even a souvenir remains! In the Berlin museum there is a delightful painting by Simon Marmion devoted to the legend of St. Bertin: two scenes represent people in a cemetery; twice, beneath the arcades of the cloister, we see a miniature Danse Macabre.[91] In what town of northern France had Simon Marmion seen the original he copied here?—Several of our Danses Macabres are at present little more than shadows: those of the church at Cherbourg and of the *aître St.-Maclou*, at Rouen, are examples.[92]

Fortunately two, in Kermaria and in La Chaise-Dieu, are somewhat better preserved.

The Kermaria (Côtes-du-Nord) Danse Macabre is invested with the poetry that old Breton churches impart to everything, but it is better not to look too closely or we will discover coarse details. The painter, as naïve as his public, thought to make the dead even more terrible by giving an occasional one the muzzle of an animal or the head of a toad. The work seems to be contemporary with Charles VII: the pointed-toed shoes and certain details of costume would indicate a date somewhere near 1450 or 1460. Thus, it is much earlier than the book of Guyot Marchant and could not have been inspired by it. The original from which it derives could only be the Danse Macabre of the Cemetery of the Innocents: and in fact, the personages follow in exactly the same order, and the verses inscribed below their feet are the very same as those once in Paris.[93] Several small details could lead one to believe that the Kermaria painter was familiar with the original: the constable carries a sword in his hand, the laborer carries a pick on his shoulder, the minstrel lets his musical instrument fall at his feet. All these details are found in Guyot Marchant's book and could only have come from a common source. But we must not conclude that the painting of Kermaria is an exact copy of the fresco in the Cemetery of the Innocents.[94] This rustic work, full of improprieties, does not give a just idea of the original. The painter worked from memory, or he had before him a mediocre sketch which he interpreted in his own way. Between the copy by the Kermaria painter and the copy in Guyot Marchant's book the choice is clear.

The Danse Macabre of La Chaise-Dieu (Haute-Loire) is more than an interesting document, it is a true work of art (figs. 211-215). It harmonizes perfectly with the bare melancholy of the great monastic church lost on high plateaus, forever battered by winds. Everything speaks of death in this austere place. Edith, the widow of Edward the Confessor, went there to die after seeing her country vanquished at the Battle of Hastings. A pope was buried near her. Clement VI had a magnificent tomb erected in the center of the choir which was supposed to conquer time and oblivion; but in 1562, the Protestants, then the masters of the abbey, smashed the mausoleum, mutilated the statues,

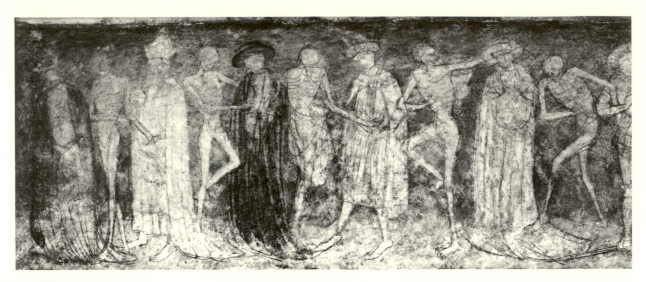

211. Dance of Death: pope, emperor, cardinal, king, and patriarch. La Chaise-Dieu (Haute-Loire), Church of St.-Robert. Wall painting, choir (detail).

and boasted of drinking from the pope's skull. These gloomy memories add elements of Shakespearean tragedy to the stern granite church. It is no surprise to find the Danse Macabre in a place of honor.

The painting at La Chaise-Dieu seems to be almost contemporary with that of Kermaria. I would assign it a date of 1460 or 1470; in any case, the pointed-toed shoes worn by the figures rule out a date any later than 1480. Thus, it is sure that the painting at La Chaise-Dieu is earlier than the woodcuts of Guyot Marchant.

German scholars who have written about the Danse Macabre of La Chaise-Dieu have all assumed that it was restored at the end of the sixteenth century;[95] evidently none of them saw the original. All they had seen was the poor drawing published by Jubinal in 1841.[96] Now nothing could be less faithful to the original than this drawing;[97] we might even say that it does not give the least notion of the work it claims to reproduce. The painting at La Chaise-Dieu is only a sketch, but one full of life; the figures, drawn in outline and slightly tinted, stand out against a red background. The artist had worked so quickly that he did not even trouble to erase the lines of the first sketch he later corrected: one figure with crossed arms was first drawn in with clasped hands; another with head bowed was first drawn with head thrown back; the lines of the first sketch are perfectly visible. Not a single figure fails to bear the mark of improvisation. To suggest that such a work had ever been restored only shows ignorance of it; a sketch is never restored. The painting of La Chaise-Dieu, therefore, must belong entirely to the fifteenth century. How is it related to the fresco of the Cemetery of the Innocents? The similarities between the two seem to have been close, insofar as we can judge from the more or less faithful copy of Guyot Marchant. The resemblances are sometimes striking: in

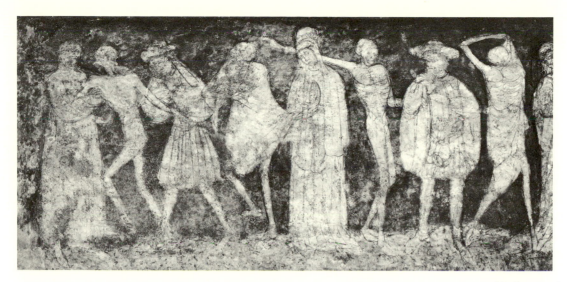

212. Dance of Death: astrologer (?), bourgeois, canon, and merchant. La Chaise-Dieu (Haute-Loire), Church of St.-Robert. Wall painting, choir (detail).

both, the sergeant-at-arms holds a mace, the priest a large book, the peasant a pick over his left shoulder; in both, the minstrel lets his viol fall at his feet. The figures follow each other in almost identical order. And lines drawn in the lower part of the painting indicate that the traditional verses were to accompany it, but the painter did not have time to write them in. Everything in this hasty work suggests it is unfinished—as if Death had taken the artist by the hand and drawn him too into the dance.

If the Danse Macabre of La Chaise-Dieu resembles that of the Cemetery of the Innocents, it also has its differences. The Jubinal drawing would lead us to believe that these were great; it shows women mingling with the men and also drawn along by the dead. Obviously the artist, who was careless at best, was on this point completely unfaithful to the original. In the original, the "woman" following the sergeant-at-arms is actually a monk clad in his hooded robe, and the "woman" preceding the merchant is actually a canon in long surplice.[98]

The differences between the painting of La Chaise-Dieu and that of the Cemetery of the Innocents are not such as to make us doubt their common origin. They are almost always due to happy bursts of genius on the part of the artist of La Chaise-Dieu. For example, his dead are drawn with great originality. He invented several poses not to be found elsewhere: his best is the gesture of the corpse concealing his hideous face behind a bony arm so as not to frighten the infant; he even seems to be ashamed. Whoever thought of this was a true and great artist. We can easily believe that with such a temperament, he would have taken many a liberty with his model.

It is very doubtful, moreover, that the model was exclusively the Danse Macabre of the Cemetery of the Innocents. The painter of La

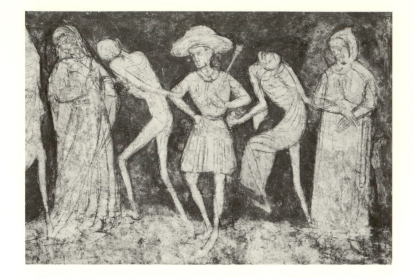

213. Dance of Death: Carthusian (?),
sergeant, and monk. La Chaise-Dieu
(Haute-Loire), Church of St.-Robert. Wall
painting, choir (detail).

Chaise-Dieu must have had in front of him an illustrated manuscript closely related to the Paris fresco (since the figures follow in the same order and have the same attributes), but which differ at several points. Unsatisfactory as the Jubinal drawing is, it at least has the merit of being old. In 1841, certain figures reproduced by the artist could still be seen distinctly: there was a preacher in a pulpit, and seated at its base was a half-effaced figure apparently playing an instrument. Now when we turn to the Danses Macabres of northern Europe, those of Berlin and Reval, we find the same figures.[99] The musician seated at the base of the pulpit is one of the dead playing a bagpipe; his music sets the rhythm for the dance. There was nothing like this at the Cemetery of the Innocents; neither the verses of the St.-Victor manuscripts nor the first reproduction of Guyot Marchant lead us to believe that the bagpipe player had figured in the fresco.[100] We must conclude that the painter of La Chaise-Dieu, as well as the painters of Berlin and Reval, had known a French original that differed somewhat, although very little, from the famous painting of the Cemetery of the Innocents. Who knows if this original did not go back in date to the fourteenth century, and was not the earliest form of the Danse Macabre? One detail would make it seem so: the Jubinal drawing gives a glimpse of a group of figures at the edge of the Danse Macabre of La Chaise-Dieu who do not take part in the dance.[101] What is this indiscriminate crowd? The old Spanish poem, the *Denza general de la muerte*, tells us.[102] They are those who have no place in the hierarchy, who cannot be counted and who as only a nameless crowd follow after the others. As Seelmann has pointed out, the Spanish poem is an archaic form of the Danse Macabre and gives us an idea of the fourteenth-century

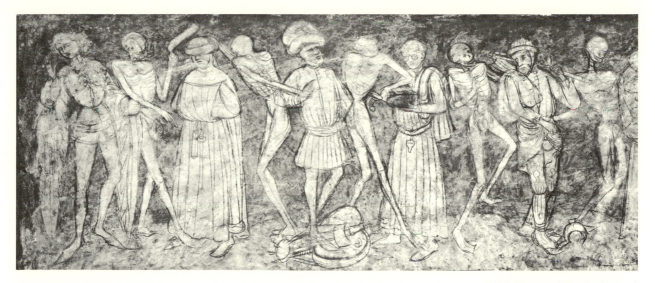

original. By reproducing this primitive detail, the painter of La Chaise-Dieu gives us, in effect, the date of his model.

Thus, a fourteenth-century French painting probably existed (no doubt in an illustrated manuscript) from which all the Danses Macabres in Europe, with their variants, derived, even that of Innocents. But it is no less true that the Danse Macabre of the latter was responsible for the others: it was the first to present the subject in monumental form, and it was admired by all the foreign clergy who frequented the University of Paris; the others were painted to rival it.

The rapid success of the Danse Macabre is an unusual phenomenon. How hard it is for us to imagine the state of mind of the people who bought Guyot Marchant's *Danse macabre*! How can we believe that at the time they took so much pleasure in owning and looking through this gloomy album of death? Is it not extraordinary that the first edition sold out in the space of several months? To please his public, Guyot Marchant enriched the second edition of 1486 with several figures: the legate, the duke, the schoolmaster, the soldier, the *promoteur*, the jailer, the pilgrim, the shepherd, the halberdier, the fool. He took pains to embellish his subject and give it fresh charm: for example, he printed on the first page a picture of four dead musicians leading the dance.

Vérard, the most famous publisher of the time, was jealous of Guyot Marchant's success, and in 1492, placed on sale a *Danse macabre* that strangely resembles that of his rival. Vérard's book was well received by the public, and soon, the provincial printers of Lyon[103] and Troyes wanted to print their own *Danse macabre*; thousands of copies were sold at the famous fair of Troyes. The craze was such that the Danse Macabre was included among the illustrations of Books of Hours, and

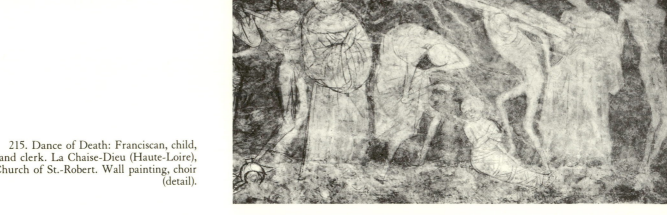

215. Dance of Death: Franciscan, child, and clerk. La Chaise-Dieu (Haute-Loire), Church of St.-Robert. Wall painting, choir (detail).

became one of the motifs that the Christian had before him every hour of the day.[104]

Guyot Marchant, however, thought he had not yet squeezed success dry, and something quite daring occurred to him. On 7 July 1486, a passerby would have seen in the window of his shop, behind the Collège de Navarre, a *Danse macabre des femmes* (Women's Danse Macabre); and to create a maximum of interest in the volume, Marchant had included the *Légende des trois morts et des trois vifs*, the *Débat du corps et de l'âme*, and the *Complainte de l'âme damnée*. It made a fine funeral wreath.

However, the Women's Danse Macabre does not compare with the other. We sense at once that it is the work of one man, and not of a century. The old Danse Macabre, a collective work, came to us charged with thought and emotion. The Women's Danse Macabre, the work of Martial d'Auvergne, has only what could be contained in the head of the untalented poet.[105] The verses have no bite; death has lost its sting and no longer jeers and insults; and the resigned victims praise Providence, who does nothing in vain. The work would be quite flat were it not for a few touches. The squire's wife regrets dying because she has never worn the dress she bought at the fair; the little girl leaves her doll to her mother; the nurse for the woman in childbed also regrets going, for even she has had her good moments: sitting beside the bed curtains

> Où étaient maints bouquets pendus,
>
> (Where many bouquets hung,)

she eats the cakes and quince preserves intended for the young mother.

The woodcuts themselves are roughly and vigorously drawn (fig. 216), but they do not have the quality of those we already know. The artist was not sustained by the powerful original we sense behind the male Danse Macabre. He gave a little variety to the women and was rarely able to invent a new gesture, whether tragic or farcical, for a corpse. He did, however, invent one thing, and a terrible one: by attaching several strands of long hair to their skulls, he identified the sex of the corpses who lead the women away. Following the ancient tradition, they are the women's doubles, and the horror inspired by these mummified corpses is even greater. This is what the female body becomes,

> *Qui tant est tendre,*
> *Poly, souef et précieux.*[106]

> (Which is so tender
> Smooth, soft and delicate.)

The works just cited are not the only ones inspired by the *danse macabre*[107]; it haunted the imaginations of poets who wrote ingenious variations on the subject.

In 1466, Michaut published his *Danse aux aveugles* (Dance of the Blind), which does not lack originality despite the many reminiscences of Petrarch's *Triumphs.*[108] The three blind persons that make men dance are Love, Fortune, and Death. Love and Fortune are blindfolded, but Death has no eyes at all. Men and women pass these ballet masters holding hands. The *Danse macabre* unfolds around the figure of Death, who is armed with an arrow and mounted on an ox symbolizing Death's calm and regular pace.[109]

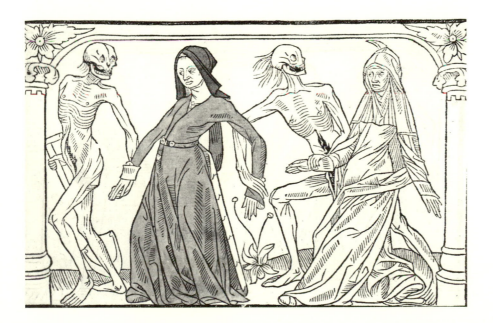

216. Womens' Danse Macabre. Paris, G. Marchant, May 2, 1491. Paris, Bibliothèque Nationale, Rés. Ye 86 (1), fol. A5.

Michaut's book was not without influence on the visual arts. I have no doubt[110] that his poem gave several artists the idea of representing Death mounted on an ox and threatening men with a long arrow (fig. 217).[111]

Even more interesting for us is the curious poem entitled *Le Mors de la pomme* (The Bite of the Apple), which was written about 1470. Strangely enough, this fairly late work seems to take us back to the very origins of the Danse Macabre. The entire first part is like a sermon: such, no doubt, were the ideas developed by the fourteenth-century Franciscan and Dominican preachers, before the actors in the drama came on the scene. The poet explains that Death entered the earthly

217. Dance of Death. Hours for use of Besançon. Paris, Simon Vostre, ca. 1512. Marginal decoration. Cambridge (MA), Houghton Library, Department of Printing and Graphic Arts, no. 298.

218. Dance of Death. Hours for use of Besançon. Paris, Simon Vostre, ca. 1512. Marginal decoration. Cambridge (MA), Houghton Library, Department of Printing and Graphic Arts, no. 298.

paradise at the very moment our first parents sinned. When the angel drove Adam and Eve from the Earthly Paradise he gave Death three long arrows and a brief of written instructions, with the Lord's seal upon it.[112] In this brief, God speaks like a sovereign, and makes known to all that he has given full powers to Death. That is why Death, with his credentials in order, calmly sets to work. Beside Cain when he kills his brother, it is Death himself who strikes Abel; then he travels across the world, his brief in one hand and his arrows in the other. He finds plenty to do. At this point in the poem, a kind of *danse macabre* begins, far less simple and well regulated than the usual one. What is new is that the figures are not isolated and presented as social abstractions: Death strikes them when they are in the midst of activity, in the street, in a crowd, at the family table. The artists who illustrated the work contributed in large part to the creation of a new type of Danse Macabre, and he is often more precise than the poet. We see Death striking down the pope among his cardinals and the emperor surrounded by his court; Death strikes the solider with his arrow in the midst of battle, the young girl in her room before her mirror; he snatches the infant from its mother and one lover from another.

Thus, the *danse macabre* presented in this poem is something quite new: it was the pretext for a series of genre scenes in which the imagination of the artist had free rein.

The illustrated manuscripts of the *Mors de la pomme* certainly inspired the artist who composed the borders of the Hours of 1512, for the publisher Simon Vostre.[113] The Danse Macabre is conceived in the same way, and often has the same episodes. Death, with his arrows, appears at the moment when Adam and Eve are driven from Eden; he is present when Cain kills Abel; farther on he strikes down a soldier in battle (fig. 217), and a young girl in her room; he takes the infant from its cradle despite the cries of its little brothers (fig. 218). Once the theme was established, the possible variations on it were infinite; consequently, Simon Vostre's artist did not feel obliged to copy his model exactly. He invented several episodes: Death strikes the mason from his ladder, conspires with a brigand and helps him kill his victim in a wood, but is also beside the gallows at Montfaucon when the hangman leads the assassin to the scaffold.

Was it the illustrated manuscript of *Le Mors de la pomme* that Holbein knew, or was it Simon Vostre's Book of Hours? It is difficult to say, but I feel sure that Holbein knew one of the French originals. In his great Danse Macabre[114] there are striking resemblances to the two books we have just examined. First there is the Creation, soon followed by the original sin. Death appears at the moment Adam and Eve are driven from the Earthly Paradise, and ironically regales the exiles with a tune on his viol. Then the episodes unfold in a series of genre pictures. More

than one of the scenes invented by the author of the poem or by Simon Vostre's artist were taken over by Holbein. He, too, shows Death seizing the pope among his cardinals and the emperor in the midst of his court; and he, too, has Death contend with the soldier. He also shows Death accompanying the empress on her walk, walking beside the ploughman, snatching the infant from its mother and little brothers. And in Holbein's work, as in the Hours of Simon Vostre, Death is vanquished in the end, for the final woodcut represents the Last Judgment, that is, the triumph of eternal life.

So many similarities cannot be the result of chance. In short, Holbein has given us a new illustration of *Le Mors de la pomme*; his conception of the Danse Macabre goes back that far. Thus, at the source of one of the most beautiful works ever inspired by the idea of Death, we find a French poem and the drawings of French artists.[115]

IV

Ars Moriendi (The Art of Dying). The engravings of the *Ars Moriendi*.

The Danse Macabre illustrates two truths: men's equality in the face of death, and the suddenness with which death strikes. Isolated and stripped of its commentary, such a work, it is true, would have no intrinsic Christian character. The unlettered who looked at it in the Cemetery of the Innocents, without being able to read the edifying verses of the preamble and conclusion, were free to interpret it as they pleased. Most of them probably found it an encouragement to do better, but some would have seen it as an invitation to enjoy their brief lives. In the Cemetery of the Innocents, prostitutes wandered through the cloisters and among the tombs.

It is dangerous to evoke death and stir man's feelings so profoundly. The Church seemed to be aware of this. During the time when so many of the somewhat pagan images of the *danse macabre* were produced, a small book appeared, *Ars moriendi* (The Art of Dying).[116] The text was often striking, but it was the astonishing woodcuts above all that spread its fame throughout Europe. Here it is indeed a question of Christian hopes and fears: death appears not as a farcical dance, but as a serious drama played around the bed of the dying man; angel and devil stand at his side, contending for the soul that will soon depart. Formidable moment! The Christian needed to know in advance the temptations and anguish of the terrible dark hours to come in order to learn how to triumph over them.

The *Ars moriendi* is the work of a monk or priest who had seen many people die. In this little book we have the somber experience of a man who had collected together many last words, barely spoken. That priest was probably a Frenchman, because his inspiration came from a tract by Gerson that had been adopted in one of their synods by the bishops

of France, for the education of the clergy. He not only borrowed Gerson's title, but some of his words, so there is no doubt about the relationship of the two works.[117] Our anonymous *Ars moriendi* is thus written after Gerson's *Ars moriendi*, and it would not be far wrong to assign it to the early years of the fifteenth century.[118]

The woodcuts assured the book's success. They are of lively interest for the history of art, because they are among the earliest known. From what country do they come? Until now, all scholars have assigned them to the Low Countries. For more than a century the tradition has been that any early print of unknown origin could only have come from Flanders or Holland. Must we add that this tradition rests on no proof? All that Dutuit wrote about the three schools which, according to him, placed their stamp on the first woodcut editions of the *Ars moriendi*—the schools of Flanders, Cologne, and Ulm—is based on nothing.[119] It is simpler to admit that the truth is still not known. Nevertheless, since the text does suggest a French influence, we would perhaps be wise to ask ourselves if the woodcuts might not be French.[120]

The success of the *Ars moriendi* was even more extraordinary than the success of the Danse Macabre. Printed editions began to appear after the woodcut editions.[121] Each country had its own; the *Ars moriendi* was translated into the principal languages of Europe. It appeared in turn in French, German, English, Italian, and Spanish.[122] The old prints continued to reappear, with scarcely no retouching or up-dating of costumes. Even Italy, where Gothic barbarity was so scorned, was influenced by the crude woodcuts of the *Ars moriendi*,[123] although it is true it robbed them of most of their original character. For the somber drama was not suited to the symmetry, clarity, and youthful optimism of the art of the Renaissance. It was as if Shakespeare had been rewritten by Voltaire.

The *Ars moriendi* is one of the most curious works of fifteenth-century art and thought. The most interesting commentary is found in the edition published by Vérard, *L'Art de bien vivre et de bien mourir* (The Art of Good Living and Good Dying). The Latin text, often obscure because of its brevity, is here translated, explained, and developed by a real writer who spoke a noble language already classic French.[124]

The finest prints are those of the woodcut editions, and in particular those of the edition Dutuit named after a collector, Weigel. The illustrations in Vérard's edition were made after the Weigel edition, but it must admitted that the Parisian artist somewhat weakened the originals, which have something rough and jarring about them that harmonizes perfectly with the horror of the subject. In the Vérard edition, the figures of devils conform to the traditional type; they would terrify no one. In the woodcut edition, on the other hand, these monsters with calves' heads, cocks' beaks, gross dog chops, were born of fear. The

peasant who had encountered the devil at the crossroads, and the monk who had seen him slide under his bed, could recognize him and affirm that this was indeed what he looked like.

A book that edified all of Europe is worth some study. The Vérard edition opens with a beautiful preamble. The author expresses the nameless anguish of the dying who feel completely abandoned; their very senses through which all joy came "are already stopped and sealed by the powerful and horrible seal of death." A sort of dizziness seizes the soul; this is the troubled moment the devil is waiting for. The hounds of hell, who rove about the deathbed, deliver the most furious attack on the Christian that he has ever known: let him doubt at this final moment, let him despair and blaspheme, and his soul goes to the enemy. "O Virgin, protect him!" St. Bernard said. "A soul is more precious than the whole universe. While there is still time, therefore, let the Christian learn to die in holiness and save his soul."

The dying man is exposed to five principal temptations. God, however, does not abandon the Christian, and five times he sends his angel to comfort him.

The first temptation attacks his faith. The old print shows the dying man on his deathbed; his naked arms are as thin as those of his sinister companion who leads him in the *danse macabre*. Christ and the Virgin are at his side, but he does not see them, for a devil raises the covers behind his head and hides the heavens from him: so little is required for men to forget God. His eyes, meanwhile, stray to a vision sent him by the devil. He thinks he sees pagans kneeling before their idols, and an ironic voice whispers in his ear: "These people at least saw the gods they adored, but you believe in something you have never seen, something nobody will ever see. Have you ever heard of a dead man returning from up there to bear witness and affirm your faith?"[125]

The poor dying man finds no answer. But on the following page we see that an angel from God has swooped down to his bedside. "Do not listen to the word of Satan," the angel says. "He has lied since the beginning of the world. No doubt all that you believe is not clear, but God has willed it thus, so that you shall have the merit of believing. This is a part of freedom. Therefore, stand firm in your belief; think of the abiding faith of the patriarchs, the apostles, and the martyrs." And the saints of the Old and the New Law appear at the head of the deathbed. Behind the foremost ranks, we see other nimbuses. With a few strokes the artist has given the impression of a great army receding into the background.

When the devil cannot shake the dying man's faith, he changes tactics. He no longer denies God, but represents him as inexorable. After attacking faith he now tries the virtue of hope. Hideous monsters again rove around the sick man's bed (fig. 219). One presents him with a

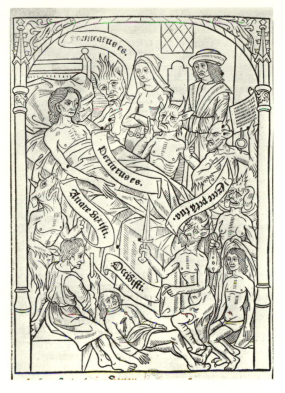

219. Dying man sees his sins. *L'Art de bien vivre et de bien mourir.* Vérard, 1492. Paris, Bibliothèque de l'Arsenal.

large parchment document: this is the list "of all the evils that the poor creature has committed during his sojourn on earth." And by a maleficent incantation, his crimes take bodily form and appear before him. He again sees a woman with whom he has sinned, and a man he has cheated; he sees the poor hungry and naked beggar he has turned away from his door; and finally, he contemplates with horror the corpse of the man he killed, whose wounds are still bleeding. The chorus of demons howls: "You fornicated, you took no pity on the poor, you murdered." And Satan adds, "You were a son of God, but you became the son of the devil; you belong to me."

The angel again descends from heaven, accompanied by four saints (fig. 220). They are St. Peter, who thrice denied his Master; Mary Magdalene, the sinner; St. Paul, the persecutor whom God struck down to convert him; and the good thief, who repented on the cross. These are the great witnesses of divine mercy. The angel presents them to the dying man and speaks words filled with celestial sweetness: "Do not despair. Even though you had committed as many crimes as there are drops of water in the sea, one contrite impulse of the heart is enough. The sinner has only to moan in order to be saved, for the mercy of God is greater than the greatest crimes. There is only one grave sin, and that is despair. Judas was more guilty for despairing than were the Jews who crucified Christ." When they hear these words, the devils disappear, crying: "We are vanquished!"

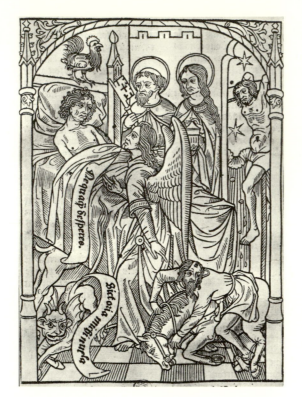 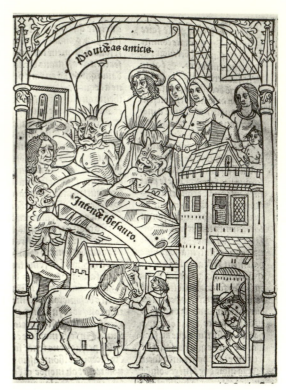

220. Dying man consoled by angel. *L'Art de bien vivre et de bien mourir*. Vérard, 1492. Paris, Bibliothèque de l'Arsenal.

221. Dying man thinks of property and house. *L'Art de bien vivre et de bien mourir*. Vérard, 1492. Paris, Bibliothèque de l'Arsenal.

If God pardons all who are truly contrite, then Satan must turn man's thoughts away from his own salvation, and prevent him from repenting. That is why he causes soul-shaking images to pass before the eyes of the dying man. He shows him his wife and baby (fig. 221). Without him, what will become of them? What will happen to his house? A devil stretches forth an arm and the house appears; the door of the wine cellar is open and a worthless servant taps a barrel of wine; a thief enters the courtyard and unceremoniously makes off with the horse in the stable. What can he do? How can he save these riches "that he loved more than God himself?"

The angel again comes to the Christian's aid. In turn, it makes images appear to the dying man, but images that console. It shows him Christ naked on the cross. Following his example, we also must die stripped of everything; like our Master, we must renounce the things of this earth; and be at peace about the fate of our loved ones: God will watch over them. And in fact, an angel covers the dying man's beloved wife and infant with a veil.[126]

The devil does not yet give up. If he cannot make the sick man think of others, he must be made to think of his own sufferings: he must be made to blaspheme, and accuse God. Satan whispers in his ear: "You suffer too much; God is not just. Look at the people around you. They pretend to sympathize with your ills, but they really are thinking only of your money." When he hears this, the dying man rises up in his bed

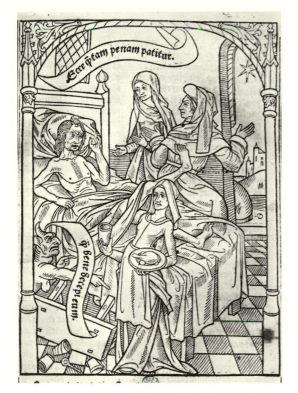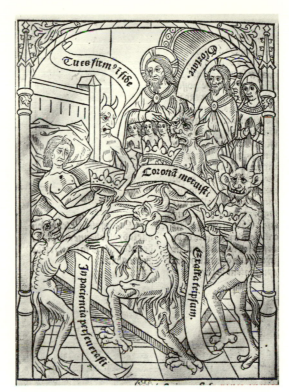

222. Dying man chasing away his heirs. *L'Art de bien vivre et de bien mourir.* Vérard, 1492. Paris, Bibliothèque de l'Arsenal.

223. Last temptation of dying man. *L'Art de bien vivre et de bien mourir.* Vérard, 1492. Paris, Bibliothèque de l'Arsenal.

(fig. 222). He is filled with hatred for God and for men; he throws back the covers, pushes over the table on which bottles and concoctions stand, and with a kick pushes back the heir who had come to his bedside. The servant stands stupefied, a tray in her hand.

The angel reappears and the room fills with consoling visions. Glorified martyrs triumphantly carry the instruments of their torture: St. Lawrence, St. Stephen, St. Barbara, St. Catherine, and Christ himself as he had appeared to St. Gregory.[127] The angel speaks with its accustomed gentleness: "Do not complain. The Kingdom of Heaven is not for those who murmur. What are your sufferings compared with your sins? Moreover, these sufferings will be accounted to you; bear in mind that suffering is useful; it obliges men to turn to God. Look at Christ and all the holy martyrs; they suffered without complaint, and were patient until death."

Repulsed as always, Satan makes a final assault. With his profound knowledge of sin, he knows that pride is the last sentiment in man's soul to die. Thus, he appeals to the pride of the dying man who is breathing his last. Demons with heads of animals place crowns around his bed (fig. 223). "You have had faith, hope, and charity," they say. "Ah, you are not like those men who, after a life of crime, repent on their deathbed. Why you are a saint; you deserve a crown."

The dying man is about to die with his heart full of pride when a troup of angels fly to his aid. One shows him the mouth of Leviathan

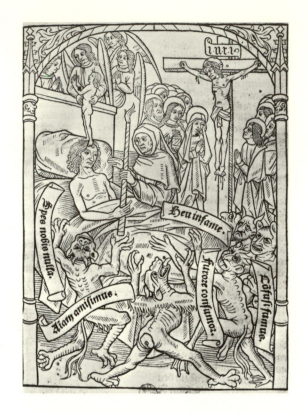

224. Soul of dead man carried to heaven.
L'Art de bien vivre et de bien mourir.
Vérard, 1492. Paris, Bibliothèque de
l'Arsenal.

into which the devils had been cast because of pride, another points to
St. Anthony who triumphed over all temptations through humility; and
another says to him: "You must be as humble as a small child to enter
heaven; think of the Virgin chosen by God because of her humility."
And the heavens open at once to reveal the Virgin beside the Trinity.

The struggle is over. Panting and sweating in anguish, the dying
man has fought the last battle and won. The reader also pants. How
arduous it is, the birth of the soul into eternal life! The last page of
the book brings a sense of deliverance. The Christian has just died (fig.
224), and the priest who has heard his last words places a wax candle
in his hand. His soul is saved. With claws extended, jaws open, and
hair bristling, the demon pack howls. But in vain. The soul is carried
tranquilly to heaven by an angel.

The reason for the success of the *Ars moriendi* is now clear. The
pathos of the text and the awesome prints profoundly stirred the souls
of people constantly occupied with the thought of death.[128] In other
times, the work would have been introduced into monumental art and
carved on the portals of cathedrals. In the fifteenth century, the printing
press took it over; reproduced in thousands of copies, it reached as
many souls as if it had been carved on the façades of churches.[129]

Essentially, the *Ars moriendi* appeared as one episode in the eternal
struggle between good and evil, the great Psychomachia that had been
represented in so many different forms during the Middle Ages. It was

concerned with the moment when the soul leaves the body and the two contenders engage in their supreme struggle. Artists had represented this battle as early as the thirteenth century: at the very instant when the soul, in the form of a small child, left the body, the angel and the demon sprang forward to seize it. They waged a furious battle that lasted until one of the two was victorious.

Although fairly rare in the thirteenth century, and even more so in the fourteenth, representations of the battle for the possession of a soul became extremely frequent in the fifteenth century. Illuminated Books of Hours contain numerous examples.[130] The miniaturist usually represented the enclosure of a cemetery, with its chapel, its cloisters, and its charnel houses filled to bursting like rich granaries. Two gravediggers place the corpse, wound in a shroud from head to foot, in an open grave. Meanwhile, the supreme battle is taking place in the sky, the angel and the devil contend, and the trembling soul awaits the victory that will decide his fate. The angel was rarely characterized. However, artists occasionally gave it the armor and sword of St. Michael (fig. 201). St. Michael is Satan's ancient rival, and every day he carries on the battle that was begun before the creation of the world. Thus, St. Michael is the angel of death, the protector to be invoked while awaiting the outcome of the great combat; in wills, St. Michael's name was sometimes placed after that of the Holy Trinity.

It was in this abridged form that the artists represented the battle between the contenders for the Christian soul. The popularity of this scene in the fifteenth century is no doubt explained by the success of the *Ars moriendi*; the struggle for the possession of the soul that has just left the dying man is told on the last page and is its supreme episode.

Thus, at the end of the Middle Ages, the image of death was seen everywhere, in churches as well as cemeteries. The Christian saw it when he turned the pages of his Book of Hours; at home he would find a skull carved on the mantel of his fireplace, or a page from the *Ars moriendi* tacked to the wall. At night, when he slept in forgetfulness, he was startled out of his sleep by the nightwatchman, who droned in the darkness:

> *Réveillez-vous, gens qui dormez,*
> *Priez Dieu pour les trépassés.*
>
> (Wake up, sleepers,
> And pray for the dead.)

IX

Art and Human Destiny: The Tomb

I

The many tombs in France in earlier times.
The Gaignières Collection.

A Christian dies. His soul has already appeared before its judge; but his body remains with us, awaiting the final day when it will be born again to be judged in its turn.

The tomb that held his immortal dust was, during the wonderful centuries of the Middle Ages, a profoundly religious monument. Ardent faith and hope, tender respect for the human clay fashioned by God, aspiration for the infinite in which regret for the transitory, lately beloved creatures was intermingled—all this was expressed by the tomb.

All that the Middle Ages thought about death was engraved on its tombs. The dead were honored and the living instructed at the same time. Still today we are struck by a funerary statue abandoned in a cloister or a worn tomb slab embedded in the pavement of a church; it is difficult to look on these images purely as art: we are too deeply involved. What can we learn from them about the great mystery? What did those who have preceded us in death think about it? What can they tell us? These are the first questions that occur to us, and we shall try to answer them.

Consequently, this chapter will not provide a complete history of tombs; that would require an entire volume. But within the space of a few pages, it is possible to study tomb iconography; we can set forth briefly the great ideas that death engendered in the medieval soul, and show how they were expressed in art.[1]

The age under study in this volume is the age of tombs, for the most extraordinary monuments left by the waning Middle Ages are funerary. Thus, this is a more appropriate place for such a chapter than the preceding volume; but to make the ideas we are about to develop perfectly clear, we must go back to their origins in the thirteenth century.

We can scarcely imagine today the prodigious number of tombs that once filled our churches. We came too late. We would have had to set out on St. Barnabus' Day in the spring of 1708 with Dom Edmond

Martène and Dom Durand, and go from abbey to abbey, cathedral to cathedral.[2] Then, despite wars of religion, ancient France was still magnificent; the churches were paved with tomb slabs and the cloisters filled with funerary statues whose lively colors had not yet faded. In monasteries whose very names are forgotten today, there were marvelous tombs of enamel on copper, seemingly made of azure and gold;[3] nothing equaled the magnificence of these Limoges masterpieces.[4] There was not a church whose tombs did not record the history of a province. Unfortunately, Dom Martène and Dom Durand were not artists. They passed unmoved before masterpieces now forever lost, transcribing only the epitaphs.

But by good fortune, one extraordinary man in the seventeenth century loved what others scorned. Roger de Gaignières had a passion for the past, or rather, for death. He spent the greater part of his life collecting drawings of tombs. Accompanied by an artist more willing than talented, he traveled throughout France examining tombstones and funerary statues. In this way he put together the astonishing collection of tomb drawings now shared by France and England.[5] Never was there such a monument to death. We leaf through these thirty volumes with almost overwhelming admiration for the many beautiful works that have disappeared without leaving a trace. What did Gaignières have in mind? Why was he so passionately recording monuments that were of no interest to anyone at the time except two or three Benedictines? He probably did not know himself. But this odd fellow was not gathering material for books. A mysterious instinct impelled him. He hurried, and not without reason; for without knowing it, he was working to save ancient France for us.

We must turn to the Gaignières Collection to discover the important place the dead held among the living. At Notre-Dame, one walked not on paving stones but on carved tomb slabs or on brass plaques engraved with effigies. Even our greatest cathedrals were too small, and the tombs filled the cloisters and chapter halls. There were nearly two thousand tombs in the cathedral of Langres and its annexes.[6]

However, the cathedrals were not the most beautiful burial places of the Middle Ages. The great feudal families preferred the solitude of abbeys: there, there were no crowds to tread upon the faces of the dead; there was eternal silence, broken only by prayers, and a profound peace that evoked the thought of heaven. Gaignières' volumes and the work of modern scholars have restored their poetry to our ancient abbeys: Maubuisson, Royaumont, St.-Yved-de-Braine, the Abbaye du Lys, and a score of others, to us only charming names, are again peopled by their dead.

At Maubuisson were the tombs of famous women: Queen Blanche in nun's habit; Countess Mahaut d'Artois who had been so fond of

artists; Catherine de Courtenay, daughter of the Emperor of Constantinople, carved in black marble;[7] Bonne de Bohême, mother of Charles V, who, when her tomb was opened in 1635, was found seated on a throne, her hair braided with strands of gold.[8] Charles V wanted to be buried beside his beloved mother, but his tomb had already been prepared at St.-Denis. He decided that only his entrails were to be placed beside her body, but he wanted his image to lie near hers.

Royaumont watched over the tombs of St. Louis' children. It was there that the king had buried his eldest son, young Louis of France, who was mourned by all. A relief carved on his sarcophagus recalls that the King of England wished to carry the young prince's coffin on his shoulders. In this church, where he had so frequently to return, St. Louis knew the depths of grief, and there too he endured his Passion. For long centuries, the memory of the sainted king and his tears has permeated the cloister of Royaumont with their poetry.[9]

St.-Yved-de-Braine was the necropolis of a heroic race: there, under the watchful eyes of the Premonstratensians, the family of royal blood of the Counts of Dreux were buried. The first were the valiant counts of the thirteenth century: Robert II, who had fought at Bouvines; Jean of Dreux whose body lay at Nicosia and his heart at St.-Yved; Pierre Mauclerc who had distinguished himself at Mansura and Ptolemaïs. Only Philip of Dreux was missing, the bishop of Beauvais and hero of Tiberias and St. Jean d'Acre, who fought with a mace because the pope had forbidden him the sword.[10] After these tomb statues of warriors decked out in the wonderful battle dress of the thirteenth century, lay the statues of the soldiers of the Hundred Years War. There is something fierce and sad about these figures crammed into their tight armor; they were no longer transfigured, as their ancestors had been, by the beautiful names of Syria and the light of the East. They had not lost cast, for all that; but these are the vanquished: Jean VI de Roucy was killed at the Battle of Agincourt.[11]

Such was the church of Braine in its prime, filled with two centuries of heroic history. Here, the dream of Victor Hugo, author of the *Légende des siècles* became reality; generations of knights lying still in their armor.

Ancient France was rich in such burial centers. The great feudal families, following the example of the kings of France who for centuries had chosen to be buried in St.-Denis, each selected an abbey in which to erect its tombs.

The first House of Burgundy buried its dead at Cîteaux. The Counts of Auvergne wanted to be buried in the Cistercian abbey of Bouchet. The House of Bourbon, apparently troubled by the presentiment of its great destiny, never settled on one place: each century, it chose a different monastery for its dead. The old sires of Bourbon had their tombs on the acropolis of the Montet-aux-Moines, overlooking their little domain.

In the thirteenth century, they had their tomb statues in the Cistercian Abbey of Bellaigue, in Auvergne. In the fourteenth century they were buried in the church of the Jacobins in Paris. In the fifteenth, they chose for their sepulchers the Abbey of Souvigny, bordering their château at Moulins; and it was then that they added to the austere Romanesque church the beautiful luminous chapel where their tombs still stand. The secret had finally been revealed: it at last became known that the word "Espérance!" on their mysterious blazon was prophetic. They became kings. And, henceforth, their coffins would lie side by side on iron trestles in the crypt of St.-Denis.

That our abbeys are filled with so many tombs is not surprising when we recall that distinguished persons often had several graves. The kings of France followed this custom for centuries. In their wills, they often divided their remains into three parts: first, their bodies were to be buried at St.-Denis so that in death they would not be separated from their ancestors;[12] then their hearts were to go to one church and their entrails to another. This is the reason why the entrails of Charles V were buried at Maubuisson and his heart in the cathedral of Rouen: by this he meant that he had left his heart in the Normandy he had governed as a young man. Apparently, the old masters of Normandy the Magnificent never had been able to tear themselves away, for years before, Richard the Lion-Hearted had left his body to the nuns of Fontevrault, but his heart to the cathedral of Rouen.[13]

Kings usually preferred monastery churches, where prayers were said day and night, to the cathedrals. They gave their hearts or their entrails to the nuns of Poissy, the Carthusians of Bourgfontaine, the Dominicans of the Rue St.-Jacques, or to the Celestines. With strange funerary realism, the hands of their recumbent tomb statues sometimes hold a heart,[14] or a leather bag of entrails (fig. 225).[15]

In this way funerary monuments multiplied. Only a few remain today; the most precious have disappeared. The fabulous silver tombs of the Counts of Champagne, the brass and enamel tombs of the bishops of Paris and of Angers are only a memory; the tomb of King René

225. Tomb statue of Philip VI. Paris, Louvre.

d'Anjou no longer exists; those of the Duke of Berry and the Bourbon dukes have been mutilated; only a few copper statuettes remain from the magnificent tomb of Louis de Male.[16]

The Revolution destroyed most of them, but it obliterated the past with savage grandeur. When the enemy invaded France in 1792, the municipalities were ordered to open all family tombs and make bullets from the lead caskets; the tombs were also searched for saltpeter. It was then that so many tombs and tombstones were shattered.[17] And soon after, all brass tablets and bronze statues were ordered to be melted down.[18] The statue of Blanche of Castile was transformed into a cannon. But the continuity of history, which the Revolutionaries wished to shatter, flowed on: the dead rose from their tombs to fight beside the living.

II

The earliest tomb statues and the earliest tomb slabs.

In all probability, the first recumbent tomb statues date from the early twelfth century.

We no longer agree with Dom Montfaucon that the funerary statue of Philippe I, still in the church of St.-Benoît-sur-Loire (Loiret), was carved in 1108, immediately after the death of the king.[19] Montfaucon was mistaken by at least a century, for despite restorations, the work bears all the marks of thirteenth-century art.

It is not surprising that old tombs were remade after a century or so, and decorated with statues; examples of such transformations abound. In the thirteenth and fourteenth centuries, the monks—attached to the cult of memorials—often provided the abbey founders with tombs worthy of them. Raoul and Guillaume de Tancarville, Norman barons of the eleventh and twelfth centuries, were buried in the Abbey of St.-Georges de Boscherville (Seine-Inférieur) which they had founded; their tombs are magnificent, but they date from the thirteenth century. In fact, in their tomb statues,[20] they are clad in the costume of the Compagnons de St. Louis, with golden coats of mail, red tunics sprinkled with stars, and wide blue belts.[21]

Haymon, the first Count of Corbeil, lived in the tenth century; he had bought relics, founded churches, fought against the Normans, and in the minds of the people left an illustrious memory. Legend transfigured him: it was said he had vanquished a dreadful dragon that was devastating the countryside. No monument perpetuated the memory of this folk hero, and it was only in the fourteenth century that the tomb in St.-Spire was erected in his honor, on which the old Carolingian hero appeared as a knight of the reign of Philip the Fair (fig. 226).

Many similar examples could be cited,[22] but there is one more eloquent than all the others.

The kings of the eleventh and twelfth centuries had their tombs at St.-Denis, but there were certainly no effigies on them.[23] This is indicated by the fact that, St. Louis, out of filial piety, had tomb statues carved for some of his most illustrious predecessors: Hugues Capet, Robert the Pious, Henri I, Louis VI, not to mention certain Merovingian and Carolingian kings. These effigies are all alike: calm, grave, invested with a kind of sacred character. They are images of the ideal Christian king, his head anointed with holy oil, as conceived by the thirteenth century. If Louis VI had no tomb statue at St.-Denis, it is quite evident that Philippe I, who died thirty years before him, would have had none at St.-Benoît-sur-Loire.

In the twelfth century, the heads of the great feudal families, like the kings of France, had no funerary images. Through the drawings in the Gaignières Collection, we are familiar with the tombs built for the members of the first House of Burgundy in the Abbey Cîteaux:[24] they were simple sarcophagi, without statues.

Moreover, the Gaignières Collection, so rich in tomb statues from all epochs, shows none that we can assign to a period earlier than the last years of the twelfth century. To judge by the costumes, the earliest are those of Elie, Count of Maine, at the Abbey of Couture, in Le Mans (Sarthe),[25] and of an unknown knight at the Abbey of Bonneval, in Le Dunois (Eure-et-Loire),[26] and they can scarcely have been erected earlier than 1180 or even 1200.

I am not speaking of the famous statues of English kings and queens in the Abbey of Fontevrault (Maine-et-Loire): they clearly date from the early thirteenth century, since Richard the Lion-Hearted died in 1199 and Eleanor of Aquitaine in 1204. Henry II died in 1189, it is true, but his statue does not appear to be any earlier than the others. There are so many resemblances among these tomb statues that they must all have been done at the same time, at the beginning of the thirteenth century.[27]

226. Tomb statue of Haymon, Count of Corbeil. Corbeil (Seine-et-Oise), Church of St.-Spire.

The tombstones or slabs, on which the effigy of the deceased was carved in outline, did not appear earlier than tomb statues. Some, no doubt, date from the late twelfth century, but I confess I know of none earlier than the thirteenth century.[28] Dom Plancher, who explored Burgundy so carefully, states that, in all that province, he found only two tombstones from the twelfth century; and he adds that one was carved with a cross and the other with a simple epitaph.[29]

Gaignières gives several tomb slabs from the twelfth century, but not one bears the image of the deceased. In the twelfth century, for example, the bishops of Châlons-sur-Marne (Marne) had only an inscription on their tomb slabs, which were made of flagstones set in the pavement.[30] The tomb slabs covering the bodies of twelfth-century abbesses in the church of La Trinité, at Caen (Calvados), were of touching modesty: they bore only an epitaph and the abbey cross,[31] even though one of these abbesses was the daughter of William the Conqueror.

Such simple gravestones were to be found even later (fig. 227). Only a cross was carved on the tomb slabs of Victor, abbot of St.-Georges de Boscherville (Seine-Inférieure), in 1210;[32] of Nivard, abbot of St.-Seine (Côte-d'Or), in 1213;[33] of Gérard, abbot of Barbeau, in 1218;[34] of Eudes, abbot of Jouy (Eure-et-Loire), in 1221.[35] Knights were as modest as monks. The tombstones of early thirteenth-century barons were

227. Tomb slab of an abbot. Vaux-de-Cernay (Seine-et-Oise). Drawing from Guilhermy, *Inscriptions de la France du Ve siècle au XVIIIe*, vol. III, p. 448.

sometimes of moving simplicity. On one we see only a magnificent sword with the name of its owner on the blade;[36] on another, there is not even a name, only the shield and sword of the soldier.[37] The Templars loved these mute stones with swords carved on them.[38] Such splendid abnegation, worthy of the great period of the Order, calls to mind the Temple's devise: *Non nobis, Domine, sed nomini tuo da gloriam.*

It was between 1220 and 1230 (at least to judge by extant examples) that images of the deceased began to appear on tomb slabs.[39] Pierre de Corbeil, archbishop of Sens who died in 1222, was shown in episcopal dress on the slab covering his tomb in the cathedral;[40] and this is the earliest example I can cite. Barthélemy, bishop of Paris who died in 1229, had a tombstone in the choir of Notre-Dame on which he was shown holding his crozier in his left hand, and with his right hand raised in blessing.[41]

The first embellished tomb slabs are wider at the head than at the foot, in the form of a trapezoid. There is something funereal in this coffinlike shape. The noble spirit of the thirteenth century, which rejected anything that might recall the ugliness of death, was shocked by it, and artists soon abandoned it.

III

Tomb iconography, still very sketchy in the twelfth century, was fully realized in the thirteenth. Into it went all the poetry of that great century.

Beginning with the thirteenth century, and until almost the end of the Middle Ages, the dead were shown in a way that is at first surprising: they lie on their tombs or on gravestones with hands clasped and eyes open (fig. 228). These pretended dead are thus living.[42]

Christianity believes only in life, and audaciously denies death even before the tomb. Nothing perishes, neither the body nor the soul. Even when the tomb contains no more than dust, that is merely appearance; the artist speaks the truth when he shows the deceased as he is in the mind of God, as he will be when the trumpet sounds and all eyes open to eternal light.

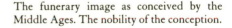

The funerary image as conceived by the Middle Ages. The nobility of the conception.

228. Tomb statue of Robert of Artois. Saint-Denis (Seine), Abbey Church.

Not only is the deceased alive; he is already what he will become on the great day. He was old and now he is young again: at Châlons, a mother lying between her two daughters is the same age as they. No statue or tomb slab of the great period shows an aged person; all the dead seem to be thirty-three years old, Christ's when on resurrection, the age all men will be when they too rise from the dead.[43]

Some of the deceased must surely have been ugly; at the very least life must have left its mark on them: yet if we look at the funerary images of the thirteenth century, we see only faces of purity clothed in beauty totally devoid of individuality. Already elevating the individual to the ideal, the artist performed the Lord's sublime labor in advance— when, on the Last Day, all mankind would be recast in perfect beauty.

No doubt the religious conceptions of the Middle Ages, in this as in all else, guided the sculptors' hands. Such a transfiguration of death has touching charm, even for those who know nothing about the theology of the thirteenth century. Was there ever a more beautiful idea? The idea that death beautifies all it touches was never better expressed than by the delightful Greek funerary steles. As in great art, what is shocking and distracting is omitted; the dead are revealed as they would have liked to be, as they sometimes were, as they would often have been, had the miseries of life not prevented them.

Thus, in the most beautiful works of the Middle Ages, the dead appear with a serenity and nobility already not of this world. Is it because they are among the blessed? We could believe this to be so, and the artist would like to persuade us that it is. It was not without reason that he placed above the head of the deceased a carved canopy like the canopies above the heads of the saints on cathedral portals. The dead were shown beneath a beautiful trefoil archway surmounted by the bell-towers of a holy city, in the same way that saints were shown in stained glass windows of the thirteenth and fourteenth centuries. The resemblance is striking. Thus, this symbolic archway, through which angels sometimes fly, is a gateway to another world, and the transfigured dead seem to cross the threshold of eternity.

It was doubtless somewhat bold to put themselves in the place of the Judge, to pronounce sentences in advance and to open wide the gates of heaven, but I do not see that medieval Christians were like Jansenists. They did not tremble; they hoped. Everything was to be expected from the goodness of God. The Church's prayers for the dead expressed this unshakeable faith in the indulgence and partiality of the Father for his children. To be sure, we read in the Missals that the dead are not without sin, but the soul incurred these blemishes because in this sad world it had to live with the body.[44] God would not want to judge his servant, for who then would find grace in his eyes?[45] Unfailing compassion and an inexhaustible forgivingness: such is God.[46] In the mag-

nificent words of the Missal of Fontevrault, he is "the eternal lover of souls."⁴⁷ So why tremble? In the old antiphonary of Ste.-Barbe-en-Auge, the dead person himself speaks and sings: he addresses God, reminding him that he, the lowly sinner, has been redeemed by his blood; and his faith in divine goodness is such that when the coffin is carried to the gates of the cemetery, he cries: "Open the gates of justice to me, I enter into the place of the miraculous tabernacle, I enter the house of God."⁴⁸

Artists expressed the sublime confidence of the liturgy. We must believe all our dead will be saved, for it is impious to despair of our own salvation and the salvation of others. That is why the funerary effigies resembled images of the blessed: angels descending from heaven approach the deceased and swing censers before him, as they do before the confessors and the martyrs.⁴⁹

One further detail deserves our attention: there is almost always an animal lying beneath the feet of the deceased. This symbolic support makes the resemblance between the funerary effigies and the images of saints even more striking. The custom of placing a monster or an animal beneath the feet of the deceased surely came from a mystical idea. Certain of the oldest figures in Gaignières Collection are characterized by the presence of a dragon the deceased seems to trample upon;⁵⁰ bishops and abbots almost always tread on a dragon and plunge their croziers into its throat. We naturally think of the biblical verse: "Thou shalt walk upon the asp and the basilisk: and thou shalt trample underfoot the lion and the dragon."⁵¹ The statue and the biblical verse are not brought together gratuitously, for the connection is supported by at least one monument. On a gravestone (admittedly sixteenth century) we see a prior standing on a dragon, and beside him is this inscription: *Conculcabis leonem et draconem.*⁵²

Thus, the monster is a symbol. Such seems to have been the thought of the artists who first associated the dragon with funerary effigies. The Christian who enters eternal life is an image of Christ; like him, he tramples the dragon, the asp, and the basilisk underfoot which, according to the interpretation of the Church Doctors, means that he crushes temptation and sin.⁵³ Consequently, the image of the vanquished monster completes the transformation of the deceased into the blessed.

The symbolism of the dragon had never been completely forgotten, and up to the sixteenth century, a dragon was almost always placed under the feet of the clergy.⁵⁴

Nevertheless, we shall see that animals of less lofty significance were sometimes substituted for the symbolic dragon.

The imprint of eternity on the medieval funerary image explains the attitude of the deceased: all he can do is contemplate, with folded hands, the light we do not yet see. Never, even on gravestones where the artist might have taken greater liberties, is the deceased engaged in an every-

day action. The exceptions are so few as to be negligible.[55] True, the priest sometimes holds a chalice in his hand as if celebrating the Mass, but nothing in this can turn our thoughts from the eternal: *Tu es sacerdos in aeternum*, the Church said.

Just one category of funerary monuments fails to conform with the rule we have just laid down: these are the tombstones of professors. They are always shown in their chairs, facing attentive listeners (fig. 229).[56] This was an honorable exception made for scholars and men of thought: apparently that to teach the truth was the only occupation that partook of the nature of eternity.

Such was the concept of the tomb in the thirteenth century; certainly a noble one and filled with idealism. The mystical impression they gave must have been far greater in the past when the tomb statues and tombstones faced the east. Revolution and restoration have thrown confusion into our churches, but until the sixteenth century, the funerary monuments were all precisely oriented.[57] Abbé Lebeuf's dissertation and the numerous observations he made in the course of his travels leave no doubt about this:[58] moreover, even today, wherever tombs remain in place, the rule laid down by William Durandus[59] is confirmed. Thus, all the dead, their eyes turned to the east, seemed to contemplate the light at its source.

Our beautiful funerary effigies of the thirteenth, fourteenth, and sometimes even fifteenth centuries are incomparable. Some stones are

229. Tomb of Canon Jean de Villeneuve de Guingamp, d. 1417. From church of St.-Yves, Paris. Paris, Bibliothèque Nationale, Gaignières Collection, Pe 1j, fol. 41.

among the purest works of the Middle Ages. The Greeks themselves had no surer hands. There is not a superfluous detail; there is imposing simplicity and lines that seem to confer a character of immutability upon the deceased. Never had the divine aspect of man been so well expressed.

I must admit that I have not found so noble a concept of death in the rest of Europe. Italy is much inferior to France in this. Its elaborate tombs, so richly decorated from the Quattrocento on, with all the sensual charms of the Renaissance, dazzle at first, and when we see them in our youth, we dare not make any comparisons. But later on, with our mind's eye full of remembrances of France, we are astonished to find them so lacking in any religious sense. The deceased lying on his magnificent bed is no longer a live man, but a corpse; the trumpet of the Last Judgment would not wake him. His eyes are closed, his hands unnobly folded on his stomach, and no symbolic animal beneath his feet.[60] This is reality, often interpreted with consummate skill, but nothing more. True, Angels often surround the funerary bed, but doing what? They open heavy marble curtains to give us a glimpse of the deceased before closing them again so that he may sleep his last sleep in peace.[61] This is completely foreign to the true spirit of the Middle Ages.

At first, English tombs closely resembled the French and were only imitations; but the national spirit soon manifested itself. The beautiful collections of funerary monuments published by Stothard,[62] Hollis,[63] and Cotman[64] make a strange impression as we turn their pages—one of entering a wild and poetic world. English barons of the fourteenth century still wear the long mustache of northern heroes. Lady Beauchamp, her head resting on a swan, seems to float toward the island of King Arthur. All the knights of the crusades or the Hundred Years War are open-eyed. They are alive, too alive. It is interesting to see how little the heroic and barbaric English spirit understood the beautiful, mystical thought of French artists. The English cannot lie in repose on their tombs; they draw their swords, threaten, bend their legs as if about to rush forward; even in death they cannot forsake action, and even if sometimes they make a gesture of worship their great battle gauntlets do not allow them to join their hands in prayer.

The Germans, too, followed the French example at first. In the thirteenth century their most beautiful funerary effigies differed little from ours; but very soon feudal pride was to burgeon and grow.[65] As early as 1300, casques, coats of arms, and emblems cover the tombstones. From the fourteenth century on, the dense vegetation of symbols and monsters that so delighted Victor Hugo divested the German funerary monuments of all true grandeur. We forget that the deceased knight was also a man. We see nothing but blazons, banners, prodigious casques

surmounted by *fleurs de lis*, swans' wings, sirens,[66] terrible arms bran-
dishing oak trees torn from the ground with all their roots. A physician
of Augsburg, Nicolas Hofmair, no doubt only recently ennobled, almost
disappears from the tomb between two enormous crested helmets em-
blazoned with his arms.

The old French nobility had a better sense of proportion. They never
took this childish display so seriously. To the Emperor Charles V, who
always listed his titles in his dispatches, François I once replied by
signing himself: *François, Sire de Gonesse.*

IV

Tomb iconography. The tomb as testimony
to the faith of the deceased.

Thus far, we have spoken only of the image of the deceased. But this
image was not always isolated; it was often accompanied by figures that
enriched the thought.

The feelings they expressed can be reduced to two: one heavenly,
the other terrestrial: profound faith, and deep family feeling.

Thoughts of the other world came first. The dead placed all their
confidence in the efficacy of the prayers of the Church, for they knew
that prayers saved souls. They had themselves buried in an abbey church
or founded a chapel so that prayers would be recited over their graves
until the Day of Judgment.

This idea was clearly expressed in art. Many funerary statues in the
Gaignières Collection show two small figures of monks reading their
breviary on either side of the deceased, no doubt reading what the
Church called the *commemoratio defunctorum*. The deceased could be
thought to hear the constant murmur of the penitential psalms, verses
from the Book of Job, and all the lessons of the liturgy for the dead.
Such monastic figures appeared many times during the Middle Ages,
including on gravestones.[67]

These prayers were no doubt valuable, but the most efficacious seemed
to be those recited on the day of the funeral. In the Office of the Dead
we read that the soul can be saved, if God wills it, by virtue of the
Mass celebrated in the presence of the coffin.[68]

Understandably the Christian wanted to preserve the record of these
all-powerful Church prayers on his tomb: apparently the work of the
artist could perpetuate their effect. It is to be noted that tombs and
tombstones (for the most part from the fourteenth century on) were
often decorated with representations of the funeral ceremony.[69] The
moment most generally chosen by the artist was that of the absolution
at the end of the Mass: the priest comes forward preceded by acolytes
carrying the cross, the holy-water basin, and lighted candles, symbol of
the immortal soul, daughter of the light.[70]

But faith in the efficacy of Church prayers was given even more

beautiful form: personifications of prayer were carved on the tombstone. In all medieval missals, the Office of the Dead contains the following invocation: "Send thy Holy Angels to him, O Lord, and save his soul carried by their hands into Abraham's bosom." This formula scarcely varied at all from the twelfth to the sixteenth century;[71] it was repeated several times, and each time, the supplication seemed to gain in intensity. The supplication was repeated once more on the tombstone of the deceased. In fact, above the funerary effigy, angels were often represented[72] between the pinnacles of a heavenly Jerusalem. They bear the soul of the deceased in the form of a small child, and place it in the folds of Abraham's robe. Thus, both the priest and the prayers he recited were placed near the dead.

The Office of the Dead of certain churches contained another invocation. At Rouen, for example, the priest repeated the following prayer three times: "Lamb of God who washes away the sins of the world, give him rest."[73] This prayer was certainly in use in the diocese of Liège, for the gravestones of this region often show the figure of the Mystical Lamb alongside the image of the deceased. Here again, the liturgical word was given form.

As we see, the deceased appeared on his tomb with a retinue of prayers, but these prayers could disarm God only if the dead, throughout his transgressions, had preserved his faith and hope. "Because he has hoped and believed in thee, O Lord, thou wilst not deliver him over to eternal punishment." Thus spoke the Office for the Dead.[74]

The tomb thus testified to the faith of the deceased. Gravestones were particularly explicit: from the fourteenth century on, the symbols of the four evangelists were engraved in their four corners (fig. 229). Often, the apostles were also placed at the sides of the funerary effigy; for as we know, each apostle symbolized an article of the Credo.[75]

Thus, their gravestones affirmed the deceased's belief in the Gospels and in the symbol of the apostles. A tomb slab decorated with the figures we have just passed in review would clearly state: "The prayers recited by the priest over the coffin of this dead person will be efficacious; the angels will carry his soul into Abraham's bosom, because he believed in the truths taught by the Church."

The great sculptured tombs also expressed, but with greater freedom, the faith of the deceased. Apostles and evangelists were sometimes carved on them, but in general they showed scenes from the life of Christ propounded by the Church as dogma.[76] Sometimes, only one significant event was chosen from the Gospels. The Raising of Lazarus was sometimes carved[77] above the statue of the deceased, at the back of the niche (or *enfeu*, as it is called) in which the tomb was placed,[78] to affirm his faith in the omnipotence of God, and to proclaim the defeat of death.[79]

But more often, another resurrection, the great one of Judgment Day, was represented. From the fourteenth century on, the scene carved above the funerary statue was the appearance of Christ in heaven between the Virgin and John, at the moment the dead rise from their tombs (fig. 230).[80] A funerary inscription says, the dead person does not fear this terrible moment; he hopes for it: *Exspecto resurrectionem mortuorum.*[81] The Last Judgment and final resurrection is the scene frequently to be seen on tombs;[82] and also frequently in Books of Hours of French origin, on the page where the prayers for the dead begin.[83]

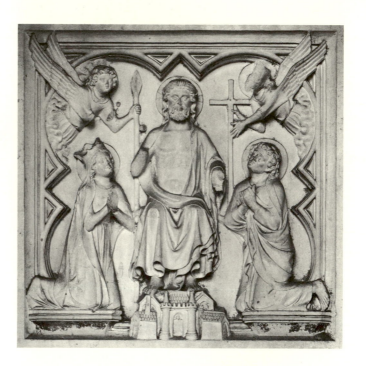

230. Last Judgment with Christ, Virgin, and St. John. Limoges (Haute-Vienne), Cathedral of St.-Etienne. Tomb of Bernard Brun (detail). XIV c.

In the fifteenth and sixteenth centuries, the age of pathos for Christian art, the tombs were often decorated with a Pietà. The image of Christ lying on the lap of his mother was carved above the recumbent image of the deceased.[84] Clearly, the Christian placed his hope in the God who himself had known death and had triumphed over it for the sake of mankind. The Pietà was the usual subject of the small funerary reliefs that multiplied toward the end of the Middle Ages. In fact, many of the dead could not aspire to the honor of a funerary statue or even a slab and had to content themselves with an inscription embellished with an engraving or a relief, set into the wall of the church.[85] The deceased, accompanied by his patron saint, is almost always shown kneeling before the dead Christ lying on the lap of the Virgin (fig. 231).[86] The remarkable thing is that there is here only one image of the dead, and it is of Christ. Death, apparently, was no longer a concern of man: had Christ not died so that man would die no more?

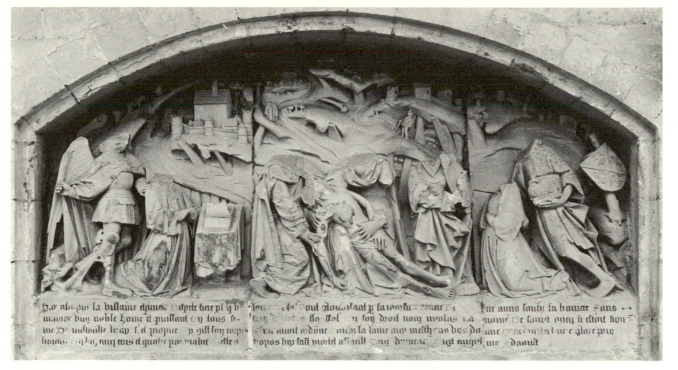

Par als: pur la billaine chimer · espite tire pl'q̃ b¹º ʃou · iʃe' ʃont doulolant p la iomſic²maur · t Par anns ſoubt ta baïuer ~aus ⟶
maïnce buy noble home et puiſſant en tous ſr· ſacti iactis ſla'ſtal' en loy droit noiʒ iuoolas ·a nomie ᴐe ſaint euïq û eſtoit liou⁵
ine ᴐt uoleuſlic liiap f;el propuc ~ p gitſ ſon coips ·iu auoit oiᴅouc ~ ouïn ſa laiue auɔ meſth ~ as bes ᴅo iue ᴐ·iiiɔu'ïia iaire gloie qʒuo
houïue ~g̃ lu, ciuq cous ᴅ quïʒ̃r par iialue ~ſcle · ✝opos lɩp falt ɯiotel a²iull ~euq ᴅeimear;~ïgt auïpel·ïuc ~ ᴅiauït

231. Pietà with two donors and patron saints. Eu (Seine-Inférieure), Church of St.-Lawrence. Stone relief.

As the sixteenth century approached, confidence in the intercession of the Virgin and the saints seems to have prevailed, and changed somewhat the character of funerary decoration. It is unusual to find images of the deceased's patron saints on thirteenth- and even four-teenth-century tombs;[87] then salvation came through faith in Jesus Christ, and nothing else; and funerary sculpture had the same gravity as the liturgy. But in the late Middle Ages, people clung more and more to the hope that the Virgin and the saints might be powerful intercessors at the hour of death. Certain fifteenth-century funerary monuments are uniquely, or almost uniquely, decorated with images of the saints and the Virgin.[88] At Valmont, in Normandy, Jacques d'Estouteville and his wife, Louise,[89] lie on their tombs under the protection of the Virgin, St. Anne, St. Adrian, St. Catherine, and three patrons, St. James (Jacques) and St. Louis.

The old captain of Evreux, Robert de Floques,[90] is protected on his tomb slab by young saints, Barbara and Catherine. These graceful vir-gins also decorated the tomb of Renée of Orléans[91] in the church of the Celestines, in Paris. They are more appropriate there; it is as if the dead girl were one of them.

These saints' images perhaps took something of the traditional gravity away from tombs, but they also, in their own way, testified to the faith of the people of the time. From the thirteenth century on, funerary art tried first of all to express that unalterable faith.

V

Tomb iconography. The tomb as family feeling.

These dead, their eyes fixed on heaven and their souls already resting in Abraham's bosom, did not, however, forget this world. They left behind a bit of their hearts, for death does not kill love. They thought of their loved ones and wanted to have them nearby.

The dead man wanted first of all to have his wife buried beside him; inseparable in life, they would remain so in death. Many times, we have seen them lying side by side on the marble slab, as if they were in the conjugal bed: images of a beautiful gravity, symbolic figures of the indissolubility of Christian marriage.

The dates inscribed on these tombs or tomb slabs are often strangely surprising. Sometimes, the woman represented had died thirty or forty years after her husband; thus, she had had her own funerary effigy carved while she was still living. This good wife knew her husband's wish; she knew that he did not want to lie alone on his marble bed. Catherine d'Alençon, who died forty-four years after her husband, Pierre de Navarre, could see herself throughout many long years lying at his side in the church of the Carthusians, in Paris;[92] for twenty years, Catherine de' Medici could contemplate her own image after death on the tomb slab beside Henry II.[93] These coupled statues did not always tell the truth: Isabeau of Bavaria had her own image carved beside that of Charles VI, at St.-Denis. This was homage rendered to a noble tradition.[94]

Sometimes a tombstone on which husband and wife are represented gives the date of the husband's death and leaves a blank for the wife. In these cases, it seems clear that the tombstone with double effigies had been put in place during the wife's lifetime, and after her death no one had troubled to add the date of her death.[95]

But it was not only his still living wife, but his children also, that the deceased wanted to have near him. Gravestones often represented an entire family united in death (fig. 232).[96]

At Creney (Aube), Jean de Creney has beside him not only his wife, who died twenty-six years after him, but all of his children (fig. 233); his magnificent family of eleven sons and six daughters are lined up below the feet of the father and mother;[97] here was a man who did not want to be alone in death.

Similar gravestones are encountered quite frequently.[98] One of the most curious was still to be seen in the time of Abbé Lebeuf at Tournan, a village in the diocese of Paris:[99] the lady Havise, who died in 1230, was represented with all her children—five knights, a priest, and a monk; below the feet of the mother there was this simple inscription, revealing clearly her maternal pride: *Haec fuit mater eorum* (Here lies the mother of all these).

232. Tomb slab of a knight and his family (1333). Champeaux (Seine-et-Marne), Church of the College of St. Martin.

233. Tomb of Jean de Creney and children. Creney (Aube), Church of St.-Aventin. Stone relief (gravely damaged in 1940).

Family feeling, the need not to be alone in death, was to be found even among those who had renounced family ties. At Châlons-sur-Marne, a canon holding a chalice lies on his tombstone beside a young man and a young woman, no doubt his nephew and niece.[100] In Paris, a canon has beside him on his tombstone two small figures, a man and a woman whom an inscription names Jacquet and Isabeau—no doubt his father and mother (fig. 234).[101] At Malesherbes, a tomb relief dating from the early thirteenth century (if not the late twelfth century), shows an abbot beside his brother, a knight in full armor.[102] United in this life, they will not be separated in the next. An inscription has the abbot say to the knight: "You will go with me to Our Lord."

Family feeling went very deep. Never have men believed more deeply in the strength of the blood tie. The history of the Middle Ages is the history of a few great families and their alliances; coats of arms told their story. That is why the deceased often wished to have all those of his line grouped around his tomb. The family, with its tradition of generosity, honor, and courage, as well as power, sustained the dead person lying on his tomb. It had been his strength during his lifetime, and it was only natural to want near him those to whom he owed so much.

234. Tomb slab of Canon Jean. Paris,
Ecole des Beaux-Arts. Stone relief from
Church of Ste.-Geneviève, Paris.

This cult of the feudal family found its expression in art as early as the thirteenth century. The earliest and the most beautiful of these monuments has disappeared. Before the Revolution, there was a magnificent enameled tomb in the collegiate church of St.-Etienne, in Troyes, which bore the silver statue of Thibaut III, Count of Champagne. Statuettes, also of silver, decorated the four faces of the monument; they represented those who had made the House of Champagne one of the greatest in Europe: King Louis VII, ancestor of Thibaut; Henri I, Count of Champagne, and his wife Marie of France; Henri II, king of Jerusalem and of Cyprus; Sancho the Great, king of Navarre; Henry II, king of England.[103] What is expressed here is more than mere pride— it is the steady faith in the values of the extended family.

There were other monuments of the same type. At St.-Yved-de-Braine, the enameled tomb of Marie de Bourbon, who died in 1274, was surrounded by small figures in gilded copper, representing her family and its connections. Among them were the highest nobility of the time: the king of Sicily, brother of St. Louis; the Queen of Navarre, the Duke of Burgundy, the Duke of Nevers.[104] We sense that the Bourbons had developed very early a faith in themselves and in their great destiny.

It may seem surprising that a pope should choose, not the images of apostles and saints, but those of his brothers, nieces, and nephews to surround his tomb, but less so when we learn that the pope in question was Clement VI. For Clement VI, who belonged to the great houses of Beaufort and Turenne, always remained faithful to his origins: he had both the virtues and the faults of a great gentleman. Like a true feudal baron, he was convinced that he had no duties more sacred than those to his family, and consequently, he made all of his relatives cardinals, archbishops, and bishops. The more he showered upon them, the dearer they became to him. He wanted to have all of them around his funerary statue, and ordered his sculptor, Pierre Roye, to put them there: his brother, Cardinal of Tulle; his uncle, Archbishop of Rouen; his cousins, the Archbishops of Saragossa and Braga; and many, many more. The tomb was carved at Avignon, under his watchful eyes, and transported in 1351, a year before his death, to La Chaise-Dieu.[105] And there this monument to the glory of a family was installed: the pope seemed to want to protect his own even after his death, and to defend them with his great renown; but in the sixteenth century, the Protestants smashed the cardinals and the archbishops, the Turennes and the Beauforts, and today Clement VI lies alone on his slab of black marble.

In the fifteenth century, an even more famous monument was erected to honor the foremost feudal family of Christendom. Philip the Good, Duke of Burgundy, was seized with remorse when he remembered that his ancestor, Louis de Male, Count of Flanders, had no tomb.[106] It was not fitting that the illustrious man from whom so many princes were descended should still have no monument worthy of him, sixty years after his death. Consequently, a tomb was erected in the collegiate church of St.-Pierre, in Lille, that could be seen there until the Revolution.[107] Around the marble sarcophagus, on which the Count and Countess of Flanders lay, were twenty-four copper statuettes representing the descendents or connections by marriage of Louis de Male, a line as illustrious as that of the kings. There were John the Fearless, Philip the Good, Charles the Rash, the Duke of Brabant, the Duke and Duchess of Savoie; then there were the daughters of John the Fearless and those of Philip the Bold, one of whom had been the Duchess of Bavière, and the other, the Duchess of Austria. Thus, glory accrued to Louis de Male from his grandchildren, not from his ancestors: all the majesty of the great House of Burgundy surrounded him.[108]

The cult of the family expressed on medieval tombs was a strong and fertile sentiment. It appears to have been exclusively aristocratic, and one regrets that the bourgeoisie and the lower classes did not share this great moral force; but as we learn more, we discover that they, too, were in communion with their ancestors. Today, in the small churches of Navarre, each family has its burial vault, and on the days

when Offices are said, each kneels at the spot where his dead are buried.[109] This nice custom, scarcely found any longer outside Spain, is a legacy from the Middle Ages. We once had similar traditions: documents prove that in Normandy from the fourteenth until the seventeenth century, people bought, or, to use the hallowed expression, "enfeoffed" (*fieffait*) a place in the church to bury their dead; that holy place belonged to them henceforth, and was there they went during the celebration of the Mass.[110]

Thus, the commoners as well as the aristocracy felt the presence of their ancestors; as they knelt on the tomb slabs, they were even nearer to them. How much wise counsel and good thought has risen from these tombs! Never, even in classical antiquity when the hearth stood on the stone of the dead, was the continuity of succeeding generations more strongly felt.

VI

The tombs of the Dukes of Burgundy. The Mourners.

The two kinds of feeling we have just examined—faith in the efficacy of Church prayers, and the feudal cult of the family—were brought together in the most famous of all our medieval tombs, the tomb of Philip the Bold, at Dijon (fig. 235).[111]

This famous work has long been misunderstood. Art critics, and even more serious, restorers of art, believed that the small figures arranged around the sarcophagus were all statues of monks; they were thought to be monks of the Chartreuse de Champmol (where the Duke was buried), who were praying and meditating beneath the arcades of the cloister. Montégut attempted to read in their faces the moral reasons that had led each of these men to the monastery.[112] Ingenious psychologizing, but fraught with dangers: for most of these figures were not monks at all.

When Philip the Bold died in Brussels in 1404, two thousand ells of black cloth were bought to provide mourning for those who were to walk in the funeral procession.[113] The funerary attire consisted of a voluminous mantle resembling a monk's robe, but differing in the shape of the hood and a kind of tragic fullness (fig. 236). For more than a month, his sons, son-in-law, and all the officials of the House of Burgundy, with their hoods pulled down over their eyes, followed the Duke's casket, draped in cloth of gold, as it was slowly drawn from Brussels to Dijon. These are the figures the artist represented around the tomb of Philip the Bold.[114]

There is no possible doubt of this. A fifteenth-century French manuscript, now at Breslau, shows the royal funeral ceremonies;[115] behind the casket walk the princes of the blood and the great vassals, all dressed in hooded cloaks much like those worn by the mourners of Dijon.[116]

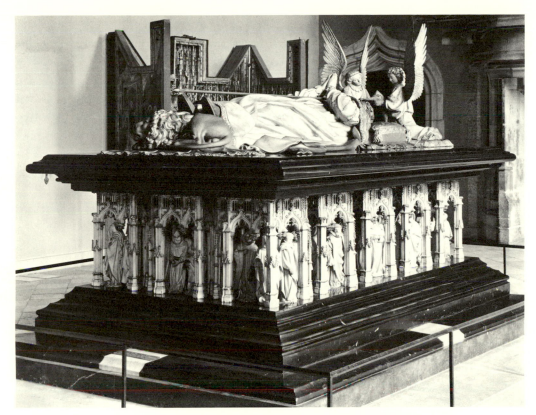

235. Tomb of Philip the Bold. Dijon, Museum.

236. Mourner. Dijon, Museum. From tomb of Philip the Bold.

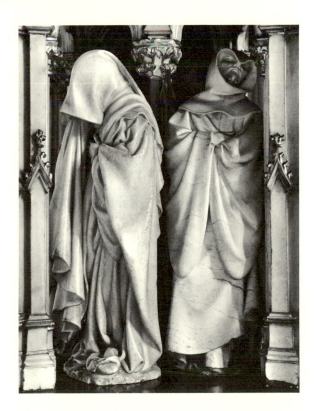

The so-called monks of the tomb of Philip the Bold are the relatives of the Duke, his sons obviously, the great officers of his court, and his most faithful subjects, all those who had made, and would make after him, the greatness of his House;[117] this was the *familia*, in the classical sense of the word. The clergy had its place in the procession, and it would be strange had it been otherwise: the man who, in his will, had asked that such a prodigious number of masses be said for the repose of his soul, clearly wanted his faith in the prayers of the Church to be inscribed on his tomb. And in fact, when the statues were still in place, before the Revolution, a bishop accompanied by deacons and acolytes led the procession, and monks and priests brought up the rear;[118] all seemed to be reciting the prayers for the dead.

Thus, the sumptuous monument to Philip the Bold, of such great artistic value, did not enrich funerary iconography; it teaches us nothing new; it expresses exactly the same sentiments as the more modest tombs of the fourteenth century: the faith of the deceased, and his love for his own relatives.[119]

Even the hooded mourners appeared almost a century before Claus Sluter. I came upon them for the first time on the tombstone in the church of St.-Andoche, at Autun, bearing the date 1316,[120] and on another in the abbey of Bonport, in Normandy, bearing the date 1317;[121] after that, mourners were to be seen on several tombs in the fourteenth century.[122]

However, Claus Sluter and his nephew, Claus de Werve, gave such powerful truth to their mourners that they seem to be entirely new creations. Like all great artists, they put their seal upon an idea that belonged to everyone, and henceforth there would be no mourners other than theirs.

They were perhaps still in the artists' workshop when they were imitated for the tomb of Guillaume de Vienne, archbishop of Rouen, who died in 1406 and was buried in the old Burgundian abbey of St.-Seine.[123]

But the rapid spread of the vogue of the motif of the mourners was a reflection of the admiration of Philip the Good, who had mourners put around the tomb of his first wife at St.-Bavon, in Ghent,[124] around that of his sister, the Duchess of Bedford, in the church of the Celestines in Paris;[125] and around that of his father, which was to be placed in the Chartreuse of Dijon.[126] The latter, the famous tomb of John the Fearless, is only a copy of the tomb of Philip the Bold.

Philip the Good's sister shared his enthusiasm for the work of Claus Sluter, for she wanted the tomb in which she was to be buried alongside her husband, Charles de Bourbon, at Souvigny (Allier), to be decorated with mourners in imitation of those of Dijon.[127]

The admiration shown by the House of Burgundy for the tomb of

Philip the Bold was contagious: it infected Charles VII. When he had the tomb of the Duke of Berry made at Bourges,[128] he clearly proposed to the artist the Dijon monument as model; in fact, the Duke of Berry's tomb, before its partial destruction, was surrounded by arcades under which a procession of the traditional mourners walked.

From that time on, every fine tomb had its mourners. Some of these tombs still exist: the tomb of an abbot of Baume-les-Messieurs (Jura), of the Bâtard de St. Pol at Ailly-sur-Noye (Somme), of Nicolas d'Estouteville at Valmont,[129] of the Sire de Chaource at Malicorne (Sarthe),[130] and the almost completely destroyed tomb of Charles III, Count of Provence, in the cathedral of Aix.[131]

Many such tombs must have disappeared,[132] like that of the Prince of Talmont in the abbey of Thouars, listed by Gaignières,[133] and the tomb prepared for Louis de Laval shown in his Book of Hours (fig. 237).

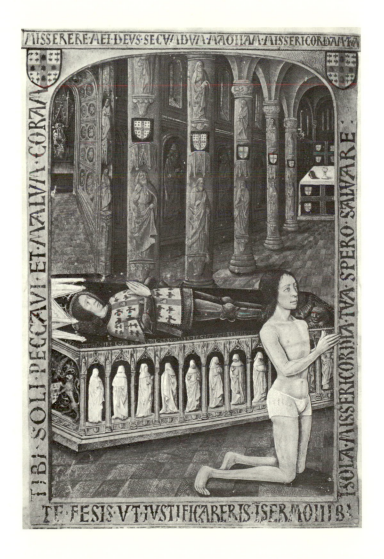

237. Tomb with mourners. Hours of Louis de Laval. Paris, Bibliothèque Nationale, ms. lat. 920, fol. 334v.

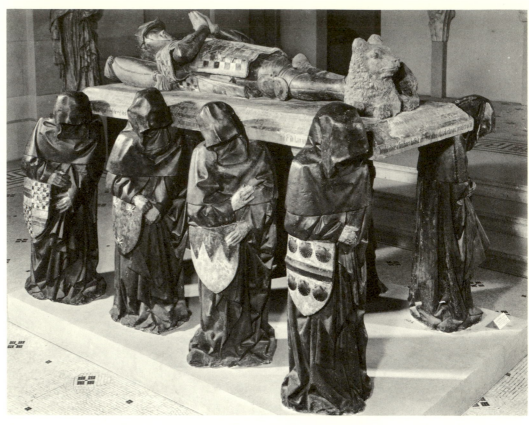

238. Tomb of Philippe Pot. Paris, Louvre.

All these sculptors were content to imitate a work that time had consecrated, but one, them brought to imitation the kind of creative genius that renews a subject. We do not know the name of the astonishing artist who, about 1480,[134] designed the tomb of Philippe Pot, formerly at Cîteaux and now in the Louvre (fig. 238). The mourners, enlarged to life-size, have been transformed into pallbearers, and on their shoulders rests the stone slab bearing the recumbent effigy of the Seneschal of Burgundy, clad in his armor. These are eight relatives, all of the noble house of Burgundy, for each one carries a shield on which his kinship is indicated. They tread with heavy step, bowed down by the weight of the deceased on their shoulders, but apparently with even greater weight in their hearts. Nothing could be more real, more solid, than these eight knights as massive as Romanesque pillars; yet at the same time, nothing could be more mysterious. The great figures veiled in black are as frightening as specters of the night. Certainly, they do not belong to this world: sent by Death, they show themselves for a moment, but shortly they will vanish, to return to the land of shadows.

The remarkable tomb of Philippe Pot, the work of a visionary artist, could not set a style: a clumsy imitation in the church of St.-Martin, at Lux, proves that a work of such genius could not be repeated.[135]

In the sixteenth century, our artists still looked toward Dijon, and continued to imitate Claus Sluter's mourners. Until the time of Francis I, there was scarcely a funerary monument of any pretentions to grandeur that did not have the traditional mourners, including the tomb of the Duke of Brittany at Nantes, that of Marguerite de Bourbon at Brou, and of the Cardinals of Amboise, at Rouen.

The carvers of tomb slabs also remained faithful to the old motif of mourners until about 1530.[136] Such was the incredible creative force of Claus Sluter's work.

It is probably true that in the sixteenth century the mourners no longer had a precise meaning for people; they were, as was said, figures "in an attitude of mourning." They symbolized the regret for the loss of the deceased, and probably no one remembered that on the tomb of Philip the Bold the mourners were the son, the relatives, and the trusted vassals of the Duke. The idea of surrounding a man with all those who had constituted his strength was no longer understood.

The tombs of the kings of France are so badly damaged that it is impossible to know whether they expressed the same ideas as the tombs of the Dukes of Burgundy. The kings may also have wanted to be surrounded in death by their faithful subjects draped in mourning. But our kings did even better: they ordered that their most valiant subjects be buried at St.-Denis, near the place marked out for themselves. An unheard of honor! Simple knights were buried in this royal basilica where the royal children themselves were rarely admitted. St. Louis had near him Pierre le Chambellan, "the most loyal man and the most upright that I ever saw," according to Joinville. At St.-Denis, he lay at St. Louis' feet, as he so often had in the crusader tent in Egypt or Syria. Charles VII had Guillaume du Chastel, who had been killed in action, buried beside him, and Louis XI did the same for Louis de Pontoise, who had died at his side in the siege of Le Crotoy. But none revealed greater heart than Charles V; he wanted to be surrounded by those who had worked with him for France: the great Bertrand du Guesclin; Louis de Sancerre, victor of Roosebeke; his councillor, the amiable and clever Bureau de la Rivière. We have only one regret, that he did not include one of our great artists within the company of his faithful subjects. The monks understood better than kings the dignity of art. The Benedictines of St.-Germain-des-Prés buried the architect, Pierre de Montereau, alongside their abbots in the beautiful chapel of the Virgin he had built. The monks of St.-Ouen, at Rouen, wanted the two great masters of the works of the basilica, Alexander and Colin de Berneval, to have a tomb beneath its vaults. We see them on their tomb slab holding the rose windows of the transepts: unhesitatingly, they present these man-made masterpieces to God's judgment.

Changes in tomb iconography. The use of portraits. Death masks moulded on the faces of the deceased.

Such were the tombs of the Middle Ages. Everything about them was noble: the effigies of the dead were idealized images, and the accompanying figures expressed faith and love. A beautiful concept in which we recognize the spirit of the great thirteenth century that had ennobled life and embellished death.

These traditions were followed for a long time and, as we have seen, some were perpetuated even beyond 1500.

But in the last years of the thirteenth century, new concepts began to form, which with time were to change the aspect of tombs.

After reviewing the monuments of the thirteenth century, when our eyes have become accustomed to those beautiful, impersonal faces, the tomb of Philip III the Bold at St.-Denis (fig. 239), comes as a surprise: large nose, wide mouth, square chin—these are the principal traits of this expressive but not very noble face. Clearly the artist wanted to make a portrait, and this is the earliest [funerary] portrait in France.

239. Head of Philip III (the Bold). St.-Denis (Seine), Abbey Church. From tomb statue.

Thus, as early as 1298,[137] the elevated thoughts that had long turned artists away from seeking likenesses had lost their force. Why the old traditions had given way can easily be explained; to try to transmit to posterity the authentic image of a king of France was quite natural. Yet the artist might not have striven for verisimilitude had he not been prompted by a recent invention.

It was in the last years of the thirteenth century, in fact, that the idea of death masks of the deceased first appeared.[138] The first royal personage known to have undergone this process was none other than the wife of Philip III, Isabelle d'Aragon. The young princess, who was accompanying the remains of St. Louis, died in 1271 from a fall from her horse in lower Calabria; she was buried in the faraway cathedral of Cosenza. Her tomb, long hidden beneath a layer of plaster, was discovered in 1891. Its effigy is extraordinary: the face is the face of a dead woman, with eyes closed, mouth contorted with pain and swollen left cheek. This has nothing to do with art; the sculptor simply copied exactly a cast taken from the queen's face immediately after her death.[139]

Consequently, the process generally believed to be much more recent was known as early as 1271. It is probable, not to say almost certain, that Philip III underwent the same proceedings after his death; for how could a sculptor have made so characteristic an image of a king who had been dead for thirteen years without a death mask before him?[140] The artist, moreover, showed a nice sense of tact; he made use of the model but refrained from copying it. Faithful to tradition, he represented the king as living, with open eyes;[141] nothing about the face recalls death.

The degree of verisimilitude in the funerary effigies of our fourteenth-century kings is no longer surprising. Philip VI, with his large nose, and John the Good, with the vulgarity of his blubbery lips and puffy face, remain in the memory of all attentive visitors to St.-Denis. These true-to-life statues, however, were made later than the death of the kings they represent. They date from the reign of Charles V, who had them begun at the same time as his own.[142] They presuppose wax casts that were later interpreted by gifted sculptors. True, documents are silent on the subject.[143] However, the practice of carrying, in funeral ceremonies of the kings of France, a fully dressed likeness of the dead monarch lying in state, probably dates from this period. For the funeral rites of Charles VI, of which all the details are known, casts were made of the king's face, hands, and feet. These casts were used to fashion "the form." This was a kind of royal double, clad in a dalmatic of cloth of gold decorated with *fleurs de lis*, which received the customary honors and was finally taken to St.-Denis along with the coffin. The texts do not refer to these singular practices as something new, and it seems that the Painter in Ordinary to the king had long been designated as the one to render the king this final duty.[144]

In 1403, nearly twenty years before the death of Charles VI, the Duke of Orleans gave orders that "the likeness of his face and hands, in an attitude of death, be placed on his tomb"[145]—a phrase indicating clearly enough that the practice of making a mould of the faces and hands of distinguished dead was by that time well-established. We can go back

even further. In about 1352, the monks of La Chaise-Dieu had in their possession a wax figure of Clement VI, which had been sent to them by the painter to the pope, Matteo da Viterbo.[146] What could this effigy modeled by the painter have been, if not a death mask?

Therefore, it can be unhesitatingly affirmed that death masks were made of the kings of France in the fourteenth century. These masks were certainly preserved, for by ancient privilege, everything that had been a part of the king's funeral ceremonies became the property of the Abbot of St.-Denis;[147] and our artists could have studied them there.[148]

The practice of casting from nature was one of the reasons for the astonishing renewal of art in the fourteenth century. This invention (actually only the revival of an ancient practice),[149] yielded rich consequences: artists learned to observe. Until then, they had contemplated an idealized image carried within themselves; henceforth, they would note the thousand details that make one man different from another.[150] So it is useless to try to ascribe the realism of the tomb statues of St.-Denis by the temperament of the Flemish artists who made them, as Courajod tried to do. In the fourteenth century, the Flemings were neither more nor less realistic than the French since the only art they knew was French.[151]

Whether French or Flemish, sculptors knew how to use the discovery that had opened their eyes: they looked directly at reality, having until then contemplated only the idea of it.

In the fifteenth century, the habit of making death masks became general. Many famous busts from the Italian Renaissance seem to be simple death masks retouched by skillful artists. In France, we can point to frequent use of casts: I need only cite the frightening statues known as the "Donors" in the museum of Toulouse,[152] which bear the seal of death on their sunken cheeks and open mouths (fig. 240). When a famous man died, a cast of his face was taken at once: it is known that Bourdichon was commissioned to make the death mask of St. Francis of Paola.

This explains the increasing realism of funerary statues. We should add that, in the fourteenth, and even more frequently, in the fifteenth century, persons of note were wont to prepare their own mausoleums; their effigies were carved before their own eyes. Why, then, should we be surprised to find portraits on tombs?

While the sculptors tried to make realistic statues, the engravers of tomb slabs remained faithful to the old tradition. Until about 1540, they were still incising ideal images, as their thirteenth-century ancestors had done, and we very rarely find an image on a tomb slab that can be considered a portrait.

The reason is simple. The tomb slabs, usually shipped to distant

240. "The Donor." Toulouse, Museum. Statue with death mask (formerly in St.-Sernin).

purchasers, represented people the artist had never seen. In fact, almost all the workshops of "tomb makers" (*tombiers*), as they were called, were located in Paris. Most of the tombstones that we admire in Normandy, Champagne, and Burgundy were made in Paris (at least from the fourteenth century on). Already in the fourteenth century, Paris was what it is today—the source of creativity from which works were sent afar.

At Celsoy (Haute-Marne), there is a beautiful tomb slab representing the physician Guilbert de Celsoy, who died in 1394 (fig. 229).[153] Feature by feature, it resembles the tombs of professors made in Paris at that time: a close examination shows that the stone came from a quarry in the region of Paris.[154] This proves that, as early as the late fourteenth century, the tomb slabs of Paris were being sent as far as Burgundy.

The Gaignières Collection and our Corpus of gravestones establish this fact beyond doubt. From the fourteenth century on, the churches of Champagne, Normandy, and Anjou contained thousands of tomb slabs and engraved copper funerary plaques exactly like those of Paris[155]— where they originated. It was the Parisian tomb makers who, in the

fourteenth century[156] had invented the gravestones framed by two rows of acolytes and apostles, surmounted by the image of Abraham, and with the symbols of the four evangelists, for this was the form of almost all the tombstones in the churches of Paris.

Written as well as graphic proofs exist. If the fourteenth century furnished us with no documents, and the fifteenth with very few,[157] the sixteenth century left them in profusion. A great many contracts drawn up between patrons and Parisian tomb makers during the years 1515 to about 1530 have been published,[158] and they are extremely interesting. Through them we come to know those excellent artists who were really only poor workmen laboring with one or two helpers from six in the morning until seven at night. We even know their names: Pierre Prisié and his widow Comtesse, Bastien Bernard, Pierre Dubois, and most famous of all, Jean Lemoine, who sometimes signed his gravestones and whose works are still to be found.[159]

These documents have another kind of interest for us. They prove that the workshops of Paris furnished carved stones to all the neighboring provinces: they were sent to Soissons, Beauvais, Meaux, Melun, Les Andelys, Evreux, Châteaudun, Verneuil, Vernon, Laon, Noyon, Péronne, Auxerre, and Troyes.[160] But the texts don't tell everything, and the Parisian tomb slabs often went to even more distant places.

Thus, regions, that in the thirteenth century had their own artists and traditions,[161] had now become tributaries of Paris. This had been the case, I am convinced, since the late fourteenth century. There is another significant fact: the farther we go from the region centering on Paris, the rarer beautiful gravestones become. Those of the province of Berry had already become coarse, products of a rustic and traditionless art. Those of the Bourbonnais were no better;[162] and as we go farther south, we are surprised by the paucity of gravestones, and chancing upon one, we are even more surprised by its mediocrity. The tomb slabs of the archbishops of Toulouse[163] are an indication that the art of carving tombstones was little practiced in the southern provinces.[164]

Clearly then, the most beautiful tombstones of northern France were made in Paris.[165] It is not surprising, therefore, that the effigies have no individual character. The contract called for the figure of a knight, a young girl, a canon; it sometimes specified that the personages be dressed in such and such a way, but no mention was made of likenesses. The artist was sent a drawing of the armorial bearings and the text of the inscription but never a portrait; sometimes he was even told simply to copy a particular tomb in a Paris church.

Consequently, we should not look for anything more than an idealized portrait of the knight, the noble lady, or the priest, on the gravestones of whatever epoch.[166] And it was out of necessity more than

conviction that the tomb makers remained attached to the ancient tra-
ditions of their art.

It was the tomb statue most of all that suffered the loss of something
of its spiritual quality from the fourteenth century on. At the same
time, there is a gradual disappearance of some of the symbolic features
that had lent such nobility to the thirteenth-century tombs.

The rôle of angels was no longer truly understood. They were no
longer conceived as heavenly spirits, brothers to the immortal soul they
bore to Abraham's bosom: in the fifteenth century, they became young
pages absorbed in paying their last respects to their powerful lords; they
carry the emblazoned shield or the crested helmet of their master. On
the tomb of Philip the Bold, it takes two angels to hold up the helm
of Burgundy with its *fleur de lis* crest.

At the same time, the symbolic significance of the animals placed
under the feet of the dead became less and less clear. As early as the
thirteenth century, the lion had appeared under the feet of the knight,
the dog under those of the noble lady. The significance of these animals
was perhaps not as lofty as that of the dragon, but at least their meaning
was quite clear: the lion signified virile courage,[167] the dog both fidelity
and the womanly domestic virtues. The little dog under the lady's feet
is always a pet gnawing on a bone or snapping at another dog. Thus,
it is the household pet who rarely leaves the house and who lives between
the hearth and the table: an excellent image of woman's fate in the
Middle Ages.[168]

Sometimes, there is a dog under the feet of the gentleman, but it is
a dog of another breed: a hunting dog, the greyhound (fig. 241). It
symbolized another aspect of the feudal baron's life: hunting and making
war comprised his entire existence. Also, hunting was one of his priv-
ileges, and the one to which he was most attached. This explains why
the hunting dog is as frequent as the lion under the feet of male statues.

These traditions were long respected; it can even be said that most
artists remained faithful to them until the sixteenth century; however,
there had been some nonconformists even as early as the fourteenth
century. Tombstones, especially, present strange confusions: on one, a
noble lady is mounted on a lion;[169] on another, a cleric treads not on
the traditional dragon, but on two little house dogs quarreling over a
bone;[170] and on another, the cleric has a lion beneath his feet.[171]

Clearly certain artists no longer attached any particular meaning to
these animal figures, and considered them as pure ornament.[172] As a
result they soon began to take even greater liberties with tradition. They
put under the feet of the deceased the animal figuring on his coat of
arms: an abbot of Montierneuf, whose blazon carried a boar's head,
had a boar under his feet;[173] the Duke of Berry had the heraldic bear

that recalled his famous devise: *Oursine un temps venra*; the Duke of Orléans had a porcupine, in memory of the Order he founded.

Fantasy was carried even farther. Artists amused themselves by punning on the name of the deceased: beneath the feet of a merchant named Chasse-Conée, a dog was placed in pursuit of a rabbit (*conil*);[174] at Loches, the feet of Agnès Sorel rested on two lambs (*agneaux*); and an artist had the impertinence to place the feet of Andry Lasne, a bourgeois from the suburbs of Paris, on an ass (*âne*) (fig. 242).[175]

However, we should not think that these examples of poor taste were frequent; on the contrary, they were fairly rare. Even in the sixteenth century, there were artists who still knew the meaning of the symbols: in 1522, a unicorn, symbol of virginal purity, was placed beneath the feet of a young girl, Renée d'Orléans.

In spite of certain lapses, French tombs preserved something of their ancient beauty well into the sixteenth century. This is especially true of tomb statues: these are, of course portraits and not transfigured images; nevertheless, as in the past, the dead opened their eyes as if awakened to another life.

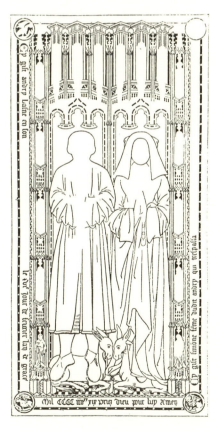

241. Tomb of Pierre de Villemétrie, d. 1340. Abbey of Notre-Dame de la Victoire (Oise). Paris, Bibliothèque Nationale, Gaignières Collection, Pe 1e, fol. 105.

242. Tomb slab of Andry Lasne and wife. Vaux-de-Cernay (Seine-et-Oise). From drawing in Guilhermy, *Inscriptions*, vol. III, p. 454.

On the whole, the changes we have just indicated are fairly slight, evident perhaps only to the archeologist. But there are others that are more serious.

Just as some artists no longer knew the meaning of symbolic animals they placed under the feet of the dead, there were soon some who no longer knew why the funerary statue should have its eyes open. Many artists thought they had to choose, and represent either a real dead person or a real living person. Thus, while the old tradition persisted and continued to inspire masterpieces, artists began to express two new, quite opposite, concepts. Some represented the dead man kneeling on his tomb, but omitted anything that might recall death; while others stiffened the body, closed its eyes, caved in its cheeks, and in fact depicted a corpse.

However, the two different concepts did not occur to artists simultaneously, as might be gathered from what we have said: kneeling statues appeared more than a hundred years earlier than the statues of recumbent figures transformed into corpses.

The earliest kneeling tomb statues to be carved by a French artist seems to be that of Isabelle d'Aragon, wife of Philip III, at Cosenza, in Calabria.[176] There is no doubt that this statue, lost in the depths of Italy, is French:[177] the work is French, but we sense that it was not executed in France; the conception is too bizarre to have been tolerated in Paris or at St.-Denis. Kneeling at the feet of the Virgin, the young queen, prays with clasped hands, but strangely enough her eyes are closed and her face bears all of the marks of a violent death. We have already said that the artist had simply copied her death mask. Thus, the first attempt to change the time-hallowed tomb conventions resulted in an absurdity: Isabelle d'Aragon is no more than a kneeling corpse.

As we have seen, it had occurred to some artists as early as 1271 that there were other ways of representing the dead than as recumbent figures on their tombs.

The idea had not been lost, but became productive only in the fourteenth century. The famous Countess Mahaut d'Artois, buried at Maubuisson, also had a tomb in the abbey of Thieuloye, which she had founded near Arras. This tomb has disappeared, but we can form an idea of it from a seventeenth-century drawing.[178] The sculptor represented the countess kneeling, offering God a small church (the abbey of Thieuloye), and sheltering a nun under her mantle. Here, an idea we glimpsed in the late thirteenth century is realized. The Countess Mahaut died in 1329, but documents lead us to believe that this new kind of tomb had been erected during her lifetime, and it may have been in place by 1323.[179] The artist had clearly been inspired by the

The statue kneeling on the tomb. The recumbent effigy transformed into a corpse. The kneeling statue and the cadaver both used on the same tomb. The tomb of Louis XII. Its influence. The appearance of pagan tombs.

figures of donors so often seen in windows or reliefs, kneeling at the feet of the saints: the figure of Mahaut, like that of Isabelle d'Aragon, was probably kneeling before a statue of the Virgin. In this way, the audacity of raising a recumbent tomb figure was somewhat attenuated. There had been a tradition, traces of which can be found up to the late fifteenth century, of showing the kneeling dead looking toward an altar or images of saints to which their prayers could be addressed.[180] At Sens, Jean de Salazar and his wife kneel on a platform, and with clasped hands venerate the Virgin and St. Stephen.[181] The tomb has disappeared, but the figures of the Virgin and St. Stephen still exist.

Before the Revolution, there was a kneeling funerary statue representing Cardinal Dubec in the Carmelite church at the Place Maubert.[182] It must have been almost contemporary with the tomb of the Countess Mahaut; perhaps it was even a little earlier, if we assume that it was begun immediately after the death of the cardinal in 1318.[183]

Consequently, the kneeling statue first appeared in the early part of the fourteenth century. Possibly the need to save space in churches already filled with tombs contributed little by little to the success of this innovation. For the kneeling statue was not necessarily placed on a sarcophagus; it might rest on a simple column, against a wall, or high above the funerary slab covering the remains of the dead. It interfered in no way with the movements of the clergy or the congregation, and took up far less space than a recumbent statue.

Nevertheless, kneeling funerary statues, rare in the fourteenth century,[184] were still unusual in the fifteenth. However, in the fifteenth century, people of the highest rank began to adopt this fashion. The famous tomb of Louis XI, at Notre-Dame in Cléry, was surmounted by a kneeling statue. The aged king, faithful out of vanity to the idealistic habits of the thirteenth century, required the artist to represent him as young and elegant, with a full head of hair.[185]

Prior to Louis XI, kneeling statues of several celebrated men had been carved and placed on their tombs: Cardinal de Saluces, in the cathedral of Lyon,[186] and Jean Jouvenel des Ursins, at Notre-Dame in Paris.[187] Sometimes, the wife kneeled beside her husband, as on the tombs of Jouvenel des Ursins and of Jean de Salazar in the cathedral of Sens.

It was only in the sixteenth century that kneeling statues became widespread; by 1550 they had triumphed. Everywhere, they replaced the ancient recumbent statues with clasped hands and open eyes—the meaning of which had been lost. The Middle Ages were definitively over, and henceforth in French churches we encounter only these noble marble figures kneeling on their prayer stools. Lacking in mystery, they rarely move us. Once or twice, however, we again experience the feeling conveyed by ancient tombs. At Aubigny, in Calvados, six statues kneel

gravely, one behind the other; the oldest wears the attire of the period of Henry IV, the most recent that of the time of Louis XVI: they are six generations of the same family. There is stirring grandeur in this tranquil affirmation of the strength of lineage; the six Aubigny statues seem to be monuments of another age.

The kneeling statue won out, but only at the end of two centuries.

However, there was no desire to renounce the ancient recumbent statue, which undoubtedly seemed more Christian and had a long tradition behind it, but since many artists no longer understood the mystical meaning of this figure, which seemed to be both dead and alive, they transformed it into a corpse.

We have already said that the tombs of Guillaume de Harcigny at Laon (1393), and of Cardinal Lagrange at Avignon (1402) offer the earliest realistic and almost repulsive images of death; we have explained how these strange representations appeared at the moment when the *danse macabre* had taken hold of men's imaginations.[188] The idea of death was all-powerful at the time and it is not surprising that it erased the idea of immortality from some tombs.

After 1400, these tombs form an almost uninterrupted series. In 1412, Cardinal Pierre d'Ailly was represented in the cathedral of Cambrai as a dead body lying in its shroud;[189] in 1424, Jacques Germain was carved on his tombstone wrapped in a tragic shroud (fig. 243);[190] in 1434, two skeletons were engraved on the tomb slab that was to cover the remains of Richard de Chancey, a councillor of Burgundy, and his wife;[191] in 1457, the children of Jacques Coeur had a funerary monument surmounted by the nude figure of their dead mother erected in her honor in the church of St.-Oustrille, in Bourges;[192] about 1467, the place where the sepulcher of Canon Yver had been interred in Notre-Dame, at Paris, was marked by the famous relief showing the already decomposed corpse of the dead man; toward 1490 or 1500, a fleshless image bearing the mitre and cross was placed on the sarcophagus of Jean de Beauveau, bishop of Angers.[193]

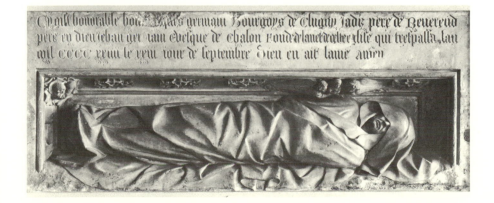

243. Tombstone of Jacques Germain. Dijon, Museum.

The sixteenth century showed an even livelier taste than the fifteenth for this kind of representation.[194] Corpses came to be represented not only on tombs, but even on stained-glass windows. In Normandy, the deceased were sometimes shown in the lower section of the windows that had been given in their names by their widows. At St.-Vincent, in Rouen, a kind of parchment-skinned mummy is laid out in the lower part of a large window devoted to scenes from the Resurrection; the poor dead man still implores, and from the depths of his abyss cries: *Jesus, sis mihi Jesus* (Jesus, help me Jesus); that is to say, "Jesus, keep your promise and since you triumphed over death, help me to triumph in turn." At St.-Patrice, in Rouen, there is a corpse in the lower part of the window of the Annunciation; at Conches (Eure), the body of a dead man is to be seen below the feet of Christ celebrating the Last Supper; he lies among poppies and jonquils and his widow prays at his side. These strange works are to be dated between 1520 and 1560.[195]

Thus, to return to our subject, in the sixteenth century, the more serious and religious recumbent figure of yore was almost completely abandoned, replaced by either the kneeling statue or the representation of a corpse.

About 1517, it occurred to some artist to combine the kneeling statue and the corpse on the same tomb. This gave rise to the scheme of the great tombs of Louis XII, François I, and Henri II. Certainly all magnificent works, whose praise we would not begrudge, these tombs will not surprise anyone who has studied the funerary art of the fifteenth century. All elements had been in use for a long time;[196] they had only to be united in a single monument. The idea of doing it may well have first occurred to the artist who designed the tomb of Louis XII erected at St.-Denis; we wonder, however, whether some earlier monument had not suggested to him the conception of this famous tomb.[197]

Double tombs on which the same personage was shown twice had, in fact, been known in the thirteenth century. There was one at Longpont, dating perhaps from 1220 or 1230, which was the tomb of the Blessed Jean de Montmirail.[198] At first a knight, he suddenly renounced the world and became a monk. His tomb was therefore made of two platforms, one above the other. On the lower lay the figure of the soldier, on the upper a monk.[199] The example is not unique. Arnaud Amalric, who died in 1225, had an almost identical tomb at Cîteaux. He had been a Cistercian abbot, and later become bishop of Narbonne, both of which offices were recalled by the two statues placed one above the other: one showed Amalric in a monastic habit, the other in episcopal attire.[200]

Such monuments are in some ways similar to the tombs of St.-Denis, although, granted, the similarities are slight; the thought expressed is clearly quite different, but the disposition of the figures is the same.

Let us take a closer look. The relief of Canon Yver at Notre-Dame in Paris strikes us as a kind of sketch for the tomb of Louis XII. The Canon is represented twice: below in the form of a hideous, already decomposed corpse, about to become something nameless; above, he is shown again, but as a living man with clasped hands and eyes lifted toward the Judge who appears in the clouds. The idea is perfectly clear; the frightful corpse is merely deceptive in appearance; on the last day it will resume its true form at the summons of the Lord.

Thus, the idea of representing the deceased as both dead and alive on the same tomb had already been current among artists as early as the fifteenth century. Many monuments of this kind must have disappeared; we have only ruins with which to reconstruct the history of French art.[201]

However, we know enough to sense that, in designing the tomb of Louis XII, the artist drew as much upon memory as invention. He may also have taken as a starting point the impressive ceremonies that were part of the funerals of the French kings. After the body of the king had been closed in its coffin, his funerary effigy lay in state on a catafalque for several days. Morning and evening, a table was set and a meal served before this puppet with a wax mask; as though no one wanted to believe the evidence and admit that the king was dead. Finally, when taken to St.-Denis, the effigy was placed on a litter raised above the coffin, and the heavy funerary structure was carried on the sturdy shoulders of the salt porters, who were very jealous of their ancient privilege.[202] A text shows that in the funeral ceremonies for Charles VIII, when the body was brought to the church for the recitation of prayers, the effigy was placed on the upper platform of a catafalque, and the coffin on the lower platform.[203] The same seems to have been done at the funeral of Louis XII;[204] and this gives us the broad outlines of the tomb that would later be erected by the Giusti brothers. The effigy on the upper platform called for a recumbent statue, but such figures had gone almost completely out of fashion by 1517: both Louis XI and Charles VIII, the two predecessors of Louis XII, had been represented kneeling on their tombs, and we recognize that the artist here was following the new fashion. His originality consisted in breaking open, so to speak, the coffin on the lower platform to reveal the miserable reality concealed by the emblazoned leaden box and the cloth of gold with its *fleurs de lis*. Many others had depicted corpses, but no one had yet dared to represent the dead king as he lay below the living king. A terrifying funeral oration! Reliefs surrounding the monument tell the victories of Louis XII, in the manner of court preachers: he crossed the Ligurian Alps, entered Milan in triumph, and won the battle of Agnadello. The victor, humble only before God, soars above his victories and the heads of other men. And then we see what all this has come

to: the conqueror "such as death has made him," naked, with sunken cheeks, pinched nose, open mouth, stomach slit open by the embalmer, already frightful and soon to become hideous, as abject as a dead beggar. Queen Anne, her head resting on her unbound hair, lies beside him. These two beings, abandoned and alone in the world, produce one of the strongest impressions of anguish ever expressed in art. The somber spirit of the Middle Ages in its decline seems here to have uttered its supreme and final thought. If the Giusti brothers conceived this tomb—which has not been proved—we must recognize that these Italians had quickly learned to think and feel as we do; it is not surprising that they were long taken to be French from the banks of the Loire.[205]

The influence of the tomb erected for Louis XII at St.-Denis was extraordinary: all the great French tombs built after 1531 are more or less faithful imitations of it. The tomb of Philip the Bold, at Dijon, had inspired almost all the tombs of the fifteenth century; the tomb of Louis XII at St.-Denis was the model sixteenth-century artists always had in mind.

The tomb of Cardinal Duprat in the cathedral of Sens was one of the first imitations. Duprat died in 1535 and his tomb was probably erected not long after. The monument was almost completely destroyed during the Revolution,[206] but a drawing in the Gaignières Collection shows its design.[207] The Cardinal knelt on an upper platform; below, his corpse lay on a sarcophagus. The drawing is so poor that we cannot tell whether the artist truthfully portrayed Duprat as the corpulent man he was—*vir amplissimus*, as Théodore de Bèze laughingly called him. Reliefs carved on the substructure recalled the solemn entries of the Cardinal into Paris and Sens and four statues of the Virtues were placed at the four corners of the tomb. The imitation could scarcely have been closer: the Sens tomb was nothing more than a simplified copy of the tomb at St.-Denis.

About the same time, an anonymous artist began the tomb of Louis de Brézé, in the cathedral of Rouen.[208] Was he Jean Goujon, as people have often said? Many details lead us to think so, but the entire conception reveals the fine imagination of a great artist. To some degree, the Rouen tomb derives from the tomb at St.-Denis, but of all the imitations, it is the freest. The soaring knight, the corpse watched over by the praying widow, the Virtues incorporated into the mausoleum as caryatids, all have a new character; there is no detail that was not recreated by a naturally creative mind. If Jean Goujon did not design the tomb of Louis de Brézé, there must have been another first-rank artist in the sixteenth century whose name remains unknown.

Neither Philibert Delorme, nor Primaticcio, both of whom designed funerary monuments, showed as much originality: they took far fewer liberties with their model. In fact, the tomb of François I, done by

Philibert Delorme, and that of Henri II, the work of Primaticcio and Germain Pilon, reproduced the tomb of Louis XII in all but a few details.[209] The architecture is more classical: the tomb of François I resembles a triumphal arch, that of Henri II, a temple; but the general arrangement is the same. These magnificent imitations are not always superior to the original; the praying statues lack the touching fervor of the old tomb of Louis XII; the corpses are less terrible. Henri II resembles a beautiful Christ in the Sepulcher; his queen is represented in the pose of the Medici Venus.

Still other monuments can be cited: the tomb of Claude de Guise at Joinville,[210] and the later tomb of Valentine Balbiani, on which the figure of the corpse is placed beneath the statue of the living (fig. 244).[211] They perpetuate the tradition of St.-Denis.

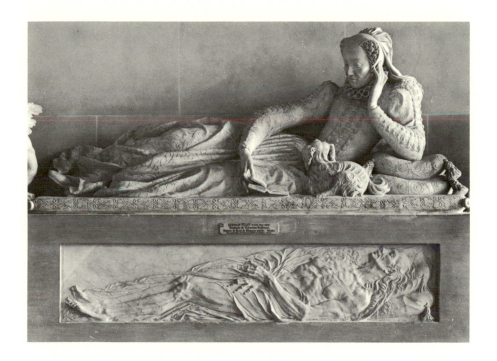

244. Tomb of Valentine Balbiani. Paris, Louvre.

Such was the extraordinary fate of these two beautiful fourteenth-century creations: the kneeling figure and the corpse recumbent of the tomb. The great monuments of St.-Denis, less moving than the modest thirteenth-century tombs, are nevertheless eloquent in their own way; they anticipate the language of Bossuet.[212] Contemplating them, we are reminded of the funeral oration for the Prince de Condé; they express the same thought, and have almost the same structure. The arch of triumph, which is the tomb, and the Victories placed around a corpse, speak plainly of the emptiness of glory, while the kings humbly kneeling before God seem to proclaim that "piety is the sole object of man."

Thus, at the height of the Renaissance, the tomb remained Christian, and the tradition of the Middle Ages was perpetuated. Frankly pagan tombs were still rare, and appeared only shortly before the middle of the sixteenth century. They showed the deceased neither lying on a tomb slab, nor kneeling; he half reclines in an abandoned attitude, leaning on plump cushions. He resembles the dead of classical antiquity who appear to be resting from the fatigue of living, and gaze indifferently out from their tombs. No thought of eternity is mirrored in their vacant eyes.

Such is the figure of Admiral Chabot, whose tomb is now in the Louvre. He holds the commander's whistle casually, for death has liberated him from the futile duties of the living. He contemplates his life as if it were a dream he is surprised to have lived, as an enigma to which he had found no answer.

Chabot died in 1543; his tomb, in which there is nothing that recalls Christianity, no doubt dates from the same year. Here, our artists were merely following the example of Italy. They had undoubtedly seen the pagan tombs of Florence; and even without going so far, they could see the Italian tomb of the Prince de Carpi at Paris, in the church of the Cordeliers.[213] However, this example was rarely followed, and the half-recumbent figures who neither prayed nor hoped were exceptions in the sixteenth century.

The artists of the Renaissance remained much more firmly attached to tradition than is ordinarily believed; the interesting thing is that the ancient recumbent figure remained in use until the end of the sixteenth century. Roberte Legendre, lying on his tomb with clasped hands, is as grave as a thirteenth-century knight.[214] The first baron of France provided an example of fidelity to the past; his tomb statue is no doubt one of the last *gisants* (recumbent effigy) ever to be carved in France.[215]

245. Tomb statue of Roberte Legendre.
Paris, Louvre (detail).

We cannot but regret the disappearance of these dignified and solemn statues who speak of hope, and unlike the naked corpse, do not affront poor human nature. Let us admit, however, that the most beautiful of the sixteenth-century recumbent effigies are only half understood. What is more exquisite than the statue of Anne de Montmorency (fig. 245)?[216] At first glance, what could seem worthier of the great art of the thirteenth century? But when we look closely, we see that the eyes are closed:[217] this woman who clasps her hands and seems to pray is dead. She is not one of the happy souls who has crossed the threshold of the other life and already contemplates the eternal light.

X

Art and Human Destiny: The End of
the World. The Last Judgment.
Punishments and Rewards.

I

The fifteen signs before Doomsday.

The dead man we have seen lying on his tomb has already been judged, but he will be judged a second time on the last day of the world. Thomas Aquinas, and all later theologians including the Fathers of the Council of Trent, explained the necessity of the second Judgment.[1] At the hour of death, they said, God judges only the soul, but on the day of resurrection he will judge the body as well. The body takes part in our sins: it is only just that it share the punishment, for God will call it to account for its rebellion against the spirit.

And also, the specific judgment God pronounces on each soul is not enough. He wants the sentence to be public so that the innocence of the unrecognized just man will shine forth, and the hypocrite masked of virtue will be confounded and exposed for all to see.

Finally—what is a highly significant idea—man cannot be definitively judged at the hour of death, for he does not die completely. His works, his books, and his doctrines live after him. Some men of genius are more active after death than alive. He may lack works, but even the humblest has children, and a word said by a father to a son can have incalculable consequences. Therefore, God will await the end of the time before pronouncing his final word on each man.

This is how medieval theologians explained the necessity of the Last Judgment.

The drama of the end of the world, already so amply developed by the artists of the thirteenth century, was enriched with new details in the fifteenth.

The threat of the Apocalypse seems to preoccupy man's soul more fully than ever before: strange ideas, that appear scarcely at all in the works of the early theologians, were now accepted as articles of faith

and were spread by popular books. Henceforth, it was an accepted belief that the end of the world would be announced by three great phenomena of the world of the spirit and fifteen cosmic signs.[2]

We must read the account of the last days of the world in *L'Art de bien vivre et bien mourir*, published by Vérard; nothing could be more somber. The Middle Ages, just then drawing to a close, gazed disconsolately upon the universe. There was no faith in the earthly destiny of humanity, and no idea of what was later to be called "progress"; far from becoming better, men would become worse, and this would be the sign that time was up.

First of all, and this is the initial sign, charity will turn cold in men's hearts. The author compares humanity to an aging man whose vital heat diminishes; the human soul will pass through a kind of glacial period; the flame of love that had for so long warmed men's hearts will burn low, and then be extinguished.

Consequently, and this is the second sign, selfishness will reign supreme in the world: dedication, self-sacrifice, such words will no longer have meaning; self-interest, that is, immediate self-interest, will become the universal law.

Finally, and this is the third sign, out of selfishness man will break all his ancient ties with the past. There will be no more nations, no more families; the son "will rise up against his father"; the husband "will abstain from his own wife who sleeps in his arms."

Is the aged author dreaming? Or had he glimpsed some dreadful truth? No one knows, but his naïve prose is terrifying.

When harmony is destroyed in the soul of man, it will also be destroyed in the entire universe, for the same law that rules the human soul rules the earth and the stars. Fifteen cosmic catastrophes will announce the final day. These are, in all their naïveté, as follows: (1) in certain places the sea will rise above the mountains; (2) it will then subside and sink into the depths of the earth; (3) sea monsters will appear and make frightening sounds; (4) the sea and all the rivers will burn; (5) trees and plants will produce a vermilion sweat, like blood; (6) all the buildings on earth will crumble; (7) stones will collide and break against each other; (8) the earth will shake and open; (9) mountains will be leveled to the ground; (10) the living who have hidden themselves in underground shelters will rush out in terror; (11) the earth will vomit up the dead and their bones will come out of their tombs; (12) the stars will fall from the heavens and the beasts will have nothing to eat; (13) all that is living on earth will die; (14) fire will burn sky and earth; (15) the dead will rise to be judged by God.

In the fifteenth century there was more widespread belief in this somber picture than there is today in the speculations of scientists on the end of our planet. The fifteen signs were presented on the authority

of the great St. Jerome, so no questions were raised. The Venerable Bede, who first enumerated the fifteen signs, traced them back to this Church Father: "St. Jerome found them in the Annals of the Hebrews," he said.[3] Today, there is nothing like this to be found in the works of Jerome. Unless Bede was mistaken, then he must have seen a book that has since disappeared.

The long forgotten passage from the Venerable Bede was brought to light by Peter Comestor in his famous *Historia scholastica:*[4] he reproduced it with some slight changes.[5] In his *Speculum historiale*, Vincent of Beauvais copied the page from Comestor.[6] Thus, the tradition was established that ended in *L'Art de bien vivre et de bien mourir;*[7] and on the authority of Bede, these fifteen signs were always placed under the patronage of St. Jerome.

Although such a theme seems ill suited to art, artists took it up at the beginning of the fifteenth century. In the inventory of the Dukes of Burgundy, under the date 1413, we find listed "a tapestry of the fifteen signs."[8] How did the designer of the cartoon manage to express all these great cosmic catastrophes? No one knows, but it is sure to have been a work of the utmost naïveté.

The woodcuts in Vérard's *Art de bien vivre et de bien mourir*, although they date from the late fifteenth century, give some idea of the tapestry. Their ingenuousness makes one smile; once or twice, however, the extreme simplicity of the drawing almost attains grandeur.

The effects of the first sign are represented in a surprisingly bizarre way (fig. 246). To convey the idea of the sea rising above the mountains,

246. First sign of the End of the World. *L'Art de bien vivre et de bien mourir.* Vérard, 1492. Paris, Bibliothèque de l'Arsenal.

the artist has drawn a sort of fountain of petrified water: the sea is congealed against the sky in the form of a basaltlike rock; fish arranged in tiers on this reef indicate that the rock is supposed to be made of water.

The third sign is the appearance of sea monsters (fig. 247). Now what sort of monsters are they? A mermaid and a triton, who express the mystery of unknown oceans where a man might encounter anything.

The fourth sign is the burning of seas and rivers, and the flames look like the simple foliage of the iris or gladiola.

In the ninth sign, the mountains are leveled, and in fact, nothing is left above the ground except a few mounds of dirt like those that children make.

For the twelfth sign, famished animals, dying on a devastated earth without grass or water, raise their heads to watch the stars fall from the skies.

The fourteenth sign is a fine hieroglyph. Sky and earth are being consumed. All we see is two lines of fire, one above and the other below: that is the entire universe.

We would not discuss these popular images had they not been quite frequently imitated. Reduced and simplified versions appear in the margins of Books of Hours;[9] others, painted on glass, are in the north rose window of the cathedral of Angers. They probably figured in other works unknown to us, for the vogue of the fifteen signs was widespread in the fifteenth century. And France was not alone in taking up this new theme; the fifteen signs were known all over Germany through

247. Third sign of the End of the World. *L'Art de bien vivre et de bien mourir.* Vérard, 1492. Paris, Bibliothèque de l'Arsenal.

the woodcuts of the famous book entitled *Der Entkrist*.[10] These prints, earlier than the French, are very mediocre; French artists seem to have known them but owe almost nothing to them.[11]

II

The Apocalypse. Dürer's work and its influence in Germany and France. The windows of Vincennes.

The popularity of the fifteen signs did not mean, however, that the Apocalypse had been forgotten, for St. John's images of the last days of the world had grandeur of another kind. This astonishing poetry had inspired artists throughout the centuries, and continued to do so.[12]

The late fifteenth century and the early sixteenth mark one of the moments in history when the story of the Apocalypse took greatest hold of men's imaginations.[13] Are we to believe that the hatred smouldering against Rome at the time of the Reformation had at first adopted this symbolic mask? Can it be true that the artists, precursors or champions of Luther, had wished to cast anathema upon the whore of Babylon? This hypothesis has been advanced, and it is not entirely unlikely.[14]

But I believe there is a simpler explanation for the popularity of the vision of the Apocalypse among Catholics as well as Protestants.

In 1498, Dürer published an illustrated Apocalypse that was considered definitive. Dürer's woodcuts seemed to have the same eternal character as the words of John; all that could be done henceforth was to imitate them. And in fact, as we shall demonstrate, *all* the Apocalypses of the sixteenth century derive, either directly or through intermediaries, from Dürer's Apocalypse. He had taken over the Apocalypse as Dante did Hell.

Like Dante, Dürer had his precursors, and he by no means invented everything. It would be easy to prove that when he designed the wood blocks for the Apocalypse, he had earlier drawings before him: these were the woodcuts in the Cologne Bible (1480), or rather the copies made by Koberger for the Nuremberg Bible (1483).[15] Dürer's famous knights, and his angel whose legs are two pillars, were already to be found in these Bibles. But who knows that today? And who was aware of it after 1498?

This young man of twenty-seven was a visionary of an unknown kind. Never did dreams take more solid forms, never did nightmares weigh more heavily. The angels seem clothed in robes of brass; enormous clouds of smoke solidify in the sky; jets of molten metal rise from the towns: it is as if the universe has been melted down in a furnace and then cooled again. This is a world of ringing metal in which horses' hooves and the clash of swords reverberate.

We can imagine the stupefaction of those who saw the work when it was new. What a contrast with the childish images and the wordy text of the woodcut *Apocalypses* then known by the Germans! Dürer

needed only fourteen pictures to summarize all the threats and all the promises of the book.

In order to make clear what is to follow, I shall review the subjects of the fourteen woodcuts.

The Son of Man appears to John among seven golden candlesticks. He holds seven stars in his right hand, from his mouth comes a sharp two-edged sword, and his eyes spurt flames of fire. These two flashes of light give the mysterious being a fiery head of hair and his countenance superhuman grandeur.[16]

Far above the earth soars the throne of God. Around it, the seven lamps and the four-and-twenty elders form a crown of poetry and light. The Lamb approaches the throne and takes the book (fig. 248).[17]

The Lamb has broken the first four seals. Four horsemen rush forward, as if hurled by a catapult: the first carries a bow, the second a sword, the third a pair of scales which he whirls in the air like a sling for casting stones, the fourth threatens with a trident, and the mouth of hell opens beneath the horses' feet (fig. 249).[18]

The martyrs lying below the altar cry out for vengeance; an angel tells them that the time is near and gives them white robes. Meanwhile, the stars fall from the sky in a rain of fire; in terror, men hide themselves

248. Throne of God and the Lamb. From the woodcut series of the Apocalypse. Albrecht Dürer, Nuremberg, 1498. London, British Museum, Department of Prints and Drawings.

249. The Riders on the Four Horses. From the woodcut series of the Apocalypse. Albrecht Dürer, Nuremberg, 1498. London, British Museum, Department of Prints and Drawings.

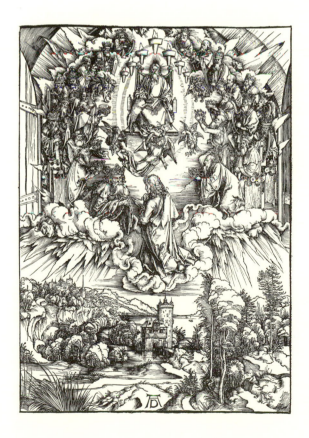

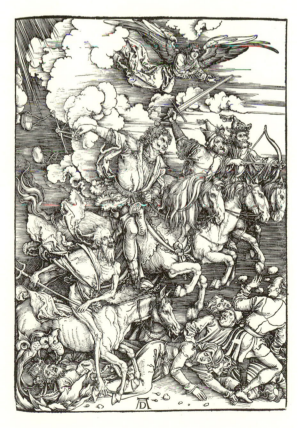

in the dens and rocks of mountains. A mother, who has the face of a tragic sibyl, gathers her child to her breast (fig. 250).[19]

Four terrible angels, leaning on the two-handed sword of the Italian wars, listen to a voice from heaven telling them to pause in their destruction of the world until a celestial messenger has signed the foreheads of the servants of God with the blood of the chalice. The four soldiers of God obey, and one threatens the wind that dares to blow and show its face among the clouds (fig. 251).[20]

The heavens open to reveal the saved who appear in a palm grove. One of the elders leans down from on high toward St. John and explains that these heroes are the martyrs who have washed their robes and made them white in the blood of the Lamb: "They shall no more hunger nor thirst: and God shall wipe away all tears from their eyes."[21]

After "a half-hour silence," the divine wrath bursts forth again. Standing behind the altar, God distributes seven trumpets to seven angels (fig. 252). An angel gives the sign by casting fire from the golden censer onto the earth. The first five trumpets sound, and frightful cataclysms convulse the world: towns burn like torches; two enormous hands issue from the clouds and cast a fire-vomiting mountain into the

250. White robes given to martyrs. Stars falling from heaven. From the woodcut series of the Apocalypse. Albrecht Dürer, Nuremberg, 1498. London, British Museum, Department of Prints and Drawings.

251. Angels restraining the Four Winds. The Elect sealed on their foreheads. From the woodcut series of the Apocalypse. Albrecht Dürer, Nuremberg, 1498. London, British Museum, Department of Prints and Drawings.

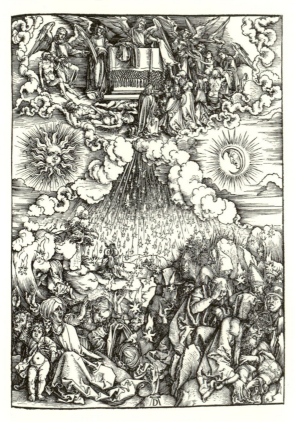

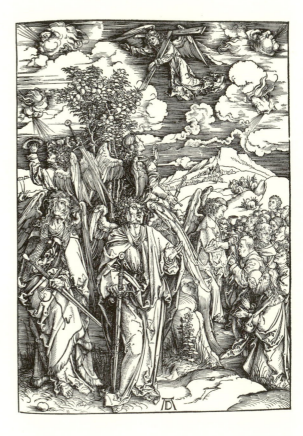

sea; ships sink, a great star falls into the bottomless pit and a cloud of locusts settles on the earth; an ominous face appears in the sun; an eagle flies across the heavens, crying with loud voice: "Woe! woe!"[22]

The sixth trumpet sounds, and the four waiting armed angels receive the order to massacre a third of mankind. They strike out, their hair flying in the wind, their great swords slashing. Meanwhile, in the clouds, phantom knights, dressed in the armor of Maximilian's time, ride lions vomiting flames.[23]

An angel descends from heaven, clad in a cloud. Only the face is shown, radiating light; the legs are two pillars, one resting upon the earth, the other upon the sea. With the left hand, the miraculous being presents a book to St. John, who devours it, and with the right hand calls God to witness that the mystery is accomplished.[24]

A woman appears, wearing a crown of twelve stars; she floats through the air borne by the wings of an eagle. She has just given birth to a son, and a monstrous dragon leaps forward to devour the child, but the angels have already taken him and carry him to God; the enraged beast raises an astonishing arabesque of seven necks and seven heads, and with its tail destroys a third of the stars.[25]

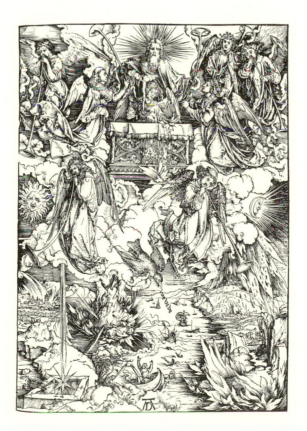

252. The Seven Angels with trumpets. The first four trumpets sound. From the woodcut series of the Apocalypse. Albrecht Dürer, Nuremberg, 1498. London, British Museum, Department of Prints and Drawings.

Angels struggle against the dragon: a large and stern St. Michael crushes the monster underfoot and drives a lance into its throat, without even lowering his glance.[26]

Two new beasts emerge: one, rising from the sea, has seven heads; the other, rising from the earth, has two horns and an equivocal face combining the features of a bear and a wolf. Men bow down in adoration, but the vengeance of God is already being prepared: the Son of Man, armed with the harvester's sickle, appears in the heavens between two angels.[27]

The Babylonian whore is mounted on the beast's back. She holds a beautiful golden cup of German workmanship, resembling a cluster of grapes; monks, burghers, and soldiers in all their finery, admire her. But the hour of punishment has already come: a towering flame rises to the clouds from a town; an angel casts a huge millstone into the sea, saying: "Thus shall Babylon be thrown down," and a great multitude led by a victorious horseman appears in the sky.[28]

The demon is vanquished; an angel bearing an enormous key shuts him up in the bottomless pit. The end of time has come, and from the summit of a mountain John contemplates the New Jerusalem: it is a kind of Nuremberg with its beautiful towers, situated near the forest, the mountains, and the sea; the sky is cloudless, birds fly in the pure air, and an angel awaits the travelers at the gates of the city.[29]

Thus, the Apocalyptic visions that readers had found so boundless, intractable to form, and impossible to circumscribe, were suddenly given body; and the tyranny of Dürer's work was such that sixteenth-century artists were unable to see anything in the subject other than what he had seen.[30]

In Germany, the most remarkable copy of Dürer's Apocalypse was made for the famous illustrated Wittenberg Bible, which appeared in September 1522. The copy would be almost literal if the anonymous artist had not divided several of the illustrations. More than once, Dürer united several successive events on the same page; the copyist separated them. He made a woodcut of the episode of the white robes distributed to the martyrs, and another of the stars falling from the sky.[31] He did not want to show the defeat of the devil and the New Jerusalem on the same page. In this way, the number of illustrations was increased without the artists having to invent anything new. However, in fact, this meticulous artist decided that Dürer's work was incomplete; according to him, the scene of the divine harvest was not represented in sufficient detail. He borrowed the figure of the Son of Man appearing in the heavens with sickle in hand from Dürer, but placed angels harvesting the wheat and gathering the grapes below. In this, he was interpreting the text to the letter.[32]

When Dürer illustrated the Apocalypse, he omitted one extremely

obscure passage, perhaps because it had not aroused his imagination. It had to do with the two witnesses who will come at the end of time to give testimony to God; when they have spoken and performed miracles, the beast will ascend out of the bottomless pit and kill them; but at the end of three days, they will soar heavenward in a cloud.[33] This passage seems to have had great symbolic meaning for Luther. The artist who illustrated his Bible could not leave it out, and consequently, he represented God's two witnesses and the crowned beast; but nothing could be worse than the print he made without a model, nor provide a better measure of Dürer's genius.[34]

The Wittenberg Bible soon became famous in Germany; it gave definitive form to illustrations of the Apocalypse. The slight changes made in Dürer's work were henceforth adopted, and the two or three additional prints were also adopted.

Several months after the appearance of the Wittenberg Bible, three illustrated editions of the Apocalypse appeared in Germany. All three were published in 1523 and were the work of Burgkmair, Schaufelein, and Holbein, respectively.[35] Study of the three series quickly shows them to have been modeled on the Wittenberg Bible; the publishers clearly wanted to compete with that already famous book. Again we find in the three print series the details already pointed out: the division of certain subjects, and illustrations of two or three passages omitted by Dürer. It goes without saying that all three artists knew Dürer's woodcuts; Burgkmair and Schaufelein were overwhelmed by them. They were unable to shake off the dead weight of Dürer's genius; they rearranged some figures, reversed some of the details or omitted part of the composition—all useless effort, for the copying is immediately obvious.

Holbein's illustrations are unworthy of him; he clearly did not like Dürer's woodcuts. But he kept to the proposed model, the Bible of Wittenberg, and copied it apathetically. Of all men, Holbein was the least suited to illustrate the Apocalypse: he was a great artist, to be sure, but of another mould than Dürer's. He had to feel the good earth beneath his feet, unable to soar among the stars and clouds. The Son of Man who shone like a precious stone, and the angel who wore a rainbow for a crown, were not his kind of models; they do not hold up under close scrutiny, as do his portraits of Erasmus and Archbishop Fisher. Holbein had his limitations, and we touch upon them here.

These illustrated editions of the Apocalypse were soon followed by others: Hans Sebald Beham himself made two. As we might expect, this pupil of Dürer imitated his master very closely, but, strangely enough, he also adopted the corrections and additions of the Wittenberg Bible. Thus, the illustrations for the Apocalypse had become established, and there was a canon from which no one dared stray. All the Bibles

published in the German-speaking countries conformed to it: it will be sufficient to cite the Bible of Frankfurt am Main published in 1566.[36] This again was an imitation of Dürer's work, with the additions of the Wittenberg Bible, but it was weakened and made insipid by artists who did not know the originals, and were copying copies.

Dürer's woodcuts were known quite early in France. Hardouyn copied them in 1507 in the margins of his Hours for the use of Rome (fig. 253).[37] But in France as in Germany, artists preferred to copy the complete series of the Wittenberg Bible: such was the illustrated Apocalypse at the end of the French Bible of Martin L'Empereur, printed in Antwerp in 1530. Soon, Lyon, then a European city, open to ideas from Germany as well as Italy, made the German Apocalypse known throughout France through its beautiful illustrated books. The Bible published by Sébastien Gryphe, in 1541, contains one illustration of the Apocalypse which conforms exactly to the canon of the Wittenberg Bible. Another appeared in the *Figures du Nouveau Testament*, the work

253. White robes given to martyrs. Hours for use of Rome. G. Anabat for Germain Hardouyn, 1507. Paris, Bibliothèque Nationale, Vélins 1562, fol. f.iiii.

of an elegant artist, Bernard Salomon (usually called Le Petit Bernard), which Jean de Tournes published in 1553 (figs. 260-262).[38]

Thus, Dürer's imagination reigned over France as well as Germany.

But there is something even stranger. There are several sixteenth-century stained glass windows devoted to the Apocalypse still in existence in France; on close study I was surprised to find that they are all alike. That is, they conform to the German formula. They were made by glass painters who had either Dürer's prints in front of them, or an illustrated Bible similar to the Wittenberg Bible. I can cite the windows of St.-Martin-des-Vignes, at Troyes; those of Granville and of Chavanges (Aube) (fig. 254), and of La Ferté-Milon (Aisne) (fig. 255). The Chavanges windows are perhaps the most beautiful because they are closest to Dürer's originals; there had been no intermediaries between the glass painter and the master:[39] the three horsemen, the two beasts, the Babylonian whore adored by men are reproduced with greater fidelity than was usual in copies. Here we see how well-suited Dürer's

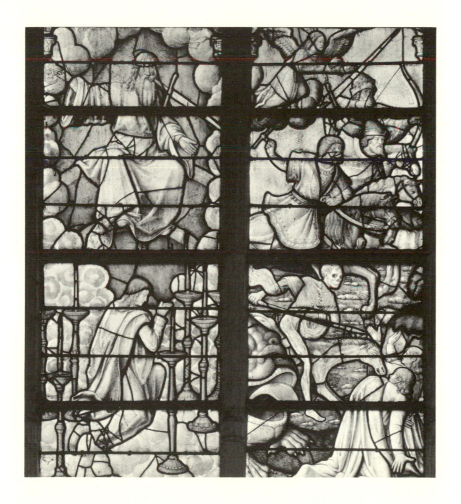

254. St. John beholding the Seven Golden Candlesticks. The Riders on the Four Horses. Chavanges (Aube), Church of St.-George. Stained glass window (detail).

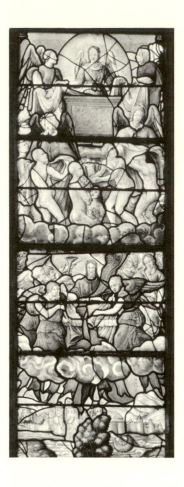

255. White robes given to martyrs. God presenting trumpets. La Ferté-Milon (Aisne), Church of St.-Nicolas. Stained glass panel. XVI c. Restored.

prints were to a large space, for their bold silhouettes outlined in the lead of the window seem designed for it, and we understand why the glass painter often went to his woodcuts for models.⁴⁰

The windows of St.-Martin-des-Vignes and of Granville also betray a direct, but somewhat less scrupulous, imitation of Dürer. The window of La Ferté-Milon, a late sixteenth-century work, reproduces Bible illustrations derived from the Wittenberg Bible.⁴¹

But estimable as they are, what do these windows amount to alongside the magnificent ones of the chapel of Vincennes? This work is surely the most sumptuous ever devoted to the Apocalypse. However, all we have left are fragments: they have been mutilated, displaced,⁴² put back in place, and restored; but even so, the windows of Vincennes remain one of the great works of the sixteenth century (figs. 256-259). Contemplating these heroic figures, which seem to have been drawn by a pupil of Michelangelo, no one, I imagine, ever thinks of Albrecht Dürer. Nonetheless, this masterpiece also derives from him.

The unknown master who drew the cartoons for the windows of Vincennes was inspired by an illustrated Bible derived from the Wittenberg Bible. The clear proof is that he inserted in the series of visions

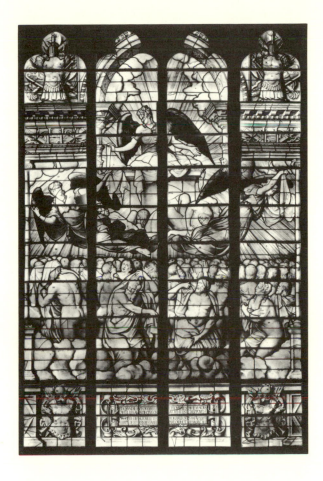

256. White robes given to martyrs. Vincennes, Château, Chapel. Stained glass window, choir.

two subjects omitted by Dürer and whose origins we have already indicated: the two witnesses killed by the beast, and the angels who tread the grapes and harvest the wheat (fig. 259).[43] There is still another proof: in the Vincennes windows, the four angels sent to massacre mankind are accompanied by horsemen mounted on lions, but instead of passing through clouds as in Dürer's work, these horsemen ride on the earth and fight beside the angels.[44] Now this new arrangement, found for the first time in the Wittenberg Bible, was used in all subsequent illustrated Bibles.

Had the Master of Vincennes, then, known only a copy of Dürer's work? I do not believe so. Two or three details seem to me to prove that he had seen the original woodcuts. The window shows two great hands issuing from the clouds and casting a mountain into the sea when the second trumpet sounds (fig. 258): this was Dürer's invention, as we have seen.[45] But the curious thing here is that this strange detail was never imitated; the illustrated Bibles we know never present it. Therefore, it must be that the designer of the window borrowed it from Dürer's print. Other details of the same kind can be pointed out. When the fourth trumpet sounds, an eagle flies out, crying "Woe! woe!"

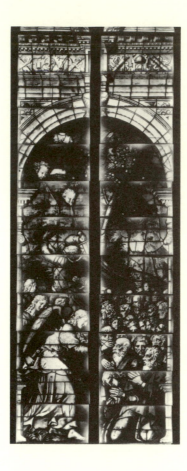

257. Elect sealed on their foreheads. Vincennes, Château, Chapel. Stained glass window, choir.

258. The Cataclysms. Vincennes, Château, Chapel. Stained glass window, choir.

Strangely enough, the Wittenberg Bible and those deriving from it, show, not an eagle, but an angel.[46] The Master of Vincennes went back to Dürer's interpretation: like Dürer, he drew an eagle, and again like him, had these two letters, "Ve, ve," issue from its beak, seeming to be carried on waves of sound. There are other details in the Vincennes windows that testify to a direct connection between the Dürer prints and the windows. In the window of the just, the angel who commands the wind to be still and threatens it by raising sword and small shield toward heaven (fig. 257), resembles the angel of the engraving too closely (fig. 251) not to be a direct copy; the same can be said for the magnificent flowerlike flames that burst the trunks of trees, shooting forth like great blossoms of fire.

Thus, Dürer's inspiration is everywhere present in the Vincennes windows. How can it be that on seeing them no one thinks of Dürer? There is more than one reason.

First of all, the most beautiful of Dürer's pages, those on which he left his mark forever, are missing at Vincennes. There were no scenes showing John prostrated before the Son of Man, the Four Horsemen, or the great harlot mounted on the beast. Perhaps these pages had been

259. The Lord holding the sickle.
Vincennes, Château, Chapel. Stained glass
window, choir.

lost, or perhaps the artist had omitted them because he thought them
too difficult to adapt to the laws of his aesthetic.

For the Master of Vincennes' conception of beauty was very different
from young Dürer's. The explosion of creative imagination in Dürer's
art obeys no laws but its own. The Master of Vincennes believed that
imagination could engender only chaos if it did not obey the superior
laws of symmetry, rhythm, and number. These were the three new
divinities that Italy had made known to the world; this is "divine
proportion." To be transfigured into beauty, inner storms must submit
to law. Here the eternal conflict between Latin discipline and northern
lyricism. As early as 1300, Italy had shown through Dante that perfect
beauty resides in the union of strength and discipline; from that time
on, Italian painters, sculptors, and architects taught the same lesson.
The Master of Vincennes had been imbued with these great truths: in
his work, tumult, passion, violence—all are resolved into a beautiful
symmetry. The angels who distributed robes to the martyrs and are as
light as the draperies they hold, fly out harmoniously from the two
sides of the altar (fig. 256); below, four corresponding nude martyrs
give unity to the multitude. Around the bottomless pit, falling men

make symmetrical groups, and the angel with spread wings, soars in the center of the sky. Pure Ionic architecture frames the tragic visions and seems to communicate to them something of its equilibrium and serenity. These scenes, at once violent and noble, make us think of Virgil's art that clothed slaughter, horror, and death with divine beauty.

Such a man might very well have borrowed his subjects from Dürer, but he could not be like him. He translated Dürer's Teutonic language into beautiful Renaissance Italian; the language of Michelangelo came naturally to him. All that is pinched, hard, and jarring in the original takes on heroic breadth. His old men with torsos of athletes who receive the white robes, and his magnificent angels aloft on a great current of air, belong to the same race as the formidable heroes of the Sistine Chapel.

Our instinctive respect for the windows of Vincennes can now be explained. We sensed there was somehow greatness here—a greatness which, without our knowing it, came partly from the inspiration of Dürer and partly from the genius of Michelangelo.

I asked myself whether anyone in France, before the Master of Vincennes, had tried in a similar way to translate Dürer's Apocalypse into the language of the Italian Renaissance. The Vincennes windows seem to have been finished about 1558.[47] Now in 1553, a series of prints appeared in Lyon that have extraordinary resemblances to the Vincennes windows. I refer to the illustrated Apocalypse of "Le Petit Bernard."[48] As we have said, the work of Le Petit Bernard derives from the Wittenberg Bible; however, it does contain one innovation, of which I have found no earlier example. The catastrophes accompanying the sound of the first five trumpets furnished the artist with subjects for five separate prints: he presented in minute detail what Dürer summarized in one illustration, and the Wittenberg Bible in two.[49] Now this is precisely what the Master of Vincennes did: five windows recount the scourges that come down upon the world when the first five angels, one after the other, sound their trumpets. This is a striking resemblance, but there are others. Le Petit Bernard, he too, had submitted the German originals to the Italian law of symmetry and rhythm, with the result that certain of his woodcuts are identical with the Vincennes windows. The episodes of wine making and the reaping of wheat (figs. 262 and 259), and the distribution of robes to the martyrs (figs. 261 and 256), would be exactly alike if the glass painter, having a large space to fill, had not added one or two figures.

Are we to believe that the prints of Le Petit Bernard served as models for the Master of Vincennes? That is what I concluded in the first excitement of discovery, but too hastily. It must be remembered that if the Vincennes windows were completed about 1558, they were perhaps begun more than ten years earlier. Thus, it is possible that the cartoons

260. Lord enthroned with Lamb.
Engraving by Bernard Salomon in printed
Bible. Lyon, Jean de Tournes, 1554, p.
1134. Cambridge (MA), Houghton
Library, Department of Printing and
Graphic Arts.

261. White robes given to martyrs.
Engraving by Bernard Salomon in printed
Bible. Lyon, Jean de Tournes, 1556, fol.
E8r. Cambridge (MA), Houghton Library,
Department of Printing and Graphic Arts.

262. The Lord holding the sickle.
Engraving by Bernard Salomon in printed
Bible. Lyon, Jean de Tournes, 1554, p.
1144. Cambridge (MA), Houghton
Library, Department of Printing and
Graphic Arts.

for the windows date from a much earlier period than the prints; it is even possible that Le Petit Bernard was inspired by the Vincennes cartoons.

For more than a century, it has been said repeatedly that the Vincennes windows are the work of Jean Cousin. Unfortunately, no evidence has appeared to confirm this old tradition. On the other hand, it has been maintained, on the basis of fairly vague evidence, that Le Petit Bernard was a pupil of Jean Cousin.[50] Could these two legends, by any chance, be true?

In any case, it cannot be denied that the work of Le Petit Bernard is closely related to the Vincennes windows. At the moment, that is all that can be said.

The Vincennes windows merit this long discussion, because despite restoration,[51] they remain works of great beauty. We are stirred by the russet smoke clouds obscuring the horizon, by the great angels whose dark blue wings, striated with red, resemble a stormy sky lit by lightning, by the cries, the gestures, the tumult, and even the resounding silence. They fill the sanctuary with ominous portent, and we wonder what mysterious thought impelled our kings to decorate their chapel with scenes of such catastrophe and terror.

After this superior work, there is little point in citing other imitations of Dürer. Suffice it to say that until the end of the sixteenth century, popular engravings perpetuated in France the formulas of the German master.[52]

Even the seemingly less submissive arts conformed to the general rule: sculptors also copied Dürer's Apocalypse. On the tomb of Jean de Langeac, in the cathedral of Limoges, there is a relief representing the four horsemen armed with bow, sword, scales, and trident.[53] We have no trouble in recognizing the original. But the Limoges sculptor was no servile copyist; his work shows greater knowledge and passion than even Dürer's. It may have been he, indeed, who brought Dürer's idea to perfection.

III

The Last Judgment. The influence of the Mystery plays.

The great catastrophes of the Apocalypse bring us to the end of the world. God destroys with fire the universe he created: then suddenly, in the prodigious silence, the trumpet of the Last Judgment resounds.

The detailed study we have already made of the scenes of the Last Judgment on our cathedrals will permit us here to be brief. The theological ideas responsible for the arrangement of the figures in the drama on the tympanums of thirteenth-century churches were still operative. Thus, there continued to be representations of Jesus showing his wounds to mankind, of angels carrying the instruments of the Passion, of the

apostles seated for the judgment, and of the Virgin and John kneeling as intercessors. On superficial examination, nothing seems to have changed.

Nevertheless, several small details overlooked at first warn us that art had not stood still. It was in the fifteenth century that innovations appeared that I believe can be explained by the influence of *tableaux-vivants* and Mystery plays.[54]

Let me first point out that the Virgin and John were shown kneeling at either side of the Judge less often than in the past (when it was the rule); now they were fairly frequently shown seated in majestic chairs of carved wood, similar to baronial thrones (fig. 263).[55] Now if we read the Prologue to the only Mystery of the Last Judgment preserved in France,[56] we learn that "a nicely decorated chair must be placed on the stage to seat Our Lady at the right side of her son." It is clear that the nonprofessional actors playing the roles of the Virgin and John could not remain on their knees during the three or four hours' duration of the play. The painters imitated what they saw, without thinking that they were depriving the Virgin and John of their most moving function. Of necessity, the Virgin and John had to kneel: their role was to hope against all hope, and, in spite of the formidable machinery of justice, to believe that love can be stronger than the law.

263. Last Judgment. Chinon (Indre-et-Loire), Church of St.-Mexme. Fresco, vault.

Other details testify even more clearly to the influence of the theater. We know that in thirteenth-century Last Judgment scenes, the dead raised the lids of their coffins and stood upright in their sarcophagi. There is nothing like this in the fifteenth century: the dead never rise up out of stone tombs, but from a pit dug in the earth. Many times, the miniatures of Books of Hours and the woodcuts of incunabula represent the Resurrection in this way. Why had tradition been forgotten? The reason is very simple: in the theater, when the trumpet of the Last Judgment sounded, the dead rose waist-high out of rectangular holes cut in the stage floor. And this is what the artists copied. A study of an engraving in the Cabinet des Estampes (fig. 264)[57] will dispel any doubt about this; there in the clearest possible way we see that the pits are simple trapdoors opening in the floor of the stage, through which the dead, concealed in the cellar beneath, appear at the proper moment.

The same engraving shows how paradise was usually staged. In the thirteenth century, it was a simple arch which was presumed to open to heaven; thus, it was a pure symbol, almost a hieroglyph.[58] In the fifteenth century, the setting required the construction of a wooden house, preceded by a stairway, on the stage. The engraving shows this simple building, no doubt a copy of the stage set. If we add a few steps to the stairs and make the building a bit more majestic, we have the Gateway to Heaven such as Memling represented it in his Last Judgment.[59]

264. Last Judgment. Engraving. Paris, Bibliothèque Nationale, Cabinet des Estampes.

Careful study of fifteenth-century Last Judgments reveals other details that betray the influence of the Mystery plays.

The beautiful tapestry of the Last Judgment made during the reign of Louis XII, acquired several years ago by the Louvre, has certain features that at first seem hard to explain (fig. 265).[60] Two crowned women stand before the Judge, one carrying a lily and the other a sword; the woman carrying the sword threatens a group of female sinners, some of whom are magnificently dressed. What is the meaning of these figures? We have only to read the Provençal *Mystery of the Last Judgment*.

The crowned women are Justice and Mercy, two abstractions dear to medieval dramatists. As we have seen, they appeared at the moment of the Incarnation; and they appear again at the final hour of judgment to personify the division in the soul of the Judge. In the Provençal Mystery play, one implores his pity and the other arouses his anger against the sinners. This is what the artist wished to convey by giving one a lily and the other the sword ordinarily placed near the mouth of the Judge.

The women threatened by the sword of Justice are not ordinary sinners. Without any doubt, they are supposed to be seen as the Seven Capital Sins. For in the Provençal Mystery play, Pride, Avarice, Lust, Gluttony, Wrath, Envy, and Sloth are personified by women who, one after the other, are thrown into hell.

265. Last Judgment with Mercy at head of Elect and Justice banishing capital sinners to hell. Paris, Louvre. Tapestry (detail).

The influence of the theater is evident here.[61] It is also evident in the famous Last Judgment attributed to Van Eyck, now in the Metropolitan Museum.[62] This Last Judgment, which in other respects follows the formula adopted by fifteenth-century artists, introduces a new and formidable figure: Death. Death appears as a skeleton who envelops all of hell in its bat-wings.

What is Death doing here? Was this an invention of the painter? Not at all. In the theater, Death appeared in the scene of the Last Judgment, as our Provençal Mystery play proves.

In the drama, Death is seated on the stage, and is called before God who judges his case. He accuses Death of failing to carry out orders. He had ordained that man should live for a hundred and twenty years, but death has never waited that long. And Death enjoys doing evil: he kills young children, and even kills them at the moment of their birth; he strikes down sinners without giving them time to repent. Instead of obeying God, he has walked the earth in the footsteps of the devil and "has filled the earth with his spite." Thus, Death merits punishment. And God adds these words: "Henceforth, you shall live in hell, where the damned will ask for you constantly without ever having you, because you will have lost your powers."[63]

This explains the presence of Death in the Last Judgment attributed to Van Eyck; Death has been cast into hell, where he will remain forevermore.

These are some of the details that reveal the influence of the Mystery plays.[64] Such innovations may seem to be of little value, and we may prefer the grandeur of the old simpler and more condensed composition whose every detail expressed a thought. No fifteenth-century Last Judgment, not excepting even the magnificent Last Judgment at Beaune, can compare with the wonderful tympanums of the thirteenth century.

IV

The punishments of the damned. *La Vision de Saint Paul* (The Vision of St. Paul). The journeys of St. Brendan, Owen, and Tungdal to the land of the dead. The influence of these books on art. *Le Calendrier des bergers* (The Shepherds' Calendar) and the mural painting at Albi. The stalls of Gaillon.

If scenes of the Resurrection and the Judgment of the Dead offer nothing that merits extended study, the same cannot be said for the scenes that follow: the Punishment of the Damned and the Rewards of the Saved. In these, there are many innovations that are of the greatest interest.

To begin with, let us look to the left of the Judge.[65] In thirteenth-century Last Judgments, the damned, bound together by a long chain, are led by devils toward the mouth of Leviathan. Usually, that is all. In that monster's mouth we sometimes glimpse a boiling pot, which sufficed to symbolize the punishments of the other life. The artist stopped us at the threshold of hell, just as the sibyl stopped Aeneas at the gates of Tartarus.

But this was not true in the late Middle Ages. Art was no longer

squeamish. Some paintings, like those in the cathedral of Albi, represent the sufferings of the damned in terrifying detail.[66] What a skilled torturer the artist was! But most astonishing is the order and method he brought to the choice of tortures. He had a system: each kind of torture corresponds to a capital sin; he could be a prosecuting attorney at the Châtelet. Are we really to believe that he invented it all? The painters of his day were rarely inventive. It has been proposed that he had read the *Divine Comedy*, but even the most superficial examination shows that there is no connection between his work and Dante's.

Happily, I have since found the key to the enigma. The Albi painter invented nothing, and in fact he was no more than a copyist conforming to a long tradition whose origins we must seek. Let no one be astonished to find us going back to the early centuries of Christianity; for complete understanding, we must go back that far.

A Christian hell was first described by a Greek writer of the second century; his book was attributed to St. Peter and bore the title, *Apocalypse de Pierre* (The Apocalypse of Peter). It was discovered in 1887 in Egypt, during the excavation of the necropolis of Akhmin;[67] this is indeed a strange book, but it need not be considered here since it was unknown in the Middle Ages.

The book read at that time was the *Vision de Saint Paul* (The Vision of St. Paul), and not the *Apocalypse de Pierre*. The *Vision de Saint Paul* also was written at an early date, and goes back at least to the fourth century. The earliest copies cited by Epiphanius and Augustine have been lost: the Greek and Syrian texts existing today are fairly late.[68] The author of this strange tale was one of the people. He invented very little, and among other works had read the *Apocalypse de Pierre*, from which he borrowed. He would seem to have gathered together the traditions that were handed down in the East. Greeks who converted to Christianity never gave up their old beliefs entirely; they could not imagine a hell very different from that described by their poets and furnished with the revolving wheel of Ixion, the river in which Tantalus stood, and the beautiful fruit which evaporated in one's hand. The churches of Asia Minor accepted ancient traditions from Persia, and believed that after death the soul must cross a narrow bridge suspended over a chasm.

These, along with other fables of unknown origin, are the principal elements of the Greek story. They passed into Latin very early;[69] they were soon translated into the modern languages—French, English, Italian, and Provençal.[70] They provided subjects for poems, one of which was illustrated in the fourteenth century with curious miniatures.[71]

It will be helpful to summarize the *Vision de Saint Paul*, which had an extended influence on literature and art.

The author, interpreting in his own fashion a biblical passage in

which St. Paul says that he was "caught up to the third heaven,"[72] imagined that he had also descended into hell, led by an angel. Thus, his story is presented as St. Paul's vision—a happy idea, for instead of a simple description, we have an account of the emotions of a terror-stricken man, who is moved by pity, and who weeps. The *Divine Comedy* is already anticipated.[73]

At the very gates of hell, St. Paul first meets trees of fire from whose branches hang the damned, tied by the feet, the hands, the tongue, or the ears.

Seven furnaces next appear to him: as they vomit flames, shrieks and sobs issue forth, for in the seven furnaces burn the souls of those who refused to repent.

Then he meets a wheel of flame to which souls are bound; it revolves a thousand times a day, and at each revolution it tortures a thousand souls.

Paul and his companion arrive at the edge of a precipice, a baleful stream flows below. A narrow bridge has been thrown across the chasm. The just pass over the bridge, weightless as angels, but the wicked plunge into the abyss. They sink to a depth that varies more or less according to the gravity of their sins; fornicators are embedded to their navels, and those who rejoice in the misfortunes of their neighbors, to their eyebrows. Monstrous fish rove around them and sometimes swallow them up.

The apostle then enters a dark and somber place. Here, men and women devour their own tongues: these are the usurers; elsewhere, young girls, dressed in black, are tormented by serpents: they are the unwed mothers who have thrown their babies to the swine. Farther on, sinners are burned by raging flames that suddenly turn to ice: they are the ones who have harmed orphans.

Paul arrives at another stream whose banks are lined with beautiful fruit-ladened trees. Is this the abode of happiness? Far from it. Plunged into this stream are the bad Christians who have broken their fast before the prescribed time: like Tantalus of antiquity, they are able neither to drink nor eat; they reach for the fruit, but the branches elude them.

Finally the most terrible place of all appears: the bottomless pit. A dense smoke issues from it, and an unbearable odor. This is the gulf into which those are hurled who refused to believe in Christ; they sink into horror and are lost; no one knows their names; even God has forgotten them.

The spectacle of so much wickedness overwhelms St. Paul. Along the way, he meets other men and women devoured by serpents, and troops of demons who torture the souls. Filled with pity, he beseeches God on behalf of the damned; he addresses so fervent a prayer to him that it cannot go unanswered; out of love for the apostle, God decides

that the damned will be given several hours of respite each week, from Saturday evening until the first hour of Sunday.

Such is this ancient picture of the world of the damned, a naïve work mingling cruelty with pity.

Once in the West, the *Vision de Saint Paul* had great influence. It inspired other stories, and we find traces of it in most of the later legends.

It was from Ireland that all the stories now came of journeys to the land of the dead, and this is not surprising.[74] The Celtic imagination lived in a world of dream, intoxicated by the unknown. In the poems of the Round Table, there is always a mysterious object to be found, a magical castle to be entered, a fairy who appears and then vanishes. It was the "quest" and the "adventure," the search for a miraculous thing that no one has ever seen, that gave value to life.

For poets who dreamed only of the unattainable, what voyage could be more beautiful than a journey to the other world? There are three such journeys in Irish literature: those of St. Brendan, of Owen, and of Tungdal.

As Easter approached, St. Brendan left his monastery, accompanied by seven monks. They embarked in a light boat made of rushes and beef hides, painted red.[75] The wind from the sea propelled them toward unknown waters. Islands soon appeared from which came perfumes borne on the breeze. The sweet atmosphere of Holy Week lay upon these islands. Each day, Brendan and his companions went ashore to celebrate the Mass: there they heard birds singing psalms, there on a column they found a chalice and paten already prepared beside the sea; elsewhere, they visited a miraculous monastery where the monks were fed by angels.

But then, the waves carried them toward a forbidding, treeless island, bare except for chalky rocks. As they approached, they heard the wheezing of bellows and the ring of hammers on anvils. This was hell. The travelers wished to land, but the devils had spied them and hurled blocks of red hot iron that sizzled as they fell into the sea, making it boil. St. Brendan and his monks departed and landed on a neighboring island which seemed to have been burned by volcanic fire. A man was sitting on the shore, silent and exhausted, with pincers on his feet. They questioned him. This stranger was the great traitor—Judas. His punishment was to burn in a furnace where he liquefied and became like molten lead. But the mercy of God descends even upon him. Each Saturday evening he again takes on his own form and rests by the shore of the sea until Sunday night.[76]

The terrified travelers fled from these dreadful places. The wind carried them to other oceans, and on a delightful island they finally discovered the earthly paradise.

St. Brendan had only a glimpse of hell. The knight Owen visited the whole of it.[77] On an island of Lake Derg (Ulster), there was a cavern leading to the abode of the dead; this was the path St. Patrick had taken in the past to descend into the other world.[78] Owen confessed himself, fasted, and undertook the journey.

He arrived first in a great dim cloister, where the light was like that of a winter's day at the hour of vespers. Demons roved in the shadows and tried to seize him, but he pronounced the name of Jesus Christ and at once became invincible. Henceforth, the demons were obliged to obey him and to lead him across their kingdom.

First, in a vast plain, he saw naked men and women riveted to the earth. Some were devoured by a great dragon, others by fiery serpents and toads, and still others were whipped by demons as an icy wind blew across them.

Farther on, he saw fiery furnaces in which sulphur burned. Above them the damned were suspended by iron chains and hooks. Some were fastened by their arms, some by the feet, others by the eyes and nostrils; several, instead of being attached to a gallows, were stretched on grills, and demons filled their eyesockets with molten lead.

In another region, a wheel of fire turned, carrying with it the souls who were hooked to its iron teeth. A great building resembling a bathhouse rose up before him; in it, men and women were plunged into tubs, but the liquid in which they bathed was molten metal.

A strong wind rose, blowing the damned into a frozen river. On the far bank, the bottomless pit opened up and towering flames belched forth: this was the most terrible place, the true hell and place of Satan. Owen then had only to cross a narrow bridge thrown over an abyss to arrive at the golden gates of paradise.

In this story we sense the untamed imagination of a Celtic bard, to be sure, but we also recognize more than one borrowing, and it would be superfluous to point out that the author had read the *Vision de Saint Paul*.

Sir Owen crossed hell like a man drunk with terror. He did not have enough presence of mind to learn anything. What crimes were being punished on the wheel, in the frozen river, and in the depths of the abyss? He did not know.

The Irish warrior Tungdal, who like Sir Owen traversed the other world, was a better observer.[79]

This warrior died, and his soul—scarcely separated from his body— was surrounded by a crowd of monstrous spirits. The poor soul was bewildered. Everything in the other life was new to it, and it wished to return to the body it had just abandoned. Happily, an angel appeared, drove away the spirits, reassured the soul, gently telling it: "You are about to travel through hell; remember what you see so that you can

tell it to mankind, for at the end of three days, you will return to earth and will again be united with your body."

The journey began under the guidance of the angel. First they came to a deep valley where murderers were punished; they were consumed and then liquified in a pot boiling on a great brazier.

Tungdal arrived at the foot of a steep mountain: on one side was a lake of fire, on the other a lake of ice; here, the souls of perjurers were submerged. From time to time the devils took a soul from the lake of fire and threw it into the lake of ice.

An abyss opened before Tungdal; a thick cloud of smoke and an odor of sulphur rose from it; a narrow bridge was thrown across. The souls of the proud were obliged to pass over it, but none could cross the gulf. They tottered, fell, and disappeared. Tungdal passed over, helped by the angel.

At the far end of a great plain, something enormous blocked the horizon. Was it a mountain? He at first thought so, but on coming closer, he discovered it to be a monster. This formidable beast was feeding on the souls of misers: each time he opened his mouth, fire came out, and the cries of the damned in his belly could be heard.

Another bridge appeared, narrow also, but more dangerous still, for it bristled with spikes; this was the path those must follow who had taken the goods of others. None could advance: all sank into a smoking quagmire full of toads, serpents, and hideous beasts.

Those who had given way to the appetites of the body—the gluttonous and the lustful—were led into a large barn, a sort of slaughterhouse where the devils dealt with them as if they were cattle: brandishing huge butcher knives, the executioners cut them open, carved and quartered them.

Tungdal fled, but another monster, lying on a frozen pond, stopped him. This was an enormous beast who, like the others, fed on souls; it gulped down monks who had been unfaithful to their vows. But the atrocious thing was that the beast vomited the souls, who then swelled and gave birth to fiery serpents that turned on them and devoured them.

Hammers rang out: this was the forge of Vulcan, who is one of the devils; where impenitent sinners were punished;[80] Vulcan threw a pile of them onto the anvil, striking them with his hammer, amalgamating them into a nameless, formless mass.

The terrible journey ended. An angel then gave Tungdal a glimpse of Purgatory, pointing out the old kings of Ireland: Donach, Cormach, and Conchobar. And from afar, he saw St. Patrick, the hero of Hibernia, shining in Paradise.

As we see, the author of the *Vision* of Tungdal knew the *Vision de Saint Paul,* and even the journey of St. Brendan; but even so, we must

concede that he had an original imagination. What an astonishing faculty for imagining the horrible! Dante does not surpass him. But Dante's work has architectural beauty. The Italian encloses pity, love, and hate in the perfect form of a circle. The poor Celtic poet's dreams are not shaped by art; he is like a child vaguely watching the landscapes created by the flames on the hearth.

And yet, these Irish dreams conquered France. It has often been asked why Dante's poem was so long unknown to us; it was because we already had our hell.

Several of our poets had translated the adventures of St. Brendan and of Owen into French verse as early as the twelfth century;[81] they were again translated in the following century. At the same time, the legend of Tungdal passed into the many languages of Europe.[82]

However, theologians did not deign to notice these popular stories, and they were not mentioned in the thirteenth century. St. Thomas merely said that the account they gave of the sufferings in hell should be construed in a symbolic sense.[83] Serious minds had no use for these already famous legends, and it is not surprising that in the totally theological art of the thirteenth century there is not one detailed representation of hell.

In the fourteenth century, the clergy were more receptive. Guillaume de Deguilleville was not a theologian, it is true, but he was a monk, and although his poem is a completely dogmatic work, his description of hell was none the less inspired by Owen's account. In his *Pèlerinage de l'âme* (Pilgrimage of the Soul), he speaks of a wheel with iron teeth on which perjurers are fastened,[84] and of a gibbet where the damned hang by their tongues above a brazier.[85]

In the fourteenth century, these legends still preserved the appearance of poetic inventions, but in the fifteenth, they were presented as truths. One of the most celebrated theologians of the time, Denis the Carthusian,[86] in his treatise on the four ends of man entitled *Quatuor novissima*, describes hell by first using Owen's story, and then by reproducing Tungdal's vision almost verbatim.[87]

It is clear that by this time the Irish legends had become a part of teaching and of sermons; one is made aware of this by the entirely new aspect given to works of art dealing with hell.

In the early fifteenth century, artists began trying their hand at representing the various punishments of hell. In the *Très Riches Heures* of the Duke of Berry, at Chantilly, there is a representation of the center of hell (fig. 266). Assuredly, there is great creative freedom in this miniature; nevertheless, there is one detail that could only have been taken from the vision of Tungdal. The monster lying on his back and feeding on souls is represented as Satan, and he is shown at the very moment when he vomits up the souls he has gulped down. Tiny figures

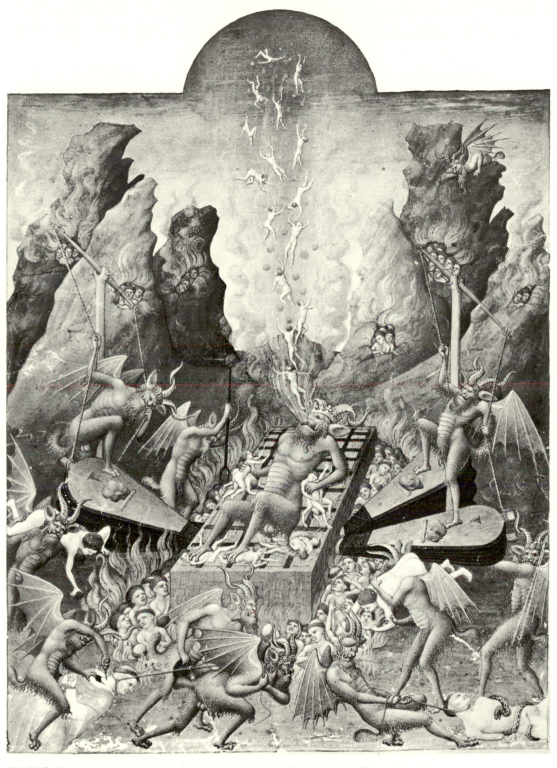

266. Hell. *Très Riches Heures* of the Duke of Berry. Chantilly, Musée Condé,
ms. lat. 1284, fol. 108r.

are spewed from his mouth among smoke and flames, and the smallness of their proportions indicates the great size of the monster. Such details are not invented twice.

Toward the middle of the fifteenth century, the punishments of hell were used in monumental art, and by carving them on the portals of cathedrals, they were given almost the dignity of dogma.

On the archivolts of the great portal at St.-Maclou, in Rouen, there are figures of demons and the damned; they are part of the Last Judgment and are naturally placed at the left of the Judge.[88] This delicate work has suffered damage and in places has become somewhat confusing, but we can still clearly make out the famous wheel on which the sinners were fastened.

The archivolts of the central portal of the cathedral of Nantes also have groups of the damned tormented by demons; and there, also, is a wheel. But not far away, a strange scene attracts attention: devils transformed into blacksmiths raise heavy hammers above an anvil composed of a heap of male and female bodies (fig. 267); the demons seem to be trying to amalgamate them. Do we not recognize here Tungdal's vision of the punishment reserved for the impenitent sinners?

267. The Damned. Nantes (Loire-Inférieure), Cathedral. Main portal, voussoirs. Wheel of Torture (detail).

Thus, toward 1470,[89] the Church adopted the ancient legends and consecrated them in art.

From that time on, there were many naïve frescoes devoted to the punishments of hell painted in country churches. And some of them still exist. Those of the church of Benouville, near Caen, are especially interesting.[90] Their author chose certain details from the Irish visions,

and others from the *Vision de Saint Paul*. The gibbet on which the damned hang, and the boiling pot into which they are plunged, were borrowed from Owen's journey, but the barren tree from which the damned hang could have come only from the *Vision de Saint Paul*. The wheel could have been taken from either account.[91] He also borrowed the bottomless pit which, with childish naïveté, he surrounded by a stone curb and surmounted with a pulley. The idea of the isle of the blessed being adjacent to hell was probably taken also from Owen's journey, for there, the joys of paradise are represented immediately after the sufferings of the damned.

The church of St.-Dézert, at Chalon-sur-Saône, was decorated with a mural painting representing hell. A comparatively early drawing of the work shows the tree of the damned and the wheel described in the *Vision de Saint Paul*: there is no doubt of this since, at various stages of the journey, the artist represented St. Paul guided by the angel.

The old churches of Poitou still preserve some fifteenth-century frescoes which have all but disappeared. At Champniers, near Civray, there was a fresco of hell in which the wheel can still be distinguished; at the chapel of Boismorand-sur-Gartempe, there is a fresco in which men and women hang from a gibbet, as in Owen's story, and farther on, the damned lying on a grill are basted with molten lead by devils.

If it is not already too late, a methodical exploration of village churches would reveal many similar works; and I am convinced that they all derive from the same source.

Wherever we look, we recognize the original Greek or Irish texts.

For example, if we study fifteenth-century woodcuts, hell is presented in a familiar way. There is a famous collection of woodcuts called the *Oraison dominicale*, in which the *Pater* is commentated and illustrated. On the page devoted to the verse *Libera nos a malo*, the punishments of the damned are represented: one is riveted to the ground by a devil, another is fastened to a wheel, others are plunged into a vat, and another approaches a bridge built across a river.[92] We already know the stories from which these details were taken.

If we look into illuminated manuscripts, we find the same pictures. In a beautiful manuscript that belonged to the Duke of Nemours,[93] hell is represented with obvious satisfaction by a talented artist. But nothing in it is new to us: the damned are fastened to the gibbet by their heads or feet, they are bathed in a vat, or melted on a grill;[94] we see the bottomless pit, and the serpents who rush upon the sinners. On all sides, the artist's imagination was bounded by the legend.

As the fifteenth century advanced, there was less and less room for imagination. In 1492, a small book appeared that combined all the earlier stories and gave them definitive form. This was *Le Traité des peines de l'Enfer* which Vérard had added to *Le Traité de bien vivre et*

de bien mourir. The work was already a number of years old, for I have found a Latin edition that goes back to 1480.[95]

The version used by Vérard was nothing more than a wordy translation of the original. The author, a schoolman accustomed to classification, was shocked by the lack of method in the *Vision de Saint Paul* and the Irish legends: sins were either not named or chosen arbitrarily. Therefore, classification was mandatory: the punishments should be related to the Seven Capital Sins, and this is what he did. On the other hand, it was hard for him to credit these grave revelations to unknown Irish knights. He decided that an ancient and widespread French tradition would be worthier of belief. According to it, Lazarus, after his resurrection, revealed the mysteries of the other world at the time Jesus dined in the house of Simon the Leper; on that day, the formidable man who had passed through death and thereafter seemed to seal his mouth, consented to speak: he described the punishments of hell to his table companions. This could be read in a sermon attributed to St. Augustine,[96] and in the *Historia scholastica* by Peter Comestor;[97] it could be seen when the *Passion* was performed in the theater.[98]

Thus, it was natural enough for our author to pass Owen and Tungdal by, and to take as his authority the story told in the name of Lazarus. In fact, it is Lazarus who speaks, and the first illustration of Vérard's book shows the repast in the house of Simon.

At the risk of being tedious, we must summarize Lazarus' description of hell, for this is the only way we can explain the fresco at Albi.

The first punishment is that of the wheel (fig. 268): it is reserved for the proud. The wheels are placed on high mountains, and Leviathan, "Captain of the Proud," presides over the torment.[99]

The envious are plunged into a river, some to the navel, others to the armpits (fig. 269). A bitter wind obliges them to sink into the water, but there they find the cold even more unbearable. It is then that Beelzebub, "Prince and Captain of Envy," seizes on them in the ice and hurls them into a lake of fire. Sometimes he throws them to a monster called Lucifer, whose mouth is always open and who either absorbs them or vomits them up.

The sin of wrath is punished in a deep dark cave resembling a butcher's shop. Aided by all his helpers, Baalberith, "Chief of the Wrathful," cuts up the damned on tables. The devils seize on the pieces, hammer them on anvils, and then throw them to other devils who beat and fuse the formless masses.

In a place of dark shadows, the slothful are eaten by serpents. Often tiny serpents pierce their hearts like arrows. Then a great winged beast named Astaroth devours them; the souls are immediately vomited up, they swell and give birth to other serpents who again tear them to pieces.

268. Tortures of Hell: wheel. *L'Art de bien vivre et de bien mourir*. Vérard, 1492. Paris, Bibliothèque de l'Arsenal, fol. eii.

269. Tortures of Hell: frozen river. *L'Art de bien vivre et de bien mourir*. Vérard, 1492. Paris, Bibliothèque de l'Arsenal, fol. eiiii.

The avaricious are plunged into vats in which water is transformed into molten metal. A devil called Mammon tortures them with an iron spike.

The gluttons sit at a table beside a river. A demon, Beelphegor, forces them to eat either their own members or disgusting beasts.

The lustful are plunged into wells, under the watchful eye of a demon called Hasmodée. Serpents and toads fasten on their sex and devour it.

As we see, our compiler invented scarcely anything. Along the way, we recognize passages taken from the *Vision de Saint Paul* or the legends of Owen and Tungdal.[100] He has only one merit; he is methodical.

The French translation published by Vérard is accompanied by woodcuts. Clear and reasonable, but without mystery, they lack the atmosphere of dream that envelops the Irish visions. It is useless to expect a revelation of the infernal regions from Vérard's artist, a witty observer who depicted so well the thin Parisian populace, the worried bourgeois, and the cantankerous hooded housewife. He carefully avoided everything that was beyond his own imagination, such as the monstrous beast gulping down souls, and the forge on which demons hammered the souls on an anvil. However, some of his woodcuts have character: the large turning wheels burdened with criminals, and the river from which despairing faces rise under an empty sky, are forceful illustrations.

Vérard's book was soon imitated. To give his *Calendrier des bergers* (The Shepherds' Calendar) greater interest, Guyot Marchant introduced a chapter devoted to the punishments of hell.[101] This is a short summary of the treatise published by Vérard; and the illustrations in Marchant's book are shameless imitations.

The *Calendrier des bergers* was a great success, read throughout France. The fresco in the cathedral of Albi gives new proof of the book's extraordinary vogue. The painting usually gives rise to talk of Dante and Italy, when in reality it was inspired by the illustrations in Marchant's book. Consequently, the Italians, who covered the cathedral of Albi with their paintings, cannot claim credit for it. The inspiration for the frescoes came from another source.

It is simple to prove that the Albi artist took, not Vérard's, but Marchant's book as model. Each section of the fresco, in fact, is accompanied by an inscription: these inscriptions reproduce the text of the *Calendrier des bergers* almost exactly.[102]

The proof is conclusive: the Albi fresco, until now thought to be the work of an unusual artist who was both methodical and ingenious, has lost all claim to originality. Nevertheless, it remains interesting; imagine all that had to be melted down and combined to make such a work possible: the Greek imagination, the dreams of the Celtic world, the classifications of the Schoolmen, the clear and unmistakable talent of Paris artists.

The Albi fresco, to which the date of cira 1450 is sometimes assigned, can only have been done in the last years of the fifteenth or the very early sixteenth century.

The Albi fresco is an imitation, but often a fairly free one of the woodcuts in the *Calendrier des bergers*;[103] the Gaillon choir stalls of inlaid wood, now at St.-Denis, are literal copies (figs. 270, 271). There we see the punishment of the wheel and the envious plunged into the river of ice; demons cut up the damned on tables, and farther on, give them disgusting things to eat. The engravings in Marchant's book are faith-

270. The Damned: wheel of torture. St.-Denis (Seine), Abbey Church, nave. Painted wood stalls from chapel of Château of Gaillon.

271. The Damned: frozen river. St.-Denis (Seine), Abbey Church, nave. Painted wood stalls from chapel of Château of Gaillon.

fully copied throughout. The artist invented only one detail: above the river where the damned are plunged, he depicted an enormous head rising above the clouds. This head with puffed-out cheeks is the cold wind that strikes the envious when they wish to emerge from the river of ice. The Gaillon panels are perhaps the work of Italian artists, but if such be the case, they invented little, content to copy the French originals.

The Gaillon choir stalls date from the early sixteenth century.

Thus, the Renaissance was dawning when the punishments of hell began to appear in art. Such a conclusion does not conform to accepted ideas. Since Stendhal, it has been endlessly repeated that the thought of hell was the great, even unique preoccupation of medieval man: the study of works of art and theological literature prove the contrary. Our thirteenth-century cathedrals give hardly a glimpse of the punishments reserved for sinners. We must go to the fifteenth century to find imaginations avidly interested in punishment; a large book like *Le Barathre*, which sets forth all that the pagans and the Christians said about hell, establishes the date.[104] Let us repeat once more: the thirteenth century spoke to the mind, the fifteenth to the feelings. In French art, hell, suffering, and death blossomed like the sad flowers of autumn.

V

Let us look now to the right of the Judge in the Last Judgment and see how our artists represented the elect. This was a difficult undertaking. It has always been easier to imagine the sufferings of hell than the delights of heaven. The idea of endless happiness can scarcely be conceived; how can it be made visible to the eye?

In the thirteenth century, the beatitudes of the soul in eternal life were personified in accordance with theological speculation. At Chartres, Liberty, Concord, Health, and Honor are truly celestial figures,[105] but this noble symbolism was not imitated.

It was not that theological speculations on paradise lacked beauty in the fifteenth century;[106] quite the contrary. There are countless beautiful ideas in the works of the theologians of the late Middle Ages, but they were not from the domain of art. For instance, read the little work entitled *La Forme et manière du grand jugement général de Dieu* (The Form and Manner of the Last Judgment of God);[107] it is a popular and vivid summary of accepted doctrine.

After judgment, it tells us, men will become like angels and contemplate the eternal essence with unutterable joy. And from whence comes this joy? From love. Through love, the blessed will be united with God, but by love also they will be united with one another; each soul will shine upon other souls; the happiness of the blessed will be made up

Paradise. The painting by Jean Bellegambe.

of the virtues of all the saints, the charity of the apostles, the courage of the martyrs, the piety of the confessors, and the chastity of virgins.

But, the aged author warns us, all this cannot be conceived of; it is an ocean of felicity; one drop upon our lips would disgust us with living; in our world, only music and light can give an inkling of this consummate bliss. To repeat the words of St. Bernard: "There will be nothing in paradise but rejoicing, joy, song, clarity, light."

Music and light: these had always been the symbols of heaven.[108] In a landscape by Claude Lorrain, Virgil groups the blessed around the lyre of Orpheus; Dante united music with fire and clothed his singing spirits in flames.

Dazzling light, song, and music. This is all that our fifteenth-century artists borrowed from the theologians.

In Fouquet's work, we find a beautiful example of the symbolic virtue of light. For the *Hours* of Etienne Chevalier he painted the Triumph of the Virgin (fig. 272). The sky opens and paradise is revealed, just as it was often represented in the Mystery plays: the Father, the Son, and the Holy Ghost are enthroned on high-backed chairs surmounted by canopies, and the Virgin is seated at their right. The angels and the blessed form great concentric circles. We sense that theatrical scaffolding lies beneath their feet, and the composition would be somewhat heavy were it not transfigured by color. The Father, the Son, the Holy Ghost, and the Virgin, all clothed in white, seem to be the source of all light, as if they sit in the center of the sun. Around them, the blessed are bathed in a golden half-light, but all are touched by rays of the divine light, and all have highlights of gold, glimmerings of the rising sun, on their foreheads and shoulders. The old master naïvely translated the thoughts of the theologians into his own language.

But more often, the painters take up another metaphor: they put musical instruments in the hands of the angels to indicate that the music of the earth is only a symbol of the harmonies of heaven. Our stained glass windows contain hundreds of images of angel musicians: we see them singing, and playing the flute or the viol, amid the flamboyant tracery of the rose windows.[109] The whole upper part of the window is often given over to their flight and their songs. In the cathedral of Bourges, the paradise filling the upper section of the Tullier window is a marvel of grace; even the poetry of light is there, for the sky filled by the music of the beautiful angels is more dazzling than the most brilliant of summer days.[110]

Sculptors could not call light to their aid; they could, it is true place harps in the hands of their angels and sometimes did. But some among them were able, by the sheer power of line, to express the ecstasy of heaven.

272. Paradise. Hours of Etienne Chevalier. Jean Fouquet. Chantilly, Musée Condé.

At St.-Maclou, in Rouen, in one of the archivolts near the Last Judgment, there are charming figures of the angels and the blessed: the angels seem to represent to God the saved, who kneel with clasped hands and uplifted faces, and strain with all their being toward their Saviour. These pretty figurines, somewhat worn by time, now resemble the rough drafts of modern masters; we seem to see their smiles appear through the wet cloth sculptors throw over their unfinished work (fig. 273).

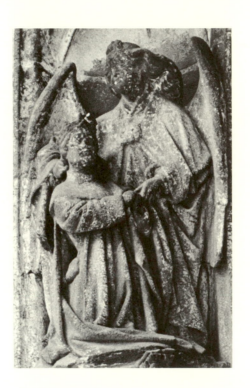

273. Angel and one of the Elect. Rouen (Seine-Maritime), Church of St.-Maclou. West façade, central portal, voussure (detail).

The groups of angels and the blessed decorating the archivolts of the cathedral of Nantes derive from the same feeling. The angels' heavy hair is wafted by the wind; the elect presented to God smile in ecstasy, arms crossed on their breasts, heads and hearts lifted toward the happiness awaiting them.

But of all the works devoted to the joys of heaven, I think that the most original is the triptych painted by the old master of Douai, Jean Bellegambe.[111] The Last Judgment fills the center; at the left of Christ is the Punishment of the Damned, and at his right (fig. 274), the Rewards of the Saved.

The right panel would be one of the purest masterpieces of Christian art had Jean Bellegambe been able to paint as well as Memling, had he used that soft color that imbues a face with spirituality and seems a luminous emanation of the soul.

What deserves praise in his painting is the beauty of the conception. Jean Bellegambe was inspired by the passage from St. Matthew[112] always quoted in describing the Last Judgment:[113] "Then shall the king say to them that shall be on his right hand: 'Come, ye blessed of my Father, possess you the kingdom prepared for you from the foundation of the world. For I was hungry, and you gave me to eat: I was thirsty, and you gave me to drink: I was a stranger, and you took me in: Naked, and you covered me; sick, and you visited me: I was in prison, and you

274. Reward of the Blessed. Last Judgment altarpiece, left wing. Jean Bellegambe. Berlin, Staatliche Museen, Gemäldegalerie.

came to me.' Then shall the just answer him, saying: 'Lord, when did we see thee hungry and feed thee; thirsty and give thee drink?' Then the king answers them: 'As long as you did it to one of these my least brethren, you did it to me.' "

Jean Bellegambe started from there, and this is what he imagined: the saved are gathered in a beautiful field, with angels pressing around them; one might say they are serving them solicitously, and in fact they do. On this day, each work of mercy is rewarded: those who clothed the poor receive rich robes; those who fed them gather miraculous fruit offered by an angel; those who gave them drink are seated around a beautiful fountain and angels fill their cups with a divine nectar; those who cared for the sick walk across the sward guided by other angels. In the background, splendid palaces rise and fade into the luminous distance; but it is not the perspectives opened onto the other world that attract us: it is the enchanted field. By a miracle of love, we are still on earth, and the earth had already become a paradise. How rich in meaning is Bellegambe's beautiful painting! With the simplicity of his time, he tells us that if men only loved one another, the earth would become almost as beautiful as heaven.

XI

How the Art of the Middle Ages
Came to an End

I

This long analysis has shown that the art of the fifteenth century, although it did not develop as coherent a system as that of the thirteenth, also had its traditions and its laws. Art's rich iconography seems never to have been more alive and productive than at the beginning of the sixteenth century. How did it happen, then, that a few years later it could dissolve and disappear, almost without leaving a trace?

The first idea that comes to mind is that the traditions of the Middle Ages were killed in France by the art of the Italian Renaissance.

It must be acknowledged, in fact, that the principle of medieval art was in direct opposition to the principle of Renaissance art. The waning Middle Ages had expressed all the humble aspects of the soul: suffering, grief, resignation, acceptance of the Divine Will. The saints, the Virgin, and Christ himself, had often been wretched and thus akin to the poor of the fifteenth century, their only radiance emanating from the soul. This is an art of profound humility; it is imbued with the true spirit of Christianity.

Renaissance art is quite different. Its hidden principle is pride; henceforth, man would be sufficient unto himself and aspire to godhead. The highest expression of art was the undraped human figure;[1] the idea of the Fall and human disgrace that had long turned artists away from the nude figure was no longer operative. To make of man a hero radiating strength and beauty, escaping the fate of the race to be elevated to the ideal, unaware of suffering, compassion, resignation, all the feelings that diminish him—this (with all its variations) was indeed the ideal of sixteenth-century Italian art.

Such art, introduced to France at the time of François I, brought confusion into our religious art. The saints, and even Christ himself, were made to resemble heroes of antiquity or deified emperors hovering above mankind.

The spirit of medieval art and the spirit of Renaissance art.

But this new concept of art changed nothing in the old iconographic schemes. The spirit was different, but the form remained the same, as can easily be demonstrated by some examples.

A charming stained glass window at La Couture de Bernay (fig. 275) represents the Nativity with all the Renaissance grace of the time of François I. In the background we see Roman triumphal arches and the ancient candelabra of the Certosa of Pavia. The figures balance each other with elegant symmetry. The shepherds who adore their God are crowned with laurel, like the shepherds of Virgil. The Virgin and Joseph have the beautiful profiles and noble lines of Raphael's heroes. This may seem new, but basically it all conforms to tradition. The Virgin kneels before the completely naked Infant on the ground; the angels surround the newborn Child, and Joseph shields his candle against the wind: no fifteenth-century artist could have been more scrupulous.

Another example is the window of Pont-Audemer (Eure), representing the Death of the Virgin; it dates from almost the same time as the window at La Couture. The composition follows Italian aesthetic laws: symmetrical groupings, skillful balance, and a noble architectural frame. Such a work would seem to have nothing in common with the past. But we have only to look more carefully to note that none of the naïve details imagined by the Middle Ages is missing: John places a taper in the hand of the Virgin, an apostle reads the prayers for the dead from his missal, and another blows on the embers of the censer.

The stained glass windows at La Couture and Pont-Audemer are not exceptions; all our sixteenth-century works were conceived in the same spirit. Thus, as the art of the Italian Renaissance took root in France, it did not destroy the old French iconography, but adapted itself to it.

If the medieval tradition died, it was killed not by the Renaissance, but by the Reformation.

The Reformation put an end to the long tradition of legend, poetry, and dream, by forcing the Catholic Church to watch over all aspects of its thought and to turn strongly in upon itself.[2]

II

The influence of the Reformation. Gradual disappearance of the Mystery plays.

One of the first consequences of the Reformation was to make Catholics suspicious of their old religious theater. For the first time, they became aware that the authors of the Mystery plays had added a thousand stories, platitudes, and vulgarities to the text of the Gospels. It must be admitted that the Protestants were not altogether wrong when they said that these detestable poets "converted the sacred words of the Bible into farce."[3] The happy age of innocence, when all was full of charm, was now past.

275. Adoration of the Shepherds. Bernay (Eure), Basilica of Notre-Dame-de-la Couture.
Stained glass window.

In 1541, the municipal magistrates of Amiens objected to "the public performance of the Word of God." Seven years later, on 17 November 1548, the Parliament of Paris, in a famous decree, expressly forbade the confraternities to represent either "the Mystery of the Passion of Our Saviour, or any other sacred Mystery." The parliamentary decree applied only to Paris; thus, the act of 1548 did not, as has often been said, put an end to the medieval religious theater.[4] The members of the confraternities, no longer allowed to present their Mystery plays in Paris, sometimes went to Rouen to perform them. In Normandy, the famous confraternity of Argentan continued to represent the Passion, as in the past.

Nevertheless, the old Christian theater was clearly doomed. In 1556, re-enactment of the Passion given in the cemetery of the Hôtel-Dieu, at Auxerre, led to grave disorders. The year 1556 marks a more decisive moment in the history of the Mystery plays than the year 1548. The Parliament of Rouen forbade the representation of the *Mystère de Job*; and at Bordeaux, the confraternity was forbidden to perform its play "concerning the Christian faith, the veneration of the saints, and the holy institutions of the Church."

The life went out of our religious theater. After 1571, the ancient confraternity of Argentan, which had instructed so many generations, fell silent. It was only in a few remote provinces that the Mysteries were still obstinately played: the Passion was still being performed at the end of the fifteenth century in the Alps at Lanslevillard, Modane, and St. Jean-de-Maurienne.

The disappearance of the Mystery plays had serious consequences for Christian art. As we have shown, the Mystery plays had contributed to the transformation of late medieval iconography, and it was through them that many traditions were preserved. If, until about 1570, in the scene of the Garden of Olives (to choose one example among a hundred), Jesus was represented wearing a purple tunic, Judas carrying a purse, and Malchus a lantern, it was because this had been the unvarying practice in the theater for more than two hundred years.

When the religious theater died out, the only remaining traditions were those perpetuated for a time in the workshops. The old artists remained faithful to what they had seen in their youth. This explains why, until the end of the sixteenth century, the traditional iconography is to be found in some stained glass windows.

The ancient formulas died with the old masters, because these practices, no longer consecrated by the theater, had no meaning for the new generations.

As a result, at the end of the sixteenth century, our artists suddenly found themselves with no traditions in dealing with Christian subjects. No doubt their pride was flattered, for Italy had taught them that great

artists owe nothing to anyone except themselves; but Christian art was the loser. The old dying traditions embraced more of poetry, tenderness, and suffering than one man, even a genius, could infuse into his work.

Thus, by killing the medieval theater, the Reformation dealt an indirect blow to the old iconography.

III

At the very time the Christian theater was dying out, the Church announced that it would keep close surveillance over works of art. In 1563, in its twenty-fifth and last session, the Council of Trent spoke in these terms of the statues and paintings that must henceforth decorate the churches:

> The Holy Council forbids any image to be exhibited in churches which represents false doctrines and might be the occasion of grave error to the uneducated; it earnestly desires that all lasciviousness be avoided and that images not be adorned with seductive charms. In order to assure respect for these decisions, the Holy Council forbids exhibiting in any place, even in churches not subject to visits by the Ordinary, any unusual image unless it has been approved by the bishop.[5]

This was another consequence of the Reformation. The Protestants had declared war on images, so they must be given no legitimate reason for scoffing at the credulity of the Catholics or their lack of moral scruple.

The decision of the Council of Trent might lead one to believe that for a long time the clergy had exercised no control over works of art: such a deduction would be quite wrong. On the contrary, close study of documents proves that the men of the Church had never ceased to furnish the artists with programs. In 1509, when the canons of Rouen decided to have the great portal of the cathedral decorated with statues, they did not leave the choice of subjects to the imagination of the artists. They asked three members of their chapter, the precentor Jean Le Tourneur, Etienne Haro, and Arthur Fillon, the future bishop of Senlis, to discuss together which figures would be most suitable. It was they who decided that the tympanum of the great portal should be decorated with a Tree of Jesse, and the archivolts with small statues of angels, prophets, and sibyls. The following year, another member of the chapter, Canon Mesenge, was given the task of supervising these "projects." It seemed to him that the most efficient way to supervise was to ask the sculptors to furnish drawings of these images, and he offered to have the drawings made at his own expense.[6]

Close study of the art of the late Middle Ages forces the somewhat

The Church in the late Middle Ages and works of art: its tolerance. Paganism. The liberties taken in popular art.

surprising conclusion that certain works which might be thought to have been imagined by the painters had been worked out in every detail by clerics. The Coronation of the Virgin of Villeneuve-lès-Avignon, a rich painting in which we see the Trinity, the saints, paradise, hell, the Mass of St. Gregory, Rome and Jerusalem, would seem to testify to the artist's knowledge of iconography; a contract signed before a notary has established that the painter Enguerrand Charonton was given no scope for his imagination. Everything had been worked out by a priest, Jean de Montagnac; the artist was not free even to choose the color of Our Lady's robe; it had to be "of white damask."[7]

Many works must have been the result of this kind of collaboration between an artist and a cleric.[8] The laymen commissioning paintings did not always trust the painter's knowledge of holy matters, and sometimes specified that he consult a priest or a learned monk. In 1471, when the wool merchants of Marseille asked Pierre Villate to paint the story of St. Catherine of Siena, their patron, they wrote into the contract the express condition that he seek the advice of Antoine Leydet, prior of the Dominican monastery.[9]

Thus, the clergy seems never to have stopped serving as guides to artists. Obviously, this clergy had none of the scruples awakened by the Reformation. The canons and bishops of the late Middle Ages were the least severe of censors; they gave proof of a tolerance and breadth of spirit for which we are grateful today. They were not at all shocked by the graceful legends and pretty fairy tales that so charmed the people. They saw nothing wrong with showing, in a stained glass window, Christ as a blacksmith working in the smithy of St. Eligius, nor were they scandalized by images of the heroes of antiquity in their churches. The beautiful rood screen, begun in 1533, that Jean de Langeac, bishop of Limoges, ordered to be carved for his cathedral, was decorated in the upper part by images of the Virtues, the Fathers of the Church, angels carrying the instruments of the Passion, and in the lower section, by six reliefs representing the labors of Hercules (fig. 276).[10] The prelate's

276. Labors of Hercules. Limoges (Haute-Vienne), Cathedral of St.-Etienne. Relief, jubé.

motto was *Marcescit in otio virtus*, and he no doubt thought that the legend of Hercules was the perfect symbol for the struggles a great soul likes to engage in with destiny.[11] The images of pagan gods carved on the façade of a church, or even within the church itself, shocked no one. When the bishop visited his diocese, he could see Mars and Venus on the portal of Pont-St.-Marie, near Troyes; or the twelve great Olympian gods in the cartouches of the vault of Beaumont-le-Roger. If he were curious enough to leaf through the Book of Hours from which the congregation read the Office of the Virgin (fig. 277), in the margins he would find Ceres crowned with heads of wheat, Bacchus, Pluto, the god Sylvanus with goat's feet, the story of the love of Pyramus and Thisbe.[12] The bishop would have thought these inoffensive gods to be no more than charming forms, beautiful arabesques worthy of embellishing the house of God, for all that is beautiful should be received gratefully. Beauty comes from heaven. All beautiful work, whether pagan or Christian, is a message from God. Had the Pope himself not opened the Vatican to the marvels of the ancient world?

Such was the spirit of the greater part of the cultivated clergy of France toward 1530, and it was the spirit of the great popes of the Renaissance.

277. Ceres and Bacchus. Calendar page for July (detail of margin). Hours for use of Rome, G. Hardouyn, 1524-7. Paris, Bibliothèque Nationale, Vélins 1528, fol. 6r.

Hospitable to the beauties of antiquity, the clergy were no less so to the caprices of the popular imagination, to its bursts of Gallic gaiety. The simple good nature of the canons, fully as much as that of the artists, is brightly reflected in the choir stalls that were carved for them and that they approved.

There is no better testimony to their tolerance than the choir stalls carved in the fifteenth and sixteenth centuries. There was no place there for things of heaven; they dealt with everyday life. One shows the water carrier on the way to the fountain, and the candlemaker in his shop;[13] on another we see a farmer returning from the fair with a lamb on his shoulders,[14] the reaper sharpening his scythe,[15] the archer practicing for the contest on St. Sebastian's Day,[16] the peasant asleep in the hay.[17]

Others show the fireside tales that frightened children: the man who talks to the bird-woman in the forest,[18] the monk who meets a monster,[19] the sorcerer-toad stirring a strange brew with a spoon.[20]

Farther on are other stories, the endless tales in which the wife is the heroine and the poor man feels sorry for himself. Dame Anieuse quarrels with her husband over who will wear the pants in the family;[21] a sculptor models the statue of a woman and Satan helps him, for man alone cannot create a woman, he needs the help of the devil (fig. 278). And the devil himself, powerful though he is, is not as strong as a woman: two women cut the devil in half with as scythe;[22] a weak woman ties a cord around the devil's neck and leads him around like a pet dog.[23]

Thus, the good natured artists amused themselves. The stalls are like the conversation of the old folk of times gone by; they are sprinkled with proverbs and maxims. A peasant girl offers a bouquet of mar-

278. Sculptor, aided by Satan, modeling statue of woman. St.-Martin-aux-Bois (Oise), Church. Relief on choir stall. XV c.

guerites to a pig (*margaritas ante porcos*);[24] the devil splashes about in a holy-water basin;[25] a half-skinned fox issues from the mouth of a drunkard:[26] in the language of old, to skin the fox meant to suffer the consequences of intemperance. We see the sow who spins,[27] the duck who plays the clarinet;[28] and to round out the picture, there were broad jokes and even some of the innocent vulgarities that made our ancestors laugh.[29]

These images were surely neither dangerous nor corrupting. At most, they might tend to retain the soul in somewhat lowly regions. Nevertheless, the clergy accepted them. After all, such was human nature; mankind was made this way. The magnificent images of the saints who had conquered corrupt nature shone all the more brilliantly in the upper parts of the choir and in the stained glass windows. As in the past, the Church welcomed all of humanity, being persuaded that a lesson could be drawn from all aspects of life.

It must not be thought that these popular figures were introduced into the church because the clergy were indifferent; they knew perfectly well what the artists were doing. In 1458, the canons of Rouen visited the workshop of the woodcarver Philippot Viart, who had just begun the choir stalls for the cathedral. They saw how the master intended to decorate the misericords. They were shown some of the little reliefs that still amuse us today—the tambourine players, the monsters, the husband beating his wife, the rustics exchanging blows—and went away well satisfied.[30]

IV

At the Council of Trent, the Church examined its own conscience. It asked itself whether it had always faithfully fulfilled its duties; and it promised to be stricter in the future. Iconoclastic Protestantism had condemned art; the Church would save it, but it wanted it to be above reproach.[31]

The decision of the Council of Trent cited above is very short; it needed commentary.

In the second half of the sixteenth century, several works appeared which deduced all the consequences of the principles set forth by the Council.

A book brought out in Italy promised to be a capital work, but unfortunately the author was unable to finish it. This was the *Discorso intorno alle imagini sacre e profane* (Discourse on the subject of sacred and profane images), by Cardinal Paleotti.[32] Paleotti's book often reveals the greatness of his mind; in opposition to the Protestants, he established the legitimacy of art with the noblest of arguments. He leaves our respectable French theologians far behind—a René Benoist, for example,

The Council of Trent puts an end to this tradition of freedom. Books inspired by the Council of Trent. The *Discorso* by Paleotti. The *De historia sanctarum imaginum et picturarum (Treatise on Holy Images)*, by Molanus. The end of medieval art.

who nevertheless has written pages full of good sense on the same subject.[33] Paleotti has that fine Italian elegance that reminds one of the beautiful rhythms of Palladio. He was a Renaissance Platonist of Marsilio Ficino's stamp; we sense his worship of beauty. According to him, painting leads us successively into three worlds. First it reveals the world of the senses, of pure pleasure: there, a line or a color suffice to enchant us. Then it uncovers the world of the intellect: it shows the thought that engendered the forms. Finally, painting raises us to the world of love: here the soul, ravished by the beautiful truths it has discovered, is no longer content to contemplate them; it loves them.[34] The contemplation of an Annunciation painted by a great artist not only has to do with tasting the pleasures produced by line and color, it brings about the understanding, and then the love, of God's goodness.[35]

This exalted philosophy of art announced a splendid book on Christian iconography. That book was never written: among Paleotti's papers only the chapter titles were found. It is clear that Paleotti intended to examine all the subjects treated by the painters of his time, and to point out their errors.[36]

What Italy had not accomplished, Flanders did. The work came out of the famous University of Louvain which, in the sixteenth century, was the bulwark of Catholicism in the northern countries. As early as 1586, five years after the Council of Trent, Jean Molanus lectured at Louvain on the usefulness of images: he also undertook to refute the iconoclastic doctrines and to set forth the claims of Christian art.[37] His is a learned work, but the animating love of beauty in Paleotti's work is missing: Molanus was a scholar only.

After establishing that Christian art is not a form of idolatry, Molanus went on to ask what this art should be henceforth. This is the real subject of his book; it is a kind of treatise on iconography which submits traditional scenes and consecrated types to close examination. Molanus sternly exercised the powers of judgeship delegated to bishops by the Council of Trent.

His long indictment of medieval art is of extreme interest—we witness here the ruin of all the ancient iconography.

Symbolism, the very soul of thirteenth-century art, that beautiful idea that reality is only appearance, that rhythm, number, and hierarchy are the fundamental laws of the universe—all the world of ideas in which the old theologians and artists had dwelled was closed to Molanus. The little he says about hierarchy indicates that the spirit of the works of the past was completely foreign to him. He thought it of no importance whether St. Paul was placed before St. Peter, whether the Virgin was shown at the left or the right side of Christ, or whether one order of saints was placed before another in heaven.[38] As for symbolism itself, he scarcely deigns to allude to it. However, he does say a word about

the four evangelical animals, but the meaning he attributes to them clearly proves that he was not familiar with medieval symbolism. He imagined that the eagle, the man, the lion, and the ox have no other function than to recall the first verses of each Gospel:[39] and that, certainly, is a meager lesson.

To read Molanus is to sense that the old symbols were withering and dying. There is not one line in all his book that has to do with the famous concordance between the Old and New Testaments—the great ensembles that were so dear to the Middle Ages, and which the sixteenth century itself did not completely reject.

The new religious art was not only to be deprived of the poetry of symbol, but of the poetry of legend, besides. The art of the Middle Ages had lived on dreams. At least half the masterpieces we admire in our churches were inspired by fables. These legends had been more fertile and salutary than any history at the time when they were taken to be true; but that time was past. Molanus had read his adversaries, and he knew that it was no longer possible to give credence to the Pseudo-Abdias, that is, to the history of the apostles as told in the *Golden Legend*. The stern theologian pitilessly condemned the stories that for four centuries had been the inspiration of artists.[40] Henceforth, artists would not be permitted to represent the miraculous voyage of St. Thomas to India, nor the struggle between St. James and the magician Hermogenes which, even in the early sixteenth century, the bishop of Amiens had allowed to be carved for his cathedral.[41] Molanus went further: he was bold enough to state that the life of the Virgin, as told by the artists, was not beyond critical attack. First of all, the history of her parents, and then the story of her childhood and her sojourn in the temple, might be believed by the pious but could not be presented as incontestable truth. Must the innumerable works of art devoted in the past to the childhood of the Virgin be destroyed? Not at all. But it was the Church's duty to enlighten the simple-mindedness of the faithful, so that they would know in what spirit to look on these works. Moreover, might it perhaps be wise, even while respecting the past, to cease making such works?[42]

But what was even more serious, Molanus said outright that the circumstances of the Death of the Virgin rested on apocryphal testimony only.[43] Thus, the beautiful story that had been painted or carved a thousand times and into which the artists had put their faith and their love, the story of the apostles who had surrounded the deathbed of the Virgin, the miraculous funeral ceremony, the tomb over which angels watched—all this was mere poetry and had nothing to do with history. What would the old masters of Notre-Dame of Paris have said? Would their work have radiated so pure a beauty had they thought they were carving a legend they were permitted to disbelieve? This cold little

chapter in Molanus' book indeed marks the end of an age of humanity. So, the life of the Virgin was not proven at every point, and there were perhaps some false jewels in the marvelous crown that the Middle Ages had fashioned with so much love!

Once this confession was made, it was easier to take away some of the legendary aspects of the lives of the saints. Molanus reduced the old epic saints, so dear to the people, to human proportions.

St. Christopher had really existed, he said; he was not a pure symbol, as the Protestants claimed, but he in no way resembled the monstrous giant, the Polyphemus, represented by the artists. He had never borne the Infant Jesus on his shoulders, but as a valiant missionary, he had carried the name of Christ to the pagans. He did not have the privilege of fending off sudden death; that was a gross superstition. An end would be put to it by removing his images.[44]

St. George had not been a knight-errant who killed monsters and delivered princesses; he was a confessor of the faith who had saved many a victim from the demon, or if you will, "from the teeth of the dragon." One of his miracles had converted the Empress Alexandra, and it was this empress, transformed by ignorant painters into a young virgin, whom St. George had saved from the monster.[45]

St. Nicholas of Baki had no doubt performed many miracles, but the one most usually painted was the one with no foundation in fact. The story of the three children in the salting tub could not be justified, and in fact, how such a fable could have been created was beyond comprehension. If artists wanted to give St. Nicholas an attribute, it would be much wiser to show him carrying three golden balls on a book, as was sometimes done. This would be an allusion to the three purses with which he had saved the honor of the three poor girls who were to be sold [into prostitution] by their father.[46]

Thus, poetry retired before common sense. Unhappily, pure reason has never inspired artists and there was henceforth no hope that the legend of St. George might provoke the creation of a masterpiece.

The popular Christianity of the Middle Ages was not all that was condemned by the new spirit. The Christianity of pathos, which we might call Franciscan Christianity, was condemned also.

How many great works had the old masters created of the Virgin fainting at the foot of the cross! Then, it would not have occurred to anyone that such an image could one day become an object of scandal, but that is what happened. Through the testimony of the fathers and doctors of the Church, Molanus established that the Virgin had remained standing at the foot of the cross, and to represent her in a faint was to insult her.[47] The entire Church followed Molanus' opinion; the Jesuits themselves condemned the audacity of painters who dishonored the Virgin by investing her with human weakness.[48] Several pictures

showing a swooning Virgin on Calvary were removed from Roman churches.[49]

The grief of God the Father seemed as shocking as that of the Virgin. In the years following the Council of Trent, a priest in Antwerp received for his church an image of the dead Christ on the knees of his Father; this was the group, so filled with pathos, that St. Bonaventura had inspired fourteenth-century artists to represent. Such a subject might very well have troubled a priest who was mindful of the decisions of the Council; he wrote to Molanus, already a famous man, to seek counsel. Molanus replied that he must consult his bishop, but as for himself, he would never give his approval to such an image.[50]

Molanus also thought it inappropriate to represent Christ, after his Passion, coming to kneel before his father to show him his wounds and the instrument of his torture.[51]

Thus, the images that Franciscan devotion had occasioned for three centuries were indignantly rejected.

However, Molanus did not dare demand that images of the Pietà, or of the Virgin pierced with seven swords, be removed from churches, any more than he dared reject the touching figure of Christ seated on Calvary awaiting his death. Erasmus scoffed in vain. Molanus sensed that the ancient images fed the piety of simple people, but he was careful to observe that nothing in the Gospels nor in the writing of the Church Fathers justified such representations.[52] To speak thus was to cast suspicion on what he pretended to defend; and in fact, few images of the Pietà and of Christ seated on Calvary survived after the appearance of Molanus' book.[53]

The impassioned Christianity of the mystics that came from the heart no more touched Molanus than the naïve Christianity that came from the popular imagination. It could be foreseen that he would show little indulgence toward the wealth of iconographic details borrowed by artists from the theater. Without knowing their origin, he condemned them. What shocked him especially was the taste for the pictorial, for the décor and the beautiful costumes borrowed above all from the theater. It was improper to represent the Marriage at Cana as an Epicurean banquet.[54] It was improper to represent the daughter of Herodiade dancing before Herod.[55]

Nothing displeased Molanus more than the rich costumes that contrasted so strongly with the simplicity of the scriptures. He complained of the painters' lack of modesty in giving to Mary Magdalene—the sublime figure of repentance—the costume of a great lady.

His appeal to austerity was only too well heard. Strangely enough, in this the Renaissance conspired with the Church. Several years before the Council of Trent, our sculptors had learned from the Italians that nothing was nobler than unadorned drapery. Slashed sleeves, sumptuous

bodices, robes embellished with embroidery, mantles fastened with buckles of precious stones, all this luxury of the past aroused only scorn in our young artists. Anything that might suggest a period or a place was vulgar; nobility was attained only through abstraction. In consequence, it was under the double influence of the Italian aesthetic and the Council of Trent that the reign of flowing drapery began.

Molanus, who liked neither picturesque décor nor rich costume, was no fonder of flights of fancy. He cited the famous passage in which St. Bernard so sternly reprimanded the monks for permitting representations of monkeys, lions, hunters, centaurs, and nameless monsters to be placed on the capitals of their cloisters.[56] This was a warning to canons not to allow the artists to carve any more childish scenes on choir stalls. What had seemed innocent in a naïve age was no longer so: all representations of nudity were severely proscribed, and it was not fitting to show David watching Bathsheba in her bath.[57] All the more reason why the pagan gods should not be made pleasing to Christians,[58] and there was no possible interpretation that justified their presence in the church.

Thus dawned an age of propriety and reason. After 1560, everything conspired to destroy medieval art. The iconographic traditions disappeared along with the Mystery plays; at the same time, the Church discovered, in reviewing these traditions, that most of them bore the mark of the excessive credulity of times past, and urged artists to abandon them.[59]

The art of the Middle Ages was doomed. Its charm had lain in the preservation of the innocence of childhood, in the clear eyes of its young saints. It resembled the medieval Church itself—a faith that did not argue, but sang.

Such art could not be brushed by doubt. Here we see how the mysterious power of poetry and art are independent of the progress of reason. Art and poetry come from the heart and from some obscure region inaccessible to reason. The artist who examines, judges, criticizes, doubts, and conciliates, has already lost half his creative force. That is why the art of the Middle Ages, which expressed naïve faith and spontaneity, could not survive the critical spirit born of the Reformation.

But Christian art was not to die with the Middle Ages; in the seventeenth century, religious feeling was powerful enough to create a new art. This art was not the work of individual imagination, as is ordinarily believed; instigated and watched over by the Church, it had its traditions and even its rules, like the art of the past. A new iconography was created that is extremely interesting in itself, for it expresses the spirit of its time as clearly as past art had done. And this is what we shall discuss in the next volume.

NOTES

PREFACE (FIRST EDITION)

1 The collection (as well as the Library) was made available to me by MM. Marcou and Perrault-Dabot. I am most grateful to them for their kindness and here express my thanks.

PREFACE (SECOND EDITION)

1 We are indebted above all to the book by Gabriel Millet, *Recherches sur l'iconographie de l'Evangile*, Paris, 1916, for this deeper knowledge of Byzantine iconography.

CHAPTER I

1 [For the iconography of the Crucifixion, see G. Schiller, *Iconography of Christian Art*, Greenwich, Conn., 1971 (English translation of *Ikonographie der christlichen Kunst*, Gütersloh, 1969, 1st ed. 1966), II, pp. 88-164, with bibliography; L. Réau, *Iconographie de l'art chrétien*, Paris, 1957, II, pt. 2: "La Crucifixion," pp. 462-512. These publications are hereafter cited as *Schiller* and *Réau*.]

2 Matthew 27:54.

3 Louise Lefrançois-Pillion saw very clearly that the angels of the Crucifixion in Rouen are of Italian origin. See her article, "Nouvelles études sur les portails du transept à la cathédrale de Rouen," *Revue de l'art chrétien*, 63 (1913), p. 288. [Cf. M. Weinberger, "Remarks on the Role of French Models within the Evolution of Gothic Tuscan Sculpture," *XXth International Congress of the History of Art* (Studies in Western Art I), Princeton, 1963, pp. 206ff. See also E. Rosenthal, *Giotto in des späten Mittelalters; seine Entstehungsgeschichte*, Augsburg, 1924.]

4 In the collection of Baron Maurice de Rothschild and published by L. Delisle, *Les Heures dîtes de Jean Pucelle*, Paris, 1910. [The Hours of Jeanne d'Evreux are now at the Cloisters Collection of the Metropolitan Museum of Art, New York. The miniatures are illustrated in J. Rorimer, *The Hours of Jeanne d'Evreux, Queen of France*, New York, 1957. See also K. Morand, *Jean Pucelle*, Oxford, 1962, especially pp. 13-16 and p. 41; E. Panofsky, *Early Netherlandish Painting*, Cambridge, Mass., 1953, I, pp. 29-35.]

5 This group by Duccio was copied a second time at the end of the fourteenth century by Jacquemart de Hesdin in the *Petites Heures* of the Duke of Berry (Paris, Bibl. Nat., ms. lat. 18014, fol. 89v). The motif seems to have been retained by the School of Pucelle, which continued for a long time thereafter. Jacquemart de Hesdin several times used themes familiar to Pucelle. [See O. Pächt, "Un tableau de Jacquemart d'Hesdin?" *Revue des arts*, 3 (1956), pp. 149-160.]

6 [For the iconography of the Entombment, see *Schiller*, II, pp. 168-184; *Réau*, II, pt. 2: "La Mise au Tombeau," pp. 521-528; G. Simon, *Die Ikonographie der Grablegung Christi vom 9 bis 16 Jahrhundert*, Rostock, 1926.]

7 Windows of the Passion in Bourges, Tours, Troyes. The relief on the Portail de la Calende, Rouen. Altarpiece from St.-Denis in the Cluny Museum; (Paris, Bibl. Nat., ms. fr. 186), fourteenth century; numerous ivories. In fourteenth-century ivories, St. John and the Virgin are sometimes present at the Anointing of the Body and begin to show their emotion.

8 Almost the same scene is found in another manuscript of Jean Pucelle, the Book of the Hours of Yolande of Flanders, which belonged to Yates Thompson (London, Brit. Mus., Yates Thompson ms. 27). He reproduced it in *Illustrations of One Hundred Manuscripts in the Library of Henry Yates Thompson*, London, 1907-1918, V, pls. xxiff. [See also S. C. Cockerell, *The Book of Hours of Yolande of Flanders*, London, 1905 (facsimiles); Morand, *Jean Pucelle*, pp. 22-23 and cat. no. 5.]

9 [For the iconography of the Annunciation, see *Schiller*, I, pp. 33-52; *Réau*, II, pt. 2: "L'Annonciation ou la salutation angélique," pp. 174-194; J. Villette, *L'Ange dans l'art d'occident*, Paris, 1940, pp. 218ff.; D. M. Robb, "The Iconography of the Annunciation in the Fourteenth and Fifteenth Centuries," *Art Bulletin*, 18 (1936), pp. 480ff.]

10 B. Prost, "Recherches sur 'Les Peintres du Roi' antérieure au règne de Charles VI," *Les Etudes d'histoire du moyen âge dédiées à Gabriel Monod*, 1896, pp. 389ff.

11 *Ibid.*, p. 324.

12 J. Viard, *Les Journaux de trésor de Charles IV le Bel*, Paris, 1917, p. 74 (332); A. Venturi, *Storia dell'arte italiana*, Milan, 1907, V, p. 186.

[For Italian artists active in France in the early fourteenth century, see M. Meiss, "Fresques italiennes, cavallinesques et autres, à Béziers, *Gazette des beaux-arts*, 18 (1937), pp. 275ff.]

13 In 1328, Jehan de Gand, who was living in Paris, sold to the Countess of Artois some paintings "à ymaiges de l'ouvrage de rome" (with figures painted in Rome). C. Dehaisnes, *Documents et extraits divers concernant l'histoire de l'art dans la Flandre, l'Artois et le Hainaut avant le XVe siècle*, Lille, 1886, I, p. 377.

14 *Bible moralisée* (Paris, Bibl. Nat., ms. fr. 9561). The miniatures of the Life of Christ are by two different hands. [See A. de Laborde, *Etude sur la bible moralisée illustrée*, 4 vols. Paris, 1911-1927.]

15 The Sienese must have circulated a rather large number of manuscripts of this kind. There was one in the collection of Yates Thompson entitled *Vita Christi iconibus depicta*. See *Illustrations of One Hundred Manuscripts*, II.

16 [Before the French Revolution, Simone Martini's Christ Bearing the Cross (Louvre) was at the Chartreuse de Champmol, Dijon. See P. Quarré, "L'Influence de Simone Martini sur la sculpture bourguignonne," *Bulletin de la Société Nationale des Antiquaires de France*, 1960, pp. 53-55.]

17 [For studies on the School of Avignon, see E. Castelnuovo, *Un pittore italiano alla corte di Avignone. Matteo Giovannetti e la pittura in Provenza nel secolo XIV*, Turin, 1962, pp. 47ff., for Chapel of St.-Martial (1346), see figs. 23-49; M. Laclotte, *L'Ecole d'Avignon*, Paris, 1960 (includes the fifteenth century).]

18 Painted in grisaille between 1364 and 1377, perhaps by Jean d'Orléans, painter to the king. [For the Parement of Narbonne, see C. Sterling and H. Adhémar, *Musée National du Louvre. Peintures–école français XIVe, XVe et XVIe siècles*, Paris, 1965, pls. 2-7, cat. no. 2, pp. 1-2. It is attributed to an "Atelier Royal (Paris) vers 1375." The authors view the attribution to Jean d'Orléans as plausible, but, lacking documentation, hypothetical. The hanging must have been painted before 1378, the date of the queen's death. See also M. T. Smith, "Use of Grisaille as a Lenten Observance," *Marsyas*, 8 (1957-1959), pp. 43-54.]

19 For examples of these changes, see A. Rossi, "Les Ivoires gothiques français du musée sacré et profane de la Bibliothèque Vaticane," *Gazette des beaux-arts*, 33 (1905), p. 399;

R. Koechlin, "Quelques ateliers d'ivoiriers français aux XIIIe et XIVe siècles," *Gazette des beaux-arts*, 34 (1905), pp. 51 and 53, and *idem, Les Ivoires gothiques français*, 3 vols., Paris, 1924.

20 *Très Belles Heures* (Brussels, Bibl. Roy., ms. 11060-11061). [See J. Porcher, "Les Très Belles Heures de Jean de Berry et les ateliers parisiens," *Scriptorium*, 7 (1953), pp. 121-123; H. Fierens-Gevaert, ed., *Les Très Belles Heures de Jean de France, Duc de Berry*, Brussels, 1924; P. Quarré, *Chartreuse de Champmol; Foyer d'art au temps des ducs Valois*, Dijon (Musée Municipal), 1960.]

21 The miniature is given to the Master of the Boucicaut Hours by P. Durrieu, "Le Maître des Heures du Maréchal de Boucicaut," *Revue de l'art ancien et moderne*, 19 (1906), p. 401, and 20 (1906), p. 21. He points out the Master's adaptations from Italian art. [See also Panofsky, *Early Netherlandish Painting*, pp. 54ff.; M. Meiss, *French Painting in the Time of Jean de Berry. The Boucicaut Master*, London, 1968; J. Longnon, "Le Livre d'Heures d'un preux chevalier," *L'Oeil*, 36 (1957), pp. 24-31. For the iconography of the Descent from the Cross, see *Schiller*, II, pp. 164-168; *Réau*, II, pt. 2: "La Descente de Croix," pp. 513-518; E. Rampendahl, *Die Ikonographie der Kreuzabnahme von IX bis XVI Jahrhundert*, Bremen, 1916.]

22 [Fouquet went to Italy between 1445 and 1447. See P. Wescher, *Jean Fouquet and His Time*, E. Winkworth, tr., London, 1947; and cf. O. Pächt, "Jean Fouquet, a Study of His Style," *Journal of the Warburg and Courtauld Institutes*, 4 (1940-1941), pp. 85-102.]

23 P. Durrieu, *Les Très Riches Heures de Jean de France, Duc de Berry*, Paris, 1904, pp. 45-48, had already indicated some of the Limbourgs' Italian imitations. [See also F. Winkler, "Paul de Limbourg in Florence," *The Burlington Magazine*, 56 (1930), pp. 94ff.; Panofsky, *Early Netherlandish Painting*, pp. 61-66; entry by J. Porcher in the *Encyclopedia of World Art*, London, 1964, IV, cols. 251-257. For new biographical data concerning the brothers, see M. Rickert, review (in English) of F. Gorissen, "Jan Maelwael und die Brüder Limburg; eine Nimweger Künstlerfamilie um die Wende des 14 Jhs," (*Vereeniging tot beoefening van Geldersche geschiedenis, oudheidkunde en recht, Bijdragen en mededelingen*, 54 [1954], pp. 153-221), *Art Bulletin*, 39 (1957), pp. 73-74. Two major exhibition catalogues treat the International

Style: Vienna, Museum of Art History, *Europäische Kunst um 1400*, Vienna, 1962; Baltimore, Walters Art Gallery, *The International Style, The Arts of Europe around 1400*, Baltimore, 1962. See also Panofsky, *Early Netherlandish Painting*, chap. 2: "The Early Fifteenth Century and the 'International Style,'" pp. 51-75.]

24 For the iconography of the Bearing of the Cross—the Road to Calvary, see *Schiller*, II, pp. 78-82; *Réau*, II, pt. 2: "Le Portement de Croix ou la montée au Calvaire," pp. 463-469.]

25 It is curious that the Limbourgs borrowed the great gate through which the procession passes, and the arcaded wall of which it forms a part, from Christ Carrying the Cross by Pietro Lorenzetti, in Assisi. They also borrowed from him the idea of having the two thieves take part in the procession. Nevertheless, the most typical details link their Christ Carrying the Cross to Simone Martini, not Pietro Lorenzetti.

26 These horsemen appeared in France at the end of the fourteenth century; they are found in a French painting representing the Crucifixion in the Bargello, Florence (Museo Nazionale). They are of Italian origin; Giovanni Pisano seems to have been the first to introduce them into the scenes of the Passion which he carved between 1302 and 1310 on the pulpit in the cathedral of Pisa. The horsemen reappear a little later in the Christ Carrying the Cross and in the Crucifixion that Pietro Lorenzetti painted at Assisi. [The French origin of the "Carrand Diptych" (Bargello) has been doubted by Panofsky, *Early Netherlandish Painting*, p. 83: "The 'Carrand Diptych,' the cornerstone of the 'Paris School of about 1400,' is in reality a product of Valencia, datable in the first third of the fifteenth century." See also *Europäische Kunst um 1400*, cat. no. 14, p. 88 and pp. 78-79. The relief by Giovanni Pisano is illustrated in H. Keller, *Giovanni Pisano*, Vienna, 1942, pls. 101-102. For an illustration of Pietro Lorenzetti's Crucifixion, see C. Brandi, *Pietro Lorenzetti, affreschi nella basilica di Assisi*, Rome, 1958, pls. II-XIX.]

27 [For the iconography of the Nativity and the Adoration of the Magi, see *Schiller*, I, pp. 58-88, 94-114; *Réau*, II, pt. 2: "La Nativité et l'Adoration des Mages," pp. 213-255; S. Waetzold, "Drei Könige," *Reallexikon zur deutschen Kunstgeschichte*, O. Schmitt, ed., Stuttgart, 1958, IV, cols. 476-501, with

bibliography (volumes covering A-FA have been published). This publication is hereafter cited at *Reallexikon*. See also H. Cornell, *The Iconography of the Nativity of Christ*, Uppsala, 1924, and Panofsky, *Early Netherlandish Painting*, p. 46 n. 3.]

28 Fragment of the choir screen of Chartres (thirteenth century): the recumbent Virgin caresses the Child; Belleville Breviary (Paris, Bibl. Nat., ms. lat. 10483, fol. 242v), before 1343: recumbent Virgin caresses the Child; Breviary of Charles V (Paris, Bibl. Nat., ms. lat. 1052), between 1364 and 1380: recumbent Virgin suckling the Child; *Pèlerinage de l'âme* (Paris, Bibl. Nat., ms. fr. 312), 1393: recumbent Virgin suckling the Child; *Miroir historial* (Paris, Bibl. Nat., ms. fr. 312, fol. 271), copied for Louis d'Orléans in 1396: recumbent Virgin suckling the Child; Missal of St.-Martin-des-Champs (Paris, Bibl. Mazarine, ms. 416, fol. 14), 1408: recumbent Virgin caresses the Child. [For the choir screen at Chartres, see E. Mâle, *Notre-Dame de Chartres*, Paris, 1948, fig. 3; E. Houvet, *Monographie de la cathédrale de Chartres*, Paris, 1927(?), pl. 60.]

29 [Nativity from Fouquet's Hours of Etienne Chevalier, Chantilly, Musée Condé, ca. 1450. See C. Sterling, *The Hours of Etienne Chevalier. Jean Fouquet*, New York, 1971, pl. 8.]

30 [Cornell, *The Iconography of the Nativity of Christ*, fig. 8.]

31 The Virgin kneeling before the Child is found also in a fresco of the fourteenth century in the cathedral of Orvieto. [Bernardo Daddi, Nativity (Uffizi) reproduced *ibid.*, fig. 9, and cf. also p. 6 n. 2. Cornell emphasizes the influence of St. Bridget of Sweden on the representation of the Virgin kneeling before the Christ Child. See also Panofsky, *Early Netherlandish Painting*, pp. 125ff., 46 n. 3.]

32 [For relations between depictions of the Adoration of the Magi and liturgical drama, see E. Mâle, "Les Rois Mages et le drame liturgique," *Gazette des beaux-arts*, 4 (1910), pp. 261-270.]

33 For example, in the Hours of the Duke of Berry in Brussels, (*Très Belles Heures*, Bibl. Roy., ms. 11060-11061); in a beautiful manuscript in Vienna (Bedford Hours, Imperial Lib., ms. 1855, fol. 70v), published in the *Bulletin de la Société Française de Reproductions des Manuscrits à Peintures*, 2 (1912), pl. VII; and in a painting, probably French, in the Bargello, Florence (Museo Nazionale). [For the Vienna manuscript by the so-called Master of the Bedford Hours,

see E. Spencer, "The Master of the Duke of Bedford: The Bedford Hours," *The Burlington Magazine*, 107 (1965), pp. 495-502, and E. Trenkler, *Livre d'Heures: Handschrift 1855 des Oesterreichischen Nationalbibliothek*, Vienna, 1948. For an illustration of the "Small Bargello Diptych," see G. Ring, *A Century of French Painting, 1400-1500*, London, 1949, pl. 16.]

34 The Presentation of the Child in the Temple is a clear imitation of the Presentation of the Virgin in the Temple by Taddeo Gaddi and Giovanni da Milano in S. Croce, Florence, but the scene thus conceived was not found again in French art; it had no subsequent influence. [For the iconography of the Presentation in the Temple, see *Schiller*, I, pp. 90-94.]

35 *Petites Heures* (Paris, Bibl. Nat., ms. lat. 18014).

36 *Petites Heures* (Paris, Bibl. Nat., ms. lat. 18014, fol. 162).

37 Here are examples taken from the manuscripts: Book of Hours (Paris, Bibl. Nat., ms. lat. 18026, fol. 94) from the early fifteenth century; Life of Christ (Paris, Bibl. Nat., ms. fr. 992, fol. 116), late fifteenth century; *Miroir historial* (Paris, Bibl. Nat., ms. fr. 50, fol. 231), late fifteenth century; Book of Hours (Paris, Bibl. Nat., ms. lat. 13289, fol. 81), late fifteenth century. [For the iconography of Christ Nailed to the Cross, see *Schiller*, II, p. 86 and *Réau*, II, pt. 2: "Jésus est cloué sur la Croix," pp. 473-474.]

38 [See Chapter VI, n. 43.]

39 Miniature reproduced by P. Toesca, *La pittura e la miniatura nella Lombardia*, Milan, 1912, p. 281. This manuscript, a Prayer Book (Monaco, Staatsbibl., cod. 23215), was illuminated between 1350 and 1378.

40 Psalter (Paris, Bibl. Nat., ms. lat. 8846). This Psalter was published in facsimile by H. Omont, *Psautier illustré (XIIIe siècle), Reproduction des 107 miniatures du manuscrit latin 8846 de la Bibliothèque Nationale*, Paris, 1906. See the Christ Nailed to the Cross, pl. 77 (fol. 117). [Also illustrated by M. Meiss, "Italian Style in Catalonia and a Fourteenth-Century Catalan Workshop," *Journal of the Walters Art Gallery*, 4 (1941), pp. 45-87, fig. 27, as shop (?) of the Master of St. Mark, fourteenth century.]

41 *Petites Heures* (Paris, Bibl. Nat., ms. lat. 18014, fol. 286).

42 [See Chapter III, n. 167, for the problem of the origin of the Pietà.]

43 [For the Virgin's role in these scenes, see O. G. von Simson, "*Compassio* and *Coredemptio* in Roger van der Weyden's *Descent from the Cross*," Art Bulletin, 35 (1953), pp. 9ff.]

44 This influence was indicated by L. Bréhier in an excellent chapter of his *L'Art chrétien*, Paris, 1918, pp. 321-331; but the detailed demonstration was made by G. Millet, *Recherches sur l'iconographie de l'Evangile au XIV, XV, et XVIe siècles*, Paris, 1916, pp. 601-610. [Hereafter cited as Millet, *Recherches*. See Bibliothèque Nationale exhibition catalogue *Byzance et la France mediévale* (intro. by J. Porcher), Paris, 1958. For the influence of Byzantine art on the West, see J. H. Stubblebine, "Byzantine Influence in Thirteenth-Century Italian Panel Painting," *Dumbarton Oaks Papers*, 20 (1966), pp. 85ff.; O. Demus, *Byzantine Art and the West*, New York, 1970. See also Panofsky, *Early Netherlandish Painting*, pp. 22ff.]

45 Millet, *Recherches*, p. 432.

46 *Ibid*., p. 443.

47 *Ibid*., p. 417.

48 Mosaic in S. Marco, Venice. [See P. Toesca and F. Forlati, *Mosaics of St. Mark's*, Greenwich, Conn., 1958, pl. xxx and another example from the Baptistery, fig. 17.]

49 See the reproduction published by Bibliothèque Nationale (ed. H. Omont), *Evangiles avec peintures byzantines du XIe siècle*, Paris, 1908, pl. 176. [For the appearance of this scene in Byzantine art, see *Schiller*, II, p. 66.]

50 See Millet, *Recherches*, pp. 366 and 391. [See also G. de Jerphanion, *Une Nouvelle Province de l'art byzantine; Les Eglises rupestres de Cappadoce*, 3 vols., Paris, 1925-1944.]

51 Millet, *Recherches*, p. 394.

52 See J. Seroux d'Agincourt, *Histoire de l'art par les monuments*, Paris, 1823, IV, pl. XIV. [English translation: *History of Art by Its Monuments*, London, 1847. See also A. L. Frothingham, "A Syrian Artist Author of the Bronze Doors of St. Paul's, Rome," *American Journal of Archaeology*, 18 (1914), pp. 484-493.]

53 As was shown by Millet, *Recherches*, chap. x, pp. 498ff. [For the iconography of the Lamentation, see *Schiller*, II, pp. 174-179; G. von der Osten, "Beweinung Christi," *Reallexikon*, II, cols. 458-475; K. Weitzmann, "The Origin of the Threnos," *De Artibus Opuscula XL, Essays in Honor of Erwin Panofsky*, New York, 1970, I, pp. 476-490.

54 Gospel Book (London, Brit. Mus., Harley

ms. 1810, fol. 205v), thirteenth century; Gospel Lectionary (Rome, Bibl. Apost., Vat. ms. gr. 1156, fol. 194v), eleventh-twelfth century; [Weitzmann, *op. cit.*, II, figs. 11 and 16.] Melisende Psalter (London, Brit. Mus., Egerton ms. 1139, fol. 9r). [See H. Buchthal, *Miniature Painting in the Latin Kingdom of Jerusalem*, Oxford, 1957, pl. 9a.] Gospel of Gelat. See Millet, *Recherches*, fig. 535. [See also *ibid.*, pp. 493-494 and 740.]

55 [For the Stone of Unction, see Panofsky, *Early Netherlandish Painting*, p. 274; M. A. Graeve, "The Stone of Unction in Carvaggio's Painting for the Chiesa Nuova," *Art Bulletin*, 40 (1958), pp. 227ff.; W. H. Forsyth, *The Entombment of Christ: French Sculptures of the Fifteenth and Sixteenth Centuries*, Cambridge, Mass., 1970, p. 8.]

56 [On the iconography of the Entombment, see notes 6 and 53; cf. also Panofsky, *Early Netherlandish Painting*, pp. 23-24 and p. 24 n. 1-2.]

57 Millet, *Recherches*, pp. 501-505.

58 George of Nicomedia, Homilies, Migne, *P. G.*, 100, cols. 1470ff.

59 *Ibid.*, cols. 1485-1487.

60 Simeon Metaphrastes, Homilies, *ibid.*, 114, col. 209.

61 The Franciscans of Quaracchi, in volume x of their definitive edition of St. Bonaventura (1902), p. 25, placed the *Meditations* among the works attributed to St. Bonaventura that do not belong to him. [I. Jeiler, *Doctoris Seraphici S. Bonaventurae S. R. E. Episcopi Cardinalis Opera Omnia, edita studio et cura P. P. Collegii S. Bonaventurae in fol. ad Claras Aquas* (Quaracchi), 10 vols., 1882-1902.] These *Meditations* are the work of an Italian Franciscan of the thirteenth century called, in some manuscripts, Johannes de Calibus. It is correct, then, to speak not of St. Bonaventura, but of the Pseudo-Bonaventura. [See translation by I. Ragusa, *Meditations on the Life of Christ, an Illustrated Manuscript of the Fourteenth Century, Paris, Bibliothèque Nationale, ms. ital. 115*, I. Ragusa and R. Green, eds., Princeton, 1961. This translation hereafter cited as *Meditations*. See also L. Oliger, "Le *Meditationes Vitae Christi* del Pseudo-Bonaventura," *Studi Francescani*, 7 (1921), pp. 143-183, 8 (1922), pp. 18-47.]

62 [The frescoes in the church of the convent of S. Lucchese at Poggibonsi are by Bartolo di Fredi, Jacopo di Cione, Segna di Bonaventura, among others.]

63 He could also have known some of those meditations on the Passion which are to be found in early Byzantine literature.

64 *Meditations*, chap. IV, p. 19.

65 *Ibid.*, chap. VII, pp. 34-36.

66 *Ibid.*, chap. IX, pp. 50-51. In a fourteenth-century French painting shown at the Exposition des Primitifs, the eldest of the Kings kisses the hand of the Child. [*Exposition des primitifs français au palais du Louvre: Catalogue*, H. Bouchot, ed., Paris, 1904, p. 4, no. 5, Adoration of the Magi (illus., p. 8). Now in the Pierpont Morgan Library, New York, the painting is dated ca. 1395 and generally assigned to the Bohemian School. See Ring, *A Century of French Painting*, no. 25, p. 194.]

67 *Meditations*, chap. LXXVII, pp. 331-332.

68 *Ibid.*, chap. LXXX, pp. 338-339.

69 The earliest example of the fainting Virgin, as we have said, is to be found on one of the panels of the pulpit in Pisa, carved by Nicola Pisano in 1260. At this date, then, the *Meditations* were already known in Italy. [See Simson, "*Compassio* and *Co-Redemptio*," p. 13.]

70 [For the date of the Rohan Hours (Paris, Bibl. Nat., ms. lat. 9471), between 1418 and 1425, see J. Porcher, *Medieval French Miniatures*, New York, 1960 (?), p. 69. See also *idem, The Rohan Book of Hours*, London, 1959 (French ed., Geneva, 1943); A. Heimann, "Der Meister der 'Grandes Heures de Rohan' und seine Werkstatt," *Städel-Jahrbuch*, 7-8 (1932), pp. 1ff.; E. Mâle, *Les Grandes Heures de Rohan (Bibliothèque Nationale)*, Paris, 1947; Panofsky, *Early Netherlandish Painting*, p. 74 and nn. 4-6.]

71 *Meditations*, chap. LXXI, pp. 341-342.

CHAPTER II

1 [The development of religious drama in the Middle Ages has been most comprehensively treated by K. Young, *The Drama of the Medieval Church*, 2 vols., Oxford, 1933, with extensive bibliography; see also G. Frank, *The Medieval French Drama*, Oxford, 1954. On the relationship between art and the religious theater, see, e.g., J. Mesnil, *L'Art au nord et au sud des Alpes à l'époque de la Renaissance*, Paris, 1911, chap. 5: "Les Mystères et les arts plastiques," pp. 86-126; L. van Puyvelde, *Schilder-Kunst en tooneelvertooningen op het einde van de middeleewen*, Ghent, 1912; A. Rapp, *Studien über den Zusammenhang des geistlichen Theaters mit der bildenden Kunst im ausgehenden Mittelalter*,

Kallmünz, 1936; G. Cohen, "The Influence of the Mysteries on Art in the Middle Ages," *Gazette des beaux-arts*, 24 (1943), pp. 327-342; *idem, Histoire de la mise en scène dans le théâtre religieux français du moyen âge*, Paris, 1951, especially chap. 3: "Art et mystère," pp. 104-141; O. Pächt, *The Rise of Pictorial Narrative in Twelfth-Century England*, Oxford, 1962, especially "Pictorial Representation and Liturgical Drama," pp. 33-59; M. D. Anderson, *Drama and Imagery in English Medieval Chronicles*, Cambridge, 1963. See also *Réau*, I, pp. 254-266, especially "La Prédication et le théâtre religieux," pp. 261-264. On the relation between the Byzantine and Latin theater, see G. la Piana, "The Byzantine Theater," *Speculum*, 11 (1936), pp. 171-211, with extensive bibliography, and O. Jodogne, "Recherches sur les débuts du théâtre religieux en France," *Cahiers de civilisation médiévale* (Université de Poitiers), 8 (1965), pp. 179ff.]

2 See J. Bédier, "Fragment d'un ancien mystère," *Romania*, 24 (1895), pp. 86-94; A. Thomas, "Le Théâtre à Paris et aux environs à la fin du XIVe siècle," *Romania*, 21 (1893), pp. 609-611; W. Creizenach, *Geschichte des neueren Dramas*, I, Halle, 1893; E. Roy, "Le Mystère de la Passion en France," *La Revue bourguignonne de l'enseignement supérieur*, XIII-XIV, Paris and Dijon, 1903-1904.

3 See especially the Mystery plays (ca. 1400) published by Jubinal from the manuscript in the Bibliothèque Ste.-Geneviève. They date from ca. 1400. [A. Jubinal, *Mystères inédits du quinzième siècle*, 2 vols., Paris, 1837.]

4 Certain details prove that the *Meditations* had been utilized as early as the fourteenth century. [See Chapter I n. 61 and below, pp. 41-47.]

5 This is not to say that they were inspired solely by the *Meditations*. E. Roy, "Le Mystère de la Passion," has shown that Gréban knew the *Postilles* of Nicolas de Lira and followed them very closely. He has also shown that almost all the dramatic writers had read the *Meditations*, not in the Latin text, but in French translations or imitations. [See note 22.]

6 Gerson. [Jean le Charlier de Gerson, churchman and spiritual writer, 1363-1429; see Chapter III n. 4.]

7 L. Petit de Julleville, *Histoire du théâtre en France*, II, pt. 1: "Les Mystères," Paris, 1880.

8 Ludolf of Saxony, *De vita Christi*, Paris, 1498,

chap. II, says it expressly, as does the Pseudo-Bonaventura. [St. Bernard, Sermon 1, J.-P. Migne, *P.L.*, 183, cols. 387ff. For other links to the sermons of St. Bernard, see C. Fischer, "Die *Meditationes Vitae Christi*, Ihre handschriftliche Uberlieferung und die Verfasserfrage," *Archivum Franciscanum Historicum*, 25 (1932), p. 457. For Mercadé as the first to introduce the theme into the drama, see Frank, *The Medieval French Drama*, p. 180 and n. 4. See also H. Traver, "The Four Daughters of God: A Mirror of Changing Doctrine," *Publications of the Modern Language Association*, 40 (1925), pp. 44-92; Anderson, *Drama and Imagery*, pp. 132-133; S. C. Chew, *The Virtues Reconciled*, Toronto, 1947; P. Verdier, "L'allegoria della Misericordia e della Giustizia di Giambellino agli Uffizi," *Atti dell'Istituto Veneto di scienze lettere ed arte*, 3 (1952-1953), pp. 97-116.]

9 Creizenach, *Geschichte des neueren Dramas*, I, p. 294.

10 *Ibid.*, p. 348.

11 A. d'Ancona, *Sacre rappresentazioni dei secoli XIV, XV e XVI*, Florence, 1872, I, p. 182. See also the *Ravello Mystery*.

12 He makes this fairly clear when he says, chap. XIII: "Unde *possibile est* quod puer Jesus inde transiens in reditu suo invenit eum (Joannem) ibidem." ("Thus it is likely that the boy Jesus, passing it on his return, found him there," cf. *Meditations*, p. 82.)

13 In the twelfth century, Peter Comestor, in whom all the old traditions converged, did not know the story of the meeting of Jesus and John (*Historia scholastica: In Evangelia*, chap. XXIII). [Migne, *P.L.*, 198, cols. 1549-1550.] In the thirteenth century, Vincent of Beauvais, in his *Speculum historiale* (Paris, Bibl. Nat., ms. fr. 50), said nothing about it. [For this theme, see M. A. Lavin, "Giovannino Battista, a Study in Renaissance Religious Symbolism," *Art Bulletin*, 38 (1955), pp. 85-101. Lavin points out, pp. 86-87, that the iconography is apocryphal and eastern in origin and passed from there into the *Meditations*. See also below, note 56.]

14 The Mystery was published by d'Ancona, *Sacre rappresentazioni*, I, pp. 241-253, from an incunabulum of the fifteenth century.

15 Creizenach, *Geschichte des neueren Dramas*, I, p. 329.

16 MARIE
Vous, Elisabeth, ma cousine
Dites moy où est votre enfant.

ELISABETH

Certe, Dame, il est maintenant,
Non de maintenant, mais pieça,
Ou grant désert, où il a ja
Fait mainte grande abstinence.

MARY

(Tell me, Elizabeth, my cousin,
Where is your child?)

ELIZABETH

(To be sure, Lady, he is now,
Not only just now, but for a long time,
In the great desert, where in sooth
He has made many a long fast.)

(*Le Mystère d'Arras*, published by J.-M. Richard, Arras, 1893.)

[On the attribution of the *Arras Passion* to Mercadé, rhetorician, logician and theologian (d. 1440), see A. Thomas, "Notice bibliographique sur Eustache Mercadé," *Romania*, 35 (1906), pp. 583-590. A signed manuscript, the *Vengeance Jésus-Christ*, follows the *Arras Passion* in the same manuscript and is similar in tone. See also Frank, *The Medieval French Drama*, pp. 179-181; G. Cohen, *Le Théâtre en France au moyen âge*, Paris, 1928, pp. 46-47.]

17 *Meditations*, chap. LXXI, pp. 305-306.

18 It was the same in Italy, for example, in the *Passion* of Castellano Castellani. See d'Ancona, *Sacre rappresentazioni*, I, p. 309. See also F. Torraca, *Il teatro italiano dei secoli XIII, XIV, XV*, Florence, 1885, p. 47.

19 *Meditations*, chap. LXXVI, p. 328, LXXVII, p. 331, and LXXVIII, p. 333.

20 There is no reason to believe that the dialogue between St. Anselm and the Virgin (Migne, *P.L.*, 49, col. 271ff.), where all these features are found, predates the *Meditations*.

21 In the Escorial. [Now at the Prado, Madrid; cf. M. J. Friedlander, *Early Netherlandish Painting* (N. Veronée-Verhaegen, ed.), New York, 1967, II, pp. 60-61 and pls. 6-7.]

22 Verses 21182-21273. [G. Paris and G. Raynaud, eds., *Le Mystère de la passion d'Arnould Gréban*, Paris, 1878, pp. 277-278. This publication is hereafter cited as Gréban, *Le Mystère*. Arnoul Gréban, *Cest le Mistère de la passion Iesucrist*, printed by Jehan Driart, Paris, 1486. Written by Gréban, ca. 1478, it was subsequently edited by Jean Michel, ca. 1484. See J.G.T. Grässe, *Trésor des livres rares et précieux*, Milan, 1950, IV, p. 640 (German ed., Dresden, 1859-1869). See also below, note 38. Gréban's Mystery was performed in Paris at least three times before 1493. See Frank, *The Medieval French Drama*, pp. 181-187;

Cohen, *Le Théâtre à Paris*, pp. 48-64; P. Champion, *Histoire poétique du XVe siècle*, Paris, 1927 II, pp. 133-138.]

23 Verses 24162-24225. [Gréban, *Le Mystère*, pp. 316-317.]

24 Verses 24650-24683. [*Ibid.*, p. 323.]

25 *Meditations*, chap. XCVII, pp. 380-381. The celebrated poem by Guillaume de Deguilleville, *Le Pèlerinage de Jésus-Christ* (Paris, Bibl. Nat., ms. fr. 14976), fourteenth century, is often only a paraphrase of the *Meditations*. [See J. J. Stürzinger, ed., *Le Pèlerinage Jhesucrist de Guillaume de Deguilleville*, London, 1897.]

26 Verse 33275. [Gréban, *Le Mystère*, p. 435.]

27 This stage direction is found in Mercadé [see above, note 16]: *Marie à genoux devant son enfant qui est nez et est accompaigniez de plusieurs angèles qui rendent grande clarité et font grant mélodie.* (Mary kneels before her Child who is just born and is accompanied by several angels who radiate great light and make great melody.) Gréban puts into the mouth of Joseph the following verses, which are precise enough to make stage directions unnecessary:

J'aperçois un enfant qui pleure
Tout nu sur le ferre gisant
Et la mère à genoux devant
L'adorant par grand révérence.

(I see a baby who is crying
As He lies completely naked on the straw,
And the mother kneeling before him
Adores him with great reverence.)
And he adds:

. . . Qu'ay-je à faire
Sinon à moi ruer à terre
Et adorer le nouveau-né?

(. . . What must I do
Except fling myself on the ground
And also adore the new-born babe?)

Verses 5050ff. [Gréban, *Le Mystère*, p. 65.] [The *Revelations* of St. Bridget (VII, 21 and 22) are cited by Cornell, *The Iconography of the Nativity of Christ*, pp. 9-13, as a source of the kneeling Nativity. Cf. above, chap. I n. 27.]

28 Dante, *Paradiso* Canto XI [Dante Alighieri, *The Divine Comedy*, tr. with commentary by Charles S. Singleton, 6 vols., Princeton, 1975.]

29 N. Rondot, "Les Peintres de Lyons du quatorzième au dix-huitième siècle," *Réunion des sociétés des beaux-arts des départements*, 1887, p. 431.

30 The manuscript he illuminated, the *Passion*

from Valenciennes (Paris, Bibl. Nat., ms. fr. 12536), gives the scenery for the play, and contains miniatures representing the principal scenes. [For Hubert Caillaux, cf. *La Vie théâtrale au temps de la Renaissance* (Institut Pédagogique National), Paris, 1953 (March, April, May), pp. 15-19; Anderson, *Drama and Imagery*, pp. 115-130.]

31 See also *Archives de l'art français*, i (1851-52), p. 137. [1468 reference to collaboration with artists on the performances.]

32 It is difficult to establish a chronology. All that can be said is that the scene scarcely ever appeared before the first part of the fifteenth century. There is something resembling an early draft of it, done about 1430, in the Breviary of the Duke of Bedford (Paris, Bibl. Nat., ms. lat. 17294, fol. 440). [Also known as Breviary of Salisbury, cf. V. Leroquais, *Les Bréviaires manuscrits des bibliothèques publiques de France*, Paris, 1934, iii, p. 271.] There, Gabriel bows to God the Father before the Annunciation. In Paris, Bibl. Nat., ms. lat. 18026, fol. 113, Peace and Justice, Truth and Mercy, embrace near the cross of Jesus Christ. The manuscript would seem to date from ca. 1400, but it is curious that the miniature in question seems to have been done later than the others; it could date from 1420 or 1430.

33 Life of Christ (Paris, Bibl. Nat., ms. fr. 992, fol. 2), ca. 1485. [See Paris, Bibliothèque Nationale, *Les Manuscrits à peintures en France du XIIIe au XVIe siècle*, Paris, 1955, cat. no. 324.]

34 Especially *Speculum historiale* of Vincent de Beauvais (Paris, Bibl. Nat., ms. fr. 50, fol. 197) and Book of Hours (Paris, Bibl. Nat., ms. lat. 13294, fol. 2).

35 Breviary of René of Lorraine (Paris, Bibl. de L'Arsenal, ms. 601, fol. 58v).

36 See the *Passion* by Gréban and the *Mystère de la Nativité de Rouen*. [See above, notes 5 and 22.] The scene is found, it is true, in the *Meditations*, chap. iv, p. 15, but it is barely indicated. [Cf. *Meditations*, chap. i, pp. 5-6.] In the Mystery plays, on the contrary, it is developed at length. The same patriarchs and prophets who appear in the miniatures speak by turn.

37 The *Golden Legend* (Paris, Bibl. Nat., ms. fr. 244, fol. 4), end fifteenth century. The same thing is found in a manuscript in the Mazarine (Paris, Bibl. Mazarine, ms. 412, fol. 1).

38 See the illustrated edition of the *Mystère de la Passion* by Jean Michel. [A. Gréban, *Cest le Mistère de la passion Iesucrist*, J. Michel, ed., printed by Antoine Vérard, Paris, 1490. The Vérard edition has a single woodcut. For fuller illustrations, see the edition printed by the widow of J. Trepperel and J. Jehannot, Paris, 1518 (?), cf. H. M. Davies, ed., *Catalogue of a Collection of early French Books in the Library of C. Fairfax Murray*, London, 1961, i, no. 393, pp. 561-563.]

39 Woodcut by Antoine Vérard and Etienne Jehannot in A. Claudin, *Histoire de l'imprimerie en France au XVe et au XVIe siècle*, Paris, 1900, ii, p. 243.

40 Reproduction in X. Barbier de Montault, "Rome chrétienne," *Annales archéologiques*, 15 (1855), p. 235.

41 [For illustration, see H. Göbel, *Wandteppiche*, Leipzig, 1923, ii, pt. i, fig. 121: "Redeeming Blood of Jesus Christ" (the so-called throne tapestry of Emperor Charles V, ca. 1520).]

42 [For the Last Judgment tapestry in the Louvre, see R.-A. d'Hulst, *Tapisseries flamandes du XVe au XVIIIe siècle*, Brussels, 1960, no. 15, pp. 121-128, 298-299. (Cf. also translation by F. J. Stillman, *Flemish Tapestries from the Fifteenth to the Eighteenth Century*, New York, 1968).]

43 The window, of mediocre quality, dates from the second half of the sixteenth century; in it we can detect the influence of the School of Fontainebleau.

44 There is another at Rumilly-les-Vaudes (Aube).

45 These hanging keystones must date from the beginning of the seventeenth century; the date of 1561 must have been added later.

46 *Excita potentiam et veni.*

47 *Inclina coelos et descende.*

48 *Ibidem Joseph, qui erat magister lignarius, forte aliqualiter se clausit.* (*Meditations*, chap. vii, p. 32.)

49 Breviary of Salisbury (Paris, Bibl. Nat., ms. lat. 17294, fol. 56). [Breviary for Salisbury use, for the Duke of Bedford, executed in Paris. See Leroquais, *Les Bréviaires*, iii, p. 271 and pls. lv-lxv.] The books which belonged to the Duke of Berry furnish more than one example of it: for example the Missal and Pontifical of Etienne Loypeau (Paris, Bibl. Nat., ms. lat. 8886, fol. 130v), 1380-1390; *Petites Heures* (Paris, Bibl. Nat., ms. lat. 18014, fol. 38), ca. 1390. [See V. Leroquais, *Les Pontificaux manuscrits des bibliothèques publiques de France*, Paris, 1937, ii, p. 148 and pls. lxxxiii-xciii and *idem, Les Livres*

d'heures manuscrits des bibliothèques publiques de France, Paris, 1927, II, pp. 175-187 and pls. XIV-XIX.] Also Paris, Bibl. Nat., ms. lat. 1383, fol. 52v; Book of Hours (Paris, Bibl. Nat., ms. lat. 1158, fol. 80); Paris, Bibl. de l'Arsenal, ms. 647, fol. 41. There is another more typical example than any we have given: in the museum of Augsburg, an anonymous painting from the middle of the fifteenth century represents the Nativity; it shows Joseph braiding branches for the enclosure. Here we find the specific influence on this scene of the Mystery plays.

50 *Meditations*, chap. VII, p. 32.

51 Portinari Altarpiece, Florence, Uffizi.

52 [For Memling, see illustrations in Friedländer, *Early Netherlandish Painting*, VIA: Nativity, St. John's Hospital, Bruges (Floreins Altar), pl. 6; Nativity, Prado, Madrid, pl. 3.]

53 In Städtisches Museum, Nördlingen. [Cornell, *Iconography of the Nativity of Christ*, fig. 26. In chap. I, pp. 1-47, he points out features suggested by St. Bridget, such as the mantle spread on the ground and the kneeling position of the figures. See also note 27, above.]

54 No precise indication is to be found in the Mystery plays of 1400, published by Jubinal, *Mystères inédits*. The earliest Flemish Mystery plays are lost (Creizenach, *Geschichte des neueren Dramas*, I, p. 339). [Panofsky, *Early Netherlandish Painting*, I, p. 277 n. 3, notes that in St. Bridget's *Revelations* (I, 10), the Virgin mentions the column of the Flagellation in describing how she foresaw the Passion as soon as she had given birth to Christ.]

55 It is true that at one side there is an old man and a woman leading a child by the hand. Could this be the Holy Family in Egypt?

56 However, I can cite, in the *Petites Heures* of the Duke of Berry (Paris, Bibl. Nat., ms. lat. 18014, fol. 208), an infant St. John in the desert. He is surrounded by animals as realistic as those of Pisanello. [The miniature is reproduced by Panofsky, *Early Netherlandish Painting*, II, fig. 33. Panofsky suggests, I, p. 45 n. 1, that Jacquemart de Hesdin was inspired by Calvalca, *Vite dei Santi Padri* (thirteenth century). See also, Lavin, "Giovanni Battista," p. 89 n. 28.]

57 *Meditations*, chap. XI, p. 64.

58 [For illustrations of these compositions by Raphael, see S. J. Freedberg, *Painting of the High Renaissance in Rome and Florence*, 2 vols., Cambridge, Mass., 1961: La Belle Jardinière, 1507 (Louvre), fig. 55; Holy Family

of Francis I, 1518, with Giulio Romano (Louvre), fig. 436. The Madonna of the Blue Diadem (Louvre), not generally accepted as a work by Raphael, is illustrated in A. Rosenberg, *Raffael*, (Klassiker der Kunst), Stuttgart and Leipzig, 1909, p. 76.]

59 The scene of the two children playing beside the Virgin is less frequent in French art. There is a representation of it in Souvigny (Allier); the Virgin and two children are seen playing with a lamb.

60 *Life of Christ* (Paris, Bibl. Nat., ms. fr. 992, fol. 83v), from the second half of the fifteenth century. [See above, note 33.]

61 The artist who designed the window in the choir at Conches (Eure) had before him the engraving by Albrecht Dürer. [See L. Réau, "L'Influence d'Albert Dürer sur l'art français," *Bulletin et mémoires de la Société des Antiquaires de France*, 1924, pp. 219-222.]

62 Michel's version of Gréban's *Passion*, performed in Angers in 1486, has never been properly edited. See Frank, *Medieval French Drama*, pp. 187-189; see also above, notes 22 and 38.]

63 A Gospel Book of the Celestine of Amiens (Paris, Bibl. de l'Arsenal, ms. 625, fol. 47v), and a tapestry in the Hôtel-Dieu at Reims show Christ appearing to his mother after his resurrection, followed by all the patriarchs he had released from Limbo. The manuscript is from the early sixteenth century; the tapestry also dates from the sixteenth century.

64 This engraving appears at the end of the *Passio domini Nostri Jesu* by Olivier Maillart, printed by Jean Lambert, Paris, 1493. [Cf. Grässe, *Trésor de livres*, IV, p. 343.]

65 In the *Arras Passion*, God says to his son who has come to show him his wounds:

> *Ça beau fils venez vous asseoir*
> *Séez-vous à ma dextre droit-cy.*

(Come hither splendid son and be seated
Sit at my right hand here.)
And a note adds: *Cy est Jésus assis à la dextre de Dieu le Père....*

(Here Jesus sits at the right hand of God the Father....) [Mercadé, *Le Mystère d'Arras*, cf. note 16 above.

66 We have indicated the origin of this group in *L'Art religieux du XIIe siècle en France*, chap. V. [Eng. ed., Princeton, 1978.]

67 Carved on the façade of the church of St.-Riquier and on that of St.-Vulfran at Abbeville. The same thing abroad: for example, the painting of All Saints (The Martyrdom

of the Ten Thousand) by Albrecht Dürer, in the Kunsthistorisches Museum of Vienna. [For the illustration of the Dürer, see E. Panofsky, *Albrecht Dürer*, Princeton, 1943, II, fig. 166. For this motif, known as the Throne of Grace, or *Gnadenstuhl*, see *Réau*, II, pt. 1: "L'Iconographie de Dieu," p. 24, and *Schiller*, II, pp. 122-124.

68 The *Petites Heures* of the Duke of Berry (Paris, Bibl. Nat., ms. lat. 18014, fol. 70) and the *Grandes Heures* of the Duke of Berry (Paris, Bibl. Nat., ms. lat. 919, fol. 93). [See M. Meiss, *French Painting in the Time of Jean de Berry; The Late Fourteenth Century and the Patronage of the Duke*, New York, 1967, II, figs. 101 and 230; M. Thomas, *The Grandes Heures of Jean Duke of Berry*, New York, 1971, pl. 91. On the iconography of the Trinity, see *Schiller*, especially I, pp. 7-9, 150-152, and II, pp. 122-124. See also D. Denny, "The Trinity in Enguerrand Quarton's 'Coronation of the Virgin,'" *Art Bulletin*, 45 (1963), pp. 48-52; G. von Camp, "Iconographie de la Trinité dans un triptyque flamand de ca. 1500," *Revue belge d'archéologie et d'histoire de l'art*, 21 (1952), pp. 55-58.]

69 *Le Pèlerinage de Jésus-Christ* (Paris, Bibl. Nat., ms. fr. 376, fol. 228). [See also above, note 25.]

70 Verses 5153ff. [Gréban, *Le Mystère*, pp. 66ff.] The same details are found in the *Mystère de la Nativité*, published by Jubinal, *Mystères inédits*, II, pp. 1-78. [For Joseph at the Nativity, see *Schiller*, I, pp. 65-76 and *Réau*, III, pt. 2: "Joseph," pp. 752-760.]

71 *Petites Heures* of the Duke of Berry (Paris, Bibl. Nat., ms. lat. 18014, fol. 143); Breviary of the Duke of Bedford (Paris, Bibl. Nat., ms. lat. 17294, fol. 56); Missal of the Bishops of Paris (Paris, Bibl. de l'Arsenal, ms. 621, fol. 11), illuminated from 1427 to 1438. [For the Arsenal manuscript, see V. Leroquais, *Les Sacramentaires et les missels manuscrits des bibliothèques publiques de France*, Paris, 1924, III, p. 594.] Also, Breviary of Orgemont (Paris, Bibl. de l'Arsenal, ms. 660, fol. 169v), illuminated from 1484 to 1409; Bibl. de Rouen (Leber coll.), ms. 137, fol. 40v, beginning of the fifteenth century; Bibl. de Rouen (Martinville coll.), ms. 192, beginning of the fifteenth century. As an exception, the *Golden Legend* (Paris, Bibl. Nat., ms. fr. 244) dates from ca. 1500. [This theme receives further treatment in M. Schapiro, "'Muscipula diaboli,' the Symbolism of the Mérode Altarpiece," *Art Bulletin*, 27 (1945), pp. 182-187.]

72 Verses 547ff. [Gréban, *Le Mystère*, pp. 7off.] In Italy also, the shepherds gave presents (D'Ancona, *Sacre rappresentazioni*, I, p. 194).

73 Verses 4702ff. [Gréban, *Le Mystère*, pp. 6off.]

> *Bergier qui ha pannetière*
> *Bien cloant, ferme et entière,*
> *C'est un petit roy,*
> *Bergier qui ha pannetière. . . .*

(The shepherd who has a scrip
That closes well, is sturdy and whole,
He is a little king.
The shepherd who has a scrip . . . etc.)

74 Or at least the last years of the fourteenth century. The earliest example I know of the Adoration of the Shepherds (the shepherds are still completely in the background) is to be found in the Book of Hours (*Très Riches Heures*) of the Duke of Berry, at the Musée Condé, Chantilly, fol. 44v. [For an illustration, see M. Meiss, *The Très Riches Heures of Jean, Duke of Berry*, New York, 1969, pl. 40. Panofsky, *Early Netherlandish Painting*, I, p. 63 n. 3, points out earlier examples of the introduction of the shepherds to the scene of the Nativity.]

75 Usually three; sometimes, however, there are four or five. There are four at Chappes (fig. 29).

76 Galleria dell'Accademia, Florence.

77 Book of Hours (Paris, Bibl. de l'Arsenal, ms. 646), from the second half of the fifteenth century. The same detail appears in printed books; see Claudin, *Histoire de l'imprimerie*, II, p. 66.

78 Book of Hours (Paris, Bibl. de l'Arsenal, ms. 1189), fifteenth century.

79 Book of Hours (Bibl. de Rouen, [Leber Collection], ms. 3028, fol. 142). This is an admirable Flemish manuscript done at the end of the fifteenth century.

80 Credit is due to Cohen for bringing this example to light in his *Histoire de la mise en scène dans le théâtre religieux français du moyen âge*, p. 117. [See also M. Delbouille, "De l'intérêt des nativités hutoises de Chantilly et de Liège," *Mélanges d'histoire du théâtre du moyen-âge et de la renaissance offerts à Gustave Cohen*, Paris, 1950, pp. 75-84.]

81 Liturgical drama in the Bibliothèque d'Orléans. E. du Méril, *Les Origines latines du théâtre moderne*, Leipzig, 1897, p. 170.

82 See *L'Art religieux du XIIIe siècle en France*, 4th edition, pp. 216ff. [Eng. ed. Princeton, 1985.]

83 Window in the chapel of the Virgin, cathe-

dral of Evreux; window in the church of the Magdalene at Verneuil-sur-Avre (Eure), north aisle.

84 All these scenes fill the first window on the left and a part of the second. Some panels are not in their correct places.

85 The Miracle of the Loaves was shown in the twelfth century, and then was no longer used. [For the Miracle of the Loaves, see *Schiller*, I, pp. 164-167; for the other themes, see *Réau*, II, pt. 2: "La Femme adultère," pp. 324-325, and "La Samaritaine au Puits," pp. 322-324; *Schiller*, I, pp. 160-161, and pp. 159-160.]

86 The window in the church of the Magdalene at Verneuil, contemporaneous with that of Evreux, has the same subjects.

87 In the window at Evreux, at the moment of the Arrest of Christ in the Garden of Olives, the soldiers fall backward because of the power of the Saviour. The artists of the thirteenth and fourteenth centuries never represented this scene from the Gospel. It appeared in art because it was played in the theater (see Gréban and Michel). The same detail of the prostration of the soldiers occurs in the *Très Riches Heures* of Chantilly (fol. 142v), and in the window of the church of St.-Jean, in Elbeuf (end of the fifteenth century). In the *Valenciennes Passion* (Paris, Bibl. Nat., ms. fr. 15236, fol. 204 bis), a miniature represents the soldiers overcome by the word of Christ.

88 Window of the Woman Taken in Adultery at St.-Patrice, in Rouen (sixteenth century). A beautiful window at Caudebec-en-Caux shows both the Samaritan Woman and the Woman Taken in Adultery (sixteenth century).

89 To these new subjects can be added the appearance of Christ to his mother at the moment of his resurrection. This scene came into art toward the middle of the sixteenth century because it was woven into the plot of the Mystery plays at that time. Mercadé did not use it, but it is found in Gréban and Michel. In a window at Louviers (sixteenth century), two angels appear near the Virgin. In the *Passion* of Gréban, Christ is preceded by the Archangel Gabriel who announces to his mother the coming of her son.

90 The painting is in the Uffizi, Florence. [The Raising of Lazarus is treated in E. Mâle, "La Résurrection de Lazare dans l'art," *Revue des arts*, I (1951), pp. 44-52. See also *Schiller*, I, pp. 181-186; *Réau*, II, pt. 2: "La Résur-

rection de Lazare," pp. 386-391: Panofsky, *Early Netherlandish Painting*, pp. 320ff.]

91 Enamel of the Passion, in the Louvre. [See Marquet de Vasselot, "Les Emaux de Monvaërni au Musée du Louvre," *Gazette des beaux-arts*, 3 (1910), pp. 299-316, illus. p. 303; M. Gauthier and M. Marcheix, *Limoges Enamels*, London, 1962, p. 19.]

92 [Hours of Anne of Brittany (Paris, Bibl. Nat., ms. lat. 9474, fol. 111v), 1507. See L. Delisle, *Les Grandes Heures de la reine Anne de Bretagne et l'atelier de Jean Bourdichon*, Paris, 1913; D. MacGibbon, *Jean Bourdichon, A Court Painter of the Fifteenth Century*, Glasgow, 1933. For illustration, see Paris, Bibliothèque Nationale, *Heures d'Anne de Bretagne* (H. Omont, ed.), Paris, 1906, no. 30.]

93 [For an illustration of the Raising of Lazarus by Jan Joos van Calcar, church of St.-Nicolas, Calcar, see G. J. Hoogewerff, *De Noord-Nederlandsche Schilderkunst*, The Hague, 1936, II, fig. 217.]

94 This manuscript, which belongs to the collection of Baron Edmond de Rothschild, has been studied by P. Durrieu, "Les 'Belles Heures' du Duc de Berry," *Gazette des beaux-arts*, 35 (1906), pp. 265-292, illus. p. 285. The attribution to the Limbourg brothers is beyond doubt. [This manuscript was acquired by the Metropolitan Museum of Art, Cloisters Collection, in 1954. See New York, Metropolitan Museum of Art, *The Belles Heures of Jean, Duke of Berry, Prince of France* (introd. by J. Rorimer), New York, 1958; Paris, Bibliothèque Nationale, *Les Belles Heures de Jean de France Duc de Berry* (J. Porcher, ed.), Paris, 1953.]

95 [For an illustration of this scene on the left wing of Matsys' Pietà altarpiece, Musée Royale des Beaux-Arts, Antwerp, see L. van Puyvelde, *La Peinture flamande au siècle des Van Eyck*, Paris, Brussels, 1953, p. 315. Anderson, *Drama and Imagery*, pp. 108-109, points out that the scene of Herodias and the knife occurs in a British stained-glass window at Gresford (Denbigh).]

96 [For Masolino, see R. van Marle, *The Development of the Italian Schools of Painting*, The Hague, IX, 1928, chap. III, pp. 17-314, and fig. 184.]

97 Byzantine Gospel Books of the eleventh century published by Omont, *Evangiles avec peintures byzantines du XI siècle*, I, pls. 25 and 69. [H. W. Janson, *The Sculpture of Donatello* (Incorporating the Notes and Photographs of Jenö Lanyi), Princeton, 1963, p. 70, notes

that Herodias sits next to the king in the delivery scene in the mosaics of the dome of the Baptistery in Florence.]

98 See the drawing of the head in Du Cange, *Traité historique du chef de saint-Jean-Baptiste*, 1665, p. 135.

99 It is said in the *Meditations* that the table of the Last Supper was square. The author affirms that he had seen it at St. John Lateran. This detail could have passed from the *Meditations* into the Mystery plays.

100 At St.-Pierre, Louvain.

101 The "fèvre" and the "févresse" also figure in the *Mystère* in the Bibliothèque Sainte-Geneviève.

102 [For more on this theme, see *Schiller*, III, pp. 51-56; *Réau*, II, pt. 2: "L'Arrestation de Jésus," pp. 434-435.]

103 *Pèlerinage du Jésus-Christ* (Paris, Bibl. Nat., ms. fr. 823, fol. 226), 1393. At Livry (Calvados), there is a retable from the early fifteenth century in which the old woman figures. She raises her lantern at the moment when Judas kisses Christ. See A. Rostand, "Le Retable de Livry (Calvados)," *Revue de l'art chrétien*, 1914, pp. 81-85.

104 L. Dorez, *Les Manuscrits à peintures de la bibliothèque de Lord Leicester*, Paris, 1908, pl. XXVII. We see the wife of the "fèvre" forging the nails of the Passion; she appears again in the early fourteenth century in a miniature of the famous Psalter of Queen Mary. See G. Warner, *Queen Mary's Psalter, Miniatures and Drawings by an English Artist of the Fourteenth Century Reproduced from Royal Manuscript 2 B VII in the British Museum*, London, 1912, fol. 256. In France, the earliest example is found in the Hours of Yolande of Flanders (London, Brit. Mus., Yates Thompson ms. 27, fol. 70v), illuminated by Jean Pucelle. [See S. C. Cockerell, *The Book of Hours of Yolande of Flanders*, London, 1905, unnumbered pl. 4d.]

105 Cluny Museum, no. 4589; The Kiss of Judas.

106 La Fons-Melicocq, "Drame du XVIe siècle," *Annales archéologiques*, 8 (1848), pp. 269-274.

107 Mark 14:50-52: "And they all forsook him, and fled. And there followed him a certain young man, having a linen cloth cast about his naked body; and the young men laid hold on him: And he left the linen cloth, and fled from them naked."

108 Verses 12924ff. [Gréban, *Le Mystère*, pp. 250ff.] A miniature of the *Valenciennes Passion* (Paris, Bibl. Nat., ms. fr. 12536, fol. 204 bis) shows

the apostle pursued by the soldier who wrests his cloak from him.

109 See G. Duriez, *La Théologie dans le drame religieux en Allemagne au moyen âge*, Paris, n.d., p. 377.

110 [Dürer's Arrest of Christ, from the small woodcut Passion, is reproduced in W. Kurth, *The Complete Woodcuts of Albrecht Dürer*, New York, 1946, fig. 233; the Arrest from the engraved Passion is illustrated in E. Panofsky, *Albrecht Dürer*, Princeton, 1948, II, fig. 187.]

111 Hours of Etienne Chevalier (Chantilly, Musée Condé), below Christ before Pilate. [For illustration, see Sterling, *Etienne Chevalier*, pl. 15.]

112 In Turin. [For illustration, see C. Aru and E. de Geradon, *Les Primitifs flamands. I. Corpus de la peinture des anciens pays-bas méridionaux au quinzième siècle*, fasc. 5: *La Galerie Sabauda de Turin*, Antwerp, 1952, pp. 14-20, and pls. XXII-XL, especially pl. XXVII.]

113 Verses 22816ff. [Gréban, *Le Mystère*, pp. 298ff.]

114 Veronica, seen from the back, is in the foreground.

115 [Jan Mostaert, Triptych of Oultremont, painted ca. 1510 for the church of St.-Bavon of Haarlem (Brussels Museum). See H. Fierens-Gevaert, *La Peinture au Musée Ancien de Bruxelles*, Brussels, Paris, 1931, pls. LXVI, LXVII.]

116 At Ecouis (Eure), a fourteenth-century statue represents Veronica holding the veil on which the face of Christ is imprinted. This is one of the earliest examples that can be cited. [Cf. *Schiller*, II, pp. 78-79; *Réau*, III, pt. 3: "Véronique d'Edesse, de Jérusalem et de Soulac," pp. 1314-1317.]

117 [For the theme of the Resurrection, see H. Schrade, "Auferstehung Christi," *Reallexikon*, pp. 232-249.]

118 [Andrea da Firenze, 1366-1368; see E. Borsook, *The Mural Painters of Tuscany*, London, 1960, fig. 36.]

119 Window at St.-Saens. Hours of Pigouchet. [Philippe Pigouchet for Simon Vostre, *Heures à l'usage de Rome*, Paris, 1498. See P. Lacombe, *Livres d'heures imprimés au XVe et au XVIe siècle, conservés dans les bibliothèques publiques de Paris*, Paris, 1907, cat. nos. 59, 64.]

120 [For the Pentecost of Bourdichon (Paris, Bibl. Nat., ms. lat. 9474, fol. 49v), see Delisle, *Les Grandes Heures de la reine Anne de Bretagne*, pl. 37.]

121 [The subject of angels in liturgical costume

is treated in J. Villette, *L'Ange dans l'art d'occident*, Paris, 1940, pp. 88ff.; see also J. B. McNamee, "Further Symbolism in the Portinari Altarpiece," *Art Bulletin*, 45 (1963), pp. 142-143, and *idem*, "The Origin of the Vested Angel as Eucharistic Symbol in Flemish Painting," *Art Bulletin*, 54 (1972), pp. 263-278.]

122 Wings of the altarpiece of St.-Bavon, Ghent. [For illustration, see Panofsky, *Early Netherlandish Painting*, pl. 150.]

123 Missal (Paris, Bibl. Nat., lat. ms. 8886, fol. 408), ca. 1380, perhaps. [Missal and Pontifical of Etienne Loypeau, datable before 1407. See Leroquais, *Les Pontificaux*, ii, p. 148.

124 I may say in passing that this is new proof of the place the theater held in the imagination of fifteenth-century artists. [See Cohen, "The Influence of the Mysteries on Art in the Middle Ages," pp. 339ff., for a discussion of this miniature. See also O. Fischel, "Art and Theater," *Burlington Magazine*, 66 (1935), pp. 4-14, 54-56; J. Gessler, "A propos d'un acteur dans le jeu de sainte Apolline," *Miscellanea Leo van Puyvelde*, Brussels, 1949, pp. 269-276. For an illustration of the Martyrdom of St. Apollonia, see Sterling, *Etienne Chevalier*, pl. 45.]

125 In 1474, when the *St.-Romain Mystery* was played in Rouen, the chapter lent, for the performance, and episcopal crozier, church ornaments, antunics for two children who played in Rouen, the chapter lent, for the performance, an episcopal crozier, church ornaments, and tunics for two children who *1474*, P. Le Verdier, ed., Rouen, 1886, p. lii). In 1519, the chapter of St.-Junien, in Limoges, lent all the ornaments it possessed for the presentation of the *Mystère de la Sainte Hostie* (*Bulletin du Comité des travaux historiques, section d'histoire et de philologie*, 1893). This was evidently a custom, and a custom which must have gone back far into the past.

126 There is a God with the triple tiara in a *City of God* (Paris, Bibl. Nat., ms. fr. 22913, fol. 408v), illuminated for Charles V, between 1371 and 1375; this is the earliest example that I know.

127 He is shown in this way in all the Missals (opposite the Crucifixion), until about 1380. [Cf., e.g., Leroquais, *Les Sacramentaires et les missels manuscrits*, pls. *passim*.]

128 Altarpiece of St.-Bavon, Ghent. [The precise identification of the upper central figure in the Ghent Altarpiece is still a matter of conjecture. See Panofsky, *Early Netherlandish*

Painting, i, pp. 214-215; L. B. Philip, *The Ghent Altarpiece and the Art of Jan van Eyck*, Princeton, 1971, pp. 51, 61-62, 76 and notes 148-149, 156.]

129 *Valenciennes Passion* (Paris, Bibl. Nat., ms. fr. 12536).

130 It will suffice to cite for the fifteenth century the window of the church of the Magdalene at Verneuil, and for the sixteenth, the window of St.-Alpin, at Châlons-sur-Marne.

131 L. Muratori, ed., *Rerum italicarum scriptores,* Milan, 1723ff., xii, p. 1018.

132 Nicola Pisano, on the pulpit in Siena (after 1266), had already sketched the procession of the magi.

133 A. d'Ancona, *Origini del teatro in Italia*, Florence, 1877, i, pp. 229ff.

134 [See G. Soulier, *Les Influences orientales dans la peinture toscane*, Paris, 1924, especially chap. vii: "La Representation des types orientaux," pp. 161ff.]

135 [Now in Bressanone; ca. 1417. For illustration, see van Marle, *The Development of the Italian Schools of Painting*, vii, fig. 167.]

136 Fresco in one of the domes of the cathedral of Cahors (fourteenth century). [See Y. Bonnefoy, *Peintures murales de la France gothique*, Paris, 1954, pl. 24.]

137 Historiated Bible of Guyart Desmoulins (Paris, Bibl. Nat., ms. fr. 15394, fols. 312v, 333, and 404v), end of the fourteenth century. [More recently dated ca. 1410-1415; see Paris, Bibl. Nat., *Les Manuscrits à peintures*, no. 172.]

138 The idea has been expressed by Roy, *Revue bourguignonne*, xiv, p. 436; see also A. Kleinclausz, *Claus Sluter et la sculpture bourguignonne au XVe siècle*, Paris, 1905, p. 368. [Cf. *Réau*, i, p. 260; H. David, *Claus Sluter*, Paris, 1951, pp. 82-83; D. Roggen, "De Kalvarieberg van Champmol," *Gentsche Bijdragen tot de Kunstgeschiedenis*, 3 (1936), pp. 31-85.]

139 The concordance is not absolutely perfect, because the Solomon of the Mystery does not appear at Dijon.

140 [For illustrations of the windows at Auch (ca. 1510, by A. de Moles), see M. Aubert *et al., Le Vitrail français*, Paris, 1958, figs. 178 and 184.]

141 [See J. Mellot, "A propos du théâtre liturgique à Bourges, au moyen âge et au XVIe siècle," *Mélanges d'histoire du théâtre du moyen âge et de la Renaissance offerts à Gustave Cohen*, Paris, 1950, pp. 193-198.]

142 Hours of Etienne Chevalier (Chantilly, Mu-

sée Condé). [For illustration, see Sterling, *Etienne Chevalier*, pl. 16.]

143 A miniature from this same *Valenciennes Passion* (Paris, Bibl. Nat., ms. fr. 12536, fol. 215bis) also represents a bishop not far from Pilate, who judges Christ. [For this manuscript, see above note 30.]

144 Window in the choir.

145 Missal (Paris, Bibl. Nat., ms. lat. 8886, fol. 451). However, the old tradition persisted for several more years; for example: *Golden Legend* (Paris, Bibl. Nat., ms. fr. 404, fol. 316), of 1404: St. Michael in combat wears the robe of an angel; Missal of Paris (Paris, Bibl. de l'Arsenal, ms. 622, fol. 297v) of 1426: St. Michael again wears an angel's robe, but this is one of the last examples. After 1440, St. Michael is almost always dressed as a knight; Missal (Paris, Bibl. de l'Arsenal, ms. 621, fol. 436), illuminated between 1439 and 1447. [See also *Réau*, II, pt. 1; "Saint Michel," pp. 44-49.]

146 [For an illustration of the St. Michael from the Last Judgement in the Campo Santo, Pisa, see E. Carli, *Pittura pisana del trecento*, Milan, 1958, I, pls. xv and 97. The polyptych by Orcagna (1357) is illustrated in Van Marle, *The Development of the Italian Schools of Painting*, III, pl. IX.]

147 [On the identification of these figures, see W. Stechow, "Joseph of Arimathea or Nicodemus?" *Studien zur toskanischen Kunst, Festschrift für Ludwig Heinrich Heydenreich*, Munich, 1964, pp. 289-303.]

148 Some examples, which could easily be multiplied, are: Roger van der Weyden, Descent from the Cross, in the Escorial [see above, note 21]; Master of Flémalle, Descent from the Cross, in Liverpool; Van der Meire, Entombment, Antwerp; Petrus Christus, The Deposition from the Cross, Brussels; School of Roger van der Weyden, Descent from the Cross, The Hague; Mabuse, Entombment, drawing in the Albertina, Vienna; Quentin Matsys, Entombment, Antwerp; Master of the Life of Mary, The Deposition from the Cross, Cologne; Schühlein, Entombment, panel of the Tiefenbronn Altarpiece; School of Schongauer, Entombment, museum of Colmar; Holbein the Elder, Entombment, Donaueschingen; Adam Krafft, Entombment, Nuremberg; Israel van Meckenem, Descent from the Cross, engraving; Ursus Graf, Entombment, engraving; Walter von Assen, Entombment, engraving.

149 Window in the Chapel of the Virgin, fif-

teenth century. Also a painting in the Louvre (Gallery of French Primitives).

150 [See Robb, "The Iconography of the Annunciation in the Fourteenth and Fifteenth Centuries," pp. 480-526.]

151 Verses 3431ff. [Gréban, *Le Mystère*, pp. 44ff.]

152 Hours of Etienne Chevalier (Chantilly, Musée Condé). This was perhaps the Ste.-Chapelle of Bourges. As early as 1360 or 1365, in the Breviary of Charles V (Paris, Bibl. Nat., ms. lat. 1052, fol. 352), the Virgin was shown seated in a chamber, reading before a lectern. [Leroquais, *Les Bréviaires*, III, p. 49, pls. XLIII-XLVII.] In the early fifteenth century, she was shown in a church: Hours of Louis of Savoy (Paris, Bibl. Nat., ms. lat. 9473, fol. 17) and Book of Hours (Paris, Bibl. Nat., ms. lat. 13264, fol. 50v). [For an illustration of the miniature from the Hours of Louis of Savoy, see Leroquais, *Les Livres d'Heures*, I, 293 and III, pl. LVI. For the Ste.-Chapelle, see R. Branner, *Saint Louis and the Court Style in Gothic Architecture*, London, 1965, pp. 56-85, and J. Evans, *Art in Medieval France 987-1498*, Oxford, 1952, pp. 194-198. For the Ste.-Chapelle of the Duke of Burgundy, see P. Quarré, *La Sainte-Chapelle de Dijon* (Musée de Dijon), Dijon, 1962.]

153 The French Mystery plays give no indications on this subject, but the light carried by Joseph is mentioned in the drama of the Nativity of Christ by the Austrian poet Edelpöck. Before the birth of Jesus, the Virgin asks Joseph to find a light: "Mein Joseph, gee bald und bring ein leichte" (v. 429: My Joseph, go quickly and bring a light). Edelpöck's drama was written during the second half of the sixteenth century and has been published by K. Weinhold, *Weihnacht: Spiele und Lieder aus Süddeutschland*, Graz, 1855. In the thirteenth century, it was known in France that Joseph carried a candle at the moment of the Nativity. The poet Geufroi, of Paris, in his *Bible des sept états du monde*, has the Virgin waking Joseph at the moment of the Nativity and asking him to light a candle:

> Or sus, fait-elle, sans respit,
> Et feu et chandelle allumez
> (Come now, she said, without delay,
> And light a fire and candle.)

Notices et extraits des manuscrits de la Bibliothèque Nationale et autres bibliothèques, 39 (1929), pt. 1, p. 284. [For more on this theme, see Cornell, *Iconography of the Na-*

tivity of Christ, p. 13; Panofsky, *Early Netherlandish Painting*, p. 409; Meiss, "Light as Form and Symbol in some Fifteenth Century Paintings," *Art Bulletin*, 27 (1945), pp. 175-181.]

154 Germany could give us numerous examples of this detail because there the Agony of Christ in the Garden of Olives had taken on funereal significance. It was represented endlessly on gravestones and in cemeteries.

155 It is still found in the work of Le Petit Bernard, engraver of the mid-sixteenth century, who was however under the Italian influence of Fontainebleau. [See pp. 414-416.]

156 [For the iconography of the *Noli me tangere*, see *Réau*, II, pt. 2: "Apparition à Madeleine," pp. 556-559; *Schiller*, I, pp. 158-159; Panofsky, *Early Netherlandish Painting*, p. 22 n. 5. For the Magdalen and the theater, see below, pp. 73-74; also Cohen, *Etudes d'histoire du théâtre en France au moyen âge et à la Renaissance*, Paris, 1956, pp. 204-230.]

157 Historiated Bible (Paris, Bibl. Nat., ms. fr. 8561, fol. 186).

158 The window and the engravings are from the fifteenth century. [For an illustration of the *Noli me tangere* from Dürer's small woodcut Passion, see Kurth, *The Complete Woodcuts of Albrecht Dürer*, fig. 253.]

159 [For this theme, see *Réau*, III, pt. 1: "La Prédication de Saint Jean dans le désert," pp. 448-449.]

160 It is found from the fifteenth century on: Paris, Bibl. Nat., ms. lat. 1292, fol. 9.

161 The Rouen window was copied in the sixteenth century at Pont-Audemer, but the copy is not as good as the original.

162 [For Germain Pilon, see A. Blunt, *Art and Architecutre in France, 1500-1700*, Baltimore, 1954, pp. 98-102.]

163 *Valenciennes Passion* (Paris, Bibl. Nat., ms. fr. 12536, fol. 77v).

164 In the *Mystère de la Conception et Nativité de la Vierge* (Paris, Bibl. Nat., ms. rés. YF16), printed by Jean Petit by Geoffroy Marnef and Michel Le Noir, and illustrated by woodcuts, John the Baptist preaches from the rustic tribune we have described.

165 Collection of Baron Gustave de Rothschild. [As of 1954, collection of James de Rothschild, London; illus. Delisle, *Les Grandes Heures de la reine Anne de Bretagne*, pl. 61.] The same motif is to be found in a series of manuscripts illuminated by the pupils of Bourdichon. The motif passed from there into the Books of Hours printed in Paris,

which are closely linked with the School of Tours. The Bath of Bathsheba had been represented in the early fifteenth century, but without charm. See the Hours of Neville (Paris, Bibl. Nat., ms. lat. 1158, fol. 102), from about 1430.

166 [For representations of David, see *Réau*, II, pt. 1, pp. 254-256.]

167 [See Cohen, Etudes d'histoire du théâtre en France, pp. 60-70.]

168 Creizenach, *Geschichte des neueren Dramas*, I, pp. 357ff.

169 On this subject, see the book by H. Martin, *Les Miniaturistes français*, Paris, 1906.

170 This atelier is discussed in Mâle, *Art et artistes du moyen âge*, Paris, 1927, chap. III. [Cf. also the extensively illustrated paperbound edition, Paris, 1968 (series: *Images et Idées, arts et métiers graphiques*).]

171 On this subject, see J. Lafond, "Etudes sur l'art du vitrail en Normandie: Arnoult de la Point, peintre et verrier de Nemègue et les artistes étrangers à Rouen aux XVe et XVIe siècles," *Bulletin de la Société des Amis des Monuments Rouennais*, 1911, pp. 141-172. [For the influence of the *Speculum* on the iconography of the Tree of Jesse, see R. Ligtenberg, "De Genealogie van Christus," *Oudheidkundig Jaarboek*, 9 (1929), pp. 42-43; A. Watson, *Early Iconography of the Tree of Jesse*, London, 1934.]

172 A beautiful Book of Hours of the School of Rouen (Paris, Bibl. de l'Arsenal, ms. 416, fol. 7r). [See G. Ritter and J. Lafond, *Manuscrits à peintures de l'école de Rouen*, Rouen, Paris, 1913, pp. 55-56 and pl. LXIX.] Also, Paris, Bibl. de l'Arsenal, ms. 429, and Paris, Bibl. de l'Arsenal, ms. 635 (School of Rouen).

173 Rouen: St.-Godard (a most beautiful window done in 1506); St.-Vincent (window closely related to the miniatures); St.-Maclou; Elbeuf: church of St.-Etienne (Tree of Jesse from 1520, the best of St.-Etienne's windows); Bourg-Achard; Evreux: cathedral (Chapel of the Virgin); Bernay: church of Notre-Dame-de-la-Couture (1499); Pont l'Evêque: Verneuil (church of the Magdalen). The type became distorted as it moved away from Rouen. On the other hand, the influence of Rouen extended as far as the Somme (window of the Tree of Jesse in the church of Roye).

174 [This may refer to the Netherlandish engraver with the initials F vB. See M. Lehrs, "The Master FVB," *Print Collector's Quarterly*, 9 (1923), pp. 3-30, 149-166.]

175 *Gaistliche Usslegung des Lebes Jhesu Christi.*
The Italians also imitated Martin Schon-
gauer. I have seen a Christ appearing to the
Magdalene by Nicolas Rossex of Modena
which is clearly inspired by Schongauer's
engraving. [See A. M. Hind, *Early Italian
Engraving*, London, 1948, v, pt. 2, cat. no.
96, p. 133, and vi, pl. 685.]

176 In 1521. Lucas van Leyden also knew Schon-
gauer.

177 Not to mention Marcantonio Raimondi and
Campagnola.

178 Imitations of Dürer by our fifteenth-century
glass painters are frequent. There are almost
literal copies of the engravings at Brou,
Conches, and Les Riceys (Aube). There are
many others. Chapter iv, pt. 2, is devoted in
part to the influence of Dürer's Apocalypse
on our artists and particularly on our glass
painters. [See also J. Held, *Dürers Wirkung
auf die niederländische Kunst seiner Zeit*, The
Hague, 1931; Réau, "L'Influence d'Albert
Dürer sur l'art français," pp. 219-222. For
the influence of the engravings of Marcan-
tonio Raimondi on windows at Conches, see
Mâle, *Art et artistes du moyen âge*, 1968 edi-
tion (cf. above, note 173), pp. 222-223 (De-
scent from the Cross), and pp. 224-225 (Mar-
tyrdom of Ste. Foy).]

CHAPTER III

1 Yet, in a way, this grave Teaching Christ
remains the Triumphant Christ, because he
treads upon the adder and the basilisk. See
Mâle, *L'Art religieux du XIIIe siècle en France*,
4th ed., p. 61 [Eng. ed. Princeton, 1985].

2 [For the iconography of the Man of Sorrows,
see *Schiller*, ii, pp. 119-229; *Réau*, ii, pt. 2:
"Le Christ Souffrant," pp. 42ff.; S. Ringbom,
Icon to Narrative, Abo, Finland, 1965, chaps.
3-4: "From the Man of Sorrows to the
Deposition"; "The Suffering Christ," pp. 107-
171; Panofsky, *Early Netherlandish Painting*,
pp. 123-125. See also G. van der Osten, *Der
Schmerzensmann*, Berlin, 1935; W. Mersmann,
Der Schmerzensmann, Düsseldorf, 1952.]

3 [For a general discussion of the mystical
movement and its influence, see W. R. Inge,
Christian Mysticism (Bampton Lectures for
1899), 7th ed., London, 1933; E. Underhill,
Mysticism, 4th ed., New York, 1912; *Réau*,
i, pt. i: "La Mystique," pp. 267-277;
J. Huizinga, *The Waning of the Middle Ages*,
London, 1924.]

4 [For Gerson, see C. Nordenfalk, "Saint

Bridget of Sweden as Represented in
Illuminated Manuscripts," *De artibus opuscula,
op. cit.*, pp. 371-393, esp. pp. 388-389.]

5 [Machiavelli, *Discourses*, iii, 1: "In religious
bodies these renewals are also necessary, as
we see through the example of our religion,
which, if Saint Francis and Saint Dominic
had not brought it back toward its begin-
nings, would have entirely disappeared."
Machiavelli, *The Chief Works*, A. Gilbert, tr.,
Durham, N.C., 1965, p. 422. For the influence
of St. Francis of Assisi on art, see H. Thode,
*Der Heilige Franz von Assisi und die Anfänge
der Kunst der Renaissance in Italien*, Berlin,
1914; L. Gillet, *Histoire artistique des ordres
mendiants*, Paris, 1912; H. E. Goad, *The Fame
of St. Francis of Assisi*, London, 1929;
B. Knipping, *De Iconografie van de Con-
trareformatie in de Nederlanden*, i, Hilversum,
1939, pp. 201-206; R. Jullian, "Le franci-
scanisme et l'art italien," *Phoebus*, i (1946),
pp. 105-115.]

6 *Vita*, bk. iii, chap. xlii. [*The Life and
Revelations of St. Gertrude*, M. F. Cusack, tr.,
London, 1870, 3, chap. 34, p. 220.]

7 *Vita*, bk. iv, chap. xxvi. [Cusack, *St. Gertrude*,
2, chap. 11, p. 95.]

8 *Vita*, bk. xv. [*The Exemplar: Life and Writings
of Blessed Henry Suso*, A. Edward, tr.,
N. Heller, ed., Dubuque, Iowa, 1962, i, chap.
13, pp. 32-35. See also U. Weymann, *Die
seusesche Mystik un ihre Wirkung auf des
bildende Kunst*, Berlin, 1938.]

9 The *De Planctu Beatae Mariae* is rightly
rejected as a work of St. Bernard by the
authors of the *Histoire littéraire de la France*,
Paris, 1824-1906, iii, p. 224. As for the
Dialogue de la Vierge et de Saint Anselme on
the Passion, it was clearly written much later
than St. Anselm's time. St. Anselm himself
appears in it and has already been canonized.
The crown of thorns of the Sainte Chapelle
is also mentioned. See Migne, *P.L.*, 159, col.
271.

10 [*Analecta hymnica medii aevi*, G. M. Dreves
and C. BLume, eds., i-lv, Leipzig, 1886-
1892; H. A. Daniel, *Thesauri hymnologici
hymnarium*, i-ii, Leipzig, 1908-1909 (li-lii
of *Analecta hymnica*); F. J. Mone, *Lateinischen
Hymnen des Mittelalters*, i-iii, Freiburg, 1853-
1855; U. Chevalier, *Repertorium Hy-
mnologicum*, i-vi, Louvain, 1892-1920.]

11 In 1390-1395. The statutes of the Order are
preserved in Paris, Bibl. de l'Arsenal, ms.
2251.

12 This book is simply an adaptation of the *Meditations*, by the Pseudo-Bonaventura.

13 Migne, *P.L.*, 162, col. 562.

14 *Ibid.*, 158, col. 675.

15 *Ibid.*, 153, col. 761.

16 St. Bridget, *Revelationes*, Rome, 1628, I, p. 22. This passage was translated by Oliver Maillard and used in his *Histoire de la Passion*. [See Chapter II n. 64. See also the translation, W. P. Cumming, ed., *The Revelations of Saint Birgitta* (Early English Text Society, Original Series, no. 178), London, 1929. On the influence of St. Bridget on the arts, cf. Panofsky, *Early Netherlandish Painting*, p. 378; Nordenfalk, *St. Bridget of Sweden, op. cit.*, pp. 371-393; *Lexikon der Marienkunde*, K. Algermissen *et al.*, eds., I, cols. 799-808.]

17 Johannes Tauler, *Exercitata de vita et passione salvatoris nostri Jesu Christi*, Cologne, 1548, chap. XXIV. [See translation by A.P.J. Cruikshank, *Meditations on the Life and Passion of Our Lord Jesus Christ*, Westminster, 1906, pp. 183-198, hereafter cited as Tauler, *Meditations*.]

18 Maillard, *Histoire de la Passion*. This was the accepted number: "If the fifteen paternosters of the Rosary were recited every day for a year, they would add up to the number of the wounds of Christ (5475)." Johannes de Langheym, *De Rosario*, Moguntiae, 1495.

19 [Jean Quentin, *L'Orologe de dévotion*, printed by Etienne Jehannot, Paris, 1500 (?). See Graesse, *Trésor de livres*, V, p. 521.]

20 *Revelationes*, I, p. 22. Same detail in Tauler, *Meditations*, chap. 26.

21 *Meditations*, chap. LXXVIII, p. 333. Tauler, *Meditations*, chap. 33. [See Chapter I n. 61.]

22 Udalrich Pinder, *Speculum passionis domini nostri Jhesu Christi*, Nuremberg, 1507, fol. 44. [See Graesse, *Trésor de livres*, V, p. 298.]

23 Same detail in Jean Gerson, *Expositio in passionem domini*, in *Opera omnia*, E. DuPin, ed., Antwerp, 1706, III, pp. 1190ff.

24 Tauler, *Meditations*, chap. 36.

25 St. Bridget, *Revelationes*, I, p. 22.

26 Pinder, *Speculum*, fol. 62v.

27 Quentin, *Orologe de dévotion*.

28 *De Planctu Beatae Mariae* (attributed to St. Bernard). [See above, n. 9.]

29 Maillard, *Histoire de la Passion*, beginning.

30 *Méditations sur la Passion*, printed by the widow of J. Trepperel and J. Jehannot, Paris, ca. 1518. [See Davies, *Catalogue of a Collection of Early French Books in the Library of C. Fairfax Murray*, cat. no. 393.] From this also comes the title *Orologe*, given to the meditations on the Passion. The *Horologium passionale* (published perhaps by the Franciscans of Augsburg) also belongs to this genre: twenty-four images of the Passion correspond to the twenty-four hours of the day and night. Another, the *Precationes cotidianae* (unique copy in the Library of Heidelberg University), makes the days of the week correspond with the instruments of the Passion: On Sunday, one must meditate on the crown of thorns; on Monday, on the winding-sheet and the sponge; Tuesday, on the scourge, etc.

31 It seems evident to me, moreover, that the large wooden altarpieces carved in Flanders in the fifteenth and sixteenth centuries, were in origin only enlarged imitations of our ivory triptychs. For example, when we compare the ivory triptych of St.-Sulpice-du-Tarn, now in the Cluny museum, with the large Flemish altarpiece of Champdeuil, we are struck by the resemblances. In both, the Crucifixion is placed in the center and dominates the whole composition; at the left is Christ Carrying the Cross, and at the right, the Descent from the Cross. Below are analogous scenes of the Infancy (the Adoration of the Magi and the Presentation in the Temple are shown in the triptych; the Adoration of the Magi and the Nativity in the altarpiece). The style of architecture, the choice and disposition of the episodes are identical. Only the iconography differs, which is natural enough since the ivory is from the fourteenth century and the altar from the fifteenth. In the Flemish altars of Meignelay and Antwerp, in the Cluny museum, we recognize the French original at once. The Flemish sculptors, however, were not always faithful to this prototype. Many of their altarpieces (augmented by painted wings) are devoted entirely to the scenes of the Passion. These pictorial works, rich in small episodic figures—soldiers blowing horns, children riding sticks, knights with long-plumed helmets—have nothing to do with great art. They might be called toy-boxes. Nonetheless, people contemplated them with lively, childlike sympathy. It is possible that they had more effect on simple souls than the true masterpieces

32 Altarpieces of Lawarde-Mauger (Somme) and of Vignory (Haute-Marne).

33 In the Books of Hours. On this subject, see C. Urseau, *La Peinture décorative en Anjou du XVe au XVIIIe siècle*, Angers, 1918, pp.

12ff. [See e.g., Book of Hours (Paris, Bibl. de l'Arsenal, ms. 434), ca. 1485, illustrated in R. Limousin, *Jean Bourdichon*, Paris, 1954, fig. 187. For the iconography of the Carrying of the Cross, see *Schiller*, II, pp. 78-82; *Réau*, II, pt. 2: "Les Portements de croix allégoriques et collectifs," p. 467.]

34 The head and arms of Christ had already been disposed in this way in the fourteenth century. What is characteristic of the fifteenth century is the attitude of the rest of the body. [Cf. e.g., the Crucifixion in the Rohan Hours (Paris, Bibl. Nat., ms. lat. 9471), illustrated in P. Thoby, *Le Crucifix des origines au Concile de Trente, étude iconographique*, Paris, 1959, pl. CLI.]

35 [A Crucifixion with the Virgin and St. John, given by Louis XII in 1499 to the Cour de Echiquier of Normandy. See A. Michel, *Histoire de l'art*, Paris, 1909, IV, 2, p. 748.]

36 [For fifteenth- and early sixteenth-century French stained glass, see *ibid.*, IV, 2; L. Grodecki, *Vitraux de France du XIe au XVIe siècle; Catalogue de l'exposition du Musée des Arts Décoratifs*, Paris, 1953; H. Wentzel, *Meisterwerke der Glasmalerei*, Berlin, 1954; Aubert *et al.*, Le Vitrail français, esp. chaps. by J. Lafond: "De 1380 à 1500," pp. 179-212, "La Renaissance," pp. 213-256.]

37 However, F. de Mély, *Les Primitifs et leur signatures*, Paris, 1913, p. 24 and fig. 31, has pointed out an example. The Christ crowned with thorns had already been represented in the time of St. Louis on the cover of the Gospel Book of the Sainte Chapelle (Paris, Bibl. Nat., ms. lat. 8892). This isolated example was clearly influenced by the famous relic preserved in the Sainte Chapelle. [See *Réau*, II, pt. 2: "Le Couronnement d'épines," pp. 457-459.]

38 See J. Déchelette and E. Brassart, *Les Peintures morales du moyen âge et de la Renaissance en Forêz*, Montbrison, 1900, pl. VIII (Crucifixion). The St.-Bonnet fresco probably dates from about 1400. This type of Christ on the Cross appears frequently in the manuscripts of the early fifteenth century. See Rohan Hours (Paris, Bibl. Nat., ms. lat. 9471, fols. 10, 27, and 165v) and Book of Hours (Paris, Bibl. Nat., ms. lat. 924, fol. 30). [See Chapter I n. 70, and Leroquais, Les Livres d'heures, I, p. 39, pls. xx-xxii. For the frescoes of St.-Bonnet-Le-Château, see Bonnefoy, *Peintures murales de la France gothique*, pl. 57.]

39 For example, in the bas-relief of the Villeneuve-l'Archevêque. [For the ico-nography of the *Ecce Homo*, see *Schiller*, II, pp. 74-76; *Réau*, II, pt. 2, pp. 459-460; K.-A. Wirth and G. von der Osten, "Ecce homo," *Reallexikon*, IV, cols. 674-700; E. Panofsky, "Jean Hey's 'Ecce Homo': Speculations about its Author, its Donor and its Iconography," *Bulletin des musées royaux des beaux-arts*, 5 (1956), pp. 95-132; Ringbom, *Icon to Narrative*, chap. IV, pp. 142-170.]

40 [Calvary is the Latin word for skull (*calvaria*).]

41 This bas-relief is from the fifteenth century.

42 [See Museum of Arras, *Jean Bellegambe, le maître des couleurs*, Re. Genaille, ed., Arras, 1951.]

43 Many other significant examples could be cited. The seated Christ of Notre-Dame-d'Auxonne (Côte-d'Or) still wears attached to his belt the board studded with nails that wounded him at every step in climbing Calvary. An analogous detail is found in Spain in one of the large bas-reliefs surrounding the choir of the cathedral of Burgos. In the Hours of Pigouchet, the border drawings fairly often show the seated Christ waiting for the executioners to drill holes in the cross. See also the anonymous print of the fifteenth century reproduced here (fig. 46). [For the Pigouchet Hours, see Chapter II n. 122.]

44 [For the iconography of the seated Christ in Distress, see G. von der Osten, "Christus im Elend, ein niederdeutsches Andachtsbild," *Westfalen*, 1952, pp. 185ff.; *idem*, "Christus im Elend und Hergottsruhbild," *Reallexikon*, III, cols. 644ff.; *idem*, "Job and Christ," *Journal of the Warburg and Courtauld Institutes*, 16 (1953), pp. 153-158. See also *Réau*, II, pt. 2: "Le Christ, assis sur le Calvaire, attend son supplice," pp. 469-471; "Christus im Elend," *Lexikon der Marienkunde*, I, cols. 1138-1139.]

45 I am convinced that by the fifteenth century this figure of the seated Christ had already taken on symbolic meaning. At the beginning of his Passion, Albrecht Dürer represented a seated Christ with *feet and hands pierced*. As we have said, this is truly, a resumé of the entire Passion. He is the Man of Sorrows. This explains why it was possible very early to call this figure an *Ecce homo*, and even place the reed scepter in the hands. (There is an example of this at St.-Etienne in Beauvais, in which the reed, however, may be a modern addition.) This figure, whose original meaning began to be forgotten, seemed appropriate to represent no matter what event of the Passion. The name

ordinarily given it was the Man of Sorrows (*Dieu de pitié or Dieu pitieux*). [See Panofsky, *Dürer*, II, fig. 186, and I, pp. 139-145.]

46 [See C. Eisler, "The Athlete of Virtue. The Iconography of Asceticism," *De artibus opuscula*, *op. cit.*, pp. 82-97.]

47 Or it could be the head of a Christ Carrying the Cross.

48 [See above, n. 2.]

49 [The theme of the Mass of St. Gregory is discussed in *Schiller*, II, pp. 226-228; *Réau*, III, pt. 2: "La messe de Saint Grégoire," pp. 614-615; cf. also J. A. Endres, "Die Darstellung der Gregoriusmess im Mittelalter," *Zeitschrift für christliche Kunst*, 30 (1917), pp. 146-156; M. Vloberg, *L'Eucharistie dans l'art*, Grenoble, Paris, 1946, II, pp. 199-208; R. Berliner, "The Freedom of Medieval Art," *Gazette des beaux-arts*, 28 (1945), pp. 263-288; J. de Borchgrave d'Altena, "La Messe de Saint Grégoire, étude iconographique," *Bulletin des musées royaux des beaux-arts*, 8 (1959), pp. 3-34. See Dürer woodcut of 1511 in Panofsky, *Dürer*, II, fig. 183.]

50 *Acta Sanctorum*, March, II.

51 See R. Besozzi, *La Storia della basilica di Santa Croce in Gerusalemme*, Rome, 1750, p. 155. Another seemingly far more recent tradition would have it that the appearance had taken place in the church of St. Gregorio on the Celio. An inscription and a bas-relief recall this event. See X. Barbier de Montault, *Oeuvres complètes*, Poitiers, 1889-1894, VI, p. 235. In our fifteenth-century Books of Hours, we sometimes find another tradition. It was said that the vision took place in the Pantheon, which seems unlikely, since at the time of St. Gregory the Pantheon was not yet a church. In the contract made in Avignon between a priest and the painter Charonton (it has to do with the famous painting of Villeneuve-lès-Avignon), the vision of St. Gregory is placed in S. Croce in Gerusalemme. Completely ignoring chronology, the contract adds that St. Hugh, a Carthusian, must accompany St. Gregory. [For more on Charonton, see C. Sterling, *Le Couronnement de la Vierge, par Enguerrand Quarton*, Paris, 1939.]

52 There was, in fact, a subterranean chapel dedicated to St. Gregory the Great in S. Croce in Gerusalemme, and the painting we will discuss must certainly have hung there; see Besozzi, *op. cit.*, p. 65.

53 This painting was found recently in S. Croce in Gerusalemme; it is a Byzantine mosaic, 28 x 23cm, in a frame of gilded silver. It was copied exactly by Israel van Meckenem (fig. 50). The reliquary in which it is contained bears the inscription: *Fuit sancti Gregorii magni.* See A. Thomas, "Das Urbild der Gregoriusmesse," *Rivista di archeologia cristiana*, 10 (1933), pp. 51-70 (illustrated on p. 53, fig. 1).

54 This image, in fact, appeared in the East as early as the twelfth century. See Millet, *Recherches*, pp. 483ff.

55 Book of Hours (Paris, Bibl. Nat., ms. lat. 10528, fol. 19v), end fourteenth century.

56 Paris, Bibl. Ste. Geneviève, ms. 2705, fol. 20. The same number is found in an engraving: see J. W. Holtrop, *Monuments typographiques des pays-bas au XVe siècle*, The Hague, 1868.

57 Altarpiece of the Mass of St. Gregory in a chapel of the cathedral of Aix-la-Chapelle.

58 Book of Hours of the Illiers family (Paris, Bibl. de l'Arsenal, ms. 428, fol. 185). The same numbers occur in the printed Book of Hours for Poitiers use by Philippe Pigouchet for Simon Vostre, 1491. [See R. Limousin, *Jean Bourdichon*, Paris, 1954, p. 88; H. Bohatta, *Bibliographie der Livres d'Heures des XV. und XVI. Jahrhunderts* (2nd ed.), Vienna, 1924, p. 16, no. 374.]

59 This Christ is now in the Berlin Museum.

60 Christ is represented with his back leaning against the cross, as in the engraving by Israel van Meckenem (fig. 50). The Milan bas-relief is reproduced by A. Venturi, *Storia dell'arte italiana*, Milan, 1906 (2nd ed., 1967), IV, p. 589, fig. 469.

61 J. H. Roman, *Manuel de sigillographie française*, Paris, 1912, p. 180.

62 Hours of Marguerite de Clisson (Paris, Bibl. Nat., ms. lat. 10528, fol. 20). See also Hours of Jean de Montauban (Paris, Bibl. Nat., ms. lat. 18026, fol. 196v), a manuscript almost contemporaneous with the preceding. [Cf. Paris, Bibl. Nat., *Manuscrits à peintures*, pp. 110-111, no. 236.] In 1383, Philip of Burgundy bought from the painter Jean d'Orléans a painting representing "Our Saviour in the sepulcher and the angel supporting him"; Dehaisnes, *Documents et extraits divers*, II, p. 599.

63 The Man of Sorrows (*Christ de pitié*) at Ecos (Eure). [It is likely that the two angels raising a curtain reveal the image of the Holy Cross of Jerusalem, even though the engraving by Israel van Meckenem (fig. 50) does not show them. That they are shown in the oldest

copy, that of Giovanni Pisano, seems to prove it. They also appear in the Milan bas-relief which seems to be the most faithful copy of the original.]

64 In France, this theme of Christ placed between the Virgin and St. John is less frequent. We do find it, however; for example, the triptych of embroidery in the museum of Chartres. [For the Pietà by Bellini, see R. Palluchini, *Giovanni Bellini*, Milan, 1959, pl. VII. For the embroidered triptych from the museum of Chartres, see *Guide des musées de France*, Fribourg, Switzerland, 1970, p. 52.]

65 See the examples in H. Bouchot, *Les deux cents incunables xylographiques du Département des Estampes*, Paris, 1903, nos. 106, 107, 108, 109, 110, 111. According to Bouchot, these popular prints were originally from Lorraine, Champagne, and Picardy.

66 Netherlandish engraver during the end of the fifteenth and early sixteenth centuries. [For the Master S, see G. K. Nagler, *Die Monogrammisten*, Munich, 1850(?), IV, pp. 1082-1093, no. 3862; F.W.H. Hollstein, *Dutch and Flemish Etchings, Engravings and Woodcuts*, ca. 1450-1700 (XIII. *Monogrammists of the Sixteenth and Seventeenth Centuries*), Amsterdam (1956), p. 213, fig. 414.]

67 The Mass of St. Gregory's reached its greatest popularity in France in the late fifteenth and early sixteenth centuries. The subject is very frequent in the Books of Hours, both in manuscript and printed books: It is found fairly frequently in stained glass windows: at Ste.-Croix (Saône-et-Loire), Groslay (Val d'Oise), and Nonancourt (Eure). The Mass of St. Gregory was sometimes painted in fresco: church of L'Absie (Deux-Sèvres).

68 [For the iconography of the *Arma Christi*, see *Schiller*, II, pp. 184-197; *Réau*, II, pt. 2: "Les Instruments de la Passion," pp. 508-509; R. Berliner, "Arma Christi," *Münchner Jahrbuch der bildenden Kunst*, 6 (1955), pp. 35-152; *The International Style* (Walters Art Gallery), cat. no. 6, pp. 6-7, and pl. XVIII; cat. no. 125, pp. 122-123, pl. CIX.]

69 Book of Hours (Paris, Bibl. de l'Arsenal, ms. 228, fol. 15).

70 This expression is found in the inscription of the altarpiece at Aix-la-Chapelle, which we have already mentioned. [See above, n. 57.]

71 See Dreves, *Analecta Hymnica*, IV and V. See also the collection of Daniel, *Thesauri*, I and II (cf. above, n. 10). [See also Chevalier, *Repertorium Hymnologicum*.]

72 *Ibid.*, II, p. 215.

73 *Ibid*, II, p. 348.

74 They seem fairly recent. At St.-Patrice, in Rouen, a confraternity of the Passion was founded in 1374: the members in procession carried the instruments of the Passion. See *Société des bibliophiles normands*, Rouen, III, p. XXXVIII.

75 Also, a window at St.-Vincent, Rouen. Indulgence was gained by praying before these emblems; a manuscript in the Bibliothèque Nationale, Hours of Marguerite de Clisson (Paris, Bibl. Nat., ms. lat. 10528, fol. 19v), end of the fourteenth century, says: "He who contemplates *these arms* honoring the Passion, will gain six thousand years of true pardon."

76 Window of the Passion at Pleyben (Finistère), and at Moulins (Allier).

77 Left aisle, sixteenth-century window. Below are figures of saints.

78 In Daniel, *Thesauri*, II, p. 224.

79 There are other fragments of the same kind in *ibid.*, I, p. 336, and II, p. 355.

80 *Vita*, bk. II, chaps. IV and V. [Cf. the anonymous *Life of St. Gertrude the Great*, London, 1912, and Cusack, *St. Gertrude* (see above, n. 6).]

81 Book of Hours (Paris, Bibl. de l'Arsenal, ms. 650, fol. 111), late fourteenth century. [Cf. Meiss, *French Painting*, 1967, I, p. 311.] The examples from the fifteenth century are numerous. There are even Masses of the five wounds: Book of Hours (Paris, Bibl. Nat., ms. fr. 442, fol. 184), late fifteenth century; they occurred frequently in printed missals.

82 I have found a confraternity of the five wounds at Felletin (Creuse), which had a Mass said every Friday. There were many others.

83 On the pillar of the church of St.-Germain, in Argentan, we read that the pillar was given by Jean Pitard, who had founded a Mass of the Five Wounds (1488). On the devotion to the five wounds, see Barbier de Montault, *Oeuvres complètes*, VII. [See also, F. Saxl, "Pagan Sacrifice in the Italian Renaissance," *Journal of the Warburg and Courtauld Institutes*, 2 (1939), pp. 346-367; *Réau*, II, pt. 2: "Les cinq plaies," pp. 509-510.]

84 Book of Hours (Paris, Bibl. de l'Arsenal, ms. 650, 111) and Hours of Jean de Montauban (Paris, Bibl. Nat., ms. lat. 18026, fol. 196v), mid-fifteenth century. "You will not die on the day you say them with good heart" (the prayers of the five wounds). This explains

why the cult of the five wounds developed at the time of the great plagues.

85 See A. Lecler, *Etude sur les mises au tombeau*, Limoges, 1888, p. 10.

86 Engraving by Israel van Meckenem, Cabinet des Estampes, Ea 48.

87 [See K. Künstle, *Ikonographie der christlichen Kunst*, I, "Das Herz-Jesu-Bild," pp. 615-618.]

88 In W. Schmidt, *Die frühesten und seltensten Denkmäler des Holz-und-Metallschnittes*, Munich, Nuremberg, 1883-1884.

89 [See V. Gurewich, "Observations on the Iconography of the Wound in Christ's Side, with Special Reference to its Position," *Journal of the Warburg and Courtauld Institutes*, 20 (1957), pp. 358-362.]

90 *Image du Monde* (Paris, Bibl. Nat., ms. fr. 574, fol. 136v), ca. 135. [See Meiss, *French Painting*, 1967, I, p. 313.]

91 *Vitis mystica*, Migne, *P.L.*, 184, cols. 711ff. The *Vitis mystica* is not by St. Bernard, but by St. Bonaventura: See *S. Bonaventurae opera omnia*, Quaracchi, VIII, pp. 189-229, and X, p. 16.

92 [*The Works of Bonaventure*, José de Vinck, tr., Paterson, N.J., 1960, I, "Mystical opuscula," pp. 128-129. For the influence of the *lignum vitae* on aspects of devotional imagery of the fourteenth and fifteenth centuries, see F. Hartt, "*Lignum vitae in medio paradisi*, The Stanza d'Eliodoro and the Sistine Ceiling," *Art Bulletin*, 32 (1950), pp. 115-145, 181-218, esp. pp. 132ff.; R. L. Füglister, *Das Lebende Kreuz*, Zurich and Cologne, 1964.]

93 A cloistered nun of the Third Order of St. Francis, who died in 1309. [See *L'Autogiografia e gli Scritti della Beata Angela da Foligno*, M. C. Humani, tr., M. R. Pulignani, ed., Città di Castello, 1932, esp. pp. 312-323. See also *The Book of the Divine Consolation by the Blessed Angela da Foligno*, M. G. Steegmann, tr., New York, 1909.]

94 *Theology of the Cross*, Paris, 1598, pt. 2, chaps. II: 5, 7, and V: 1.

95 Paris, Bibl. de l'Arsenal, ms. 563, fol. 97, late fourteenth century; Paris, Bibl. Nat., ms. lat. 922, fol. 181, early fifteenth century; *Les Livres de la Bible Hystorians* (Paris, Bibl. Nat., ms. fr. 152, fols. 442, 468), early fifteenth century; Paris, Bibl. Nat., ms. fr. 400, fols. 13, 14), late fourteenth century; Book of Hours, use of Rennes (Paris, Bibl. Nat., ms. lat. 10551, fol. 142v), end of fifteenth century.

96 See Recueils Ea 5 rés. and Ea 16 in the Cabinet des Estampes, Paris, Bibliothèque Nationale. See also W. L. Schreiber, *Manuel de l'amateur de la graveur sur bois et sur métal au XV siècle*, Berlin, 1891-1911, I, pp. 104-106. The most curious example in this genre is from a beautiful manuscript Book of Hours in the library of Rouen (Martinville coll., ms. 183), ca. 1500. The Infant Jesus sits on the lap of his mother; he is nude, and his body appears to be covered with wounds as if he had already met death. The miniaturist meant to convey, as the inscription explains, that because of our sins, the Passion of Christ began with his birth. [See also P.-A. Lemoisne, *Les Xylographies du XIV et du XV siècle au cabinet des estampes de la Bibliothèque Nationale*, Paris and Brussels, 1927-1930, pp. 50, 72, 124, 129, 150, 158.]

97 [For the iconography of the "Fountain of Life," see W. von Reybekiel, "Der 'Fons vitae' in der christlichen Kunst," *Niederdeutsche Zeitschrift für Volkskunde*, 12 (1934), pp. 87-136; D. Roggen, "De 'Fons vitae' van Klaas Sluter te Dijon," *Revue belge d'archéologie de d'histoire de l'art*, 5 (1935), pp. 107-118; Vloberg, *L'Eucharistie dans l'art*, II, pp. 164ff.; P. Underwood, "The Fountain of Life," *Dumbarton Oaks Papers*, 5 (1950), pp. 43-138; *Réau*, II, pt. 2, p. 421; Panofsky, *Early Netherlandish Painting*, p. 216; J. Bruyn, "A Puzzling Picture at Oberlin: The Fountain of Life," *Allen Memorial Art Museum Bulletin*, Oberlin College, 16 (1958), pp. 5-17.]

98 [See L. D. Ettlinger, *The Sistine Chapel before Michelangelo*, Oxford, 1965, pp. 81-84; H. Appuhn, "Der Auferstandene und das Heilige Blut zu Weinhausen," *Niederdeutsche Beiträge zur Kunstgeschichte*, I (1961), pp. 73-139. The famous relic of the Holy Blood in Mantua is discussed in M. Horster, "Mantuae Sanguis Preciosus," *Wallraf-Richartz Jahrbuch*, 25 (1963), pp. 151-180.]

99 A. Leroux de Lincy "Poème sur le précieux sang," *Essai historique et littéraire sur l'abbaye de Fécamp*, Rouen, 1840, pp. 147-148.

100 C. L. Carton, *Essai sur l'histoire du Saint Sang depuis les premiers siècles du christianisme*, Bruges, 1850.

101 C. A. Dehaisnes, *La Vie et l'oeuvre de Jean Bellegambe*, Lille, 1890, p. 109.

102 E. Paccully, "Le retable d'Oporto, *Gazette des beaux-arts*, 18 (1897), pp. 196-204. P. Lafond, "L'art portugais," *Revue de l'art ancien et moderne*, 23 (1908), pp. 305-316, who proposed the attribution of the painting in Oporto to a Portuguese master, did not seem to have

known the article by Paccully. The painting has also been attributed to Bernart van Orley. [See L. Reis-Santos, *Masterpieces of Flemish Painting of the XV and XVI Centuries in Portugal*, Lisbon, 1962, pp. 79-80, pl. xxviii.]

103 See E. Wechssler, *Die Sage vom heiligen Gral*, Halle, 1898, pp. 115-116 n. 17, which gives a list (incomplete) of the churches in Europe that possessed drops of the Holy Blood. Another list, also incomplete, is found in Barbier de Montault, *Oeuvres complètes*, vii.

104 R. Koechlin and J. J. Marquet de Vasselot, *La Sculpture à Troyes et dans la Champagne méridionale au seizième siècle*, Paris, 1900, p. 364.

105 *Jesus*
Sibi nil reservat sanguinis.
Venite quotquot criminum
Funesta labes inficit,
In hoc salutis balneo
Qui se lavat mundabitur.

106 See Abbé Bergier, *Etude sur les hymnes du bréviaire romain*, Besançon, 1884, pp. 61ff.

107 Mass of the Five Wounds in the Missal of the Eremites of St. Augustine, August first, sequence dating from the fourteenth or fifteenth century; Daniel, *Thesauri*, ii, p. 230. See also in Dreves, *Analecta hymnica*, iv, p. 21, a fifteenth-century hymn on the same subject.

108 *Sanguis, animarum lavacrum, lava nos.*
Sanguis, piscina languentium, salva nos.
Sanguis, fons puritatis, irriga nos.
And further on: *Ut laventur stolae nostrae in sanguine tuo, te rogamus.* This Mass is found for the first time in Dom Le Hulle, *Trésor ou abrégé de l'histoire de la noble et royale abbaye de Fécamp*, 1684, published by Alexandre in 1893. The date of the office of the Precious Blood of Fécamp is not known, but it might very well date from the fifteenth century. [Cf. M. D. Chenu, "Sang du Christ," *Dictionnaire de théologie catholique*, A. Vacant *et al.*, eds., Paris, 1939, xiv, pt. 1, cols. 1094-1097.]

109 Window in the church of St.-Etienne, sixteenth century, badly damaged. [See L. Lefrançois-Pillion, "Le Vitrail de la Fontaine de Vie et de la Nativité de Saint-Etienne à l'église de Saint-Etienne de Beauvais," *Revue de l'art chrétien*, 53 (1910), pp. 367-378.]

110 Fresco of St.-Mexme (= St.-Maximin). This fresco belongs to the School of Tours, and I believe that it was done by an artist who had worked in the atelier of Jean Bourdichon.

111 Sixteenth-century window. [Illustrated in Vloberg, *L'Eucharistie dans l'art*, ii, p. 169.]

112 Painting in the museum. It is perhaps not amiss to recall in this connection that several drops of Christ's blood were preserved at St.-Maximin; it was said that it was brought by Mary Magdalene; see F. Collius, *De sanguine Christi*, Milan, 1617, p. 957. Thus, Provence also had its relic of the Holy Blood, and consequently it is not astonishing to find a Fountain of Life there.

113 Fresco in the chapel of the château, reproduced in J. C. Robuchon, *Paysages et monuments du Poitou*, Paris, 1890-1894, ii.

114 The window of the château of Boumois was sold some years ago and replaced with white glass. I made a useless trip to see it, and similar misadventures are becoming more and more frequent. My source for what I have said here is X. Barbier de Montault, "Le château, la terre, le prieuré et les chapellenies de Boumois," *Commission archéologique de Maine et Loire, répertoire archéologique d'Anjou*, 1858-1859, pp. 85-117, esp. pp. 99ff.

115 In 1855, a restoration completely changed the window of St.-Jacques, in Reims. This certainly had been a Fountain of Life as the inscription, pointed out in 1825 by Pavillon-Piérard, proves: *Jam lavasti fonte vivo. . . .*

116 The window of Boumois was quite similar to the window of Vendôme. Adam and Eve are also shown in the first basin (fig. 61), but instead of praying, the clergy and laymen undress and enter the lower basin.

117 One carries a phial of perfume, the other, clothed in her hair, sometimes holds the three loaves of bread (Dissais, Lille, Reims, St.-Antoine-du-Rocher).

118 This is what the meager verses at Chinon say. See Comte de Galembert, "Mémoire sur les peintures murales de l'église Saint-Mesme de Chinon," *Mémoires de la société archéologique de Touraine*, 5 (1855), pp. 145-202, pl. 2. In the hexagonal chapel of the château of Dissais, all the frescoes seem to me to be related to the idea of redemption by the blood of Christ. Near the basin, besides Mary Magdalene and Mary of Egypt, we see Sts. Peter and Paul, who are considered as sinners; Christ has pardoned the one for having denied him, and the other for having persecuted him. Another fresco shows Eve committing the original sin, and in another we see King David, who in the Old Testament is the type of the repentant sinner.

We find an analogous composition from the seventeenth century. See L. H. Marsaux, "La Fontaine de Vie: étude sur une miniature," *Notes d'art et d'archéologie*, Paris, 1889-1892, 5 vols., see Dec., 1891. In the window at St.-Antoine-du-Rocher, St. Peter and St. Paul, St. John the Baptist and St. Anthony, the patron saint of the church, are placed beside Mary Magdalene and Mary of Egypt.

119 It was the same at Boumois.

120 Daniel, *Thesauri*; Dreves, *Analecta hymnica*; Mone, *Lateinischen Hymnen des Mittelalters*; F.W.E. Roth, *Lateinische Hymnen des Mittelalters*, Augsburg, 1887-1888; W.H.J. Weale and E. Misset, *Analecta Liturgica*, London, Lille, 1888-1892; P. Wackernagel, *Das deutsche Kirchenleid*, 5 vols., Leipzig, 1864-1867.

121 See especially A. Anglicus, *Destructorium vitiorum*, printed by Anton Koberger, Nuremberg, 1496, chap. XXII; also the *Lavacrum conscientiae*, Rouen, 1506, chap. XX, fols. 96-100v.

122 On the Mystic Wine Press, see L. H. Marsaux, *Représentations allégoriques de la Sainte Eucharistie*, Bar-le-Duc, 1898; X. Barbier de Montault, "Les mésures de dévotion," *Revue de l'art chrétien*, 32 (1881), pp. 408ff.; L. Lindet, "Les représentations allégoriques du moulin et du pressoir dans l'art chrétien," *Revue archéologique*, 36 (1900), pp. 403-413; J. Corblet, *Histoire du sacrement de l'Eucharistie*, Paris, 1886; F. de Lasteyrie, "Notice sur quelques représentations allégoriques de l'Eucharistie," *Mémoires de la Société Nationale des Antiquaires de France*, 39 (1878), pp. 82ff. [See also *Schiller*, II, pp. 228-229; *Réau*, II, pt. 2: "Le pressoir mystique," pp. 421-424.]

123 Walafrid Strabo, *Glossa ordinarium*, Numbers 13: 24; Migne, *P.L.*, 114, col. 403.

124 Isaiah 63:1-3: "Who is this that cometh from Edom, with dyed garments from Bozrah? This that is glorious in his apparel, traveling in the greatness of his strength? I that speak in righteousness, mighty to save. Wherefore art thou red in thine apparel, and thy garments like him that treadeth in the wine vat? I have trodden the wine press alone; and of the people there was none with me."

125 *Glossa ordinarium*, Isaiah 63: *Torcular scilicet crucem et omnia tormenta Passionis, in quibus, quasi prelo pressus ut etiam sanguis funderetur.* After St. Jerome. [Cf. Migne, *P.L.*, 113, cols. 1306-1307; Jerome commentary on Isaiah 63:3, Migne, *P.L.*, 24, col. 636: *Torcular calcavit Dominus virgini filiae Juda, idea ego ploro.*

126 *Primus botrus in torculari pressus est Christus*, St. Augustine, *Ennaratio in Psalmum LV*, Migne, *P.L.*, 36, col. 649.

127 For example, Petrus Venerabilis (Peter the Venerable), *Rythmus in laudem salvat*:

> *Uva dum premitur*
> *Vinum ejicitur,*
> *Et preli pondere*
> *Caro dum patitur*
> *Sanguis effunditur*
> *Sub crucis onere.*

Petrus Damianus, Rythmus 61, *De Maria Virgine*:

> *Ex te botrus egreditur*
> *Qui crucis prelo pressus*
> *Vino rigat arentes. . . .*

See also Dreves, *Analecta hymnica*, IV, p. 21, fifteenth-century hymn, and the series of prayers called the Fifteen Prayers of St. Bridget.

128 There exists a twelfth-century German miniature which represents Christ on the Cross; not far from the cross the Prophet Isaiah crushes grapes in a vat bearing this inscription: *Torcular calcavi solus*. See A. Bastard d'Estang, *Documents archéologiques*, Paris, Bibliothèque Nationale, Cabinet des Estampes, "Article Crucifix," fol. 28. But this reminder of the prophecy has only a slight relation to the Mystic Wine Press of the fifteenth century. A miniature in the *Hortus deliciarum* of Herrad of Landsberg (died 1195), formerly in Strasbourg, shows Christ pressing the grapes, while the apostles, the pope, bishops, and nuns carry the grapes to the press. [See G. Cames, *Allégories et symboles dans l'Hortus deliciarum*, Leiden, 1971. *Hortus Deliciarum*, fol. 241, illustrated on pl. lvii, fig. 103.] This was a first draft of the great sixteenth-century compositions. But the twelfth-century miniature lacks the ferocious realism of the later scene: Christ is not under the screw of the press and it is not his blood that flows into the vat. The difference is great. Barbier de Montault, "Les mésures de dévotion," pp. 408ff., pointed out a Mystic Wine Press in a fourteenth-century manuscript. According to him, this is a Bible in the Bibliothèque Nationale that is numbered 6. Evidently he refers to the Historiated Bible (Paris, Bibl. Nat., ms. fr. 6) which does in fact belong to the fourteenth century. I have looked through this volume carefully and found no representation of the press. It is certain that the motif goes back at least to the beginning of the fifteenth century. In

the inventory of Pope Nicholas V (1377-1455), a tapestry is mentioned which represents Christ under the press.

129 Historiated Bible (Paris, Bibl. Nat., ms. fr. 166, fol. 123v). The first part of the manuscript was illuminated about 1390 or 1400. The second part, a mediocre work belonging to the School of Tours, must have been illuminated shortly after 1500. The miniature of the press is found in the second part. [Cf. Paris, Bibl. Nat., *Manuscrits peintures*, no. 188.]

130 This is a relief from the sixteenth century. The upper part of the press has disappeared, but the holes for the pression screws can still be seen. The signature, Segogne, is not that of the sculptor, but of one of the panel's last owners. See E. Thoison, "Le pseudo-retable de recloses," *Annales de la Société Historique et Archéologique du Gatinais*, 18 (1900), pp. 1-17, illustration on p. 6.

131 Sixteenth-century painting. [For illustration, see Vloberg, *L'Eucharistie*, II, p. 177.] We can cite other Mystic Wine Presses: a tapestry at Notre-Dame-de-Vaux, in Poitou, represents it; Christ, lying in a tomb transformed into a pressing vat, is crushed by the cross and the column. See A. LeTouzé de Longuemar, *Anciennes fresques du Poitou*, Poitiers, n.d., p. 163. There are several Mystic Wine Presses on tombs. In the cloister of Corbie, before its destruction, there was a Mystic Wine Press below the tomb of Jean Du Mont. (See *La Picardie historique et monumentale*, pp. 445ff.)

132 *Ut plena sit redemptio*
 Sub torculari stringitur, etc.
The date of this hymn is not known, but in Dreves, *Analecta hymnica*, IV, p. 21, there is one dating back to the fifteenth century.

133 South aisle. The window dates from 1552.

134 All the glass is not of the same date; it was made in stages after a plan agreed upon in advance.

135 The engraving has all the characteristics of late sixteenth-century art. The analogy between the engraving and the window is almost perfect; only the verses inscribed below the scenes differ. [A. Linzeler, *Inventaire du fonds français*, Paris, 1932, II, p. 353: Jacques Lalouette (active in Paris, 1572-1587), *Le Pressoir de Nostre Sauveur Jesus Christ*, woodcut. *Réau*, II, pt. 2, p. 422, points out that the window of St.-Etienne-du-Mont was dedicated in 1622, a gift of a local wine merchant.]

136 One of these works has recently been recovered: a painted canvas discovered at Reims in 1920. It is almost exactly like a window at St.-Etienne-du-Mont and is much earlier, because it dates from the first part of the sixteenth century. Thus, the theme must have existed before the Reformation, but its great vogue was contemporaneous with the religious struggles of the sixteenth century. Without any doubt, it was seen as a refutation of Protestantism.

137 [H. Sauval, *Histoire et recherches des antiquités de la ville de Paris*, 3 vols., Paris, 1724.]

138 A. Bouillet, "Une église disparue: Saint-André-des-Arts," *Notes d'art et d'archéologie*, 2 (1890-1891), pp. 53-61.

139 The window of St.-Père at Chartres was the work of Jean Pinaigrier. There are still fragments of this window at St.-Père.

140 The window at Andrésy (Val d'Oise), which is unfortunately damaged, was conceived in almost the same way as that of St.-Etienne-du-Mont.

141 This detail is seen also in the windows at Conches and Andrésy.

142 This part of the window at St.-Etienne-du-Mont is damaged, but the engraving gives the entire scene.

143 The neighboring windows show some of these symbols.

144 See *L'Art religieux du XIIIe siècle*, 4th ed., pp. 171ff.

145 [For the Virgin of Sorrows, see *Réau*, II, pt. 2, pp. 102ff.]

146 St. Bridget, *Revelationes*, I, p. 35.

147 *Lavacrum conscientiae*, fol. LXXXI.

148 Suso, *Vita*, I, p. 414. [See above, n. 8.]

149 We are given some idea of the profundity of these feelings by reading in the Books of Hours the prayers devoted to the sorrows of the Virgin; for example: Book of Hours (Paris, Bibl. Nat., ms. lat. 10534, fol. 137), fifteenth century, or the Passion of the Virgin as told in her own words, Book of Hours (Paris, Bibl. Nat., ms. lat. 1352, fol. 199), late fourteenth century.

150 *Sacr. concil. nova et ampliss. collectio*, Venice, 1785, 28, col. 1057. [Cf. S. Beissel, *Geschichte der Verehrung Marias in Deutschland während des Mittelalters*, Freiburg-im-Breisgau, 1909 (new ed., Darmstadt, 1970), p. 407 n. 3.]

151 Paris, Bibl. Nat., ms. fr. 400. An approximate date is indicated by the military costumes; see the St. Eustache on fol. 32.

152 An account of the origins of the devotion of the Seven Sorrows, under the title "La Vierge

aux sept glaives," appeared in the *Analecta Bollandiana*, 12 (1893), pp. 333-352. This account is very interesting, but it contains some errors, the most grave being the statement that there is no mention of any of the Seven Sorrows of the Virgin before the end of the fifteenth century. The author is mistaken by a century. [J. Baltrusaitis, "Cercles astrologiques et cosmographiques à la fin du moyen-âge," *Gazette des beaux-arts*, 21 (1939), pp. 65-84; *Réau*, II, pt. 2, pp. 108-110. Cf. Walters Art Gallery Catalogue, *International Style*, no. 119, on the Crucifixion panel.]

153 [Luke 2:35: "Yea, a sword shall pierce through thine own soul also."]

154 A miniature represents the Virgin surrounded by emblems which summarize the entire Passion: for example, a column and a scourge with the inscription *Pretorium Pilati*; a cross, a lance, and a sponge with the inscription *locus Calvariae*, etc. This motif reappears in fifteenth-century woodcuts.

155 Collection of prayers to the Virgin (Paris, Bibl. Mazarine, ms. 520, fol. 53), ca. 1380-1390.

156 However, in the later lists, Christ Carrying the Cross is usually given this place.

157 In *Les Louanges de Notre-Dame*, an undated incunabulum, printed by Michel Le Noir.

158 Christ Carrying the Cross and the Flight into Egypt are placed in the same panel.

159 Analogous works must have been frequent in France. In 1515, a painter of Marseille named Etienne Peson made an altarpiece on which the Seven Sorrows are painted. L. Barthélemy, "Documents inédits sur les peintres et les peintres-verriers de Marseilles de 1300 à 1500," *Bulletin archéologique du comité des travaux historiques et scientifiques*, 1885, p. 388.

160 Collection of prayers to the Virgin (Paris, Bibl. Mazarine, ms. 520, fol. 58v).

161 *Analecta Bollandiana*, pp. 333-352.

162 *Quodlibetica decisio perpulchra de septem doloribus*, Antwerp, n.d., and *Miracula confraternitatis septem dolorum*, Antwerp, 1510. These two are united in a single volume in Paris, Bibl. Mazarine, Incunabulum no. 1173. The confraternity had been approved by the pope in 1495. Are the engravings ornamenting these books really the earliest to show the image of the Virgin pierced by the seven swords?

163 H. Gaidoz, "La Vierge aux sept glaives," *Mélusine*, 6 (1892-1893), pp. 126-138, claimed that the Virgin of the Seven Swords derived from an image of the Goddess Ishtar surrounded by a trophy of arms. This is an exercise of imagination that has nothing to do with reality.

164 Miniature in the Book of Hours of Perrenot de Granvelle (London, Brit. Mus., add. ms. 21235), 1532; see J. Gauthier, "Le Livre d'heures du chancelier Nicolas Perrenot de Granvelle au British Museum," *Réunion des sociétés des beaux-arts des départements*, 20 (1896), pp. 104-109. See also miniature in the Gospel Book of the Celestines of Amiens (Paris, Bibl. de l'Arsenal, ms. 625, fol. 171v).

165 From the late sixteenth century.

166 For example, collection of prayers to the Virgin (Paris, Bibl. Mazarine, ms. 520, fol. 53).

167 [For the iconography of the Pietà, see *Schiller*, II, pp. 179-181; *Réau*, III, pt. 2, pp. 103-108; Beissel, *Geschichte der Verehrung Marias*, pp. 398ff. See also W. Körte, "Deutsche Vesperbilder in Italien," *Jahrbuch der Biblioteca Hertziana*, 1 (1937), pp. 3-138; T. Müller, *Sculpture in the Netherlands, Germany, France and Spain*, Baltimore, 1966, pp. 39ff. (with bibliography); Kunstle, *Ikonographie der christlichen Kunst*, 1, pp. 483-486.]

168 A relief at Vernou, in Touraine, which seems to be the copy of a miniature, could go back to 1460; see P. Vitry, *Michel Colombe*, Paris, 1901, p. 84. The archbishop Jean de Bernard must have had this altarpiece carved between 1455 and 1464. [There is evidence that in 1388 the Duke of Burgundy commissioned a Pietà from Perrin Denys, a sculptor living in Paris. See J. B. Ford and G. S. Vickers, "The Relation of Nuno Gonçalves to the Pietà from Avignon, with a Consideration of the Iconography of the Pietà in France," *Art Bulletin*, 21 (1939), p. 9, and see G. Troescher, *Claus Sluter*, Freiburg-im-Breisgau, 1932, pp. 62-65; A. Liebreich, *Recherches sur Claus Sluter*, Brussels, 1936, pp. 170ff.; G. Troescher, "Die 'Pitié-de-Nostre-Seigneur' oder 'Notgottes,'" *Wallraf-Richartz Jahrbuch*, 9 (1936), pp. 148-149; K. Gerstenberg, "Zur Niederländischen Skulptur des 15 Jahrhunderts," *Oudheidkundig Jaarboek*, 3 (1934), pp. 12-15; Müller, *Sculpture in the Netherlands*, p. 49.]

169 There are other dated Pietàs, but they are from the sixteenth or seventeenth centuries.

170 *Quodlibetica decisio perpulchra* (Paris, Bibl. Mazarine, incunabulum 1173).

171 Rohan Hours (Paris, Bibl. Nat., ms. lat. 9471, fol. 41); Hours of Jean de Montauban (Paris,

Bibl. Nat., ms. lat. 10826, fol. 9); Hours of the Ango family (Paris, Bibl. Nat., ms. nouv. acq. lat. 392, fol. 145v). [See further E. Panofsky, "Reintegration of a Book of Hours executed in the Workshop of the 'Maitre des Grandes Heures de Rohan,' " *Medieval Studies in Honor of A. Kingsley Porter*, Cambridge, Mass., 1939, II, pp. 479-499, esp. p. 491.]

172 For example, Rohan Hours (Paris, Bibl. Nat., ms. lat. 9471, fol. 131).

173 St. Bernardine of Siena, *Opera Omnia*, Paris, Lyons, 1536, I, Sermon 51. [See also G. Firestone, "The Sleeping Christ-child in Italian Renaissance Representations of the Madonna," *Marsyas* 2 (1942), pp. 43-62, and Panofsky, "Reintegration of a Book of Hours," p. 491.]

174 St. Bridget, *Revelations*, bk. I, chap. 10.

175 Ludolf of Saxony, *Vita Christi*, Paris, 1498, pt. II, chap. 65, no. 5. [For modern edition, see L. M. Rigollot, Paris, 1870.]

176 Sometimes, conforming with the text of the *Meditations* (chap. LXXXII, p. 342), the Virgin looks at the face of her son and cannot restrain her tears when she sees that his hair has been chopped off and his beard pulled out. In fact, the *Grandes Heures* of the Duke of Berry (fig. 20) shows, on the lap of his mother, a Christ whose hair and beard have been pulled out. And there are other examples. [For a discussion of the attribution of this Pietà to the master of the St. Martha in the Madeleine at Troyes, see Müller, *Sculpture in the Netherlands*, p. 190.]

177 This *contentio miserabilis* is found in all the writings of the fourteenth- and fifteenth-century mystics. See *De Planctu Mariae*; Pinder, *Speculum passionis*, fol. 64; Gerson, *Expositio in Passionem*; *L'Orologe de dévotion*; Tauler, *Meditations* (chap. 54, p. 432), etc.

178 St. Bonaventura, "*De natura distinctionis inter caritatem et gratiam sanctificantem*," 48, dub. 4. [See Chapter 1 n. 61.]

179 For example at Neuville-les-Decize (Nièvre).

180 Pietà at Chalon-sur-Saône (Saône-et-Loire), chapel of the hospital.

181 Moreover, this is not the only formula found in Champagne. Sometimes one also sees a Virgin who gently raises the left arm of her son, as if she wished to press it to her breast or to take it to her lips. For example, at Brantigny, and at St. Aventin (Aube).

182 Windows at Bérulles, Longpré (fig. 68), and Nogent-sur-Aube. Sculptured groups: Les Noé (Aube, St.-Phal, St.-Nizier in Troyes).

183 The Virgin of the Pietà was very often a funeral motif in the fifteenth century. From it, people took courage to endure the loss of the beloved dead.

184 Book of Hours of Isabeau of Bavaria. [Cf. L. Delisle, *Le Cabinet des manuscrits*, Paris, 1868, I, pp. 49-50.]

185 Window at Herbisse (Aube); tapestry in the treasury at Sens; sculptured groups at St.-Pierre-le-Moutier (Nièvre), Jailly (Côte-d'Or), St.-Ayoul at Provins; altarpiece at Ternant (Nièvre). This is a Flemish work: the Magdalene wringing her hands is imitated from Roger van der Weyden; numerous examples in the Books of Hours and the engravings of the fifteenth century. [For the Jailly group, dated 1557, see H. David, *De Sluter à Sambin*, Paris, 1933, II: "La Renaissance," p. 393, fig. 124.]

186 In the Pietà at Ahun, the two aged men do not appear.

187 St. Bridget.

188 [For the iconography of the Holy Sepulcher, see *Schiller*, II, pp. 181-184 and *Réau*, II, pt. 2: "L'ensevelissement dans le Saint-Sépulcre," pp. 522-524. See also N. C. Brooks, *The Sepulchre of Christ in Art and Liturgy*, University of Illinois, 1921; R. Krautheimer, "Introduction to an 'Iconography of Medieval Architecture,' " *Journal of the Warburg and Courtauld Institutes* 5 (1942), pp. 1-33; Forsyth, *The Entombment of Christ*, pp. 8ff.]

189 A. Couret, *Notice historique sur l'ordre du Saint-Sépulcre de Jérusalem*, 2nd ed., Paris, 1905.

190 A. L. Millin, *Antiquités nationales ou receuil de monuments*, Paris, 1790-1796, III, pt. 4, has left a very precise description of the chapel in the Rue St. Martin, which he had seen before its demolition. If there had been an Entombment in the aedicula of the Sepulcher, he would not have failed to mention it.

191 In the church of the Temple, in Paris, there was also a vault representing the Holy Sepulcher in which an Entombment was installed, but only at the end of the fifteenth century. See H. de Curzon, *La Maison du Temple de Paris*, Paris, 1888, p. 90.

192 See J. du Breul, *Le Théâtre des antiquités de Paris*, Paris, 1612, p. 536.

193 L. E. Marcel, *L'Ancien Sépulcre de la cathédrale de Langres*, Langres, 1918.

194 The dead Christ preserved in the convent of the Annonciades of Langres does not belong to this Entombment, no matter what

has been claimed; it is a seventeenth-century work.

195 The discovery of the Holy Sepulcher in Langres takes away much of the interest from the brochure in which Abbe Lecler claimed to establish that the earliest Holy Sepulcher with figures was carved in Limoges in 1421 by an Italian: A. Lecler, *Étude sur les mises au tombeau*, Limoges, 1888. He said that a widow from Limoges named Paule Audier, on her return from Jerusalem, had an Entombment made by an artist whom she had brought from Venice. The work was installed in the church of St.-Pierre-du-Queyroix, in 1421. Later it disappeared without leaving a trace. But there is an obvious error in the interpretation of the document, because if we return to the text we see that it deals not with an Entombment, but simply with a Holy Sepulcher modeled on that in Jerusalem. Here is the text: "In the year A.D. 1421, Paule Audier of Limoges, returning from a pilgrimage to Jerusalem and passing through Venice, brought with her a sculptor who carved and furnished the design (*le dessin*) of the *monument of Our Saviour, in the likeness of his sepulcher in Jerusalem*, which he made and placed in the church of St.-Pierre of Limoges." (*Bulletin de la société archéologique de la Corrèze*, XIV, p. 196.) This form of devotion was long held in honor. In several churches, notably at Tournai and at St.-Nicholas, in Troyes, there were vaults or aediculae of exactly the same dimensions as those of the Holy Sepulcher in Jerusalem. These measurements seemed sacred and endowed with a mysterious virtue. Some pilgrims wore belts whose length had been measured by that of the Holy Sepulcher (Barbier de Montault, *Oeuvres complètes*, VIII, pp. 365ff.). Nevertheless, there had been an Entombment with figures in the church of St.-Pierre-du-Queyroix, because we know that the Entombment of the cathedral of Limoges was an imitation of it. But what was the date of the Entombment in the church of St.-Pierre? We do not know.

196 See V. Nodet, "Séance du 14 Juin," *Bulletin de la Société Nationale des Antiquaires de France*, 1905, pp. 238-240.

197 There is an Entombment dated 1433 in the cathedral of Fribourg in Switzerland. It conforms to the French Holy Sepulchers. [The Entombment at Tonnerre (Yonne) was executed between 1451 and 1454 by Jean Michel and Georges de la Sonnette. See G. Troescher, *Die burgundische Plastik des ausgehenden Mittelalters*, Frankfurt, 1940, p. 120; Müller, *Sculpture in the Netherlands*, p. 57, pls. 66, 67, A and B.]

198 [For more information on the Entombment in the abbey of Solesmes, dating from 1496, see *ibid.*, pp. 191ff., pls. 190, 191, A and B.]

199 Matthew 17:61: "And there was Mary Magdalene, and the other Mary, sitting over against the sepulcher."

200 Examples: Schühlein, wings of the altarpiece of Tiefenbronn; Entombment in the museum of Colmar (School of Schongauer); Hans Holbein the Elder, Entombment in Donaueschingen; Burial of Christ by Cranach, in the museum of Berlin; Flemish altarpiece at Ternant (Nièvre); Hours of the Dame of Lalaing (Paris, Bibl. de l'Arsenal, ms. 1185, fol. 204v), work of a Flemish miniaturist.

201 They are not by the same hand, as Koechlin and Marquet de Vasselot, *La Sculpture à Troyes et dans la Champagne méridionale*, p. 104, clearly saw. There are few Holy Sepulchers in which some of these inconsistencies are not present; almost always, several artists worked on them. The Holy Sepulcher of Tonnerre is the work of two sculptors.

202 At Eu (Seine-Maritime), for example. [This theme has received further treatment by D. Schorr, "The Mourning Virgin and St. John," *Art Bulletin*, 22 (1940), pp. 61-69.]

203 At Neufchâtel-en-Bray, in Normandy.

204 E. Delignières, "Les sépulcres ou mises au tombeau en Picardie," *Réunion des sociétés des beaux-arts des départements*, 30 (1906), pp. 33-69, has given very interesting statistics about the Holy Sepulchers preserved in Picardy.

205 Books of Hours (Paris, Bibl. Mazarine, ms. 521, and Paris, Bibl. Ste. Genevieve, ms. 2713, fol. 175v), fifteenth century.

206 An early author, speaking of a chapel in St.-Quentin where a Holy Sepulcher had been placed, said: "This chapel seems to attract great devotion, as much because of this representation (the Entombment) as because of its darkness." Cited by E. Fleury, *Antiquités et monuments de L'Aisne*, Paris, Laon, 1877-1882, IV, p. 239.

207 Lancelot de Buronfosse, the burgher of Tonnerre who gave the beautiful Entombment we have mentioned, was buried in the chapel where it was placed: Lecler, *Etude sur les mises au tombeau*, p. 11. At St.-Germain, in Amiens, a certain Dame Le Cat, the donor,

was buried beneath the Entombment (1522). We can still read on the border of the robe of one of the figures: *Fili Dei, miserere mei.*

208 [C. de Tolnay, "Renaissance d'une fresque," *L'Oeil*, Jan., 1958, pp. 36-41; U. Schlegel, "Observations on Masaccio's Trinity Fresco in Sta. Maria Novella," *Art Bulletin*, 45 (1963), pp. 19-33; P. Durrieu, "Une 'Pitié de Nostre Seigneur,'" *Monuments et mémoires, fondation Eugène Piot*, 23 (1918-1920), pp. 63-111.]

209 [Rohan Hours (Paris, Bibl. Nat., ms. lat. 9471). See Chapter 1, n. 70.]

210 St. Bridget.

211 Fernand de Mély attributes it to Henri Bellechose. [For this painting, see C. Sterling and H. Adhémar, *La Peinture au musée du Louvre, école français, XIVe, XVe, XVIe siècles*, Paris, 1965, cat. no. 8, pls. 21-25. For the iconography, see G. von der Osten, "Engelpietà," *Reallexikon*, v, cols. 601-621 (with bibliography).]

212 Genesis 27:33: "And he knew it, and said, It is my son's coat; an evil beast hath devoured him; Joseph is without doubt rent in pieces."

213 *L'Arbre de la croix de saint Bonaventura*, French translation published by Simon Vostre in the late fifteenth century.

214 *Vide an sit tunica filii tui annon.*

215 *Bestia pessima devoravit filium.*

216 However, there are some examples of this scene. At Barbery-St.-Sulpice (Aube), a window in grisaille represents it, and the inscription is the same as that of the Chapelle-St.-Luc painting: *Vide an sit tunica filii tui annon.* See C. Fichot, *Statistique monumentale du département de l'Aube*, Paris, Troyes, 1900, 1, p. 102. S. Reinach, "Notes de Voyage," *Revue archéologique*, 7 (1906), p. 352, cited a similar scene in a French manuscript now at Gotha. He viewed the miniature as related to the circular Louvre panel (fig. 83).

217 Missal of Angers (Paris, Bibl. Nat., ms. lat. 868, fol. 132v); Paris, Bibl. de l'Arsenal, ms. 1189, and Paris, Bibl. de l'Arsenal, ms. 1192, fol. 167.

218 Window at Kerfeunten (Finistère), in the lower part of the Tree of Jesse; window at St.-Saulge (Nièvre).

219 Bas-relief at St.-Pantaléon, Troyes, fairly late sixteenth century.

220 Albrecht Dürer. [See Panofsky, *Dürer*, pl. 185.]

1 [For the iconography of the Infancy of Christ, see Ringbom, *Icon to Narrative*, pp. 72-107. See also H. Wentzel, "Ad Infantiam Christi zu der Kindheit unseres Herren," *Das Werk des Künstlers. Studien zur Ikonographie und Formgeschichte, Herbert Schrade zum 60. Geburtstag dargebracht von Kollegen und Schülern*, Stuttgart, 1960, pp. 134-160.]

2 [For the iconography of the crèche, see R. Berliner, *Denkmäler der Krippenkunst*, Augsburg, 1925, and *idem, Die Weichnachtskrippe*, Munich, 1955.]

3 *Meditations*, chap. x, pp. 55-56. [See Chapter 1, n. 61.]

4 *Ibid.*, chap. xi, p. 56.

5 *Ibid.*, chap. xiii, p. 78 and chap. xii, pp. 69-76.

6 St. Gertrude, *Vita*, bk. ii, chap. xvi.

7 Daniel, *Thesauri*, ii, p. 342:

> *Parvum quando cerno Deum*
> *Matris inter brachia,*
> *Colliquescit pectus meum,*
> *Inter mille gaudia*

8 [Cf. e.g., G. de Deguilleville, *Trois Romans-Poèmes du XIVe siècle. Les pèlerinages et la divine comédie*, J. Delacotte, ed., Paris, 1932; see also Chapter ii, n. 25. For *Imitations*, see Thomas à Kempis, *Of the Imitation of Christ*, G. Cumberledge, tr., (The World's Classics), London, New York, 1955.]

9 For the iconography of the Throne of Solomon, see *Réau*, ii, pt. 1, pp. 293-294; A. D. McKenzie, *The Virgin Mary as the Throne of Solomon in Medieval Art*, i-ii (Ph.D. diss.) New York University, 1965; C. Michna, *Maria als Thron Salomonis* (diss.), Vienna, 1950; F. Wormald, "The Throne of Solomon and St. Edward's Chair," *Essays in Honor of Erwin Panofsky, De Artibus Opuscula*, pp. 532-539; I. H. Forsyth, *The Throne of Wisdom: Wood Sculptures of the Madonna in Romanesque France*, Princeton, 1972, pp. 24-30.]

10 [*Réau*, ii, pt. 2: "La Vierge de Tendresse," pp. 95-102 and 72-73, for examples of a tender and maternal Virgin in Byzantine art of the eleventh century and, even earlier, in Coptic art. See also below, n. 16.]

11 The Virgin of the cathedral of Langres (1341), and the marble Virgin of the collegiate church of Ecouis (Eure) also carry a half-nude Infant. These two Virgins are almost contemporaneous with that of Jeanne d'Evreux. See

L. Régnier, *L'Eglise Notre-Dame d'Ecouis*, Paris, Rouen, 1913, p. 156.

12 The nude Infant was frequently represented in the late fourteenth century: Book of Hours for use of Troyes (Paris, Bibl. Nat., ms. lat. 924, fol. 44). [See *Manuscrits à Peintures*, no. 311.]

13 Virgin of Belmont (Haute-Marne).

14 Virgin of Langres; Virgin of Notre-Dame du Marthuret, at Riom (Puy-de-Dôme). [See H. Friedmann, *The Symbolic Goldfinch, its History and Significance in European Devotional Art*, Washington, 1946. See also D. Shorr, *The Christ Child in Devotional Images in Italy during the XIV Century*, New York, 1954.]

15 [See pp. 154-155 for the significance of the Virgin nursing the Child; also *Réau*, II, pt. 2, p. 122.]

16 [For Egyptian connections, see M. Werner, "The *Madonna and Child* Miniature in the Book of Kells, Part I," *Art Bulletin*, 54 (1972), pp. 1-23, and fig. 3.]

17 In Paris, Bibliothèque Nationale. [Cf. ivories in *ibid.*, figs. 4 and 11.]

18 A little later, in 1271, the counter-seal of the Bishop of Clermont shows the Virgin giving suck to the Infant. A. Coulon, *Inventaire des sceaux de la Bourgogne*, Paris, 1912, p. XXXIX. [For Le Petit Quevilly fresco, see Bonnefoy, *Peintures murales de la France gothique*, pls. 2 and 3.]

19 A fresco at St.-Lizier (Ariège) dating from 1303 represents the Virgin giving suck to the Infant. B. Bernard, "Saint-Lizier," *Bulletin monumental*, 15 (1885), p. 592.

20 Virgin in wood at Voutenay (Yonne), the first part of the fourteenth century.

21 *Golden Legend* (Paris, Bibl. Nat., ms. fr. 404), from the time of Charles VI; Bible historiale of the Duke of Berry (Paris, Bibl. Nat., ms. fr. 20090). [Cf. *Manuscrits à peintures*, no. 128. For the iconography of this type, see Shorr, *The Christ Child in Devotional Images*, pp. 38-57, and I. Grabar, "Sur les origines et l'évolution du type iconographique de la Vierge Eleousa," *Mélanges Charles Diehl*, Paris, 1930, II, pp. 29-42.]

22 *Meditations*, chap. VIII, p. 44.

23 *Ibid.*, p. 44.

24 *Ibid.*, chap. X, p. 55.

25 Koechlin and Marquet de Vasselot, *La Sculpture à Troyes et dans la Champagne méridionale au seizième siècle*, p. 118.

26 [Cf. W. Pinder, "Zum Problem der 'Schönen Madonnen' um 1400," *Jahrbuch der preuszischen Kunstsammlungen*, 44 (1923), pp. 148ff., and Müller, *Sculpture in the Netherlands*, p. 38 n. 68.]

27 Book of Hours for use of Metz (Paris, Bibl. Nat., ms. lat. 1403, fol. 15). This, however, is the work of a mediocre artist. [Cf. *Manuscrits à peintures*, no. 101. The crown is a reference to the future coronation of the Virgin.]

28 Paris, Bibl. Nat., ms. lat. 10542, fol. 186, first part of the fifteenth century; Hours of Philip the Good (Paris, Bibl. Nat., ms. lat. 10538, fol. 27), ca. 1410. [Cf. *ibid., Manuscrits à peintures*, no. 199.]

29 Paris, Bibl. de l'Arsenal, ms. 636, fol. 154v, beginning of the fifteenth century.

30 Paris, Bibl. Ste.-Geneviève, ms. 1279, fol. 187, end of the fourteenth century.

31 [See M. Vloberg, *La Vierge et l'enfant dans l'art français*, Paris, 1954, esp. pp. 195-202.]

32 See especially Mone, *Lateinische Hymnen des Mittelalters*, II, pp. 184ff. and Daniel, *Thesauri*, I, p. 342. [See also Chevalier, *Repertorium Hymnologicum*, nos. 13211 and 13732 (II, pp. 208, 240).]

33 Mone, *op. cit.*, pp. 189ff.

34 St. Gertrude, *Vita*, bk. IV, chap. 50, v. 4. [For the Virgin and Child in an elaborately rendered garden setting, see P. Regamey, *Les plus beaux textes sur la Vierge Marie*, Paris, 1946, pp. 157ff.; *Réau*, II, pt. 2: "La Vierge au jardinet ou à la haie de Roses," pp. 100-102; E. M. Vetter, *Maria im Rosenhag*, Düsseldorf, 1956. For the closely related theme of the Madonna of Humility, see *Schiller*, I, pp. 47-48; G. G. King, "The Virgin of Humility," *Art Bulletin*, 17 (1935), pp. 474-491; M. Meiss, "The Madonna of Humility," *Art Bulletin*, 18 (1936), pp. 435-464; *Réau*, II, 2, pp. 97-99.]

35 Breviary of the Duke of Bedford (Paris, Bibl. Nat., ms. lat. 17294, fol. 56), Paris, 1424-1435, and Hours for the use of Paris (Paris, Bibl. Nat., ms. lat. 10545, fol. 66, mid-fifteenth century.

36 Hours of Philip the Good, called Hours of Joseph Bonaparte (Paris, Bibl. Nat., ms. lat. 10538, fol. 63), beginning of the fifteenth century.

37 Breviary of the Duke of Bedford (Paris, Bibl. Nat., ms. lat. 17294, fol. 56). [See Chapter II, n. 32.]

38 Hours for use of Paris (Paris, Bibl. Nat., ms. lat. 1379, fol. 58v), beginning of the fifteenth century.

39 Hours for use of Troyes (Paris, Bibl. Nat.,

ms. lat. 924, fol. 95), end of the fourteenth century. [Cf. *Manuscrits à peintures*, no. 311.]

40 Paris, Bibl. Ste.-Geneviève, ms. 1274, fol. 61, fifteenth century. A window at Epernay is of the same inspiration.

41 Book of Hours (Paris, Bibl. Ste.-Geneviève, ms. 2696, fol. 60), fifteenth century.

42 Montauban Hours (Paris, Bibl. Nat., ms. lat. 18026, fol. 55).

43 The stalls of Montréal date from 1522, but the motif of the Infant pushed in a wheeled carriage by angels is found from the fifteenth century on in our manuscripts: for example, Paris, Bibl. de l'Arsenal, ms. 655, fol. 20, beginning of the fifteenth century.

44 [For Christ in the carpenter's shop, see *Réau*, II, pt. 2: "L'Apprenti Charpentier," p. 287; see also *Réau*, III, pt. 2, pp. 759-760.]

45 Sixteenth-century window. See *Revue archéologique*, 10, pl. 228. The window of St. Aignan was obviously inspired by the engraving by Albrecht Dürer. [For Dürer's woodcut of the "Sojourn of the Holy Family in Egypt," 1501-1502, see Panofsky, *Dürer*, II, fig. 142.]

CHAPTER V

1 [For the iconography of saints in France at the end of the Middle Ages, see *Réau*, III, pts. 1, 2 and 3. See also Huizinga, *The Waning of the Middle Ages*, pp. 165-177.]

2 C. Dehaisnes, "L'art à Amiens vers la fin du moyen âge dans ses rapports avec l'école flamande primitive," *Revue de l'art chrétien*, 33 (1890), p. 33.

3 Now in the Louvre.

4 [For an art historical study of the pilgrimage road, see A. K. Porter, *Romanesque Sculpture of the Pilgrimage Roads*, I-X, Boston, 1923. See also V. and H. Hell, *The Great Pilgrimage of the Middle Ages*, New York, 1966.]

5 E. Thoison, *Saint Mathurin*, Paris, 1889, pp. 68ff.

6 M. Mallay, "La fête de Saint-Georges à Désertines," *Annales scientifiques, littéraires et industrielles de l'Auvergne* (Clermont-Ferrand), 22 (1849), pp. 231.

7 X. de la Perraudière, "Traditions locales et superstitions," *Mémoires de la société nationale d'agriculture, sciences et arts d'Angers*, 10 (1896).

8 Breviary of Charles V (Paris, Bibl. Nat., ms. lat. 1052, fols. 412v, 540 and 543v). [*Manuscrits à peintures*, no. 111.]

9 Book of Hours (Paris, Bibl. Mazarine, ms.

491, fol. 261). Here, however, St. George already wears the costume of a knight.

10 In the Hours of Etienne Chevalier, miniature in the Louvre. [Fouquet's St. Martin Dividing his Cloak is illustrated in Sterling, *Etienne Chevalier*, pl. 36. For representations of St. Martin, see also Tours, Musée des Beaux-Arts: *St. Martin dans l'art et l'imagerie, Exposition*, Tours, 1961.]

11 Left aisle, the first window after the entrance; St. Adrian is standing behind a personage who kneels before the Virgin.

12 In the Louvre.

13 First chapel on the right, before the transept. [At the Battle of Melegnano, on 13 and 14 September 1515, the French defeated the Swiss to regain a position of dominance in northern Italy.]

14 Hours of François de Vendôme (Paris, Bibl. de l'Arsenal, ms. 417). I have shown that this manuscript was by Bourdichon. [E. Mâle, "Jean Bourdichon et son atelier," *Gazette des beaux-arts*, 32 (1904), pp. 441-457. The Flight into Egypt is illustrated in Limousin, *Jean Bourdichon*, fig. 63.]

15 This statue came from the church of St.-Laurent, at Verneuil (Eure), and belonged to the carpenters' guild. See Abbé Dubois, *L'Eglise Notre-Dame de Verneuil*, Rennes, 1894, p. 87. There is a very similar statue at Esseintes (Gironde). [For the story of the flowering rod, see *Réau*, pt. 2, pp. 170-171.]

16 Visitation in the church of St.-Jean, at Troyes. [See Koechlin and Marquet de Vasselot, *La Sculpture à Troyes*, fig. 54, p. 140.]

17 Miniature in the Hours of Etienne Chevalier (Paris, Bibl. Nat., nouv. acq. ms. lat. 1416). [St. Anne and the Three Marys is illustrated in Sterling, *Etienne Chevalier*, pl. 44.]

18 Miniature in the Hours of Etienne Chevalier, at Chantilly, Musée Condé. [See above, n. 10. See also *Réau*, III, pt. 2: "Martin de Tours," pp. 900-917.]

19 [Cf. Müller, *Sculpture in the Netherlands*, p. 193.]

20 Now in St. Pantaléon. See Koechlin and Marquet de Vasselot, *La Sculpture à Troyes*, p. 336.

21 Examples: at Geraudot (Aube), window of St. Pierre, given by Pierre Martin (1540); at Romilly-St.-Loup (Aube), window of St. Nicholas, given by Nicholas Prunel (1519); at St.-Parre-les-Tertres (Aube), window of St. Nicholas, given by Nicholas Vinot, etc.

22 Triptych of the Dukes of Bourbon in the

sacristy of Moulins: Tullier window at Bourges, etc.

23 This window, in the church of St.-Laurent at Beauvais, dated 1516, was destroyed in 1798. An old description of it is given by L. E. Deladreue, "L'église collegiale de Saint-Laurent de Beauvais," *Mémoires de la société académique d'archéologie, sciences et arts du département de l'Oise*, 9 (1927), p. 145.

24 The gesture of the Virgin showing her breast, so frequent in the art of the late Middle Ages, seems to have been inspired, not by a passage from St. Bernard, but by the *De laudibus beatae Mariae Virginis* by Arnaud de Chartres, abbot of Bonneval in 1138. See P. Perdrizet, *La Vierge de miséricorde*, Paris, 1908, pp. 237ff. [For more on the "double intercession," wherein the Virgin shows her breast to her son, who in turn displays his wound to God the Father, see M. Meiss, "An Early Altarpiece for the Cathedral of Florence," *Metropolitan Museum of Art Bulletin*, 12 (1954), pp. 302-317.]

25 The Blainville window no longer exists. It was reproduced by Gaignières, Cabinet des Estampes Pe 8, fol. 4. [*Bibliothèque Nationale. Inventaire des dessins executés pour Roger de Gaignières*, H. Bouchot, ed., Paris, 1891, cat. no. 4157.]

26 This is a small funerary bas-relief.

27 Cathedral of Albi, paintings in the chapel of the Sainte-Croix (late fifteenth century).

28 *La revue du Maine*, 1900, p. 54, mistakenly calls this figure St. John the Baptist. The crucifix and the cardinal's hat prove that it is St. Jerome.

29 Schreiber, *Manual de l'amateur de la gravure sur bois et sur métal au XVe siècle*, II, no. 1548.

30 Cabinet des Estampes, Ed 5, réserve.

31 I wish to cite another curious window at Thennelières (Aube), in which François de Dinteville, bishop of Auxerre, is presented by his patron, St. Francis, to St. Jerome. [For studies of St. Jerome in art, see M. Meiss, "French and Italian Variations on an Early Fifteenth-Century Theme: St. Jerome and His Study," *Essais en l'honneur de Jean Porcher, Gazette des beaux-arts*, 61 (1963), pp. 147-170; *Réau*, III, pt. 2: "Jérôme," pp. 740-750.]

32 See L. A. Bosseboeuf, *Le Château et la chapelle de Champigny-sur-Veude*, Tours, n.d. The château of Champigny belonged to the Bourbons. [The Bourbon dynasty has been traced by A. Allier, *L'Ancien Bourbonnais*, I-IV, Moulins, 1934-1938.]

33 The windows must have been made between 1470 and 1485. There are beautiful reproductions of them in L. Bégule, *Vitraux du moyen âge et de la Renaissance dans la région lyonnaise*, Paris, 1911.

34 There are other figures of saints also: Sts. Nicholas, Martin, etc.—saints who were honored in all of France.

35 Unless she is St. Dorothea.

36 There is another saint who has only a book as her attribute, and whose name I do not know.

37 The chapel founded by Dunois dates from 1464. Dunois died in 1468. It seems clear that the two Sts. John are there to recall his Christian name (Jean, bâtard d'Orléans). The statue of Dunois in the chapel was originally on a gable of the château.

38 L. Coudray, *Histoire du château de Châteaudun*, Paris, 1871 (2nd ed.), pp. 32-33, 108-112. [For the French practice of burying the heart separately, see V. L. Goldberg, "Graces, Muses and Arts: The Urns of Henry II and Francis I," *Journal of the Warburg and Courtauld Institutes*, 29 (1966), pp. 206-218.

39 See C. Ouin-Lacroix, *Histoire des anciennes corporations d'arts et métiers et des confréries religieuses de la capitale de la Normandie*, Rouen, 1850.

40 See C. de Beaurepaire, *Nouveau recueil de notes historiques et archéologiques*, Rouen, 1888, p. 394.

41 P. A. Flouqet, *Histoire du privilège de Saint-Romain*, I, Rouen, 1833.

42 L. Gilbert, "Notes sur les confréries à Vire," *Bulletin de la société des antiquaires de Normandie*, 18 (1898), pp. 293-299, and A. Gasté, "Les confréries laiques et ecclésiastiques établies, avant la Révolution, dans l'église Notre-Dame de Vire," *Bulletin historique et philologique du comité des travaux historiques et scientifiques*, 1894, pp. 367-381.

43 Rance de Guiseuil, *Les Chapelles de Notre-Dame de Dôle*, Paris, 1902.

44 A. DeCaix, "Histoire du Bourg d'Ecouché (Orne)," *Mémoires de la société des antiquaires de Normandie*, 4 (1859), p. 499.

45 The important *mémoire* of E. Veuclin, *Recueil des travaux de la société libre d'agriculture, sciences, arts, et belles-lettres de l'Eure*, 1891, containing all the bibliography on the subject, should be cited first. See also the article by H. de Formeville, *Bulletin de la société des*

antiquaires de Normandie, 4 (1866), pp. 518-549, and that of C. Vasseur, "Le Registre de la Charité de Surville," *Mémoires de la société des antiquaires de Normandie*, 5 (1863), pp. 549-570.

46 M. A. Margry, "Notice sur deux anciennes maisons de Senlis, "*Mémoires du Comité archéologique de Senlis*, 3 (1877), p. 291.

47 B. Prost, "Notice historique sur les chevaliers de l'arquebuse de la ville de Poligny," *Bulletin de la société d'agriculture, sciences et arts de Poligny (Jura)*," 12 (1871), pp. 49ff.

48 *Mémoires de la société d'émulation d'Abbeville*, 1898-1900, p. 203.

49 A. Janvier, "Notices sur les anciennes corporations d'archers et d'arbalétriers des villes de Picardie," *Mémoires de la société des antiquaires de Picardie*, 14 (1856), pp. 259-260.

50 However, the archers of Châlons-sur-Marne had a painting made representing the victory they had won in 1431 near Châlons over the English and the Burgundians: A. Sellier, *Notice historique sur la compagnie des archers ou arbalétriers et ensuite des arquebusiers de la ville de Châlons-sur-Marne*, Châlons, 1857. [For the contribution of these paintings to the development of the group portrait, see A. Riegl, "Das holländische Gruppenporträt," *Jahrbuch der kunsthistorischen Sammlungen des allerhöchsten Kaiserhauses*, 23 (1902), pp. 70-278.

51 E. Veuclin, *Notes inédites sur les corporations artistiques en Normandie*, Paris, 1893, p. 10.

52 A. A. Chauvigné, *Histoire des corporations d'arts et métiers de Touraine*, Tours, 1885, p. 15.

53 L. Grignon, *L'ancienne corporation des maîtres cordonniers de Châlons-sur-Marne*, Châlons, 1883, p. 24.

54 C. Fichot, *Statistique monumentale du département de l'Aube*, i, p. 9.

55 Cabinet des Estampes, Re 13, fol. 69. This curious engraving belongs to the collection of images of the confraternities.

56 L. Barthélemy, "Documents inédits sur les peintres et les peintres-verriers de Marseille de 1300 à 1500," *Bulletin archéologique du comité des travaux historiques et scientifiques*, 1885, pp. 378-379, 407-409. [Villate, born in the diocese of Limoges, had collaborated with Enguerrand Quarton in Avignon in 1452.]

57 *Ibid.*, p. 390.

58 Canon Albenès, "Les arts à Toulon au moyen âge," *Bulletin archéologique du comité des travaux historiques et scientifiques*, 1897, pp. 36ff.

59 There are many curious texts in the two volumes of the *Bulletin* just cited.

60 [See H. Bouchot, *Les Primitifs français, Exposition des primitifs français*, Paris, 1904.]

61 At Rouen, the crossbowmen, who, by exception, venerated St. George, had given the church of St.-Sépulcre a life-size image of St. George on horseback: Ouin-Lacroix, *Histoire des anciennes corporations*, p. 479.

62 [For the St. Sebastian window at St.-Nizier at Troyes, see Aubert *et al., Le Vitrail français, 1380-1500*, pp. 179-213; esp. Lafond, "Renaissance," pp. 213-256 and fig. 169.]

63 Veuclin, *Recueil des travaux de la société de l'Eure*, p. 47.

64 Paris, Bibl. de l'Arsenal, ms. 2263, fol. 9v.

65 C. de Beaurepaire, *Mélange historique et archéologique concernant le départment de la Seine-Inférieure*, Rouen, 1897, p. 97.

66 E. Veuclin, "Artistes Normands," *Réunion des sociétés des beaux-arts des départements*, 16 (1892), p. 353.

67 Barthélemy, "Documents inédits," pp. 387 and 395.

68 See Abbé Gontier, *Saint-Martin de Laigle*, La Chapelle-Montligeon, 1896, p. 52. The windows of St. Porcien were paid for by the confraternity on 15 February 1557. [See *Réau*, iii, pt. 3: "Pourçain," pp. 1118ff.]

69 [*Réau*, iii, pt. 2: "Jacques le Majeur," pp. 690-702; E. Mâle, *Les Saints compagnons du Christ*, Paris, 1958, pp. 135-168; W. Starkie, *The Road to Santiago*, New York, 1957. See also, Mâle, *Religious Art of the Twelfth Century*, chap. viii.]

70 A. de Caix, "Histoire du Bourg d'Ecouché (Orne)," *Mémoires de la société des antiquaires de Normandie*, 4 (1859), pp. 531-535.

71 See P.C.E. Prarond, *Saint-Vulfran d'Abbeville*, Paris, Abbeville, 1860, p. 126.

72 E. de Beaurepaire, "Les fresques de Saint-Michel de Vaucelles," *Bulletin de la société des antiquairies de Normandie*, 12 (1884), pp. 643-674. The statutes of the confraternity date from 1446.

73 Veuclin, *Recueil des travaux de la société de l'Eure*, p. 47. The confraternity of St. Eustache had two other patrons, St. Sebastian and St. Lô.

74 P. J. Grosley, *Mémoires historiques et critiques pour l'histoire de Troyes*, Paris, 1811-1812, ii, p. 320. I see no reason to doubt that our St. Martha is the one Grosley speaks of. St.

Martha, symbol of the active life, was the natural patron of servants.

75 A. de Lamartine, *Geneviève; histoire d'une servante*, Paris, 1851.

76 On the gable of the church of St.-Pierre at Cholet (Maine-le-Loire), there is an escutcheon with three sheaves of wheat, probably the insignia of the confraternity which contributed from its funds to the reconstruction of the church: A. Manville, "Eglise Saint-Pierre de Cholet," *Bulletin monumental*, 62 (1897), p. 68.

77 C. Leymaire, "La sculpture decorative à Limoges," *Réunion des sociétés des beaux-arts des départements*, 19 (1895), pp. 579-587.

78 X. Barbier de Montault, *Régistre de la confrérie de Saint-Pierre à Limoges*.

79 F. de Guilhermy, *Inscriptions de la France du Ve siècle au XVIIe siècle*, Paris, 1883, V, p. 147.

80 Baron Cavrois, "L'Email de vaulx en Artois," *Réunion des sociétés des beaux-arts des départements*, 22 (1898), pp. 167-172.

81 Carved alms-box of Corbeil (Seine-et-Oise), 1388, belonging to the confraternity of Saint-Spire. See M. Laroche, "Notice sur un tronc portatif en cuivre appartenant à l'église Saint-Spire de Corbeil," *Commission des antiquités et des arts de Seine-et-Oise*, 1882, pp. 80-82.

82 R. de Lasteyrie, "Séance du 5 Avril 1893," *Bulletin archéologique du comité des travaux historiques et scientifiques*, Paris, 1893, p. xlviii.

83 Gasté, "Les confréries laïques," p. 371. [For similar observances in Europe, see also C. de Boom, "Le culte de l'eucharistie d'après la miniature du moyen-âge," *Studia eucharistica DCCI anni a condito festo Sanctissimi Corporis Christi 1246-1946*, Bossum-Antwerp, pp. 326-332.]

84 It is in the ambulatory (early sixteenth century).

85 In a compartment of the window are these meager verses: *Douze confrères, gens de bien,—en douze apôtres revêtus, sont accoustrés par bon moyen—pour décorer le doux Jésus*. (Twelve confreres, good men,—dressed as twelve apostles—are well rigged out—to ornament sweet Jesus.)

86 In the second half of the thirteenth century, St. James was shown with hat and staff on the portal of St.-Honoré, at Amiens.

87 See the Burgundian St. James in the Louvre, the perfect type of the traveler on the road to Compostela. [The pilgrim St. James in the Louvre is from Lemus-en-Auxois (Côte d'Or). See David, *De Sluter à Sambin - I: La Fin du Moyen Age*, fig. 29 and pp. 81ff.; G. Mougeot, "Le saint Jacques de Semur," *Revue de l'art chrétien*, May, 1912, pp. 221-223; Müller, *Sculpture in the Netherlands*, p. 85.]

88 The members of the confraternities who had not been to St. James of Compostela did not have the right to carry the pilgrim's staff in procession.

89 See the article by L. Regnier on the St. James of Verneuil in the album published by the *Société des amis des arts du département de l'Eure*, 2nd ser., 1902, pl. III. The statue of St. James has been greatly restored.

90 C. de Beaurepaire, *Nouveau recueil des notes historiques et archéologiques*, p. 394.

91 Petit de Julleville, *Les Mystères*, p. 351.

92 A. Sorel, "Notice sur les mystères representés à Compiègne au moyen âge, "*Bulletin de la société historique de Compiègne*, 2 (1875), pp. 35-55.

93 *Legenda aurea. De Sancto Jacobus major*. [Jacobus de Voragine, *The Golden Legend or Lives of the Saints as Englished by William Caxton*, F. S. Ellis, ed., 7 vols., London, 1930 (orig. ed., 1900).]

94 The Miracle of St. James has been preserved only in the dramatic literature of Provence, and there we have only the first part of the work: *Ludus sancti Jacobi, fragment de mystère provençal*, published by C. Arnaud, Marseille, 1868. The French Mystery play was certainly identical, for the Provençal Mystery plays were usually only adaptations of the original French versions.

95 The window in the museum of Vendôme was formerly in the church of Villiers; M. de Launay, "Observations sur le vitrail de l'hospice Saint-Jacques de Vendôme," *Congrès archéologique de France*, 1872, pp. 194-197.

96 At Châtillon-sur-Seine (Côte-d'Or) an inscription expressly names the chambermaid.

97 The confraterntiy of Roye (Somme) gave to their church a window representing the miracle of St. James. It existed until 1914, but in a mutilated condition. What remained proves that it was like all those we have enumerated. We have said above that the pilgrims of Roye had attended a performance of the *Miracle de saint Jacques* given by the members of the confraternity of Compiègne. Thus, the relations between the theater and art cannot be doubted.

98 The window at Gisors dates from 1530, that of Clermont from 1550. The cartoons had been kept in the atelier of the glass painter. This painter was an artist attached to the atelier of the Leprinces in Beauvais, as the style of the window proves. Certain scenes, at Gisors and Clermont, are absolutely alike. There is only one difference: at Clermont the work is more complete and contains some scenes which are lacking in the other (story of the relics). We cite also the window of Bourg-en-Bresse and that of Brienne, both from the sixteenth century.

99 The *Mystère de saint Crépin et de saint Crépinien*, published by Dessalles and Chabaille, Paris, 1836, is unfortunately not complete. All the beginning is missing. Consequently, we cannot compare the first panels of the window (birth, conversion, apostolate of the saints) with the Mystery play. [For more on these saints, see *Réau*, III, pt. 1: "Crépin et Crépinien de Soissons," pp. 350-353; R. Moutard-Uldry, *Saint Crépin et Saint Crépinien*, Paris, 1942.]

100 The window of Sts. Crépin and Crépinien, in the church of the Quinze-Vingts, in Paris, was similar to those of Gisors and of Clermont, and also ended with the episode of the relics. This is also true of a compartmented painting in the cathedral of Clermont-Ferrand (late sixteenth century).

101 The window is in the left aisle and dates from the beginning of the sixteenth century. See Jubinal, *Mystère inédits du XV siècle*, I, "Le martyre de Saint Denis et de ses compagnons," pp. 100-169. [See also *Réau*, III, pt. 1: "Denis de Paris, pp. 374-382.]

102 Printed for the first time at Lyon, in 1605, by Pierre Delay. It is reworked from a much earlier text. [The Magdalene's appearance in medieval religious drama has been analyzed in G. Cohen, "Le personnage de Marie-Madeleine dans le drame religieux du moyen âge," *Convivium*, 24 (1956), pp. 141-163; *idem*, *Etudes d'histoire du théâtre en France au moyen-âge et à la Renaissance*, pp. 204-230; O. Jodogne, "Marie-Madeleine pécheresse dans les passions médiévales," *Scrinium Lovaniense, Etienne van Cauwenbergh*, Louvain, 1961, pp. 272-284. See also *Réau*, III, pt. 2: "Madeleine," pp. 846-859; Mâle, *Les Saints compagnons*, pp. 63-86; V. Saxer, *Le Culte de Marie Madeleine en occident des origines à la fin du moyen âge*, I-II, Paris, 1959.]

103 At Lyon in 1500, at Montélimar in 1530, at Auriol in 1534, at Grasse in 1600. But what are these indications worth compared to what we do not know?

104 The same miracle of Mary Magdalene is told in a window at Sablé, which also dates from the first part of the sixteenth century.

105 [According to F. S. Ellis, no other book was as frequently reprinted between 1470 and 1530 in Latin editions and translations. Cf. Voragine, *The Golden Legend*, I, p. vii.]

106 [St. Christopher has been treated in a detailed study by H. F. Rosenfeld, *Der Hl. Christophorus, seine Verehrung und seine Legende*, Abo (Finland), 1937. See also Bréhier, *L'Art chrétien*, pp. 378ff.; *Réau*, III, pt. 1: "Christophe," pp. 304-313; Aurenhammer, *Lexikon*, I, "Christophorus," pp. 435-453; Walters Art Gallery, *The International Style*, cat. no. 30, pp. 32-33.]

107 Book of Hours (Paris, Bibl. Nat., ms. lat. 924, fol. 309), dating from 1395 or 1400. The text says:

Il nous garde de mort subite,
Et quiconque le requiert
De bon coeur, il a ce qu'il quiert.

(He protects us against sudden death,
And whoever calls on him
With a good heart, will have
what he asks for.)

108 The St. Christopher of Auxerre (Yonne) was destroyed in 1768, that of Notre-Dame of Paris, in 1784. The clergy of the eighteenth century were embarrassed by these giants whom they thought worthy only of amusing little children.

109 Especially in Hautes-Alpes. See J. Roman, "Eglises peintes du département des Hautes-Alpes," *Réunion des sociétés des beaux-arts des départements*, 6 (1882), p. 86.

110 [For further material on the cult of St. Barbara, see comte de Lapparent, "Les Saints eucharistiques. Sainte Barbe," *L'Eucharistie*, 1928, pp. 739-742; Vloberg, *L'Eucharistie dans l'art*, pp. 257-259; *Réau,* III, pt. 2: "Barbe," pp. 169-177. See also the examples listed under "Barbara" in the index of Müller, *Sculpture in the Netherlands*, p. 239, and pl. 102B, which illustrates the well-preserved north French (?) St. Barbara in the Metropolitan Museum of Art in New York.]

111 *Les Suffrages et oraisons des saints*, printed by Antoine Vérard, Paris, n.d. Several of these prayers are found in the manuscript Books of Hours, for example Book of Hours (Paris, Bibl. Nat., ms. lat. 13264), ca. 1430.

112 Schreiber, *Manuel de l'amateur de la gravure*

sur bois, III, nos. 2550ff. In France, her usual attribute is a tower (fig. 106). This is the tower in which her father imprisoned her.

113 L. Du Broc de Segange, *Les Saints patrons des corporations*, Paris, 1889, II, p. 522.

114 J. B. Pardiac, "Notice sur les cloches de Bordeau," *Bulletin monumental*, 24 (1858), p. 255.

115 *Ibid.*, p. 257.

116 It is clear why the military confraternities of the harquebusiers had chosen St. Barbara as their patron.

117 See the very interesting brochure by L. Boucher, *La Peste à Rouen*, Rouen, 1897.

118 For example, Sts. Sebastian and Adrian. See the *Suffrages et oraisons des saints*. On the other hand, St. Christopher was sometimes invoked against the plague: P. Mainguet, *Saint Christophe*, Tours, 1891.

119 [See *Réau*, III, pt. 3: "Sebastien," pp. 1190-1199.

120 See C. Cahier, *Les Caractéristiques des saints dans l'art populaire*, Paris, 1866-1868, II, p. 661, and Perdrizet, *La Vierge de miséricorde*, pp. 107ff.

121 The arrows with which St. Sebastian was pierced explain why the confraternities of archers had chosen him as their protector. This patronage has no connection with the one we are discussing here.

122 *Petit Thalamus* of Montpellier. [The *Petit Thalamus* of Montpellier is a volume of 565 pages containing descriptions of customs, ordinances of the kings of Aragon, an historical chronicle, etc., covering the years 1088 to 1064.]

123 [See *Réau*, III, pt. 1: "Adrien," pp. 23-24. The well-known St. Adrian in the Musées Royaux in Brussels is illustrated in Müller, *Sculpture in the Netherlands*, pl. 95.]

124 Corblet mentions a twelfth-century missal in the Library of Amiens, in which St. Adrian was already invoked against all the evils which can befall us suddenly (*mala imminentia*): J. Corblet, *Hagiographie du diocèse d'Amiens* Paris, Amiens, 1868-1875, IV, p. 128.

125 *Legenda Aurea de Sancto Adriano*. [See above, n. 93.]

126 *Le Mystère de saint Adrien* (published by Emile Picot for the Roxburghe Club), London, 1895, vv. 7916-7920:

> *Que ceux qui en afflicion*
> *Me prieront par dévocion,*
> *Il te plaise les secourir*
> *Espécialement de morir*
> *D'épidémie et mort soubdaine.*

(Those who in affliction
Pray to me with devotion,
May it please Thee to keep them
Especially from dying
From epidemics and sudden death.)

127 [For the "fire of St. Anthony," see J. Morawski, *La Légende de Saint Antoine Ermite*, Poznan, 1939, pp. 117ff. See also *Réau*, III, pt. 1: "Antoine Abbé," pp. 101-115; Aurenhammer, *Lexikon*, I, pp. 157-163.]

128 Dijon, *L'Eglise abbatiale de Saint-Antoine en Dauphiné*, Paris, 1902.

129 *Mémoires de la société archéologique de l'Aube*, I, p. 150; and A. Falco, *Historiae Antonianae*, Lyon, 1534.

130 *Histoire miraculeuse de trois soldats*, Paris, 1576. It was said that the miracle had taken place near Châtillon-sur-Seine. See also Sauval, *Histoire et recherches des antiquités de la ville de Paris*, I, p. 41.

131 [See *Réau*, III, pt. 3: "St. Roche de Montpellier," pp. 1155-1161.]

132 The relics of St. Roch were stolen in 1485. In 1856, Venice returned half of the body of St. Roch to Montpellier. See abbé Recluz, *Histoire de saint Roch et de son culte*, Montpellier, 1858.

133 Abbé Moret, *Manuel de la confrérie de Saint-Roch*, Moulins, 1899.

134 Compare A. J. Crosnier, *Hagiologie Nivernaise*, Neves, 1858.

135 Petit de Julleville, *Les Mystères*, I, p. 345. The text of the deliberation is worth citing: "Whereas, since for the past six years the said city has not been free of the contagious malady called the plague, the inhabitants of this city in honor of God and St. Sebastian, intercessor for this malady, so that it may please God the Creator to withdraw his hand and that the aforesaid inhabitants may from this day onward be preserved from this malady, [decree] that the play and Mystery of the glorious friend of God, Monsieur St. Sebastian, shall be performed."

136 This occurred at Laval in 1520, following a performance of the *Mystère de saint Sébastien* which lasted for seven days. See L. P. Piolin, *Le Théâtre chrétien dans le Maine*, Mamers, 1891, p. 138.

137 See the curious collection of engravings in P. Heitz and W. Schreiber, *Pestblätter des XV. Jahrhunderts*, Strasbourg, 1901.

138 It was Cahier, *Charactéristiques des saints*, II, p. 512, who first said that the lion was borrowed from the arms of Flanders. I believe

it to be true in this case. The abbeys often published engravings representing their saints accompanied by the blazon of the monastery, the city, or the province. An engraver may have added the lion of the blazon to the subject of the picture.

139 I have explained this at greater length in Mâle, *L'Art religieux du XIIIe siècle*, 4th ed., p. 341 (*Religious Art in France: The Thirteenth Century*, Bollingen XC.2, Princeton, 1984, p. 289).

140 The beautiful statue of St. Anthony in Ocquerre (Seine-et-Marne) is one of the best examples.

141 Later he did penance in the lonely wilderness of the mountain which bears his name.

142 Recluz, *Histoire de Saint Roch*, p. 115, has published a Latin description, written in the early eighteenth century, of this portrait.

143 A life of St. Roch, added later to the *Golden Legend*, even says explicitly "that his thigh was pierced by an arrow," which is most remarkable.

144 The fact that the dog was so inseparable from St. Roch must have led people to call him "un roquet" [a cur], and I believe that to be the true explanation of this word whose etymology Littré, as well as Darmesteter, Hatzfeld, and Thomas say they do not know. When Victor Hugo wrote: "Saint Roch et son chien saint roquet," he undoubtedly had no idea he was so close to the truth: V. Hugo, *Les Chansons des rues et des bois*, Paris, 1933, p. 102. [See E. Littré, *Dictionnaire de la langue français*, Paris, 1958 (orig. ed. 1889); VI, p. 1701.]

145 The presence of these three saints near the tomb can only be explained by a vow made in the time of an epidemic by Raoul de Lannoy. [See G. Durand, "Les Lannoy, Folleville et l'art italien dans le nord de la France," *Bulletin monumental*, 70 (1906), pp. 329-404.]

146 Window at Triel (Seine-et-Oise), and at Claville (Eure).

147 Painted panel in the church of Langeac (Haute-Loire); keystone of the church of Poix (Somme); triptych by Bellegambe in the cathedral of Arras.

148 The name of St. Margaret must be added to the six names of Sts. Christopher, Barbara, Sebastian, Anthony, Adrian, and Roch, who protected against sudden death. Women invoked Margaret against death in childbirth.

149 [See M. L. David-Daniel, *Iconographie des saints médecins Côme et Damien*, Lille, 1958.]

150 [*Réau*, III, pt. 3: "Yves de Tréguier," pp. 1353-1356.]

151 [*Ibid.*, III, pt. 1: "Eloi de Noyon," pp. 422-427.]

152 [*Ibid.*, III, pt. 2; "Honoré d'Amiens," pp. 656-657.]

153 Window in the church of St.-Ouen at Pont-Audemer (Eure), given by the bakers.

154 We have already spoken elsewhere of St. Nicholas: Mâle, *L'Art religieux du XIIIe siècle*, 8th ed.; p. 330. [*Religious Art in France: The Thirteenth Century*, Bollingen XC.2, Princeton, 1984, p. 327]. We recall here only that he was one of the most popular saints of the Middle Ages, that a number of confraternities recognized him as their patron, and that the works of art devoted to him are even more numerous in the fifteenth and sixteenth than in the thirteenth century.

155 The confraternities of young women were sometimes under the patronage of St. Ursula and the eleven thousand virgins; that is why we sometimes find in French churches the statue of St. Ursula protecting her companions under her mantle (at St.-Michel, in Bordeaux, for example). [See further *Réau*, III, pt. 3: "Ursule de Cologne," pp. 1296-1301, and G. de Terverant, *La Légende de sainte Ursule dans la littérature et l'art du moyen-âge*, I-II, Paris, 1930. For St. Catherine, see *Réau*, III, pt. 3, pp. 262-272, and D. Roggen, *A. Beauneveu en het Katharianbeeld van Kortrijk*, Ghent, 1954.]

156 Mone, *Lateinische Hymnen des Mittelalters*, III, p. 212.

157 On this usage, see Corblet, *Hagiographie du diocèse d'Amiens*, IV, p. 199. In the diocese of Amiens alone, two hundred churches, not so long ago, still had statues of St. Catherine. It must be added that St. Catherine was the patron of certain corporations, for example that of the wheelwrights (because of the wheel of her martyrdom).

158 Rance de Guiseul, *Les Chapelles de Notre-Dame de Dôle*, p. 56. [For St. Anne, see below, pp. 205-209.] The cult of St. Anne is discussed in Künstle, *Ikonographie*, pp. 328-341; M. V. Roman, *St. Anne, Her Cult and Her Shrines*, New York, 1927; Aurenhammer, *Lexikon*, I, pp. 139-146; Smits, *De Iconografie van de Nederlandsche Primitieven*, pp. 34-41; *Lexikon der Marienkunde*, I, cols. 230-257; *Reallexikon*, II, cols. 177-180.

159 See the images of the confraternities preserved in the Cabinet des Estampes, Re 13, fols. 11, 15 and 17.

160 This window, once in the Abbey of Fontaine-Daniel, is known only by the watercolor in the Gaignières collection, Cabinet des Estampes, Pe lg fol. 178. It dates from ca. 1540. [For Gaignières, see above, n. 25.]

161 *"Sancta Maria, succurre miseris, juva pusillanimes, refove flebiles, ora pro populo, interveni pro clero, intercede pro devoto femineo sexu."* Missal of Bayeux. [Cf. e.g., Bayeux, Bibl. du Chapitre of Bayeux, ms. 63, Leroquais, *Sacramentaires et missels*, III, p. 279.]

162 The words of the antiphon are inscribed in the lower part of the windows. The work dates from the early sixteenth century. See E. Veuclin, "Un specimen de la peinture sur verre," *Réunion des sociétés des beaux-arts des départements*, 24 (1900), p. 135.

163 This type is also referred to as the "Virgin of Mercy." Barthélemy, "Documents inédits," p. 393, and *Réunion des sociétés des beaux-arts des départements*, 13 (1889), pp. 129, 175.

164 The painting in Chantilly, made in collaboration by Charonton and Villate, is one of the most beautiful works ever inspired by this subject. The Virgin, her head slightly bent, and slender with delicate hands, virginal yet maternal, is a poetic figure (fig. 112). [The painting was commissioned in 1452 by Jean Cadard's son, Pierre. See P. Durrieu "La Vierge de la Miséricorde d'Enguerrand Charonton et Pierre Villate au Musée Condé," *Gazette des beaux-arts*, 33 (1904), pp. 5-12; Ring, *A Century of French Painting*, cat. no. 117, pl. 62; Sterling, *Le Couronnement de la Vierge, par Enguerrand Quarton*.]

165 This account is found in C. von Heisterbach, *Dialogus miraculorum*, Cologne, ca. 1475, VII, p. 58. On the origins and development of this type of Virgin, see the excellent article by Leon Silvy, the learned youth who was so richly endowed and who died at the age of twenty-five: L. Silvy, "L'Origine de la Vierge de la Miséricorde," *Gazette des beaux-arts*, 34 (1905), pp. 401-410; the work by E. Krebs, *Sonderabdruck aus den Freiburger Münsterblättern*, first year, first cahier; and finally, the remarkable doctoral thesis of Perdrizet, *La Vierge de Miséricorde*, in which all aspects of the question are studied. It contains a catalogue of the monuments which needs to be completed for France. [See also Künstle, *Ikonographie*, I, pp. 635-638; Réau, II, pt. 2, p. 113; V. Sussmann, "Maria mit dem Schutzmantel," *Marburger Jahrbuch für Kunstwissenschaft*, 5 (1929), pp. 285-352; M. L. D'Ancona, *The Iconography of the Immaculate Conception in the Middle Ages and Early Renaissance*, New York, 1957, pp. 33-34.]

166 Seal of the Cistercian abbey at Cercamp (Pas-de-Calais), 1352, and of the definitors of Cîteaux (fourteenth and fifteenth centuries).

167 I say probably, because the mediation of the monks of Citeaux in the diffusion of the type, as likely as it seems, does not seem to me definitely proven as yet. The oldest Virgins of Mercy of Cistercian origin (such as the seals cited above) date from no earlier than the fourteenth century. In the middle of the thirteenth century, the Roman confraternity of the Raccomandati had their members represented on their knees under the mantle of the Virgin: See Perdrizet, *La Vierge de Miséricorde*, p. 64. Also in the thirteenth century, St. Ursula sheltering the saints under her mantle was represented on a reliquary of the cathedral of Albi. So, until Cistercian images of the Virgin of Mercy dating from the thirteenth century are found, the proof has not been established. We might even wonder whether the type of the Virgin of Mercy predated the vision of the Cistercian monk.

168 Jean de Cirey, *Collecta*, Dijon, 1491. At the beginning of the sixteenth century, all the heads of Orders were represented under the mantle of the Virgin. See the frontispiece in the book entitled *Corona nova beatae Mariae*, 1512.

169 In France, the earliest example of the new conception is a painting at Le Puy, which must date from around 1410. The fresco of the Virgin of Mercy in the chapel of St.-Ceneri (Orne) is earlier; the presence of the armorial bearings of Pope Urban V assigns it a date somewhere between 1362 and 1372; but the figures kneeling at the feet of the Virgin form an indistinct crowd in which the two hierarchies are not distinct from each other. (See a reproduction in J. Adeline, J. Baillaird *et al.*, *La Normandie monumentale et pittoresque*, Le Havre, 1893-1899, IV, pt. 1, p. 72.) The Virgin of St.-Ceneri is probably a simple imitation of a drawing in the *Speculum humanae salvationis*. This famous collection contributed its share to the spread of the type of the Virgin of Mercy.

170 See P. Perdrizet, "La 'Mater Omnium' du Musée du Puy," *La Société française d'ar-*

chéologie, Congrès archéologique de France,
Puy, 1904, p. 581, illus. opp. p. 574.

171 Some very similar popular images are found
in Heitz and Schreiber, *Pestblätter*.

172 For example, see *Missal of Chartres*, printed
by Thielman Kerver, Paris, 1529: *Exaudi nos,
Deus salutaris noster, et, intercedente beata Dei
genitrice Maria, populum tuum ab iracundiae
tuae terroribus libera.* This is the Mass com-
posed by Clement VI during the plague of
1348.

173 Paris, Bibl. Nat., ms. fr. 9198 and 9199, vol-
umes which belonged to Philip the Good,
Duke of Burgundy.

174 *Hours of the Virgin*, printed by Thielman
Kerver, Paris 1505.

175 This legend has already been discussed in
Mâle, *L'Art religieux du XIIIe siècle*, 8th ed.,
pp. 261ff. [*Religious Art in France. The Thir-
teenth Century*, pp. 259ff.] We shall not take
it up again here.

176 Petit de Julleville, *Les Mystères*, II, p. 185.

177 The windows of St.-Nizier at Troyes, at
Montangon (Aube), at Le Grand-Andely
(Eure), 1540, and Baumont-le-Roger (Eure),
all associate the legend of Theophilus with
the Marriage at Cana.

178 *Translatio miraculosa Ecclesiae Virginis de Lo-
reto*, 1507 (Paris, Bibl. Nat., Réserve D, 3945).

179 *Voyage de Jacques le Saige de Douai*, pub-
lished by H. R. Duthilloeul, Douai, 1852.

180 U. Chevalier, *Notre-Dame-de-Lorette*, Paris,
1906. [See further, L. Rinieri, *La Verità sulla
Santa Casa di Loreto*, Turin, 1950, and *Réau*,
II, pt. 2, pp. 632-633.]

181 It was believed that Notre-Dame du Puy,
"the angelic church," had also been mirac-
ulously placed on its rock.

182 The kneeling figure who contemplates the
house passing through the sky must be the
holy man whom the Virgin, according to
the legend, honored with a revelation.

183 [An illustration of the window at St.-Etienne
in Beauvais is found in Aubert *et al., Le
Vitrail français*, fig. 17.]

184 Schreiber, *Manuel de l'amateur de la gravure*,
I, nos. 1102-1104.

185 [Mâle's discussion of Marian iconography in
the fifteenth and sixteenth centuries has been
followed by a number of important studies,
including the comprehensive *Lexikon der
Marienkunde*, which is in the process of pub-
lication. See also J. Dupont, "Le Sacerdoce
de la Vierge," *Gazette des beaux-arts*, 8 (1932),
pp. 265-274. A far-reaching aspect of Marian

iconography is the association of the Virgin
with the grain of wheat, signifying the Eu-
charist. See J. Graus, *Maria im Ahrenkleid
und die Madonna cum Cohazono vom Mai-
länder Dom*, Graz, 1904; R. Berliner, "Zur
Sinnesdeutung der Ahrenmadonna," *Die
christliche Kunst*, 26 (1929-1930), pp. 97ff.;
A. Pigler, "La Vierge aux épis," *Gazette des
beaux-arts*, 74 (1932), pp. 129-136; "Ahren-
madonna," *Lexikon der Marienkunde*, I, cols.
49-54; Vloberg, "La Vierge à l'hostie," *L'Eu-
charistie dans l'art*, II, pp. 269ff., with biblio-
graphical references; *Réau*, II, pt. 2, p. 91.]

186 There are to be found in Mone, *Lateinische
Hymnen*; Dreves and Blume, *Analecta hy-
mnica mediiaevi*; Daniel, *Thesauri*; and Weale
and Misset, *Analecta Liturgica*, which we have
already cited. [See Chapter III, nn. 10 and
120.]

187 *Salve, altitudo montis,*
 Salve, claritudo fontis. ...
 Salve, dulce tempus veris,
 Tu virtutum sertum geris. ...
 Mone, *Lateinische Hymnen*, II, p. 275.

188 *Ibid.*, p. 185.

189 Dreves and Blume, *Analecta hymnica*, VII, p.
80.

190 *Aurora lucis rutilat*
 Aeternae lucis nuntia,
 Exsultans mundus jubilat
 Novae lucis ob gaudia ... *etc.*
 Ibid., IV, p. 48.

191 This was the name he gave himself.

192 *Vita*, chap. VI (*Oeuvres mystiques de Suso*, Thi-
riot, tr., Paris, 1899). [Cf. *The Exemplar; Life
and Writings of Blessed Henry Suso*, Edward,
tr., Heller, ed., see chap. III, n. 8. See also
Weymann, *Die Seusesche mystik und ihre
Wirkung auf des bildende Kunst*.]

193 *Vita*, chap. XXXVIII.

194 *Ibid.*, chap. XII.

195 [The symbolic crown of roses has been stud-
ied in M. Vloberg, *La Madone aux roses*,
Paris, 1930; Künstle, *Ikonographie*, I, pp. 638-
646; F.H.A. van der Oudendijk-Pieterse,
*Dürer's Rosenkranzfest, en de ikonografie der
Duitse rosenkransgroepen van de XVe en het
begin der XVIe eeuw*, Amsterdam, 1939;
J. Fried, *Der Rosenkranz der allerseligsten
Jungfrau Maria*, Vienna, 1946; R. Guardini,
Der Rosenkranz unserer Lieben Frau, Würz-
burg, 1954, *Réau*, II, pt. 2, pp. 120-122.]

196 C. Joret, *La Rose dans l'antiquité et au moyen
âge*, Paris, 1892, p. 413.

197 And not St. Dominic in the thirteenth cen-

tury; this has been established by recent works. See H. Duffaut, "Une hypothèse sur la date et le lien de l'institution du Rosaire," *Analecta Bollandiana* 18 (1899), p. 290, and *Revue du clergé français*, December, 1901.

198 [See G. Durand, *Tableaux et chants royaux de la confrérie du Puy, Notre-Dame d'Amiens* (Société d'archéologie du département de la Somme), 1911.]

199 See article by A. Noyon, *Etudes* (a review published by the Fathers of the Society of Jesus), C, p. 763. The feast was inscribed in the Anglo-Saxon calendar before the Norman Conquest. It goes back farther still, and Father Thurston has shown that the Church of Ireland, in the tenth and even in the ninth centuries, commemorated the Conception of the Virgin: see *Revue du clergé français*, 39, and J. C. Broussolle, *Etudes sur la Sainte-Vierge*, Paris, 1908. [See the study by D'Ancona, *The Iconography of the Immaculate Conception; Réau*, II, pt. 2, pp. 75-83; see also A. M. Lépicier, *L'Immaculée Conception dans l'art et l'iconographie*, Spa, 1956; Künstle, *Ikonographie*, I, pp. 646-658.]

200 E. de La Quérière, *Notice sur l'ancienne église paroissiale Saint-Jean de Rouen*, Rouen, 1860. The legend of the tempest is found in the *De Conceptione Virginis Mariae*, attributed to St. Anselm. [Migne, *P.L.*, 158, cols. 301-323.]

201 Book of Hours (Paris, Bibl. Nat., ms. fr. 19243). In this Book of Hours written at the beginning of the sixteenth century, we read (fol. 48):

> *N'avons-nous pas du duc Guillaume*
> *Qui la fit (la Conception) fêter en sa terre*
> *Dont il acquesta le royaume*
> *Et tout le pays d'Angleterre.*
>
> (We have it from Duke William
> Who caused it [the Conception]
> to be celebrated in his domain
> When he acquired the kingdom
> And all the land of England.)

202 An edition of this book appeared in 1471.

203 I cite particularly: *Libellus recollectorius de veritate conceptionis beatae Mariae Virginis* (Paris, Bibl. Nat., ms. lat. 9591), 1478, and *Le Défenseur de l'originale innocence de la glorieuse Vierge Marie* (Paris, Bibl. Nat., ms. fr. 989), translated from the Latin of Pierre Thome by Antoine de Lévis for Jeanne of France, duchess of Bourbonnais. Also R. Gaguin, *Epistolae et orationes: Carmen de puritate conceptionis beatae Mariae Virginis*, printed by André Bocard for Durand Gerlier, Paris, 1498.

204 In 1476, Sixtus IV had an office composed for the Feast of the Conception. Sixtus IV was a Franciscan and the Franciscans constantly defended the doctrine of the Immaculate Conception against the attack on it by the Dominicans.

205 From 1496 on, the new professors of the Sorbonne declared under oath that they accepted the doctrine.

206 Since these lines were written, Jules Leroux has suggested that the central part of the triptych, believed lost, has been found in the sacristy of the church of Notre-Dame at Douai. This central panel represents the Virgin surrounded by the emblems of the litanies. This seems altogether possible. See J. Leroux, "A propos d'un tableau de l'église Notre-Dame à Douai," *Revue du nord*, 5 (1914), pp. 89-100.

207 The phrases assigned to each doctor are not always the same in the painting and in Clichtove's book, but the works referred to above are a mine of citations that could be easily culled. All this literature was available to the creator of the painting. [Jodicus Clichtovus, *Tractatus de puritatae conceptionis beatae Mariae Virginis*, Paris, 1513.]

208 It would be somewhat naïve to believe with Dehaisnes, *La Vie et l'oeuvre de Jean Bellegambe*, pp. 185-186, that the artist himself was so erudite.

209 About 1511 in Italy, Francia painted for the church of San Frediano in Lucca, an altarpiece which somewhat resembles the painting by Jean Bellegambe. See M. Carmichael, *Francia's Masterpiece*, London, 1909. [This painting, by a Ghirlandaiesque master and now in the Pinacoteca, Lucca, has been discussed in an article by S. Symeonides, "An Altarpiece by 'The Lucchese Master of the Immaculate Conception,'" *Marsyas*, 8 (1959), pp. 55-66.]

210 [For the iconography of the Virgin of the Apocalypse, see L. Burger, *Die Himmelskönigen der Apokalypse in der Kunst des Mittelalters*, Berlin, 1937. See also, for further bibliography, A. Cutler, "The 'Mulier Amicta Sole' and Her Attendants," *Journal of the Warburg and Courtauld Institutes*, 25 (1962), pp. 326-330; B. J. Le Frois, *The Woman Clothed with the Sun*, Rome, 1954.]

211 Book of Hours (Paris, Bibl. Nat., ms. lat. 1405, fol. 61v), dating from about 1450.

Bourdichon represented this figure several times. [See Limousin, *Bourdichon*, figs. 54 and 99: Book of Hours (Modena, Bibl. Est., ms. lat. 22 a k 7.2), Bourdichon workshop.]

212 See Schreiber, *Manuel de l'amateur de la gravure sur bois*, I, nos. 1053, 1083, 1084, 1085, etc. The Virgin is sometimes shown standing on the crescent moon.

213 *Ibid.*, no. 1107.

214 He placed it at the beginning of his Apocalypse. [See Panofksy, *Dürer*, II, fig. 180 (The Virgin appears to St. John on Patmos, ca. 1511) and fig. 181 (frontispiece to the *Life of the Virgin*, 1511).]

215 This is one of the most celebrated blockbooks of the fifteenth century. [See Schreiber, *Manuel de l'amateur de la gravure sur bois*, IV, pp. 151-152, and the facsimiles of the Scriverius copy in the British Museum (London, 1860) and the copy in the Bayerischen Staatsbibliothek (Munich, 1922).]

216 The young Virgin (often in an aureole with rays) who clasps her hands (fig. 115) bears a singular resemblance to the bride in the aureole of the woodcut Song of Songs (fig. 117).

217 Missal of the abbey of St.-Corneille of Compiègne; Misset and Weale, *Analecta liturgica*, II, p. 473.

218 Missal of Evreux, 1497. The names the Middle Ages loved to give the Virgin have been assembled by A. Salzer, *Die Sinnbilder und Beiworte Mariens*, Linz, 1893. [For more information on French missals, especially those of 1481 printed by Jean du Pré, see H. Bober, "The 'First' Illustrated Books of Paris Printing: A Study of the Paris and Verdun Missals of 1481 by Jean du Pré," *Marsyas*, 5 (1947-1949), pp. 87-104.]

219 R. P. Angelo de Santi, *Les Litanies de la Vierge, étude historique et antique*, A. Boudinhon, tr., Paris, 1900.

220 These invocations to the Virgin seem, however, to have often been recited in the fifteenth century to ask protection against the two great scourges of the times: the plague and the Turks. Angelo de Santi, *op. cit.*

221 [For an excellent discussion of the symbolic implications of the new realism in imagery in the generation of Jan van Eyck, see C. de Tolnay, *Le Maître de Flémalle et les frères van Eyck*, Brussels, 1938, p. 38. See also J. Böheim, *Das Landschaftsgefühl des ausgehenden Mittelalters*, Leipzig, 1934. For the writings of Nicholas of Cusa, which reflect concerns similar to those in the art, see Nich-

olas of Cusa, *The Vision of God*, E. G. Salter, tr., E. Underhill, ed., New York, 1960.]

222 Perhaps there had also been precedents. Around the Virgin of the Unicorn (ancient symbol of the virginity of Mary), several emblems were sometimes tastefully grouped: the gates of heaven, the fountain, the fleece of Gideon, the rod of Aaron. It could be that these representations had predated our Virgins of the Immaculate Conception. See L. Germain, *La Chasse à la Licorne*, 1897, and review by "J.H.," "La Legende de la Licorne ou du Monocéros par le Dr. Fred. Schneider," *Revue de l'art chrétien*, 38 (1888), p. 16. [See also O. Shepard, *The Lore of the Unicorn*, London, 1930.]

223 Maxe-Werly, *Iconographie de l'Immaculée-Conception*, 1903; L. Bataillon, *Revue archéologique*, 1923, p. 284. [D'Ancona, *Iconography of the Immaculate Conception*, pp. 65-70, discusses earlier examples of this type.]

224 [A sequence, or *prose*, is a piece of verse or rhythmical prose that is introduced in the Mass on certain occasions, and is sung or recited after the epistle.]

225 L. de Vesly, "Notice sur Pierre des Aubeaux," *Réunion des sociétés des beaux-arts des départements*, 25 (1901), p. 409; F. Blanquart, "L'Imagier Pierre des Aubeaux et les deux groupes du Trépassement de Notre-Dame à Gisors et à Fécamp," *Congrès archéologique de France*, 1890, p. 378.

226 Tapestry in the cathedral of Reims.

227 Stalls at Amiens.

228 Mural painting in the abbey of St.-Seine (Côte-d'Or).

229 Bas-relief at Souvigny (Allier).

230 Maxe-Werly, *op. cit.*, has compiled a catalogue of them, but additions could easily be made.

231 L. Marsaux, "Glanes iconographiques," *Revue de l'art chrétien*, 56 (1906), pp. 110-113.

232 Missal of Bayeux. The other metaphors are found in the collection in Dreves, *Analecta hymnica*.

233 After the figure of the Virgin, St. Anne and St. Joachim present themselves at the Temple. The work has all the characteristics of the School of Champagne and must have come from Troyes.

234 On the origin of the *Palinods*, see J. Loth, "Les derniers jours de l'Académie des Palinods de Rouen," *Mémoires lus à la Sorbonne*, 1886, pp. 346-361. [*Palinod* was the name given by literary confraternities in the fifteenth and sixteenth centuries to pieces com-

235 It must have been very interesting: we know that the choir and the nave were decorated with the arms of the princes of the *Palinods*.

236 Reprinted by E. de Robillard de Beaurepaire, Rouen, 1897.

237 Albanès, "Les arts à Toulon au moyen âge," p. 36.

238 *Missal of Chartres*, printed by Theilman Kerver, 1529.

239 It is known that, according to medieval tradition, the kings of Judah were considered to be the ancestors of both St. Joseph and the Virgin.

240 [For the Beauvais window (ca. 1525), see Paris, Musée des arts decoratifs, *Vitraux de France du XIe au XVIe siècle*, 2nd ed., Paris, 1953, cat. no. 51, pp. 94-96, color pl. V.]

241 [For the themes of the Tree of Jesse and the Immaculate Conception, cf. D'Ancona, *The Iconography of the Immaculate Conception*, pp. 46-50; "Arbor Virginis," *Lexikon der Marienkunde*, I, cols. 339-341; *Réau*, II, cols. 339-341; *Réau*, II, pt. 2: "L'arbre de Jessé," pp. 129-140; R. Ligtenberg, "De Genealogie van Christus," pp. 2-54; Watson, *The Early Iconography of the Tree of Jesse*; M. Lindgren-Fridell, "Der Stammbaum Maria aus Anna und Joachim," *Marburger Jahrbuch für Kunstwissenschaft*, 1938-1939, pp. 289-308; O. Goetz, *Der Feigenbaum in der religiosen Kunst des Abendlandes*, Berlin, 1965, p. 103ff.]

242 Ambulatory, on the right. The window dates from the beginning of the sixteenth century.

243 *Anna. radix uberrima,*
 Arbor tu salutifera,
 Virgas producens triplices
 Septem onusta fructibus.
Mone, *Lateinische Hymnen*, III, p. 195.

244 The engraving in the *Encomium trium Mariarum* by Jean Bertrand of Périgueux (1529) shows, besides the three husbands of St. Anne, the three spouses of her daughters (fig. 119). (Paris, Bibl. Nat., Inv. Rés. H, 1010.)

245 Sixteenth-century statues, often remarkable, show the three Marys with their children, as for example at Mont-les-Seurre (Saône-et-Loire), or one of the Marys with her children, as at La Bonneville (Eure). The artists sometimes gave these children the attributes they would have when they were grown and had become apostles. See Hours for the use of Chartres (Paris, Bibl. Nat., ms. lat. 1406, fol. 131), fifteenth century.

246 This is seen in the altarpiece of St.-André-les-Troyes, cited above.

247 Johann Tritheim, *De laudibus sanctissimae matris Annae tractatus*, Mainz, 1494.

248 E. Schaumkell, *Der Kultus der heiligen Anna am Ausgange des Mittelalters*, Fribourg, 1893.

249 *"Concepit sine originali macula, peperit sine culpa."* Tritheim, *op. cit.*, chap. VII, entitled "Quod sancta Anna filiam suam sine originali macula concepit," should be read in particular.

250 This is the question treated, in *ibid.*, chap. V: *"Quod omnipotens Deus sanctam Annam matrem suae genitricis elegerit ante mundi constitutionem."*

251 *"O numquam sine honore nominandus uterus, in quo archa Dei sine macula meruit fabricari ... Beatus venter qui coeli Dominan portavit!"*

252 Mone, *Lateinische hymnen*, III, p. 189.

253 See the *De Rosario* by Joannes de Lamzheim, 1495.

254 The inscription is not found in all the editions. The engraving reproduced here (fig. 121) does not give it. It is taken from the Hours of Simon Vostre for Angers use (Paris, Bibl. Nat., Cabinet des Estampes, Re 25, fol. 82v), edition of 1530. [For more information on St. Anne and the Immaculate Conception, see D'Ancona, *The Iconography of the Immaculate Conception*, pp. 39-41; J. de Dieu, "Sainte Anne et l'immaculée conception," *Etudes franciscaines*, 30 (1934), pp. 16-39.]

255 The imitation is less striking in the window of the church of St.-Valérien at Châteaudun (Eure-et-Loire).

CHAPTER VI

1 [For studies of late medieval allegory, see J. Pépin, *Mythe et allégorie*, Paris, 1958; H. de Lubac, *Exégèse médiévale*, Paris, 1959, esp. chap. IV, D. W. Robertson, Jr., *A Preface to Chaucer*, Princeton, 1962, esp. "Christian Allegory," pp. 286-317.]

2 [For the windows of St.-Ouen at Rouen, ca. 1495, see *Vitraux de France du XIe au XVIe siècle*, cat. no. 45.]

3 *Mémoires de la société historique et archéologique de Langres*, I (1847), p. 100.

4 This kind of correspondence appeared in the fourteenth century on the altar of Notre-Dame of Avioth.

5 Fairly late sixteenth century.

6 Sixteenth-century paintings, badly restored in the seventeenth. See R. Charles, "Etude historique et archéologique sur l'église et la

paroisse de Souvigné-sur-Mâme (Sarthe)," *Revue historique et archéologique de Maine*, 1 (1876), p. 61.

7 It was not yet recognized that the eight statues of the buttress of the church of Rue represent the four evangelists and the four Fathers of the Church, and not, as had been repeatedly claimed (*Guide Joanne*), Pope Innocent VII, Cardinal Jean Bertrandi, etc.

8 The evangelists and Church Fathers carved on the panels of the door at Beauvais are placed in a single row in this order: Sts. John, Matthew, Mark, Luke, Augustine, Gregory, Jerome, Ambrose (see figs. 122, 123). Clearly, in the artist's mind, John corresponded to Augustine, Matthew to Gregory, Mark to Jerome, and Luke to Ambrose.

9 In the painting in the Louvre (1516), as in the engraving by the Master of 1466, St. Jerome has the lion of St. Mark beside him, while the other Fathers are accompanied by the angel of St. Matthew, the ox of St. Luke, and the eagle of St. John. [Pier Francesco Sacchi (1485-1528), Four Fathers of the Church, earlier in S. Giovanni di Prè in Genoa.]

10 I have been fortunate in seeing this hypothesis confirmed. Emile Delignières noted escutcheons beneath several statues which can only be those of the guilds that defrayed the costs. See E. Delignières, "Un grand fauconnier du XVIe siècle au portail de l'église de Sainte-Vulgran à Abbeville," *Réunion des sociétés des beaux-arts des départements*, 24 (1900), p. 288.

11 Begun at the end of the fifteenth century, as was St.-Vulfran. Moreover, the façade of St.-Riquier contains some ingenious ideas: for example, on the great portal, the flamboyant mullions of the tympanum become the branches of a Tree of Jesse. But this is only ingenuity.

12 See L. Pigeotte, *Etude sur les travaux d'achèvement de la cathédrale de Troyes*, Paris, 1870.

13 Certain statues decorating the façade of the cathedral of Troyes were donated by individuals (*ibid.*, p. 119, no. 2). If the statue presented was that of the donor's patron saint, which is not at all impossible, then the idea of a unified whole disappeared. This is the case at Abbeville.

14 Take the statues of Charles V, of Charles VI, of Bureau de la Rivière, and of their protector saints, on the north side of the cathedral of Amiens—this is a form of vanity unknown in the thirteenth century.

15 Paris, Bibl. Nat., ms. fr. 8, fol. 10.

16 Paris, Bibl. Nat., ms. fr. 5, fols 5 and 6 (ca. 1350); *Cité de Dieu* Paris, Bibl. Nat., ms. fr. 22912, fol. 2v, (illuminated between 1371 and 1375); *Bible historiale* Paris, Bibl. Nat., ms. fr. 3, fols. 5ff., (late fourteenth century); Paris, Bibl. Nat., ms. fr. 9, fols. 4 and 5 (early fifteenth century); Paris, Bibl. Nat., ms. fr. 15393, fol. 3 (early fifteenth century; Paris, Bibl. Nat., ms. fr. 247, fol. 3 (early fifteenth century). These are the first of Fouquet's Josephus, which were illuminated prior to Fouquet's participation. [For Paris, Bibl. Nat., ms. fr. 22912-13, see L. Delisle, *Fac-similé de livres copiés et enluminés pour roi Charles V*, Nogent-le-Rotrou, 1903, p. 365 n. 105 and p. 379 n. 10. For Paris, Bibl. Nat., ms. fr. 3, see Meiss, *French Painting in the Time of Jean de Berry: The Late XIV Century and the Patronage of the Duke*, 1, p. 354.]

17 For a full discussion of these ideas, see Mâle, *L'Art religieux du XIIIe siècle*, 8th ed., pp. 35ff. [*Religious Art in France: The Thirteenth Century*, Bollingen XC. 2, Princeton, 1984, pp. 38ff.].

18 This occurs hundreds of times in Books of Hours. The earliest examples I know are: Paris, Bibl. Nat., ms. lat. 924, fols. 17ff. (end of the reign of Charles V, I believe); Paris, Bibl. Nat., ms. lat. 18206 is a little later. From the fifteenth century on, the examples are too numerous to cite.

19 The evangelists themselves become very prosaic. They are represented by the figures of notaries, wearing fine fur hats and enveloped in comfortable fur-lined cloaks. See above.

20 [See L. Goppolt, *Typos. Die typologische Deutung des Alten Testaments im Neuen*, Gütersloh, 1939; Künstle, *Ikonographie*, 1, pp. 82-86; *Réau*, 1, pt. 1: "Le Symbolisme typologique ou la concordance des deux Testaments," pp. 192-222.]

21 *Bible moralisée* (Paris, Bibl. Nat., ms. fr. 166). This great lord did not have the pleasure of seeing his book completed as it was still being worked on at the end of the fifteenth century. A number of miniaturists, two of whom did exquisite work, labored on it for at least eighty years and were never able to finish it. [See *Manuscrits à peintures*, no. 188.]

22 *Bible moralisée* (Paris, Bibl. Nat., ms. fr. 166, fol. 1v).

23 *Ibid.*, fol. 10.

24 *Bible moralisée* (Paris, Bibl. Nat., ms. fr. 167). This book dates from ca. 1400.

25 In the first part of the fifteenth century an unknown artist illuminated a remarkable Book of Hours for the Rohan family (Paris, Bibl. Nat., ms. lat. 9471), which has similar allegories in the margins. [For the Rohan Hours, see Chapter 1, n. 70. Jean sans Peur was assassinated at the Montereau bridge in 1419 (b. 1317).]

26 [For such "disguised symbolism," see Panofsky, *Early Netherlandish Painting*, chap. 5: "Reality and Symbol in Early Flemish Painting: spiritualia sub metaphoris corporalium," pp. 131-148.]

27 *Bible moralisée* (Paris, Bibl. Nat., ms. lat. 11560; Oxford, Bodleian Lib., ms. 270B; London, Brit. Mus., Harley ms. 1526-1527). L. Delisle, *L'Histoire littéraire de la France*, Paris, 1733-1749, XXXI, p. 216, has fully explained this relationship. See also, Michel, *Histoire de l'art*, II, pp. 336, and A. de Laborde, *La Bible moralisée conservée à Oxford, Paris et Londres, reproduction intégrale du ms. du XIIIe siècle*, I-V, Paris, 1911-1927.

28 They were given in 1518 by Jacques de Saint-Nectaire, but they were probably begun as early as 1492, when Jacques de Saint-Nectaire became abbot of La Chaise Dieu. [See J. Guiffrey, "Les tapisseries de la Chaise-Dieu," *Congrès archéologique de France*, Puy, 1904, pp. 397-401; E. Mâle, "Les Originaux des tapisseries de la Chaise-Dieu," *Congrès archéologique*, Puy, 1904, pp. 402ff. See also P.-R. Gaussin, *L'Abbaye de la Chaise-Dieu (1043-1518)*, Paris, 1962, p. 455 and fig. opp. p. 476.]

29 The tapestries of Reims appear to be exactly contemporary with those of La Chaise-Dieu; they are reproduced in M. Sartor, *Les Tapisseries, toiles, peintes et broderies*, Reims, 1912.

30 I have presented these results in a report read at the Académie des Inscriptions et Belles-Lettres in 1902, and in a series of articles: see E. Mâle, "L'Art symbolique à la fin du moyen âge," *Revue de l'art ancien et moderne*, 18 (1905), pp. 81ff., 195ff., and 435ff. [The part taken by the *Speculum* and the *Biblia Pauperum*, in the development of late medieval allegory has been analyzed in Lubac, *Exégèse médiévale*, IV, pp. 373ff.]

31 J. Guibert, "Les Origines de la Bible des Pauvres," *Revue des Bibliothèques*, 15 (1905),

pp. 312-315, has shown that the *Biblia pauperum* derives from the *Aurora* of Pierre de Riga, and consequently could date from the last years of the twelfth century. [Further information on the *Biblia Pauperum* may be found in: H. Cornell, *Biblia Pauperum*, Stockholm, 1925; Künstle, *Ikonographie*, I, pp. 90-92; H. Englehart, *Der theologische Gehalt der Biblia Pauperum*, Strasbourg, 1927; H. Rost, *Die Bibel im Mittelalter*, Augsburg, 1939, pp. 214-231; G. Schmidt, *Die Armenbibeln des XIV Jahrhunderts*, Graz, 1959; H. T. Musper, *Die Urausgaben der holländischen Apokalypse und Biblia pauperum*, I-III, Munich, 1961; H. Zimmermann, "Armenbibel," *Reallexikon*, I, cols. 1072-1084; "Armenbibel," *Lexikon der Marienkunde*, I, cols. 353-354; *Réau*, I, pp. 195-196. For a survey of typology, see Goppolt, *Typos*, and Künstle, *Ikonographie*, I, "Die typologischen Bilderkreise im allgemeinen," pp. 82-86.]

32 The manuscript is incomplete and contains only six leaves. It has been studied by A. Blum, "Un manuscrit inédit du XIIIe siècle de 'Bible des pauvres,'" *Monuments et mémoires* (Fondation Piot), 1926, pp. 95-111. [This manuscript is now in the Cabinet des Estampes of the Louvre. For an English translation of a *Biblia Pauperum* text, see A. N. Didron, *Christian Iconography*, New York, 1965, II Appendix III, pp. 403-430.]

33 This title appears on the manuscript at Wolfenbüttel, but it was added later. [Formerly in Wolfenbüttel, it is now in Paris, Bibliothèque Nationale. See P. Heitz, *Biblia Pauperum*, Strasbourg, 1903, and Cornell, *Biblia Pauperum*.]

34 They were studied first by G. Heider, "Beiträge zur christlichen Typologie aus Bilderhandschriften des Mittelalters," *Jahrbuch der Klassiker-Kust. Zentral-Kommission zur Erforschung und Erhaltung der Baudenkmale*, V, 1861, pp. 1-128; then by W. L. Schreiber in the preface to Heitz, *Biblia Pauperum*. His work is very interesting. We see the iconography and disposition of the scenes change little by little as they gradually approach the type adopted in the first blockbook editions.

35 It is characteristic of blockbook editions that the drawing and the text are engraved on the same block of wood.

36 [See A. Blum, *Les Primitifs de la gravure sur bois; étude historique et catalogue des incunables xylographiques du Musée du Louvre (Cabinet*

des Estampes, Edmond de Rothschild), Paris, 1956.]

37 See Schreiber, *Manuel de l'amateur d'estampes*, IV, pp. 1-105.

38 Preface to Heitz, *Biblia pauperum*. The rights of France have been upheld in a remarkable book: H. Bouchot, *Les deux cents incunables xylographiques du département des Estampes*, Paris, 1903.

39 Cornell, *Biblia pauperum*, still maintains that the blockbook edition is Flemish. Guibert, "Les origines de la Bible des pauvres," pp. 323-325, believes that the blockbook edition of forty plates of the *Biblia pauperum* was published by the Carmelite Order. He has noticed that the prophets Elijah and Elisha, legendary ancestors of the Carmelites, wear their habit. [And cf. F. Courboin, *Histoire illustrée de la gravure en France*, I, Paris, 1923; P. A. Lemoisne, *Les Xylographies du XIVe et du XVe siècle au Cabinet des Estampes de la Bibliothèque Nationale*, I, Paris, 1927.]

40 Especially, Paris, Bibl. Nat., ms. lat. 9587.

41 *Incipit prohemium cujusdam nove compilationis edite sub anno millesimo CCCXXIV. Nomen auctoris humilitate siletur et titulus sive nomen operis est Speculum humanae salvationis.* It is then to no purpose that the later manuscripts attribute the book to Ludolphus the Carthusian or to Vincent of Beauvais. Without factual foundation, the name of Conrad d'Alzheim has also been mentioned on the basis of Tritenheim.

42 P. Perdrizet, *Etude sur le Speculum humanae salvationis*, Paris, 1908, using good arguments, tried to prove that the book was of Dominican origin.

43 Some of these symbolic figures were borrowed from profane authors. The legend of the golden table recovered by the fishermen comes from Valerius Maximus. See *ibid.*, p. 95.

44 It is to be noted that the prophets and prophetic texts are missing from the *Speculum humanae salvationis*, except in the copy in the library of Brussels (Brussels, Royal Library, ms. 281-283), German (Prussian), ca. 1390. [For more information on the *Speculum*, see E. Breitenbach, *Speculum humanae salvationis, eine typengeschichtliche Untersuchung*, Strasbourg, 1930. For a facsimile of the copy in the Berlin Staatsbibliotek, see *Speculum humanae salvationis*, E. Kloss, ed., Munich, 1925. See also *Speculum humanae salvationis*, M. R. James and B. Berenson, eds., Oxford, 1926 (facsimile of Paris, Bibl. Nat., ms. lat. 9584). For the influence of the *Speculum* of

Finnish painting, see Cutler, "The 'Mulier Amicta Sole' and her attendants," pp. 132ff. See also Künstle, *Ikonographie*, I, pp. 99-101. For a discussion in English of the contents of the *Speculum*, see Didron, *Christian Iconography*, I, pp. 196-232.]

45 The manuscripts of the *Speculum humanae salvationis* are very numerous: I shall cite Paris, Bibl. Nat., mss. lat. 511, 512, 9584, 9584). For the influence of the *Speculum* on 400, 460, 6275. It is still impossible to know if the book was composed in France or elsewhere. For a very useful reproduction of a manuscript, see J. Lutz and P. Perdrizet, *Speculum humanae salvationis*, I-II, Leipzig, 1907-1909.

46 See E. Dutuit, *Manuel de l'amateur d'estampes*, Paris, 1881, I, p. 209.

47 This is the edition published by Heitz and Schreiber, *op cit.*, based on the only copy in Paris. [See above, nn. 33-34. See also the facsimile of the Klosterneuberg manuscript in Vienna, Austrian National Library, cod. indob. 1198, 1330-1331; *Die Wiener Biblia Pauperum*, F. Unterkircher, ed., introd. by G. Schmidt., I-III, Graz, 1962.]

48 The reproductions of the Turin manuscript were published by Paul Durrieu on the occasion of the jubilee of Léopold Delisle. [L. Delisle, *Heures de Turin*, Paris, 1902; P. Durrieu, *Les Très Belles Heures de Notre Dame de Duc Jean de Berry*, Paris, 1922.]

49 The text tells how Tubal prefigured the suffering of Christ. It could not be more subtle: "By striking with his hammers," says the author, "Tubal invented music. While Christ was nailed to the cross by blows of the hammer, there came from his lips, like the sweetest of music, this prayer: 'Forgive them, for they know not what they do.'"

50 For example, near the flagellated Christ in the *Speculum*, Job is tormented by the devil and by his wife.

51 This triptych was shown at the *Exposition des primitifs flamands et d'art ancien* in Bruges in 1902. It belonged to M. Helleputte of Louvain. The documents concerning the painting have been published by W.H.J. Weale, "La dernière peinture de Jean van Eyck," *Revue de l'art chrétien*, 45 (1902), pp. 1-6. [The Ypres altarpiece, also called the Madonna of Nicholas van Maelbeke, is now in an English private collection. See Panofsky, *Early Netherlandish Painting*, pp. 190-191, and fig. 259, and Philip, *The Ghent Altarpiece*, pp. 201-212.]

52 This is also true of the *Speculum humanae salvationis* (Paris, Bibl. Nat., ms. lat. 9585), fifteenth century. In this manuscript, the Vision of the Three Magi accompanies the Nativity, while in the other manuscripts, it is placed further on. [The Golden Legend on the Nativity may have been another source of the same iconography, as in the Bladelin Triptych. See Panofsky, *Early Netherlandish Painting*, p. 277 and n. 2.]

53 Two wings of the Bouts School (Crews collection) represent the Burning Bush and the Fleece of Gideon. Clearly the central part, which has disappeared, represented the Nativity. [The wings are now in the Marion Kogler Art Institute, San Antonio, Texas. For illustration, see Friedländer, *Early Netherlandish Painting*, III, pl. 59. See also W. Schöne, *Dieric Bouts und Seine Schule*, Berlin, Leipzig, 1938, p. 190, no. 83, where it is attributed to Albrecht Bouts and dated ca. 1490.]

54 (1) Annunciation: Eve with the Serpent, The Fleece of Gideon; (2) Nativity: The Burning Bush, The Flowering Rod of Aaron; (3) Massacre of the Innocents: Saul Having the Priests Killed, Athaliah Having Her Grandsons Killed; (4) Temptation of Christ: Adam and Eve Tempted, Esau Selling His Birthright; (5) Resurrection of Lazarus: Elijah Bringing the Widow's Son Back to Life, Elisha Reviving a Child; (6) Entry of Christ into Jerusalem: David Carrying the Head of Goliath, Elisha Received at the Gates of the City; (7) The Last Supper: Abraham and Melchisedek, The Manna; (8) Christ Carrying the Cross: Isaac Carrying the Wood for the Sacrifice, The Widow of Sarepta Collecting Two Pieces of Wood; (9) Christ on the Cross: The Sacrifice of Abraham, The Brazen Serpent; (10) Entombment of Christ: Joseph Descending into the Well, Jonah Thrown to the Whale; (11) Resurrection of Christ: Samson Carrying Off the Gates of the City, Jonah Cast Up by the Whale; (12) Ascension of Christ: Enoch Carried to Heaven, Elijah's Chariot of Fire; (13) Descent of the Holy Spirit: Moses Receiving the Law, The Fire from Heaven Consuming the Offering of Elijah; (14) Coronation of the Virgin: Solomon Seating His Mother Beside Him, Ahasuerus and Esther.

55 (1) The Holy Women at the Tomb: Reuben Bringing His Brother Up from the Well; (2) Christ Appearing to Mary Magdalene: The King Goes to See Daniel in the Lions' Den;

(3) The Last Judgment: The Judgment of Solomon.

56 (1) Flight into Egypt: David Escapes through a Window, The Idol Dagon Collapses before the Ark (this subject accompanies the Fall of the Idols in the *Biblia pauperum*); (2) The Kiss of Judas: Abner Killed by Jacob, The Fall of the Bad Angels (this subject, in the *Biblia pauperum*, accompanies The Fall of the Soldiers Who Wished to Seize Christ).

57 (1) Adoration of the Magi: The Three Soldiers Carrying the Water to David; The Queen of Sheba before Solomon; (2) The Flagellation: Achior Flagellated, Job Smitten by the Devil; (3) Christ Mocked: The Drunkenness of Noah; The King of the Ammonites and the Envoys of King David; (4) Christ in Limbo: Lot Saved from Sodom, The Three Hebrews in the Furnace.

58 Baptism of Christ: Passage of the Red Sea (scene borrowed from the *Biblia pauperum*), Naaman the Leper Healed in the Jordan (scene borrowed from the *Speculum*).

59 There are three remaining tapestries (Pilate Washing His Hands, Judas and the Thirty Pieces of Silver, The Incredulity of St. Thomas), which are accompanied by types borrowed from the *Biblia pauperum*, but with some variations.

60 C. Loriquet, *Les Tapisseries de la cathédrale de Reims*, Paris, 1882, pp. 59-143.

61 The artist had in front of him a complete *Biblia pauperum* (in fifty scenes). These are the scenes represented: (1) Marriage of the Virgin: Sarah Married to Tobias, Rebecca Married to Isaac, (2) Annunciation: Eve and the Serpent, Fleece of Gideon; (3) Nativity: Moses and the Burning Bush, The Flowering Rod of Aaron; (4) Adoration of the Magi: David Kneeling before Abner, The Queen of Sheba before Solomon; (5) The Child Jesus Presented in the Temple: Presentation of the First-Born, Samuel Presented by Anne; (6) Flight into Egypt: Jacob Sent by His Father to Laban, Michol Helping David Escape; (7) Assumption and Coronation of the Virgin (Solomon and His Mother; Esther and Ahasuerus. The artist carried fidelity to the point of reproducing the inscriptions of the *Biblia pauperum* which explain the subjects. For example, below the Adoration of the Magi and its biblical symbols, is written: *Plebs notat hae gentes Christo jungi cupientes.* See the good book on the subject published in Reims in 1912: Sartor, *Les Tapisseries*.

62 Four tapestries remain for which I have found

no model in either the *Biblia pauperum* or the *Speculum*, and which must have been laid out by a theologian. They are: (1) Anne and Joachim Cast Out by the Priest: Adam and Eve Cast Out of Paradise; Hannah, the Mother of Samuel, Sent away by Eli; (2) Nativity of the Virgin: Struggle of Jacob and the Angel, Balaam's Ass (a figure in the *Biblia pauperum*); (3) The Visitation (The Hebrews in the Furnace, Habakkuk and Daniel); (4) Death of the Virgin: Death of Miriam, Sister of Moses; Death of Sarah, Wife of Abraham.

63 The windows of Mulhouse in Alsace are copied from the *Speculum humanae salvationis*: see Lutz and Perdrizet, *op. cit.*

64 [Jacques-Antoine Dulaure (1755-1835), member of the National Convention and author of numerous historical studies.]

65 They date from the end of the fifteenth century.

66 As in the *Biblia pauperum*, the figures of the prophets accompany the symbolic correspondences. See the beautiful reproductions in L. Begule, *L'Eglise Saint-Maurice, ancienne cathédrale de Vienne*, Paris, 1914, pp. 147-148. [See also R. A. Koch, "The Sculptures of the Church of Saint-Maurice at Vienne, the *Biblia Pauperum* and the *Speculum Humanae Salvationis*," *Art Bulletin*, 32 (1950), pp. 237-253.]

67 The sculptor was Nicolas Halins: See Pigeotte, *Etude sur les travaux d'achèvement de la cathédrale de Troyes*, pp. 114-118.

68 Ivories, no. 1060.

69 For example: Annunciation and Temptation of Eve; Nativity and the Burning Bush; Entry into Jerusalem and David Carrying the Head of Goliath, etc. The scenes are arranged without much order.

70 This proves that the coffer was not made in the fourteenth century, as the catalogue says. It is later than the first blockprint editions of the *Biblia pauperum*, and consequently later than the middle of the fifteenth century.

71 See the Limoges enamel published by L. Bourdery, "Note sur un triptyque en émail peint de Limoges," *Bulletin archéologique du comité des travaux historiques et scientifiques*, 1892, pp. 426-433. The Annunciation is accompanied by David who says, *Domine, sicut pluvia*, and Isaiah, who says, *Ecce Virgo concipiet*. These are texts from the *Biblia pauperum*.

72 These figurines placed on the frames or hidden in the background are not always noticed. The great Flemish altarpiece of Baume-les-Messieurs (Jura) shows beside the Entombment, Jonah Thrown into the Sea; and beside The Last Supper, The Gathering of the Manna and The Meeting of Abraham and Melchisedek.

73 Hours for the use of Rome (Paris, Bibl. Nat., Vélins 1643), ca. 1488, printed by Antoine Caillaut. [See Lacombe, *Catalogue des Livres d'Heures imprimés*, no. 14.]

74 With the title, *Miroir de la Rédemption*. This is our first illustrated book. Moreover, the woodcuts of the *Miroir de la Rédemption* were those used by Richel for the *Speculum humanae salvationis* printed in Basel in 1476.

75 With this title: *Les Figures du Viel testament et du Nouvel.*

76 See the Printed Hours for the use of Paris, Paris, 1495.

77 Hours for the use of Rome, printed by Kerver and Wolff, 1498; Hours for the use of Lyon, printed by Pigouchet, 1495; Hours of the Virgin, printed by Etienne Jehannot, 1497.

78 These Books of Hours, in turn, probably furnished artists with more than one scene from the Old Testament placed in correspondence with one from the New.

79 De la Fons Mélicocq, "Drame du XVIe siècle," *Annales archéologiques*, 8 (1848), pp. 272ff.

80 If we compare The Burning Bush by Nicolas Froment with the plate in the *Biblia pauperum* devoted to the same subject, we will easily recognize that the painter had the engraving in front of him. The gesture of Moses is the same; the tree has this same nest like form. There is only one difference: Froment has replaced God with the Virgin. [Cf. E. Harris, "Mary in the Burning Bush, Nicolas Froment's triptych at Aix-en-Provence," *Journal of the Warburg and Courtauld Institutes*, 1 (1938), pp. 281-286. See also C. I. Minott, "A Note on Nicolas Froment's 'Burning Bush Triptych,'" *Journal of the Warburg and Courtauld Institutes*, 25 (1962), pp. 323-325, and E. Vetter, "Maria im Brennenden Dornbush," *Das Münster*, 10 (1957), pp. 237-253.]

81 [Pope Clement VI (1291-1352), who had been a monk at Chaise-Dieu, began the present church. It was finished by his nephew, Pope Gregory XI (d. 1378). The tomb of Clement VI is in the choir of the abbey church of

St.-Robert at Chaise-Dieu. See Gaussin, *L'Abbaye de la Chaise Dieu*.]

82 [For the conjunction of prophets and apostles, see *Réau*, II, pt. I, pp. 365ff.; *Reallexikon*, I, "Apostel," cols. 811-829.]

83 Sermon 240, Migne, *P.L.*, 39, col. 2188. This sermon was rejected by the Benedictines of the seventeenth century as an apocryphal work of St. Augustine.

84 These are the sentences pronounced by each apostle: (1) Peter: *Credo in Deum patrem omnipotentem, creatorem coeli et terrae*; (2) Andrew: *Et in Jesum Christum, filium ejus*; (3) James the Greater: *Qui conceptus est de Spiritu Sancto, creatus ex Maria Virgine*; (4) John: *Passus sub Pontio Pilato, crucifixus, mortuus et sepultus est*; (5) Thomas: *Descendit ad inferna. Tertia die resurrexit a mortuis*; (6) James the Less: *Ascendit ad coelus, sedet ad dexteram partis omnipotentis*; (7) Philip: *Inde venturus est judicare vivos et mortuos*: (8) Bartholomew: *Credo in Spiritum Sanctum*; (9) Matthew: *Sanctam Ecclesiam catholicam, sanctorum communionem*, (10) Simon: *Remissionem peccatorum*, (11) Thaddaeus: *Carnis resurrectionem*; (12) Matthias: *Vitam aeternam*.

85 *Rationale*, bk. IV, 25. [William Durandus, ca. 1237-1296, Bishop of Mende, was one of the most important liturgical writers of the Middle Ages. The *Rationale divinorum officiorum*, 1st. ed., Mainz, 1459, was written in 1286, and treats the ritual of the Church, including the symbolism of rites and vestments. See *Rational ou manuel des divins offices de Guillaume Durand*, M. C. Barthélemy, tr., I-V, Paris, 1854. For English translation, see J. P. Neale and B. Webb, *The Symbolism of Churches and Church Ornaments*, London, 1906, (1st ed., Leeds, 1843).]

86 *Sentent.*, bk. III, dist. 25, q. 2 no. 9.

87 Paris, Bibl. Mazarine, ms. 742, fol. 107v, thirteenth century, and Paris, Bibl. de l'Arsenal, ms. 1037, fol. 6, late thirteenth century.

88 Paris, Bibl. Mazarine, ms. 742, fol. 107v: "*Beatus Augustinus et majores doctores Ecclesiae tradunt . . .*"

89 *Petites Heures* of Jean Duke of Berry (Paris, Bibl. Nat., ms. lat. 18014), ca. 1390; Paris, Bibl. de l'Arsenal, ms. 1100, fifteenth century; windows of St.-Serge in Angers; *L'Art de bien vivre et de bien mourir*, printed by Antoine Vérard, Paris, 1492; *Le Calendrier des Bergers*, printed by Guy Marchant, Paris, 1493 [see Chapter VII, n. 4]; frescoes by Vecchietta in the Baptistery, Siena (ca. 1452);

choir stalls in the cathedral of Geneva. [For illustrations of the choir stalls in the cathedral of St.-Pierre, Geneva, see W. Deonna, *Les Arts à Genève des origines à la fin du XVIIIe siècle*, Geneva, 1942, figs. 142-146. Choir stalls in Lausanne are reproduced in E. Bach, L. Blondel and A. Bovy, *La Cathédrale de Lausanne*, Basel, 1944, figs. 275-276. For frescoes by Vecchietta in the Baptistery of Siena, dated 1450-1453, see van Marle, *The Development of the Italian Schools of Painting*, XVI, pp. 232ff.]

90 *Verger de soulas* (Paris, Bibl. Nat., ms. fr. 9220, fol. 13v), ca. 1290 (French), and *Speculum theologiae* (Paris, Bibl. de l'Arsenal, ms. 1037, fol. 6), early fourteenth century (French). [Also, the Howard Psalter (London, Brit. Mus., ms. A. 83, I, fol. 12), ca. 1300-1308 (English). See also Lubac, *Exégèse médiévale*, IV, p. 375.]

91 This important concordance is as follows: (1) Peter: *Credo in Deum omnipotentem, creatorem coeli et terrae*; Jeremiah: *Patrem invocabitis qui terram fecit et condidit coelum*. (2) Andrew: *Et in Jesum Christum Filium ejus*; David: *Dominus dixit ad me filius meus es tu*. (3) James the Greater: *Qui conceptus est de Spiritu Sancto, natus est ex Maria Virgine*; Isaiah: *Ecce Virgo concipiet*. (4) John: *Passus sub Pontio Pilato, crucifixus, mortuus et sepultus est*; Daniel: *Post septuaginta hebdomadas occidetur Christus*. (5) Thomas: *Descendit ad inferna, tertia die resurrexit a mortuis*; Hosea: *O mors, ero mors tua, morsus tuus ero, inferne*. (6) James the Less: *Ascendit ad coelos, sedet ad dexteram patris omnipotentis*; Amos: *Qui aedificat in coelo ascensionem suam*. (7) Philip: *Inde venturus est judicare vivos et mortuos*; Zephaniah: *Ascendam ad vos in judicium et ero testis velox*. (8) Bartholomew: *Credo in Spiritum sanctum*; Joel: *Effundam de Spiritu meo super omnem carnem*. (9) Matthew: *Sanctam Ecclesiam catholicam, sanctorum communionem*; Micah; *Invocabunt omnes nomen Domini et servient ei*. (10) Simon: *Remissionem peccatorum*; Malachi: *Deponet Dominus omnes iniquitates nostras*. (11) Thaddaeus (Jude): *Carnis resurrectionem*; Zacchariah: *Educam te de sepulchris tuis, popule meus*. Matthias: *Vitiam aeternam*, Ezekiel: *Evigilabunt alii ad vitam, alii ad mortem*. These are the usual texts, but there were some variants.

92 *Verger de Soulas* (Paris, Bibl. Nat., ms. fr. 9220). [*Manuscrits à peintures*, no. 66.]

93 H. Y. Thompson, *The Book of Hours of Joan II, Queen of Navarre*, London, 1899, published with reproductions. Thompson owned this beautiful manuscript, which was the work of Jean Pucelle. [Panofsky, *Early Netherlandish Painting*, p. 34 n. 2 (a), dates these Hours between 1336 and 1349. See also Morand, *Jean Pucelle*, pp. 20-21, and cat. no. 15.]

94 Belleville Breviary (Paris, Bibl. Nat., ms. lat. 10483), the work of Jean Pucelle and his atelier. [*Ibid.*, pp. 9-12, cat. no. 10, Morand dates the manuscript in the mid-1320s; Panofsky, *Early Netherlandish Painting*, pp. 32-35, and p. 32 n. 2, dates it between 1323 and 1335. For illustrations, see Leroquais, *Les Bréviairies*, pls. xxvii-xxxvi.]

95 While Isaiah announces that a "virgin will give birth," and St. James the Greater teaches that "Jesus Christ was conceived by the Holy Ghost and was born of the Virgin Mary," St. Paul proclaims that "God sent his only Son, made of a woman" (Galatians 4:4).

96 The phrases inscribed below St. Paul are found neither in the Book of Hours of Joan of Navarre nor in the Belleville Breviary, but they are found in the *Grandes* and the *Petites Heures* of the Duke of Berry. They are indispensable. This and other details prove that the Book of Hours of Joan of Navarre and the Belleville Breviary were not the originals copied by the miniaturists of the Duke of Berry. There was a prototype which perhaps went back to the thirteenth century.

97 To these two manuscripts already cited we must add the Psalter of John of Berry (Paris, Bibl. Nat., ms. fr. 13091). The prophets and the apostles are the work of André Beauneveu. [See *Manuscrits à peintures*, no. 180.[

98 In the crypt of the cathedral of Bourges. [The Sainte-Chapelle windows (1405) are reproduced in Musée des arts décoratifs, *Vitraux français*, pl. 24, and cat. no. 36.]

99 One of the statues of Bourges offers a striking resemblance to a miniature of the Psalter illuminated by André Beauneveu. See the reproductions in A. de Champeaux and P. Gauchery, *Les Travaux d'art du duc de Berry*, Paris, 1894, pp. 95-96, and plates.

100 Perhaps from the chapel of the château of Mehun-sur-Yèvre. [For Beauneveu, see Panofsky, *Early Netherlandish Painting*, pp. 40ff., and H. Bober, "André Beauneveu and Mehun-sur-Yèvre," *Speculum*, 28 (1953), pp. 741-753.]

101 Except for the examples cited above, I can indicate for the fourteenth century only two tapestries: one of the Duke of Burgundy (1386), and the other of the Duke of Orléans (1395). They represent the *Credo*, and the prophets correspond to the apostles. J. Guiffrey, *Histoire de la tapisserie en France*, Paris, 1878, i, p. 18.

102 Flemish tapestry, now in Rome; paintings in the Baptistry of Siena; stalls at Lausanne and Geneva. [See above, n. 89.]

103 And not by the Duke of Berry. See Champeaux and Gauchery, *Les Travaux d'art du duc de Berry*, p. 55.

104 We cite again the windows of St.-Serge, in Angers, and those of the apse of St.-Maclou, in Rouen. (At Rouen, two pairs of apostles and prophets are all that remain.)

105 [The Albi statues are reproduced in E. Mâle, *La Cathédrale d'Albi*, Paris, 1950, pls. 94-120 and figs. 5 and 6. See also H. David, "Les Bourbons et l'art slutérien au XVe siècle," *Annales du Midi*, 1936, pp. 337-362; Müller, *Sculpture in the Netherlands*, p. 137 (with additional bibliography), and pl. 145 A.]

106 These very large brackets are well preserved.

107 At Cluny, the apostles were arranged in the following order: Peter, Andrew, James the Greater, John, James the Less, Thomas, Matthew, Bartholomew, Philip, Simon, Jude (Thaddaeus), Matthias.

108 The Albi apostles are not placed side by side: they face each other; from St. Peter, on one side of the choir, we must cross to St. Andrew, on the other side, etc.

109 The inscriptions of Cluny have been transcribed by J. Pougnet, "Théorie et symbolisme des tons de la musique grégorienne," *Annales archéologiques*, 26 (1896), pp. 380-387; those of Albi are found in E. de Rivières, "Epigraphie Albigeoise, Inscriptions des statues du choeur," *Bulletin monumental*, 41 (1875), p. 726.

110 It must be noted, for example, that at Cluny and Albi the prophecy of the death of Christ (which corresponds to the words of St. John) is not by Daniel, but by Zaccariah (12:10). He said, *"Adspicient ad me Dominum suum quem confixerunt"* (And they shall look upon me whom they have pierced).

111 The chapel of Cluny was built in the time of Jean de Bourbon, who was abbot from 1456 to 1485. The enclosure of the choir of Albi dates from the time of Louis I d'Amboise, who was bishop from 1473 to 1502. It

must not be forgotten that at Cluny, Jean de Bourbon had Jacques d'Amboise, who was the brother of Louis I, bishop of Albi, as coadjutor from 1481. Might Jacques d'Amboise have recommended to the bishop of Albi the atelier which had worked and perhaps was still working at Cluny in 1481?

112 I have not forgotten Petrarch and the precursors of the fourteenth century. [For the survival of classical antiquity in the Middle Ages, see J. Adhémar, *Influences antiques dans l'art du moyen âge français*, London, 1939; E. Panofsky and F. Saxl, "Classical Mythology in Medieval Art," *Metropolitan Museum Studies*, 4 (1932-1933), pp. 228-280; J. Seznec, *Survival of the Pagan Gods* (Bollingen xxxviii), New York, 1953; E. Panofsky, *Renaissance and Renascences in Western Art*, Stockholm, 1960.

113 [For further discussion of Virgil's appeal to the Middle Ages, cf. D. Comparetti, *Virgilio nel medio evo*, i-ii, Florence, 1937-1946, and Lubac, *Exégèse médiévale*, iv, pp. 239-240. For Virgin and sixteenth-century France, see A. Hulubei, "Virgile en France au XVIe siècle," *Revue du XVIe siècle*, 18 (1931), pp. 1-77.]

114 *De probatione fidei christianae per auctoritatem paganorum* (Paris, Bibl. de l'Arsenal, ms. 78). This treatise, attributed to Jean de Paris, was copied by an Italian between 1474 and 1477.

115 *Liber de christiana religione ad Laurentium Medicem*, Florence, 1474. [For more information on Ficino's influence on the visual arts, see A. Chastel, *Marsile Ficin et l'art*, Geneva, Lille, 1954.]

116 [The iconography of Raphael's *Disputà* and School of Athens has been discussed by *idem, Art et Humanisme à Florence*, Paris, 1959, in the chapter, "Le 'Miroir Doctrinal': La Chambre de la Segnatura," pp. 469-483.]

117 [In the French of the original text, Mâle makes a pun which does not carry into translation, viz: "Il affirmait ainsi, en plein Vatican, que la pensée antique est sainte, que les philosophes sont les ancêtres legitimes des théologiens. . . ."]

118 In France, however, around the tomb of the bishop Jean Olivier (d. 1540), Moses and Solomon are placed alongside Plutarch, Aeschylus, Ovid, Cicero, Diogenes, Pythagoras, Ptolemy and Boethius, who pronounce consoling words on death. The remains of this tomb are in the museum of Angers.

119 [For the iconography of the sibyls, see *Réau*, ii, pt. 2, pp. 420-430; X. Barbier de Montault, *Iconographie des sibylles*, Arras, 1871; F. Neri, "Le tradizione italiane della sibilla," *Studi medievali*, 4 (1912-1913), pp. 220ff.; M. Hélin, "Un texte inédit sur l'iconographie des sibylles," *Revue belge de philologie et d'histoire*, 15 (1936), pp. 349-366; L. Freund, *Studien zur Bildgeschichte der Sibyllen* (diss.), Hamburg, 1936; Cutler, "The 'Mulier Amicta Sole' and Her Attendants," pp. 117-134.]

120 See Mâle, *L'Art religieux du XIIIe siècle en France*, 8th ed., pp. 339ff. [*Religious Art in France: The Thirteenth Century* Bollingen XC. 2, Princeton 1984, pp. 333ff.]

121 The Erythraean Sibyl was also known in Italy and was sometimes represented. I have discussed this in a Latin thesis: E. Mâle, *Quomodo Sibyllas recentiores artifices repraesentaverint*, Paris, 1899, pp. 16ff.

122 The Greek historians Malalas, Suidas, and Cedrenus imagined an interview between Augustus and the Pythian who foretold to him the reign of the Son of God. In the twelfth century, Godefroi of Viterbo replaced the Pythian by a sibyl: "*Speculum regum,*" *Monumenta germaniae historica*, G. H. Pertz, ed., Hanover, 1872, xxii, p. 68. An anonymous writer, a little later, spoke for the first time of the Tiburtine Sibyl, and gave the legend as we have told it (*ibid.*). The same legend is found in the *Mirabilia urbis Romae*. [See *Merveilles de Rome*, printed by Guy Marchant for G. de Marnef, Paris, 1499, fol. 15v.]

123 Marble altar of the Aracoeli, from the late twelfth century. It is reproduced by L. A. Muratori, *Antiquitates italicae medii aevi*, Milan 1938-1942, iii, p. 880.

124 Thanks to the *Speculum humanae salvationis*, which had adopted it. The earliest representations show, as does the *Speculum*, Augustus alone with the sibyl: *Très riches Heures* of Chantilly; painting by Jan van Eyck for the church of Ypres [see above, n. 51]. But with Roger van der Weyden's Middleburg Triptych in Berlin (fig. 27, left wing), the scene is suddenly enriched. Near Augustus are three figures who are witnesses to the miracle. Who are they? We have only to read the *Mystère de l'Incarnation* played at Rouen, or the *Mystère d'Octavien et de la Sibylle* [see Chapter ii, n. 36]. There, Augustus (Octavian) is accompanied by his faithful followers, Senechal, Prevost, and

Constable; and when the Virgin carrying the Child appears in the sky, Augustus uncovers his head, then takes a censer *(Mystère de l'Incarnation)* and censes. In the painting by Roger van der Weyden, Augustus, kneeling with bared head, holds in one hand a hat adorned with precious stones and, in the other, a censer (fig. 27). A miniature in the Grimani Breviary contains a similar scene [(Venice, Bibl. di San Marco, ms. lat. I, 99), Flemish, ca. 1500. See M. Salmi, *Grimani Breviary*, London, 1972.] Thus, there was an artistic tradition which came from the theater. In our French art, the vision of the Emperor is found very often at the beginning of the sixteenth century. It is found on the Tour de Beurre of the cathedral of Rouen. This was a subject particularly dear to the glass painters of Champagne: windows of St.-Leger-lez-Troyes; St.-Parres-les-Tertres; Ervy; St.-Alpin at Chalons; Sens; and the chateau of Fleurigny. [The Sens window, of 1542, is illustrated in Lafond, "Renaissance," from Aubert *et al.*, *Le Vitrail français*, pp. 213-256, fig. 166.] In all these windows the influence of the Mystery plays is evident. Augustus, it is true, does not hold the censer, but in all of them he is kneeling, has his royal hat adorned with a crown placed before him, and near him are his chief officials. The windows of Champagne contain a new detail: the sibyl is also accompanied by her retinue. Is this a fantasy of the artists or was there a Mystery play in which the sibyl was represented with her retinue? The latter hypothesis seems to me most likely. A tapestry in the Cluny Museum representing the vision of Augustus also shows three followers behind the Tiburtine Sibyl. [The Cluny tapestry, made in Brussels in the first third of the sixteenth century, is reproduced in Göbel, *Wandteppiche*, II, pt. I, pl. 55. For the theme of Augustus and the Tiburtine Sibyl, see F. Kampers, "Die Sibylle von Tibur und Vergil, II," *Historisches Jahrbuch*, 29 (1908), pp. 243-244; C. A. Thomas-Bourgeois, "Le Personnage de la sibylle et la légende de l'ara coeli dans une nativité wallone," *Revue belge de philologie et d'histoire*, 18 (1939), pp. 883-912; *Réau*, II, pt. 2: "Les Sibylles," pp. 420-430; P. Verdier, "A Medallion of the 'Ara Coeli' and the Netherlandish Enamels of the Fifteenth Century," *Journal of the Walters Art Gallery*, 29 (1961), pp. 8-37; *The International Style* (Walters Art Gallery, Baltimore), pp. 132-133, cat. no. 136; "Augustus,"

Reallexikon, I, cols. 1269-1275; Aurenhammer, "Augustus und die Sibylle von Tibur," *Lexikon*, I, pp. 272-275. For Antoine Caron's painting in the Louvre of ca. 1580, which has been related to the *Mystère d'Octavien et de la Sibylle*, given at Paris in 1575 and 1580, and G. Lebel, "Un tableau d'Antoine Caron," *Bulletin de la société de l'histoire de l'art français*, 1937, pp. 20-37; *idem*, "Notes sur Antoine Caron et son oeuvre," *Bulletin de la société de l'histoire de l'art français*, 1940, pp. 7ff.; R. Rosenblum, "The Paintings of Antoine Caron," *Marsyas*, 6 (1950-1953), pp. 1-7. See also Cutler, "The 'Mulier Amicta Sole' and Her Attendants," pp. 125ff., and *idem*, "Octavian and the Sibyl in Christian Hands," *Vergilius*, 11 (1965), pp. 22-32. The statues of the Tour de Beurre of the cathedral of Rouen are discussed by L. Lefrançois-Pillion, "Le mystère d'Octavien et la Sibylle dans les statues de la Tour de Beurre à la cathédrale de Rouen," *Revue de l'art*, 47 (1925), pp. 145-153, 221-231.]

125 [Lucius Caecilius Firmianus Lactantius (from ca. 250 to after 317), *Divinae institutiones*, Migne, *P.L.*, 6 cols. 111-1100. For an English translation, see M. F. McDonald, *The Divine Institutes*, Washington, 1964. See also below, n. 129.]

126 [The sibyls of the Tempio Malatestiano are discussed by C. Ricci, *Il Tempio Maltestiano*, Milan, Rome, 1925, pp. 481-498.]

127 [For illustrations, see W. Vöge, *Jörg Syrlin der Altere und seine Bildwerke*, Berlin, 1950, II pls. 4-11, 42-67. See also Müller, *Sculpture in the Netherlands*, pp. 111-116, and pls. 112-123, for Heinrich Steinhövel's part in devising the program; and A. Feulner and T. Müller, *Geschichte der deutschen Plastik* (Deutsche Kunstgeschichte, II), Munich, 1953, pp. 306ff. and fig. 248.]

128 The prophesy of the Hellespontine Sibyl was borrowed, with a distortion, from Sozomen's *Ecclesiastical History* (*A Select Library of Nicene and Post-Nicene Fathers*, II, New York, 1891, pp. 1890ff.), bk. II, chap. I. That of the Sibyl Cimeria was borrowed from Virgil, that of the Erythraean Sibyl from the acrostic verses cited by St. Augustine. [Salmarius Hermias Sozomen (b. last quarter of fourth century, d. 447-448) was a famous historian of the early Church.]

129 We know that the first book printed in Italy, at Subiaco in 1465, was the *Divinae institutiones* of Lactantius. The book had such success that new editions were brought out in

1468, 1470, 1471, 1472, 1474, and 1478. This printed book by Lactantius surely had arrived at Ulm when Syrlin began the stalls of the cathedral. It is evident that the sibyls of Rimini could only have been borrowed from a manuscript. [See Graesse, Trésor de livres, IV, pp. 65-66.]

130 The following is the passage Lactantius borrowed from Varro: *Ceterum Sibyllas decem numero fuisse [ait Varro], easque omnes enumeravit sub auctoribus qui de singulis scriptitaverunt. Primam fuisse de Persis, cujus mentionem fecit Nicanor, qui res gestes Alexandri Magni scripsit. Secundam Libyssam, cujus meminerit Euripides in Lamiae prologo. Tertiam Delphicam, de qua Chrysippus loquatur in eo libro quem de Divinatione composuit. Quartam Cimmeriam in Italia, quam Naevius in libris Belli Punici, Piso in Annalibus nominet. Quintam Erythraeam, quam Apollodorus Erythraeus affirmat suam civem fuisse, eamque Graiis Ilium petentibus vaticinatum, et perituram esse Trojam et Homerum mendacia scripturum. Sextam Samiam, de qua scribat Erathosthenes in antiquis annibus Samiorum repperisse se scriptum. Septiman Cumanam, nomine Amalthaeam, quae ab aliis Demophile vel Herophile nominetur, eamque novem libros attulisse ad regem Tarquinium Priscum ... Octavam Hellesponticam, in agro Trojano natam, vico Marpesso, circa oppidum Gergithium quam scribat Heraclides Ponticus Colonis et Cyri temporibus fuisse. Nonam Phrygiam quae vaticinata est Ancyrae. Deciman Tiburtem, nomine Albuneam, quae Tiburi colatur ut des juxta ripas amnis Anienis, cujus in gurgite simulacrum ejus inventum esse dicitur, tenens in manu librum." Divinae institutiones*, bk. I, chap. vi.

131 For a better understanding of this chapter, we have grouped here the sibylline prophecies scattered through the book of Lactantius: On God: *Solus Deus sum et non est Deus alius* (*ibid.*, I, vi). On Christ: *Ipsum tuum cognosce Deum qui Dei filius est* (*ibid.*, IV, vi). On Christ as Redeemer: *Jugum intolerabile super collum nostrum tollet* (*ibid.*, VII, xviii). On the miracles of Christ: *Panibus simul quinque et piscibus duobus hominum millia quinque in deserto satiabit et reliqua tollens post fragmenta omnia duodecim implebit cophinos in spem multorum* (*ibid.*, IV, xv). On the Passion of Christ: *In manus iniquas infidelium postea veniet; dabunt autem Domino alapas manibus incestis et impurato ore expuent venenatos sputus: dabit vero ad verbera*

simpliciter sanctum dorsum.—Et colaphos accipiens tacebit ne quis agnoscat quod verbum vel unde veniat et corona spinea coronabitur.—Ad cibum autum fel et ad sitim acetum dederunt: inhospitalitatis hanc monstrabunt mensam.—Ipsa enim, Judaea insipiens, tuum Deum non intellexisti Iudentem mortalium mentibus, sed spinis coronasti et horridum fel miscuisti (*ibid.*, IV, xviii): taken from the *City of God*, XVII, xxiii. [Augustine, *City of God*, D. Knowles, ed., Baltimore, 1972.] On the death of Christ: *Templi vero velum scindetur, et medio die nox erit tenebrosa nimis in tribus horis* (*Divinae institutiones*, IV, xviii): taken from St. Augustine. On the Resurrection of Christ: *Et mortis fatum finiet, et morte morietur tribus diebus somno suscepto et tunc ab inferis regressus ad lucem veniet primum resurrectionis initium ostendens* (*ibid.*, VII, xviii): taken from St. Augustine. On the Last Judgment: *Tuba de coelo vocem luctuosam emittet* (*ibid.*, VII, xvi).—*Tartareum chaos tunc ostendet terra dehiscens: venient autem ad tribunal regis reges omnes* (*ibid.*, VII, xx). *Deus ipse judicans pios simul et impios, tunc demum impios in ignem et tenebras mittet, qui autem pietatem tenent, iterum vivent* (*ibid.*, VII, xxiii).

132 See E. Reuss, "Les Sibylles chrétiennes," *Nouvelle revue de théologie*, 3 (1861), pp. 193-274; Alexandre, *Oracula Sibyllina*, Paris, 1841-1856, Excursus; H. P. Delaunay, *Moines et Sibylles dans l'antiquité judéo-greque*, Paris, 1874; A. Bouché-Leclercq, *Histoire de la divination dans l'antiquité*, Paris, 1879-1882, II, pp. 169ff. [For English translation of *Oracula Sibyllina*, see *The Sibylline Oracles*, M. S. Terry, tr., New York, 1890.]

133 The Greek text of the *Oracula Sibyllina* appeared for the first time in Basel in 1545 (edition of Sextus Betuleius). [Sixtus Birken.]

134 See my Latin thesis: Mâle, *Quomodo Sibyllas*, pp. 45ff.

135 One is at the Grand Séminaire of Liège, the other at the Abbey of Tongerloo in Belgium. These two manuscripts have been studied by Hélin, "Un texte inédit sur l'iconographie des sibylles," pp. 349-366.

136 A long time passed before it was printed, if we are to believe the preface of the editor, Philippus de Lignamine: *Decrevi caracteribus perpetuis imprimere celeberrima opuscula, quae celeberrimus artium et theologiae interpres, magister Philippus, ex ordine praedicatorum ... edidit.*

137 There is no point in giving the entire verses

recited by the prophets. We transcribe only the first words.

138 There are many unintelligible passages in Filippo Barbieri's book. These obscurities are sometimes accountable to the printing. *Tractatus de discordantia inter Eusebium, Hieronymum et Augustinum* (Paris, Bibl. de l'Arsenal, ms. 243) whose text is more correct than the printed version, has enabled us to make some corrections. We indicate the variants. Here, instead of *statua* the manuscript gives *statera* which is not much clearer.

139 Ms.: *cujusdam*.

140 It should read *Cimmeria*.

141 The manuscript adds *nutrit puerum*.

142 Ms. *jus*.

143 It is possible that Appellas designated the Jews (cf. Horace, *Satirae*, I, IV, v. 100: *credat Judaeus Apella*). As for the aged woman, perhaps she is the prophetess Anne. [See E. P. Morris, *Horace: Satires and Epistles*, Norman, Okla., 1968.]

144 In the manuscript, it should be noted that the Erythraean Sibyl holds a naked sword. Sometimes there are also rather notable differences between the costume of the sibyls of the manuscript and those of the book. It is curious that we also find variants in the different printed editions of Barbieri.

145 We transcribe here the entire passage attributed to Johan by Filippo Barbieri. The Bible puts these words in the mouth of Gideon. The error probably came from the printer, who, in place of *Judices* VI, or perhaps of *Gede*, read *Jone* VI. This slight error deserves mention because, as we shall explain further on, it is doubltess to it that we owe the Jonah of the Sistine Chapel.

146 Here the manuscript differs singularly from the book. The manuscript reads: *Sibylla Phrigia, induta veste rubea, nudis brachiis, antiqua Saturnina facie, crinibus sparsis, digitio indicans, dicens sic: "Flagellabit dominus . . ."*

147 According to J. J. Boissard, *Tractatus de divinatione et magicis*, Oppenheim, 1611, p. 215, this *taurus pacificus* refers to the Emperor Augustus.

148 In the manuscript, the Sibyl of Tibur is seen in another respect; *Sibylla Tiburtina, non multum senex, veste rubea induta desuper, ad collum pellem hircinam per scapulas habens, capillis discoopertis, simulacrum tenebat verbi, scriptum erat: "Nascetur. . . ."*

149 The manuscript gives some details about the aspect and the costume of Sibyl Agrippa: *simul et impios, tunc demum impios in ignem et tenebras mitet, qui autem pietatem tenent, iterum vivent.* (*Divinae institutiones*, VII, XXIII).

150 I believe that the strange name "Agrippa," adopted in France and Italy, came about through a copyist's mistake. In the manuscript of the *Tractatus de discordantia inter Eusebium Hieronymum et Augustinum* (Paris, Bibl. de l'Arsenal, ms. 243), we read · Aegyptia instead of Agrippa.

151 This is the belief of Alexander stated in the preface to his *Oracula Sibyllina*. See the chapter entitled: *De mediis aevi Sibyllis*.

152 Paris, Bibl. de l'Arsenal, ms. 78, fol. 65v: sibyls and prophets (fifteenth century), and Paris, Bibl. Nat., ms. lat. 6362 (fifteenth century).

153 The text which inspired Filippo Barbieri says: *Postquam Taurus pacificus, sub levi mugitu, climata turbata concludet, illis diebus agnus caelestis veniet.* This peaceful Bull seems quite clearly to denote the emperor Augustus.

154 What clearly proves that these oracles were borrowed from an older source is that one of the two statues of the sibyls in the cathedral of Siena, attributed to Giovanni Pisano, carries these words on a phylactery: *Educabitur deus et homo.* This is the last part of a sentence which Filippo Barbieri assigned to the Erythrean Sibyl more than a century and a half later.

155 I have shown in E. Mâle, "Une Influence des mystères sur l'art italien du XVe siècle," *Gazette des beaux-arts*, 35 (1906), pp. 89-94, that the engraver was inspired by a Mystery played in Florence. [Cf. J. Mesnil, *L'Art au nord et au sud des Alpes a l'époque de la Renaissance*, Paris, 1911, pp. 102ff., and A. M. Hind, *Early Italian Engraving: A Critical Catalogue*, London, 1938, I, pt. I, pp. 153-186. The Baldini sibyls have been linked to a tradition of author portraits such as those of Hrabanus Maurus, *De Universo* (Library of Monte Cassino, cod. 132), early eleventh century: see Freund, *Studien zur Bildgeschichte*, pp. 22ff.; Hélin, "Un texte inedit," pp. 349ff., and other bibliography cited by C. de Tolnay, *The Sistine Ceiling*, Princeton, 1945, p. 153.]

156 [Breviary of Matthias Corvinus, King of Hungary (Rome, Vat. Lib., cod. urb. lat. 112, fol. 7v). For Pollaiuolo, see L. D. Ettlinger, "Pollaiuolo's Tomb of Sixtus IV," *Journal of the Warburg and Courtauld Institutes*, 16 (1953), pp. 239-274.]

157 [For illustrations of Pinturiccio sibyls, see

F. Hermanin, *L'Appartamento Borgia in Vaticano*, Rome, 1934, pp. 11-24.]

158 Mâle, *Quomodo Sibyllas*, pp. 39ff., can be consulted for more details.

159 [For Michelangelo's source for the sibyls and the prophets, cf. Tolnay, *The Sistine Ceiling*, p. 152; K. Borinski, *Die Rätsel Michelangelos, Michelangelo und Dante*, Munich, 1908, p. 187; F. Hartt, "*Lignum vitae in medio paradisi*, The stanza d'Eliodoro and the Sistine Ceiling," pp. 143ff. On the conjunction of sibyls and prophets, see also Künstle, *Ikonographie*, I, pp. 303-312.]

160 F. X. Kraus, *Geschichte der christlichen Kunst*, II, pt. 2 (revised and continued by J. Sauer, Freiburg-im-Breisgau, 1908, p. 360), has said that Michelangelo represented the prophets whose texts were read during Lent and Holy Week. But his list does not entirely agree with that of Michelangelo's painted prophets.

161 We know that in 1481, Filippo Barbieri was in prison for having attacked two popes, Paul II and Sixtus IV. Thus, it is possible that he could not correct the proofs of his book, published by his compatriot, the physician Philippus de Lignamine. [See above, n. 136.]

162 I am convinced that Michelangelo was also inspired by the writings of Savonarola. Alongside the prophets, he depicted children who seem to speak to them. Isaiah is addressed so bluntly by one of the children that his hair bristles and he scarcely dares turn his head. These children are angels which Michelangelo, as usual depicted without wings. Savonarola's doctrine of prophetic inspiration was, in substance, the following: "God communicates something of his eternity to the prophets. To do so, he has recourse *to the ministry of angels*, who produce images and visions in the souls of the prophet. But sometimes, these *angels take human form*, appear before the eyes of the prophets, and unveil the future to them." This explanation is found in the book, *Revelatio de tribulationibus nostrorum temporum*, Paris, 1496. Michelangelo, who according to Vasari was a great admirer of Savonarola, had certainly read it. [For the Platonic conception of the essence of sibyls in relation to Michelangelo, see Tolnay, *The Sistine Ceiling*, p. 154. See also Freund, *Studien zur Bildgeschichte*, p. 25; H. Baron, *Leonardo Bruni Aretino*, Leipzig, 1928, p. 156. For more on Michelangelo's view of Savonarola, see J. Schnitzer, *Savo-*

narola, Ein Kulturbild aus der Zeit der Renaissance, Munich, 1924, II, pp. 831ff.]

163 [The *Mystère de l'Incarnation* was edited by Le Verdier in 1886. See Chapter II, n. 128. For the *Mystère de Valenciennes*, see above, pp. 67, 72, 75. For the alternation of sibyls and prophets in the Mystery plays, see also M. Sepet, *Les Prophètes du Christ (Biliothèque de l'Ecole des Chartes)*, Paris, 1878, and P. Weber, *Geistliches Schauspiel und Kirchliche Kunst*, Stuttgart, 1894, pp. 53ff.]

164 Sainte-Chapelle Missal (Paris, Bibl. Mazarine, ms. 412, fol. 17). The manuscript was probably illuminated in Paris.

165 The Persian Sibyl says: *Ecce bestia conculcaberis et gignetur dominus . . .* , etc. The Libyan Sibyl says: *Ecce veniet die et solvetur nexus Synagogae . . .* , etc.

166 In a passageway leading to the sacristy. See Jourdain and Duval, "Les Sibylles peintures murales de la cathédrale d'Amiens," *Mémoires de la société des antiquaires de Picardie*, 7 (1846), pp. 275ff., and G. Durand, *Monographie de l'église-cathédrale Notre-Dame d'Amiens*, Amiens, 1902, II, pp. 345ff.

167 The Sibyl Agrippa says: *Invisibile verbum palpabitur*; the Libyan Sibyl: *Ecce veniet dies et tenebit illum in gremio virgo* etc.

168 The Cumaean Sibyl says: *In manus infidelium veniet*; the Hellespontine: *Et coronam portabit spineam*; the Phrygian Sibyl: *In cibum autum fel et in sitim acetum dabunt*; the Samian Sibyl: *Medio die nox erit tenebrosa nimis*, etc. The chapel decorated with these paintings by Simon de Châlons has disappeared. These frescoes are known only through a book entitled: *Traité de l'établissement de la compagnie de messieurs les Pénitents blancs d'Avignon, fait par un religieux du couvent des frères prêcheurs d'Avignon*, n.d.

169 This book was cited long ago by Schreiber, *Manuel de l'amateur de la gravure sur bois et sur métal*, VII (Atlas), pl. ix. G. Huart, "A Propos d'un vitrail du XVIe siècle de la cathédrale d'Evreux," *Bulletin de la société nationale des antiquaires de France*, 1939-1940, pp. 115ff., has also called attention to this volume. He recalls that the book was in the Library of St. Gall in 1477.

170 Hours of Louis de Laval (Paris, Bibl. Nat., ms. lat. 920). As a note at the end of the volume indicates, Louis de Laval gave these Hours in his will to Anne of France, daughter of Louis XI. On this volume see Leroquais, *Les Livres d'Heures*, I, pp. 15-30. [For more on this Book of Hours from the work-

shop of Jean Colombe, ca. 1480-1489, see *Manuscrits à peintures*, no. 326; K. Perls, *Jean Fouquet*, London, 1940, p. 271; and Wescher, *Jean Fouquet and His Time*, pp. 78ff.]

171 The monster which the sibyl treads under her feet, and which figured in the Orsini palace fresco, is the beast of which the oracle speaks: *Ecce bestia conculcaberis.*

172 Mâle, *L'Art religieux de XIIIe siècle en France,* 4th ed., p. 290.

173 All the inscriptions cited (except for the part in italics) are taken from the Orsini palace, or rather from the manuscripts that used them. Moreover they are similar to those of Filippo Barbieri.

174 The same amputated hand is one of the attributes of the Passion disposed around the Christ of the Mass of St. Gregory.

175 This prophecy, attributed by our author to the Phrygian Sibyl, is given to the Sibyl of Tibur in the Orsini palace fresco, and by Filippo Barbieri.

176 It does not mention the public life of Christ. The theologian who arranged these oracles was faithful to the old tradition. For him, as for the artists of the thirteenth century, the Infancy and the Passion summarize the entire life of Christ. See Mâle, *L'Art religieux du XIIIe siècle en France*, 8th ed., pp. 180ff. [*Religious Art in France: The Thirteenth Century*, Bolligen XC.2, Princeton, 1984, pp. 183ff.]

177 In the early sixteenth century, the Germans also took the oracles of the sibyls sometimes from Lactantius and sometimes from Filippo Barbieri, as is proved by the curious series of sibyls, painted by Hermann Tom Ring, now in the museum of Augsbourg. But these oracles are distributed haphazardly, without any method in the selection.

178 Hours of the Chappes family (Paris, Bibl. de l'Arsenal, ms. 438), late fifteenth century. [*Manuscrits à peintures*, no. 339.]

179 Hours of René II of Lorraine (Paris, Bibl. Nat., ms. lat. 10491). René II of Lorraine died in 1508.

180 For example:

Sibylle Libica en l'aage
De XXIII ans a prédit
Que Jésus pour l'humain lignaige
Viendrait rempli du Sainct Esprit.

(The Libyan Sibyl, at the age
Of XXIII years foretold
That Jesus, for the human race,
Would come filled with the Holy Spirit.
And:

Sibylle Cumana n'avait
Que XVIII ans d'âge parfaite,
La nativité prédisait
De Jésus souverain prophète . . . , etc.

(The Cumaean Sibyl was
Exactly XVIII years old
When she foretold the Nativity
Of Jesus sovereign prophet . . . , etc.)

These verses are found in the Hours of Simon Vostre for the use of the diocese of Chartres (1501). There are some very similar verses in the part of the *Mistère du Viel Testament* (printed by Pierre le Dru, 1500) devoted to the sibyls.

181 There is no question about the influence of the Books of Hours. At the cathedral of Auxerre (Yonne), the organ case was decorated in the sixteenth century with paintings representing the sibyls. They carried the usual attributes, and above them were such inscriptions as these: The Sibyl Libyca aged twenty-four predicted / that Christ for the human race / would come filled with the Holy Spirit. The Cumaean Sibyl / eighteen years old exactly / predicted the Nativity / of Jesus the sovereign prophet.—They are simply the inscriptions from the Hours of Simon Vostre given in the preceding note. A chapel in the parochial church of Cunault (Maine-et-Loire) is also decorated with frescoes representing the sibyls. They are accompanied by French verses which were also taken from the Hours of Simon Vostre: these verses are to be found in X. Barbier de Montault, *Iconographie des Sibylles*, Arras, 1871.

182 The following are the principal series of sibyls; they are all contemporaneous with Louis XII or with Francis I: Clamecy (Nièvre), portal of the church; Autun (Saône-et-Loire), altarpiece of the cathedral; St.-Bertrand de Comminges (Haute-Garonne), stalls (1537); Beauvais: cathedral, panel of the north door, clerestory window under the north rose window, organ (1532); church of St.-Etienne, wood paneling; Dreux, portal (after 1524); Bordeaux, portal of the church of St.-Michel; Aix, portals of the cathedral commissioned from the sculptor Guiramand in 1509; Auch (Gers), windows (1531) and stalls; St.-Maurille-des-Ponts-de-Cé (Maine-et-Loire), stalls from La Haye-aux-Bonshommes; stalls of Gaillon, now in St.-Denis (ca. 1510); Noyon (Oise), cathedral: sculpture in one of the chapels; Château-Thierry (Aisne), organ case (before 1538); Chambly (Oise), sculptured panels of the tribune; St.-Ouen of Rouen,

windows in the nave (late fifteenth century). With very rare exceptions, the attributes are always the same. The differences are for the most part due to a mistake of the artist. Two variants, however, are worth mention. At St.-Bertrand de Comminges, as, moreover, in the manuscript of the Arsenal illuminated by Jean de Montluçon (Paris, Bibl. de l'Arsenal, ms. 438), the Cumaean Sibyl, who foretells a new order of things, carries a sphere in her hand. This sphere no doubt symbolizes the world. I also point out that in the windows of Beauvais, as well on the north portal (fig. 123), and in the panels of Chambly, the Phrygian Sibyl carries a column. This is the column of the Flagellation. It no doubt comes from the prophetic text of Lactantius: *Dabit vero ad verbera simpliciter sanctum dorsum*. The beautiful sibyls of the window of Notre-Dame-d'Estampes (Seine-et-Oise), the work of the School of Fontainebleau, do not have attributes. They carry cartouches that contain the prophecies given by Barbieri or Lactantius. Only the Tiburtine Sibyl carries a text, of unknown origin. This window has been studied by E. Lefèvre, "Les inscriptions prophétiques dans le vitrail des sibylles de l'église Notre-Dame d'Etampes," *Revue de l'art chrétien*, 53 (1910), pp. 259ff.

183 Published by D'Ancona, *Sacre rappresentazioni*, I, pp. 169ff. The engravings of the prophets and the sibyls attributed to Baccio Baldini were made after the performance of this Mystery play. See Mâle, "Une influence des mystères sur l'art italien du XVe siècle," pp. 89-94.

184 Stalls of the former abbey of La Haye-aux-Bonshommes.

185 For example, in the Hours by Jean de Montluçon (Paris, Bibl. de l'Arsenal, ms. 438). The same thing occurs in the Hours of Munich (French manuscript described by F. Piper, *Mythologie und Symbolik der christlichen Kunst*, Weimar, 1847, I, p. 501). The sibyl is on one page, the prophet and the apostle on the other. Above or below, the mystery to which the sibyl, the prophet and the apostle allude is represented in action. Thus, facing the Erythraean Sibyl, we see Isaiah, who says: *Ecce virgo concipiet*, and St. Luke, who says: *Ecce concipies et paries filium*. Below is represented the Annunciation. This formula is also found in our fifteenth-century books of engravings, for example in the *Sacri canonis Missae exposito*,

printed by Guyot Marchant, 1496. We also find it—and this is even more interesting—in stained glass windows. The window of Ervy (Aube) devoted to the sibyls, puts the sibylline texts in relation to the prophetic and evangelistic texts. Near each sibyl is represented the event of the life of Christ which she foretold. The same representation, but simplified, is in the window of Montfey (Aube) and of Pont-l'Evêque (Calvados). In the fragments of the windows discovered in the chapel of Dissay (Vienne), the sibyl is accompanied by an apostle and a scene from the life of Christ. See Salvini, *Les Ensembles décoratifs dans le diocèse de Poitiers*, 1939.

186 [See Martin, *Les Vitraux de la cathédrale d'Auch*, Toulouse, 1922; Musée des arts décoratifs, *Vitraux français*, no. 49. Additional bibliography is cited in H. Polge, *Topobibliographie monumentale de Gers*, Auch, 1952, pp. 19-26.]

187 The grouping could, moreover, be even more rigorous and methodical.

188 These are the small scenes of the Sistine Chapel all of which depict a father, a mother, and an infant. The names of the ancestors of Christ written beside them leave no doubt as to the meaning of the figures.

189 Michelangelo painted the Sistine ceiling between 1508 and 1512; Arnaud de Moles made the windows of Auch between 1507 and 1513.

190 There are other works of the same kind. In the church of Tauriac (Lot), frescoes from the beginning of the sixteenth century also show the creation of the world, the creation of man and of woman, the fall, and then the series of prophets and sibyls who foretell the Saviour. See E. Rupin, "Peintures murales de l'église de Tauriac (Lot), XVI siècle," *Revue de l'art chrétien*, 45 (1895), pp. 21-34.

191 The windows of the Erythraean Sibyl at Auch are reproduced in Musée des arts décoratifs, *Vitraux français*, pl. 32.]

192 Sophocles, first chorus of Oedipus Rex. [Sophocles, *Oedipus the King*, Fr. Storr, tr., New York, 1955.]

193 [The iconography of the triumph has been studied in Van Marle, *L'Iconographie de l'art profane*, II, pp. 111ff., 144ff.; W. Weisbach, *Trionfi*, Berlin, 1919; J. M. Chartou, *Les Entrées solonnelles et triomphales à la Renaissance*, Paris, 1928. For the Triumph of Christ, see Knipping, *De Iconografie van de Contra-Reformatie in de Nederlanden*, I, pp. 70-78, and Künstle, *Ikonographie*, I, pp. 97-98.]

194 [For reproductions of the Mantegna Triumphs, see E. Tietze-Conrat, *Mantegna*, London, 1955, pls. 108-117. The paintings, which Mâle refers to as "cartoons" (*cartons*), are actually finished paintings on canvas, surviving in poorly preserved form at Hampton Court Palace. According to the documents, Mantegna was working on the set from as early as 1486 to as late as 1492. See *ibid.*, pp. 183-184. For an interpretation of the iconography, see K. Giehlow, "Die Hieroglyphenkunde des Humanismus in der Allegorie der Renaissance," *Jahrbuch der kunsthistorischen Sammlungen in Wien*, 32 (1915), pp. 1-229.]

195 [Dürer's Triumph of Maximilian is reproduced in Kurth, *The Complete Woodcuts of Albrecht Dürer*, figs. 312-337, and p. 38.]

196 G. Le Breton, "Peintures murales de l'école de Fontainebleau découvertes à Gisors," *Réunion des sociétés des beaux-arts des départements*, 7 (1883), pp. 174-183.

197 The Hours of the Virgin of 1508 contain it, not to mention several other Books of Hours by Simon Vostre; see Lacombe, *Catalogue des livres d'heures*. [See also J. Remouvier, *Des Gravures sur bois dans les livres de Simon Vostre libraire d'heures*, Paris, 1862, and Davies, *Catalogue of a Collection of early French Books in the Library of C. Fairfax Murray*, II, p. 1078, with a list of Vostre's border subjects.]

198 In the *Champfleury* of Geoffroy Tory, see a charming Triumph of Apollo. See also the Triumph of the Seasons, engraved by Théodore de Bry; the Triumph of the Months, the Triumph of Music, engraved by Virgile Solis, etc. [For Troy, see below, n. 214.]

199 A great many editions of the *Triumphus Crucis* were brought out in Florence and Venice at the end of the fifteenth century. Several are not dated. One carries the date of 1497. An Italian translation attributed to Savonarola himself also appeared. There was a French translation in the sixteenth century. [See also G. Gruyer, *Les Illustrations des écrits de Jérôme Savonarole publiés en Italie au XVe et au XVIe siècle*, Paris, 1879; L. Ferretti, il *"Trionfo della Croce" di Fra Girolamo Savonarola*, Siena, 1899; M. Ferrara, Bibliografia Savonaroliana: bibliografia ragionata degli scritti editi dal principio del secolo XIX ad oggi, Florence, 1958.]

200 Chapter II.

201 This is only the main outline. We shall give other details in their proper place further on.

202 See E. Müntz and V. Massena, Prince of Essling, *Pétrarque*, Paris, 1902.

203 G. Vasari, *Le Vite de' più eccellenti pittori, scultori ed architetti* (1568), G. Milanesi, ed., Florence, 1878-1885, III, p. 317.

204 Vasari says that the engraving was published in 1508; like that of Botticelli, he calls it the Triumph of the Faith; cf. *ibid.*, VII, p. 431. [For reproductions of Titian's Triumph, see P. Kristeller, *Il Trionfo della Fede*, Berlin, 1906. See also H. Tietze, *Titian, The Paintings and Drawings*, New York, 1950, p. 10, who dates it after 1511.]

205 The Titian woodcut does not name the sibyls, but there is a copy of it in which their names are given, in French. They are also designated by name in another copy made by the engraver Théodore de Bry.

206 The designer of the cartoon, a painter of Brussels whose name we do not know, was not a man of much imagination. He borrowed the upper part of his window from Titian, and the lower, which represents the Coronation of the Virgin after her Assumption, from an engraving of Albrecht Dürer. [See A.-N. Didron, *Monographie de Notre-Dame-de-Brou*, Lyon, 1842.]

207 Chapter II.

208 *Ibid.*

209 The idea for this window came perhaps from *tableaux-vivants*. In 1550, at the time of the entry of Henry II and Catherine de' Medici into Rouen, allegorical performances were given in their honor, among which was the *Char de Religion*. See *Mystère de l'Incarnation*, published by le Verdier, preface, p. 4. [See Chapter II, n. 128.]

210 Hieronymous Cock (1510-1570) was an engraver, who came from Antwerp.

211 This is the way he appeared in the upper part of the window of St.-Patrice.

212 Vasari (Life of Marc-Antonio) described this engraving. It must still exist, but I have searched in vain for it in the Cabinet des Estampes.

213 Literature offers analogous works. In 1554, Henri de Barran published a morality play entitled: *Tragique comédie françoise de l'Homme justifié par Foy*. In it, we find Sin, Death, Concupiscence, Faith, and Grace. Henri de Barran was a Protestant, but aside from the title, his play could almost be the work of a Catholic. In 1549, Guillaume des Autels staged a morality play at Valence entitled: *L'Homme, le ciel, l'esprit, la chair*. In 1520, a morality play was presented in

which Mundus, Caro, and Daemonia struggled with the Christian knight.

214 See A. Bernard, *Geoffroy Tory*, Paris, 1865, p. 324. [Cf. A. Bernard, *Geoffroy Tory: An Account of His Life and Works*, G. B. Ives, tr., New York, 1909.]

215 This prophet is clearly telling him of the brazen serpent which we see in the background: this is the prefiguration of the other Victim.

216 Which means justification.

217 This engraving was imitated more or less freely on a cameo in the Cabinet des Médailles: see Chabouillet, *Notice du Cabinet des Médailles*, Suppl. p. 622; on various Limoges plates, one of which is in the museum of Geneva. Other engravings (frontispieces of Lutheran or Catholic Bibles) were inspired by it.

218 Hours of the Virgin. See the copy in Paris, Bibl. Nat., Rés. B, 21303. The book, although prepared by G. Tory, appeared after his death, in 1542. It was published by his successor, Olivier Mallart. [Tory died in 1531. Three Hours of the Virgin published in his lifetime contain this plate. It appears pasted in the Hours for the Use of Rome, Paris, 1525 (New York Public Library, Spencer coll.); in the same edition in Paris, Bibl. de l'Arsenal, no. Th 2984; and bound into the Hours for the Use of Rome, Paris, 1531 (Bibl. de la Ville de Versailles, F.A. Ob. 93).]

219 In Geoffroy Tory's *Champ Fleury*, there is a Triumph of Apollo. Bacchus, Ceres, and Venus are captives who walk behind the chariot. Before the chariot are the Virtues and the Muses. The man who imagined this Triumph seems to have been the same who composed the Triumph of the Virgin. [See Tory, *Champ Fleury*, Ives, tr., fol. xxiv.]

220 See J. Lemaire de Belges, *Oeuvres*, J. Stecher, ed., Louvain, 1882-1891, III, p. 128.

221 See A. Bouillet, "L'Eglise Sainte-Foy de Conches (Eure) et ses vitraux," *Bulletin monumental*, 54 (1888), pp. 289-293.

222 The window at Conches bears the date 1553. [The School of Fontainebleau has been studied by S. Béguin, *L'Ecole de Fontainebleau, Le maniérisme à la cour de France*, Paris, 1960.]

223 The inscriptions and even the verses, which are scarcely changed at all, are reproduced in the window.

224 The window of St.-Vincent, in Rouen, is earlier than that of Conches. In spite of what L. Palustre, *La Renaissance en France*, Paris, 1879-1885, II, pp. 249ff., says of it, we would not date it ca. 1550. Such a work could not have been done later than the reign of Francis I. But what Palustre did see very clearly is that the window belongs to the School of Beauvais and came from the atelier of the Leprinces.

225 I have looked through the manuscripts of the library of Rouen and those of the Bibliothèque Nationale. Paris, Bibl. Nat., ms. fr. 1537 should be cited particularly. Only one passage vaguely alludes to the window of the triumphal chariots: these very vague verses refer to a Triumph (Paris, Bibl. Nat., ms. fr. 379, fol. 2v). How well we understand the scorn of Du Bellay for "les chants royaux et autre épiceries" (the *chants royaux* and other confections) when we have studied these manuscripts!

226 *Chants royaux en l'honneur de la Vierge au Puy d'Amiens* (Paris, Bibl. Nat., ms. fr. 145). Book written by Louise de Savoie between 1517 and 1518. [See W. J. Müller, "Christus als Apotheker," *Reallexikon*, II, cols. 636-639.]

227 Paris, Bibl. Nat., ms. fr. 145 is decorated with miniatures. On the other hand, some paintings which are illustrations of the *chants royaux* have been preserved in the museum of Amiens.

228 Archives of Rouen, C. 7322. The manuscript dates from 1720.

229 See E. de La Quérière, *Description historique des maisons de Rouen*, Paris, 1841, II, p. 137. This house was at number 13, rue de l'Ecureuil.

230 This is very evident when we compare the French and the Italian Sibyls.

CHAPTER VII

1 [Additional material for the study of French sixteenth-century books and manuscripts may be found in: Harvard College Library, Department of Printing and Graphic Arts, *Catalogue of Books and Manuscripts, Part I: French 16th Century Books*, R. Mortimer, ed., I-II, Cambridge, Mass., 1964. For a useful catalogue and source book for French graphic arts of the sixteenth century, see A. Linzeler and J. Adhémar, *Inventaire du fonds français, graveurs du seizième siècle* (Bibliothèque Nationale, Département des Estampes), I-II, Paris, 1932-1938. The indices in the second volume include subjects and are invaluable for French sixteenth-century iconographical studies. See the "Table méthodique des sujets

représentés" as well as the alphabetical index.]

2 [See Chapter VI, n. 197.]

3 [M. Bucci, *Camposanto Monumentale di Pisa*, Pisa, 1960, cat. no. 28, figs. 99, 100.]

4 After 1496, the *Calendrier des bergers* (printed by Guyot Marchant), a treatise on astronomy and hygiene, ended with a treatise on morality, which contains the tree of vices and virtues, the punishments of Hell, the Paternoster, the Ave, the Credo, and the Commandments of the Church. It is typical of the popular books that taught what cathedrals had taught in the past. [See the facsimile of *Le grand Calendrier des bergers* (printed by Jean Belot, Geneva, 1497), G. Grunau, ed., H. Blösch and A. Fluri, introd., Bern, 1920. For a study of these publications in France and England, see the introduction by H. O. Sommer, *The Kalendar of Shephardes* (1503 and 1506 English texts), London, 1892.]

5 Only the figure of God is missing.

6 In the sixteenth century especially, one of the magi was represented as a Negro.

7 It has been said that the first discoveries of the navigators had made fashionable the figures of "wild men" so frequently found in heraldic art. This is hard for me to believe. W. Mannhardt, *Der Baumkultus der Germanen* (I: *Wald-und Feldkulte*), Berlin, 1875, has shown that the "wild man" is a figure from popular tales; it is a wood sprite, a spirit of vegetation. [See also R. Bernheimer, *Wild Men in the Middle Ages*, Cambridge, Mass., 1952.]

8 See A. Bouché-Leclercq, *L'Astrologie grecque*, Paris, 1899, p. 624. [See also T. O. Wedel, *The Medieval Attitude toward Astrology, Particularly in England*, New Haven, 1920; E. Panofsky and F. Saxl, "Classical Mythology in Medieval Art," *Metropolitan Museum Studies*, 4 (1933), pp. 228-280. Astrology and early Christianity have been studied by F. Boll and C. Bezold, *Sternglaube und Sterndeutung: die Geschichte und das Wesen der Astrologie*, W. Gundel, ed., 4th ed., Berlin, 1931. For St. Augustine's views on astrology, see L. Thorndike, *A History of Magic and Experimental Science during the First Centuries of our Era*, New York, 1923, I, chap. 22.]

9 When we look through the list of incunabula, we are struck by the number of works devoted to astrology. [The renewal of interest in astrology was in part due to the diffusion of neo-Platonic literature. See N. Robb, *Neo-Platonism of the Italian Renaissance*, London, 1935. For more on astrology and the Renaissance, see J. Burckhardt, *The Civilization of the Renaissance in Italy*, S.G.C. Middlemore, tr., London, New York, 1929, chap. IV, pt. VI; F. Saxl and E. Panofsky, *Dürers Kupferstich Melancholia I* (Studien der Bibliotek Warburg, II), Leipzig, 1923; E. Cassirer, *Individuum und Cosmos in der Philosophie der Renaissance*, Leipzig, Berlin, 1927, chap. 3; A. Warburg, "Heidnisch-antike Weissagung in Wort und Bild zu Luthers Zeiten," *Gessamelte Schriften*, Leipzig, 1932, II, pp. 487-558; *idem*, "Italienische Kunst und internationale Astrologie im Palazzo Schifanoja zu Ferrara," *ibid.*, II, pp. 459-481; Seznec, *The Survival of the Pagan Gods*, chap. 2; F. Saxl, *Lectures* (Warburg Institute, University of London), I-II, London, 1957.]

10 Above all, in the Hours of Pigouchet. [For more on the "Zodiacal Man," see H. Bober, "The Zodiacal Miniature of the *Très Riches Heures* of the Duke of Berry: Its Sources and Meaning," *Journal of the Warburg and Courtauld Institutes*, 11 (1948), pp. 1-34. The "microcosm" is treated by Seznec, *The Survival of the Pagan Gods*, pp. 64ff.; P. I. Herwegen, "Ein mittelalterlichen Kanon des menschlichen Körpers," *Repertorium für Kunstwissenschaft*, 32 (1909), pp. 445-446; F. Saxl, *Verzeichnis astrologischer und mythologischer illustrierter handschriften des lateinischen mittelalters* (Sitzungsberichte der Heidelbergerakademie der Wissenschaften), I-VIII, 1916-1953 (VII: H. Bober, ed., Warburg Institute, London, 1953). See also L. Choulant, *History and Bibliography of Anatomic Illustration*, M. Frank, tr., Chicago, 1920.]

11 The Choleric Temperament has a lion beside him, "because he is of the nature of fire and of the lion"; the Phlegmatic has a lamb, "because he is of the nature of water and of the lamb"; the Sanguine, "who is of the nature of air and of the monkey," has a monkey; the Melancholic, "who is of the nature of the swine and of the earth," has a pig. The doctrine of the four temperaments is linked to that of the four elements, and goes back to ancient Greek physics.

12 Personifications of the planets also decorate the organ of Notre-Dame-de-l'Epine near Châlons-sur Marne (sixteenth century). But here it is probable that the seven planets were placed in relation to the seven notes of the scale. The seven planets give a celestial concert, the prototype of all human music (the music of the spheres).

13 This is the consecrated metaphor. See Bouché-Leclercq, *L'Astrologie greque*.

14 See M. Thausing, *Albert Dürer, sa vie et ses oeuvres*, G. Gruyer, tr., Paris, 1878, p. 490. [Dürer's painting of Sts. John the Evangelist, Peter, Mark, and Paul (called the Four Apostles) is dated 1526 (Munich, Alte Pinacotek). See Panofsky, *Dürer*, I, pp. 230-235, cat. no. 43, figs. 294, 295, 296, 298. Panofsky traces the idea of the correspondence of the four humors and the four ages to William of St. Thierry's *De natura corporis et animae* (Migne, *P.L.* 180, col. 707). See also Seznec, *The Survival of the Pagan Gods*, pp. 122ff.]

15 [Hind, *Early Italian Engraving*, I, pt. I, pp. 77-83, dates the original series before 1465.]

16 Women, strangely enough, are yoked to the chariot of the Moon. Woman was thought to be entirely under the influence of the moon. She was the *lunatic* par excellence.

17 The rest of the inscription indicates the influence exercised by Mercury over human physiognomy, over metals, over such and such a day or night of the week, over such and such an hour of the day, etc. The same ideas are expressed, with many more details, in any fifteenth-century book of astrology, for example in the *Flores astrologiae* of Albumasar, Augsburg, 1488, or in the *Liber isagogicus* of Alchabitius. The astrological lore is even richer than the Italian engravings would lead us to believe. Each planet not only presides over human aptitudes, but also reigns over one part of the world, over a people, an animal, a metal. Saturn, for example, is related to dissipation, death, sorrow, India, the Jews, laborers, caves, wells, lead, the elephant, the camel, the ostrich, the black serpent, the right ear, rabies, gout, the color black, the Orient, Saturday, the first and the fourth hours. There would be no reason to mention these oddities if art had not been inspired by them. In the Palazzo della Ragione of Padua, decorated with frescoes in the fourteenth century, each planet is accompanied by the creatures or objects over which it has dominion. The book of the astrologer Pietro d'Abano, *Principium Sapientiae*, served as a guide to the artist. This has been pointed out by W. Burges, "La Ragione de Padoue," *Annales archéologiques*, 18 (1858), pp. 331-343, who brought order into this seemingly incoherent composition. [Saxl traces the influence of the miniatures of the *Anima astrologiae* of Guido Bonatti (Vienna, State Lib., cod. Vindob. 2539), fourteenth century, in addition to Pietro d'Abano, *Astrolobium planum*, printed by Johannes Engel, Augsburg, 1488, with illustrations stemming from the manuscript of Albumazar (Rome, Vatican Lib., cod. Vat. Reg. 1283). See Saxl, *Verzeichnis astrologischer und mythologischer illustrierter Handschriften des lateinischen Mittelalters*, II, *Die Handschriften der National-Bibliothek in Wein*, pp. 49-68, and A. Barzon, *I Cieli e la loro influenza negli affreschi del Salone in Padova*, Padua, 1924. The theme of the "influence of the planets" has been treated by Seznec, *The Survival of the Pagan Gods*, pp. 71ff.; J. Mesnil, *L'Art du nord et au sud des Alpes à l'époque de la Renaissance*, Brussels, Paris, 1911, chap. 4; F. Saxl, "Probleme der Planetenkinder," *Kunstchronik* 54 (1919), pp. 1016ff.; *idem*, "The Literary Sources of the Finiguerra Planets," *Journal of the Warburg and Courtauld Institutes*, 2 (1938-1939), pp. 72-74; G. de Tervarent, *Les Enigmes de l'art*, III, *L'Héritage antique*, Paris, 1946, pp. 65-71.]

18 F. Lippmann, *The Seven Planets*, F. Simmonds, tr., London, 1895.

19 For example, the *Flores Astrologiae* of Albumazar, which appeared in Augsburg in 1488. [Albumazar was an Arabian astrologer who died in 886. See also Albumazar's Astrological Treatises (New York, Pierpont Morgan Library, M. 785), Bruges, early fifteenth century, which had belonged to the Duke of Berry. Cf. Saxl and Panofsky, "Classical Mythology in Medieval Art," pp. 230-248.]

20 Schreiber, *Manuel de l'amateur de la gravure sur bois et sur métal au XVe siècle* VIII, pl. CXI.

21 See above, n. 18.

22 Etienne Delaune also made engravings representing the planets which, in certain features, conform to the old tradition: Cabinet des Estampes Ed 4a Rés. [Robert-Dumesnil, *Inventaire du fonds français*, Paris, 1967, I, pp. 234-236, cat. nos. 88-94, 95-101.] See also Bouchot, *Les deux cents incunables xylographiques du département des Estampes*, p. 256, no. 185. [For a discussion of the astrological tradition in the late fifteenth and early sixteenth centuries that takes into account the contributions of north and south in art and literatures, see L. B. Philip, " 'The Peddler' by Hieronymus Bosch, a Study in Detection," *Nederlands Kunsthistorisch Jaarboek*, 9 (1958), pp. 1-81.]

23 We will show farther on (Chapter x, p. 432) that the artist of Gaillon also borrowed from the *Calendrier des bergers* the images of the torment of Hell which accompany the little scenes inspired by astrology. [For Gaillon, see J. J. Marquet de Vasselot, "Les Boiseries de Gaillon," *Bulletin Monumental*, 86 (1927), pp. 321-369; E. Chirol, *Le Château de Gaillon*, Rouen, Paris, 1952; R. Weiss, "The Castle of Gaillon in 1509-1510," *Journal of the Warburg and Courtauld Institutes*, 16 (1953), pp. 1-12.]

24 [The theme of the "Ages of Man" is discussed in Van Marle, *Iconographie de l'art profane*, I, pp. 144-163; Knipping, *De iconografie van de contrareformatie in de Nederlanden*.]

25 *Etas hominum secundum exposicionem mensium* (Paris, Bibl. Nat., ms. fr. 1728, fol. 271). The manuscript is contemporary with Charles V and perhaps belonged to him.

26 An interesting detail which testifies to the uncertainty and precariousness of life at the time.

27 In the Musée St.-Raymond in Toulouse.

28 School is always represented in this fashion. Window of Gisors.

29 This is the picturesque translation of the following quatrain:

Avoir grands biens ne faut que l'omme cuide,
S'il ne les ha à cinquante quatre ans,
Non plus que s'il a sa grange vuide
En septembre, plus de l'an n'aura rien.

(Man must not think of having great riches
If he does not have them at fifty-four,
Just as if he has an empty barn
In September, the rest of the year he will
	have nothing.)

The original fourteenth-century poem can still be recognized behind these mediocre verses.

30 Paris, Bibl. Nat., ms. fr. 990, fol. 2 (beginning of the fifteenth century).

31 Printed by Vérard, under Gerson's name. [For Gerson, see Chapter II, n. 4.]

32 See *Les Vices et les branches qui descendent des sept pechiez mortelz* (Paris, Bibl. Nat., ms. fr. 1051, fol. 66), fifteenth century.

33 [For the sources of an interest in the lives of the humble, the peasantry, and the poor in the monastic literature of the Brotherhood of Common Life at Windesheim and the works of Thomas à Kempis, see R. and M. Wittkower, *Born under Saturn*, London, 1963, pp. 111-112.]

34 Paris, Bibl. Nat., ms. fr. 9608, fol. 20.

35 *Ibid.*, fol. 232.

36 [For more material on the Virtues, see P. D'Ancona, *L'Uomo e le sue opere nelle figurazioni italiane del medioevo*, Florence, 1923, chap. 2: "Le virtù e i vizi"; F. Saxl, " 'Allertugenden und Laster Abbildung'; eine spätmittelalterliche Allegoriesammlung, ihre Quellen und ihre Beziehungen zu Werken des frühen Bilddrucks," *Festschrift Julius Schlosser zum 60. Geburtstage*, Vienna, 1927, pp. 104-121; Künstle, *Ikonographie*, I, pp. 156-167; A. Katzenellenbogen, *Allegories of the Virtues and the Vices in Medieval Art from Early Christian Times to the Thirteenth Century*, London, 1939; Chew, *The Virtues Reconciled. An Iconographical Study*; F. Nordström *Virtues and Vices on the Fourteenth-Century Corbels in the Choir of Uppsala Cathedral*, Stockholm, 1956; R. Tuve, "Notes on the Virtues and Vices," *Journal of the Warburg and Courtauld Institutes*, 26 (1963), pp. 264-303, and 27 (1964), pp. 42-72.]

37 Breviary of Charles V (Paris, Bibl. Nat., ms. lat. 1052), Paris, second half of the fourteenth century (before 1380). [*Manuscrits à peintures*, no. 111.]

38 Mâle, *L'Art religieux du XIIIe siècle en France*, 8th ed., pp. 111ff. [*Religious Art in France: The Thirteenth Century*, Bollingen XC.2, Princeton, 1984, pp. 111ff.]

39 Justice has the scales (Paris, Bibl. Nat., ms. lat. 1052, fol. 292v). Hope receives crowns (fol. 219). Faith is encircled by a large aureole in which are drawn, in hieroglyphic form, the principal events of the life of Christ, which have become the articles of the Credo (fol. 209). This strange figure had already been used in the Belleville Breviary (Paris, Bibl. Nat., ms. lat. 10483). [For this manuscript, see *Manuscrits à peintures*, no. 106.]

40 Breviary of Charles V (Paris, Bibl. Nat., ms. lat. 1052, fol. 245v).

41 *Ibid.*, fol. 232.

42 *Le Miroir du Monde* (Paris, Bibl. Nat., ms. fr. 14939). The manuscript dates from 1373. [*Manuscrits à peintures*, no. 120.]

43 *Ibid.*, fol. 97. The text says "demandant l'une ple à l'autre": does this mean "'parole"?

44 The two other Virtues are more clearly characterized. Justice has the scales and the sword. Fortitude carries a lion in a *compas roont*, that is, in a disc she holds in her hand.

45 The *Petites Heures* of the Duke of Berry (Paris, Bibl. Nat., ms. lat. 18014, fol. 278v), which dates ca. 1390, must be cited, however. There we find four small figures of Virtues

which follow the old traditions. Faith has a chalice; Hope holds out her arms toward an angel in the sky; Charity gives alms to two children; Justice holds the scales and the sword. [*Manuscrits à peintures*, no. 182.]

46 The Virtues figure in Charles VII's entry in 1437.

47 Alain Chartier gives an attribute only to Hope: a box of unguents and a golden anchor whose point is fixed in the heavens. This is an exception. The chronicler who describes the entry of Charles VII in 1437 speaks of the costumes of the Virtues, but not of their attributes: "Faith, Hope, Charity, Justice, Prudence, Fortitude, and Temperance followed, mounted on horseback and dressed according to their particular virtues." In 1453, when Philippe of Bourgogne gave the marvelous banquet at Lille which Olivier de La Marche has described in such detail, twelve women represented twelve virtues. They could not be identified except for "un brief" held in their hands, where "their names and their powers were written." Olivier de La Marche, *Mémoires* (Société de l'histoire de France), H. Beaune and J. d'Arbaumont, eds. Paris, 1883-1888, II, p. 374. [For more on Alain Chartier, ca. 1386-1449, see E. J. Hoffmann, *Alain Chartier, His Work and Reputation*, New York, 1942.]

48 *Le Château perilleux* (Paris, Bibl. Nat., ms. fr. 445).

49 *Le Champion des Dames* (Paris, Bibl. Nat., ms. fr. 12476, fol. 144).

50 *Miroir historial* (Paris, Bibl. Nat., ms. fr. 50). This manuscript belonged to the Duke of Nemours; consequently, it is earlier than 1477, the date of his death. [*Manuscrits à peintures*, no. 265.]

51 *Ibid.*, fols. 10v and 11.

52 Paris, Bibl. Nat., ms. fr. 18, fol. 3v.

53 Let us also add here *Le Songe de la Voie d'Enfer et de Paradis* (Paris, Bibl. Nat., ms. fr. 1051). This book, illuminated about 1450, also shows the Virtues without attributes.

54 *Aristote trad. Legouais* (Rouen, Library, ms. I. 2 (927), fol. 170v). [See also E. van Moé, "Les 'Ethiques, politiques et économiques' d'Aristote traduits par Nicole Oresme, manuscrit de la Bibliothèque de la Ville de Rouen," *Les Trésors des bibliothèques de France*, Paris, 1930, III, pp. 9-11, and pl. 1, 2; D. and E. Panofsky, *Pandora's Box*, New York, 1956, chap. III; Tuve, "Notes on the Virtues and Vices," pp. 264-303.]

55 Paris, Bibl. Nat., ms. fr. 9186, fol. 304.

Frontispiece to the translation of Seneca's *Treatise on the Four Virtues*. [This manuscript contains Jehan de Courtecuisse's version of the pseudo-Seneca.]

56 He had his Tristan copied in 1463. There is nothing previous to this in his accounts. See Delisle, *Le Cabinet des manuscrits*, I, p. 86.

57 [For further examples, see Tuve, "Notes on the Virtues and Vices," p. 279, n. 1. For the development of Christian emblems in the sixteenth and later centuries, see M. Praz, *Studies in Seventeenth Century Imagery*, I-II, London, 1939; W. S. Heckscher and K. A. Wirth, "Emblem, Emblembuch," *Reallexikon*, V, cols. 85-22; E. Panofsky, *Studies in Iconology. Humanistic Themes in the Art of the Renaissance*, New York, 1939; G. de Tervarent, *Attributs et symboles dans l'art profane, 1400-1600*, Geneva, 1958; van Marle, *Iconografie*, esp. II: *Allégories et symboles*.

58 Didron, who did not know these verses, made more than one error in trying to explain the attributes of the cardinal Virtues. It must be said, moreover, that the work of Didron on the Virtues is scarcely worthy of him. Periods are all confused.

59 I have studied the Rouen manuscript and have found no explanation in it for the attributes of the Virtues.

60 The proof seems to be that in Bernard de Lutzemburg's *Sermons* (see below, n. 182), there are some figures symbolizing the Vices and Virtues which have a characteristic attribute in the guise of a crest.

61 [For Hope with a beehive, see I. Bergstrom, "The Iconological Origins of *Spes* by Pieter Brueghel the Elder," *Nederlands Kunsthistorisch Jaarboek*, 7 (1956), pp. 53-63. See also D. and E. Panofsky, *Pandora's Box*, fig. 11.]

62 [See further on the symbolism of the pelican, an emblem of Christian piety and self-sacrifice, Mâle, *Religious Art in France: The Thirteenth Century*, pp. 45-46; Terverent, *Attributs et symboles*, pp. 302-303.]

63 *Caritas comparatur igni* (*Dieta Salutis*). [See above, n. 154.]

64 These are the verses accompanying Temperance:

> Qui a l'horloge soy regarde
> En tous ses faicts heure et temps garde.
> Qui porte le frein en sa bouche
> Chose ne dict qui a mal touche.
> Qui lunettes met a ses yeux
> Pres lui regarde sen voit mieux.

Experons montrent que cremeur
Font estre le josne homme meur.
Au moulin qui le corps soutient
Nul exces faire n'appartient.

65 [On the clock as a symbol of Temperance, see H. Michel, "L'Horloge de Sapience et l'histoire de l'horlogerie," *Physis*, 2 (1961), pp. 291-298; E. P. Spencer, "L'Horloge de Sapience," *Scriptorium*, 27 (1963), pp. 277-299; Tuve, "Notes on the Virtues and the Vices," pp. 277ff.]

66 [On eyeglasses as an attribute of Temperance, see C. G. Stridbeck, *Bruegelstudien*, Stockholm, 1956, pp. 163-164.]

67 What do these verses mean:

Esperons montrent que cremeur (la crainte)
Font estre le josne homme meur.

No doubt that spurs are just as useful in retreating as in advancing. A not very chivalrous maxim, certainly. The spurs are much better suited to Prudence than to Temperance.

68 Is this the interpretation of the last two verses?

69 *L'espée du souverain juge*
 Est dessur cil qui autrui juge
 Pour la vérité maintenir
 Doit on l'espée en main tenir.
 La balance justement livre
 A chascun le sien et délivre.
 Le lit enseigne qu'en repos
 Doit juge dire son pourpos.
 Comme est l'orlier au lit propice
 Est miséricorde a justice.

70 [For Prudence with a mirror, see G. F. Hartlaub, *Zauber des Spiegels*, Munich, 1951, pp. 158-172.]

71 This last detail is missing in the Rouen manuscript, and is found only in the manuscript of the Duke of Nemours.

72 These are the verses:

 De bonne coutume s'amort (se mortifie)
 Qui pense souvent a sa mort.
 En beau miroir sa face mire
 Qui son estat voit et remire.
 Mémoire de la Passion
 Targe male tentation
 Discrétion (discernement) *est ou gredier*
 (le crible)
 Quant du grain retrait le paillier
 De n'est que peine et décevance
 D'amasser planté de chevance.

73 In the Rouen manuscript the anvil rests on the head of Fortitude.

74 These are the verses:

 L'enclume se rend clere et fine
 Par souvent prendre discipline.

La force de cuer est la tour
Qui n'est vaincue par nul tour.
Qui mest hors de sa conscience
Le mauvais ver est grant science
Au pressoir de contrition
Sont lermes (larmes) de dévotion.
Ainsi qu'un pressoir ferme a vis
Force se conduit par aviz.

Sin and consciousness of sin are compared to a worm in the same manuscript (Paris, Bibl. Nat., ms. fr. 9186, fol. 299). It says, in conformity to the word of Isaiah in the last chapter of his book, that the *worm of Conscience* does not die with the damned: *Vermis eorum non morietur* (Their worm shall not die, Isaiah 66:24).

75 [For an earlier dating of the new iconography, e.g., *Livre des quatre vertus* (Oxford, Bodleian Lib., ms. Laud misc. 570), 1450, cf. Tuve, "Notes on the Virtues and the Vices," pp. 279, 285, pls. 32 b,c,d.]

76 [Cf. *ibid.*, pp. 290, 295.]

77 There is nothing against assigning an earlier date to the manuscript in the library of Rouen than to the manuscript of the Duke of Nemours. Everything seems to prove that the manuscript of Rouen was actually illuminated in Rouen, because it was copied for the city magistrates.

78 In the south transept. It bears the date of 1521.

79 See the ancient lives of St. Romain published by the Bollandists, *Acta Sanctorum*, Antwerp, 1643-1931, x, p. 91.

80 At the top of the window.

81 Only the symbolic objects are missing which, in the Rouen manuscript, served as pedestals.

82 There are also other scenes. St. Romain, whose birth was foretold by an angel, comes into the world: Faith welcomes him. St. Romain surrounded by his clergy is seated on a throne: Prudence accompanies him. St. Romain routs the devil who inhabited an ancient temple sacred to Venus: Fortitude with her anvil on her head, escorts him. St. Romain, accompanied by Justice, converses with a clerk before a table covered with precious objects.

83 In the courtyard of the Ecole des Beaux-Arts, in Paris. [See Chirol, *Le Château de Gaillon*, pp. 137, 154.]

84 See *Chants royaux sur la Conception, couronnes au puy de Rouen de 1519 a 1528* (Paris, Bibl. Nat., ms. fr. 1537, fol. 50), sixteenth century, and *Recueil des chants royaux en*

l'honneur de la Vierge (Paris, Bibl. Nat., ms. fr. 379, fol. 45v), sixteenth century.

85 Missal for Paris use (Paris, Bibl. Mazarine, ms. 412, fol. 151, second part). Henri de Berg, *L'Orologe de Sapience* and other sixteenth-century works (Paris, Bibl. Nat., ms. fr. 22922, fol. 153), and a collection of religious works (Paris, Bibl. Nat., ms. fr. 9608, fol. 41v), fifteenth century, are manuscripts which seem Parisian to me. As for Guillaume Fillastre, *Toison d'Or* (Paris, Bibl. Nat., ms. fr. 138), sixteenth century, in which the virtues so closely resemble those of the Rouen manuscript, I could not say whether it was done in Paris or Rouen.

86 Museum of Lille.

87 These figures were reproduced in A. F. Calvert, *Leon, Burgos, Salamanca*, London, 1908, pl. 235.

88 On the stalls of St. Bertrand-de-Comminges, she carries the bit in her mouth. Also on the stalls of the chapel of Gaillon, now in St. Denis.

89 Flemish tapestries in Madrid (Fig. 199).

90 On the stalls of Gaillon, Prudence carries a mirror in which the instruments of the Passion can be seen. The Cour des Comptes, built at the time of Louis XII in the courtyard of the Ste.-Chapelle, had the four cardinal Virtues on its façade. Temperance carried a clock and eyeglasses, Justice a sword and scales, Prudence a mirror and a sieve, Fortitude pulled the dragon from the tower. See M. Poéte, *Commission du Vieux Paris*, Paris, 1917.

91 Hours of Simon Vostre. Stalls of Auch.

92 Paris, Bibl. Nat., ms. fr. 1863, fol. 2v.

93 Portal of Vétheuil (Seine-et-Oise) and Petrarch, *Des Remèdes de Fortune* (Paris, Bibl. Nat., ms. fr. 225, fol. 8), Paris, 1503. [See also Tervarent, *Attributs et symboles*, p. 27.]

94 Stalls of Auch; Hours of Simon Vostre. On the stalls of Gaillon, the monogram with rays is replaced by a star. The famous Brussels tapestries (in the royal palace in Madrid) provide the most typical series of the Virtues of the sixteenth century. This is the French tradition at its purest. [For Charity holding a heart, see also examples in R. Freyhan, "The Evolution of the Caritas Figures in the Thirteenth and Fourteenth Centuries," *Journal of the Warburg and Courtauld Institutes*, 11 (1948), pp. 68-86; Tervarent, *Attributs et symboles*, pp. 102-103.]

95 At S. Eustorgio, in Milan. The tomb dates from 1339. [For this work, sculpted by Gio-

vanni di Balduccio, see J. Pope-Hennessy, *Italian Gothic Sculpture*, London, 1955, fig. 4 and pl. 57.]

96 This is the "arca" (tomb) of St. Augustine at S. Pietro, in Pavia. The work was begun in 1362. [See *ibid.*, fig. 75 and pl. 58.]

97 [For the monument of Cansignorio della Scala, Sacristy of S. Maria Antica, Verona, by Bonino da Campione, 1370-1374, see *ibid.*, fig. 77 and pl. 60.]

98 [For the tomb of Pope Innocent VIII, St. Peter's, Rome, executed under the direction of Antonio Pollaiuolo from 1492-1498, see J. Pope-Hennessy, *Italian Renaissance Sculpture*, London, 1958, fig. 71 and pl. 87. See also L. D. Ettlinger, "Pollaiuolo's Tomb of Pope Sixtus IV," *Journal of the Warburg and Courtauld Institutes*, 16 (1953), pp. 239-271.]

99 [Examples in Naples include the series of sepulchral monuments executed by Tino da Camaino, including the monument of Catherine of Austria, S. Lorenzo Maggiore. See Pope-Hennessy, *Italian Gothic Sculpture*, pl. 30. For the monument of Mary of Valois, S. Chiara, see *ibid.*, pl. 31, fig. 58. For tombs of the Doges in Venice with Virtues, see Pope-Hennessy, *Italian Renaissance Sculpture*, pp. 348-354, figs. 154, 158, 160, 162; pls. 128, 129, 137, 140, 141.]

100 Tomb of St. Peter Martyr in Milan, 1339 [see above, n. 95]; Tomb of Pope John XXIII (d. 1417), in the Baptistry of Florence, by Donatello [see Janson, *The Sculpture of Donatello*, pls. 26-27]; Tomb of Sixtus IV (d. 1484) in St. Peter's, Rome [see Pope-Hennessy, *Italian Renaissance Sculpture*, fig. 72, pls. 86, 88, 89]; Tomb of Innocent VIII (d. 1492), at St. Peter's, Rome [see above, n. 98].

101 Tomb of St. Peter Martyr. Baptistery of Bergamo.

102 Florence, door of the Baptistery by Andrea Pisano [see Pope-Hennessy, *Italian Gothic Sculpture*, pl. 42]; relief of the Campanile.

103 Tombs of John XXIII, Sixtus IV, Innocent VIII, in Rome; pulpit of S. Croce in Florence [Pope-Hennessy, *Italian Renaissance Sculpture*, fig. 51]; Altar of S. Fina in collegiata at San Gimigniano by Benedetto da Maiano [see L. Düssler, *Benedetto da Majano*, Munich, 1924, fig. 6]; tomb of Tartagni in the church of S. Domenico in Bologna.

104 Altar of San Gimignano. Certain attributes, such as the cornucopia, the vase from which flames escape (tomb of John XXIII, door of the Baptistery in Florence, reliefs of the Campanile) always remain exceptions. [For

more on Charity suckling infants, see Freyhan, "The Evolution of the Caritas Figures," pp. 83-85.]

105 Tomb of St. Peter Martyr in Milan; pavement of the cathedral of Siena; fresco by Perugino in the Cambio of Perugia; tomb of the Doge Vendramin in Venice. As we know, Giotto gave as the attribute to Temperance the sword sheathed in the scabbard (Padua, Arena Chapel). The idea is not very clear, and it was adopted by only a very few artists (reliefs of the door of the Baptistery of Florence, tomb of Francesco Pazzi in S. Croce, in Florence).

106 Tombs of St. Peter Martyr and St. Augustine; pavement of the cathedral of Siena. [For a discussion of the representation of Prudence in relation to Titian's Allegory (London, National Gallery), see E. Panofsky and F. Saxl, "A Late Antique Religious Symbol in Works by Holbein and Titian," *Burlington Magazine*, 2 (1926), pp. 177-181. See also H. Liebeschütz, *Fulgentius metaforalis, ein Beitrag zur Geschichte der antiken Mythologie im Mittelalter*, Leipzig, 1926; E. Panofsky, *Herkules am Scheidewege*, Leipzig, 1930, pp. 12ff.]

107 Tomb of Cansignorio della Scala, Verona; relief of the Campanile [see Venturi, *Storia dell' Arte*, IV, fig. 550]; relief by Orcagna in the tabernacle of Orsanmichele. Giotto has provided the example by representing Prudence with two faces in the fresco in the Arena Chapel. [Prudence with two heads is also found in Raphael's Stanza della Segnatura.]

108 Relief of S. Miniato, 1466. [For the relief of Prudence, with mirror and serpent, one of the four cardinal Virtues decorating the ceiling of Chapel of the Cardinal of Portugal in S. Miniato al Monte, Florence, see Pope-Hennessy, *Italian Renaissance Sculpture*, fig. 65 (1461-1466). See also L. Planiscig, *Luca della Robbia*, Vienna, 1940, figs. 91, 94.]

109 Giotto, in the Arena Chapel, had already given Prudence the attribute of the mirror.

110 The serpent is shown on the door of the Florentine Baptistery, the Campanile, and the tabernacle of Orsanmichele. In the fifteenth century, Prudence was sometimes characterized by the serpent alone (tomb of Valentino d'Ansio del Poggio, d. 1483, at S. Sabina, in Rome), sometimes by the mirror and the serpent (tomb of Sixtux IV; tomb of Astorgio Agnense, d. 1451, in S. Maria sopra Minerva).

111 This is the most archaic type (fresco in the Arena Chapel, doors of the Florentine Baptistery, tomb of Francesco Pazzi), but it persisted into the fifteenth and sixteenth centuries (Perugino, frescoes of the Cambio). The shield is sometimes replaced by a globe or circle symbolizing the world (tomb of St. Peter in Milan, Baptistery of Bergamo, tomb of Sixtus IV).

112 See Fortitude in Cabinet des Estampes, Ed 5. An inscription expressly compares Fortitude to Samson. From the same Paris, Bibl. Nat. manuscripts, facsimile 130.

113 Italian manuscript of the thirteenth century with Latin commentary: *Homélies et oraisons latines* (Paris, Bibl. Nat., ms. ital. 112, fol. 116v). Fortitude has two columns which she seems to shake. Table of Or San Michele.

114 Playing cards said to have belonged to Charles VI, Italian work of the fifteenth century, Cabinet des Estampes, Kh 24; pavement of the cathedral of Siena; cathedral of Como. [See also Tervarent, *Attributs et symboles*, pp. 106-107.]

115 [For the origin of Virtues in cathedral portals, see Mâle, *L'Art religieux du XIIIe siècle en France*, 9th ed., pp. 135-160.]

116 [For Matteo Civitali's relief of Hope (Florence, Bargello), see C. Yriarte, *Matteo Civitali*, Paris, 1886, pl. opp. p. 48.]

117 [For Andrea Pisano, see above, n. 102.]

118 Predella of the Entombment, in the Vatican Library, Rome.

119 [For illustrations of the Albi Virtues, see E. Mâle, *La Cathédrale d'Albi*, Paris, 1950, pls. 54, 64-65.]

120 [Tomb of François II of Brittany and Marguerite de Foix, 1502-1507.] The tomb of Charles VIII in St.-Denis (now destroyed) was decorated with figures of the Virtues; but the work was conceived and executed by an Italian, Guido Mazzoni. The Virtues on the tomb at Dol (Ille-et-Vilanie) and those of the tomb at Ferrières (Loiret) are also Italian work. [For a drawing of the tomb of Charles VIII, see E. Panofsky, *Tomb Sculpture; Four Lectures on Its Changing Aspects from Ancient Egypt to Bernini*, H. W. Janson, ed., New York, 1964, fig. 325.]

121 See P. Vitry, *Michel Colombe*, Paris, 1901, pp. 382ff. Vitry has fully indicated the preponderant role of Jean Perréal in all this. [See also P. Pradel, *Michel Colombe, le dernier imagier gothique*, Paris, 1953, pp. 44ff. and C. Sterling, "Une peinture certaine de

122 See the figures of Fortitude by Perugino and by Pinturicchio.

123 The compass Prudence carries is a French attribute; the mirror is both Italian and French. [For Italian examples of Prudence with a compass, cf. Tervarent, *Attributs et symboles*, p. 110.]

124 [For drawing by Millin of tomb of Pierre de Roncherolle, at Ecouis, see Vitry, *Michel Colombe*, fig. on p. 504.]

125 Vitry, *ibid.*, pp. 444ff., has shown the resemblances linking a great number of these works to the atelier of Michel Colombe. It is evident that Fortitude, Temperance, Prudence and Justice on the Rouen tomb are imitations of the Virtues of Nantes. Other works could be cited which, unfortunately, we know only through the inadequate drawings of Gaignierès. They are: the tomb of Gauvain de Dreux (d. 1508), at St.-Nicholas-de-Loye in Normandy: Temperance with the clock, Justice with sword and scales, Fortitude pulling the monster from the tower, Prudence with the mirror and compass (Gaignières, Pe 1, fol. 91); the tomb of Guy de Rochefort (d. 1508) and of his wife (d. 1509), at Cîteaux: Temperance with the clock, Justice with sword and scales, Fortitude pulling the monster from the tower, Prudence with the mirror (Gaignières, Pe 4, fol. 17).

126 The tomb of Amiens (1543) is the work of Laignel: see G. Durand, *Monographie de l'église-cathédrale Notre-Dame d'Amiens* (Mémoires de la société d'antiquaires de Picardie), II, Amiens, 1903. The Virtues of Folleville are identical and can only have come from the atelier of Laignel. Prudence has the mirror and the compass for attributes as at Rouen. [For Lannoy tomb at Folleville, see Panofsky, *Tomb Sculpture*, fig. 272. See also G. Durand, "Les Lannoy, Folleville et l'art italien dans le nord de la France," *Bulletin monumental*, 70 (1906), pp. 329-404.]

127 Cabinet des Estampes. Drawings by Gaignières, 1, fol. 38.

128 Perhaps Temperance did not have the clock, but she must have had the bridle and the bit.

129 Millin, *Antiquités nationales*, article on Ecouis. [See Part II, Chapter IX, n. 82.] The drawing is not only very bad, it also appears to be incorrect. Justice, for example, holds a scale and a mirror. This is clearly a mistake of the artist. The mirror belongs to Prudence, her neighbor, who is given no attribute in the drawing. For the attribute of Temperance, two amphorae can be clearly seen, as the text of Millin confirms.

130 I refer, naturally, only to the attributes. The style is still quite French. The tomb of the Poncher family is in the Louvre.

131 We know it only from a drawing. See J. Guiffrey, "Le tombeau des Poncers d'après un dessin inédit de Percier," *Gazette archéologique*, 8 (1883), p. 169.

132 Petrarch, *Des Remèdes de Fortune* (Paris, Bibl. Nat., ms. fr. 225, fol. 8), 1503; Faith and Hope are seen in a painting carried by Reason.

133 On the tomb of Charlotte d'Albret at Lemotte-Feuilly (Indre), begun some years after 1514 (date of the death of Charlotte d'Albret), there were already some Virtues who seem to be entirely Italian. Fortitude has a column, Temperance makes the gesture of mixing water and wine. See H. Aucapitaine, "Statue de Charlotte d'Albret dans l'église de la Motte-Feuilly," *Revue archéologique*, 9 (1852), pp. 703-705, and pls.

134 In some tombs of lesser importance, the figures of the Virtues still remain a little more faithful to French iconography.

135 A. de Montaiglon, "La famille des Juste en France," *Gazette des beaux-arts*, 12 (1875), pp. 385ff., 515ff., and 13 (1876), pp. 552ff. The tomb of Louis XII was finished in 1531.

136 Especially the style of the kneeling figures of the king and queen. See Vitry, *Michel Colombe*, p. 454.

137 In 1559; it had been worked on for a long time. H. A. Geymüller, *Die Baukunst der Renaissance in Frankreich*, Stuttgart, 1902, II, pp. 628ff., has given the entire history of the monument. See also L. Dimier, *Le Primatice*, Paris, 1926.

138 These mutilated attributes have been restored.

139 Geymüller, *loc. cit.*

140 The letters of Primaticcio published by Stein prove that the general design of the tomb and the figures of the Virtues are indeed his. See H. Stein, *Quelques lettres inédites du Primatice*, Fontainebleau, 1911. [Cf. Dimier, *Le Primatice*, pp. 54-55, 90-93, and p. 92 n. 2; A. Blunt, *Art and Architecture in France*, 1500-1700 (Pelican History of Art), Baltimore, 1953, pp. 54-55, 84.]

141 [For the iconography of the Vices, see M. W. Bloomfield, *The Seven Deadly Sins. An Introduction to the History of a Religious*

Concept with Specific Reference to Medieval English Literature, East Lansing, Mich., 1952. See also S. Chew, "Spenser's Pageant of the Seven Deadly Sins," *Studies in Art and Literature for Belle da Costa Greene*, Princeton, 1954, pp. 37-54.]

142 See Mâle, *L'Art religieux du XIIIe siècle en France*, 8th ed., pp. 110ff. [*Religious Art in France: The Thirteenth Century*, Bollingen XC. 2, Princeton, 1984, pp. 110ff.]

143 Job, who symbolizes Hope, is shown near Judas. [For the theme of the suicide of Judas, see O. Goetz, "Die hencktt Judas," *Form und Inhalt. Kunstgeschichtliche Studien. Otto Schmitt zum 60 Geburtstage*, Stuttgart, 1950, pp. 105-137. See also S. Snyder, "The Left Hand of God: Despair in the Medieval and Renaissance Tradition," *Studies in the Renaissance*, 12 (1965), pp. 18-59.]

144 Breviary of Charles V (Paris, Bibl. Nat., ms. lat. 1052, fol. 238).

145 Guillaume de Deguilleville, *Pèlerinage de la vie Humaine*, J. J. Stürzinger, ed. (Roxburghe Club), London, 1893. [For Lydgate's English translation of 1426, see *The Pilgrimage of the Life of Man*, F. J. Furnival and K. B. Locock eds., 2 vols. London, 1899-1904. For the miniatures, see L. Delaissé, "Les miniatures du 'Pèlerinage de la vie humaine' de Bruxelles et l'archéologie du livre," *Scriptorium*, 10 (1956), pp. 233-250.]

146 In Huon de Meri, *Tournoiement de l'Antechrist*, Sloth is mounted on an elephant.

147 *Somme le Roi* (Paris, Bibl. de l'Arsenal, ms. 6329. [The *Somme le Roi* is a series of moral treatises compiled in 1279 by a Dominican brother Laurent (Lorens) for Philip the Bold (d. 1285). For an account of the illustrated copies, see L. Delisle, *Recherches sur la libraire de Charles V*, Paris, 1907, pt. 1, pp. 236-247. See also, H. Martin, "La Somme le Roi, Bibl. Mazarine no. 870," *Les Trésors des Bibliothèques de France*, Paris, 1925, 1, pp. 42-57. For a facsimile, see *An Illuminated Manuscript of La Somme le Roy*, G. Millar, introd. (Roxburghe Club), Oxford, 1953.]

148 [For other interpretations of animals in antiquity, cf. W. C. McDermott, *The Ape in Antiquity*, Baltimore, 1938, and Bloomfield, *The Seven Deadly Sins*, pp. 27-29.]

149 Already, in the *Hortus deliciarum*, animals symbolizing the vices surround the chariot of Avarice: the fox is fraud, the lion ambition, the bear violence, the wolf rapacity, the vulture love of wealth, etc. *Hortus deliciarum*, pl. LI. [For a facsimile of the *Hortus deliciarum* of Herrade von Landsberg, abbess of Hohenburg, in the late twelfth century, see *Hortus Deliciarum, un manuscrit alsacien à miniatures du XIIe siècle*, Rott, introd., Strasbourg, 1945. For the subject of animals as Vices, see Katzenellenbogen, *Allegories of the Virtues and the Vices*, pp. 60ff.]

150 *Speculum humanae salvationis* (Paris, Bibl. Nat., ms. fr. 400). Collection of images in which the military costumes seem to date from the very end of the fourteenth century. This manuscript was known by Fathers Cahier and Martin, who published the figures of the Vices which we shall discuss. See A. Martin, "Chasse de S. Taurin d'Evreux," *Mélanges d'archéologie, d'histoire et de littérature*, 2 (1851), pp. 21ff.

151 The theologians, moreover, had long recognized the seven cardinal sins. As early as the twelfth century, Jean Beleth had written a treatise on the subject. See *Histoire littéraire de la France*, Paris, 1733-1949, XIV, p. 219.

152 Inscriptions accompanying the miniatures give the names of the personages and the animals.

153 [For Luxuria associated with the He-goat, see R. Hamann, "The Girl and the Ram," *Burlington Magazine*, 60 (1932), pp. 91ff.]

154 Without justification. See St. Bonaventura, *Opera Omnia*, edited by the Franciscans of Quaracchi, X, p. 24. The book must date from the fourteenth century. The *Dieta Salutis* was often reprinted in the fifteenth century. [One example from the end of the fifteenth century of the many editions of the *Dieta Salutis* attributed to St. Bonaventura: *Diaeta Salutis. Contemplatio de nativitate Christi: De resurrectione hominis a peccato e praeparatione ad gratiam*, printed by Pierre le Dru for Jean Petit and C. Jaumar, Paris, 1497.

155 The text is not very explicit. No doubt it has to do with the birds of the night. This explains why the artist has given Avarice an owl as attribute.

156 The *Dieta Salutis* does not mention the other animals that figure in our miniatures, but they are almost all self-explanatory. It is only natural that the lion and the eagle, kings of the animals, symbolize Pride. And we can also understand that Wrath would be characterized by the cock, Sloth by the owl who sleeps during the day, Gluttony by the wolf, Lust by the goat or the he-goat. It is possible to explain, too, why the dog and the hawk represent Envy.

157 There are many variants. I know several fourteenth-century works in which animals are related to the Vices. No two are exactly alike. In a manuscript of the fourteenth century, Paris, Bibl. Nat., ms. fr. 19271, fol. 218, for example, the stag symbolizes Pride and the hare Avarice. Another, Paris, Bibl. Nat., ms. fr. 6276, fol. 29v, gives the lion to Pride, the fox to Avarice, the bear to Sloth, etc. There was the same uncertainty in the fifteenth century. In a little tract entitled *Articuli fidei*, and published by Michel Lenoir at the end of the fifteenth century, Pride is associated with the lion, Envy with the dog, Wrath with the wolf, Sloth with the ass, Avarice with the camel, Gluttony with the bear or the pig, Lust with the he-goat. Clearly this is a long way from the solid and reasoned symbolism of the thirteenth century.

158 Guiffrey, *Histoire de la tapisserie en France*, p. 22.

159 *Ibid.*, p. 25.

160 L. Petit de Julleville, *Répertoire du théâtre comique en France au moyen-âge*, Paris, 1886, p. 324.

161 Or perhaps a fox.

162 Such is not the case at Roussines, but everywhere else it was the adopted formula.

163 Névaches, Largentière, Vigneaux, Orres (frescoes almost destroyed) and Notre-Dame-du-Bourg at Digne. These frescoes have been described by J. Roman, "Le tableau des vertus et des vices," *Mémoires de la société nationale des antiquaires de France*, 41 (1880), p. 22. These, like the preceding frescoes, date from the end of the fifteenth or the beginning of the sixteenth century.

164 La Pommeraie, Névaches, Digne, Largentière, Vigneaux.

165 Engravings of the *Château de labour*, printed by Pigouchet for Simon Vostre, Paris, 1499.

166 Churches in the Hautes-Alpes: *Château de labour*; *Eruditorium penitentiale*, printed by A. Caillaut, Paris, 1487; Jacques le Grand, *Livre des bonnes moeurs*, printed by A. Caillaut, Paris, 1487. [For the two incunabula published by Caillaut, see Davies, *Catalogue of a Collection of Early French Books in the Library of C. Fairfax Murray*, nos. 155 and 309.]

167 La Pommeraie, Chemille, miniatures of the Cluny museum, *Eruditorium penitentiale*.

168 Névaches, Digne.

169 *Miroir historial* (Paris, Bibl. Nat., ms. fr. 50, fol. 25). [See above, n. 50.]

170 J. von Schlosser, "Giustos Fresken in Padua und die Vorlaufer der Stanza della Segnatura," *Jahrbuch der kunsthistorischen Sammlungen des allerhöchsten Kaiserhauses*, 17 (1896), pp. 13-100.

171 *Homélies et oraisons latines* (Paris, Bibl. Nat., ms. ital. 112). [See above, n. 113.] The names of the personages trampled underfoot have been forgotten.

172 The Chantilly manuscript has been published, described and annotated by Léon Dorez. See L. Dorez, *La canzone delle Virtù e delle Scienze di Bartolomeo di Bartolo da Bologna*, Bergamo, 1904.

173 The Chantilly manuscript must be dated ca. 1355; Dorez, *loc. cit*.

174 These frescoes have disappeared; we know of them through an old description.

175 [For the frescoes of the Spanish Chapel, by Andrea da Firenze, see van Marle, *L'Iconographie de l'art profane*, II, pp. 203ff., fig. 242.]

176 In the Chantilly manuscript, as in the *Somme le Roi*, Judith is shown beheading Holophernes.

177 However, there is something very close to the proof we are looking for: it could be the proof itself. In the accounts of Philip the Bold, Duke of Burgundy, under the date 1396, we read: "A tapestry with the images of the seven Virtues and the seven Vices, and below the said images in this tapestry are several emperors, kings, and other personages providing examples that elucidate these images." Guiffrey, *Histoire de la tapisserie*, p. 24. This tapestry was bought, it is true, from two Genoese merchants, but these merchants lived in Paris, and the inventory says that the tapestry was made of thread from Arras.

178 There has been a substitution of names. Temperance, with Tarquinius underfoot (fig. 195), is clearly Prudence, as her attributes indicate. The coffin has been replaced by a skull.

179 [For the tomb of Lamarch, see H. Jacob, *Idealism and Realism*, Leyden, 1954, p. 63 and p. 253; drawing reproduced p. 64, fig. 9.]

180 He was almost Dante's contemporary. He composed his poems from 1330 to 1335.

181 John Bunyan's famous *Pilgrim's Progress*, the Anglo-Saxons' most popular book after the Bible, is known to be only an imitation of the *Pèlerinage de la vie humaine* of Guillaume de Deguilleville. [See above, n. 145. On this question, see further, A. Pompen, "Bunyan's

Pelgrimsreise," *De Katholiek*, 1914, pp. 222-240, 265-284.]

182 Sermons of Bernard of Lutzemburg (Bernardus of Lutzenburgo), *Sermones de symbolica colluctatione septem Vitiorum capitalium et Virtutem*, Cologne, 1516. [Bernard of Lutzemburg (d. 1535) was a Dominican theologian and Inquisitor of the Archdioceses of Cologne, Mainz, and Thier. For a French translation of Prudentius' *Psychomachia*, see the edition and commentary of M. Lavarenne, *La Psychomachie de Prudence*, Paris, 1933.]

183 Performed at Tours. *La Moralité de l'Homme pécheur*, printed by Antoine Vérard, Paris, 1481. It was also printed by Le Petit Laurens and the widow of Jehannot Treperel. [See Graesse, *Trésor de livres*, III, pp. 341-342.]

184 Printed by Vérard, Paris, 1508. [*Ibid.*, p. 341.]

185 Printed by Pigouchet for Simon Vostre, in 1499 (now in Paris, Bibl. Mazarine), [*Ibid.*, pp. 156-157.]

186 He deviated only in giving Wrath a bear as a mount instead of a wild boar.

187 These are detached sheets.

188 The sheet representing Diligence opposing Sloth is missing.

189 In 1474, 1479, 1482. See R. Müther, *Die deutsche Buchillustration der Gotik und Frührenaissance*, Munich, Leipzig, 1884, I, p. 38.

190 Cited above, n. 182.

191 Collection of Baron Erlanger; tapestry reproduced by E. Müntz, *La Tapisserie*, Paris, 1882, p. 200.

192 In the Vatican tapestry, Envy is mounted on a wild boar, but she has a dragon on her shield and on her armor a bat, as in the book at Augsburg.

193 Certain animals are difficult to identify and resemble nothing known. But in the Augsburg book, there are also fabulous animals which the artist could not have known how to represent, for example, the Onix, the mount of Avarice, and the Orasius, the mount of Charity, not to mention the Monocastes and the Koredulus.

194 See also the engravings by Aldegrever and by Pencz. Several of the animals serving as attributes of the Vices derive from the Augsburg book.

195 The eleven tapestries under discussion are evidently contemporary and form a series. There is the same rich, subtle, and learned thought in all of them. These tapestries are from the Brussels school. [These tapestries, dating ca. 1525, are illustrated in Göbel, *Wandteppiche*, II, pt. 1, pls. 87, 88.]

196 Alain de Lille, inspired the second part of the *Roman de la Rose*, which is taken from his *De Planctu naturae*. Dante also imitated it. When the writers of the Middle Ages find their rightful places, Alain de Lille will appear to be one of the most remarkable. [For the influence of Alain de Lille on the *Roman de la Rose*, see E. Langlois, *Origines et sources du Roman de la Rose*, Paris, 1891, pp. 148-150. See also Alain de Lille, *Anticlaudianus*, R. Bossuat, ed., Paris, 1955, p. 45 n. 4, for fragments of this work inserted by Jean de Meun in the second part of the *Roman*.]

197 In the tapestries, the names of the horses as well as that of Reason are written in French.

198 The second part is not by Alain de Lille; it belongs, it seems, to the author of the libretto. This anonymous author had still other ingenious ideas. For instance, while on one side of Divine Wisdom, Prudence and Reason are mounted on their chariot, on the other, Prometheus steals fire from heaven. This no doubt means that there are two ways of discovering the truth: methodical research and inspiration.

199 The designer of the tapestries has placed mythological personages or heroes of antiquity in the river.

200 [For the *Psychomachia*, see *Anticlaudianus*, Bossuat, ed., bks. 8 and 9, pp. 173-198.]

201 [The *Throsne d'honneur*, written after 1497, is published in *Les faictz et dictz de Jean Molinet*, N. Dupire, ed., (Société des anciens textes français), Paris, 1936, I, pp. 52ff. For the passage cited by Mâle, see pt. 2, lines 5-10.]

202 [Jean Lemaire de Belges, ca. 1473-ca. 1525, was a Flemish poet, historian and pamphleteer who wrote in French. For more on Lemaire, see K. M. Munn, *A Contribution to the Study of Jean Lemaire de Belges*, New York, 1936; F. Simone, "La Scuola de 'Rhétoriqueurs,'" *Belgafor*, 4 (1949), pp. 529-552, with bibliography; J. Frappier, "L'humanisme de Jean Lemaire de Belges," *Bibliothèque d'humanisme et Renaissance*, 25 (1963), pp. 289-306.]

203 Certain details belong to the designer of the tapestries. Thus, outside the temple we see the falsely great men who tried to enter by

force: Holophernes, Tarquinius, Julian the Apostate, etc.

204 These tapestries could not have been executed before 1496, as F. Riano claims. J. F. Riano, *Report on a Collection of Photographs from Tapestries at the Royal Palace of Madrid*, London, 1875. The document he cites could not apply to this series.

205 From 1507 to 1513 Lemaire was one of the shining lights at the court of Margaret of Austria.

206 [Brou was the funerary church built by Margaret of Austria, Governess of the Netherlands, to house the body of her husband Philibert of Savoy. Although her court was in Malines, the church is situated in Bourg-en-Bresse (Ain) and is a major meeting ground of Renaissance and flamboyant Gothic art in the decor of the elaborate tombs of Margaret of Austria, Philip the Fair, and Margaret of Bourbon.]

207 Jean Lemaire de Belges, *Les illustrations de la Gaule et singularités de Troye*, printed by Jacques Mareschal, Paris, 1524. Since no one as yet has called attention to it, it will be useful to provide the proof for what I propose here. The Beauvais tapestries were reproduced by A. Jubinal, *Anciennes tapisseries historiées*, Paris, 1838; but he did not recognize their origin and presented them in the wrong order. (1) The first, now lost, was devoted to Samothès writing the letters of the alphabet. If we go back to the *Illustrations* of Jean Lemaire, bk. I, chap. x, we will see that Samothès, grandson of Noah, and king of Gaul, taught his people the letters of the alphabet, "which resembled those which Cadmus long afterwards brought from Phoenicia to Greece." (2) The second tapestry represents, as we learn from the inscription, Galathes, son of Hercules and Galathea, queen of the Celts; around him are placed the names of the principal divisions of France: Aquitaine, Brittany, Flanders, etc. The idea for this tapestry was borrowed from bk. I, chap. XIII, of the *Illustrations*. Jean Lemaire, after recounting the history of Galathes tells us that Galathes gave his name to the inhabitants of Gaul, and in this connection lists the different parts of France he named. (3) The third tapestry shows King Lugdus founding the city of Lyon; this is precisely what Jean Lemaire tells in this same chapter of the *Illustrations*. (4) The fourth tapestry is devoted to Belgius, founder of the city of Beauvais, "from which came Belgian Gaul." This is what Jean Lemaire says in the same chapter, with the difference that Jean Lemaire speaks of the city of Belges, his native city, while the artist who was working for Beauvais substituted for the city of Belges, the city of Beauvais itself. (5) The fifth tapestry shows us Dardanus, "founder of Troy," killing his brother Jasius, king of the Gauls, and embarking after his crime. Jean Lemaire, in fact, tells of this murder in bk. I, chap. XIV, and adds that Dardanus fled to an island of the archipelago. (6) The sixth tapestry represents a king named Paris founding the city of Paris. Now according to Jean Lemaire, bk. I, chap. XVI, Paris, the founder of Paris, was the son of the King Romus who founded Romans in Dauphiné and gave his name "to the 'rommande' language." (7) The last tapestry shows King Remus giving the hand of his daughter to Francus, son of Hector. The city of Reims is in the background. Jean Lemaire tells us, bk. I chap. XVII, that the Gaulic King Remus, contemporary of Priam, founded the city of Reims, and at the beginning of bk. IV he added that he gave his daughter in marriage to Francus, son of Hector. [See J. Frappier, "Jean Lemaire de Belges et les beaux-arts," *Actes du cinquième congrès international des langues et littératures modernes*, Florence, 1955, pp. 107-114.]

208 For a long time it was claimed that it was Roger van der Weyden; see Riano, *Report on a Collection of Photographs from Tapestries at the Royal Palace of Madrid.*

209 The author, whether Jean Lemaire or someone else, appears to have sought out the names of the heroes and the heroines who accompanied the Virtues in Guillaume Fillastre's book on the *Toison d'Or*. [The first part of the *Toison d'Or*, by Guillaume Fillastre, was offered to Charles the Bold at the eleventh chapter of the Order of the Golden Fleece, held in Bruges in 1468. It was eventually published in Paris in 1516. See above, n. 85.]

210 [Alain Chartier (ca. 1385-ca.1433), poet and diplomat, cultivated classical models in a verse which was sophisticated, latinate, and elegant. Eustache Deschamps (1340-1407), on the other hand, specialized in realistic and witty poems, mostly in the form of ballads.]

211 [Mâle refers here to the famous Italian romance of the late Quattrocento: Francesco

Colonna, *Hypnerotomachia Poliphili*, Venice, 1499.]

CHAPTER VIII

1 [Mâle first published the study incorporated in this chapter in an article: E. Mâle, "L'Idée de la mort et la danse macabre," *Revue des deux-mondes*, 32 (1906), pp. 647-679. For the iconography of death, see further: F. P. Weber, *Aspects of Death and Correlated Aspects of Life in Art, Epigram, and Poetry*, London, 1918; E. Döring-Hirsch, *Tod und Jenseits im Spätmittelalter*, Berlin, 1927; Künstle, *Ikonographie der christlichen Kunst*, I, "Tod und Sterben," pp. 205-211; van Marle, *Ikonographie de l'art profane au moyen âge et à la Renaissance*, II, chap. 2, pp. 361-415; L. P. Kurtz, *The Dance of Death and the Macabre Spirit in European Literature*, New York, 1934; W. Stammler, *Der Totentanz: Entstehung und Deutung*, Munich, 1948; J. M. Clark, *The Dance of Death in the Middle Ages and the Renaissance*, Glasgow, 1950; A. Tenenti, *La Vie et la mort à travers l'art du XVe siècle*, Paris, 1952; Huizinga, *The Waning of the Middle Ages*, pp. 124-135; H. Rosenfeld, *Der mittelalterliche Totentanz*, Münster, 1954; *Réau*, II, pt. 2, pp. 637-662; M. Meiss, *Painting in Florence and Siena after the Black Death*, New York, 1964; E. Du Bruck, *The Theme of Death in French Poetry of the Middle Ages and the Renaissance*, The Hague, 1964; *The Flowering of the Middle Ages*, J. Evans, ed., London, 1966, chap. 6 by T.S.R. Boase, "King Death—Mortality, Judgment and Remembrance," pp. 203-245. See also the important study by S. Cosacchi (Kozaky), *Makabertanz, Der Totentanz in Kunst, Poesie und Brauchtum des Mittelalters*, Meisenheim am Glan, 1965.]

2 He made considerable bequests to the city of Laon which rightly considered him one of its benefactors. See E. Fleury, *Antiquités et monuments de l'Aisne*, Paris, Laon, 1877-1882, IV, p. 241.

3 There is another older monument of this type. At Davenescourt (Somme), the tomb-slab of Charles de Hangest, who died in 1388, again gives the illusion of a parchmentlike mummy. See *La Picardie historique et monumentale*, II, p. 40. [See also R. Helm, *Skelett und Todesdarstellung bis zum Auftreten der Totentänze*, Strasbourg, 1928, pp. 67-69.]

4 *Ergo, miser, cur superbis, nam cinis es et in cadaver fetidum, cibum et escam vermium, sicut nos, reverteris.*

5 Especially, St. Augustine, *City of God* (Paris, Bibl. Nat., ms. fr. 21, fol. 29), late fourteenth century; an unrealistic corpse lies at the foot of the tree of good and evil, and symbolizes death.

6 Jacques Le Grand, *Le livre des bonnes moeurs* (Paris, Bibl. Nat., ms. fr. 1023, fol. 74), 1410. [*Manuscrits à peintures*, no. 195.]

7 This miniature could be an imitation of the fresco painted for the Celestines to perpetuate the memory of the Duke of Orléans' vision. This fresco is reproduced in Gaignières, Pe I, fol. 1.

8 Rohan Hours (Paris, Bibl. Nat., ms. lat. 9471). [See Chapter II, n. 70.]

9 *Ibid.*, fols. 159, 167, 173, 176, 182, 185, 192, 196.

10 In another manuscript, Hours for the use of Paris (Paris, Bibl. Nat., ms. lat. 13262, fol. 121), first half of the fifteenth century, by the same artist, there are three mummies standing in a cemetery. They make enigmatic gestures that produce a vague feeling of terror. They are surely "ghosts," such as the popular imagination would represent them. [*Manuscrits à peintures*, no. 232.]

11 See J. Denais, "Le Tombeau dui roi René à la cathédrale d'Angers," *Mémoires de la société nationale d'agriculture, sciences et arts d'Angers*, 6 (1892), p. 167.

12 Reproduced in Gaignières, Oxford Collection, I, fol. 6. The same figures appear in the Breviary of René II of Lorraine (Paris, Bibl. de l'Arsenal, ms. 601), fifteenth century.

13 A. de Montaiglon, "Jean Bourdichon de Tours," *Archives de l'art français*, 7 (1855-1856), p. 15.

14 [Jacques Bossuet, 1627-1704, was a French prelate and one of the most famous orators in French history.]

15 *Sum quod eris, modicum cineris* (Church of St.-Samson at Clermont d'Oise).

16 *Olim formoso fueram qui corpore, putri Nunc sum. Tu similis corpore, lector, eris.* (Cathedral of Moulins).

17 The corpse at Gisors bears the date of 1526. The Clermont d'Oise figure is an imitation of that at Gisors. The relief of Boisrogue, near Loudun (Vienne), is of the same period. It bears the same inscription as at Gisors: *Quisquis ades tu morte cades ...* (This formula, I might say in passing, is old. It had already

been inscribed on the tomb of Renault de Breban, *maître ès arts* of the University of Paris, who died in 1437: J. Lebeuf, *Histoire de la ville et de tout le diocèse de Paris*, Paris, 1863-1875, IV, p. 264.) The corpse in the cathedral of Moulins bears the date of 1557. The corpse of the cathedral of Châlons-sur-Marne is perhaps a fragment detached from a tomb (fig. 203), and recalls the art of Jean Goujon. [See L. Pressouyre, "Sculptures funéraires du XVIe siècle à Châlons-sur-Marne," *Gazette des beaux-arts*, 54 (1962), pp. 143-152.

18 The famous skeleton of Bar-le-Duc (Meuse), carved by Ligier Richier, dates from 1545. See A. Jacquot, "La Sculpture en Lorraine," *Réunion des sociétés des beaux-arts des départements*, 12 (1888), p. 853. [See also Blunt, *Art and Architecture in France, 1500-1700*, p. 72 and pl. 57. The Campo Santo is the famous Gothic cloistered cemetery in Pisa which encloses a large plot of earth believed to have been brought from the Holy Land in Pisan ships.]

19 This mantle is now in the château of Terre Neuve at Fontenay-le-Comte (Vendée).

20 The inscription accompanying a skull carved on a house in Caen (Calvados) reads: *Hoc est speculum hominis*.

21 In the museum of Dôle.

22 In the museum of Rouen.

23 [The *Heptaméron* and *Pantagruel* mirror the life and culture of sixteenth-century France from different, but not opposed, points of view. François Rabelais' *Pantagruel*, just published in 1533, combines pointed satire with a good-humored sympathy for human affairs. The *Heptaméron* was composed on the model of Boccaccio by Margaret of Angoulême, queen of Navarre, and published in 1558, after her death. See Margaret of Angoulême, *Heptaméron*, W. K. Kelly, tr., London, 1903; F. Rabelais, *Pantagruel: texte de l'édition princeps*, R. Marchal, ed., Lyon, 1935.

24 [The location of these references to death suggests the emblematic analogy between the consuming flames of the fireplace and all-consuming death. Similar emblematic thought in architectural form may be seen in Philibert de l'Orme's designs for the château of Diane de Poitiers at Anet, where the chimneys are in the form of sarcophagi. See A. Blunt, *Philibert de l'Orme*, London, 1958, p. 36, pl. 10-12b.]

25 Vincent de Beauvais, *Speculum historiale*, XXIX, 108. *Les Vers de la mort, par Hélinant* (Anciens texts français), F. Wulff and E. Walberg, eds., Paris, 1905. According to the editors, Hélinand's poem was written between 1193 and 1197. [For Hélinand, see also Cosacchi, *Makabertanz*, pp. 6-119.]

26 Innocent III, *De contemptu mundi*, Migne, *P. L.*, 217, cols. 701ff. The *De contemptu mundi* was written by Innocent III before he was elected pope. See A. Luchaire, *Innocent III, Rome et l'Italie*, Paris, 1905-1908, I, pp. 7ff.

27 Especially, Paris, Bibl. Mazarine, ms. 980, fol. 83v.

28 The moral shock that the great plagues must have produced from 1348 onward surely counted for something in this heightening of the sensibility. [Mâle's correlation of the genesis of the *danse macabre* and the activities of preaching orders seems substantiated by a mid-fifteenth century fresco of this subject in the Dominican church in Strasbourg in which the Dominican is shown giving a sermon, initiating the cycle. See Cosacchi, *Makabertanz*, pp. 666-667.]

29 The four poems were published by A. de Montaiglon, *L'Alphabet de la mort d'Hans Holbein*, Paris, 1856, unpaged. [See also W. F. Storck, *Die Legende von den drei Lebenden und von den drei Toten* (Heidelberg Diss.), Tübingen, 1910; K. Künstle, *Die Legende der drei Lebenden und der drei Toten und der Totentanz*, Breiburg, 1908; S. Glixelli, *Les Cinq Poèmes des trois morts et des trois vifs*, Paris, 1914; Künstle, *Ikonographie*, I, pp. 208-211; G. Servières, "Les formes artistiques du 'Dict des Trois Morts et des Trois Vifs,'" *Gazette des beaux-arts*, 13 (1926), pp. 19-36; R. Offner, *Corpus of Florentine Painting*, New York, 1947, sect. III, vol. V, pp. 261-263; *Réau*, II, pt. 2, pp. 642-645; W. Rötzler, *Die Begegnung der drei Lebenden und drei Toten*, Winterthur, 1961.]

30 "Un vieil âtre." From the first anonymous story.

31 Nicolas de Margival.

32 First anonymous story.

33 Baudoin de Condé.

34 The dead are skeletons enveloped in their shrouds. The young people wear the long gown of the thirteenth century. In order to keep up their courage, the first two hold hands. Paris, Bibl. Nat., ms. fr. 378, fol. 1, shows a mediocre copy of the miniature of

the manuscript in the Arsenal. [For another related miniature (London, Brit. Mus., Arundel ms. 83), see W. F. Storck, "Bemerkungen zur französisch-englischen Miniaturmalerei um die Wende des XIV Jahrhunderts," *Monatshefte für Kunstwissenschaft*, 4 (1911), pl. 36.]

35 I must say, however, that a document mentions an early fourteenth-century painting which represents the legend "of the three dead and the three living." Report of M. A. Blanchet, "Séance du 15 février," *Bulletin de la société nationale des antiquaires de France*, 1905, pp. 134-135 (p. 134 n. 1).

36 *Petites Heures* of John, Duke of Berry (Paris, Bibl. Nat., ms. lat. 18014, fol. 282).

37 It is believed that he chose this subject in memory of his nephew, the young Duke of Orléans, recently assassinated.

38 At the church of St.-Georges-sur-Eure (Eure), an unknown artist again painted the Three Dead and the Three Living in 1554. E. Veuclin, "Peintres verriers et autres artistes habitant la ville de Dreux au XVIe siècle," *Réunion des sociétés des beaux-arts des départements*, 24 (1900), p. 139. [For thirteenth-century representations of the theme, see A. Tenenti, *Il Senso della morte e dell'amore della vita nel Rinascimento*, Turin, 1957, pp. 430ff.]

39 This is the text that Guyot Marchant added to his edition of the *Danse Macabre*. [First ed., Paris, 1485. See above, no. 70.]

40 The dead, instead of standing, are lying in their coffins.

41 One of the oldest representations of the legend is found at Ste.-Ségolène, at Metz (Moselle). This is a late thirteenth-century fresco that strongly resembles a miniature in Paris, Bibl. de l'Arsenal, ms. 3142 (fig. 205). See G. Boulangé, "Fragments de la statistique monumentale du département de la Moselle," *Bulletin monumental*, 20 (1854), p. 195. [See also Cosacchi, *Makabertanz*, pp. 550-560, pl. II; F. X. Kraus, *Kunst und Alterthum in Elsass-Lothringen*, Strasbourg, 1889, III, pp. 433-443, figs. 97-99.] There are other representations of the "story of the three dead and the three living" at Fontenay, Benouville, Vaux-sur-Aure (Calvados); Clermont (Mayenne); Boismorand, Jouhet, Antigny (Vienne); Verneuil (Nièvre); Ennezat (Puy-de-Dôme); Rocamadour (Lot); St. Riquier (Somme); St.-Clément (Meurthe-et-Moselle), sculptures in the chapel of the cemetery; Campigny (Meuse).

42 At Ennezat (Puy-de-Dôme), on one side of the church, a mural painting depicts the Three Dead and the Three Living, and, opposite, the Last Judgment. The two subjects were placed in the same relationship in the Campo Santo of Pisa. [On the Campo Santo, see Meiss, *Painting in Florence and Siena after the Black Death*, pp. 74ff.]

43 [For the theme of the *Danse Macabre*, see the bibliography cited in n. 1. See also Künstle, *Ikonographie*, I, pp. 211-218; Buchmeit, *Der Totentanz*, Berlin-Grünewald, 1931; J. M. Clark, *The Dance of Death by Hans Holbein*, London, 1948; N. Z. Davis, "Holbein's Pictures of Death and the Reformation at Lyons," *Studies in the Renaissance*, 3 (1956), pp. 97-130; Tenenti, *Il Senso della morte*, pp. 155ff., 448ff., and bibliography cited in n. 81; F. Saxl, "A Spiritual Encyclopedia of the Latter Middle Ages," *Journal of the Warburg and Courtauld Institutes*, 5 (1942), pp. 82-134, esp. pp. 95ff. For the relationship of the themes of the Three Living and the Three Dead and the Dance of Death to various antique and eastern examples, see J. Baltrusaitis, *Le moyen âge fantastique*, Paris, 1955, chap. 7, pp. 237-242.]

44 Begun in 1526.

45 Langlois' old drawings are helpful. See C. Langlois, *Essai historique philosophique et pittoresque sur les danses des morts*, Paris, Rouen, 1851-1852, I, pp. 19-30.

46 The cemetery probably dates from the Gallo-Roman period. It lay along one of the main roads of Lutetia (the Latin name for Paris). [The Cemetery and Chapel of the Holy Innocents was named after the children at Herod's orders (Matthew 2:1-3, 16-18). Massacred before the martyrdom of Stephen, the official Protomartyr, the Innocents were the object of special veneration as the first to die for Christ. A relic reputedly containing the body of an Innocent encased in crystal was presented to the Chapel of the Innocents by Louis XI. See *Réau*, III, pt. 2, pp. 679-680.]

47 Louis de Beaumont de la Forest (d. 1492), *Gallia Christiana in Provincias ecclesiasticas distributa*, Paris, 1739-1877, VII, col. 154.

48 The architect of Charles V, Raymond du Temple, bought some very beautiful ones to make the steps of the stairway in the tower of the Louvre.

49 ["Le Testament," Stanza CXLIX, lines 1744-1751, in *François Villon, Oeuvres*, L. Thusane, ed., Paris, 1923, I, p. 253. For the theme of

death in Villon, see I. Siciliano, *François Villon et les thèmes poétiques du moyen âge*, Paris, 1934, pp. 227-279. See also Du Bruck, *The Theme of Death in French Poetry*, pp. 91-95.]

50 There were recluses in the Cemetery of the Innocents during the entire fifteenth century. Louis XI had a special veneration for one of them, Alix la Bourjotte, and had a copper tomb-slab made for her. Lebeuf, *Histoire de la ville et de tout le diocèse de Paris*, I, p. 47.

51 *De negotio perambulante in tenebris* is the title of a chapter on nocturnal apparitions in *Speculum spiritualium*, printed by Hopyl, Paris, 1510.

52 The word *macabre* has been given a multitude of unacceptable etymologies; it has even been thought to derive from the Arabic *magabir*, meaning tomb. Only one explanation seems reasonable. The word *macabre*, or rather *macabré* (as it was written until the seventeenth century), is the popular form of the name of the Maccabees. In Latin the *danse macabre* is called *Macchabeaorum chorea*, in Holland *Makkabeus danz*. The *danse macabre* then is linked by mysterious ties to the memory of the Maccabees. No document has yet been found that clearly explains why. I would like to point out, however, that in the medieval Church the prayers for the dead rested on the authority of a passage from the Book of Maccabees (12:13), which was recited during the masses for the dead: *Sancta ergo et salubris est cogitatio pro defunctis exorare ut a peccatis solventur*. The expression "danse macabré" goes back to the fourteenth century. In the fifteenth, no one knew its meaning. The English monk Lydgate believed that Macabré was a Church Doctor, and our French printers imagined that he was a German poet: that is why the Latin edition of the *Danse Macabre* said that the verses had been translated from the German. Gaston Paris, usually so penetrating, made a similar mistake. G. Paris, "La danse macabré de Jean le Fèure," *Romania*, 24 (1895), p. 130. He advanced the idea that the name *Macabré* could very well have belonged to the artist who painted the first *danse macabre*. This is impossible: in the Middle Ages, no matter how famous it might be, a work of art was never designated by the name of the artist. [See R. Eisler, "Danse Macabre," *Traditio*, 6 (1948), pp. 187-225. A derivation from *meqaber*, the Hebrew for "he who buries," is suggested for the origin of *macabre*. The Arabic word *maqbara* meaning "cemetery"

or "place for burial" was first put forth by J.B.B. Van Praet, *Catalogue des livres imprimés sur vélin de la bibliothèque du roi*, Paris, 1808, IV, p. 170. See also Cosacchi, *Makabertanz*, "Der Name 'Danse Macabre'—Makaber," pp. 396-412.

53 Paris, Bibl. Mazarine, ms. 980, fol. 83v.

54 *Vado mori, presul, baculum, sandalia mitram, Nolens sive volens, desino. Vado mori.*
[For the relation of the "Vadomori" tradition to Hélinand, see Cosacchi, *Makabertanz*, pp. 6-119. For the "Vadomori" manuscripts, see W. F. Storck, "Das 'Vado Mori,'" *Zeitschrift für deutsche Philologie*, 42 (1910), pp. 422-428.]

55 *Vado mori, miles, belli certamina victor, Mortem non didici vincere. Vado mori.*

56 *Vado mori, logicus. Aliis concludere novi; Conclusit breviter mors mihi. Vado mori.*

57 Rouen, Library, ms. 2215, Y 39, fol. 69.

58 At the *âitre* St.-Maclou, Rouen, a monk is also represented on the first pillar of the cloister.

59 At La Chaise-Dieu, the serpent that appears in the tree has a skull.

60 Probably a Franciscan. Very early, death became a theme for literature and art among the Franciscans. In the lower church at Assisi, a fresco represents St. Francis pointing to a skeleton. An analogous fresco is in the capitulary hall of the church of S. Antonio in Padua.

61 Creizenach, *Geschichte des neueren Dramas*, I, pp. 313ff. In the *Danse macabre* of Guyot Marchant, there is a very significant verse. The dead man who leads the Franciscan away, says to him: "Often have you preached of death." This is the preacher of the *danse macabre* himself entering in the dance.

62 See Carpentier in C. DuCange, *Glossarium mediae et infimae latinitatis*, Paris, 1845, IV, p. 168, s.v. *Machabaeorum Chorea*.

63 Document published by L. de Laborde, *Les Ducs de Bourgogne*, Paris, 1849-1852, I, pt. 2, p. 393.

64 [James M. Clark has uncovered an intriguing *danse macabre* which took place at the wedding of Alexander III of Scotland to Yolande of Dreux in Jedburgh, Scotland, in 1285. He argues that the idea for the *tableaux-vivants* which dampened wedding celebrations considerably, was brought to Scotland by Yolande de Dreux. Clark, *The Dance of Death in the Middle Ages and the Renaissance*, p. 93. Cf. *Joannis de Fordun, Scotichronicon*, W. Goodall, ed., Edinburgh, 1759, II, p. 128.]

65 *Journal d'un bourgeois de Paris*, Paris, 1881, p. 203. It has been claimed that this concerns a representation of the *danse macabre* given during seven consecutive months in the Cemetery of the Innocents. The hypothesis does not hold up. A few pages farther on, this same bourgeois says in his *Journal* that Brother Richard preached at the Cemetery of the Innocents "a l'endroit de la Danse Macabre" (p. 234), that is to say, according to the interpretation of Dimier, *facing* the *Danse Macabre*. L. Dimier, *Les Danses macabres et l'idée de la mort dans l'art chrétien*, Paris, 1902, p. 54. This surely, then, has to do with the fresco which was known to everyone.

66 In the Cabinet des Estampes, in the work of della Bella, there are engravings which are listed as copies of the *Danse Macabre* in the Cemetery of the Innocents. The error is manifest. Death Carrying Away the Child by della Bella—a work of faultless execution—could have been painted only at the end of the sixteenth century.

67 Paris, Bibl. Nat., ms. lat. 14904 and Paris, Bibl. Nat., ms. fr. 25550.

68 In Paris, Bibl. Nat., ms. lat. 14904, it says: *"La danse macabre, prout est apud S. Innocentum,"* and Paris, Bibl. Nat., ms. fr. 25550: *"Dictamina choreae Machabre quae sunt apud Innocentes Parisiis."*

69 Paris, Bibl. Nat., ms. lat. 14904 contains little more than the treatises of Gerson and Nicolas de Clemengis. Below one of the treatises is the date 1429. The manuscript does not seem to be much later.

70 The first edition, less complete than the following ones, is known to us only through a single example preserved in the Library of Grenoble. The first to study this unique book was Chompollion-Figeac, *Magasin encyclopédique*, 1811, pp. 355-369. [For a facsimile of Guyot Marchant's 1940 *Danse macabre*, see *The Dance of Death Printed at Paris in 1490. A Reproduction made from the Copy in the Lessing J. Rosenwald Collection, Library of Congress*, W. M. Ivins, introd., Washington, 1945.]

71 J. Quicherat, *Histoire du costume en France depuis les temps les plus reculés jusqu'à la fin du 18e siècle*, Paris, 1877, p. 300.

72 In Paris, Bibl. Nat., ms. lat. 14904, once or twice the copyist has made a mistake and instead of writing *le mort* has written: *la mort*.

73 In the "story of the Three Dead and the Three Living," the thought is the same. The three dead are, in fact, three mirrors for the living. The corpse carved in churches expresses a similar idea. In several illuminated manuscripts we see a corpse presenting a mirror to a lady; she looks at it and sees, instead of her face, a skull. [For the thesis that the *Danse Macabre* of the Cemetery of the Innocents is a "dance of the dead" rather than a "dance of death," cf. E. M. Manasse, "The Dance Motive of the Latin Dance of Death," *Medievalia et Humanistica*, 4 (1946), pp. 83-103. Cf. also W. Fehse, *Der Ursprung der Totentänze*, Halle, 1907; Stammler, *Der Totentanz*, p. 25; Kurtz, *The Dance of Death and the Macabre Spirit in European Literature*, pp. 95ff.; Clark, *The Dance of Death in the Middle Ages and the Renaissance*, pp. 105ff.; DuBruck, *The Theme of Death in French Poetry*, pp. 63-81; Cosacchi, *Makabertanz*, pp. 285-412, esp. pp. 293-294, 333ff.]

74 Paris, Bibl. Nat., ms. fr. 1181 and Paris, Bibl. Nat., ms. fr. 1186 (end of the fifteenth century), and Paris, Bibl. Nat., ms. fr. 25434.

75 [For the marble statue of Voltaire by Pigalle and the even more deathly looking *bozzetto*, see L. Réau, *J.-B. Pigalle*, Paris, 1950, figs. 20, 21. See also W. Sauerländer, *Jean-Antoine Houdon, Voltaire; Einführung*, Stuttgart, 1963, pp. 5-9.]

76 We note that each verse of the *Danse macabre* ends with a proverb.

77 It is clear that the doctor and the lawyer were considered to be clerics.

78 E. G. Peignot, *Recherches historiques sur les danses des morts*, Paris, Dijon, 1826, p. xxxii. [The error was first made by J. A. Fabricius, *Bibliotheca latina mediae et infimae aetatis*, Hamburg, 1734-1746, v, p. 2, who confused Minden with Münden, which is the location of the panel.]

79 See W. Seelmann, *Die Totentänze des Mittelalters*, Leipzig, 1893, p. 41. These two figures appeared in France as early as the twelfth century; they were carved on the door of the capitulary hall of St.-Georges-de-Boscherville (Seine-Inf.).

80 Büchel, who had copied the Basel fresco in the eighteenth century and had transcribed the date of 1312, later realized his mistake and that it should have read 1512. This is the date of the restoration of the work. It is astonishing that Berthier should have published the Basel fresco with the erroneous

date of 1312. (P. Berthier, *La plus ancienne danse macabre*, Paris, 1896.) A glance at the costumes would indicate a date somewhere near 1450.

81 An empress is introduced into the hierarchy after the emperor. [The Lübeck fresco was destroyed in the English bombardment of 1942; see Cosacchi, *Makabertanz*, pp. 649-677 and pl. xxvii, figs. 1-3.]

82 This is what Seelmann seemed to have established in the dissertation we have cited (Seelmann, *Die Totentänze des Mittlelalters*, p. 346). The German poem and the Spanish poem have an even more archaic aspect than the poem of the Cemetery of the Innocents. More than once, the living speaks first and the dead double replies, which must have been the primitive form of the poem. There is hardly any doubt that there was a French poem on the *danse macabre* as early as the fourteenth century. Jean le Fèvre, in his poem *Le Répit de la mort*, which bears the date of 1376, writes as follows:

> *Je fis de Macabré la dance*
> *Qui toutes gens mène à sa tresche*
> *Et à la fosse les adresche,*
>
> (I did the *Danse Macabre*
> that draws all men after it
> And leads them to the grave,)

which may indeed mean that the poet had almost died, but which can also mean that he had composed a poem on the subject of the *danse macabre*. See Paris, "La danse macabré de Jean le Fèvre," p. 131. Seelmann's theory has been attacked by W. Schreiber, "Die Totentänze," *Zeitschrift für Bücherfreunde*, 2 (1898-1899), pp. 291-304. His arguments do not seem convincing to me.

83 [For the *Danse Macabre* of Berlin, cf. W. Lübke, *Der Totentanz in der Marienkirche zu Berlin*, Berlin, 1861, and Cosacchi, *Makabertanz*, pl. xxi, fig. 4.]

84 There were two *Danses Macabres* in Basel, that of Klingenthal, a convent in Klein-Basel, and that of the monastery of the Dominicans at Gross-Basel. Moreover, the two dances were almost alike. The differences result mainly from restorations. The tradition was that the *Danse Macabre* of the Dominican monastery had been painted during the Council of Basel (about 1448).

85 This is Schreiber's belief. [See above, n. 82.]

86 F. Douce, *The Dance of Death*, London, 1883, p. 51. The London fresco, which was done before 1440, had disappeared by 1549.

87 The *Danse Macabre* was also known in Italy, but in northern Italy only (Como, Clusone), where it evidently entered from neighboring France, perhaps through the intermediary of Germany. There was indeed one *Danse Macabre* in Pinzolo in the Tyrol. Italy, however, treated the subject with great liberty. See P. Vigo, *Le danze macabre in Italia*, Livorno, 1878. [See also L. Guerry, *Le Thème du "Triomphe de la Mort" dans la peinture italienne*, Paris, 1950.]

88 Langlois, *Essai historique, philosophique et pittoresque sur les danses des morts*, I, p. 220. [See Rosenfeld, *Der Mittelalterliche Totentanz*, p. 355, for a list of French Dances of Death with bibliography. See also Tenenti, *Il Senso della morte*, pp. 448ff.]

89 At least if we can believe a copy of the *Danse Macabre*, printed by Vérard, Paris, ca. 1502, in the Cabinet des Estampes. [Langlois, *Essai historique*, I, p. 207; Schreiber, "Die Totentänze," pp. 294ff.

90 Peignot, *Recherches historiques sur les danses des morts*, p. xxxviii; it was painted by a certain Masoncelle.

91 Very similar, as far as we can judge, to the *Danse Macabre* of the Cemetery of the Innocents. Verses are written beneath the figures. [See C. C. Dehaisnes, *Recherches sur le retable de Saint-Bertin et sur Simon Marmion*, Lille, 1892, pp. 15ff.; B. Klemm, *Der Bertin-Altar aus St.-Omer*, Leipzig, 1914.]

92 Both were carved.

93 They were given by F. Soleil, *Les Heures gothiques et la littérature pieuse en XV et XVI siècles*, Rouen, 1882.

94 At Kermaria, the dead and the living form a continuous chain. In 1909, L. Bégule published reproductions of the frescoes at Kermaria. [See also M. Aubert, *La Chapelle de Kermaria-Nisquit*, Paris, 1930, and Cosacchi, *Makabertanz*, pp. 717-727, pl. 23, fig. 6.]

95 P. Wackernagel, "Die Totentänze," *Zeitschrift für deutsches Alterthum*, 9 (1893), pp. 302-365; Schreiber, "Die Totentänze," *op. cit.*; A. Goette, *Holbeins Totentanz und seine Vorbilder*, Strasbourg, 1897.

96 A. Jubinal, *La Danse des morts de la Chaise-Dieu*, Paris, 1841. [For the Chaise-Dieu series, see Cosacchi, *Makabertanz*, pp. 679-690, dated 1390-1410. See also Gaussin, *L'Abbaye de la Chaise-Dieu (1043-1518)*, p. 522; A. Brumereau, *La Danse macabre de la Chaise-Dieu*, Paris, 1925; F. Enaud, "La 'danse macabre' de la Chaise-Dieu et les problèmes de

sa conservation," *Les Monuments historiques de la France*, 5 (1959), pp. 70-91.]

97 We give some of the beautiful reproductions of M. Yperman (figs. 212-216), which are as faithful as photographs. These copies, preserved in the Trocadéro, date from 1894.

98 I am well aware that the original itself seems to show a woman preceding the sergeant-at-arms, but the work is so damaged in places that I am not absolutely certain that this supposed woman is not the Carthusian monk we would expect to find in this place. If it is really a woman, it is an invention of the artist.

99 At Lübeck, these figures have disappeared. [Manasse, "The Dance Motive of the Latin Dance of Death," pp. 90-94, interprets the figure playing a pipe as Death, and discusses various literary relationships. In Lübeck, the text alludes to the proverbial expression "dancing to one's pipe," which Manasse relates to the biblical, "We have piped unto you, and ye did not dance" (Matthew 11:17; Luke 7:32). See also Stammler, *Der Totentanz*, pp. 22ff., 33ff., 60ff. For the related themes of "Teufelstanz," "Todestanz," and the "Todes-Tanz of Christ," see Cosacchi, *Makabertanz*, pp. 293-294, and pp. 333ff.]

100 We know that Guyot Marchant in his second edition, 1486, took a notion to place at the beginning of the *Danse Macabre* "the orchestra of the dead," that is to say four standing corpses playing various instruments; but the first edition has nothing like this.

101 The *Danse Macabre* of the Innocents ended with a dead king being eaten by worms.

102 [For "Denza general de la muerte," see F. Whyte, *The Dance of Death in Spain and Catalonia*, Baltimore, 1931; Seelmann, *Die Totentänze des Mittelalters*, pp. 63ff.; Cosacchi, *Makabertanz*, pp. 615-648.]

103 In the *Danse Macabre* of Lyon, printed by Mathieu Husz (1499), we see the dead double putting his hand on the printer while he is setting type and seizing upon the bookseller in his shop. This book is not then just any ordinary book for sale at the bookshop; he made it his own and put himself into it.

104 The *Danse Macabre* is found in the Hours which came from the atelier of Pigouchet. In these Hours, the *danse macabre* of the men closely resembles that of Vérard. The *danse macabre* of the women naturally derives from that of Guyot Marchant.

105 There was another *Danse Macabre des femmes*,

composed by Denis Catlin, curate of Meudon. It is unpublished: Paris, Bibl. de l'Arsenal, ms. 3637.

106 Villon.

107 In the church of Meslay-le-Grenet (Eure-et-Loir), there is a series of frescoes which represent, on one side, the *danse macabre* of the men, and on the other, that of the women. These frescoes date from about 1500. They are not very interesting, because the artist was content to copy the woodcuts of Guyot Marchant and the accompanying verses. A *Danse Macabre*, also copied from the Marchant woodcuts, is to be seen at La Ferté-Loupière (Yonne). [For more on Meslay-le-Grenet, see Bégule, *Kermaria*, p. 38. For La Ferté-Loupière, see P. Mégnien, *La Danse macabre de La Ferté-Loupière*, Joigny, 1939.]

108 Pierre Michaut was a contemporary of Villon, and his inspiration is the same. Here, for example, is one of his stanzas on death:
Ces corps bien faits, ces féminins ymages
Dorelotés partout mignotement,
Peintz et fardéz et reluisants visages,
Je fais flétrir et puir laidement
Donnant aux vers la chaire bien nourrie.

109 Paris, Bibl. Nat., ms. fr. 22922, fol. 173v. The verses are worth citing:
Sus ce boeuf cy qui s'en va pas à pas
Assise suis et ne la hâte point,
Mais sans courir, je mets à grief trepas
Les plus bruyans lorsque mon dart les point.

110 Michaut had doubtless seen illustrations of Petrarch's *Triumphs*. The artists who illustrated the *Triumphs* were in accord in yoking oxen to the chariot of Death.

111 For example, Paris, Bibl. Nat., ms. lat. 1377, fol. 87v; stalls in the church of Poce, near Amboise, which came from the church of Fontaine-les-Blanches; borders of the Hours of Simon Vostre (fig. 217). [Paris, Bibl. Nat., ms. lat. 1377 is discussed in A. de Laborde, *La Mort chevauchant un boeuf*, Paris, 1923.]

112 Paris, Bibl. Nat., ms. fr. 17001. Miniatures, interesting but not beautiful, illustrate the text. [See *Le Mors de la pomme*, L. P. Kurtz, ed. (Institute of French Studies, no. 87), New York, 1937. The text is described in Kurtz, *The Dance of Death and the Macabre Spirit in European Literature*, pp. 39-41. See also A. Monteverdi, review of E. Schneegans, "Le mors de la pomme, texte du XVe siècle," (*Romania*, 66 [1920], pp. 537-570), *Archivum Romanicum*, 5 (1921), pp. 110-134.]

113 These borders are found in other Hours of Vostre.

114 It appeared in Lyon in 1538 and is entitled: *Les Simulacres de la mort* (printed by M. and G. Trechsel). [See A. F. Woltmann, *Holbein und seine Zeit*, Leipzig, 1874-1876 (English translation by J. Cundall, London, 1882), I, pp. 240-283. For a facsimile, see *Les Simulacres et historiées faces de la mort: Commonly called the "Dance of Death,"* A. Green, introd. (Holbein Society), London, 1869. See also Clark, *The Dance of Death by Hans Holbein*; Davis, "Holbein's Pictures of Death and the Reformation at Lyons," pp. 97-130.]

115 Holbein was also influenced by our *Danses Macabres* which he knew from the *Danses Macabres* of Basel. [Harvard College *Catalogue*, p. 308, suggests *Les loups ravissans*, printed by Antoine Vérard, Paris, ca. 1505, as a further source. See also their reproduction of some of the Holbein woodcuts, pp. 351-352, 358.]

116 [For the theme of *Ars moriendi*, see *Reallexikon*, I, cols. 1121-1127; Saxl, "A Spiritual Encyclopedia of the Later Middle Ages," pp. 82-134; M. C. O'Connor, *The Art of Dying Well*, New York, 1942; R. Rainer, *Ars Moriendi von der Kunst des heilsamen Lebens und Sterbens*, Cologne, Graz, 1957; Tenenti, *Il Senso delle morte*, pp. 80-130; *Réau*, II, pt. 2, pp. 655-657; T. Musper, "Die Ars moriendi und die Meister ES," *Gutenberg Jahrbuch*, 1950, pp. 57-66.]

117 He says that the chancellor of the University of Paris (Gerson) counseled the kinsmen of the dying not to console him with vain illusions but to speak frankly with him about death: "Nam, secundum cancellarium parisiensem, saepe par falsam *consolationem et fictam sanitatis confidentiam homo incurrit certam damnationem.*" Gerson wrote in his *De arte moriendi*: "Non detur informo nimia spes corporis salutis consequendae ... Saepe namque per unam per unam talem *consolationem et incertam sanitatis corporeae confidentiam certam incurrit homo damnationem.*" Gerson, *Oeuvres*, Antwerp, 1706, I, col. 449. This relationship was indicated for the first time by F. Falk, "Die älteste Ars moriendi und ihr Verhältniss zur Ars moriendi ex variis scripturaum sententis, zu: *Das löbliche und nussbarliche Büchlein von dem Sterben*, und zum Speculum artis bene moriendi," *Zentralblatt für Bibliothekswesen*, 7 (1890), p. 309.

118 Gerson was named chancellor of the University of Paris in 1395. The date of his *Opusculum tripartitum*, of which the *Ars moriendi* was a part, cannot be determined exactly, but it could hardly be later than 1409. After that time, Gerson would have been absorbed by the great Councils of Pisa and Constance and scarcely ever returned to Paris to perform his functions as chancellor of the university. [For Gerson's attending the Council of Pisa, cf. J. L. Connolly, *John Gerson, Reformer and Mystic*, Louvain, 1928, p. 170. For Suso as a source for Gerson, see E. P. Spencer, "L'Horloge de Sapience," *Scriptorium*, 17 (1963), pp. 277-299.]

119 Dutuit, *Manuel de l'amateur d'estampes*, I, pp. 33ff.

120 [For a facsimile, see *Ars Moriendi (editio princeps, circa 1450). A Reproduction of the Copy in the British Museum*, W. H. Rylands, ed., London, 1881. See also Tenenti, *La Vie et la mort*, Appendix C, pp. 97-120, for a facsimile of Paris, Bibl. Nat., Res. Xyl. 21 (c. 1470, probably German), and Appendix B, for a chronology of editions. For a list of French editions, see O'Connor, *The Art of Dying Well*, pp. 149-150.]

121 Woodcut editions were characterized by having the text as well as the illustrations carved on blocks of wood.

122 These editions were enumerated by Dutuit, *Manuel de l'amateur d'estampes*, I, pp. 33ff.

123 The book in question is the *Arte del ben morire* of Dominique de Capranica, bishop of Fermo; this is simply an adaptation of the *Ars moriendi*.

124 The translation was by Guillaume Tardif, reader to Charles VIII. [See Dutuit, *Manuel de l'amateur d'estampes*, I, p. 154.]

125 We have summarized as briefly as possible the commentary of the Vérard edition.

126 The print gives a detail that is not explained by the text: an old man is accompanied by his children and his flocks. This is doubtless Job, presented as an example of perfect renunciation and of submission to the divine will.

127 There is another figure unexplained by the text: God the Father carrying a scourge and an arrow. This means, evidently, that God sends us the afflictions he judges necessary for our salvation.

128 The substance of the *Ars moriendi* passed into certain ascetic books. In the *Colloquium de particulari judicio animarum post mortem*, by Denys the Carthusian, the *Ars moriendi* is freely abridged in article xxxvi: *De tentationibus quae agentibus in extremis accidere solent et de remediis contras eas.* [Denys the

Carthusian (1402-1471), *Opera omnia*, I-XLI, Montreuil, Tournay, 1896-1913.]

129 It is possible that the designers of windows were inspired by the *Ars moriendi*, as the window in the museum of St.-Jean in Angers, the only one of its kind in existence, suggests. The window, dated 1542, represents the dying man between the devil, who brings him the list of his sins, and Death. This, then, is not so much a copy as an interpretation of the *Ars moriendi*.

130 There are several examples: Paris, Bibl. Nat., ms. lat. 10542, fol. 137 (c. 1430); Hours for the use of Paris (Paris, Bibl. Nat., ms. lat. 921, fol. 125), c. 1480, the battle took place in a church; Paris, Bibl. Nat., ms. lat. 18015, fol. 134 (c. 1450); Paris, Bibl. de l'Arsenal, ms. 1189, fol. 65 (c. 1430).

CHAPTER IX

1 [For important studies on tomb iconography, see Evans, *Art in Medieval France, 987-1498*, pp. 210-220; H. Jacob, *Idealism and Realism, A Study in Sepulchral Symbolism*, Leyden, 1954; E. H. Kantorowicz, *The King's Two Bodies, A Study in Medieval Political Theology*, Princeton, 1957; R. E. Giesey, *The Royal Funeral Ceremony in Renaissance France*, Geneva, 1960; Panofsky, *Tomb Sculpture*; W. Franzius, *Das mittelalterliche Grabmal in Frankreich*, Tübingen, 1955.]

2 *Voyage littéraire de deux religieux Bénédictins*, 2 vols., Paris, 1717-1724.

3 For example, at Notre-Dame in Champaigne (Maine), there was the enameled tomb of Guillaume Roland, bishop of Le Mans (d. 1260); at Villeneuve-les-Nantes, the enameled tomb of Alix de Bretagne (d. 1220), and of her daughter (d. 1272); in the abbey of Fontaine-Daniel (Maine), the admirable enameled tomb of a thirteenth-century knight.

4 See E. Rupin, *L'Oeuvre de Limoges*, Paris, 1890, pp. 158ff.

5 Fortunately, copies of the Gaignières drawings at Oxford—of such great interest for our art and history—complete the collection in the Cabinet des Estampes (Paris, Bibliothèque Nationale). [For a discussion of the Gaignières drawings and their significance, see Jacob, *Idealism and Realism*, p. 4, and bibliography cited on pl. 241. See also Paris, Bibliothèque Nationale, *Inventaire des dessins exécutés pour Roger de Gaignières*, H. Bouchot, ed., I-II, Paris, 1891, and *Les Dessins d'archéologie de Roger de Gaignières publiés sous l'auspices de la société de l'histoire de l'art*, J. Guibert, ed. I-VIII, Paris, 1911-1914. (The Metropolitan Museum of Art, New York, has a microfilm copy of the Gaignières drawings at the Bodleian Library, Oxford.) For more on Gaignières and the interest in tomb sculpture, see H. Zimmerman, "Burgkmairs Holzschnittfolge zur Genealogie," *Jahrbuch der königlich-preussischen Kunstsammlungen*, 36 (1915), pp. 39-64, esp. p. 60; A. Schultz, "Der Weisskunig nach den Dictaten und eigenhändigen Aufzeichnungen Kaisers Maximilians I," *Jahrbuch der kunsthistorischen Sammlungen des allerhöchsten Kaiserhauses*, 6 (1888), pp. 415-552, esp. pp. 466-467; W. Lotz, "Historismus in der Sepulkralplastik um 1600," *Anzeiger des germanischen National-museums*, 1940-1953, pp. 61ff.; and L. Quarré-Reybourbon, "Trois recueils de portraits au crayon ou à la plume représentant des souverains ou de personnages de la France et des Pays-Bas," *Bulletin de la comité historiale du département du nord*, 23 (1900), pp. 1-127.]

6 C. C. Daguin, "Tombeaux de l'Eglise Saint-Mammès," *Mémoires de la société historique et archéologique de Langres*, 1 (1847), pp. 259-277.

7 See L. Courajod and P.-F. Marcou, *Musée de sculpture comparée (Moulages), Palais de Trocadéro; Catalogue*, Paris, 1892, p. 17. According to more recent opinion, the black marble statue of Catherine de Courtenay, now in St.-Denis, is in reality that of Blanche of Castille. See P. Vitry and G. Brière, *L'Eglise abbatiale de Saint-Denis*, Paris, 1908, p. 119.

8 A. Dutilleux and J. Depoin, *L'Abbaye de Maubuisson*, Pontoise, 1882-1890.

9 See H. L. Duclos, *Histoire de Royaumont*, I-II, Paris, 1867. [Louis de France, the heir presumptive, died in 1260. Following the funeral at St.-Denis, his body was taken to Royaumont, borne by the greatest nobles, including Henry III, who was in Paris for the Treaty of Abbeville. See H. Gouin, *L'Abbaye de Royaumont*, Paris, 1958, p. 14. The tomb relief is illustrated on pl. 2, opp. p. 17. See also Jacob, *Idealism and Realism*, pl. XVIIb.]

10 His tomb of copper and enamel was in the cathedral of Beauvais.

11 All the tombs, drawn by Gaignières, were published by S. Prioux, *Monographie de Saint-Yved de Braine*, Pris, 1859.

12 After the accession of the Capetians, only

three French kings were not buried at St.-Denis: Philip I was buried at St.-Benoît-sur-Loire, Louis VII at the abbey of Barbeau, and Louis XI at Notre-Dame de Cléry.

13 The tomb in the cathedral of Rouen has been done over. [See M. Desfarges, *Les Tombeaux de cœur et d'entrailles en France au moyen âge*, diss., Ecole du Louvre, 1947 (resumé in: *Bulletin des musées de France*, 12 (1947), pp. 18-20. See also Giesey, *The Royal Funeral Ceremony*, pp. 19-24.]

14 Statue of Charles of Anjou, king of Sicily, in the church of the Jacobins at Paris: Gaignières, Pe 11 b, fol. 20; statue of Charles V at Rouen: *ibid.*, Pe 1 a, fol. 42.

15 Statue of Philip VI, formerly in the church of the Dominicans in the rue St. Jacques, now in the Louvre; statue of Jeanne de Bourbon, wife of Charles V, at the church of the Celestines: *ibid.*, Pe 11 a, fol. 258.

16 [The figures from the tomb of Isabella of Bourbon, not Louis de Male (formerly at St.-Michel, Antwerp, now Rijksmuseum, Amsterdam), reproduced in Panofsky, *Tomb Sculpture*, figs. 250a, 250b, see also p. 62. See further J. Leewenberg, "De tien bronzen 'Plorannen' in het Rijksmuseum te Amsterdam," *Gentsche Bijdragen tot de Kunstgeschiedenis*, 13 (1951), pp. 13-35.]

17 In the department of the Aube, few gravestones are intact. See C. Fichot, *Statistique monumentale du département de l'Aube*, Paris, Troyes, 1887, 1, p. 17.

18 Lenoir was able to save the bronze statue of the chancellor of Birague (now in the Louvre) only by painting it white.

19 B. de Montfaucon, *Les Monumens de la monarchie françoise*, Paris, 1729, 1, p. 401.

20 Now destroyed.

21 Gaignières, Pe 8, fol. 33.

22 Several eleventh- and twelfth-century bishops had tombs which dated from the thirteenth century. At Notre-Dame of Paris, the tomb of Bishop Azelin (d. 1019), had a slab dating from the early thirteenth century (Gaignières, Pe 11 a, fol. 29). At Longpont, the tomb of Gozelin de Vierzy, bishop of Soissons, who died in 1152, was made in the late thirteenth century (Paris, Bibl. Nat., ms. lat. 17028, fol. 195). At Fontevrault, the tomb of Pierre de Châtellerault, bishop of Poitiers who died in 1135, was also from the thirteenth century (Paris, Bibl. Nat., ms. lat. 17042, fol. 67). [For the tomb of Pierre de Châtellerault, see Jacob, *Idealism and Realism*, pl. XVIc.]

23 An exception must perhaps be made for Childebert, whose tombstone in low relief dates from the end of the twelfth century. This slab, now at St.-Denis, was formerly at St.-Germain-des-Prés. The strange mosaic gravestone of the Queen Fredegund is probably from the same period. The evidence lies in its analogy to that of Bishop Frumault, found in the ruins of the ancient cathedral of Arras. Bishop Frumault died in 1180. [The Frumault tomb is reproduced in Panofsky, *Tomb Sculpture*, fig. 194.]

24 Gaignières, Pe 11 c, fols. 42 and 43. See also A. Kleinclausz, "L'art sculpture funéraire de la Bourgogne au moyen âge," *Gazette des beaux-arts*, 26 (1901), pp. 441-458 and 27 (1902), pp. 299-320.

25 Gaignières, Pe 1 h, fol. 19.

26 *Ibid.*, Pe 1 n, fols. 77 and 78.

27 The earliest recumbent tomb statue that has been preserved seems to be that of an archbishop of Rouen. It is in the ambulatory around the choir of the cathedral. Several details indicate that the tomb had once been in the old cathedral of Rouen, which burned in 1200. This tomb is the work of the late twelfth century. [Tomb of Huges III, c. 1170; see M. Aubert, "La Cathédrale," *Congrès archéologique*, 89 (1926), pp. 11-71, esp. p. 60, and Jacob, *Idealism and Realism*, p. 82.]

28 We must exclude the gravestones of Abbé Frumault (d. 1180) and of Fredegund, referred to above (n. 23); they are marble mosaics of a very special kind.

29 U. Plancher, *Histoire générale et particulière de Bourgogne*, Dijon, 1739-1748, 11, p. 522.

30 Gaignières, Pe 1 m, fols. 10 and 11.

31 *Ibid.*, Pe 1 d, fols. 3ff.

32 *Ibid.*, Pe 8, fol. 34.

33 C. Rossignol, "Sainte-Seine-l'Abbaye," *Mémoires de la commission des antiquités du département de la Côte-d'Or*, 2 (1847), pp. 137.

34 Gaignières, Pe 10, fol. 13.

35 *Ibid.*, Pe 10, fol. 52.

36 Paris, Bibl. Nat., ms. lat. 17096, fol. 35: gravestone of the abbey of Barbeau, near Melun (Seine-et-Marne). There is no date, but its trapezoid form indicates that it is from the early thirteenth century.

37 Gaignières, Pe 1 f, fol. 35: abbey of Cormery. This stone is also trapezoid in form.

38 At St.-Jean-du-Creach, near St. Brieuc, and at Charly (Cher). See L. Le Nail, "Note sur un tombeau du templier déposé au musée

de Blois," *Bulletin monumental*, 44 (1878), pp. 762-766.

39 The carved-out stone, ornamented with an image of the deceased in high relief, seems to have preceded both the statue proper and the tomb slab. In the cloister of Elne (Pyrénées-Orientales), there is a carved-out gravestone ornamented with the effigy of the bishop Guillaume Jorda who died in 1186. The tomb of Guy, abbot of Chamousey (who died after 1182), now in the museum of Epinal (Vosges), is of the same kind. The tomb of a woman at Bruay (Nord) is quite similar. This tomb at Bruay, which at first seems to be so archaic, is perhaps no earlier than the late twelfth century, because it is similar in many ways to the tomb of Marguerite d'Alsace in St.-Donat at Bruges. See Dehaisnes, *Documents et extraits divers concernant l'histoire de dans la Flandre, L'Artois, et le Hainaut avant le XVe siècle*, II, p. 382. Margaret of Alsace died in 1194. Such gravestones, which are neither tomb slabs nor statues, were still to be found in the early thirteenth century. The Countess of Dreux, who died in 1207, had a tomb of this kind at St.-Yved-de-Braîne (Aisne): Gaignières, Pe 1, fol. 74. These tombs in relief were sometimes in bronze, as, for example, that of the Bishop Eudes de Sully (d. 1208) at Notre-Dame in Paris: Gaignières, Pe 11 a, fol. 26. These stones carved in relief were awkward, and it was not long before stone or copper tomb slabs imbedded in the pavement came to be preferred. The tradition of carved-out stones lasted a long time in Italy; several still exist in the floors of Roman churches. [Cf. Jacob, *Idealism and Realism*, pp. 12-16; Panofsky, *Tomb Sculpture*, p. 51, fig. 196; Adhemar, *Influences antiques dans l'art du moyen âge français*, pp. 300-307.]

40 Gaignières, Pe 11 a, fol. 56.

41 *Ibid.*, Pe 11 a, fol. 27. I cannot agree with Fleury, *Antiquités et monuments de l'Aisne*, IV, p. 77, that the tomb slab of Barthélemy de Vire (d. 1154), of which he reproduces a fragment, dates from the twelfth century. The trilobate arch under which the bishop is placed indicates the thirteenth century. In the absence of monuments, there is no reason to believe the statement found in R. Wyard, *Histoire de l'abbaye de St.-Vincent de Laon*, Saint Quentin, 1858, that there are twelfth- and even eleventh-century tombstones with effigies at St.-Vincent, in Laon. It is probable that the tombs of the bishops of Laon buried in St.-Vincent in the eleventh and twelfth centuries were covered by tomb slabs with effigies in the thirteenth century.

42 [See J. F. Noel and P. Jahan, *Les Gisants*, Paris, 1949.]

43 This is the doctrine expounded by all the theologians of the Middle Ages. See Mâle, *L'Art religieux du XIIIe siècle en France*; 8th ed., p. 379. [*Religious Art in France: The Thirteenth Century*, Bollingen XC.2, Princeton, 1984, p. 375.] Even in the fifteenth century, in an age of realism, Louis XI wanted to be represented on his tomb as a young man. See the documents collected by L. Courajod, *Leçons professées a l'Ecole du Louvre*, Paris, 1901, II: "Les origines de la Renaissance," pp. 453ff.

44 *Ex carnali commoratione contraxerunt maculas.* Missal of Paris, printed by Simon Vostre, Paris, 1497.

45 *Non intres in judicium cum ancilla tua, Domine, quoniam nullus apud te justificabitur homo.* (In the Missal of the nuns of Fontevrault, and in many other funerary rituals.)

46 *Deus cui proprium misereri semper et parcere.* Missal of Rouen, printed by Jean Petit, Paris, 1527: *Missa pro defunctis.*

47 *Deus qui animarum humanarum aeternus amator es.*

48 *Aperite mihi portas justiciae. Ingredior in locum tabernaculi admirabilis usque ad domum Dei.* Paris, Bibl. Ste. Geneviève, ms. 113, fol. 146 (late fourteenth century).

49 The beautiful gravestone of Agnès de St. Amant, in the archeological museum of Rouen, is typical of its kind. It came from the abbey of Bonport.

50 Tomb of Henri Sanglier, archbishop of Sens (late twelfth century): Gaignières, Pe 11 a, fol. 42; tomb of the wife of the Seigneur de Lèves (late twelfth century): *ibid.*, Pe 6, fol. 10; tombs of an abbot and a knight, at Malesherbes (Loiret), ca. 1200, in E. Michel, *Monuments religieux, civiles et militaires du Gâtinais*, Lyon, 1879, pl. LII; tomb of Elie, abbot of St.-Pierre-le-Vif, at Sens; Gaignières, Pe 1 m, fol. 80, etc. It must be added that several funerary effigies, contemporary with those we have cited, have nothing beneath their feet.

51 Psalms 91:13.

52 Gaignières, Pe 11 a, fol. 46.

53 Honorius of Autun, *Speculum ecclesiae: Dominica in palmis*, Migne, *P. L.*, 172, col. 913.

54 In Gaignières, see the gravestones of the

canons of Notre-Dame in Paris. At Châlons-sur-Marne, a thirteenth-century canon has a horse under his feet, no doubt a symbol, as it is in the romance of *Fauvel*, of the base instincts of human nature. [See *Le Roman de Fauvel, par Gervais du Bus*, A. Longfors, ed., Paris, 1914-1919.]

55 In the church of St.-Memmie, near Châlons, there was a gentleman on horseback; see L. Barbat, *Les Pierres tombales du moyen âge*, Paris, 1854. There are several instances of a man with a falcon on his wrist who seems ready to depart for the hunt; for example, on a tomb slab of the abbey of Barbeau (early thirteenth century): Gaignières, Pe 11 a, fol. 126, and on a tomb slab of the abbey of Vauluisant, of the same period: *ibid.*, Pe 6, fol. 58. Even in the thirteenth century, there were some artists who did not keep to the lofty thoughts that had governed funerary iconography.

56 Several of these monuments still exist. Gaignières reproduced the tombs of the professors buried in the church of St.-Yves in Paris: *ibid.*, Pe 1 j. In the church of Ste.-Croix (Saône-et-Loire), there is a beautiful gravestone of a professor which has been reproduced in E. S. Bougenot, "Tombe d'Etienne de Sainte-Croix et l'école cathédrale de Chalon au XIVe siècle," *Bulletin archéologique du comité des travaux historiques et scientifiques*, 1892, p. 339. [For the tomb of Etienne de Ste.-Croix, see also Jacob, *Idealism and Realism*, pp. 200-208 and fig. 19.]

57 In the seventeenth century, the faithful were buried with their feet toward the east, but the priests buried in the church had to *face the faithful*. This is what the *Rituel de Boulogne* (1647), for example, indicates: *Corpora defunctorum ponenda sunt versus altare majus. Presbyteri vero habeant caput versus altare.* This was not true in the Middle Ages: priests and faithful all faced the east.

58 The mémoire is found in J. Lebeuf, *Dissertations sur l'histoire ecclésiastique et civile de Paris*, Paris, 1883, 1, p. 263. He recorded a great number of observations on the orientation of tombs in his *Histoire de la ville et de tout le diocèse de Paris*.

59 William Durandus, *Rationale divinorum officiorum*, bk. vii, chap. xxxv. [See Chapter vi, n. 86.]

60 Let it suffice to cite the tomb of Cardinal Consalvo in the church of S. Maria sopra Minerva in Rome (d. 1295) and that of Cardinal Petroni in Siena (d. 1313).

61 In France, the tomb with angels drawing the curtains is encountered once—in the cathedral of Limoges. It was erected for a bishop of Limoges who had lived in Italy. [The tomb of Raynaud de la Porte, member of the papal court at Avignon, dates after 1325.]

62 C. A. Stothard, *The Monumental Effigies of Great Britain*, London, 1817.

63 Hollis added a volume to the collection of Stothard under the same title: T. Hollis, *The Monumental Effigies of Great Britain*, London, 1840-1842.

64 J. S. Cotman, *Engravings of Sepulchral Brasses in Norfolk and Suffolk*, i-ii, London, 1839. [See also M. Stephenson, *A List of Monumental Brasses in the British Isles*, London, 1926; K. A. Esdaile and S. Sitwell, *English Church Monuments 1510-1840*, London, 1946.]

65 [For tombs in Germany, see G. G. Dehio, *Handbuch der deutschen Kunstdenkmäler*, i-vi, Munich, 1950-1952.]

66 [For the swan, a classical symbol of death that may have been known in the Middle Ages, see P. Cassel, *Der Schwan in Sage und Leben*, Berlin, 1872.]

67 Tomb of Robert, archbishop of Rouen, in St.-Père at Chartres (d. 1231): two standing monks pray beside his statue. Gaignières, Pe 1 n, fol. 48; choir of the church of the Jacobins at Evreux: tomb slab of a bishop with two monks reading. *Ibid.*, Pe 1 d, fol. 99; tomb statue of a Burgundian knight, founder of the abbey of La Bussière (d. 1334): beside the deceased are two small figures of praying monks. *Ibid.*, Pe 11 c, fol. 23; gravestone of a man (d. 1313) with three monks reading: Guilhermy, *Inscriptions de la France du Ve au XVIIIe siècle*, iii, p. 384; tomb of Pierre de Navarre (d. 1412) and of his wife, in a niche of the church of the Carthusians in Paris: beside them are praying Carthusians. Gaignières, Pe 1, fol. 22; tomb slab of a dean of St.-Hilaire at Poitiers: two seated monks pray beside him. *Ibid.*, Pe 1 g, fol. 118, etc.

68 *Absolve, Domine, animam famuli tui per hujus virtutem sacramenti ab omni vinculo delictorum.* Missal of Evreux, 1497.

69 On the gravestones, the participants are lined up along the sides; on the tombs, the funeral ceremony takes place on the sarcophagus or occupies the niche.

70 See Billotte, *Ritus ecclesiae laudunensis*, 1662, *Observationes*, p. 78.

71 Example from the late twelfth century: Lectionary (Paris, Bibl. Ste. Geneviève, ms. 124, fol. 106); example from the sixteenth century: Missal of Paris, printed by Simon Vostre. The usual formula is: *Occurrite angeli domini suscipientes animan ejus, offerentes eam in conspectu altissimi. Chorus angelorum eam suscipiat et in sinu Abrahae eam collocet.* In certain formulas there is mention of the bosom of Abraham, of Isaac, and of Jacob.

72 Especially after the beginning of the fourteenth century. The examples are innumerable.

73 Missal of Rouen.

74 *Quia in te speravit et credidit, non poenas aeternas sustineat.* Missal of Rouen.

75 On fifteenth-century gravestones, the apostles sometimes hold banderoles. The artist did not have room to carve an inscription, but if he had, he would doubtless have carved the articles of the Credo, according to custom. We should remember that frequently a cross lay on the breast of the deceased, and sometimes even a parchment on which the Credo was written. See examples given by M. P. Chevreux, "Les croix de plomb de la région vosgienne," *Bulletin archéologique du comité des travaux historiques et scientifiques*, 1904, p. 392. It has sometimes been said that the apostles were carved on our sixteenth-century tombs in imitation of Italy. Nothing could be farther from the truth, since the apostles appeared as early as 1309 on gravestones (one in St.-Etienne at Sens, bearing the date 1309, reproduced in Paris, Bibl. Nat., ms. lat. 17046, fol. 97) and on tombs dated 1342 (that of an abbot of St.-Wandrille, who died in 1342: Gaignières, Pe 8, fol. 42).

76 Tombs of the Trinité of Fécamp (late fourteenth and early fifteenth century).

77 Example: tomb of Jean de Hangest in the church of the Celestines of Rouen, 1406: *ibid.*, Pe 1 c, fol. 67.

78 Tombs set into niches in the wall had the advantage of not impeding the passage of the congregation.

79 It is to be noted that Books of Hours of Flemish origin, especially the famous Grimani Breviary, usually illustrated the prayers for the dead with a representation of the resurrection of Lazarus. This is a beautiful idea suggested to the artists by the funeral liturgy, for during the Mass for the Dead, the resurrection of Lazarus is read from the Gospel.

80 Tomb of Bernard Brun in the cathedral of Limoges (fourteenth century).

81 *Mémoires de la société archéologique de Touraine*, 36 (1891), plate.

82 The tomb of Enguerrand de Marigny, at Ecouis, was decorated, like many others, with a Last Judgment. At one side of Christ, an angel holds the lance, and at the other, an angel holds the crown of thorns. A. L. Millin, "Collégiale d'Ecouis," *Antiquités nationales*, III, Article XXVIII, who reproduced this monument, did not understand this. He imagined that one of the angels holds a crown of cords, in memory of the torture of Marigny, and the other a *toise* (measuring standard or stick) in order to measure the wrongs of King Charles of Valois. This fable was repeated by T. B. Emeric-David, *Histoire de la sculpture française*, Paris, 1853, p. 131, and, after him, by several other archeologists.

83 We sometimes see also, especially in the Books of Hours of the School of Tours (atelier of Bourdichon), the figure of Job, because in the Office of the Dead, verses are read from the book of Job.

84 Examples of the tombs in niches decorated with a Pietà: tomb of St. Jeanvrin (Cher), fifteenth century; tomb of an abbot of Evron (1484), Gaignières, Pe 1 h, fol. 90; tomb of a bishop of Le Mans at the abbey of de La Couture, *ibid.*, Pe 1 h, fol. 22.

85 Or sometimes with a simple painting (funerary paintings in the chapels of the choir, cathedral of Clermont).

86 Such is the mutilated relief in the church of Eu (fifteenth century), with the two figures of the dead at either side of the Pietà. The examples are numerous in the Gaignières Collection and in Guilhermy, *Inscriptions de la France.*

87 Here is an example from the fourteenth century: a canon, Maître Jean, former chancellor of the church of Noyon (d. 1350), buried at Ste.-Geneviève, in Paris, had on his gravestone the image of the two Sts. John, his patrons, who seem to recommend his soul to Abraham, the image of St. Julien de Brioude, patron of the image of St. Eligius, who was particularly venerated at Noyon. See Guilhermy, *Inscriptions de la France*, I, *Diocèse de Paris, Noyon (Oise)*, p. 361.

88 The small funerary reliefs of which we spoke above show the confidence felt during the fifteenth and sixteenth centuries in the intervention of the Virgin; the dead, presented

by their patron saints, are often shown kneeling before her.

89 Died in 1490 and 1494.

90 Died in 1471. See L. Le Métayer-Masselin, *Collection de dalles tumulaires de la Normandie*, Caen, 1861, p. 19.

91 Died in 1525; the tomb was sketched by Millin, *Antiquités nationales*, Article: Celestines. The restored tomb is now in St.-Denis. [For an illustration, see also Panofsky, *Tomb Sculpture*, fig. 273. See further Blunt, *Art and Architecture in France 1500-1700*, p. 14.]

92 Pierre de Navarre, count of Alençon, died in 1418, his wife in 1462. See J. Du Bruel, *Théâtre des antiquités de Paris*, Paris, 1612, pp. 474-475.

93 The tomb was finished about 1570: see Dimier, *Le Primatice*, p. 357. Catherine de' Medici died in 1589.

94 [For the increasing emphasis on funerary art in the fourteenth and fifteenth centuries in media other than sculpture, see A. Weckwerth, "Der Ursprung des Bildepitaphs," *Zeitschrift für Kunstgeschichte*, 20 (1957), pp. 147-185; P. Schönen, "Epitaph," *Reallexikon*, v, cols. 872-920. For sculptural epitaphs, see G. Ring, "Beiträge zur Plastik von Tournai im 15. Jahrhundert," *Belgische Kunstdenkmäler*, P. Clemen, ed., Munich, 1925, i, pp. 269-291; P. Rolland, "Stèles funéraires tournaisienes gothiques," *Revue belge d'archéologie et d'histoire*, 20 (1951), pp. 189-222.]

95 Example: tomb slab of Galeas de Chaumont and his wife, at Rigny-le-Ferron (Aube), sixteenth century, in Fichot, *Statistique monumentale du département de l'Aube*, i, p. 323.

96 Found much more rarely on tombs. However, at the abbey of the Chaloché there was an extraordinary tomb with four recumbent figures: the father, the mother, their son, and a woman who is doubtless the daughter-in-law (middle of the fourteenth century), Gaignières, Pe 1 g, fol. 228. There is also the famous tomb of the three Bastarnays at Montrésor (Indre-et-Loire).

97 Fichot, *op. cit.*, i, p. 17. Jean de Creney died in 1349, his wife in 1375.

98 E. Picard, "La tombe de la famille le Maire," *Mémoires de la commission des antiquités du département de la Côte-d'Or*, 13 (1895/1900), pp. 33-42, pl. VIII; Fichot, *op. cit.*, IV, p. 37; Guilhermy, *Inscriptions de la France*, IV, p. 235.

99 Lebeuf, *Histoire de tout le diocèse de Paris*, v, p. 318.

100 This tomb slab is dated 1287; it was reproduced by Barbat, *Les Pierres tombales du moyen âge*.

101 Guilhermy, *Inscriptions de la France*, i, p. 361. The two small figures in question are the last two at the bottom.

102 Michel, *Monuments religieux, civiles et militaires du Gâtinais*, pl. LII.

103 Thibault III died in 1201. An old description of the monument was published by Abbé Coffinet, "Trésor de St.-Etienne de Troyes," *Annales archéologiques*, 20 (1860), pp. 91ff.

104 The tomb, drawn by Gaignières, was reproduced by Prioux, *Monographie de Saint-Yved de Braine*.

105 The description of the tomb of Clement VI, made from documents in the archives, was published by M. Faucon, "Documents inédits sur l'église de la Chaise-Dieu," *Bulletin archéologique du comité des travaux historiques et scientifiques*, 1884, pp. 416-443. [See also E. Steinmann, "Die Zerstörung der Grabdenkmäler der Päpste von Avignon," *Monatsheft für Kunstwissenschaft*, 11 (1918), pp. 145-171; R. Gounot, "Deux fragments du tombeau de Clément VI au Musée Crozatier du Puy," *Bulletin des musées de France*, 1 (1956), pp. 21-24.

106 Begun in 1374 by Beauneveu, the tomb of Louis de Male was, it seems barely roughhewn when it was forthwith abandoned: Dehaisnes, *Histoire de l'art de la Flandre*, p. 247.

107 It was put in place in 1456. A. L. Millin, "Collégiale Saint-Pierre à Lille," *Antiquités nationales*, i, art. LIV, pl. 4 on p. 56, reproduced some interesting drawings of this tomb (after Montfaucon, *Les Monumens de la monarchie françoise*, III, pl. 29). [Cf. Jacob, *Idealism and Realism*, p. 259, for the drawings of Antonio de Succa (Brussels, Royal Lib., ms. II 1862, fols. 77, 80v) as a source for the lost monument. For the tomb's twenty-four brass statuettes by Jacques de Gerines, see M. Devigne, "Een nieuw Document voor de Geschiedenis der Beeldjes van Jacques de Gerines," *Onze Kunst*, 39 (1922), pp. 48-71.]

108 The tombs just cited were particularly magnificent. On simpler tombs, painted or sculptured escutcheons represented the ancestors of the family and its connections by marriage. Examples: tomb of an abbess of Le Ronceray in Angers: Gaignières, Pe 1 f, fol. 14 (fourteenth century); tomb of Florimond de Villers, at St.-Lucien in Beauvais: L. E. Deladreue and M. Mathon, "Histoire de l'abbaye royale de Saint-Lucien," *Mémoires*

de la société académique de L'Oise, 9 (1871-1873), p. 559.

109 J. A. Brutails, "Notes sur l'art religieux du Roussillon," *Bulletin archéologique du comité des travaux historiques et scientifiques*, 1893, p. 381.

110 Documents published in A. de Caix, "Histoire du Bourg d'Ecouché," *Mémoires de la société des antiquaires de Normandie*, 24 (1859), p. 574. An interesting document was published by J. Houday, "Tombeaux de Beaudoin V et de Louis de Male, comtes de Flandres," *Revue des sociétés savantes*, 3 (1876), p. 520.

111 [For Claus Sluter's work on the tomb of Philip the Bold, see G. Troescher, *Claus Sluter*, Freiburg, 1932, pp. 108-125; H. David, "Claus Sluter, tombier ducal," *Bulletin monumental*, 93 (1934), pp. 409-433; A. Liebreich, *Claus Sluter*, Brussels, 1936, pp. 143-153; H. David, *Claus Sluter*, Paris, 1951, pp. 107-127; Jacob, *Idealism and Realism*, pp. 93ff., 258; Giesey, *The Royal Funeral Ceremony*, p. 38; Müller, *Sculpture in the Netherlands*, pp. 11-12.]

112 E. Montégut, *Souvenirs de Bourgogne*, Paris, 1874, p. 101.

113 Plancher, *Histoire de Bourgogne*, III, p. 93.

114 This ceremony was traditional and Philip the Bold had provided for it. In 1384, when he had Jean de Marville begin work on his tomb, it had certainly been decided that the usual funeral display would be placed around the sarcophagus. In 1404, at the death of the Duke, Claus Sluter had already begun work on the mourners.

115 This is the manuscript of the *Chroniques de Froissart*. See S. Reinach, "Le manuscrit des 'Chroniques' de Froissart à Breslau," *Gazette des beaux-arts*, 33 (1905), pp. 371-389.

116 There are other examples. In the Hours for the use of Troyes (Paris, Bibl. Nat., ms. lat. 924, 1405-1410), which is almost contemporary with the funeral of Philip the Bold, there is a funeral cortège. The figures resemble monks, which they are certainly not, because the raised cowl reveals the hoods they wear (fol. 177). The same mourning attire was still worn in the sixteenth century. See O. C. Reure, "Compte des funérailles de Gilberte d'Estampes," *Bulletin de la société de l'histoire de Paris*, 30 (1903), p. 102. [For the Hours for the use of Troyes, see *Manuscrits à Peintures*, no. 311.]

117 In 1403, the duke of Orléans put in his will that his body was to be carried by his men and relatives dressed in brownish-grey.

118 The drawings of J.-P. Gilquin, *Dessins des tombeaux des ducs de Bourgogne* (Paris, Bibl. Nat., nouv. acq. ms. fr. 5916), c. 1736, show the tomb in its original state. The statues are now out of order. Several are missing and have been replaced with modern copies. [The mourners were rearranged correctly in 1932. See E. Andrieu, "Les tombeaux des ducs de Bourgogne," *Bulletin monumentale*, 90 (1933), pp. 171-193. Liebreich, *Claus Sluter*, pp. 155-163, discusses the history of the figures, three of which are in the Cleveland Museum of Art. See also H. Drouot, "Le nombre des pleurants aux tombeaux des ducs de Bourgogne," *Revue de l'art chrétien*, 61 (1911), pp. 135-141; *idem*, "De quelques dessins du XVIII siècle représentant les tombeaux des ducs de Bourgogne," *Revue de l'art chrétien*, 64 (1914), pp. 113-118; D. Roggen, "De 'plorants' van Klaas Sluter te Dijon," *Gentsche Bijdragen tot de Kunstgeschiedenis*, 2 (1935), pp. 127-173; P. Quarré, "Les pleurants des tombeaux des ducs de Bourgogne à Dijon," *Bulletin de la société nationale des antiquaires de France*, 1948-1949, p. 124; *The International Style* (Walters Art Gallery), cat. no. 96, pp. 95-96, pl. LXXXIII; W. D. Wixom, *Treasures from Medieval France*, Cleveland, 1967, cat. no. VI 21, with additional bibliography.]

119 [For further examples of the inclusion of numerous statuettes of relations in funerary sculpture, see particularly the tomb of Philippa of Hainaut, wife of Edward III of England, which had seventy-six figures surrounding the queen's effigy in Westminster Abbey, the work of Netherlandish sculptor Jean de Liège. See L. Stone, *Sculpture in Britain: the Middle Ages*, Baltimore, 1955.]

120 Gaignières, Pe 11 c, fol. 27. The costume of mourning is already recognizable, but it is shorter and without the fullness it took later, on the tomb of the eldest son of St. Louis, formerly at Royaumont and now at St.-Denis. The relief in question is a modern copy. The original decorates the supposed tomb of Abelard at Père-Lachaise. [The tomb of Louis de France (d. 1260) is illustrated in Panofsky, *Tomb Sculpture*, fig. 246, and Giesey, *The Royal Funeral Ceremony*, figs. 2, 3.]

121 L. T. Corde, *Les Pierres tombales du département de l'Eure*, Evreux, 1868.

122 At the cathedral of Amiens, in the fourth

chapel of the apse, the tomb of Bishop Simon de Goncans (d. 1325), and that of Canon Thomas de Savoie (d. 1332 or 1336), have small mourners in the lower part. Especially on a gravestone at Ploërmel which carries the date of 1340 (the cloak with hood is shorter than in Dijon) and on a tomb slab of Menneval which also dates from 1340. See Le Metayer-Masselin, *Collection des dalles tumulaires de la Normandie*, p. 33. They also appear on a tomb slab in the museum of Rouen from the late fourteenth century. See E. de Barthélemy, "Inventaire du château de Pailly, dressé à la mort de la maréchale de Saulx-Tavannes, en 1611," *Revue des sociétés savantes*, 5 (1881), pp. 306-307.

123 See C. Rossignol, "Saint-Seine-l'Abbaye," *Mémoires de la commission des antiquités du département de la Côte-d'Or*, 2 (1847), pp. 258-259; H. Chabeuf, *Monographie historique et descriptive de l'église bénédictine de Sainte-Seine-l'Abbaye*, Dijon, 1888.

124 The tomb was made by Gilles de Backere, probably between 1436 and 1442.

125 The tomb (now in the Louvre) was commissioned about 1440 from the sculptor Guillaume Veluton.

126 Work of Jean de la Huerta and of Le Moiturier. The tomb was begun in 1443 and finished in 1470. [For Sluter's influence upon Huerta, see D. Roggen, "Prae-Sluteriaanse, Sluteriaanse, Post-Sluteriaanse Nederlandse Sculptuur," *Gentsche Bijdragen tot de Kunstgeschiedenis*, 16 (1955-1956), pp. 151ff. See also Müller, *Sculpture in the Netherlands*, pp. 54-55.]

127 Begun in 1448 by Jacques Morel; the mourners have disappeared, but we have the contract which provided for them. It has been published by G. Guigue, "Jacques Morel, sculpteur de Montpellier," *Archives de l'art français*, 4 (1855-1856), pp. 311-320. [See Müller, *Sculpture in the Netherlands*, p. 55.]

128 Begun by Jean de Cambrai before 1436, finished after 1453 by Etienne Bobilet and Paul Mosselman of Ypres. Some mourners are in the museum of Bourges. [Four of the mourning figures, in marble, now in the museum of Bourges, have been assigned to the hand of Jean de Cambrai (d. 1436). See *ibid.*, p. 15. The remaining figures, mostly in alabaster, were made after his death by Bobilet and Mosselman. See Roggen, "Prae-Sluteriaanse, Sluteriaanse, Post-Sluteriaanse Nederlandse Sculptuur," p. 146. The *gisant*

marble figure of the Duke of Berry is a work of Jean de Cambrai, and may have been begun as early as 1405. See P. Pradel, "Nouveaux documents sur le tombeau de Jean de Berry, frère de Charles V," *Fondation Eugène Piot, Monuments et Mémoires*, 49 (1957), pp. 141-157, and Müller, *Sculpture in the Netherlands*, p. 15 (with additional bibliography).]

129 Shown in its original state in Gaignières, Pe 8, fol. 47.

130 Vitry, *Michael Colombe*, p. 101 (late fifteenth century).

131 After 1484.

132 The statuette of a mourner reproduced by Fleury, *Antiquités et monuments de l'Aisne*, IV, p. 245, seems to indicate that there was a tomb of this type in the region of Laon.

133 Gaignières, Pe 7, fol. 25.

134 The tomb could have been made only between 1477 and 1483. See Courajod, *Leçons professées à l'Ecole du Louvre*, II, p. 387. [Müller, *Sculpture in the Netherlands*, pp. 136-137, discusses the tomb as the work of the sculptor Antoine Le Moiturier. See also H. David, "Le tombeau de Phillipe Pot," *Revue belge d'archéologie* 5 (1935), pp. 119-133; H. Drouot, "Le Moiturier et Philippe Pot," *Revue belge d'archéologie*, 6 (1936), pp. 117ff.]

135 Gaignières, Pe 4 fol. 35.

136 Tomb slab of a precentor of Notre-Dame, in Paris, who died in 1529: Gaignières, Pe 9, fol. 37. On fifteenth-century tomb slabs of Burgundy, the mourners are sometimes almost as large as the deceased.

137 The tomb of Philip III, begun in 1298, was finished in 1307. Documents are published by B. Prost, "Quelques documents sur l'histoire des arts en France," *Gazette des beaux-arts*, 35 (1887), p. 236. [The tomb was designed by Pierre de Chelles and executed by Jean d'Arras. For the beginnings of French portraiture, see H. Keller, "Die Entstehung des Bildnisses am Ende des Hochmittelalters," *Römisches Jahrbuch für Kunstgeschichte*, 3 (1929), pp. 227-256; H. Focillon, "Origines monumentales du portrait français," *Mélanges offerts à M. Nicolas Iorga*, Paris, 1933, pp. 259-285.

138 [The subject of death masks is discussed by Giesey, *The Royal Funeral Ceremony*, pp. 105ff., 203-204, who argues that the first certain death mask was that of Charles VII (d. 1461). See also Jacob, *Idealism and Realism*, pp. 58-59. For their use in Trecento and

Quattrocento Italy, see J. Pohl, *Die Verwendung des Naturabgusses in der italienischen Porträtplastik*, Würzburg, 1938, pp. 20ff. For a study of the European effigy, see H. Keller, "Effigie," *Reallexikon*, iv, cols. 743-749.]

139 See E. Bertaux, "Le tombeau d'une reine de France à Cosenza en Calabre," *Gazette des beaux-arts*, 19 (1898), pp. 263ff.

140 Philip III died in 1285; his tomb was not begun until 1298. [Cf. Giesey, *The Royal Funeral Ceremony*, p. 204, who notes that Philip died on a military expedition in the south of France. See also J. von Schlosser, "Geschichte der Porträtbildnerei in Wachs, Ein Versuch," *Jahrbuch der Kunsthistorischen Sammlungen des allerhöchsten Kaiserhauses*, 29 (1910), pp. 192, 203-204.]

141 The eyes, which the cast showed as closed, are the least lifelike part of the face. Their form follows the tradition adopted in the thirteenth century.

142 Courajod and Marcou, *Catalogue: Musée de sculpture comparée*, p. 38.

143 L. Courajod, "Le Moulage," *Revue des arts decoratifs*, 8 (1887-1888), p. 164, states that a death mask was made of Philip VI, but I have not been able to find any proof of this assertion in the documents of the period. [See also Giesey, *The Royal Funeral Ceremony*, pp. 87-88.]

144 Documents published by Prost, "Quelques documents sur l'histoire des arts en France," pp. 327-329. Until the time of Henry II, it was always the painter to the king who took the imprint of his face after his death. No doubt this function was given to the painter to the king because he painted the wax mask to make it lifelike. Jean Fouquet had worked on the death mask of Charles VII. See P. Viollet, "Jehan Fouquet," *Gazette des beaux-arts*, 23 (1867), p. 101. [Cf. Giesey, *The Royal Funeral Ceremony*, pp. 100-101.]

145 Document transcribed by Emeric-David, *Histoire de la sculpture française*, p. 117.

146 Document published by Faucon, "Documents inédits sur l'église de la Chaise-Dieu," pp. 383-443.

147 See J. Doublet, *Histoire de l'abbaye de Saint-Denis*, Paris, 1625, p. 380. Courajod found the mask of Henry II in St.-Denis.

148 These masks perhaps were used a second time for the anniversary service. See H. Menu, "Mélanges d'épigraphie ardennaise," *Bulletin monumental*, 58 (1893), p. 36.

149 The mask taken from nature was also known in antiquity.

150 It might be useful to quote here a passage from Pliny the Elder which seems to contain an important truth: "The first person who modeled a likeness in plaster of a human being from the living face itself, and established the method of pouring wax into this plaster mould and then making final corrections on the wax cast, was Lysistratus of Sicyon, brother of Lysippus. Indeed he introduced the practice of giving likenesses, the object aimed at previously having been to make as handsome a face as possible." Pliny, *Natural History*, bk. xxxv, chap. 44. [H. Rackman, tr. (Loeb Classical Library), Cambridge, Mass., 1938-1962.

151 This has been well established by R. Koechlin, "La sculpture belge et les influences françaises aux XIIIe et XIVe siècles," *Gazette des beaux-arts*, 30 (1903), pp. 5-19, 333-348, 391-407.

152 Formerly at St.-Sernin; they are called "the donors."

153 The face is missing.

154 T. Pistollet de St. Ferjeux, "Tombe de Guibert de Celsoy," *Mémoires de la Société historique et archéologique de Langres*, 1 (1847), p. 243.

155 Clearly, all the engraved copper tomb slabs of the bishops of Beauvais came from Paris; their iconography is completely Parisian; they are to be found in Gaignières, Pe 11 a, fols. 116ff.

156 In 1308, the design of the Parisian style gravestone had already appeared: Gaignières, Pe 1 i, fol. 29. In 1370, this type was no longer made: *ibid.*, fol. 13.

157 A. des Méloizes, "Marché passé en 1503 pour l'exécution d'une tombe," *Bulletin monumental*, 56 (1890), p. 416.

158 Published by E. Coyecque, "Inventaire sommaire d'un minutier parisien pendant le cours du XVIe siècle (1498-1600)," *Bulletin de la société de l'histoire de Paris*, 20 (1893), pp. 40-58, 114-136.

159 I can cite a tombstone of 1526 in the cathedral of Troyes (a canon and his mother) which is signed: Jean Lemoine, *tombier à Paris*. There was another at Vimpelles (Seine-et-Marne) representing a fisherman and his wife. It is signed: Jean Lemoyne, *ciseleur*. See M. A. Aufauvre and C. Fichot, *Les Monuments de Seine-et-Marne*, Troyes, Paris, 1858, p. 160.

160 The published contracts do not give all the *tombiers* of Paris. A tombstone at Buno-Bonnevaux (Seine-et-Oise) was signed: Legault,

tombier of Paris, 1530. This name does not appear in the written documents.

161 There had been a very characteristic Burgundian tradition in the thirteenth and early fourteenth centuries. Knights were represented on their gravestones holding a lance. See Gaignières, especially Pe 11 c, fol. 20; Pe 4, fol. 2; and Pe 4, fols. 20ff.

162 One of the better ones, that of Vieure (1420), does not belong to any northern tradition.

163 Museum of Toulouse.

164 In the Midi, a funerary inscription set into a wall was ordinarily enough.

165 Another important center of production was Tournai. The gravestones of Tournai can be recognized by the grain of the stone and by a curious iconographic detail: a divine hand emerges from the clouds above the head of the deceased. Sometimes the tomb slabs of Tournai are found in the eastern provinces: at Vouziers, at Les Rosiers (Ardennes), at Origny-en-Thiérache (Aisne), etc. [For more on tomb sculpture of Tournai, see above, n. 94, and Müller, *Sculpture in the Netherlands*, p. 59 and p. 207 n. 50.]

166 Individualized features are extremely rare. Sometimes, however, the *tombier* must have been informed that the deceased was bald. See Guilhermy, *Inscriptions*, II, p. 188: tomb slab of the grand prior of St.-Denis, 1517.

167 The lion was placed on the shield of Fortitude in the thirteenth century.

168 Example: Guilhermy, *Inscriptions*, IV, p. 30 (1316).

169 Gaignières, Pe 3 e, fol. 3.

170 *Ibid.*, Pe 1 c, fol. 126

171 Tomb of Hughes d'Arc, Dijon. G. Dumay, "Epigraphie bourguignonne; église et abbaye de Saint-Bénigne de Dijon," *Mémoires de la commission des antiquités de la Côte-d'Or*, 10 (1874-1884), pp. 37-39, pl. VI.

172 All that was written in the seventeenth century, and even in our own day, about the animal symbolism in funerary iconography is pure fabrication. It is not true that only married women had the right to have a dog beneath their feet and that this honor was never given to nuns: L. Germain, "Tombe d'Isabelle de Musset," *Bulletin monumental*, 52 (1886), p. 43. Two drawings by Guilhermy, *Inscriptions*, IV, p. 326 and V, p. 305, prove the contrary. It is not true—as Père Pomey asserted in *Libitina*—that knights killed in enemy territory always had a live lion under their feet when they had been conquerors, and a dead lion when they had

been vanquished: Florimond Villers de St. Paul, who died defending the abbey of St. Lucien in Beauvais, had two dogs under his feet: Gaignières, Pe 3, fol. 11; Charles, count of Alençon, brother of Philip VI, killed at Crécy, had a live lion under his feet: his tomb is in St.-Denis.

173 *Ibid.*, Pe 1 g, fol. 137.

174 Guilhermy, *Inscriptions*, IV, p. 7, pl. II.

175 *Ibid.*, III, p. 454. The gravestone bears the date 1500.

176 [For an earlier tombstone with a figure kneeling before the Virgin: that of a canon named Umbertüs, dated 1226, formerly in a private collection in Vienne (Isire); see Jacob, *Idealism and Realism*, p. 134. The Cosenza tomb dates from 1271; see *ibid.*, p. 144.]

177 The proof has been established by Bertaux, "Le tombeau d'une reine de France à Cosenza en Calabre," pp. 263-276.

178 Dehaisnes, *Histoire de l'art en Flandre*, p. 427.

179 *Ibid.*, p. 427.

180 Tomb of the cardinal of Saluces, formerly in the cathedral of Lyon. The kneeling cardinal has a crucifix before him. N. Rondot, "Jacques Morel, sculpteur lyonnais (1417-1459)," *Réunion des sociétés des beaux-arts des départements*, 13 (1889), p. 631.

181 Gaignières reproduced the tomb of Jean de Salazar several times: Pe 1 m, fol. 70, and Pe 6, fols. 46 and 47. [For illustration, see Panofsky, *Tomb Sculpture*, fig. 363.]

182 Millin, "Eglise des Carmélites à la Place Maubert," *Antiquités nationales*, II, p. 17.

183 In the Gaignières Collection (church of the Jacobins in Rouen), there is a kneeling statue of the cardinal of Fréauville, who died in 1314, which was certainly made a long time after the prelate's death: Gaignières, Pe 1 c, fol. 91.

184 The kneeling statue of Pierre d'Orgemont (d. 1389) can also be cited. It was in Paris in the church of Culture-Sainte-Catherine. Lenoir moved it to the Museum of French Monuments.

185 Documents in Courajod, *Leçons*, II, p. 454.

186 This tomb, destroyed in 1562, was the work of Jacques Morel. We have the contract which was drawn up in 1420. It says: *Fiet unq ymago praedicti domini cardinalis, cum capa, genibus flexis, et manibus junctis.* Rondot, "Jacques Morel, sculpteur lyonnais," p. 631.

187 P. Carpentier, *Description historique et chronologique de l'église metropolitaine de Paris*, Paris, 1767.

188 In the preceding chapter, p. 347.

189 Statue reproduced by Gaignières (Paris, Bibl. Nat., ms. lat. 17025, fol. 34).

190 Formerly in the church of the Carmélites, now in the museum of Dijon.

191 Gaignières, Pe 1 m, fol. 89.

192 J. Chenu de Bourges, *Recueil des antiquitez et privilèges de la ville de Bourges*, Paris, 1621, p. 84. To be exact, the statue was not completely nude, but was enveloped in a shroud, according to a marginal note written by the Chevalier Gougnon, genealogist of Berry, in his copy of Chenu (today in the Library of Bourges).

193 Gaignières, Pe 1 g, fol. 169. The bishop died in 1479, but his tomb dates from the end of the century.

194 Examples of recumbent corpses on sixteenth-century tombs; tomb of the Countess of Cosse in the church of the Jacobins at Angers (1536): Gaignières, Pe 2, fol. 10; tomb of Claude Gouffier at St.-Maurice d'Oyron: *ibid.*, Pe 7, fol. 12 (after 1570). There is no point in citing here the famous tombs that will be discussed at length later on.

195 The window of St.-Patrice, which alone is dated, bears the date 1538.

196 Only the idea of placing the Virtues at the four corners of the monument was new: it came from the tomb of Nantes. [See above, p. 000.]

197 The tomb of Louis XII was in production from 1517 to 1531. It came from the atelier of the Giusti brothers; but there is nothing to prove that they furnished the design; perhaps they only carried out the plans.

198 Died in 1217.

199 Gaignières, Pe 1 e, fol. 92.

200 *Description des monuments de Cîteaux*, published in the old collection of *mémoires* of the *Académie des inscriptions et belles-lettres*, IX, pp. 193-233.

201 As early as the beginning of the fifteenth century, the tomb of Cardinal Lagrange at Avignon, if we can judge by a drawing, showed the cardinal alive on his knees before the scene of the Nativity, above his mummified body. See E. Müntz, "A travers le comtat Venaisson: le mausolée du cardinal de Lagrange à Avignon," *Ami des monuments et des arts*, 4 (1890), pp. 91-95.

202 E. du Tillet, *De Regibus Francorum Chronicon*, Paris, 1539, pp. 245ff. [See Giesey, *The Royal Funeral Ceremony*, pp. 165-166 (meal), p. 107 *passim* (effigy over coffin), p. 61 (salt carriers).]

203 *Recueil des sociétés savantes des départements*, 1873, 2nd sem., p. 231. This church was that of Notre-Dame-des-Champs, where the body was placed when it arrived in Paris. The same disposition was adopted at St.-Denis. [See also Giesey, *The Royal Funeral Ceremony*, p. 110.]

204 Du Tillet, *De Regibus Francorum Chronicon*, pp. 245ff. [Giesey, *The Royal Funeral Ceremony*, pp. 113-114.]

205 Just at the time that work on the tomb of Louis XII was to begin, a Flemish artist, Jean de Bruxelles, also called Jean de Rome, furnished the design for the tombs of Brou (1516). Two of these tombs, that of Philibert le Beau and of Marguerite d'Autriche, were conceived in much the same way as the tomb of Louis XII. They are in two tiers, and beneath the recumbent figure lies the corpse. The document calls these two tombs "modern sepulchers," as opposed no doubt to the tomb of Marguerite de Bourbon, which followed the old tradition, and simply has a recumbent statue on a sarcophagus. See V. Nodet, *Les Tombeaux de Brou*, Bourg, 1906. Thus, the double tomb appeared in the early years of the sixteenth century. [For more on this subject, see Panofsky, *Tomb Sculpture*, pp. 64-65, 78-79, figs. 341-345; Kantorowicz, *The King's Two Bodies*, pp. 431-437; Jacob, *Idealism and Realism*, pp. 55, 251.]

206 Only the reliefs have survived.

207 Gaignières, Pe 11 a, fol. 208

208 1536-1541. [The tomb is reproduced in Panofsky, *Tomb Sculpture*, fig. 378. See also Blunt, *Art and Architecture in France, 1500-1700*, pp. 67-68; Aubert, "La Cathédrale," pp. 63ff.; P. du Colombier, *Jean Goujon*, Paris, 1949.]

209 [The tombs of Francis I and Henry II are reproduced in Blunt, *Art and Architecture in France, 1500-1700*, pls. 34, 35. For an illustration of the transis of the tomb of Henry II, see Panofsky, *Tomb Sculpture*, pl. 358.]

210 1550. Designed by Primaticcio, the tomb was carved by Dominique Florentin. Only fragments remain. See R. Koechlin and J. J. Marquet de Vasselot, *La Sculpture à Troyes et dans la Champagne meridionale*, Paris, 1900, p. 307.

211 In the Louvre. [Reproduced in Panofsky, *Tomb Sculpture*, figs. 364, 366 (Gaignières drawing).]

212 [For Bossuet, see above p. 322.]

213 Carved in 1535. It is in the Louvre, no. 200.

214 Work of Barthélemy Prieur. Anne de Montmorency died in 1567; his wife, lying beside him, died in 1586. The statues are in the Louvre.

215 In Belgium, recumbent statues continued to be carved until 1650. J. Helbig, "Luc Fayd' herbe étudié dans les travaux ignorés de ses biographies," *Revue de l'art chrétien,* 36 (1893), pp. 1-13.

216 Died in 1520. The statue is in the Louvre.

217 The same is true of all the recumbent statues of the sixteenth century.

CHAPTER X

1 St. Thomas, *Summa,* 3a, Quaest. LIX, art. v. The same doctrine as in the Catachism of Trent. [See Thomas Aquinas, *Opera Omnia,* I-VIII, Rome, 1570 (new ed., I-XVI, Rome, 1882-1942).]

2 [On the fifteen signs, see the comprehensive study by W. W. Heist, *The Fifteen Signs before Doomsday,* East Lansing, Mich., 1952. See also *idem,* "Four Old French Versions of the Fifteen Signs before the Judgment," *Medieval Studies,* 15 (1953), pp. 184-198. For a discussion of another popular medieval enumeration of the final phase of the earth, the four ends of man ("*les quatre fins des hommes*"), see E. Lachner and K. A. Wirth, "Dinge, die vier Letzten," *Reallexikon,* IV, cols. 12-21. See also R. Reitzenstein, *Die nordischen, persischen und christlichen Vorstellungen vom Weltuntergant* (Vorträge der Bibliothek Warburg, 1923-1924), Berlin, 1925, pp. 156ff.]

3 Bede, *Opera,* Cologne, 1612, III, p. 494. [Usually attributed to another writer, probably somewhat later than Bede: Pseudo-Bede, Migne, *P. L.,* 94, col. 555; see Heist, *The Fifteen Signs,* p. 24. See also R. Flower, *Catalogue of Irish Manuscripts in the British Museum,* London, 1926, II, p. 487, and St. J. D. Seymour, "The Signs of Doomsday in the 'Saltair na Rann,'" *Proceedings of the Royal Irish Academy,* 36 (1923), pp. 154-163, for earlier Irish examples.]

4 Peter Comestor, *Historiae scholasticae. In Evangelia,* chap. CXLI, Migne, *P. L.,* 198, col. 1611.

5 He omitted Bede's third sign and divided the last sign (the earth will burn, and the dead resurrected and judged).

6 Vincent of Beauvais, *Speculum historiale,* bk. XXI, chap. CXI. [See Vincentius Bellovacensis, *Speculum quadruplex: naturale, doctrinale, morale, historiale* (Douai, 1624), 4 vols. Graz, 1964. See also Chapter VI, n. 32.]

7 There was another tradition, but art did not draw on it. From the thirteenth century on, poets had exercised their ingenuity in extracting from the famous acrostic verses of the Erythraean Sibyl (*Judici signum: tellus sudore madescet,* etc.) the fifteen signs of the end of the world. These signs are somewhat different from those given by Bede. For them they had the authority of the sibyl. They were vulgarized by poems written in different languages. There were several in French. On this subject, see P. Meyer, "Notice du ms. Plut. 76, no. 79 de la Laurentienne," *Bulletin de la societé des anciens textes,* 5 (1879), pp. 74, 79, 83; *idem, Daurel et Beton,* Paris, 1880, p. xcvii; M. y Fontanals, "El Canto de la Sibila en lengua de Oc," *Romania,* 9 (1880), pp. 353-365. On the different literary cycles devoted to the fifteen signs, see also the articles of G. Nolle, "Die Legende von den fünfzehn Zeichen vor dem jüngsten Gerichte," *Beiträge zur Geschichte der deutschen Sprache und Literatur,* 6 (1879), pp. 413-476, and C. Michaëlis, "Quindecim Signa ante Judicium," *Archiv für das Studium der Neueren Sprachen und Literaturen,* 46 (1870), pp. 33-60.

8 R. de B. de Sainte-Suzanne, "Les tapisseries d'Arras," *Bulletin monumental,* 45 (1879), p. 98.

9 For example, the Hours for the use of Rome, by Pigouchet, 1498.

10 Copy in Paris, Bibliothèque Nationale. See also the facsimile, *Der Enndkrist der Stadtbibliothek zu Frankfurt-am-Main,* Kelner, ed., Frankfurt, 1891. [See further the facsimile, *Das Buch vom dem Entkrist* (Blockbook in Bayerische Staatsbibliothek with mid-fifteenth century Swabian woodcuts), Leipzig, 1925. For more on this eschatological theme, see H. Preuss, *Die Vorstellungen vom Antichrist im späteren Mittelalter,* Leipzig, 1906; "Antichrist," *Reallexikon,* I, cols. 720-729; Aurenhammer, *Lexikon,* I, pp. 151-156; Young, *The Drama of the Medieval Church,* I, pp. 369ff.]

11 A small detail seems to prove that Vérard's artist knew the *Entkrist.* In fact, the fifth sign in Vérard's book shows the plants that sweat blood, as in Comestor, but curiously enough this rain of blood falls on a flock of birds. This is also found in the *Entkrist.* The *Entkrist,* which follows Comestor, has here added a new phrase to the passage from

Comestor. The German text says: "The plants will sweat blood, and the birds will assemble and will not eat." This end of the sentence is found in a commentary of Thomas Aquinas on Peter Lombard (St. Thomas, *Opera*, Venice, 1770, XIII, p. 412). St. Thomas gives the fifteen signs and, without our knowing why, introduces several variants: it is then probable that Vérard's artist had the engraving from the *Entkrist* in front of him.

12 [For the theme of the Apocalypse, see Bréhier, *L'Art chrétien*, pp. 229ff., 285ff.; M. R. James, *The Apocalypse in Art*, London, 1931; W. Neuss, "Apokalypse," *Reallexikon*, I, pp. 751-781; F. van der Meer, *Maiestas Domini, Théophanies de l'Apocalypse dans l'art chrétien*, Rome, Paris, 1938; G. Bing, "The Apocalypse Block-Books and their Manuscript Models," *Journal of the Warburg and Courtauld Institutes*, 5 (1942), pp. 143-158; *Réau*, II, pt. 2: "L'Apocalypse," pp. 663-726; Panofsky, *Early Netherlandish Painting*, I, pp. 38ff.; J. Baltrusaitis, *Reveils et Prodiges*, Paris, 1960, pp. 265-273; A. Chastel, "L'Apocalypse en 1500, la fresque de l'Antichrist à la chapelle Saint-Brice d'Orvieto," *Mélanges Renaudet*, Geneva, 1952.

13 [On the apocalyptic fervor at the end of the fifteenth century, see O. Benesch, *The Art of the Renaissance in Northern Europe*, Cambridge, Mass., 1943, pp. 8-23.]

14 In the Bible of 1522, and in several others, the harlot wears the triple papal crown. [See P. H. Schmidt, *Die Illustration der Lutherbibel 1522-1570*, Basel, 1962, pp. 96-97, fig. 59.]

15 [For the Koberger Bible, see *ibid.*, pp. 66-87.]

16 [Revelations 1:12-17—Vision of the Seven Candlesticks. It is P. 282 in handlist of Dürer's Apocalypse series, dated 1492-1498, in Panofsky, *Dürer*, II, pp. 36-37, incorporating the catalogue numbers of A. Bartsch, *Le Peintre graveur*, Vienna, 1808, VIII, pp. 30ff., hereafter simply referred to by Panofsky's catalogue number. For P. 282, see also Panofsky, *Dürer*, II, fig. 76.]

17 [Revelations 4:1-10, 5:1-8—John before God and the Elders, P. 283.]

18 [*Ibid.* 6:2,4,5,8—The Four Horsemen, P. 284.]

19 [*Ibid.* 6:9-13,15-17—The Opening of the Fifth and Sixth Seal, P. 285.]

20 [*Ibid.* 7:1-8—The Four Angels Holding up the Winds, P. 286.]

21 [*Ibid.* 14:1,3; 7:9,10,13; 19:1-4—The Adoration of the Lamb, P. 287. This should follow P. 294, see n. 27.]

22 [*Ibid.* 8:2-5,7-10,12,13; 9:13—The Seven Trumpets, P. 288.]

23 [*Ibid.* 9:3-10,13,15-17,19—The Four Avenging Angels, P. 289.]

24 [*Ibid.* 10:1-3,5,8,10—St. John Devouring the Book, P. 290.]

25 [*Ibid.* 12:1,3-5,13-16—The Apocalyptic Woman, P. 291.]

26 [*Ibid.* 12:7-9—St. Michael Fighting the Dragon, P. 292. See Panofsky, *Dürer*, II, fig. 81.]

27 [*Ibid.* 13:1-4,11,13; 14:6,14,17—The Beast with Two Horns like a Lamb, P. 294. This should follow P. 292, see n. 26.]

28 [*Ibid.* 17:1,3,4; 18:1,2,9,10,15,17,24; 19:11,12, 15—The Babylonian Whore, P. 293. This should follow P. 287, see n. 21.]

29 [*Ibid.* 20:1-3; 21:9,10,12; 22:8—The Angel with the Key of the Bottomless Pit, P. 295.]

30 [For Dürer's Apocalypse and its influence, see C. Schellenberg, *Dürers Apokalypse*, Munich, 123; Réau, "L'influence d'Albert Dürer sur l'art français," pp. 219-222; Panofsky, *Dürer*, I, pp. 50-59; James, *The Apocalypse in Art*, pp. 75ff.; *Réau*, II, pt. 2, pp. 676-681; Aurenhammer, *Lexikon*, I, p. 207, for more bibliography.]

31 [Schmidt, *Die Illustration der Lutherbibel*, fig. 60, p. 112.]

32 [Revelations 14:14-20, cf. P. 294, see n. 27.]

33 *Ibid.* 11:3-12.

34 [Schmidt, *Die Illustration der Lutherbibel*, fig. 51, p. 103.]

35 For this chronology, see Müther, *Die deutsche Bücherillustration der Gotik und Frührenaissance (1460-1530)*. Burgkmair and Schaufelein made their illustrations for Othmar at Augsburg; Holbein made his for T. Wolf at Basel (New Testament). [For illustrations of the Apocalypse by Burgkmair and Holbein, see Schmidt, *Die Illustration der Lutherbibel*, figs. 67-75, pp. 122-127 (Holbein), and pp. 128-129 (Burgkmair).]

36 [*Ibid.*, pp. 245-262.]

37 This is certainly the oldest imitation of Dürer's Apocalypse that we have in France. Two years earlier, in 1505, Thielman Kerver still followed the prints of the block-book Apocalypse in his edition of the Hours.

38 [For Bernard Salomon (Le Petit Bernard), see below n. 48.]

39 Definitive proof is that the scenes that were separated in the Wittenberg Bible are here united (the angel enchaining the demon, and the angel showing the New Jerusalem to John).

40 Several other engravings by Dürer, especially some of those devoted to the life of the Virgin, were reproduced by our glass painters.

41 It is in the church of St.-Nicolas and is dated 1598. Restoration has mixed up the subjects, but the original order could be easily reestablished.

42 Lenoir moved two of them to the Musée des Monuments Français. [For the chapel at Vincennes, see M. Roy, "La Ste. Chapelle du Bois de Vincennes," *Mémoires de la societé nationale des antiquaires de France*, 71 (1911), pp. 225-287. The article was reprinted in *idem, Artistes et monuments de la Renaissance en France*, Paris, 1929. The chapel was built by Henri II and designed by the great architect Philibert de l'Orme to provide a meeting place for the royal order of St. Michael. Headed by the king and dedicated to the militant protection of Catholic France, the order was closely concerned with the subject matter of the Revelations of St. John in which St. Michael plays such a prominent role, in his triumphant opposition to the forces of Satan. The windows were executed by a glass painter—Nicolas Beaurain—who transferred the cartoon to glass, but the name of their designer is not known. Philibert de l'Orme may himself have been involved, but the style of the windows does not agree with the few pictorial subjects known to have come from the architect's hand. Whoever the artist responsible for the windows may have been, he was clearly a major master, contemporary with Goujon and Bilon.]

43 [Schmidt, *Die Illustration der Lutherbibel*, fig. 51, p. 102; fig. 52, p. 103.]

44 *Ibid.*, fig. 50, p. 102; cf. Dürer, P. 289, see n. 23.]

45 [Revelations 8:8; see n. 22.]

46 Luther, in fact, in his translation, speaks of the angel and not of the eagle. [*Ibid.* 8:12-13; see n. 22.]

47 The date 1558, inscribed on the first window in the apse on the left, disappeared when the window was restored. See O. Merson, *Les Vitraux*, Paris, 1895, p. 198.

48 This is the book mentioned above. It was published at Lyon, by Jean de Tournes, in 1553. The exact title is: *Les Quadrins historiques de la Bible et les figures du Nouveau Testament.* [See further, Harvard College Library, Department of Printing and Graphic Arts: *Catalogue of Books and Manuscripts*, pt. 1: *French 16th Century Books*, p. 109, no. 81, and H. Schubart, *Die Bibelillustration des*

Bernard Salomon (diss., Hamburg, 1932), Amorbach, Bavaria (1932?). For more information of Salomon, who worked at Lyon from c. 1540 to 1561, see N. Rondot, *Bernard Salomon*, Lyon, 1897.]

49 For the details, however, he follows Dürer's woodcuts.

50 See Rondot, *Bernard Salomon*.

51 Photographs, preserved in the Bureau des Monuments Historiques, show the original state.

52 In the Cabinet des Estampes, see Recueil Ea 25 a. The Apocalypse of Jean Duvet, Lyon, 1561, which seems much more independent of Dürer, only appears to be so. Careful study shows it to be an imitation. [For further studies of Jean Duvet (1485-ca. 1561), see A. E. Popham, *Jean Duvet*, London, 1921; *Réau*, II, pt. 2, pp. 679-680; C. Eisler, "Jean Duvet," *L'Oeil*, Oct., 1960, pp. 20-27.]

53 The tomb dates after 1541, the year of Jean de Langeac's death. It is decorated with fourteen reliefs imitated from Dürer's Apocalypse. The most beautiful is that of the horsemen. See Abbé Texier, "Iconographie de la mort," *Annales archéologiques*, 16 (1856), p. 164. In the church of Gisors (Eure), there are still some reliefs of the Apocalypse series imitated from Dürer and Wittenberg Bible. They are the work of Jean Grappin and are slightly later than 1570. See C. Rouit-Berger, "A propos de quelques sculptures disparues de l'église de Gisors," *Bulletin monumental*, 97 (1938), p. 277. [See *Réau*, II, pt. 2, p. 680, for another work reflecting Dürer's prints, the window in the old chapel of St.-Jean in the church of St.-Florentine (Yonne), dated 1529.]

54 [For the theme of the Last Judgment, see A.-M. Cocagnac, *Le Jugement Dernier dans l'art*, Paris, 1955, and *Réau*, II, pt. 2: "Le Jugement Dernier," pp. 727-757.]

55 For example, Paris, Bibl. Nat., ms. fr. 20107, fol 28: here, there is a curious fifteenth-century Last Judgment.

56 This is a Provençal Mystery play. See A. Jeanroy and H. Teulié, eds., *Mystères provençaux du XVe siècle*, Toulouse, 1893.

57 See Bouchot, *Les deux cents incunables xylographiques du département des Estampes*, pl. 96, no. 177. On this plate there is a D within a heart, the arms of Douai. The print is reversed.

58 This can be seen at Bourges, Poitiers, etc.

59 Painting in Danzig, Museum Pomorskie,

dated 1475. [See W. Drost, *Das Jüngste Gericht des Hans Memling*, Vienna, 1941.]

60 [See Taylor, " 'A Piece of Arras of the Judgment,' The Connection of Mâitre Philippe de Mol and Hugo van des Goes with the Medieval Religious Theater," pp. 1-15.]

61 Justice and Mercy are on the right and left of Christ in the Last Judgment of Chinon (fig. 264).

62 In Berlin-Dahlem, State Museum, there is a copy of this painting attributed to Petrus Christus.

63 Verses 6965ff. [See above, n. 56.]

64 There are at least three others to be pointed out. From the fifteenth century on, Christ was always represented at the exact moment when he said: *Venite benedicti, ite maledicti.* In order to make this sign understood, a sword (as in the Apocalypse) comes out of the left side of his mouth, and a lily out of the right side. It should be recalled, also, that after the beginning of the fifteenth century, John the Evangelist was replaced at the left of the Judge by John the Baptist (fig. 264). We should also remember that from the fifteenth century on, the theological doctrine according thirty-three years to all the dead at the moment of the resurrection began to be forgotten. In the Rohan Hours (Paris, Bibl. Nat., ms. lat. 9471, fol. 154) of the early fifteenth century, there are aged people coming forth from the earth.

65 [The iconography of hell is studied in J. Mew, *Traditional Aspects of Hell*, London, 1903; *Réau*, II, pt. 2, pp. 750-753; Baltrusaitis, *Reveils et prodiges*, pp. 275-304. For the staging of hell in the theater, see A. Beijer, "Visions célestes et infernales, dans le théâtre du moyen-âge et de la Renaissance," *Les Fêtes de la Renaissance*, J. Jacquot, ed., Paris, 1956, pp. 405-417.]

66 [The Last Judgment at Albi was restored in 1943. It is illustrated in Mâle, *La Cathédrale d'Albi*, pl. 38, pp. 32-33, 68-83.]

67 *L'Apocalypse de Saint Pierre* was published with a commentary by C. G. Harnack, *Bruchstücke des Evangeliums und der Apokaylpse des Petrus* (*Untersuchungen zur Geschichte der altchristlichen Literatur*, IX, pt. 2), Leipzig, 1893. [Translation by M. R. James, *The Apocryphal New Testament*, Oxford, 1924.]

68 L. F. Tischendorf, *Apocalypse Apocriphae*, Leipzig, 1886. [The *Visio Pauli* is studied by E. J. Becker, *A Contribution to the Comparative Study of the Medieval Visions of Heaven and Hell* (Diss., Johns Hopkins) Baltimore, 1899, pp. 74ff.; H. R. Patch, *The Other World, According to Descriptions in Medieval Literature*, Cambridge, Mass., 1950, pp. 91-93; Bloomfield, *The Seven Deadly Sins*, pp. 12ff.]

69 The Latin adaptation is found in an eighth-century manuscript: Paris, Bibl. Nat., Noųv. Acq., ms. lat. 1631.

70 See the interesting article on this subject, which gives a Latin text of the *Vision de Saint Paul*: P. Meyer, "La descente de Saint Paul en Enfer; Poème français composé en Angleterre," *Romania*, 1895, pp. 357-375. [For Toulouse, ms. 815, see A. Auriol, *Descente de Saint Paul dans l'Enfer* (*Les Trésors des bibliothèques de France*, III), 1930, pp. 131-146.]

71 The collection is entitled the *Verger de Soulas* (Paris, Bibl. Nat., ms. fr. 9220). The manuscript belongs to the early fourteenth century. [See Chapter VI n. 92.]

72 II Corinthians 12:2,3,4.

73 Dante, moreover, knew the *Vision de Saint Paul*, as the passage from the second canto of the *Inferno* proves: "But I, why do I come there? And who allows it? I am not Aeneas, I am not Paul" [II, ll. 31-32].

74 [On Irish vision of hell, see St. J. D. Seymour, *Irish Visions of the Other World*, London, 1930.]

75 The Latin text of the journey of St. Brendan was published by A. Jubinal, *La Légende de Saint Brendaines*, Paris, 1836. [See also *Réau*, III, pt. 1: "Brendan d'Irlande," pp. 241-242, and P. Tuffrau, *Le Merveilleux Voyage de saint Brandan à la recherche du Paradis*, Paris, 1925. St. Brendan lived in the sixth century, but the legend of his voyage was not recorded until the tenth, with the title *Navigatio sancti Brendani*. Many German editions of *Brandons Meerfahrt* appeared in the fifteenth century, often with illustrations.]

76 Here we recognize the *Vision de Saint Paul*.

77 T. Wright, ed., *Saint Patrick's Purgatory*, London, 1884. See also P. Tarbé, ed., *Le Purgatoire de saint Patrice*, Reims, 1862.

78 Concerning the cavern of Lake Derg, see P. de Felice, *L'Autre Monde*, Paris, 1906.

79 The vision of Tungdal is attributed to the year 1149. The Latin text was published by A. Wagner, *Visio Tungdali*, Erlangen, 1881. On this vision, see A. Mussafia, *Appunti sulla visione di Tundalo*, Vienna, 1871. [For editions of Tungdal, see Baltrusaitis, *Réveils et prodiges*, pp. 278-279 and n. 29. For El Greco's knowledge of Tungdal's vision, see A. Blunt, "El Greco's 'Dream of Philip II': An Allegory

of the Holy League," *Journal of the Warburg and Courtauld Institutes*, 3 (1939-1940), p. 62. For the influence of Tungdal on Bosch, see H. Dollmayr, "Hieronymous Bosch und die Darstellung der vier letzten Dinge," *Jahrbuch der Kunstsammlungen des allerhöchsten Kaiserhauses*, 19 (1898), pp. 284ff., and C. de Tolnay, *Hieronymus Bosch*, Basel, 1937, p. 26.]

80 There is a variant in a French manuscript of the fifteenth century: Paris, Bibl. Nat., ms. fr. 12445, fol. 75. The unrepentant sinners are replaced by the envious.

81 *Histoire de saint Brendan*, translation by Benoît dedicated to Queen Aélis de Louvain, 1125. *Le Voyage d'Owen*, translations by Bérot and by Marie de France.

82 See Mussafia, *Appunti sulla visione di Tundalo*.

83 Thomas Aquinas, *Summa*. Supplement to the third part, Quaest. xcvii, art. ii. [See above, n. 1.]

84 Verses 4873ff. [Guillaume de Deguilleville, *Pèlerinage de l'âme*, (1355), J. J. Stürzinger, ed., London, 1985, pp. 162-163: illustration of the wheel. See also Delaissé, "Les miniatures du pèlerinage de la vie humaine de Brussels et l'archéologie du livre," pp. 233-250, for a discussion of *Le Songe du pèlerinage de la vie humaine* (Brussels, Bibl. Royale, ms. 10176-10178) c. 1400. The miniature of the damned over a grill is reproduced on pl. 19 b (fol. 150v). See further C. Gaspar and F. Lyna, *Les Principaux Manuscrits à peintures de la Bibliothèque Royale de Belgique*, Paris, 1937, 1, pp. 379-383.]

85 *Ibid.*, verses 4565ff.

86 1402-1471.

87 Bk. iii, art. viii. [See Chapter viii, n. 128.]

88 [For more on demons, see E. Castelli, *Il Demoniaco nell'arte. Il significato filosofico del demoniaco nell'arte*, Milan and Florence, 1952; R. H. Robbins, *Encyclopedia of Witchcraft and Demonology*, New York, 1959; *Réau*, ii, pt. 1, pp. 60-64.]

89 The church of St.-Maclou, begun in 1432, was almost finished in 1472. The cathedral of Nantes was begun in 1434; the portal was almost finished in 1480. A date of 1470 for the sculptures of these two churches cannot be far off.

90 Reproduced in E. de Beaurepaire, "Les peintures murales de l'église de Bénouville," *Bulletin archéologique du comité des travaux historiques et scientifiques*, 1897, pls. ii, iii, p. 16. These frescoes must have been done in the late fifteenth century.

91 Beaurepaire, *ibid.*, who described this fresco, thought this wheel was the wheel of fortune.

92 All are small and sketchy. The work was probably done in the second part of the fifteenth century.

93 Paris, Bibl. Nat., ms. fr. 9186, fol. 298v. The manuscript is earlier than 1477, date of the death of the Duke of Nemours.

94 Or rather they are on the spit, conforming to the interpretation of Denis the Carthusian. [See above, n. 87.]

95 Paris, Bibl. Nat., ms. fr. 20107.

96 The Sermon is apocryphal. It is included in Migne, *P. L.*, 39, col. 1929 (Sermon xcvi a). No details about hell are given.

97 *Ibid.*, 198, col. 1597. This is a reproduction of the passage from the Pseudo-Augustine.

98 See the *Passion* by Gréban, verses 15784ff. Hell is described in very vague terms. The relation to the legend of Lazarus has been pointed out by Roy, *Le Mystère de la Passion en France*, pt. 1, pp. 58-59. [See Chapter ii n. 22.]

99 Our author, who was very methodical, wished to associate a devil with each of the capital sins. This was the tradition in the fifteenth century. This is borne out by the *Mystère sant Antoni de Viennès*, P. Guillaume, ed., Paris, 1884. The names of the devils, however, are not the same.

100 The detail of the toads devouring the sex of the lustful is found neither in the Greek account, nor in the Irish legends, but it is traditional. It was used in twelfth-century art (Moissac).

101 The first edition of the *Calendrier des bergers* (1491), which is nearer in date to the *Art de bien vivre et de bien mourir*, does not contain the tortures of hell. [See Chapter vii, n. 4.]

102 It is enough to cite one example. Here is one inscription from Albi: "The male and female envious are plunged into a frozen river up to their navels and from all sides a very cold wind strikes them and when they want to escape this wind, they plunge back into the aforementioned ice." And this is the text in the *Calendrier des bergers*: "I saw a frozen river into which the male and female envious were plunged up to their navels, and from all sides a very cold wind struck them, and when they wanted to escape this wind they plunged under the ice."

103 The artist did not copy, but rather interpreted in his own way the engravings from the *Calendrier des bergers* (1491). However,

certain scenes (the envious plunged into the river) are almost exact reproductions.

104 Paris, Bibl. Nat., ms. fr. 450. The book must have been written about 1500.

105 See Mâle, *L'Art religieux du XIII siècle*, 8th ed., pp. 389ff. [*Religious Art in France: The Thirteenth Century*, Bollingen XC. 2, Princeton, 1984, pp. 384ff.]

106 [On the iconography of paradise, see *Réau*, II, pt. 2, pp. 750-753.]

107 This tract was inserted by Vérard in the *Art de bien vivre et de bien mourir*.

108 [For light symbolism in Northern art of the fifteenth century, see M. Meiss, "Light as Form and Symbol in some Fifteenth Century Paintings," *Art Bulletin*, 27 (1945), pp. 175ff. For a study of light throughout the history of Western art, see W. Schöne, *Über das Licht in der Malerei*, Berlin, 1954.]

109 The north rose of the cathedral of Sens, for example, fifteenth century.

110 [For the theme of the angelic musicians in heaven, see R. Hammerstein, *Die Musik der Engel, Untersuchungen zur Musikanschauung des Mittelalters*, Munich, 1962; K. A. Wirth, "Engelchöre," *Reallexikon*, v, cols. 555-601.]

111 Dehaisnes was right to place this triptych (now in the Berlin Museum) among the works of Jean Bellegambe. See C. Dehaisnes, *La Vie et l'oeuvre de Jean Bellegambe*, Lille, 1890, pp. 161ff.

112 Matthew 25:31-46.

113 It is found in the *Art de bien vivre et de bien mourir*.

CHAPTER XI

1 For a consideration of the nude as an important aspect of late medieval art in the North, cf. K. Clark, *The Nude*, New York, 1956; R. Krautheimer, *Lorenzo Ghiberti*, Princeton, 1956, pp. 297ff.; W. S. Heckscher, "Relics of Pagan Antiquity in Medieval Settings," *Journal of the Warburg and Courtauld Institutes*, 1 (1937-1938), pp. 204-220; Adhémar, *Influences antiques dans l'art du moyen âge français*; F. de Mély, "Du rôle des pierres gravées au moyen âge," *Revue de l'art chrétien*, 43 (1893), pp. 14-24, 98-105, 191-203; *idem*, "Les 'Très Riches Heures' du duc de Berry et les 'trois graces' de Sienne," *Gazette des Beaux-Arts*, 8 (1912), pp. 195-201; A. Springer, *Das Nachleben der Antike im Mittelalter*, Paris, 1927; Seznec, *The Survival of the Pagan Gods*.]

2 [For the effect of the Reformation upon the visual arts, see F. Buchholz, *Protestantismus und Kunst im sechzehnten Jahrhundert*, Leipzig, 1928; O. Thulin, "Bilderfrage," *Reallexikon*, II, 1948, cols. 570-572; H.A.E. van Gelder, *The Two Reformations in the Sixteenth Century*, The Hague, 1961; *idem, Erasmus, Schilders en Rederijkers*, The Hague, 1959; *Réau*, I, pp. 444ff.]

3 H. Estienne, *Apologie pour Hérodote ou traité de la conformité des merveilles anciennes avec les modernes*, The Hague, 1735, chap. XXI.

4 Lanson has shown this very clearly in the *Revue d'histoire littéraire de la France*, 1903, pp. 177ff.

5 [For the impact of the decree by the Council of Trent, see H. Jedin, "Entstehung und Tragwerte des Trienter Dekrets uber die Bilderverehung," *Theologische Quartalschrift*, 116 (1935), pp. 142ff., 404ff. For the history of the Council, see *idem, A History of the Council of Trent*, I-II, London, 1957-1961. See also C. Dejob, *De l'Influence du Concile du Trente sur la littérature et les beaux-arts*, Paris, 1884, and A. Blunt, *Artistic Theory in Italy 1450-1600*, Oxford, 1940, pp. 103ff. For the iconographical developments of the Counter-Reformation, see E. Mâle, *L'Art religieux après le Concile de Trente*, Paris, 1932. See also W. Weisbach, *Der Barock als Kunst der Gegenreformation*, Berlin, 1921; Knipping, *De Iconografie van der Contra-Reformatie in de Nederlanden*; *Réau*, I, pp. 444ff.]

6 Documents published by Beaurepaire, *Mélanges historiques et archélogiques*, pp. 203-224.

7 This contract was published in a brochure by H. Requin, *Un Tableau du roi René au musée de Villeneuve-les-Avignon*, Paris, 1890. [See also Sterling, *Le Couronnement de la Vierge par Enguerrand Quarton*.]

8 See another example in L. Barthélemy, "Documents inédits sur les peintres et peintres-verriers de Marseilles de 1300 à 1550," p. 381.

9 *Ibid.*, pp. 378-379.

10 This choir screen was placed at the entrance to the church. The statues have been mutilated, but the reliefs representing the Labors of Hercules can still be seen. The six statues of the Virtues were commissioned in 1536 from Jean Armand, *imagier* of the city of Tours. See A. Petit, "Les six statues du jubé de la cathédrale de Limoges," *Bulletin de la société archéologique et historique du Limousin*, 62 (1912), pp. 144ff. The Labors

of Hercules were carved after the plaquettes of Moderno.

11 [For the Christian interpretation of the Labors of Hercules, see M. Simon, *Hercule et le Christianisme*, Paris, 1955 and M.-R. Jung, *Hercule dans la littérature française du XVIe siècle*, Geneva, 1966.]

12 *Officium beatae Mariae Virginis*, printed by Germain Hardouyn in 1524.

13 Choir stalls of the Trinité at Vendôme

14 Choir stalls of Presles (Seine-et-Oise).

15 Also at Presles.

16 Choir stalls of Rontot (Eure).

17 Choir stalls of Villefrance-d'Aveyron.

18 Choir stalls of Fontenay-les-Louvres (Seine-et-Oise).

19 Choir stalls of St.-Martin-aux-Bois (Oise).

20 Also at St.-Martin-aux-Bois.

21 Choir stalls of Rouen, and of Presles (Seine-et-Oise).

22 Choir stalls of St.-Spire at Corbeil. See Millin, *Antiquités nationales*, 2 (1791), art. XXII, pls. I and IV.

23 Choir stalls of L'Isle-Adam. (The choir stalls of L'Isle-Adam came from St.-Seurin at Bordeaux.)

24 Choir stalls of Rouen.

25 Choir stalls of Champeaux (Seine-et-Marne).

26 Choir screen of St.-Fiacre-du-Faouet.

27 Choir stalls of L'Isle Adam.

28 Choir stalls of St.-Pol-de Léon.

29 [For the similarity to the drolleries on the borders of medieval manuscripts, see L. Randall, *Images in the Margins of Gothic Manuscripts*, Berkeley, 1966.

30 See the document in the appendix of E. Langlois, *Les Stalles de la cathédrale de Rouen*, Rouen, 1838.

31 [For a study of inconoclastic outbreaks, symptomatic of Protestant opposition to religious imagery, see L. Réau, *Histoire du vandalisme; les monuments détruits de l'art français*, Paris, 1959, pp. 67ff. For the attitude of the great reformers to religious imagery, cf. M. Luther, *Widder die hymelischen Propheten, von den Bildern und Sakrament*, printed by G. Raw, Wittemberg, 1525. For an English translation, see H. E. Jacobs, *Collected Works of Martin Luther*, I-IV, Philadelphia, 1915-1931. See also H. F. von Campenhausen, "Zwingli und Luther zur Bilderfrage," *Das Gottesbild im Abendland*, W. Schöne, ed. (*Glaube und Forschung*, XV), Witten-Berlin, 1959, pp. 139ff.; C. Garside, Jr., *Zwingli and the Arts*, New Haven, London, 1966; E. Domergue, *L'Art et le sentiment dans l'Oeuvre de Calvin*, 1902; P. Romane-Musculus, *Esquisse d'une doctrine réformée sur l'usage des images dans les églises*, Paris, 1935; L. Wencelius, *L'Esthétique de Calvin*, Paris, 1937; *idem, Calvin et Rembrandt*, Paris, 1937; *Réau*, I, pp. 444ff.]

32 The book was published in Bologna in 1582. In 1594, a Latin translation appeared in Ingolstadt with the title: *De imaginibus sacris*. Only two of the five books were written.

33 René Benoist, *Traité catholique des images*, printed by R. Chesneau, Paris, 1564.

34 G. Paleotti, *Discorso intorno alle imagini sacre e profane*, Bologna, 1582, bk. I, chap. XXII. [See above, no. 32.]

35 *Ibid.*, bk. I, chap. XXIII.

36 [See further the treatise of Gilio da Fabriano, *Due dialoghi degli errori de' pittori*, Camerino, 1564, and R. W. Lee, "Ut Pictura Poesis: The Humanistic Theory of Painting," *Art Bulletin*, 22 (1940), pp. 197ff. See also J. von Schlosser, *La letteratura artistica*, F. Rossi, tr., Florence, 1964, pp. 370-372 and F. Zeri, *Pitture e Controriforma—l'arte senza tempo di Scipione de Gaeta*, Einaudi, 1957.

37 This discourse became the first book of the *De historia sanctarum imaginum et picturarum*. [Jean Vermeulen, called Molanus (b. Lille, 1533; d. Louvain, 1585) was a censor under Philip II, a historian, and author of an extensive work on martyrology, published in 1568 in Louvain. Molanus' discourse on images, *De picturis et imaginibus sacris liber unus*, Louvain, 1570, was reprinted after his death under the title *De historia sanctarum imaginum, pro vero earum usu contra abusus libri IV*, Louvain, 1594 (reprinted in Douai, 1617). See E. Nève, *Des Travaux de J. Molanus sur l'iconographie chrétienne*, Louvain, 1847, and Blunt, *Artistic Theory*, pp. 110ff. See also, *Réau*, I, pp. 444ff.]

38 Molanus, *De historia sanctarum imaginum et picturarum* (Paquot ed.)., Louvain, 1771, p. 134.

39 *Ibid.*, p. 280.

40 *Ibid.*, p. 337.

41 Reliefs in the transept.

42 *Ibid.*, pp. 83-85: "*Docti vero ecclesiastici eas picturas non extendant.*" See also pp. 93-94.

43 He said this more clearly in the first edition than in the second. See *ibid.*, pp. 330, 331.

44 *Ibid.*, pp. 319ff.

45 *Ibid.*, p. 277. Here Molanus seems to glimpse the truth.

46 *Ibid.*, p. 387.

47 *Ibid.*, p. 443.

48 Petrus Canisius, *De Deipara*, bk. iv, chap. xxviii.

49 Joannes de Carthagena, *De religionis christianae arcanis homilae sacrae cum catholicae, tum morales*, i-iii, Antwerp, 1622, bk. xii, *homil.* xvii.

50 Molanus, *De historia sanctarum imaginum et picturarum*, p. 479.

51 *Ibid.*, p. 83. This is the scene which often ended our *Mystères de la Passion* and was borrowed, as we have said, from the *Meditations*.

52 *Ibid.*, pp. 90-93.

53 The same can be said for the Entombments. Molanus, *ibid.*, p. 93, believed that there is no proof that the Virgin was present at the burial of her son; the Virgin was the principal figure of the entombments.

54 *Ibid.*, p. 105. He takes cover here behind Quinctius Heduus.

55 *Ibid.*, p. 314.

56 *Ibid.*, p. 108.

57 *Ibid.*, p. 122, according to Erasmus.

58 *Ibid.*, p. 70.

59 [For the conservative aspect of the Counter-Reformation, reviving fifteenth-century and earlier forms because they were viewed as the most authoritative and documentary in character, see Zeri, *Pitture Controriformo*. For a good general bibliography on the art of the Reformation and Counter-Reformation, see E. Battisti, "Reformation and Counter-Reformation," *Encyclopedia of World Art*, xi, New York, 1966, cols. 894-916.]

BIBLIOGRAPHY

Adeline, J., J. Bailliard and others. *La Normandie monumentale et pittoresque*, 5 vols. Le Havre, 1893-1899.

Adhémar, Jean. *Influences antiques dans l'art du moyen âge français*. London, 1939.

Alain de Lille. *Anti-Claudianus*, ed. R. Bossuat. Paris, 1955.

Albanès, canon. "Les Artistes à Toulon au moyen âge," *Bulletin archéologique du comité des travaux historiques et scientifiques*, 1897, pp. 17-47.

Alexandre. *The Sibylline Oracles* tr. Milton S. Terry. New York, 1890.

Algermissen, Konrad, and others, eds. *Lexikon der Marienkunde*. Regensburg, 1967.

Allier, Achille. *L'Ancien bourbonnais*. 4 vols. Moulins, 1934-1938.

Altena, J. de Borchgrave d'. "La Messe de Saint Grégoire, étude iconographique," *Bulletin des musées royaux des beaux-arts*, Brussels, 1959, pp. 3-34.

Ancona, Alessandre. *Origini del teatro in Italia*. 2 vols. Florence, 1877.

———. *Sacre rappresentazioni dei secoli XIV, XV, et XVI*. 3 vols. Florence, 1872.

Ancona, M. L. d'. *The Iconography of the Immaculate Conception in the Middle Ages and Early Renaissance*. New York, 1957.

Anderson, M. D. *Drama and Imagery in English Chronicles*. Cambridge, 1963.

Andrieu, E. "Les Tombeaux des ducs de Bourgogne," *Bulletin monumental*, 90 (1933), pp. 171-193.

St. Angela da Foligno. *L'Autobiografia e gli scritti della Beata Angela da Foligno*, tr. M. C. Humani, ed. M. F. Pulignani. Città di Castello, 1932.

———. *The Book of Divine Consolation by the Blessed Angela da Foligno*, tr. Mary G. Steegmann. New York, 1909.

Angoulême, Marguerite d'. *Heptaméron*, tr. W. K. Kelly. London, 1903.

Appuhn, Horst. "Der Auferstandene und das Heilige Blut zu Weinhausen," *Niederdeutsche Beiträge zur Kunstgeschichte*, 1 (1961), pp. 73-138.

Arnaud, C. *Ludus sancti Jacobi, Fragment de mystère provençal*. Marseille, 1868.

Arras, Musée d'Arras. R. Genaille. *Jean Bellegambe, le maître des couleurs*. Arras. 1951.

Aru, C. and E. de Geradon. *Les Primitifs flamands. I. Corpus de la peinture des anciens pays-bas méridionaux au quinzième siècle* (fasc. 5: *La Galerie Sabauda de Turin*). Antwerp, 1952.

Aubert, Marcel. "La Cathédrale," *Congrès archéologique*, 89 (1926), pp. 11-71.

———. *La Chapelle de Kermaria-Nisquit*. Paris, 1930.

———. and others. *Le Vitrail français*. Paris, 1958.

Aucapitaine, Henri. "Statue de Charlotte d'Albret dans l'église de la Motte-Feuilly," *Revue archéologique*, 9 (1852), pp. 703-705.

Aufauvre, Amédée and Charles Fichot, *Les Monuments de Seine-et-Marne*. Troyes and Paris, 1858.

St. Augustine. *The City of God*, ed. D. Knowles. Baltimore, 1972.

Aurenhammer, Hans. *Lexikon der christlichen Ikonographie*. Vienna, 1959-1960.

Auriol, A. *Descente de Saint-Paul dans l'Enfer* (Les Trésors des Bibliothèques de France, III). Paris, 1930.

Bach, E., L. Blondel and Adrien Bovy. *La Cathédrale de Lausanne*. Basel, 1944.

Baltimore, Walters Art Gallery. *The International Style, The Arts of Europe around 1400*. Baltimore, 1962.

Baltrušaitis, Jurgis. "Cercles astrologiques et cosmographiques à la fin du moyen-âge," *Gazette des beaux-arts*, 21 (1939), pp. 65-84.

———. *Le Moyen Age fantastique*. Paris, 1955.

———. *Réveils et prodiges*. Paris, 1960.

Barb, A. A. "Mensa Sacra: The Round Table and the Holy Grail," *Journal of the Warburg and Courtauld Institutes*, 19 (1956), pp. 40-67.

Barbat, Louis. *Les Pierres tombales du moyen âge*. Paris, 1854.

Barbier de Montault, Xavier. *Iconographie des sibylles*. Arras, 1871.

———. "Rome Chrétienne," *Annales archéologiques*, 15 (1855), pp. 323-244.

Baron, H. *Leonardo Bruni Aretino*. Leipzig, 1928.

Barthélemy, E. D. "Inventaire du château de Pailly, dressé à la mort de la maréchale de Saulx-Tavannes, en 1611," *Revue des sociétés savantes*, 5 (1881), pp. 296-323.

Barthélemy, Louis. "Documents inédits sur les peintures et les peintres-verriers de Marseille de 1300 à 1500," *Bulletin archéologique du comité des travaux historiques et scientifiques*, 1885, pp. 371-459.

Bartsch, Adam. *Le Peintre graveur: Catalogue raisonné de toutes les estampes qui forme l'oeuvre de Dürer*, VIII. Vienna, 1808.

Barzon, A. *I Cieli e la loro influenza negli affreschi del Salone in Padova*. Padua, 1924.

Battisti, Eugenio. "Reformation and Counter-Reformation," *Encyclopedia of World Art*, XI, New York, 1966, cols. 894-916.

Beaumont de la Forest, Louis de. *Gallia Christiana in Provincias ecclesiasticas distributa*. 16 vols. Paris, 1739-1877.

Beaurepaire, Charles de. *Mélanges historiques et archéologiques concernant le département de la Seine-Inférieure*. Rouen, 1897.

————. *Nouveau recueil de notes historiques et archéologiques*. Rouen, 1850.

Beaurepaire, Eugene de Robillard de. "Les Fresques de Saint-Michel de Vaucelles," *Bulletin de la société des antiquaires de Normandie*, 12 (1884), pp. 643-674.

————. *Palinods*. Rouen, 1897.

————. "Les Peintures murales de l'église de Bénouville (près Caen)," *Bulletin archéologique du comité des travaux historiques et scientifiques*, 1897, pp. 116-122.

Beauvais, Vincent de (Vincentius Bellovacensis). *Speculum Quadruplex: Naturale, Doctrinale, Morale, Historiale* (Douai, 1624). 4 vols., Graz, 1964.

Becker, Ernest J. *A Contribution to the Comparative Study of the Medieval Visions of Heaven and Hell* (diss. Johns Hopkins). Baltimore, 1899.

The Venerable Bede. *Opera*, tr. J. A. Giles. 12 vols. London, 1843-1844.

Bedier, J. "Fragment d'un ancien mystère," *Romania*, 24 (1895), pp. 66-94.

Béguin, Sylvie. *L'Ecole de Fontainebleau, le maniérisme à la cour de France*. Paris, [1960].

Begule, Lucien. *L'Eglise Saint-Maurice, ancienne cathédrale de Vienne*. Paris, 1914.

————. *Vitraux du moyen âge et de la Renaissance dans la région lyonnaise*. Paris, 1911.

Beijer, A. "Visions célestes et infernales dans le théâtre du moyen âge et de la Renaissance," *Les Fêtes de la Renaissance*, ed. J. Jaquot, Paris, 1956, pp. 405-417.

Beissel, Stephan. *Geschichte der Verehrung Marias in Deutschland während des Mittelalters*. Freiburg-im-Breisgau, 1909 (new ed. Darmstadt, 1972).

Benesch, Otto. *The Art of the Renaissance in Northern Europe*. Cambridge, Mass., 1943.

Bergier, abbé. *Etude sur les hymnes du bréviaire romain*. Besançon, 1884.

Bergstrom, I. "The Iconological Origins of *Spes* by Pieter Brueghel the Elder," *Nederlands Kunsthistorisch Jaarboek*, 7 (1956), pp. 53-63.

Berliner, Rudolf. "Arma Christi," *Münchner Jahrbuch der bildenden Kunst*, 6 (1955), pp. 35-152.

————. *Denkmäler der Krippenkunst*. Augsburg, 1925.

————. "The Freedom of Medieval Art," *Gazette des beaux-arts*, 28 (1945), pp. 263-288.

————. "Zur Sinnesdeutung der Ährenmadonna," *Die christliche Kunst*, 26 (1929-1930), pp. 97-112.

————. *Die Weihnachtskrippe*. Munich, 1955.

Bernard, Auguste. *Geofroy Tory: An Account of His Life and Works*, tr. George B. Ives, Cambridge, Mass., 1909 (1st French ed., Paris, 1865).

Bernard, B. "Saint-Lizier," *Bulletin monumental*, 51 (1885), pp. 591-596.

Bernheimer, Richard, *Wild Men in the Middle Ages*. Cambridge, Mass., 1952.

Bertaux, Emile. "Le Tombeau d'une reine de France à Cosenza en Calabre," *Gazette des beaux-arts*, 19 (1898), pp. 263-276.

Besozzi, Raimondo. *La Storia della basilica di Santa Croce in Gerusalemme*. Rome, 1750.

Bing, Gertrude. "The Apocalypse Block Books and Their Manuscript Models, *Journal of the Warburg and Courtauld Institutes*, 5 (1942), pp. 143-158.

Blanquart, F. "L'Imagier Pierre des Aubeaux et les deux groupes du Trépassement de Notre Dame à Gisors et à Fécamp," *Congrès archéologique de France*, 1890, pp. 378-387.

Bloomfield, Morton W. *The Seven Deadly Sins; Introduction to the History of a Religious Concept with Specific Reference to Medieval English Literature*. East Lansing, Mich., 1952.

Blum, André. "Un Manuscrit inédit du XIIIe siècle de la 'Bible des pauvres,'" *Monuments et mémoires* (Fondation Piot), 1926, pp. 95-111.

————. *Les Primitifs de la gravure sur bois; étude historique et catalogue des incunables xylographiques du Musée du Louvre* (Cabinet des Estampes, Edmond de Rothschild). Paris, 1956.

Blunt, Anthony. *Art and Architecture in France 1500-1700* (Pelican History of Art). Baltimore, 1953.

————. *Artistic Theory in Italy 1450-1600*. Oxford, 1940.

————. "El Greco's 'Dream of Philip II': An Allegory of the Holy League," *Journal of the Warburg and Courtauld Institutes*, 3 (1939-1940), pp. 58-69.

————. *Philibert de l'Orme*. London, 1958.

Bober, Harry. "André Beauneveu and Mehun-sur-Yèvre," *Speculum*, 38 (1953), pp. 741-753.

————. "The 'First' Illustrated Books of Paris Printing; A Study of the Paris and Verdun Missals of 1481 by Jean du Pré," *Marsyas*, 5 (1947-1949), pp. 87-104.

————. "The Zodiacal Miniature of the *Très Riches Heures* of the Duke of Berry: Its Sources and Meaning," *Journal of the Warburg and Courtauld Institutes*, 11 (1948), pp. 1-34.

Bohatta, Hanns. *Bibliographie der livres d'heures des XV. und XVI. Jahrhunderts*. Vienna, 1924.

Böheim, J. *Das Landschaftsgefühl des ausgehenden Mittelalters*. Leipzig, 1934.

Boll, Franz and Carl Bezold. *Sternglaube und Sterndeutung: Die Geschichte und das Wesen der Astrologie*. Berlin, 1931.

————. *The Works of Bonaventure*, tr. Jose de Vinck, 2 vols. Paterson, N.J. 1960.

Bonnefoy, Yves. *Peintures murales de la France gothique*. Paris, 1954.

St. Bonaventura. *Opera Omnia*, ed. I. Jeiler, 10 vols. Clara Aqua, 1882-1902.

Boom, Charles de. "Le Culte de l'eucharistie d'après la miniature du moyen âge," *Studia eucharistica DCCI anni a condito festo sanctissimi corporis Christi 1246-1946*, Bossum-Antwerp, 1946, pp. 326-332.

Borinski, L. *Die Rätsel Michelangelos; Michelangelo und Dante*. Munich, 1908.

Borsook, Eve. *The Mural Painters of Tuscany*. London, 1960.

Bosseboeuf, Louis A. *Le Château et la chapelle de Champigny-sur-Veude*. Tours, n.d.

Bossuat, R. *Anti-claudianus*. Paris, 1955.

Bouché-Leclerq, A. *L'Astrologie grecque*. Paris, 1899.

————. *Histoire de la divination dans l'antiquité*. 4 vols. Paris, 1879-1882.

Boucher, L. *La Peste à Rouen*. Rouen, 1897.

Bouchot, Henri. *Les deux cents incunables xylographiques du département des Estampes*. 2 vols. Paris, 1903.

Bougenot, G. S. "Tombe d'Etienne de Sainte-Croix et l'école cathédrale de Chalon au XIVe siècle" *Bulletin archéologique du comité des travaux historiques et scientifiques*, 1892, pp. 339-346.

Bouillet, Auguste. "Une église disparue: Saint-André-des-Arcs, *Notes d'art et d'archéologie*, 2 (1890-1891), pp. 53-61.

————. "L'Eglise Sainte-Foy de Conches (Eure) et ses vitraux," *Bulletin monumental*, 54 (1888), pp. 253-312.

Boulangé, G. "Fragments de la statistique monumentale du département de la Moselle," *Bulletin monumental*, 20 (1854), pp. 177-199.

Bourdery, L. "Note sur un triptique en émail peint de Limoges," *Bulletin archéologique du comité des travaux historiques et scientifiques*, 1892, pp. 426-433.

Bourges, Jean Chenu de. *Recueil des antiquitez et privilèges de la ville de Bourges*, Paris, 1621.

Brandi, Cesare. *Pietro Lorenzetti; Affreschi nella basilica di Assisi*. Rome, 1958.

Branner, Robert. *Saint Louis and the Court Style in Gothic Architecture*. London, 1965.

Bréhier, Louis, *L'Art chrétien, son développement iconographique des origines à nos jours*. Paris, 1928.

Breitenbach, Edgar. *Speculum humanae salvationis, eine typengeschichtliche Untersuchung*. Strasbourg, 1930.

Breul, J. du. *Le Théâtre des antiquités de France*, Paris, 1612.

St. Bridget. The Revelations of St. Brigitta (Early English Text Society, Original Series, no. 178), ed. William P. Cumming. London, 1929.

Brooks, N. C. "The Sepulchre of Christ in Art and Liturgy with Special Reference to the Liturgical Drama," *University of Illinois Studies in Language and Literature*, 1921.

Broussolle, J. C. *Etudes sur la sainte-vierge*, Paris, 1908.

Brunereau, Aimé. *La Danse macabre de la Chaise-Dieu*. Paris, 1925.

Brutails, J.-A. "Notes sur l'art religieux du Roussillon," *Bulletin archéologique du comité des travaux historiques et scientifiques*, 1893, pp. 329-404.

Bruyn, Josua. "A Puzzling Picture at Oberlin: The Fountain of Life," *Allen Memorial Art Museum Bulletin*, Oberlin College, 16 (1958), pp. 5-17.

Bucci, M. *Camposanto monumentale di Pisa*. Pisa, 1960.

Buchholz, Friedric. *Protestantismus and Kunst im sechzehnten Jahrhundert*. Leipzig, 1928.

Buchmeit. *Der Totentanz*. Berlin-Grünewald, 1931.

Buchthal, Hugo. *Miniature Painting in the Latin Kingdom of Jerusalem*. Oxford, 1957.

Burckhardt, Jacob. *The Civilization of the Renaissance in Italy*, tr. S.G.C. Middlemore. London and New York, 1929.

Burger, Lilli. *Die Himmelskönigen der Apokalypse in der Kunst des Mittelalters*. Berlin, 1957.

Burges, W. "La Ragione de Padoue," *Annales archéologiques*, 18 (1858), pp. 331-343.

Cahier, Charles. *Les Caractéristiques des saints dans l'art populaire*. 2 vols. Paris, 1866-1868.

Caix, Alfred de. "Histoire du Bourg d'Ecouché," *Mémoires de la société des antiquaires de Normandie*, 24 (1859), pp. 499-636.

Le Grand Calendrier des Bergers printed by Jean Belot, Geneva, 1497, ed. Gustav Grunau. Bern, 1920.

Calvert, Albert F. *Leon, Burgos, Salamanca*. London, 1908.

Cames, Gérard. *Allégories et symboles dans l'Hortus deliciarum*. Leiden, 1971.

Camp, Gaston van. "Iconographie de la Trinité dans une Triptyque flamand de ca. 1500," *Revue belge d'archéologie et d'histoire de l'art*, 21 (1952), pp. 55-58.

Campenhausen, Hans F. von. "Zwingli und Luther zur Bilderfrage," *Das Gottesbild im Abendland* (Glaube und Forschung, xv), ed. W. Schone, Witten-Berlin, 1959.

Carli, Enzo. *Pittura pisana del trecento*. 2 vols. Milan, 1958-1961.

Carmichael, Montgomery. *Francia's Masterpiece*. London, 1909.

Carpentier, Pierre. *Description historique et chronologique de l'église métropolitaine de Paris*. Paris, 1767.

Carton, C. L. *Essai sur l'histoire du Saint Sang depuis les premiers siècles du christianisme*. Bruges, 1950.

Cassel, Paulus. *Der Schwan in Sage und Leben*. Berlin, 1872.

Cassirer, Ernst. *Individuum und Cosmos in der Philosophie der Renaissance*. Leipzig and Berlin, 1927.

Castelli, Enrico. *Il demoniaco nell'arte, Il significato filosofico del demoniaco nell'arte*. Milan and Florence, 1952.

Castelnuovo, Enrico. *Un pittore italiano alla corte di Avignone, Matteo Giovannetti e la pittura in Provenza nel secolo XIV*. Turin, 1962.

Cavrois, Baron Louis. "L'Email de Vaulx en Artois," *Réunion des sociétés des beaux-arts des départements*, 22 (1898), pp. 167-172.

Chabeuf, Henri. *Monographie historique et descriptive de l'église bénédictine de Sainte-Seine-l'Abbaye*, Dijon, 1888.

Chabouillet, Jean Marie Anatole. *Catalogue général et raisonné des camées et pierres gravées de la Bibliothèque Imperiale suivi de la description des autres monuments enposés dans le cabinet de médailles et antiquités*. Paris, 1858.

Champeau, A. de and P. Gauchery. *Les Travaux d'art exécuté pour Jean de France*. Paris, 1894.

Champion, Pierre. *Histoire poétique du XVe siècle*. 2 vols. Paris, 1927.

Charles, R. "Etude historique et archéologique sur l'église et la paroisse de Souvigné-sur-Même (Sarthe)," *Revue historique et archéologique de Maine*, 1 (1876), pp. 43-76.

Chartou, J. M. *Les Entrées solennelles et triomphales à la renaissance*. Paris, 1928.

Chastel, André. "L'Apocalypse en 1500; la fresque de l'Antéchrist à la chapelle Saint-Brice d'Orvieto," *Mélanges Augustin Renaudet* (Bibliothèque d'humanisme et renaissance, xiv), Geneva, 1952, pp. 124-140.

———. *Art et humanisme à Florence*. Paris, 1959.

———. *Marsile Ficin et l'art*. Geneva and Lille, 1954.

Chauvigne, A. Auguste. *Histoire des corporations d'arts et métiers de Touraine*. Tours, 1885.

Chenu, M. D. *Dictionnaire de théologie catholique*, eds. A. Vacant, E. Mangenot, and E. Amann. 15 vols. Paris, 1903-1950.

Chevalier, Ulysse. *Notre dame de Lorette*. Paris, 1906.

Chevreux, M. P. "Les Croix de plomb de la région vosgienne," *Bulletin archéologique du comité des travaux historiques*, 1904, pp. 391-408.

Chew, Samuel. "Spenser's Pageant of the Seven Deadly Sins," *Studies in Art and Literature for Belle da Costa Greene*, Princeton, 1954, pp. 37-54.

———. *The Virtues Reconciled; An Iconographical Study*. Toronto, 1947.

Chirol, Elizabeth. *Le Château de Gaillon*. Rouen and Paris, 1952.

Choulant, L. *History and Bibliography of Anatomic Illustration*, tr. M. Frank. Chicago, 1920.

Clark, James M. *The Dance of Death by Hans Holbein*. London, 1948.

———. *The Dance of Death in the Middle Ages and the Renaissance*. Glasgow, 1950.

Clark, Kenneth. *The Nude; A Study in Ideal Form* (Mellon Lectures in the Fine Arts, ii). Princeton, [1956].

Claudin, A. *Histoire de l'imprimerie en France, au XVe et au XVIe siècle*. 4 vols. Paris, 1900-1914.

Cocagnac, A.-M. *Le Jugement Dernier dans l'art*. Paris, 1955.

Cockerell, Sydney Carlyle. *The Book of Hours of Yolande of Flanders*. London, 1905.

Coffinet, abbé. "Trésor de St. Etienne de Troyes," *Annales archéologiques*, 20 (1860), pp. 80-97.

Cohen, Gustave. *Etudes d'histoire du théâtre en France au moyen âge et à la Renaissance*. Paris, 1956.

———. *Histoire de la mise en scène dans le théâtre religieux français du moyen âge*. Paris, 1951.

———. "The Influence of the Mysteries on Art

in the Middle Ages," *Gazette des beaux-arts*, 24 (1943), pp. 327-342.

————. "Le Personnage de Marie-Madeleine dans le drame religieux du moyen âge," *Convivium*, 24 (1956), pp. 141-163.

————. *Le Théâtre en France au moyen âge*. 2 vols. Paris, 1928-1931.

Colombier, Pierre du. *Jean Goujon*. Paris, 1949.

Comparetti, Domenico. *Virgilio nel medio evo*. 2 vols. Florence, 1937-1946.

Connolly, James L. *John Gerson, Reformer and Mystic*. Louvain, 1928.

Corblet, Jules. *Hagiographie du diocèse d'Amiens*. 5 vols. Paris and Amiens, 1868-1875.

————. *Histoire du sacrement de l'eucharistie*. Paris, 1886.

Corde, L. T. *Les Pierres tombales du département de l'Eure*, Evreux, 1868.

Cornell, Henrik. *Biblia Pauperum*. Stockholm, 1925.

————. *The Iconography of the Nativity of Christ*. Uppsala, 1924.

Cosacchi, Stephan. *Geschichte der Totentänze*. 3 vols. Budapest, 1956.

————. *Makabertanz, Der Totentanz in Kunst, Poesie und Brauchtum des Mittelalters*. Meisenheim am Glan, 1965.

Cotman, John Sell. *Engravings of Sepulchral Brasses in Norfolk and Suffolk*. 2 vols. London, 1839.

Coudray, Louis. *Histoire du château de Châteaudun*. Paris, 1871.

Coulon, A. *Inventaire des sceaux de la Bourgogne*. Paris, 1912.

Courajod, Louis. *Leçons professées à l'Ecole du Louvre*. 3 vols. Paris, 1899-1903.

————. "Le Moulage; principales applications, collections de modèles reproduits par le plâtre," *Revue des arts décoratifs*, 8 (1887-1888), pp. 161-168.

————, and P.–Frantz Marcou. *Musée de sculpture comparée (Moulages), Palais du Trocadero: Catalogue*. Paris, 1892.

Courboin, François. *Histoire illustrée de la gravure en France*. Paris, 1923.

Couret, Alphonse. *Notice historique sur l'ordre du Saint-Sépulcre de Jérusalem*. Paris, 1905.

Coyecque, E. "Inventaire sommaire d'un minutier parisien pendant le cours du XVIe siècle (1498-1600)," *Bulletin de la société de l'histoire de Paris*, 20 (1893), pp. 40-58, 114-136.

Creizenach, Wilhelm. *Geschichte des neueren Dramas*. 5 vols. Halle, 1893-1916.

Crosnier, Augustin J. *Hagiologie nivernaise*. Nevers, 1858.

Curzon, Henri de. *La Maison du Temple de Paris*, Paris, 1888.

Cusa, Nicholas de. *The Vision of God*, tr. E. G. Salter, New York, 1960.

Cutler, Anthony. "The 'Mulier Amicta Sole' and Her Attendants, an Episode in Late Medieval Finnish Art," *Journal of the Warburg and Courtauld Institutes*, 24 (1966), pp. 117-134.

————. "Octavian and the Sibyl in Christian Hands," *Vergilius*, 11 (1965), pp. 22-32.

Daguin, C.-C. "Tombeau de l'église Saint-Mammes," *Mémoires de la société historique et archéologique de Langres*, 1 (1847), pp. 259-277.

D'Ancona, Paolo. *L'Uomo e le sue opere nelle figurazioni italiani del medioevo*. Florence, 1923.

Daniel, H. A. *Thesauri hymnologici*. 2 vols. Leipzig, 1908-1909.

David, Henri. "Les Bourbons et l'art slutérien au XVe siècle," *Annales du Midi*, 1936, pp. 337-362.

————. "Claus Sluter, Tombier ducal," *Bulletin monumental*, 93 (1934), pp. 409-433.

————. *Claus Sluter*. Paris, 1951.

————. *De Sluter à Sambin*. 2 vols. Paris, 1933.

————. "Le Tombeau de Philippe Pot," *Revue belge d'archéologie*, 5 (1935), pp. 119-133.

David-Daniel, Marie-Louise. *Iconographie des saints médecins Côme et Damien*. Lille, 1958.

Davies, Hugh M., ed. *Catalogue of a Collection of early French Books in the Library of C. Fairfax Murray*. 2 vols. London, 1961.

Davis, N. Z. "Holbein's Pictures of Death and the Reformation at Lyons," *Studies in the Renaissance*, 3 (1956), pp. 97-130.

Déchellete, J. and E. Brassart. *Les Peintures murales du moyen âge et de la Renaissance en Forez*. Montbrison, 1900.

Dehaisnes, Chrétien. "L'Art à Amiens vers la fin du moyen âge dans ses rapports avec l'école flamande primitive," *Revue de l'art chrétien*, 33 (1890), pp. 25-38.

————. *Documents et extraits divers concernant l'histoire de l'art dans la Flandre, l'Artois et le Hainaut avant le XVe siècle*. 2 vols. Lille, 1886.

————. *Recherches sur le retable de Saint-Bertin et sur Simon Marmion*. Lille, 1982.

————. *La Vie et l'oeuvre de Jean Bellegambe*. Lille, 1890.

Dehio, G. G. *Handbuch der deutschen Kunstdenkmäler*. 6 vols. Munich, 1950-1952.

Dejob, Charles. *De l'influence du Concile de Trente sur la littérature et les beaux-arts chez les peuples catholiques; Essai d'introduction à l'his-*

toire littéraire du siècle de Louis XIV. Paris, 1884.

Deladreue, L.-E. "Notice sur l'église collégiale de Saint-Laurent de Beauvais," *Mémoires de la société académique de l'Oise,* 9 (1927), pp. 123-146.

————, and M. Mathon, "Histoire de l'abbaye royale de Saint-Lucien," *Mémoires de la société académique de l'Oise,* 8 (1871-1873), pp. 541-704.

De la Fons Melicocq. "Drame du XVIe siècle," *Annales archéologiques,* 8 (1948), pp. 269-274.

Delaissé, Léon. "Les Miniatures du 'Pèlerinage de la vie humaine' de Bruxelles et l'archéologie du livre," *Scriptorium,* 10 (1956), pp. 233-250.

Delaunay, H. P. *Moines et Sibylles dans l'antiquité judéo-greque.* Paris, 1874.

Delbouille, Maurice. "De l'intérêt des nativités hutoise de Chantilly et de Liège," *Mélanges d'histoire du théâtre du moyen âge et de la Renaissance offerts à Gustave Cohen.* Paris, 1950.

Delignières, Emile. "Un grand fauconnier du XVIe siècle au portail de l'église de St.-Vulfran à Abbéville," *Réunion des sociétés des beaux-arts des départements,* 24 (1900), pp. 287-297.

————. "Les sépulcres ou mises au tombeau en Picardie," *Réunion des sociétés des beaux-arts des départements,* 30 (1906), pp. 33-69.

Delisle, Léopold. *Le Cabinet des manuscrits.* 3 vols. Paris, 1868.

————. *Fac-similé de livres copiés et enluminés pour le roi Charles V.* Nogent-le-Rotrou, 1903.

————. *Les Grandes Heures de la reine Anne de Bretagne et l'atelier de Jean Bourdichon.* Paris, 1913.

————. *Les Heures dites de Jean Pucelle.* Paris, 1910.

————. *Heures de Turin.* Paris, 1902.

————. *L'Histoire littéraire de la France.* 38 vols. Paris, 1933-1949.

————. *Recherches sur la librairie de Charles V.* 2 vols. Paris, 1907.

Demus, Otto. *Byzantine Art and the West.* New York, 1970.

Denais, Joseph. "Le Tombeau du roi René à la cathédrale d'Angers," *Mémoires de la société nationale d'argriculture, sciences et arts d'Angers,* 6 (1892), pp. 159-198.

Denny, D. "The Trinity in Enguerrand Quarton's 'Coronation of the Virgin,'" *Art Bulletin,* 45 (1963), pp. 48-52.

Denys the Carthusian. *Opera Omnia.* 51 vols. Montreuil and Tournay, 1896-1913.

Deonna, W. *Les Arts à Genève des origines à la fin du XVIII siècle.* Geneva, 1942.

Desfarges, Marguerite. "Les Tombeaux de coeur et d'entrailles en France au moyen âge" (diss. Ecole du Louvre, 1947), résumé: *Bulletin des musées de France,* 12 (1947), pp. 18-20.

De Tolnay, Charles. *Hieronymus Bosch.* Basel, 1937.

————. *Le Maître de Flémalle et les frères van Eyck.* Brussels, 1938.

————. "Renaissance d'une fresque," *L'Oeil,* 37 (Jan., 1958), pp. 36-41.

————. *The Sistine Ceiling.* Princeton, 1945.

Devigne, M. "Een nieuw Document voor de Geschiedenis der Beeldjesvan Jac. de Gerines," *Onze Kunst,* 39 (1922), pp. 48-71.

Didron, Adolphe-Napoleon. *Christian Iconography.* 2 vols. New York, 1965.

————. *Monographie de Notre-Dame-de-Brou.* Lyon, 1842.

Dieu, Jean de. "Sainte Anne et l'immaculée conception," *Etudes franciscaines,* 20 (1934), pp. 16-39.

Dijon. *L'Eglise abbatiale de Saint-Antoine en Dauphiné.* Paris, 1902.

————. Musée Municipal. Pierre Quarré. *Chartreuse de Champmol: Foyer d'art au temps des ducs Valois.* Dijon, 1960.

Dimier, L. *Les Danses macabres et l'idée de la mort dans l'art chrétien.* Paris, 1902.

————. *Le Primatice.* Paris, 1926.

Dollmayr, Hermann. "Hieronymus Bosch und die Darstellung der vier letzen Dinge in der niederländische Malerei des XV. und XVI. Jahrhunderts," *Jahrbuch des Kunstsammlungen des allerhöchsten Kaiserhauses,* 19 (1898), pp. 284-343.

Domergue, E. *L'Art et le sentiment dans l'oeuvre de Calvin.* Paris (?), 1902.

Dorez, Léon. *La canzone delle virtù e delle scienze di Bartolomeo de Bartolo da Bologna.* Bergamo, 1904.

————. *Les Manuscrits à peintures de la bibliothèque de Lord Leicester.*

Döring-Hirsch, E. *Tod und Jenseits im Spätmittelalter.* Berlin, 1927.

Doublet, Jacques. *Histoire de l'abbaye de Saint-Denis.* Paris, 1625.

Douce, Francis. *The Dance of Death.* London, 1883.

Dreves, G. M. and C. Blume, eds. *Analecta hymnica medii aevi.* 55 vols. Leipzig, 1886-1922.

Drost, W. *Das Jüngste Gericht des Hans Memling.* Vienna, 1941.

Drouot, Henri. "Le Moiturier et Philippe Pot," *Revue belge d'archéologie,* 6 (1936), pp. 117-120.

————. "Le Nombre des pleurants aux tombeaux des ducs de Bourgogne," *Revue de l'art chrétien*, 61 (1911), pp. 135-141.

————. "De quelques dessins du XVIII siècle représentant les tombeaux des ducs de Bourgogne," *Revue de l'art chrétien*, 64 (1914), pp. 113-118.

Dubois, abbé. *L'Eglise Notre-Dame de Verneuil*. Rennes, 1894.

Du Broc de Segange, Louis. *Les Saints patrons des corporations*. 2 vols. Paris, 1889.

Du Bruck, Edelgard. *The Theme of Death in French Poetry of the Middle Ages and the Renaissance*. The Hague, 1964.

Du Breul, Jacques. *Théâtre des antiquités de Paris*. Paris, 1612.

Du Cange, Charles. *Glossarium mediae et infimae latinitatis*. 7 vols. Paris, 1840-1850.

————. *Traité historique du chef de Jean-Baptiste*. Paris, 1665.

Duclos, H. L. *Histoire de Royaumont*. 2 vols. Paris, 1867.

Duffaut, H. "Une Hypothèse sur la date et le lieu de l'institution du rosaire," *Analecta Bollandiana*, 18 (1899), pp. 290ff.

Dumay, Gabriel. "Epigraphie bourguignonne; église et abbaye de Saint-Bénigne de Dijon," *Mémoires de la commission des antiquités de la Côte d'Or*, 10 (1878-1884), pp. 37-39.

Dupont, Jacques. "Le Sacerdoce de la Vierge," *Gazette des beaux-arts*, 8 (1932), pp. 265-274.

Durand, Georges. "Les Lannoy, Folleville et l'art italien dans le nord de la France," *Bulletin monumental*, 70 (1906), pp. 329-404.

————. *Monographie de l'église Notre-Dame cathédrale d'Amiens* (Mémoires de la société d'antiquaires de Picardie). 2 vols. Amiens, 1901-1903.

————. *Tableaux et chants royaux de la Confrérie du Puy, Notre-Dame d'Amiens* (Société archéologique du département de la Somme. Amiens, 1911.

Durandus, William. *The Symbolism of Churches and Church Ornaments*, tr. J. M. Neale and B. Webb. Leeds, 1843 (2nd ed. London, 1906).

Duriez, Georges. *La Théologie dans le drame religieux en Allemagne au moyen âge*. Paris, n.d.

Durrieu, Paul. "Les 'Belles Heures' du duc de Berry," *Gazette des beaux-arts*, 35 (1906), pp. 265-292.

————. "La Peinture en France au début du XVe siècle: Le Maître des Heures du Maréchal de Boucicaut," *Revue de l'art ancien et moderne*, 19 (1906), pp. 401-415, and 20 (1906), pp. 21-35.

————. "Une 'Pitié de Nostre Seigneur,' "

Monuments et mémoires (Fondation Eugène Piot), 23 (1918-1920), pp. 63-111.

————. *Les Très Belles Heures de Notre Dame du Duc Jean de Berry*. Paris, 1922.

————. *Les Très Riches Heures de Jean de France, Duc de Berry*. Paris, 1904.

————. "La Vierge de la Miséricorde d'Enguerrand Charonton et Pierre Villate au Musée Condé," *Gazette des beaux-arts*, 33 (1904), pp. 5-12.

Düssler, L. *Benedetto da Majano*. Munich, 1924.

Dutilleux, Adolphe and J. Depoin. *L'Abbaye de Maubuisson*. Pontoise, 1882-1890.

Dutuit, Eugene. *Manuel de l'amateur d'estampes*. 4 vols. Paris, 1881-1888.

Eisler, Colin. "The Athlete of Virtue: The Iconography of Asceticism," *De Artibus Opuscula XL, Essays in Honor of Erwin Panofsky*, New York, 1961, pp.82-97.

————. "Jean Duvet," *L'Oeil*, Oct. 1960, pp. 20-27.

Eisler, Robert. "Danse Macabre," *Traditio*, 6 (1948), pp. 187-227.

Emeric-David, T. B. *Histoire de la sculpture française*. Paris, 1853.

Enaud, François. "La 'danse macabre' de la Chaise-Dieu et les problèmes de sa conservation," *Les Monuments historiques de la France*, 5 (1959), pp. 70-91.

Endres, J. A. "Die Darstellung der Gregoriusmesse im Mittelalter," *Zeitschrift für christliche Kunst*, 30 (1917), pp. 146-156.

Der Enndkrist der Stadtbibliothek zu Frankfurt-am-Maine, ed. Kelhner. Frankfurt, 1891.

Engelhart, Hans. *Der Theologische Gehalt der Biblia Pauperum*. Strasbourg, 1927.

Eringa, S. *La Renaissance et les rhétoriqueurs néerlandais Mathieu de Castelyn, Anna Bijns, Luc de Heere*. Paris, 1920.

Esdaile, K. A. and S. Sitwell. *English Church Monuments 1510-1840*. London, 1846.

Estienne, Henri. *Apologie pour Hérodote ou traité de la conformité des merveilles anciennes avec les modernes*. 2 vols. The Hague, 1735.

Ettlinger, L. D. "Pollaiuolo's Tomb of Sixtus IV," *Journal of the Warburg and Courtauld Institutes*, 16 (1953), pp. 239-274.

————. *The Sistine Chapel before Michelangelo*. Oxford, 1965.

Evans, Joan. *Art in Medieval France 987-1498*. Oxford, 1952.

————, ed. *The Flowering of the Middle Ages*. London, 1966.

Fabricius, Johann Albert. *Bibliotheca latina mediae et infimae aetatis.* 6 vols. Hamburg, 1734-1746.

Falk, Franz. "Die älteste Ars moriendi und ihr Verhältniss zur Ars moriendi ex variis scripturarum sentens, zu: *Das löbliche und nussbarliche Buchlein von dem Sterben*, und zum Speculum artis bene moriendi," *Zentralblatt für Bibliothekswesen*, 7 (1890), pp. 308-314.

Faucon, Maurice. "Documents inédits sur l'église de la Chaise-Dieu," *Bulletin archéologique du comité des travaux historiques et scientifiques*, 1884, pp. 383-443.

Fehse, W. *Der Ursprung der Totentänze.* Halle, 1907.

Félice, P. de. *L'Autre Monde. Mythes et légendes. Le Purgatoire de Saint Patrice.* Paris, 1906.

Ferrara, M. *Bibliografia Savonaroliana: bibliografia ragionata degli scritti editi dal principio del secolo XIX ad oggi.* Florence, 1958.

Ferretti, Ludovico. *Il 'Trionfo della Croce' di Fra Girolamo Savonarola.* Siena, 1899.

Feulner, Adolf and Theodor Müller. *Geschichte der deutschen Plastik* (Deutsche Kunstgeschichte, 11). Munich, 1953.

Fichot, Charles. *Statistique monumentale du département de l'Aube.* 4 vols. Paris and Troyes, 1887-1900.

Fierens-Gevaert, H. *La Peinture au musée ancien de Bruxelles.* Brussels and Paris, 1931.

————, ed. *Les Très Belles Heures de Jean de France, duc de Berry.* Brussels, 1924.

Fischer, C. "Die 'Meditationes Vita Christi,' Ihre handschriftliche Uberlieferung und die Verfasserfrage," *Archivum Franciscanum Historicum*, 25 (1932), pp. 457ff.

Fischel, Oskar. "Art and the Theater," *Burlington Magazine*, 66 (1935), pp. 4-14.

Fleury, Edouard. *Antiquités et monuments de l'Aisne.* 4 vols. Paris and Laon, 1877-1882.

Floquet, Pierre A. *Histoire du privilège de Saint-Romain.* Rouen, 1833.

Focillon, Henri. "Origines monumentales du portrait français," *Mélanges offerts à M. Nicholas Iorga.* Paris, 1933, pp. 259-285.

Fontanals, Mila y, "El Canto de la sibila en lengua de Oc," *Romania*, 9 (1880), pp. 353-365.

Ford, James B. and G. S. Vickers. "The Relation of Nũno Conçalves to the Pietà from Avignon, with a Consideration of the Iconography of the Pietà in France," *Art Bulletin*, 21 (1939), pp. 5-43.

Forsyth, Ilene H. *The Throne of Wisdom: Wood Sculptures of the Madonna in Romanesque France.* Princeton, 1972.

Forsyth, William H. *The Entombment of Christ: French Sculptures of the Fifteenth and Sixteenth Centuries.* Cambridge, Mass., 1970.

Frank, Grace. *The Medieval French Drama.* Oxford, 1954.

Franzius, W. *Das mittelalterliche Grabmal in Frankreich.* Tübingen, 1955.

Frappier, J. "L'Humanisme de Jean Lemaire de Belges," *Bibliothèque d'humanisme et Renaissance*, 25 (1963), pp. 289-306.

————. "Jean Lemaire de Belges et les beaux-arts," *Actes du cinquième congrès international des langues et littératures modernes*, Florence, 1955, pp. 107-114.

Freedberg, S. J. *Painting of the High Renaissance in Rome and Florence.* 2 vols. Cambridge, Mass., 1961.

Freund, Lothar. *Studien zur Bildgeschichte des Sibyllen* (diss.). Hamburg, 1936.

Freyhan, R. "The Evolution of the Caritas Figures in the Thirteenth and Fourteenth Centuries," *Journal of the Warburg and Courtauld Institutes*, 11 (1949), pp. 68-86.

Fried, Jakob. *Der Rosenkranz der allerseligsten Jungfrau Maria.* Vienna, 1946.

Friedländer, J. J. *Early Netherlandish Painting.* 8 vols. 1967-1972.

Friedmann, Herbert. *The Symbolic Goldfinch, Its History and Significance in Devotional Art.* Washington, D.C., 1946.

Frothingham, A. L. "A Syrian Artist Author of the Bronze Doors of St. Paul's, Rome," *American Journal of Archaeology*, 18 (1914), pp. 484-493.

Füglister, Robert L. *Das lebende Kreuz.* Zurich and Cologne, 1964.

Gaidoz, H. "La Vierge aux sept glaives," *Mélusine*, 6 (1892-1893), pp. 126-138.

Gaignières, François Roger. *Les Dessins d'archéologie de Roger de Gaignières*, ed. Joseph Guibert, 3rd ser., 8 vols. Paris, 1911-1914.

Galembert, comte de. "Mémoires sur les peintures murales de l'église Saint-Mesme de Chinon," *Mémoires de la société archéologique de Touraine*, 5 (1855), pp. 145-202.

Garside, Charles, Jr. *Zwingli and the Arts.* New Haven and London, 1966.

Gaspar, Camille, and Frederic Lyna. *Les Principaux Manuscrits à peintures de la Bibliothèque Royale de Belgique* (Société française des reproductions des manuscrits à peintures). 2 vols. Paris, 1937.

Gasté, A. "Les Confréries laïques et ecclésiastiques établies avant la Révolution, dans l'église Notre-Dame de Vire," *Bulletin histo-*

rique et philologique du comité des travaux historiques et scientifiques, 1894, pp. 367-381.

Gauchery, P. *Les Travaux d'art du duc de Berry*. Paris, 1894.

Gaussin, Pierre-Roger. *L'Abbaye de la Chaise-Dieu (1043-1518)*. Paris, 1962.

Gauthier, J. "Le Livre d'heures du chancelier Nicholas Perrenot de Grenvelle au British Museum," *Réunion des sociétés des beaux-arts des départements*, 20 (1896), pp. 104-109.

Gelder, Hendrik Enno van. *Erasmus, Schilders en Rederijkers*. The Hague (?), 1959.

———. *The Two Reformations in the Sixteenth Century*. The Hague, 1961.

Genaille, R. "L'Italianisme d'un peintre du nord au début du XVIe siècle (Jean Bellegambe)," *Revue des études italiennes*, 3 (1938), pp. 1-12.

Germain, Léon. *La Chasse à la licorne*. Paris (?), 1897.

———. "Tombe d'Isabelle de Musset," *Bulletin monumental*, 52 (1886), pp. 38-53.

Gerson, Jean. *Opera Omnia*, ed. E. Du Pin. Antwerp, 1706.

Gerstenberg, Kurt. "Zur niederländischen Skulptur des 15 Jahrhunderts," *Oudheidkundig Jaarboek*, 3 (1934), pp. 12-15.

Gertrude the Great. (Anon.) *Life of St. Gertrude the Great*, London, 1912.

———. *Life and Revelations of St. Gertrude*, tr. M. F. Cusack. 3 vols. London, 1870.

Gessler, Jean. "A Propos d'un acteur dans le jeu de sainte Apolline," *Miscellanea Leo van Puyvelde*, Brussels, 1949, pp. 269-276.

Geymuller, Heinrich Adolf. *Die Baukunst der Renaissance in Frankreich*. 2 vols. Stuttgart, 1902-1909.

Giehlow, Karl. "Die Hieroglyphenkunde des Humanismus in der Allegorie der Renaissance," *Jahrbuch der Kunsthistorischen Sammlungen in Wien*, 22 (1915), pp. 1-229.

Giesey, Ralph E. *The Royal Funeral Ceremony in Renaissance France*. Geneva, 1960.

Gilbert, Louis, "Notes sur les confréries à Vire," *Bulletin de la société des antiquaires de Normandie*, 18 (1898), pp. 293-299.

Gillet, Louis. *Histoire artistique des ordres mendiants*. Paris, 1912.

Glixelli, S. *Les Cinq Poèmes des trois morts et des trois vifs*. Paris, 1914.

Goad, Harold E. *The Fame of St. Francis of Assisi*. London, 1929.

Göbel, Heinrich. *Wandteppiche*. 4 vols. Leipzig, 1923.

Goette, Alexander. *Holbeins Totentanz und seine Vorbilden*. Strasbourg, 1897.

Goetz, Oswald. *Der Feigenbaum in der religiösen Kunst des Abendlandes*. Berlin, 1965.

———. "Die henckt Judas," *Form und Inhalt; Kunstgeschichtliche Studien. Otto Schmitt zum 60 Geburtstag*, Stuttgart, 1950, pp. 105-137.

Goldberg, Victoria L. "Graces, Muses and Arts: The Urns of Henry II and Francis I," *Journal of the Warburg and Courtauld Institutes*, 29 (1966), pp. 206-218.

Gontier, abbé. *Saint-Martin de Laigle*, La Chapelle-Montligeon, 1896.

Goodman, H. P. *Original Elements in the French and German Passion Plays* (diss., Bryn Mawr). Philadelphia, 1951.

Goppolt, L. *Typos. Die typologische Deutung des alten Testaments im neuen*. Gutersloh, 1939.

Gouin, Henry. *L'Abbaye de Royaumont*. Paris, 1958.

Gounot, Roger. "Deux Fragments du tombeau de Clement VI au Musée Crozatier du Puy," *Bulletin des musées de France*, 1 (1950), pp. 21-24.

Grabar, Igor. "Sur les origines et l'évolution du type iconographique de la Vierge Eléousa," *Mélanges Charles Diehl*, Paris, 1930, II, pp. 29-42.

Graeve, Mary Ann. "The Stone of Unction in Caravaggio's Painting for the Chiesa Nuova," *Art Bulletin*, 40 (1958), pp. 223-228.

Grässe, J.G.T. *Trésor de livres rares et précieux*. 8 vols. Milan, 1950 (German ed., 7 vols. Dresden, 1859-1869).

Graus, Johannes. *Maria im Ahrenkleid und die Madonna cum Cohanzona von Mailänder Dom*. Graz, 1904.

Green, A. *Les Simulacres et historiées faces de la mort: Commonly called the 'Dance of Death'* (publication of the Holbein Society). London, 1869.

Grignon, Louis. *L'Ancienne Corporation des maîtres cordonniers de Châlons-sur-Marne*, Châlons, 1883.

Grodecki, Louis. *Vitraux de France du XIe au XVIe siècle: Catalogue de l'Exposition du Musée des Arts Décoratifs*. Paris, 1953.

Grosley, Pierre Jean. *Mémoires historiques et critiques pour l'histoire de Troyes*. 2 vols. Paris, 1811-1812.

Gruyer, Gustave. *Les Illustrations des écrits de Jérôme Savonarola publiés en Italie au XVe et au XVIe siècle*. Paris, 1879.

Guardini, R. *Der Rosenkranz unseren Lieben Frau*. Wurzburg, 1954.

Guerry, Liliane. *Le Thème du 'Triomphe de la Mort' dans la peinture italienne*. Paris, 1850.

Guibert, Joseph, ed. *Les Dessins d'archéologie de Roger de Gaignières publiées sous les auspices*

de la société de l'histoire de l'art. 8 vols. Paris, 1911-1914.

———. "Les Origines de la Bible des Pauvres," *Revue des bibliothèques*, 15 (1905), pp. 312-315.

Guides des musées de France. Fribourg, 1970.

Guiffrey, Jules Joseph. *Histoire générale de la tapisserie en France* (Société anonyme des publications périodiques). 2 vols. Paris, 1878-1885.

———. "Les Tapisseries de la Chaise-Dieu," *La Société française d'archéologie. Congrès archéologique de France à Puy*, 71 (1904), pp. 397-401.

———. "Le Tombeau des Poncers d'après un dessin inédit de Percier," *Gazette archéologique*, 8 (1883), pp. 169-176.

Guilhermy, François. *Inscriptions de la France du Ve siècle au XVIIIe siècle.* 5 vols. Paris, 1873-1883.

Guillaume de Deguilleville. *Le Pèlerinage Jhesuchrist de Guillaume de Deguilleville*, ed J. J. Stürzinger. London, 1897.

———. *Le Pèlerinage de la vie humaine*, ed. J. J. Stürzinger (Roxburghe Club). London, 1893.

———. *The Pilgrimage of the Life of Man*, eds. F. J. Furnival and Katharine B. Locock. 2 vols. London, 1899-1904.

———. *Trois Romans-Poèmes du XIVe siècle: Les Pèlerinages et la divine comédie*, ed. J. Delacotte, Paris, 1932.

Gurevich, Vladimir. "Observations on the Iconography of the Wound in Christ's Side," *Journal of the Warburg and Courtauld Institutes*, 20 (1957), pp. 358-362.

Hamann, Richard. "The Girl and the Ram," *Burlington Magazine*, 60 (1932), pp. 91-96.

Hammerstein, Reinhold. *Die Musik der Engel; Untersuchungen zur Musikanschauung des Mittelalters.* Munich, 1962.

Harnack, Adolf C. G. von. *Bruchstücke des Evangeliums und der Apokalypse des Petrus* (Untersuchungen zur Geschichte der altchristlichen Literatur, ix, pt. 2). Leipzig, 1893.

Harris, E. "Mary in the Burning Bush: Nicholas Froment's Triptych at Aix-en-Provence," *Journal of the Warburg and Courtauld Institutes*, 1 (1938), pp. 281-286.

Hartlaub, G. F. *Zauber des Spiegels.* Munich, 1951.

Harvard College Library (Department of Printing and Graphic Arts). R. Mortimer, ed. *Catalogue of Books and Manuscripts. Part I: French 16th Century Books.* 2 vols. Cambridge, Mass., 1964.

Heckscher, W. S. "Relics of Pagan Antiquity in Medieval Settings," *Journal of the Warburg and Courtauld Institutes*, 1 (1938), pp. 204-220.

Heider, Gustav. "Beiträge zur christlichen Typologie aus Bilderhandschriften des Mittelalters," *Jahrbuch der Klassiker-Kunst. Zentral Kommission zur Erforschung und Erhaltung der Baudenkmale*, 5 (1861), pp. 1-128.

Heimann, Adelheid. "Der Meister de 'Grandes Heures de Rohan' und seine Werkstatt," *Städel Jahrbuch*, 7-8 (1932), pp. 1-61.

Heist, William H. *The Fifteen Signs Before Doomsday.* East Lansing, Mich., 1952.

———. "Four Old French Versions of the Fifteen Signs before the Judgment," *Medieval Studies*, 15 (1953), pp. 184-198.

Heitz, Paul, ed. *Biblia Pauperum.* Strasbourg, 1903.

——— and Wilhelm Schreiber. *Pestblätter des XV. Jahrhunderts.* Strasbourg, 1901.

Helbig, Jules. "Luc Fayd'herbe étudiée dans les travaux ignorés des ses biographies," *Revue de l'art chrétien*, 36 (1893), pp. 1-13.

Held, Julius. *Dürers Wirkung auf die niederländische Kunst seiner Zeit.* The Hague, 1931.

Hélin, M. "Un Texte inédit sur l'iconographie des sibylles," *Revue belge de philologie et d'histoire*, 15 (1936), pp. 349-366.

Hélinand. *Les Vers de la mort par Hélinant*, eds. F. Wulff and W. Walberg. Paris, 1905.

Hell, Vera and Hellmut. *The Great Pilgrimage of the Middle Ages.* New York, 1966.

Helm, R. *Skellet und Todesdarstellung bis zum Auftreten der Totentänze.* Strasbourg, 1928.

Hermanin, Federico. *L'Appartamento Borgia in Vaticano.* Rome, 1934.

Herrad of Landsberg. *Hortus Deliciarum. Le 'Jardin des délices,' un manuscrit alsacien à miniatures du XIIe siècle* (Editions Oberlin). Strasbourg, 1945.

Herwegen, P. I. "Ein mittelalterlichen Kanon des menschlichen Körpers," *Repertorium für Kunstwissenschaft*, 32 (1909), pp. 445-446.

Hind, Arthur M. *Early Italian Engraving: A Critical Catalogue.* 2 vols. London, 1938-1948.

Histoire littéraire de la France (Ouvrage commencé par des religieux bénédictins de la congrégation de Saint-Maur et continué par les membres de l'institut). 38 vols. Paris, 1733-1949.

Hoffmann, J. *Alain Chartier, His Work and Reputation.* New York, 1942.

Hollis, Thomas. *The Monumental Effigies of Great Britain.* 2 vols. London, 1840-1842.

Hollstein, F.W.H. *Dutch and Flemish Etchings, Engravings and Woodcuts, ca. 1450-1700.* 19 vols. Amsterdam, [1956].

Holtrop, J. W. *Monuments typographiques des pays-bas au XVe siècle*. The Hague, 1868.

Hoogewerff, G. J. *De Noord-Nederlandse Schilderkunst*. 5 vols. The Hague, 1936-1947.

Horace. *Horace: Satires and Epistles*, ed. Edward P. Morris, Norman, Okla., 1968.

Horster, Marita. "Mantuae Sanguis Preciosus," *Wallraf-Richartz Jahrbuch*, 25 (1963), pp. 151-180.

Houday, J. "Tombeaux de Beaudoin V et de Louis de Male, comtes de Flandres," *Revue des sociétés savantes*, 3 (1876), pp. 517-522.

Houvet, Etienne. *Monographie de la cathédrale de Chartres*. Paris, n.d.

Huart, Georges. "A Propos d'un vitrail du XVIe siècle de la cathédrale d'Evreux," *Bulletin de la société nationale des antiquaires de France*, 1939-1940, pp. 101-133.

Hugo, Victor. *Les Chansons des rois et des bois*. Paris, 1933.

Huizinga, Johan. *The Waning of the Middle Ages*. London, 1924 (paperback: New York, 1954).

Hulle, dom le. *Thrésor ou abrégé de l'histoire de la noble et royale abbaye de Fécamp*, 1684, publ. Alexandre, Paris (?), 1893.

Hulst, Roger A. d'. *Tapisseries flamandes du XVe au XVIIIe siècle*. Brussels, 1960 (tr. Frances J. Stillman, New York, [1968]).

Hulubei, Alice. "Virgile en France au XVIe siècle," *Revue du XVIe siècle*, 18 (1931), pp. 1-77.

Inge, W. R. *Christian Mysticism* (Bampton Lectures for 1899). 7th ed., London, 1933.

Jacob, Henriette s'. *Idealism and Realism, A Study in Sepulchral Symbolism*. Leyden, 1954.

Jacquot, Albert. "La Sculpture en Lorraine," *Réunion des sociétés des beaux-arts des départements*, 12 (1888), pp. 841-861.

James, M. R. *The Apocalypse in Art*. London, 1931.

———. *The Apocryphal New Testament*. London, 1924 (corrected ed., London, 1953).

Janson, Horst W. *The Sculpture of Donatello* (Incorporating the Notes and Photos of Jenö Lanyi). Princeton, 1963.

Janvier, A. "Notice sur les anciennes corporations d'archers et d'arbalétriers des villes de Picardie," *Mémoires de la société des antiquaires de Picardie*, 14 (1856), pp. 61-308.

Jeanroy, A. and H. Teulié, eds. *Mystères provençaux du XVe siècle*. Toulouse, 1893.

Jedin, H. "Entstehung und Tragwerte des Trienter Dekret über die Bilderverehrung," *Theologische Quartalschrift*, 116 (1935), pp. 142ff., 404ff.

———. *A History of the Council of Trent*. 2 vols. London, 1957-1961.

Jerphanion, Guillaume de. *Une Nouvelle Province de l'art byzantin; Les Eglises rupestres de Cappadoce*. 3 vols. Paris, 1925-1944.

Joannes de Carthagena. *De religionis christianiae arcanis homiliae sacrae cum catholicae tum morales*. 3 vols. Antwerp, 1622.

Joannis de Fordun. *Scotichronicon*, ed. W. Goodall. 2 vols. Edinburgh, 1759.

Jodogne, Omer. "Marie-Madeleine pécheresse dans les passions médiévales," *Scrinium Lovaniense, Etienne van Cauwenbergh*, Louvain, 1961, pp. 272-284.

———. "Recherches sur les débuts du théâtre religieux en France," *Cahiers de civilisation médiévale* (University of Poitiers), 8 (1965), pp. 1-24, 179-189.

Jourdain, Eliacon and Duval. "Les Sibylles peintures murales de la cathédrale d'Amiens," *Mémoires de la société des antiquaires de Picardie*, 7 (1846), pp. 257-302.

Joret, C. *La Rose dans l'antiquité et au moyen âge*. Paris, 1892.

Journal d'un bourgeois de Paris. Paris, 1881.

Jubinal, Achille. *La Danse des morts de la Chaise-Dieu*. Paris, 1841.

———. *La Légende de Saint Brendaines*. Paris, 1836.

———. *Mystères inédits du quinzième siècle*. 2 vols. Paris, 1837.

Jullian, René. "Le franciscanisme et l'art italien," *Phoebus*, 1 (1946), pp. 105-115.

Jung, Marc-René. *Hercule dans la littérature française du XVIe siècle; De l'Hercule courtois à l'Hercule baroque* (Travaux d'Humanisme et Renaissance, 79), Geneva, 1966.

Kampers, Franz. "Die Sibylle von Tibur und Vergil, II." *Historisches Jahrbuch*, 29 (1908), pp. 241-263.

Kantorowicz, Ernst H. *The King's Two Bodies. A Study in Medieval Political Theology*. Princeton, 1957.

Katzenellenbogen, Adolf. *Allegories of Virtues and Vices in Medieval Art from Early Christian Times to the Thirteenth Century*. London, 1939.

Keller, Harald. "Die Entstehung des Bildnisses am Ende des Hochmittelalters," *Römisches Jahrbuch für Kunstgeschichte*, 3 (1929), pp. 227-256.

———. *Giovanni Pisano*. Vienna, 1942.

Kernodle, George. *From Art to Theatre: Form and Convention in the Renaissance*. Chicago (1944).

King, Georgiana Goddard. "The Virgin of Humility," *Art Bulletin*, 17 (1935), pp. 474-491.

Kleinclausz, A. "L'Art funéraire de la Bourgogne au moyen âge," *Gazette des beaux-arts*, 26 (1901), pp. 441-458, and 27 (1902), 299-320.

———. *Claus Sluter et la sculpture bourguignonne au XVe siècle.* Paris, 1905.

Klemm, Bernhard. *Der Bertin-Altar aus St.-Omer.* Leipzig, 1914.

Knipping, B. *De Iconografie van de Contra-Reformatie in der Nederlanden.* 2 vols. Hilversum, 1939.

Koch, Robert A. "The Sculptures of the Church of Saint-Maurice at Vienne, the *Biblia Pauperum* and the *Speculum Humanae Salvationis*," *Art Bulletin*, 32 (1950), pp. 151-155.

Koechlin, Raymond. *Les Ivoires gothiques français.* 3 vols. Paris, 1924.

———. "Quelques Ateliers d'ivoiriers français au XIIIe et XIVe siècles," *Gazette des beaux-arts*, 34 (1905), pp. 49-62.

———. "La Sculpture belge et les influences françaises aux XIIIe et XIVe siècles," *Gazette des beaux-arts*, 30 (1903), pp. 5-19, 333-348, 391-407.

———, and J. J. Marquet de Vasselot. *La Sculpture à Troyes et dans la Champagne méridionale au seizième siècle.* Paris, 1900.

Körte, Werner. "Deutsche Vesperbilder in Italien," *Jahrbuch der Biblioteca Hertziana*, 1 (1937), pp. 3-138.

Kraus, Franz Xavier. *Geschichte der christlichen Kunst*, revised by S. Sauer. 2 vols. Freiburg-im-Breisgau, 1896-1908.

———. *Kunst und Alterthum in Elsass-Lothringen.* 4 vols. Strasbourg, 1876-1892.

Krautheimer, Richard. "Introduction to an 'Iconography of Medieval Architecture,'" *Journal of the Warburg and Courtauld Institutes*, 5 (1942), pp. 1-33.

———. *Lorenzo Ghiberti.* Princeton, 1956.

Kristeller, Paul. *Il Trionfo della Fede.* Berlin, 1906.

Kuňstle, Karl. *Ikonographie der christlichen Kunst.* 2 vols. Freiburg-im-Breisgau, 1926-1928.

———. *Die Legende der drei Lebenden und der drei Toten und der Totentanz.* Freiburg-im-Breisgau, 1908.

Kurth, Willi. *The Complete Woodcuts of Albrecht Dürer.* New York, 1946.

Kurtz, L. P. *The Dance of Death and the Macabre Spirit in European Literature.* New York, [1934].

Laborde, Alexandre de. *La Bible moralisée conservée à Oxford, Paris et Londres. Réproduction intégrale du manuscrit du XIIIe siècle.* 5 vols. Paris, 1911-1927.

———. *Etude sur la Bible moralisée illustrée.* 4 vols. Paris, 1911-1927.

———. *La Mort chevauchant un boeuf.* Paris, 1923.

Laborde, Léon de. *Les Ducs de Bourgogne.* 3 vols. Paris, 1849-1852.

Laclotte, Michel. *L'Ecole d'Avignon.* Paris, 1960.

Lacombe, Paul. *Catalogue des livres d'heures imprimés au XVe et au XVIe siècle conservés dans les bibliothèques publiques de Paris.* Paris, 1907.

Lactantius, Lucius Caecilius Formanius. *The Divine Institutes*, tr. Mary Frances McDonald. Washington, 1964.

Lafond, Jean. "Etudes sur l'art du vitrail en Normandie; Arnoult de la Point, peintre et verrier de Nemègue et les artistes étrangers à Rouen aux XVe et XVIe siècles," *Bulletin de la société des amis des monuments rouennais*, 1911, pp. 141-172.

Lafond, Paul. "L'Art portugais," *Revue de l'art ancien et moderne*, 23 (1903), pp. 305-316.

La Marche, Olivier de. *Mémoire* (Société l'histoire de France), eds. H. Beaune and J. d'Arbaumont. 4 vols. Paris, 1883-1888.

Lamartine, Alphonse Marie de. *Geneviève; histoire d'une servante.* Paris, 1851.

Langfors, Arthur. "Notice des manuscrits 535 de la bibliothèque de Metz et 10047 des nouvelles acquisitions du fonds français de la Bibliothèque Nationale, suivie de cinq poèmes français sur la parabole des Quatres Filles Dieu," *Notices et extraits des manuscrits de la Bibliothèque Nationale et autres bibliothèques*, 42 (1933), pp. 139-290.

Langlois, Charles. *Essai historique, philosophique et pittoresque sur les Danses des morts.* 2 vols. Paris and Rouen, 1851-1852.

Langlois, Eustache Hyacinthe. *Les Stalles de la cathédrale de Rouen.* Rouen, 1838.

———. *Origines et Sources du Roman de la Rose.* Paris, 1891.

La Piana, George. "The Byzantime Theater," *Speculum*, 11 (1936), pp. 171-211.

Lapparant, M. "Les Saints eucharistiques: Sainte Barbe," *L'Eucharistie*, 1928, pp. 739-742.

La Quérière, Eustache de. *Description historique des maisons de Rouen.* 2 vols. Paris, 1821-1841.

———. *Notice sur l'ancienne église paroissiale Saint-Jean de Rouen.* Rouen, 1860.

Laroche, M. "Notice sur un tronc portatif, en cuivre appartenant à l'église Saint-Spire de Corbeil," *Commission des antiquités et des arts de Seine-et-Oise*, 2e fasc., 1882, pp. 80-82.

Lasteyrie, Robert de. "Séance du 5 avril, 1893," *Bulletin archéologique du comité des travaux historiques et scientifiques*, Paris, 1893, p. xlviii.

Launay, Marie de. "Observations sur le vitrail d'hospice Saint-Jacques de Vendôme," *Congrès archéologique de France*, 1872, pp. 194-197.

Lavarenne, M. *La Psychomachie de Prudence.* Paris, 1933.

Lavin, Marilyn Aronberg. "Giovanni Battista, A Study in Renaissance Religious Symbolism," *Art Bulletin*, 38 (1955), pp. 85-101.

Lebel, Gustave. "Notes sur Antoine Caron et son oeuvre," *Bulletin de la société de l'histoire de l'art français*, 1940, pp. 7-34.

———. "Un Tableau d'Antoine Caron," *Bulletin de la société de l'histoire de l'art français*, 1937, pp. 20-37.

Lebeuf, Jean. *Dissertations sur l'histoire ecclésiastique et civile de Paris.* 3 vols. Paris, 1739-1743.

———. *Histoire de la ville et de tout le diocèse de Paris.* 6 vols. Paris, 1883-1890.

Le Breton, Gaston. "Peintures murales de l'école de Fontainebleau découvertes à Gisors," *Réunion des sociétés des beaux-arts des départements*, 7 (1883), pp. 174-183.

Lecler, André. *Etude sur les mises au tombeau.* Limoges, 1888.

Lee, R. W. "Ut Pictura Poesis: The Humanistic Theory of Painting," *Art Bulletin*, 22 (1940), pp. 197-269.

Leewenberg, Jaap. "De tien bronzen 'Plorannen' in het Rijksmuseen te Amsterdam," *Gentshe Bijdragen tot de Kunstgeschiedenis*, 13 (1951), pp. 13-35.

Lefèvre, Eugène. "Les Inscriptions prophétiques dans le vitrail des sibylles de l'église Notre-Dame d'Etampes," *Revue de l'art chrétien*, 53 (1910), pp. 259-269.

Lefrançois-Pillion, Louise. "Le Mystère d'Octavien et la sibylle dans les statues de la Tour de Beurre à la cathédrale de Rouen," *Revue de l'art*, 47 (1925), pp. 145-153, 221-231.

———. "Nouvelles Etudes sur les portails du transept à la cathédrale de Rouen," *Revue de l'art chrétien*, 28 (1913), pp. 281-299.

———. "Le Vitrail de la Fontaine de Vie et de la Nativité de Saint-Etienne à l'église Saint-Etienne de Beauvais," *Revue de l'art chrétien*, 53 (1910), pp. 367-378.

Le Frois, B. J. *The Woman Clothed with the Sun.* Rome, 1954.

Lehrs, Max. "The Master FVB," *Print Collector's Quarterly*, 9 (1923), pp. 3-30, 149-166.

Lemaire de Belges, Jean. *Oeuvres*, ed. J. Stecher, 4 vols. Louvain, 1882-1891.

Le Métayer-Masselin, Léon. *Collection de dalles tumulaires de la Normandie.* Caen, 1861.

Lemoisne, Paul-André. *Les Xylographies du XIVe et du XVe siècle au cabinet des estampes de la Bibliothèque Nationale.* 2 vols. Paris and Brussels, 1927-1930.

Le Nail, L. "Note sur un tombeau du templier deposé au musée de Blois," *Bulletin monumental*, 44 (1878), pp. 762-766.

Lépicier, Augustin M. *L'Immaculée conception dans l'art et l'iconographie.* Spa. 1956.

Leroquais, Victor. *Les Bréviaires manuscrits des bibliothèques publiques de France.* 5 vols. Paris, 1934.

———. *Les Livres d'heures manuscrits des bibliothèques publiques de France.* 3 vols. Paris, 1927.

———. *Les Pontificaux manuscrits des bibliothèques publiques de France.* 3 vols. Paris, 1937.

———. *Les Sacramentaires et les missels manuscrits des bibliothèques publiques de France.* 3 vols. Paris, 1924.

Le Roux de Lincy, Antoine. "Poème sur le précieux sang," *Essai historique et littéraire sur l'abbaye de Fécamp*, Rouen, 1840, pp. 147-148.

Leroux, J. "A Propos d'un tableau de l'église Notre-Dame à Douai," *Revue du nord*, 5 (1914), pp. 89-100.

Leymaire, C. "La Sculpture décorative à Limoges," *Réunion des sociétés des beaux-arts des départements*, 19 (1895), pp. 579-587.

Liebeschütz, H. *Fulgentius metaforales, ein Beitrag zur Geschichte der antiken Mythologie im Mittelalter.* Leipzig, 1926.

Liebreich, Aenne. *Claus Sluter.* Brussels, 1936.

Ligtenberg, R. "De Genealogie van Christus in de beeldende kunst der middeleewen, voornamelijk van het westen," *Oudheidkundig Jaarboek*, 9 (1929), pp. 3-54.

Limousin, Raymond. *Jean Bourdichon.* Paris, 1954.

Lindet, L. "Les Réprésentations allégoriques du moulin et du pressoir dans l'art chrétien," *Revue archéologique*, 36 (1900), pp. 403-413.

Lindgren-Fridell, M. "Der Stammbaum Maria aus Anna und Joachim," *Marburger Jahrbuch*, 11-12 (1938-1939), pp. 289-308.

Lippmann, F. *The Seven Planets*, tr. Florence Simmonds. London, 1895.

Littré, Emile. *Dictionnaire de la langue française.* 4 vols. Paris, 1888 (repr. Paris, 1958).

London, British Museum. Department of Manuscripts. Robin E. W. Flower. *Catalogue of Irish Manuscripts in the British Museum*, II, and III, London, 1926.

———. William Harry Rylands, ed. *Ars Moriendi (editio princeps, circa 1450); A Reproduction*

of the Copy in the British Museum. London, 1881.

———. George Warner. *Queen Mary's Psalter; Miniatures and Drawings by an English Artist of the Fourteenth Century Reproduced from Royal Manuscript 2 B VII in the British Museum*. London, 1912.

Longnon, Jean. "Le Livre d'heures d'un preux chevalier," *L'Oeil*, 36 (1957), pp. 24-31.

Longuemar, Alphonse Letouzé de. *Anciennes fresques du Poitou*. Poitier, n.d.

Loriquet, Charles. *Les Tapisseries de la cathédrale de Reims*. Paris, 1882.

Loth, Julien. "Les Derniers jours de l'académie des Palinods du Rouen," *Mémoires lus à la Sorbonne*, 1866, pp. 346-361.

Lotz, Wolfgang. "Historismus in der Sepulkralplastik um 1600," *Anzeiger des germanisches Nationalmuseum*, 1940-1953, pp. 61-86.

Lubac, Henri de. *Exégèse médiévale*. Paris, 1959.

Lübke, W. *Der Totentanz in der Marienkirche zu Berlin*. Berlin, 1861.

Luchaire, Achille. *Innocent III, Rome et l'Italie*. 6 vols. Paris, 1905-1908.

Luther, Martin. *Works of Martin Luther*, ed. H. E. Jacobs. 4 vols. Philadelphia, 1915-1931.

Lutz, J., and P. Perdrizet. *Speculum humanae salvationis*. 2 vols. Leipzig, 1907-1909.

MacGibbon, David. *Jean Bourdichon, A Court Painter of the Fifteenth Century*. Glasgow, 1933.

Machiavelli, Niccolo. *The Chief Works*, tr. Allan Gilbert. 3 vols. Durham, N.C., 1965.

Mainguet, Pierre. *St. Christophe*. Tours, 1891.

Mâle Emile. *Art et artistes du moyen âge* (Images et idées, Arts et métiers graphiques). Paris, 1968 (1st ed. Paris, 1927).

———. *L'Art religieux après le concile de Trente; Etude sur l'iconographie de la fin du XVIe siècle, du XVIIe siècle, du XVIIIe siècle; Italie, France, Espagne, Flandres*. Paris, 1932. (Eng. ed.: *Religious Art after the Council of Trent*. Bollingen XC.4. Princeton forthcoming.)

———. *L'Art religieux du XIIe siècle en France*, 2nd. ed. Paris, 1953. (Eng. ed.: *Religious Art in France: The Twelfth Century*. Bollingen XC.1. Princeton, 1978.)

———. *L'Art religieux du XIIIe siècle en France*. 9th ed. Paris, 1958. (Eng. ed.: *Religious Art in France: The Thirteenth Century*, Bollingen XC.2. Princeton, 1985).

———. "L'Art symbolique à la fin du moyen âge," *Revue de l'art ancien et moderne*, 18 (1905), pp. 81-96; 195-209; 435-445.

———. *La Cathédrale d'Albi*. Paris, 1950.

———. "L'Idée de la mort et la danse macabre," *Revue des deux mondes*, 32 (1906), pp. 647-679.

———. "Une Influence des mystères sur l'art italien du XVe siècle," *Gazette des beaux-arts*, 35 (1906), pp. 89-94.

———. "Jean Bourdichon et son atelier," *Gazette des beaux-arts*, 32 (1904), pp. 441-457.

———. *Notre-Dame de Chartres*. Paris, 1948.

———. "Les Originaux des tapisseries de la Chaise-Dieu," *Congrès archéologique de Puy*, 1904, pp. 402-405.

———. *Quomodo sibyllas recentiores artifices repraesentaverint* (diss.), Paris, 1899.

———. "La Resurrection de Lazare dans l'art," *Revue des arts*, 1 (1951), pp. 44-52.

———. "Les Rois Mages de le drame liturgique," *Gazette des beaux-arts*, 4 (1910), pp. 261-270.

———. *Les Saints compagnons du Christ*. Paris, 1958.

Mallay, M. "La Fête de Saint-Georges à Désertines," *Annales scientifiques, littéraires et industrielles de l'Auvergne* (Clermont-Ferrand), 22 (1849), pp. 231-234.

Manasse, E. M. "The Dance Motive of the Latin Dance of Death," *Medievalia et Humanistica*, 4 (1946), pp. 83-103.

Mannhardt, W. *Der Baumkultus der Germanen*. 2 vols. Berlin, 1875-1877.

Manville, Armand. "Eglise Saint-Pierre de Cholet," *Bulletin monumental*, 62 (1897), pp. 56-70.

Marcel, L. E. *L'Ancien Sépulchre de la cathédrale de Langres*. Langres, 1918.

Margy, M. Q. "Notice sur deux anciennes maisons de Senlis," *Comité archéologique de Senlis. Mémoires*, 3 (1877), pp. 215-360.

Marle, Raimond van. *The Development of the Italian Schools of Painting*. 18 vols. The Hague, 1928.

———. *L'Iconographie de l'art profane au moyen âge et à la Renaissance*. 2 vols. The Hague, 1931-1932.

Marquet de Vasselot, J. J. "Les Boiseries de Gaillon," *Bulletin monumental*, 86 (1927), pp. 321-369.

———. "Les Emaux de Monvaërni au musée du Louvre," *Gazette des beaux-arts*, 3 (1910), pp. 299-316.

Marsaux, Léopold Henri. "La Fontaine de vie; Etude sur une miniature," *Notes d'art et d'archéologie*, Dec. 1891.

———. "Glanes iconographiques," *Revue de l'art chrétien*, 56 (1906), pp. 110-113.

————. *Représentations allégoriques de la Sainte Eucharistie*. Bar-le-Duc, 1889.

Martin, Arthur. "Chasse de Saint-Taurin d'Evreux," *Mélanges d'archéologie, d'histoire et de littérature*, 2 (1851), pp. 1-38.

Martin, Henry. *Les Miniaturistes français*. Paris, 1906.

————. "La Somme le Roi, Bibl. Mazarine no. 870," *Les Trésors des bibliothèques de France*, Paris, 1925, I, pp. 43-57.

Martin, Henri. *Les Vitraux de la cathédrale d'Auch*. Toulouse, 1922.

McDermott, W. C. *The Ape in Antiquity*. Baltimore, 1938.

McKenzie, A. Dean. *The Virgin Mary as the Throne of Solomon in Medieval Art* (diss., New York University). 2 vols. New York, 1965.

McNamee, J. B. "Further Symbolism in the Portinari Altarpiece," *Art Bulletin*, 45 (1963), pp. 142-143.

————. "The Origin of the Vested Angel as Eucharistic Symbol in Flemish Painting," *Art Bulletin*, 54 (1972), pp. 263-278.

Meditations on the Life of Christ, an Illustrated Manuscript of the Fourteenth Century, Paris, Bibliothèque Nationale, ms. ital. 115, tr. Isa Ragusa, ed. Rosalie B. Green. Princeton, 1961.

Meer, F. van der. *Maiestas Domini, Théophanies de l'Apocalypse dans l'art chrétien, Etude sur les origines d'une iconographie spéciale du Christ*. Rome and Paris, 1938.

Mégnien, P. *La Danse macabre de la Ferté-Loupiere*. Joigny, 1939.

Meiss, Millard. "An Early Altarpiece for the Cathedral of Florence," *Metropolitan Museum of Art Bulletin*, 12 (1954), pp. 302-317.

————. "French and Italian Variations on an Early Fifteenth-Century Theme, St. Jerome in His Study," *Essais en l'honneur de Jean Porcher; Etudes sur les manuscrits à peintures (Gazette des beaux-arts)*, Paris, 1963, pp. 147-170.

————. *French Painting in the Time of Jean de Berry; The Boucicaut Master*, London, 1968.

————. *French Painting in the Time of Jean de Berry; The Late Fourteenth Century and the Patronage of the Duke*. 2 vols. New York, 1967.

————. "Fresques italiennes, cavallinesques et autres, à Beziers," *Gazette des beaux-arts*, 18 (1937), pp. 275-286.

————. "Italian Style in Catalonia and a Fourteenth-Century Catalan Workshop," *Journal of the Walters Art Gallery*, 4 (1941), pp. 45-87.

————. "Light as Form and Symbol in some Fifteenth-Century Paintings," *Art Bulletin*, 28 (1945), pp. 175-181.

————. "The Madonna of Humility," *Art Bulletin*, 18 (1936), pp. 435-464.

————. *Painting in Florence and Siena after the Black Death*, New York, 1964.

————, ed. *The Très Riches Heures de Jean, Duke of Berry*. New York, 1969.

Méloizes, Albert des. "Marché passé en 1503 pour l'exécution d'une tombe," *Bulletin monumental*, 56 (1890), pp. 416-423.

Mellot, Jean. "A Propos du théâtre liturgique à Bourges, au moyen âge et au XVIe siècle," *Mélanges d'histoire du théâtre du moyen âge et de la Renaissance offerts à Gustave Cohen*, Paris, 1950.

Mély, Fernand de. *Les Primitifs et leur signatures*. Paris, 1913.

————. "Du Rôle des pierres gravées au moyen âge," *Revue de l'art chrétien*, 43 (1893), pp. 14-24; 98-105; 191-203.

————. "Les 'Très Riches Heures' du duc de Berry et les 'trois grâces' de Sienne," *Gazette des beaux-arts*, 8 (1912), pp. 195-201.

Menu, Henri. "Mélanges d'épigraphie ardennaise," *Bulletin monumental*, 58 (1893), pp. 27-45.

Mercadé, Eustache. *Le Mystère d'Arras*. Arras, 1893.

Méril, E. du. *Les Origines latines du théâtre moderne*. Leipzig, 1897.

Mersmann, W. *Der Schmerzensmann*. Dusseldorf, 1942.

Merson, Olivier. *Les Vitraux*. Paris, 1895.

Mesnil, J. *L'Art au nord et au sud des Alpes à l'époque de la Renaissance*. Paris, 1911.

Mew, James. *Traditional Aspects of Hell*. London, 1903.

Meyer, Paul. *Daurel et Beton*. Paris, 1880.

————. "La Descente de Saint Paul en Enfer; Poème français composé en Angleterre," *Romania*, 1895, pp. 357-375.

————. "Notice du ms. Plut. 76, no. 79 de la Laurentienne," *Bulletin de la société des anciens textes*, 5 (1879), pp. 72-96.

————. "Notice sur la Bible des sept états du monde de Geufroi de Paris," *Notices et extraits des manuscrits de la Bibliothèque Nationale et autres bibliothèques*, 39 (1909), pt. 1, pp. 255-322.

Michaëlis, C. "Quindecim Signa ante Judicium," *Archiv für das Studium der neuren Sprachen und Literaturen*, 46 (1870), pp. 33-60.

Michel, André, ed. *Histoire de l'art depuis les premiers temps chrétiens jusqu'à nos jours*. 8 vols. Paris, 1905-1929.

Michel, Edmond. *Monuments religieux, civiles et militaires du Gâtinais.* Lyon, 1879.

Michel, H. "L'Horloge de sapience et l'histoire de l'horlogerie," *Physis*, 2 (1961), pp. 291-298.

Michna, Christiana. *Maria als Thron Salomonis* (diss.). Vienna, 1950.

Migne, J.-P., ed. *Patrologiae cursus completus, Series graeca.* 161 vols. Paris, 1857-1904.

———. *Patrologiae cursus completus, Series latina.* 217 vols. Paris, 1844-1905.

G. Millar, ed. *An Illuminated Manuscript of La Somme le Roy, attributed to the Parisian Miniaturist Honoré* (Roxburghe Club). Oxford, 1953.

Millet, Gabriel. *Recherches sur l'iconographie de l'Evangile au XIVe, XVe et XVIe siècles.* Paris, 1916.

Millin, Aubin Louis. *Antiquités nationales.* 5 vols. Paris, 1790-1796.

Minott, C. I. "A Note on Nicholas Froment's 'Burning Bush Triptych,'" *Journal of the Warburg and Courtauld Institutes*, 25 (1962), pp. 323-325.

Moé, Emile van. "Les 'Ethiques, politiques et économiques' d'Aristote traduits par Nicole Oresme, ms. de la bibliothèque de la ville de Rouen," *Les Trésors des bibliothèques de France*, Paris, 1930, pp. 3-15.

Molanus, Jean. *De historia sacrarum imaginum et picturarum* (1580), ed. J.N. Paquot. Louvain, 1771.

Molinari, Cesare. *Spettacoli fiorentini del quattrocento.* Venice, 1961.

Molinet, Jean. *Les Faictz et dictz de Jean Molinet*, ed. Noel Dupire. (Société des anciens textes français). 3 vols. Paris, 1936-1939.

Mone, F. J. *Lateinische Hymnen des Mittelalters.* 3 vols. Freiburg, 1853-1855.

Montaiglon, A. de. *L'Alphabet de la mort d'Hans Holbein.* Paris, 1856.

———. "La Famille des Juste en France," *Gazette des beaux-arts*, 12 (1875), pp. 385-404, 515-526, and 13 (1876), pp. 552-568.

Montault, Xavier Barbier de. "Le Château, la terre, le prieuré et les chapelleries de Boumois," *Commission archéologique de Maine et Loire, Répertoire archéologique d'Anjou*, 1858-1859, pp. 85-117.

———. "Les Mésures de dévotion," *Revue de l'art chrétien*, 32 (1881), pp. 360-419.

———. *Oeuvres complètes.* 9 vols. Poitiers, 1899-1894.

Montégut, Emile. *Souvenirs de Bourgogne.* Paris, 1874.

Monteverdi, Angelo. Review of F. Ed. Schneegans, "Le Mors de la Pomme, texte du XVe siècle," *Romania*, 66 (1920), pp. 537-570, in *Archivum Romanicum*, 5 (1920), pp. 110-134.

Montfaucon, Bernard de. *Les Monumens de la monarchie françoise.* 5 vols. Paris, 1729-1733.

Monumenta Germaniae Historica, Scriptores, ed. G. H. Pertz, T. Mommsen and others. 32 vols. Hanover, 1826-1913 (repr. Stuttgart and New York, 1963-1964).

Morand, Kathleen. *Jean Pucelle.* Oxford, 1962.

Morawski, Josef. *La Légende de Saint Antoine Ermite. Histoire, poésie, art, folklore.* Pozman, 1939.

Moret, abbé. *Manuel de la confrérie de Saint-Roch.* Moulins, 1899.

Le Mors de la Pomme (Publication of the Institute of French Studies, 87), ed. L. P. Kurtz. New York, 1937.

Moujeot, Georges. "Le Saint Jacques de Semur," *Revue de l'art chrétien*, 62 (1912), pp. 221-223.

Moutard-Uldry, Renée. *Saint Crépin et Saint Crépinien.* Paris, 1942.

Müller, Theodor. *Sculpture in the Netherlands, Germany, France and Spain.* Baltimore, 1966.

Munn, K. M. *A Contribution to the Study of Jean Lemaire de Belges.* New York, 1936.

Müntz, Eugene, and V. Massena, Prince of Essling. *Pétrarque.* Paris, 1902.

Müntz, Eugene. *La Tapisserie.* Paris, 1882.

———. "A Travers le comtat Venaissin: le mausolée du cardinal de Lagrange à Avignon," *Ami des monuments et des arts*, 4 (1890), pp. 91-95, 131-135.

Muratori, Ludovico Antonio. *Antiquitates italicae medii aevi.* 6 vols. Milan, 1938-1942.

Musper, Heinrich T. *Die Urausgaben der holländischen Apokalypse und Biblia pauperum.* 3 vols. Munich, 1961.

———. "Die Ars moriendi und die Meister ES," *Gutenberg Jahrbuch*, 1950, pp. 57-66.

Mussafia, A. *Appunti sulla visione di Tundalo.* Vienna, 1871.

Müther, Richard. *Die deutsche Buchillustration der Gotik und Frührenaissance, 1460-1530.* 2 vols. Munich and Leipzig, 1883-1884.

Le Mystère de Saint Adrien, ed. Emile Picot (Roxburghe Club). London, 1895.

Le Mystère de l'incarnation et nativité de Nôtre Seigneur et Redempteur Jesus-Christ réprésenté en 1474, ed. Philippe le Verdier. Rouen, 1886.

Le Mystère de la Passion d'Arnould Gréban, G. Paris and G. Raynaud, eds. Paris, 1878.

"Le Mystère de la Sainte Hostie," *Bulletin du*

Comité des travaux historiques. Section d'histoire et de philologie, 1893.

Le Mystère de saint Anthoni de Viennès, P. Guillaume, ed. Paris, 1884.

Nagler, G. K. Die Monogrammisten. 5 vols. Munich [1850].

Neri, Ferdinando. "Le tradizioni italiane della Sibilla," Studi medievali, 4 (1912-1913), pp. 213-230.

Nève, E. Des Travaux de J. Molanus sur l'iconographie chrétienne. Louvain, 1847.

Nodet, Victor. "Séance du 14 Juin," Bulletin de la Société Nationale des Antiquaires de France, 1905, pp. 238-240.

————. Le Tombeaux de Brou. Bourg, 1906.

Noel, J.-F., and P. Jahan. Les Gisants. Paris, 1949.

Nolle, G. "Die Legende von der fünfzehn Zeichen vor dem jüngste Gerichte," Beiträge zur Geschichte der deutschen Sprache und Literatur, 6 (1879), pp. 413-476.

Nordenfalk, Carl. "Saint Bridget of Sweden as Represented in Illuminated Manuscripts," De Artibus Opuscula XL, Essays in Honor of Erwin Panofsky, New York, 1961, pp. 371-393.

Nordstrom, Folke, Virtues and Vices on the 14th Century Corbels in the Choir of Uppsala Cathedral. Stockholm, 1956.

O'Connor, Mary Catherine. The Art of Dying Well. New York, 1942.

Offner, Richard. A Critical and Historical Corpus of Florentine Painting. Section III. 8 vols. New York, 1930-1969.

Oliger, Livario. "Les 'Meditationes vitae Christi' del Pseudo-Bonaventura," Studi Francescani, 7 (1920), pp. 143ff.

Omont, Henri. Psautier illustré (XIIIe siècle), Réproduction des 107 miniatures du manuscrit latin 8846 de la Bibliothèque Nationale. Paris, 1906.

Osten, Gert von der. "Christus im Elend, ein niederdeutsches Andachtsbild," Westfalen, 1952, pp. 185ff.

————. "Job and Christ," Journal of the Warburg and Courtauld Institutes, 16 (1953), pp. 153-158.

————. Der Schmerzensmann. Berlin, 1935.

Oudendijk-Pieterse, F.H.A. van der. Dürer's Rosenkranzfest, en de ikonografie der duitse Rozenfransgroepen van de XVe et het begin der XVIe eeuw. Amsterdam, 1939.

Ouin-Lacroix. Histoire des anciennes corporations d'arts et métiers et des confréries religieuses de la capitale de la Normandie. Rouen, 1850.

Oursel, C. "Le Rôle et la place de Cluny dans la renaissance de la sculpture en France à l'époque romane d'après quelques études et travaux récents," Revue archéologique, 17 (1923), pp. 255-289.

Paccully, Emile. "Le Retable d'Oporto," Gazette des beaux-arts, 18 (1897), pp. 196-204.

Pächt, Otto. "Zur Entstehung des Hieronimus im Gehaus," Pantheon, 3 (1963), pp. 131-142.

————. "Jean Fouquet, A Study of his Style," Journal of the Warburg and Courtauld Institutes, 4 (1940-1941), pp. 85-102.

————. The Rise of Pictorial Narrative in Twelfth-Century England. Oxford, 1962.

————. "Un Tableau de Jacquemart d'Hesdin?" Revue des arts, 3 (1956), pp. 149-160.

Palluchini, R. Giovanni Bellini. Milan, 1959.

Palustre, Léon. La Renaissance en France. 3 vols. Paris, 1879-1885.

Panofsky, Erwin. Albrecht Dürer. 2 vols. Princeton, 1948.

————, and F. Saxl. "Classical Mythology in Medieval Art," Metropolitan Museum Studies, 4 (1932-1933), pp. 228-280.

————. Early Netherlandish Painting. 2 vols. Cambridge, Mass., 1953.

————. "Jean Hey's 'Ecce Homo': Speculations about its Author, its Donor and its Iconography," Bulletin des musées royaux des beaux-arts, Brussels, 5 (1956), pp. 95-132.

————. Herkules am Scheidewege. Leipzig, 1930.

————, and F. Saxl. "A Late Antique Religious Symbol in Works by Holbein and Titian," Burlington Magazine, 2 (1926), pp. 177-181.

————, and Dora Panofsky. Pandora's Box. The Changing Aspects of a Mythical Symbol. Princeton, 1978.

————. "Reintegration of a Book of Hours Executed in the Workshop of the 'Maitre des Grandes Heures de Rohan,'" Medieval Studies in Honor of A. Kingsley Porter, Cambridge, Mass., II, 1939, pp. 479-499.

————. Renaissance and Renascences in Western Art. Stockholm, 1960.

————. Studies in Iconology, Humanistic Themes in the Art of the Renaissance. New York, 1939.

————. Tomb Sculpture: Four Lectures on its Changing Aspects from Ancient Egypt to Bernini, ed. H. W. Janson. New York, 1964.

Pardiac, J. B. "Notice sur les cloches de Bordeaux," Bulletin monumental, 24 (1858), pp. 227-273.

Paris, Bibliothèque Nationale. Henri Bouchot, ed. *Inventaire des dessins exécutés pour Roger de Gaignières*. 2 vols. Paris, 1891.

————. André Linzeler and Jean Adhémar, eds. *Inventaire du fonds français, graveurs du seizième siècle* (Département des Estampes). 2 vols. Paris, 1932.

————. Emile Mâle. *Les grandes Heures de Rohan*. Paris, 1947.

————. Henri Omont. *Evangiles avec peintures byzantines du XIe siècle*. 2 vols. Paris, 1908.

————. ————. *Heures d'Anne de Bretagne*. Paris, 1906.

————. *Les Manuscrits à peintures en France du XIIIe au XVIe siècle*. Paris, 1955.

————. Jean Porcher, ed. *Exhibition Catalogue: Byzance et la France médiévale*. Paris, 1958.

————, Institut Pédagogique National. *La Vie théâtrale au temps de la Renaissance*. Paris, 1953.

————, Musée National du Louvre. Henri Bouchot, ed. *Exposition des primitifs français au Palais du Louvre*, Paris, 1904.

————. Charles Sterling and Hélène Adhémar. *Peintures: Ecole française XIVe, XVe, XVIe siècles*. Paris, 1965.

Paris, Gaston, "La Danse macabre de Jean le Fèure," *Romania*, 12 (1895), pp. 129-132.

Patch, Howard Rollin. *The Other World, According to Description in Medieval Literature*. Cambridge, Mass., 1950.

Saint Patrick. *Le Purgatoire de Saint Patrice*, ed. Prosper Tarbé. Reims, 1862.

————. *Saint Patrick's Purgatory*, ed. T. Wright. London, 1844.

Peignot, E. G. *Recherches historiques sur les danses des morts*. Paris and Dijon, 1826.

Peltzer, Alfred. *Deutsche Mystik und deutsche Kunst*. Strasbourg, 1899.

Pépin, Jean. *Mythe et allégorie*. Paris, 1958.

Perdrizet, Paul. *Etude sur le speculum humanae salvationis*. Paris, 1908.

————. "La 'Mater Omnium' du Musée du Puy," *La Société française d'archéologie, Congrès archéologique de France*, Puy, 1904, pp. 570-584.

————. *La Vierge de miséricorde*. Paris, 1908.

Perraudière, X. de la. "Traditions locales et superstitions," *Mémoires de la société nationale d'agriculture, sciences et arts d'Angers*, 10 (1896), pp. 65-86.

Petit, Auguste. "Les Six Statues du jubé de la cathédrale de Limoges," *Bulletin de la société archéologique et historique du Limousin*, 62 (1912), pp. 144-148.

Petit de Julleville, Louis. *Histoire du théâtre en France*. 4 vols. Paris, 1882-1886.

————. *Répertoire du théâtre comique en France au moyen âge*. Paris, 1886.

Philip, Lotte Brand. *The Ghent Altarpiece and the Art of Jan Van Eyck*. Princeton, 1971.

————. "The 'Peddler' by Hieronymus Bosch, A Study in Detection," *Nederlands Kunsthistorisch Jaarboek*, 9 (1958), pp. 1-81.

Picard, E. "La Tombe de la famille le Maire," *Mémoires de la commission des antiquités du département de la Côte-d'Or*, 13 (1895-1900), pp. 33-42.

Pieters, F. *Le Triptique eucharistique de Thierry Bouts à l'église de St.-Pierre de Louvain*. Léau, 1926.

Pigeotte, L. *Etude sur les travaux d'achèvement de la cathédrale de Troyes*. Paris, 1870.

Pigler, A. "La Vierge aus épis," *Gazette des beaux-arts*, 74 (1932), pp. 129-136.

Pinder, W. "Zum Problem der 'Schönen Madonnen' um 1400," *Jahrbuch der preuszichen Kunstsammlungen*, 44 (1923), pp. 147-171.

Piolin, Léon-Paul. *Le Théâtre chrétien dans le Maine*. Mamers, 1891.

Piper, Ferdinand. *Mythologie und Symbolik der christlichen Kunst*. 2 vols. Weimar, 1847.

Plancher, Urbain. *Histoire générale et particulière de Bourgogne*. 3 vols. Dijon, 1739-1748.

Planiscig, L. *Luca della Robbia*. Vienna, 1940.

Pliny. *Natural History*, tr. H. Rackman (Loeb Classical Library). 10 vols. Cambridge, Mass., 1938-1962.

Poète, Marcel. *Commission du vieux Paris*. Paris, 1917.

Phlo, Joseph. *Die Verwendung des Naturabgusses in der italienischen Porträtplastik*. Würzburg, 1938.

Polge, H. *Topobibliographie monumentale de Gers*. Auch, 1952.

Pompen, A. "Bunyan's Pilgrimsreise," *De Katholiek*, 1914, pp. 222-240; 265-284.

Pope-Hennessy, John. *Italian Gothic Sculpture*. London, 1955.

————. *Italian Renaissance Sculpture*. London, 1958.

Popham, A. E. *Jean Duvet*. London, 1921.

Porcher, Jean. *Medieval French Miniatures*. New York (1960).

————. *The Rohan Book of Hours*. London, 1959.

————. "Les Très Belles Heures de Jean de Berry et les ateliers parisiens," *Scriptorium*, 7 (1953), pp. 121-123.

Porter, Arthur Kingsley. *Romanesque Sculpture of the Pilgrimage Roads*. 10 vols. Boston, 1923.

Pougnet, J. "Théorie et symbolisme des tons de la musique grégorienne," *Annales archéologiques*, 26 (1869), pp. 380-387.

Pradel, Pierre. *Michel Colombe, le dernier imagier gothique*. Paris, 1953.

————. "Nouveaux documents sur le tombeau de Jean de Berry, frère de Charles V," *Fondation Eugene Piot, Monuments et mémoires*, 49 (1957), pp. 141-157.

Prarond, P.C.E. *Saint-Vulfran d'Abbeville*. Paris and Abbeville, 1860.

Praz, Mario. *Studies in Seventeenth Century Imagery*. London, 1939.

Pressouyre, L. "Sculptures funéraires du XVIe siècle à Châlons-sur-Marne," *Gazette des beaux-arts*, 54 (1962), pp. 143-152.

Preuss, H. *Die Vorstellung vom Antichrist im späteren Mittelalter*. Leipzig, 1906.

Prioux, Stanislas. *Monographie de l'ancienne Saint-Yved de Braine*. Paris, 1859.

Prost, Bernard. "Notice historique sur les chevaliers de l'arquebuse de la ville de Poligny," *Bulletin de la société d'agricultures, sciences et arts de Poligny (Jura)*, 12 (1871), pp. 49-65, 97-113, 145-155, 193-198.

————. "Quelques documents sur l'histoire des arts en France d'après un recueil manuscrit de la bibliothèque de Rouen," *Gazette des beaux-arts*, 35 (1887), pp. 322-330.

————. "Recherches sur 'Les Peintres du Roi' antérieure au règne de Charles VI," *Les Etudes d'histoire du moyen âge dediées à Gabriel Monod*, 1896, pp. 389ff.

Puyvelde, Leo van. *La Peinture flamande au siècle des Van Eyck*. Brussels, 1953.

————. *Schilder-Kunst en tooneelvertooningen op he einde van de middeleeuwen*. Ghent, 1912.

Quarré, Pierre. *Chartreuse de Champmol, Foyer d'art au temps des ducs Valois*. Dijon, 1960.

————. "L'Influence de Simone Martini sur la sculpture bourguignonne," *Bulletin de la Société Nationale des Antiquaires de France*, 1960, pp. 53-55.

————. "Les Pleurants des tombeaux des ducs de Bourgogne à Dijon," *Bulletin de la Société Nationale des Antiquaires de France*, 1948-1949, pp. 124-132.

————. *La Sainte-Chapelle de Dijon* (Musée de Dijon), Dijon, 1962.

Quarré-Reybourbon, L. "Trois Recueils de portraits au crayon ou à la plume représentant des souverains ou de personnages de la France et des Pays-Bas," *Bulletin de la comité historiale du département du nord*, 23 (1900), pp. 1-127.

Quicherat, Jules. *Histoire du costume en France depuis les temps les plus reculés jusqu'à la fin du 18e siècle*. Paris, 1877.

Rabelais, François. *Pantagruel*, ed. R. Marchal. Lyon, 1935.

Rainer, Rudolf. Ars Moriendi von der Kunst des heilsamen Lebens und Sterbens. Cologne and Braz, 1957.

Rance de Guiseuil. *Les Chapelles de Notre-Dame de Dôle*. Paris, 1902.

Rampandahl, Erna. *Die Ikonographie der Kreuzabnahme von IX bis XVI Jahrhundert*. Bremen, 1916.

Randall, Lilian. *Images in the Margins of Gothic Manuscripts*. Berkeley, Cal., 1966.

Rapp, A. *Studien über den Zusammenhang des geistlichen Theaters mit der bildenden Kunst im ausgehenden Mittelalter*. Kallmünz, 1936.

Reallexikon zur deutschen Kunstgeschichte, eds. Otto Schmitt, Ernst Gall and L. H. Heydenreich. 6 vols. Stuttgart, 1948-1973.

Réau, Louis. *Histoire du vandalisme, Les Monuments détruits de l'art français*. 2 vols. Paris, 1959.

————. *Iconographie de l'art chrétien*. 3 vols. Paris, 1955-1959.

————. "L'Influence d'Albert Dürer sur l'art français," *Bulletin et mémoires de la société des antiquaires de France*, 1924, pp. 219-222.

————. *J.-B. Pigalle*. Paris, 1950.

Recluz, abbé. *Histoire de Saint Roch et de son culte*. Montpellier, 1858.

Régamey, Pié. *Les plus beaux textes sur la Vierge Marie*. Paris, 1946.

Régnier, Louis. *L'Eglise Notre-Dame d'Ecouis*. Paris and Rouen, 1913.

Reinach, Salomon. "Le Manuscrit des 'Chroniques' de Froissart à Breslau," *Gazette des beaux-arts*, 33 (1905), pp. 371-389.

————. "Notes de voyage," *Revue archéologique*, 7 (1906), pp. 349-355.

Reis-Santos, Luis. *Masterpieces of Flemish Painting of the XV and XVI Centuries in Portugal*. Lisbon, 1962.

Reitzenstein, Richard. *Die nordischen, persischen und christlichen Vorstellungen vom Weltuntergang* (Vorträge der Bibliothek Warburg, 1923-1924). Berlin, 1925.

Remouvier, J. *Des Gravures sur bois dans les livres de Simon Vostre libraire d'heures*. Paris, 1862.

Requin, H. *Un Tableau du roi René au musée de Villeneuve-les-Avignon*. Paris, 1890.

Rerum italicarum scriptores, ed. L. Muratori. 12 vols. Milan, 1723ff.

Reure, O. C. "Compte des funérailles de Gilberte d'Estampes," *Bulletin de la société de l'histoire de Paris*, 20 (1903), pp. 100-108.

Reuss, Edouard. "Les Sibylles chrétiennes," *Nouvelle revue de théologie* (Strasbourg), 3 (1861), pp. 193-274.

Reybekiel, W. von. "Der 'Fons vitae' in der christlichen Kunst," *Niederdeutsche Zeitschrift für Volkskunde*, 12 (1934), pp. 87-136.

Riano, J. F. *Report on a Collection of Photographs from Tapestries at the Royal Palace of Madrid.* London, 1875.

Ricci, Corrado. *Il Tempio Malatestiano.* Milan and Rome, 1925.

Rickert, Margaret. Review of F. Gorissen, "Jan Maelwael und die Brüder Limbourg; eine Nimereger Künstlerfamilie um die Wende des 14 Jhs," (*Vereeniging tot beoefening van Geldersche geschiedenis oudheidkunde en recht, Bijdragen en mededelingen*, 54 [1954], pp. 153-221), *Art Bulletin*, 39 (1957), pp. 73-74.

Riegl, Alois. "Das holländische Gruppenporträt," *Jahrbuch der kunsthistorischen Sammlungen des allerhöchsten Kaiserhauses*, 23 (1902), pp. 70-278.

Ring, Grete. "Beiträge zur Plastik von Tournai im 15. Jahrhundert," *Belgische Kunstdenkmäler*, ed. Paul Clemen. Berlin, 1925, I, pp. 269-291.

———. *A Century of French Painting, 1400-1500.* London, 1949.

Ringbom, Sixten. *Icon to Narrative.* Abo (Finland), 1965.

———. "'Maria in Soli' and the Virgin of the Rosary," *Journal of the Warburg and Courtauld Institutes*, 25 (1962), pp. 326-330.

Rinieri, L. *La verità sulla Santa Casa di Loreto.* Turin, 1950.

Ritter, Georges and Jean Lafond. *Manuscrits à peintures de l'école de Rouen.* Rouen and Paris, 1913.

Rivières, Edmond de. "Epigraphie albigeoise, ou recueil des inscriptions de l'arrondissement d'Albi (Tarn)," *Bulletin monumental*, 41 (1875), pp. 725-732.

Robb, David M. "The Iconography of the Annunciation in the Fourteenth and Fifteenth Centuries," *Art Bulletin*, 18 (1936), pp. 480-526.

Robb, Nesca. *Neoplatonism of the Italian Renaissance.* London, 1935.

Robbins, Rossel Hope. *Encyclopedia of Witchcraft and Demonology*, New York (1959).

Robert-Dumesnil, Alexandre-Pierre-François. *Le Peintre-graveur français, ou Catalogue raisonné des estampes gravées par les peintres et les dessinateurs de l'école française.* 11 vols. Paris, 1835-1871 (repr. Paris, 1967).

Robertson, D. W., Jr. *A Preface to Chaucer.* Princeton, 1962.

Robuchon, J. C. *Paysages et monuments du Poitou.* 13 vols. Paris, 1890-1894.

Roggen, A. *A. Beauneveu en het Katharianbeeld van Kortrijk.* Ghent, 1954.

Roggen, D. "De 'Fons vitae' van Klaas Sluter te Dijon," *Revue belge d'archéologie et d'histoire de l'art*, 5 (1935), pp. 107-118.

———. "De Kalvarieberg van Champmol," *Gentsche Bijdragen tot de Kunstgeschiedenis*, 3 (1936), pp. 31-85.

———. "De 'plorants' van Klaas Sluter te Dijon," *Gentsche Bijdragen tot de Kunstgeschiedenis*, 2 (1935), pp. 127-173.

———. "Prae-Sluteriaanse, Sluteriaanse, Post-Sluteriaanse Nederlandse Sculptuur," *Gentsche Bijdragen tot de Kunstgeschiedenis*, 16 (1955-1956), pp. 111-187.

Rolland, Paul. "Stèles funéraires tournaisiennes gothiques," *Revue belge d'archéologie et d'histoire*, 20 (1951), pp. 189-222.

Roman, Joseph H. *Manuel de sigillographie française.* Paris, 1912.

Roman, Jules. "Eglises peintes du département des Hautes-Alpes," *Réunion des sociétés des beaux-arts des départements*, 6 (1882), pp. 80-89.

———. "Le Tableau des vertus et des vices," *Mémoires de la société nationale des antiquaires de France*, 41 (1880), pp. 22-51.

Le Roman de Fauvel, par Gervais du Bus, ed. Arthur Longfors. Paris, 1914-1919.

Romane-Musculus, Paul. *Esquisse d'une doctrine reformée sur l'usage des images dans les églises.* Paris, 1935.

Ronan, M. V. *St. Anne, her Cult and her Shrines.* New York, 1927.

Rondot, Natalis. *Bernard Salomon.* Lyon, 1897.

———. "Jacques Morel, sculpteur lyonnais (1417-1459)," *Réunion des sociétés des beaux-arts des départements*, 13 (1889), pp. 622-652.

———. "Les Peintres de Lyons du quatorzième siècle," *Réunion des sociétés des beaux-arts des départements*, 11 (1887), pp. 425-591.

Rorimer, James. *The Hours of Jeanne d'Evreux, Queen of France.* New York, 1957.

Rosenberg, Adolf. *Raffael* (Klassiker der Kunst). Stuttgart and Leipzig, 1909.

Rosenblum, Robert. "The Paintings of Antoine Caron," *Marsyas*, 6 (1950-1953), pp. 1-7.

Rosenfeld, Hans-Friedrich. *Der Hl. Christophorus, seine Verehrung und seine Legende*. Abo (Finland), 1937.

———. *Der mittelalterliche Totentanz*. Münster and Cologne, 1954.

Rosenthal, E. *Giotto in des späten Mittelalters; seine Entstehungsgeschichte*. Augsburg, 1924.

Rossi, Attilio. "Les Ivoires gothiques français du musée sacré et profane de la bibliothèque Vaticane," *Gazette des beaux-arts*, 33 (1905), pp. 390-402.

Rossignol, C. "Saint-Seine-l'Abbaye," *Mémoires de la commission des antiquités du département de la Côte d'Or*, 2 (1847), pp. 193-286.

Rost, Hans. *Die Bibel im Mittelalter*. Augsburg, 1939.

Rostand, André. "Le Retable de Livry (Calvados)," *Revue de l'art chrétien*, 57 (1914), pp. 81-85.

Roth, F.W.E. *Lateinische Hymnen des Mittelalters, als Nachtrag zu den Hymnensammlung von Daniel, Mone, Vilmar und G. Morel, aus Handschriften und Incunabula*. 2 vols. Augsburg, 1887-1888.

Rötzler, W. *Die Begegnung der drei Lebenden und drei Toten*. Winterthur, 1961.

Rouit-Berger, Claude. "A propos de quelques sculptures disparues de l'église de Gisors," *Bulletin monumental*, 97 (1938), pp. 277-300.

Roy, Emile. *"Le Mystère de la Passion en France du XIVe au XVIe siècle,"* (Revue bourguignonne, 13-14). Paris and Dijon, 1903-1904.

Roy, Maurice. *Artistes et monuments de la Renaissance en France*. Paris, 1929.

———. "La Ste.-Chapelle du Bois de Vincennes," *Mémoires de la société nationale des antiquaires de France*, 71 (1911), pp. 225-287.

Rupin, Ernest. *L'Oeuvre de Limoges*. Paris, 1890.

———. "Peintures murales de l'église de Tauriac (Lot), XVIe siècle," *Revue de l'art chrétien*, 45 (1895), pp. 21-34.

Sainte-Suzanne, R. de Boyer. "Les Tapisseries d'Arras," *Bulletin monumental*, 45 (1879), pp. 85-100.

Salmi, Mario. *Grimani Breviary*. London, 1872.

Salzer, A. *Die Sinnbilder und Beiworte Mariens*. Linz, 1893.

Santi, Angelo D. *Les Litanies de la sainte Vierge; Etude historique et critique*, tr. A. Boudinhon. Paris, 1900.

Sartor, Marguerite. *Les Tapisseries, toiles, peintes et broderies*. Reims, 1912.

Sauerländer, Willibald. *Jean-Antoine Houdon: Voltaire; Einführung*. Stuttgart, 1963.

Sauval, H. *Histoire et recherches des antiquités de la ville de Paris*. 3 vols. Paris, 1724.

Saxer, Victor. *Le Culte de Marie Madeleine en occident des origines à la fin du moyen âge*. 2 vols. Paris, 1959.

Saxl, Fritz. " 'Allertungenden und Laster Abbildung'; Eine spätmittelalterliche Allegoriensammlung, ihre Quellen und ihre Beziehungen zu Werken des frühen Bilddrucks," *Festschrift Julius Schlosser zum 60. Geburtstage*. Vienna, 1927, pp. 104-121.

———, and Erwin Panofsky. *Dürers Melencolia I; ein quellen-und typengeschichtliche Untersuchung* (Kulturwissenschaftliche Bibliothek Warburg, Hamburg. Studien, II). Leipzig, 1923.

———. *Lectures* (Warburg Institute, University of London). 2 vols. London, 1957.

———. "The Literary Sources of the Finiguerra Planets," *Journal of the Warburg and Courtauld Institutes*, 2 (1939), pp. 346-367.

———. "Pagan Sacrifice in the Italian Renaissance," *Journal of the Warburg and Courtauld Institutes*, 2 (1939), pp. 346-367.

———. "Probleme der Planetenkinderbilder," *Kunstchronik*, 30 (1919), pp. 1013-1021.

———. "A Spiritual Encyclopedia of the Later Middle Ages," *Journal of the Warburg and Courtauld Institutes*, 5 (1942), pp. 82-134.

———. *Verzeichnis astrologischer und mythologischer illustrierter Handschriften des lateinischen Mittelalters* (Sitzungsberichte der Heidelbergerakademie der Wissenschaften). 8 vols. (vol. VIII, ed. Harry Bober), Heidelberg and London, 1916-1953.

Schapiro, Meyer. " 'Muscipula diaboli,' The Symbolism of the Mérode Altarpiece," *Art Bulletin*, 27 (1945), pp. 182-187.

Schaumkell, Ernst. *Der Kultus der heiligen Anna am Ausgange des Mittelalters*. Fribourg, 1893.

Schellenberg, Carl. *Dürers Apokalypse*. Munich, 1923.

Schiller, Gertrud. *Iconography of Christian Art*. 2 vols. Greenwich, Conn., 1971 (tr. of German ed., Gütersloh, 1969).

Schlegel, Ursula. "Observations on Masaccio's Trinity Fresco in Sta. Maria Novella," *Art Bulletin*, 45 (1963), pp. 19-53.

Schlosser, Julius von. "Geschichte der Porträtbildnerei in Wachs; Ein Versuch," *Jahrbuch der kunsthistorischen Sammlungen des allerhöchsten Kaiserhauses* (Vienna), 29 (1910), pp. 171-258.

Schlosser, Julius von. "Giustos Fresken in Padua und die Vorlaufer der Stanza della Segnatura," *Jahrbuch der kunsthistorischen Sammlungen des allerhöchsten Kaiserhauses* (Vienna), 17 (1896), pp. 13-100.

————. *La letteratura artistica; manuale delle fonti della storia dell'arte moderna*, tr. F. Rossi. Florence, 1964.

Schmidt, Gerhard. *Die Armenbibeln des XIV Jahrhunderts*. Graz, 1959.

Schmidt, P. H. *Die Illustration der Lutherbibel 1522-1570*. Basel, 1962.

Schmidt, Wilhelm. *Die frühesten und seltensten Denkmäler des Holz-und Metallschnittes*. 5 vols. Munich and Nuremberg, 1883-1884.

Schneider, Frederick. "La Legende de la Licorne ou du Monocéros," review by "J.H." *Revue de l'art chrétien*, 38 (1888), pp. 16-22.

Schnitzler, Joseph. *Savonarola; Ein Kulturbild aus der Zeit der Renaissance*. 2 vols. Munich, 1924.

Schöne, Wolfgang. *Dieric Bouts und seine Schule*. Berlin and Leipzig, 1938.

————. *Über das Licht in der Malerei*. Berlin, 1954.

Schreiber, W. L. *Manuel de l'amateur de la graveur sur bois et sur métal au XVe siècle*. 8 vols. Berlin, 1891-1911.

————. "Die Totentänze," *Zeitschrift für Bücherfreunde*, 2 (1898-1899), pp. 291-304.

Schubart, Herta. *Die Bibelillustration des Bernard Salomon* (diss., Hamburg, 1932). Amorbach (Bavaria), (1932).

Schultz, Alwin. "Der Weisskunig nach den Dictaten und eigenhändigen Aufzéichnungen Kaisers Maximilians I," *Jahrbuch der kunsthistorischen Sammlungen des allerhöchsten Kaiserhauses* (Vienna), 6 (1888), pp. 415-552.

Seelman, W. *Die Totentänze des Mittelalters*. Leipzig, 1893.

Sellier, Amédée. *Notice historique sur la compagnie des archers ou arbalétriers et ensuite des arquebusiers de la ville de Châlons-sur-Marne*. Châlons, 1857.

Sepet, Marius. *Les Prophètes du Christ; Etude sur les origines du théâtre au moyen âge*. (Bibliotheque de l'Ecole des Chartes). Paris, 1878.

Seroux d'Agincourt, Jean. *Histoire de l'art par les monuments*. 6 vols. Paris, 1823.

Servières, Georges. "Les Formes artistiques du 'Dict des Trois Morts et des Trois Vifs,'" *Gazette des beaux-arts*, 13 (1926), pp. 19-36.

Seymour, St. John D. *Irish Visions of the Other World*. London, 1930.

————. "The Signs of Doomsday in the 'Saltair na Rann,'" *Proceedings of the Royal Irish Academy*, 36 (1923), pp. 154-163.

Seznec, Jean. *The Survival of the Pagan Gods; The Mythological Tradition and its Place in Renaissance Humanism and Art* (Bollingen Series, no. 38), tr. Barbara F. Sessions. New York, 1953.

Shepard, Odell. *The Lore of the Unicorn*. London, 1930.

Shorr, Dorothy. *The Christ Child in Devotional Images in Italy during the XIV Century*. New York, 1954.

————. "The Mourning Virgin and St. John," *Art Bulletin*, 22 (1940), pp. 61-69.

Siciliano, I. *François Villon et les thèmes poétiques du moyen âge*. Paris, 1934.

Silvy, Léon. "L'Origine de la Vierge de Miséricorde," *Gazette des beaux-arts*, 34 (1909), pp. 401-410.

Simon, G. *Die Ikonographie der Grablegung Christi vom 9 bis 16 Jahrhundert*. Rostock, 1926.

Simon, Marcel. *Hercule et le christianisme*. Paris, 1955.

Simone, Franco. "La Scuola dei 'Rhetoriqueurs,'" *Belgafor*, 4 (1949), pp. 529-552.

Simson, Otto G. von. "'Compassio' and 'Co-Redemptio' in Roger van der Weyden's 'Descent from the Cross,'" *Art Bulletin*, 35 (1953), pp. 10-16.

Smith, Molly Teasdale. "Use of Grisaille as a Lenten Observance," *Marsyas*, 8 (1957-1959), pp. 43-54.

Smits, K. *De Iconografie van de Nederlandsche Primitieven*. Amsterdam, 1933.

Snyder, Susan. "The Left Hand of God: Despair in the Medieval and Renaissance Tradition," *Studies in the Renaissance*, 12 (1965), pp. 18-59.

Soleil, F. *Les Heures gothiques et la littérature pieuse en XVe et XVIe siècles*. Rouen, 1882.

Sophocles. *Oedipus the King*, tr. Francis Storr. New York, 1955.

Sommer, H. O. *The Kalendar of Shephardes*. London, 1892.

Sorel, A. "Notice sur les mystères représentés à Compiègne au moyen âge," *Bulletin de la société historique de Compiègne*, 2 (1875), pp. 35-55.

Soulier, Gustave. *Les Influences orientales dans la peinture toscane*. Paris, 1924.

Sozomen, S. H. *Ecclesiastical History*, eds. Henry Wace and Philip Schaff (A Select Library of Nicene and Post-Nicene Fathers, ii). New York, 1891.

Speculum humanae salvationis, eds. M. R. James and B. Berenson. Oxford, 1926.

————, ed. E. Kloss. Munich, 1925.

Spencer, Eleanor P. "L'Horloge de Sapience," *Scriptorium*, 17 (1963), pp. 277-299.

———. "The Master of the Duke of Bedford: The Bedford Hours," *Burlington Magazine*, 107 (1965), pp. 495-509.

Springer, Anton. *Das Nachleben der Antike im Mittelalter*. Paris, 1927.

Staedel, Else. *Ikonographie der Himmelfahrt Mariens*. Strasbourg, 1935.

Stammler, W. *Der Totentanz: Entstehung und Deutung*. Munich, 1948.

Starkie, Walter. *The Road to Santiago: Pilgrims of St. James*. New York, 1957.

Stechow, Wolfgang. "Joseph of Arimathea or Nicodemus?" *Studien zur toskanischen Kunst, Festschrift für Ludwig Heinrich Heydenreich*. Munich, 1964, pp. 289-303.

Stein, Henri. *Quelques lettres inédites du Primatice*. Fontainebleau, 1911.

Steinmann, Ernst. "Die Zerstörung der Grabdenkmäler der Päpste von Avignon," *Monatsheft für Kunstwissenschaft*, 11 (1918), pp. 145-171.

Stephenson, M. *A List of Monumental Brasses in the British Isles*. London, 1926.

Sterling, Charles, *Le Couronnement de la Vierge, par Enguerrand Quarton*. Paris, 1939.

———. *The Hours of Etienne Chevalier: Jean Fouquet*. New York, 1971.

———. "Une Peinture certaine de Perréal enfin retrouvée," *L'Oeil*, 103-104 (July-Aug., 1963), pp. 2-15.

St. Fergeux, Th. Pistolet de. "Tombe de Guibert de Celsoy." *Mémoires de la société historique et archéologique de Langres*, 1 (1847), pp. 243ff.

Stone, Lawrence. *Sculpture in Britain: The Middle Ages*. Baltimore, 1955.

Storck, Willy F. "Bemerkung zur französich-englischen Miniaturmalerei um die Wende des XIV Jahrhunderts," *Monatshefte für Kunstwissenschaft*, 4 (1911), pp. 123-126.

———. "Das 'Vado Mori,'" *Zeitschrift für deutsche Philologie*, 42 (1910), pp. 422-428.

Stothard, C. A. *The Monumental Effigies of Great Britain*. London, 1817.

Stridbeck, C. G. *Bruegelstudien*. Stockholm, 1956.

Stubblebine, James H. "Byzantine Influence on Thirteenth Century Italian Painting," *Dumbarton Oaks Papers*, 20 (1966), pp. 85-102.

Suso, Henry. *The Exemplar: Life and Writings of the Blessed Henry Suso*, ed. Nicholas Heller, tr. Ann Edward. Dubuque, Iowa, 1962.

Sussmann, Vera. "Maria mit dem Schutzmantel," *Marburger Jahrbuch für Kunstwissenschaft*, 5 (1929), pp. 285-352.

Symeonides, Sibilla. "An Altarpiece by the 'Lu-chese Master' of the Immaculate Conception," *Marsyas*, 8 (1959), pp. 55-66.

Tauler, Johannes. *Meditations on the Life and Passion of Our Lord Jesus Christ*, tr. A.J.P. Cruikshank. Westminster, 1906.

Taylor, Francis Henry. "'A Piece of Arras of the Judgment,' The Connection of Maître Philippe de Mol and Hugo van der Goes with the Medieval Religious Theater," *Worcester Art Museum Annual*, 1 (1935-1936), pp. 1-15.

Tenenti, Alberto, *Il Senso della morte e dell'amore della vita nel Rinascimento*. Turin, 1957.

———. *La Vie et la mort à travers l'art du XVe siècle*. Paris, 1952.

Tervarent, Guy de. *Attributs et symboles dans l'art profane, 1400-1600*. Geneva, 1958.

———. *Les Enigmes de l'art*. 4 vols. Paris, 1946.

———. *La Légende de sainte Ursule dans la littérature et l'art du moyen âge*. 2 vols. Paris, 1930.

Texier, abbé. "Iconographie de la mort," *Annales archéologiques*, 16 (1856), pp. 164-172.

Thausing, Moritz. *Albert Dürer, sa vie et ses oeuvres*, tr. Gustave Gruyer. Paris, 1878.

Thierry, Nicole and Michel. *Nouvelles Eglises rupestres de Cappadoce*. Paris, 1963.

Thoby, Paul. *Le Crucifix des origines au Concile de Trente, étude iconographique*. Paris, 1959.

Thode, Henry. *Dir heilige Franz von Assisi und die Anfänge der Kunst der Renaissance in Italien*. Berlin, 1904.

Thoison, Eugene. "Le Pseudo-retable de recloses," *Annales de la société historique et archéologique du Gatinais*, 18 (1900), pp. 1-17.

———. *Saint Mathurin*. Paris, 1889.

St. Thomas Aquinas. *Opera Omnia*. 8 vols. 1570 (repr. 16 vols. Rome, 1882-1948).

Thomas à Kempis. *Of the Imitation of Christ*, tr. Geoffrey Cumberledge (The World's Classics). London and New York, 1955.

Thomas, A. "Notice bibliographique sur Eustache Mercadé," *Romania*, 35 (1906), pp. 583-590.

———. "Le Théâtre à Paris et aux environs à la fin du XIVe siècle," *Romania*, 21 (1893), pp. 609-611.

Thomas, Alois. "Das Urbild der Gregoriusmesse," *Rivista di archeologia cristiana*, 10 (1933), pp. 51-70.

Thomas, M. *The Grandes Heures of Jean Duke of Berry*. New York, 1971.

Thomas-Bourgeois, C. A. "Le Personnage de la sibylle et la légende de l'ara coeli dans une

nativité wallone," *Revue belge de philologie et d'histoire*, 18 (1939), pp. 883-912.

Thompson, Henry Yates. *Illustrations of One Hundred Manuscripts in the Library of Henry Yates Thompson*. 7 vols. London, 1907-1918.

————. *The Book of Hours of Joan II, Queen of Navarre*. London, 1899.

Thorndike, Lynn. *A History of Magic and Experimental Science during the First Centuries of Our Era*. 6 vols. New York, 1923-1941.

Tietze-Conrat, E. *Mantegna*. London, 1955.

Teitze, Hans. *Titian, The Paintings and Drawings*. New York, 1950.

Timmers, J.J.M. *Symboliek en iconographie der Christelijke kunst*. Roermond and Maasejk, 1947.

Tischendorf, L. F. *Apocalypses apocriphae*. Leipzig, 1866.

Toesca, Pietro and Ferdinando Forlati. *Mosaics of St. Marks*. Greenwich, Conn., 1958.

————. *La Pittura e la miniatura nella Lombardia*. Milan, 1912.

Torraca, F. *Il teatro italiano dei secoli XII, XIV, XV*. Florence, 1885.

Tory, Geoffroy. *Champ Fleury*, tr. George B. Ives. New York, 1927.

Tours, Musée des Beaux-arts. *St. Martin dans l'art et l'imagerie: Exposition*. Tours, 1961.

Traver, Hope. *The Four Daughters of God; A Study of the Versions of This Allegory with Especial Reference to Those in Latin, French and English* (diss., Bryn Mawr). Philadelphia, 1907.

Trenkler, E. *Livre d'Heures: Handschrift 1855 des Oesterreichischen Nationalbibliothek*. Vienna, 1948.

Troescher, Georg. *Die burgundische Plastik de ausgehenden Mittelalters*. Frankfurt, 1940.

————. *Claus Sluter*. Freiburg-im-Breisgau, 1932.

————. "Die 'Pitié-de-Nostre Seigneur' oder 'Notgottes,'" *Wallraf-Richartz Jahrbuch*, 9 (1936), pp. 148-168.

Tuffrau, Paul. *Le Merveilleux Voyage de Saint Brandan à la recherche du Paradis*. Paris, 1925.

Tuve, Rosamund. "Notes on the Virtues and Vices," *Journal of the Warburg and Courtauld Institutes*, 26 (1963), pp. 264-303, and 27 (1964), pp. 42-72.

Underwood, Paul. "The Fountain of Life," *Dumbarton Oaks Papers*, 5 (1950), pp. 43-138.

Unterkircher, Franz, ed. *Die Wiener Biblia Pauperum*. 3 vols. Graz, 1962.

Urseau, Charles. *La Peinture décorative en Anjou du XVe au XVIIIe siècle*. Anjou, 1918.

Van Praet, J.-B. *Catalogue des livres imprimés sur vélin de la bibliothèque du roi*. 6 vols. Paris, 1822-1828.

Vasari, Giorgio. *Le vite de' più eccellenti pittori, scultori ed architetti*, ed. G. Milanesi. 9 vols. Florence, 1878-1885.

Vasseur, Charles. "Le Registre de la Charité de Surville," *Mémoires de la société des antiquaires de Normandie*, 5 (1963), pp. 549-570.

Venturi, A. *Storia dell'arte italiana*. 11 vols. Milan, 1907 (repr. Milan, 1967).

Verdier, Philippe. "L'allegoria della misericordia e della giustizia di Giambellino agli Uffizi," *Atti dell'Istituto Veneto di scienze, lettere ed arte*, 3 (1952-1953), pp. 97-116.

————. "A Medallion of the 'Ara Coeli' and the Netherlandish Enamels of the Fifteenth Century," *Journal of the Walters Art Gallery*, 29 (1961), pp. 8-37.

Vesly, Léon de. "Notice sur Pierre des Aubeaux," *Réunion des sociétés des beaux-arts des départements*, 25 (1901), pp. 406-413.

Vetter, Ewald. "Maria im brennenden Dornbush," *Das Münster*, 10 (1957), pp. 237-253.

————. *Maria im Rosenhag*. Düsseldorf, 1956.

Veuclin, E. "Artistes normands," *Réunion des sociétés des beaux-arts des départements*, 16 (1892), pp. 342-365.

————. *Notes inédites sur les corporations d'arts et métiers de Touraine*. Tours, 1885.

————. "Peintres verriers et autres artistes habitant la ville de Dreux au XVIe siècle," *Réunion des sociétés des beaux-arts des départements*, 24 (1900), pp. 139-144.

————. "Un Spécimen de la peinture sur verre," *Réunion des sociétés des beaux-arts des départements*, 24 (1900), pp. 135-138.

Viard, Jules. *Les Journaux du trésor de Charles le Bel*. 2 vols. Paris, 1917.

Vienna, Museum of Art History. *Europäische Kunst um 1400*. Vienna, 1962.

Vigo, P. *Le danze macabre in Italia*. Leghorn, 1878.

Villette, J. *L'Ange dan l'art de l'Occident*. Paris, 1940.

Villon, François. *Oeuvres*, ed. L. Thuasne. 3 vols. Paris, 1923.

Viollet, P. "Jehan Fouquet," *Gazettes des beaux-arts*, 23 (1867), pp. 97-112.

Visio Tungdali, ed. A. Wagner. Erlangen, 1881.

Vitry, P. *Michel Colombe*. Paris, 1901.

———— and G. Briere. *L'Eglise abbatiale de Saint-Denis*. Paris, 1908.

Vloberg, Maurice. *L'Eucharistie dans l'art*. 2 vols. Grenoble and Paris, 1946.

————. *La Madone aux roses*. Paris, 1930.

————. *La Vierge et l'enfant dans l'art français.* Paris, 1954.

Vöge, Wilhelm. *Jörg Syrlin der ältere und seine Bildwerke.* 2 vols. Berlin, 1950.

Voragine, Jacobus da. *The Golden Legend or Lives of the Saints as Englished by William Caxton,* ed. F. S. Ellis. 7 vols. London, 1930 (1st ed., 1900).

Voyage de Jacques le Saige de Douai, ed. H. R. Duthilloeul. Douai, 1852.

Voyage littéraire de deux religieux Bénédictins. 2 vols. Paris, 1717-1724.

Wackernagel, P. *Das deutsche Kirchenlied.* 5 vols. Leipzig, 1864-1877.

————. "Die Totentanz," *Zeitschrift für deutsches Alterthum,* 9 (1893), pp. 302-365.

Warburg, A. *Gesammelte Schriften,* ed. F. Saxl. 2 vols. Leipzig, 1932.

————. "Heidnisch-antike Weissagung in Wort und Bild zu Luthers Zeiten," *Gesammelte Schriften,* Leipzig, 1932, II, pp. 487-558.

————. "Italienische Kunst und internationale Astrologie im Palazzo Schifanoja zu Ferrar," *Gesammelte Schriften,* Leipzig, 1932, II, pp. 459-481.

Watson, Arthur. *Early Iconography of the Tree of Jesse.* London, 1934.

Weale, W. H. James, "La Dernière Peinture de Jean van Eyck," *Revue de l'art chrétien,* 45 (1902), pp. 1-6.

————, and Eugene Misset. *Analecta Liturgica.* London and Lille, 1888-1892.

Weber, Frederick Parkes. *Aspects of Death and Correlated Aspects of Life in Art, Epigram and Poetry.* London, 1918.

Weber, Paul. *Geistliches Schauspiel und kirchliche Kunst.* Stuttgart, 1894.

Wechssler, E. *Die Sage vom heiligen Gral.* Halle, 1898.

Weckwerth, A. "Der Ursprung des Bildepitaphs," *Zeitschrift für Kunstgeschichte,* 20 (1957), pp. 147-185.

Wedel, Theodore O. *The Medieval Attitude toward Astrology, Particularly in England.* New Haven, 1920.

Weinberger, Martin. "Remarks on the Role of the French Models within the Evolution of Gothic Tuscan Sculpture," *XXth Congress of the History of Art* (Studies in Western Art, I), Princeton, 1963, pp. 198-206.

Weinhold, Karl. *Weihnacht: Spiele und Lieder aus Süddeutschland.* Graz, 1855.

Weisbach, Werner. *Der Barock als Kunst der Gegenreformation.* Berlin, 1921.

————. *Trionfi.* Berlin, 1919.

Weiss, Roberto. "The Castle of Gaillon in 1509-1510," *Journal of the Warburg and Courtauld Institutes,* 16 (1953), pp. 1-12.

Weitzmann, Kurt, "Origin of the Threnos," *De Artibus Opuscula XL, Essays in Honor of Erwin Panofsky,* New York, 1970, pp. 476-490.

Wencelius, Léon. *Calvin et Rembrandt.* Paris, 1937.

————. *L'Esthétique de Calvin.* Paris, 1937.

Wentzel, Hans. "Ad Infantiam Christi zu der Kindheit unseres Herren, Das Werk des Künstlers," *Studien zur Ikonographie und Formgeschichte, Herbert Schrade zum 60. Geburtstag dargebracht von Kollegen und Schülern,* Stuttgart, 1960, pp. 134-160.

————. *Meisterwerke der Glasmalerei.* Berlin, 1954.

Werner, Martin. "The Madonna and Child Miniature in the Book of Kells, Part I," *Art Bulletin,* 54 (1972), pp. 1-23.

Wescher, Paul. *Jean Fouquet and His Time,* tr. E. Winkworth. London, 1947.

Weymann, Ursula. *Die seusesche Mystik und ihre Wirkung auf des bildende Kunst.* Berlin, 1938.

Whyte, Florence. *The Dance of Death in Spain and Catalonia.* Baltimore, 1931.

Winkler, Friedrich. "Paul de Limbourg in Florence," *Burlington Magazine,* 56 (1930), pp. 95-98.

Wittkower, Rudolf and Margot. *Born under Saturn.* London, 1963.

Wixom, William D. *Treasures from Medieval France.* Cleveland, 1967.

Woltmann, Alfred Friedrich. *Holbein und seine Zeit, des Künstlers Familie, Leben und Schaffen.* 2 vols. Leipzig, 1874-1876 (tr. Joseph Cundall, London, 1882).

Wormald, Francis. "The Throne of Solomon and St. Edward's Chair," *De Artibus Opuscula XL, Essays in Honor of Erwin Panofsky,* New York, 1961, pp. 532-539.

Wright, J. G. *A Study of the Themes of the Resurrection in the Medieval French Drama* (diss., Bryn Mawr), Philadelphia, 1935.

Wyard, Robert. *Histoire de l'abbaye de St.-Vincent de Laon.* Saint Quentin, 1858.

Young, Karl. *The Drama of the Medieval Church.* 2 vols. Oxford, 1933.

Yriarte, C. *Matteo Civitali.* Paris, 1886.

Zeri, F. *Pitture e Controriforma—l'arte senza tempo di Scipione da Gaeta.* Einaudi, 1957.

Zimmerman, Hilda. "Burkmairs Holzschnittfolge zur Genealogie," *Jahrbuch der königlichpreussischen Kunstsammlungen,* 36 (1915), pp. 39-64.

LIST OF ILLUSTRATIONS

INDEX

Library of Congress Cataloging in Publication Data

Mâle, Emile, 1862-1954.
 The late Middle Ages.

 (Studies in religious iconography) (Bollingen series; 90:3)
 Translation of: L'art religieux de la fin du Moyen Age en France. 5th ed.
 Bibliography: p.
 Includes index.
 1. Art, French. 2. Art, Medieval—France.
3. Christian art and symbolism—Medieval, 500-1500—
France. I. Bober, Harry, 1915- II. Title.
III. Series: Mâle, Emile, 1862-1954. Studies in
religious iconography. IV. Series: Bollingen series; 90:3.
N7949.A1M3313 1986 704.9′482′0944 84-26359
ISBN 0-691-09914-6 (alk. paper)